JUNE 20, 1982

DAD —

HAPPY FATHERS DAY !!

LOVE ALWAYS

Karen

FREDERIC REMINGTON

SELECTED WRITINGS

FREDERIC REMINGTON

SELECTED WRITINGS

Introduction by
Peggy and Harold Samuels

Compiled by
Frank Oppel

CASTLE

Table of Contents

FREDERIC REMINGTON
AS A LITERARY FELLOW

by Peggy and Harold Samuels

In the spring of 1900, when he was 38 years old and tall for the time at five feet nine inches, Frederic Remington weighed 295 pounds. He owned an estate in New Rochelle, an exclusive suburb of New York City, and he bought an island in the St. Lawrence River where he spent the summers.

A multi-talented man, he was the best-known magazine and book illustrator in the United States, concentrating on Western subjects in black and white. Despite his financial success, however, his role as an illustrator appeared to him to be confining, and he was beginning to see his future as a serious painter rather than as a commercial artist. His goal was "to make a part of American history his own" in fine art by chronicling the dramatic episodes that had highlighted the settlement of the West, but he feared that a decade and a half in illustration had tied him to the wrong image. His commercial background allowed the American art establishment to deprecate his accomplishments on the ground that every Remington painting told a story and story-telling paintings were not considered to be fine art.

He had also been sculpting since 1895. His statuettes of cowboys and Indians were the most popular small bronzes in the country, prominently displayed in Tiffany's window in the prestigious store on Union Square in New York City. As he said, cowboys were "cash" with him, in bronze or in paint, and his friend Theodore Roosevelt, who was Vice-President of the United States, complimented him on how he managed to "get close not only to the plainsman and the soldier, but to the half-breed and Indian" as well.

The recognition in painting that Remington wanted with all his might was to be elected a National Academician, the highest honor his peers could bestow. He was willing to quit illustrating to aid his cause but it did not help. In addition, the art establishment dismissed his statuettes as just illustrations in three dimensions. He was classed with handicrafters rather than with the European-trained sculptors, and the National Sculpture Society never invited him to exhibit at its shows. Acceptance as an artist of national rank seemed far away.

Along with his illustrating, painting, and modeling, he had been writing articles and stories for fourteen years, mainly on the West and the army. He had not gone to school to learn to write the way he had been trained as a painter, and he had not discussed the technique of writing with other authors the way he had learned to sculpt, but writing had always come easily to him. His style was journalistic, vigorous and direct. By 1900, he had over a hundred published pieces to his credit, and the illustrations for his own writings amounted to twenty per cent of all of his art.

He had begun to write in 1885, solely to explain to *Harper's* Eastern staff what his Western pictures were all about because he believed that his subjects would be strange to the public. Those first notes he sent required rewriting by the staff before publication, but soon the editors asked him to polish his submissions so that they could appear under his by-line. By 1889, the editor of *Century* magazine had told him that he was quite a "literary" fellow as he described the "Horses of the Plains" and reported on "A Scout with the Buffalo-Soldiers." In his sculpture, the first statuette "The Bronco Buster" remained the most popular with many of his fans, and in writing too, some authorities regarded these first articles as among his best.

By 1893, he was telling about and illustrating his own outdoor experiences in the Adirondacks and in the Rockies, as well as searching out remote pockets in the Southwest where cowboys rode an unfenced range. In 1897, he was still glorifying the cavalry, building up the military horsemen as an invincible force in war. The following year, however, the Spanish-American War involved Remington as a correspondent. He wrote and illustrated "With the Fifth Corps" as the view of the prudent man in the rear of the Cuban campaign, experiencing the horrors of battles but not the glory. Some of the tales he told immediately after the Cuban war, such as "The Story of the Dry Leaves," continued this melancholy theme, although he was his old optimistic self within a year.

He had begun to do short fiction in frontier dialect for the "Sundown Leflare" stories in 1897. Those were his compositional exercises and by 1900 he was ready to undertake the novel that he hoped would establish him as a master of Western fiction. His friend Owen Wister was a more versatile author, an "organ" to Remington's "drum," although Wister had not yet tried a novel either. Remington wanted to be first. He conceived of a radical idea: a story narrated from the standpoint of a wild Indian whose tribe was "pacified" by an army force like that of General George Custer in the years before the "Last Stand."

Unfortunately, Remington chose William Randolph Hearst as the publisher and Hearst was not able to print the story until 1905. Roosevelt told Remington then that "it may be true that no white man ever understood an Indian, but at any rate you convey the impression of understanding him." This book *The Way of an Indian* was rated as the best by a white man about Indians, a "high-spot" of American literature, but it was not published until three years after Owen Wister had written *The Virginian* to take over the field of the Western novel with a different kind of Anglo stereotype.

The Bookman named Remington and Wister jointly as the principal authors of Southwestern stories, but Remington had already given up writing by 1905. He had realized that he could not match Wister in popular appeal as an author, whereas in painting and in sculpting he had, since 1900, started to reach new and more satisfying heights as the leading Western artist of the day.

Paradoxically, there had never before been an artist in the Remington family, although there was plenty of precedent for writers. His father and uncle had both been journalists. The father was the star, the son of a Universalist minister whose ancestors had come from England in 1637. They lived in Canton, a college town in the rural North Country of New York State, where the upwardly striving Pierre Remington owned and edited the local newspaper in the cause of Republican politics.

Frederic Remington was an only child, born October 4, 1861. Eight weeks later, his father was mustered into the cavalry regiment he had helped to enroll for the Civil War. Pierre Remington rose from captain to brevet colonel, a slim figure whose dangling mustache and imperial made him resemble General Custer. Called faithful and fearless by his men, the Colonel was a legitimate Civil War hero.

At the expiration of his three-year enlistment, the Colonel returned to newspapering. He was a role model for his hyperactive physically-oriented mischievous son who relished the military aura while acting as the "bad boy" who painted cats, soaked dolls, and pinched girls. The Colonel personified the Universalist credo, treating his son as an individual to be taught by example and not by fear, making for a childhood that was happy and secure under a parental umbrella of continuous approval. When the Colonel received his second appointment as Collector of Customs in 1873, the family moved to Ogdensburg, New York on the Canadian border.

As a boy, Remington had doted on his dashing father but he took after his plump and stubborn mother. In the fall of 1875, he entered Vermont Episcopal Institute, a nationally known military school. The Colonel hoped that a taste of cadet life would influence his son toward a career in the army but the discipline was too strict, the courses too difficult, and the food too scanty. Remington transferred to Highland Military Academy in Massachusetts for the next two years. His highest cadet rank was acting corporal and he made lots of bold but disproportionate figure sketches.

He initially intended to go to Cornell to study journalism, to follow his father's profession, but painting won out and he enrolled in the Yale School of Fine Arts in New Haven, Connecticut for the school year 1878-79. He was a disinterested art student because the drawing classes used plaster casts as models instead of figures in action. In his second year, he was picked as a varsity rusher, a lineman on the last of the 15-man football teams. When his father became terminally ill during Christmas vacation, he dropped out of art school.

After the Colonel died in February 1880, Remington's uncle got him a record-keeping job for the state in Albany. The work was detailed and boring. When his proposal of marriage to a local young woman was refused, he became one of the "wild clerks," unhappy in his job and a worry to his family. In the summer of 1881, his uncles agreed to "a trial of life on a ranche" in the West to try to settle him down. He was in Montana and Wyoming when the hunters were wiping out a million buffalo, cattle ranching was in its infancy, and Indians were still savage. The experience was brief but Remington had "been thar." From Wyoming, he began his career as an artist by sending *Harper's Weekly* "a little sketch on wrapping paper, all scrambled up in a small envelope," that was published after being redrawn by a staff artist.

At 21 on October 4, 1882, he received a substantial inheritance under his father's will and promptly bought a sheep ranch in Kansas. He soon settled into the role of a "holiday sheepman," assigning the heavy work to the hired hands and abandoning the ranch for trips into nearby Indian Territory where he sketched. After ten months as a careless rancher, he left Kansas for Canton, recovering most of his investment just before a crash in ranch and stock prices.

By February 1884, he had moved to Kansas City, Missouri to become an iron broker. That venture did not work out either, and he invested his remaining funds in a secret partnership in a Kansas City saloon. In August, he heard that the woman he had proposed to four years earlier was still unwed. He went East, married her, and brought her to Kansas City. He did not tell her about the silent saloon-keeping but the ownership became known by chance. She returned East before the holidays while he stayed on in Kansas City, losing his investment completely before selling a few paintings and a second sketch to *Harper's Weekly.* When those earnings were dissipated, he rode penniless into the desert to fill a portfolio with drawings.

On borrowed funds, he was reunited with his wife in a shared Brooklyn apartment so that he could make the rounds of the publishers to attempt to sell his sketches. It was an opportune time because of popular interest in the Southwest that had been aroused by the struggles of the army to capture Geronimo, a renegade Apache. *Harper's Weekly* promptly launched Remington as a professional illustrator and commissioned him to make a June, 1886 trip into the Southwest desert to report on the cavalry chase after Geronimo and on soldiering in Arizona. He returned as a *Harper's* expert on Western illustration and also made a series of Geronimo drawings for *Outing the magazine.* In his first year as an illustrator, he earned about $1,200, twice the pay of a schoolteacher or a minister at that time.

He had been influenced by the style of the French military painters in these early realistic drawings that were adapted from the tens of photographs he had taken in Arizona and Mexico. What made his work unique, however, was his ability to capture figures in motion, with white, black and red men caught in the course of violent acts. He also presented an entirely different depiction of the running horse, one that departed completely from the hobbyhorses of the past in favor of a new version of the gallop that was proved by instantaneous photography. In the fall of 1887, he was commissioned to do the illustrations for Theodore Roosevelt's *Ranch Life and the Hunting Trail*, a book that was immediately a Western standard. After only two years, Remington had become one of the chief Western illustrators. His earnings doubled in 1887 and he was able to move to a posh apartment in Manhattan so he could ride in Central Park. He said that the other illustrators envied him, and that his " 'getting there' makes some of these old barnacles tired."

In April, 1888, *Century* asked Remington to sketch the "Wild Tribes" in Indian

Territory and to write his own stories. This was his start as the "literary" man, although he protested at first, saying that he had no experience other than writing his name on the reverse of a train ticket. His purpose in making the trip was to concentrate on the "Black Buffaloes," the black cavalrymen whose tightly curled hair reminded the Indians of the fur on a bison. He was taken on a scout led by a white officer who tried to make the ride so exhausting that Remington would quit. Instead, Remington loved the experience. The tour of the "Wild Tribes" that followed was just anticlimactic.

Back in his studio, he was "rushed to death" with illustrations, articles, prints, and some serious paintings. He was rich, a businessman at a trade thought to be for dreamers. His wife said that "he is talked about more than any artist in the country," as he went on Western, Canadian, and Mexican trips for sketches and stories. In 1890, he wrote the classic reports on the Sioux outbreak at Wounded Knee. To the public, the West had become what Remington made it. "Eastern people have formed their conceptions of what Far Western life is like," the critics declared, "more from what they have seen in Mr. Remington's pictures than from any other source." He also travelled to Russia and Africa on assignments. In 1895, his bronze statuette "The Bronco Buster" was the art event of the year, and the sales put a Steinway piano in his wife's Christmas stocking. He had become a wide mix of talents — sculptor, painter, illustrator, writer, correspondent, engineer, military expert, and inventor.

In December 1896, Hearst's "Yellow Press" New York *Journal* hired Remington to report on the state of the Cuban revolt against Spain. From Cuba, he told Hearst that "there will be no war. I wish to return." Hearst replied that "you furnish the pictures and I'll furnish the war." Remington returned anyhow, and wrote and drew pro-Cuban propaganda. When war was declared April 25, 1898, Remington went to Cuba as a correspondent for the *Journal, Harper's Weekly, Harper's Monthly,* the *Chicago Tribune,* and the publishing house of R. H. Russell. He saw the war as a killing ground rather than the swooping cavalry tactics he had visualized. Feverish and disillusioned, he left Cuba as soon as he could after the Battle of San Juan Hill, but his pictures and articles on the war were among the best.

After a year, he was happily doing cowboys and Indians again, saying, "That old cleaning up of the West, *That was my war,*" rather than the bloody Cuban variety. His position as the leading Western painter was being challenged, however, and he could not satisfy himself in modernizing the colors on his palette, to go from the old realism to the new impressionism that he admired. There was no prospect of election to the National Academy and his later statuettes never equalled the acceptance of his first bronze, "The Bronco Buster." At the same time, his short writings were well received and were being reprinted into popular anthologies so he devoted himself to the novel for Hearst, *The Way of an Indian.* While the publication of the Indian tale was delayed, he wrote another novel *John Ermine* that became a Broadway play, but the rewards of authorship were insufficient for him. The period of his writing and his illustrating ended. Serious painting and sculpture became his money makers.

He signed a contract with *Collier's* to reproduce his fine art paintings in the magazine, assuring financial independence. In May 1905 he began modeling a twelve-foot statue of a mounted cowboy for Fairmount Park in Philadelphia and he carried the sculpture into bronze without a hitch. His small bronzes were gaining establishment recognition. He called it "a brevet before death" when the Corcoran Gallery in Washington bought one statuette and the Metropolitan Museum of Art in New York City bought four. His friends were now the members of The Ten American Impressionists, and through them, he was adapting French Impressionism to his own Western American figures in action, concentrating on light and the illusion of vibration.

At his exhibition of paintings the end of 1908, the critics finally came around to acknowledging his greatness in color, composition, and authenticity. "I have landed among the painters," he gloated, "and well up to[o]." In May 1909, he sold his estate in New Rochelle and moved into a new mansion in Ridgefield, Connecti-

cut. His Western friends at a dinner for Buffalo Bill Cody proposed a Remington statue of an American Indian to dwarf the Frenchy Statue of Liberty in New York harbor.

For Remington, one wonderful art event followed quickly on another. *Scribner's* planned a retrospective article for January 1910. He completed models for two complex statuettes, rejoicing that he "never was so happy and so well in many a year." The National Museum purchased "Fired On," his first painting bought for a museum. His December 11, 1909 painting exhibition was reviewed as "a chronicle intimately connected with the origins of a great nation, splendid, epic, and historically important." His hopes were all coming true and he was looking forward to a commission to paint a mural of Seneca Indians in Albany.

On December 18th, he wrenched a stomach muscle shelling corn for the chickens. Two days later, he "was caught with intense pains in belly." He thought the pains were either from the muscle strain or from constipation, and he took a strong laxative. The pains were appendicitis, the laxative caused peritonitis, and on December 26th he was dead.

1.
Vagabonding
with the
Tenth Horse

THE COSMOPOLITAN.

From every man according to his ability: to every one according to his needs.

FEBRUARY, 1897.

Drawn by
Frederic Remington.

VAGABONDING WITH THE TENTH HORSE.

By Frederic Remington.

WHEN once an order is published in the military way it closes debate, consequently, on the day set by order for the troops to take up their outward march from Fort Assiniboine it was raining; but that did not matter. The horses in front of the officers' club stood humped up in their middles, their tails were hauled down tight and the water ran off their sides in tiny rivulets. If horses could talk they would have said, D—— the order, or at least I think they felt like their riders, and that is what they said.

It is not necessary to tell what we did in the club at that early hour of the day; but Major Wint slapped his boot-leg with his quirt and proceeded toward the door, we following. Major Kelly, who was to stay behind to guard the women and children, made some disparaging remarks about my English "riding things" —called them "the queen's breeches" —but he is not a serious man, and moreover he is Irish.

Down at the corrals the trumpets were going and the major mounted his horse. Three troops and the band of the Tenth marched out of the post and lined up on

3

the prairie. Down the front trotted the major to inspect, while the rain pattered and drained on the oil-skin "slickers" of the cavalrymen. I rode slowly up behind the command, enjoying myself—it being such a delight for me when I see good horses and hardy men, divested of military fuss. The stately march of the Seventh New York, or Squadron A, when it is doing its prettiest, fills my eye; but it does not inflate my soul. Too deadly prosaic, or possibly I discount it; anyhow, the Tenth Cavalry never had a "soft detail" since it was organized, and it is full of old soldiers who know what it is all about, this soldiering. They presently went slipping and sliding into column, and with the wagons following the march begins.

"Did you forget the wash-basin, Carter?" asks one of our mess.

"Yes. D—— modern invention! If this rain keeps up we won't need it," replies my host as he muffles up in his slicker, and, turning, says, "Sergeant, make that recruit sit up in his saddle—catch him lounging again make him pull mud."

"Man, sit up thar; yu ride laik yu wus in a box-car; be hittin de flat fust, yu reckon," reiterates the non-com.

And it rains, rains, rains, as mile after mile the little column goes bobity-bobity-bob up and down over the hills. But I like it. I am unable to say why, except that after I left school I did considerable of this bobity-bob over the great strange stretches of the high plains, and I have never found anything else so fascinating. The soldiers like it too, for while it is set, in its way, it is vagabonding nevertheless. I have often thought how fortunate it is that I am not secretary of war, because I should certainly burn or sell every barrack in the country and keep the soldiers under canvas and on the move.

The cavalrymen wear great oil-skin coats which cover them from hat-rim to boot-sole, in the buying of which they imitate the cow-boys, a thing which is always good for cavalry to do. There are some Montana horses in the command, fierce, vicious brutes, which do a little circus as we pass along, making every one grin smoothly except the man on the circus horse. His sentences come out in chucks: "Dog-gone, yu black son," and

the horse strikes on his forefeet; "I'll break yu haid wid——" up goes the horse in front, the carbine comes out at the socket—"a rock." His hat goes off and his cup, canteen, bags and rope play a rataplan. In plugs the spur, up mounts the pony like the sweep of an angel's wing. Oh, it is good to look upon.

In the afternoon, far on ahead, we see the infantry tents with the cook-fires going. They had started the day before and were now comfortable. As the cavalry passed the "dough-boys" stood grinning cheerfully by their fires.

"Say, honey; is yu feet muddy?" sings out an ironical cavalryman to the infantry group; but the reply comes quick, "Oh, Mr. Jones, can I come up and see yu groom yu horse this evenin'?" A great guffaw goes up, while the mounted one shrugs up in his slicker and spurs along.

The picket lines go down, the wagons are unpacked, and the herds of horse go trotting off over the hill to browse and roll. Every man about camp has something to do. Here is where the first sergeant looms up, for he who can get the most jumps out of his men has the quickest and neatest camp. It takes more ability to be a good first sergeant than it does to run a staff corps. Each troop has its complement of recruits who have never been in camp before, and to them the old non-com. addresses himself as he strides about, overlooking things.

"You sergeants stand around here laik a lot come-latelies; get these men to doin' somethin'. Throw dat cigarette away. Take hold of this pin. Done yu talk back. I'll tak hold of yu in a minute, and if I do I'll spoil yu."

In the colored regiments these first sergeants are all old soldiers—thirty years and upward in the frontier service. What will be done to replace them when they expire is a question; or rather nothing will be done. Their like will never come again, because the arduous conditions which produced them can never re-occur, unless you let me be secretary of war and burn the barracks.

The tents being up we managed a very bad supper. We had suspected, but we did not know until now, that the officer who was appointed to run our mess was in love. "All the world loves a lover,"

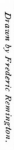

THE "DOUGH-BOYS" ON THE MARCH.

but he was an exception. That night I did not sleep a wink, having drunk a quart cup of coffee—that kola-nut of the American soldier and the secret of the long marches he has made in his campaigns. I had made out to drowse a little toward morning, when a tender young Missouri mule began a shrill "haugh-ha, haugh-ha," at the approach of the hour for half rations of grain, while presently the bugles split the dawn. Shortly an orderly came in and wanted to know if he could do up my bedding. Before having fairly gotten my boots on, the tent was pulled down over my head, and there I sat in an ocean of frosty grass bounded on one side by mountains covered with snow. Across the horizon was a streak of light, before which stood my tent-mates humped in their "slickers" and stamping from one foot to another as they talked.

" How are you this fine morning, you old citizen ?" asks my host.

" If I wasn't a d—— fool I'd be miserable, thank you."

The horses are released from the picket lines and go thundering off over the hills, kicking and neighing, glad to get the frost out of their muscles. A herder tries to mount his excited horse bareback; it plunges, rears and falls backward, spilling the man, and before he recovers the horse has got away.

" Huh!" says a soldier pulling tent-pegs near me; " dats de old Cæsar horse; I knows him. 'Pears laik he knows a recruit when he sees one."

" What have you got for breakfast ?" I ask of the lover.

"Crackers and canned tomatoes—our mess kit is not yet in order. I'll give you your breakfast bacon for dinner," he answers; but he forgets that I am solid with the infantry mess, where I betook myself.

After breakfast the march begins. A bicycle corps pulls out ahead. It is heavy wheeling and pretty bumpy on the grass, where they are compelled to ride, but they managed far better than one would anticipate. Then came the infantry in an open column of fours, heavy-marching order. The physique of the black soldiers must be admired—great chested, broad shouldered, up-standing fellows, with bull necks, as with their rifles

thrown across their packs they straddle along.

United States regular infantry in full kit and campaign rig impresses one as very useful and businesslike. There is nothing to relieve the uniform or make it gay. Their whole clothing and equipment grew up in the field, and the field doesn't grow tin-pots for head-gear or white cross-belts for the enemy to draw dead-centers on. Every means are used to keep men from falling out of ranks, for almost any reason they may allege as an excuse. Often to fall out only means that when camp is reached the unfortunate one must continue to march backward and forward before the company line, while his comrades are making themselves comfortable, until—well, until he is decided that he won't fall out again.

"I know why so many of dem battles is victorious," said one trudging darkey to another.

"Why ?" he is asked.

" Dey march de men so hard to get thar, dat dey is too tired to run away."

Very naturally when with infantry and transportation, the cavalry have time to improve their mind. Later in the day the sun came out, and Major Wint made them do "some of the things which the fools write in the books," as I heard it put. We were on a perfectly flat plain where you could see for ten miles—an ideal place for paper work. The major threw an advance and flankers, and every one had a hack at the command. I forget how many troops of cavalry I represented, but I did not have enough, and notwithstanding the brilliancy of my attack I got properly "licked." At any rate, after it was all over we knew more than the fellows who write the books, and besides, it was great fun. Handling cavalry troops is an art, not a science, and it is given to few men to think and act quickly enough. As for mistakes, it is a question how many an officer ought to be allowed to make before he has to hunt up another business where he will not have to decide between right and wrong or good and bad in the fraction of a second. It is quite startling how quickly good cavalry "rides home" over eight hundred yards of ground, and when one has to do something to meet it, he has no time to whittle a stick over the matter.

Moreover, I never expect to meet any really great cavalrymen who weigh over one hundred and sixty pounds.

Some of the old sergeants have been taught their battle tactics in a school where the fellows who were not quick at learning are dead. I have forgotten a great many miles of road as I talked to old Sergeant Shropshire. His experiences were grave and gay and infinitely varied.

them young fellers ahead thar—lots of 'em 'll nevah make soldiers in God's world. Now you see that black feller just turnin' his head; well, he's a 'cruit, and he thinks I been abusin' him for a long time. Other day he comes to me and says he don't want no more trouble; says I can get along with him from now on. Says I to that 'cruit, ' Blame yer eyes, I don't have to get along wid you; you have to get

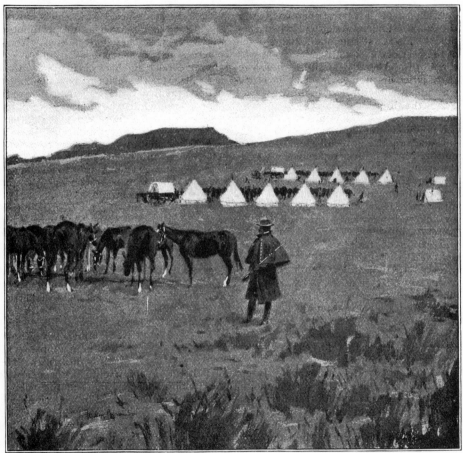

Drawn by Frederic Remington. ·SUNRISE IN THE BEAR PAWS.

"We used to have a fight every day down on the Washita, Mr. Remington," said he, "and them Indians used to attack accordin' to your ideas. A feller on the flanks nevah knew what minute he was goin' to have a horse-race back to the command, with anywhar from ten to five hundred Indians a close second.

"Ah, Mr. Remington, we used to have soldiers in them days. Now you take

along wid me. Understand?'" The column halted.

"What is the trouble, Shropshire?"

"Mule got disgusted, I reckon, sah," said he; and I rode ahead to find a "government six" stuck in the bed of a creek. I sat on the top of the bank as the dismounted men and mules and whips and sand flew, while to my ears came the lashing, the stamping, yelling and pro-

fanity. The thing was gotten out when the long lines of cavalry horses stood under the cut bank and drank at the brook, greenish-yellow with the reflection of the bank above, while the negro cavalrymen carried on conversations with their horses. Strange people, but yet not half as strange as Indians in this respect, for between these natural people and horses there is something in common which educated white men don't know anything whatever about. It is perfectly apparent that the horses understand them when they talk. This is not true of all the men, but of the best ones. That is one reason why it ought to be legally possible, when a recruit jerks his horse's head or is otherwise impatient with him, to hit the recruit over the head with a six-shooter, whereas all an officer can now do is to take him one side and promise faithfully to murder him if he ever repeats the error.

In due time the major made a permanent camp on a flat under the Bear Paw range and everything was gotten "shipshape" and "Bristol fashion," all of which nicety is to indicate to the recruit that when he rolls over in his sleep, the operation must be attended to with geometrical reference to the center-pole of the major's

Drawn by Frederic Remington.

A VIDETTE.

tepee. All about was an inspiring sweep, high rolling plains, with rough mountains, intersecting coulées and a well-brushed creek bottom, in all, enough land to maneuver forty thousand men under cover, yet within sight of the camp, and for cavalry all one could wish. Officer's patrols were sent out to meet each other through the hills. I accompanied the major, and we sat like two buzzards on a pinnacle of rock, using our field-glasses so cleverly that no one could tell what we saw by studying our movements through their own, yet we had the contestants under sight all the time.

There was an attack on the camp led by Mr. Carter Johnson, one of the most skilful and persistent cavalrymen of the

young men in the army, General Miles has said. His command was the mounted band which was to represent three troops, and with these he marched off into the hills. The camp itself was commanded on one side by a high hill on top of which the infantry rifle pitted and lay down. From here we could see everywhere, and I had previously told Mr. Johnson that I thought the camp perfectly safe, covered as it was by the intrenched infantry. It is a fact that officers have such enthusiasm each for his own arm that infantry take cavalry as they do " summer girls," whereas cavalrymen are all dying to get among "foot" and hack them up. Neither is right but both spirits are commendable.

Few cavalry orderlies stood near me while the infantry were intrenching.

" How much dirt does a dough-boy need for to protect him?" asked the saber.

"There ought to be enough on 'em to protect 'em," laughs his comrade.

But Mr. Johnson had told me that he was going to charge the infantry just for the lark, and for this I waited. I cannot tell all that happened on that field of battle, but Mr. Johnson snapped his "wind jammers" over those hills in a most reckless manner. He met the subtle approaches of his enemy at every point, cut off a flank of the defending party, and advanced in a covered way to the final attack. He drew the fire of the infantry while replying, dismounted at long range, disappeared and reappeared, coming like mad down a cut right on top of a troop of defenders. From here on I shall not admit it was "war, but it was magnificent." On he came, with yells and straining horses, right through the camp, individual men wrestling each other off their horses, upsetting each other over the tent ropes, and then in column he took off down a cut bank at least six feet high, ploughed through the creek with the water flying, and disappeared under our hill. In an instant he came bound-

Drawn by Frederic Remington.

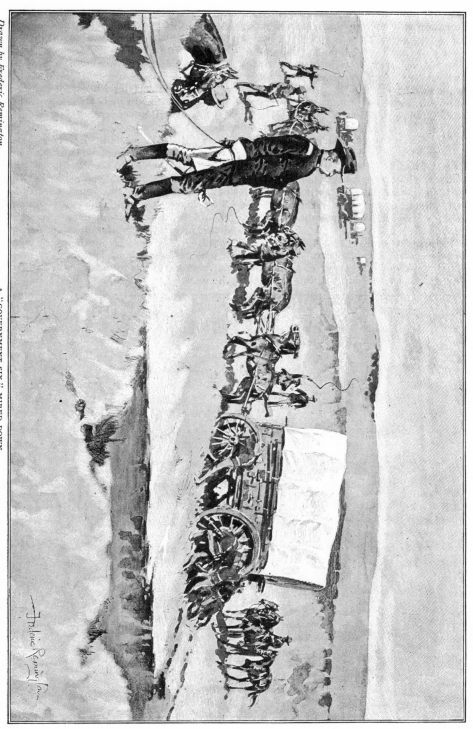

A "GOVERNMENT SIX" MIRED DOWN.

ing up, his squad in line, the horses snorting and the darkies' eyes sticking out like saucers. It was a piece of daring riding and well delivered as a charge, but the festive dough-boys lighted cigarettes and said, "Carter, your d—— band ought to be ready for burial long before now." Heroism does not count in maneuvers and miracles are barred.

This is, in my opinion, the sort of thing our militia should undertake, and they ought to eliminate any "cut-and-dried" affairs. It should be done in September, when the weather is cool, because men not accustomed to outdoor life cannot stand immediately either extreme heat or cold and do what should be expected of them.

Permanent camps like Peekskill are but one step in advance of an armory. They were good in their day but their day is passed in our militia—we have

progressed beyond it. Men will be found to like "life on the road," and officers will find that where the conditions of country are ever changing, a week's "advance and outpost" work will eclipse all the books they have ever indulged in. One of the most intelligent of military authorities, Col. Francis Green, says that our troops will never be called on to fight rural communities, but will operate in cities. This is probably true, but practice marches could be made through populous sections, with these villages, railroad tracks, fences, stone walls and other top-hamper to simulate conditions to be expected. Such a command should be constantly menaced by small detachments, under the most active and intelligent officers belonging to it, when it will be found that affairs usually made perfunctory begin to mean something to the men.

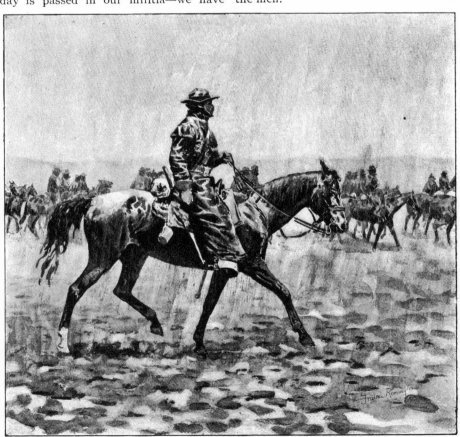

Drawn by Frederic Remington. WRAPPED IN THEIR "SLICKERS."

2.
How the Law
Got Into
the Chaparral

HOW THE LAW GOT INTO THE CHAPARRAL.

BY FREDERIC REMINGTON.

"YOU have heard about the Texas Rangers?" said the Deacon to me one night, in the San Antonio Club. "Yes? Well, come up to my rooms, and I will introduce you to one of the old originals—dates 'way back in the 'thirties'—there aren't many of them left now—and if we can get him to talk, he will tell you stories that will make your eyes hang out on your shirt front."

We entered the Deacon's cozy bachelor apartments, where I was introduced to Colonel "Rip" Ford, of the old-time Texas Rangers. I found him a very old man, with a wealth of snow-white hair and beard—bent, but not withered. As he sunk on his stiffened limbs into the arm-chair, we disposed ourselves quietly and almost reverentially, while we lighted cigars. We began the approaches by which we hoped to loosen the history of a wild past from one of the very few tongues which can still wag on the days when the Texans, the Comanches, and the Mexicans chased one another over the plains of Texas, and shot and stabbed to find who should inherit the land.

Through the veil of tobacco smoke the ancient warrior spoke his sentences slowly, at intervals, as his mind gradually separated and arranged the details of countless fights. His head bowed in thought; anon it rose sharply at recollections, and as he breathed, the shouts and lamentations of crushed men — the yells and shots—the thunder of horses' hoofs—the full fury of the desert combats came to the pricking ears of the Deacon and me.

We saw through the smoke the brave young faces of the hosts which poured into Texas to war with the enemies of their race. They were clad in loose hunting-frocks, leather leggings, and broad black hats; had powder-horns and shot-pouches hung about them; were armed with bowie-knives, Mississippi rifles, and horse-pistols; rode Spanish ponies, and were impelled by Destiny to conquer, like their remote ancestors, "the godless hosts of Pagan" who "came swimming o'er the Northern Sea."

"Rip" Ford had not yet acquired his front name in 1836, when he enlisted in the famous Captain Jack Hayes's company of Rangers, which was fighting the Mexicans in those days, and also trying incidentally to keep from being eaten up by the Comanches.

Said the old Colonel: "A merchant from our country journeyed to New York, and Colonel Colt, who was a friend of his, gave him two five-shooters—pistols they were, and little things. The merchant in turn presented them to Captain Jack Hayes. The captain liked them so well that he did not rest till every man jack of us had two apiece.

"Directly," mused the ancient one, with a smile of pleasant recollection, "we had a fight with the Comanches—up here above San Antonio. Hayes had fifteen men with him—he was doubling about the country for Indians. He found 'sign,' and after cutting their trail several times he could see that they were following him. Directly the Indians overtook the Rangers—there were seventy-five Indians. Captain Hayes — bless his memory!—said, 'They are fixin' to charge us, boys, and we must charge them.' There were never better men in this world than Hayes had with him," went on the Colonel with pardonable pride; "and mind you, he never made a fight without winning.

"We charged, and in the fracas killed thirty-five Indians—only two of our men were wounded—so you see the five-shooters were pretty good weapons. Of course they wa'n't any account compared with these modern ones, because they were too small, but they did those things. Just

13

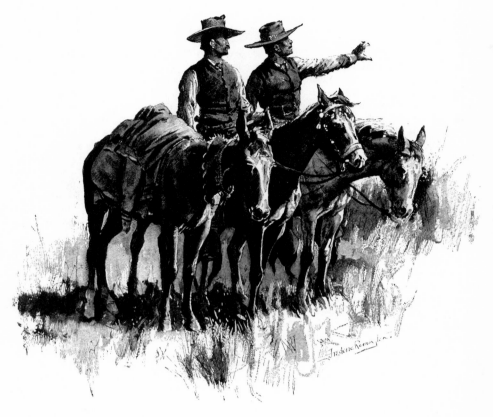

TEXAS RANGERS.

after that Colonel Colt was induced to make bigger ones for us, some of which were half as long as your arm.

"Hayes? Oh, he was a surveyor, and used to go out beyond the frontiers about his work. The Indians used to jump him pretty regular; but he always whipped them, and so he was available for a Ranger captain. About then—let's see," and here the old head bobbed up from his chest, where it had sunk in thought—"there was a commerce with Mexico just sprung up, but this was later—it only shows what that man Hayes used to do. The bandits used to waylay the traders, and they got very bad in the country. Captain Hayes went after them—he struck them near Lavade, and found the Mexicans had more than twice as many men as he did; but he caught them napping, charged them afoot—killed twenty-five of them, and got all their horses."

"I suppose, Colonel, you have been charged by a Mexican lancer?" I inquired.

"Oh yes, many times," he answered.

"What did you generally do?"

"Well—you see—in those days I reckoned to be able to hit a man every time with a six-shooter at one hundred and twenty-five yards," explained the old gentleman—which no doubt meant many dead lancers.

"Then you do not think much of a lance as a weapon?" I pursued.

"No; there is but one weapon. The six-shooter when properly handled is the only weapon—mind you, sir, I say *properly*," and here the old eyes blinked rapidly over the great art as he knew its practice.

"Then of course the rifle has its use. Under Captain Jack Hayes sixty of us made a raid once after the celebrated priest-leader of the Mexicans—Padre Jarante—which same was a devil of a fel-

low. We were very sleepy—had been two nights without sleep. At San Juan every man stripped his horse, fed, and went to sleep. We had passed Padre Jarante in the night without knowing it. At about twelve o'clock next day there was a terrible outcry—I was awakened by shooting. The Padre was upon us. Five men outlying stood the charge, and went under. We gathered, and the Padre charged three times. The third time he was knocked from his horse and killed. Then Captain Jack Hayes awoke, and we got in a big *casa*. The men took to the roof. As the Mexicans passed we emptied a great many saddles. As I got to the top of the *casa* I found two men quarrelling." (Here the Colonel chuckled.) "I asked what the matter was, and they were both claiming to have killed a certain Mexican who was lying dead some way off. One said he had hit him in the head, and the other said he had hit him in the breast. I advised peace until after the fight. Well—after the shooting was over and the Padre's men had had enough, we went out to the particular Mexican who was dead, and, sure enough, he was shot in the head and in the breast; so they laughed and made peace. About this time one of the spies came in and reported six hundred Mexicans coming. We made an examination of our ammunition, and found that we couldn't afford to fight six hundred Mexicans with sixty men, so we pulled out. This was in the Mexican war, and only goes to show that Captain Hayes's men could shoot all the Mexicans that could get to them if the ammunition would hold out."

"What was the most desperate fight you can remember, Colonel?"

The old man hesitated; this required a particular point of view—it was quality, not quantity, wanted now; and, to be sure, he was a connoisseur. After much study by the Colonel, during which the world lost many thrilling tales, the one which survived occurred in 1851.

"My lieutenant, Ed Burleson, was ordered to carry to San Antonio an Indian prisoner we had taken and turned over to the commanding officer at Fort McIntosh. On his return, while nearing the Nueces River, he spied a couple of Indians. Taking seven men, he ordered the balance to continue along the road. The two Indians proved to be fourteen, and they charged Burleson up to the teeth.

Dismounting his men, he poured it into them from his Colt's six-shooting rifles. They killed or wounded all the Indians except two, some of them dying so near the Rangers that they could put their hands on their boots. All but one of Burleson's men were wounded—himself shot in the head with an arrow. One man had four 'dogwood switches'* in his body, one of which was in his bowels. This man told me that every time he raised his gun to fire, the Indians would stick an arrow in him, but he said he didn't care a cent. One Indian was lying right up close, and while dying tried to shoot an arrow, but his strength failed so fast that the arrow only barely left the bowstring. One of the Rangers in that fight was a curious fellow—when young he had been captured by Indians, and had lived with them so long that he had Indian habits. In that fight he kept jumping around when loading, so as to be a bad target, the same as an Indian would under the circumstances, and he told Burleson he wished he had his boots off, so he could get around good "—and here the Colonel paused quizzically. "Would you call that a good fight?"

The Deacon and I put the seal of our approval on the affair, and the Colonel rambled ahead.

"In 1858 I was commanding the frontier battalion of State troops on the whole frontier, and had my camp on the Deer Fork of the Brazos. The Comanches kept raiding the settlements. They would come down quietly, working well into the white lines, and then go back a-running—driving stolen stock and killing and burning. I thought I would give them some of their own medicine. I concluded to give them a fight. I took two wagons, one hundred Rangers, and one hundred and thirteen Tahuahuacan Indians, who were friendlies. We struck a good Indian trail on a stream which led up to the Canadian. We followed it till it got hot. I camped my outfit in such a manner as to conceal my force, and sent out my scouts, who saw the Indians hunt buffalo through spy-glasses. That night we moved. I sent Indians to locate the camp. They returned before day, and reported that the Indians were just a few miles ahead, whereat we moved forward. At daybreak, I remember, I was standing in the bull-wagon road leading to Santa

* Arrows

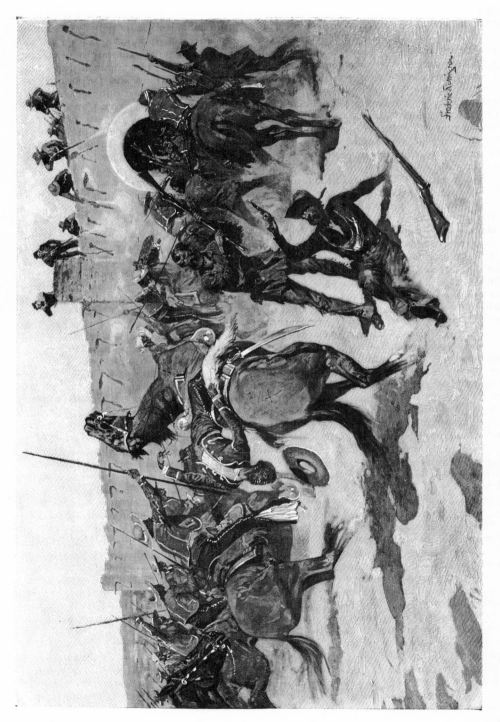

THE CHARGE AND KILLING OF PADRE JARANTE.

Fe and could see the Canadian River in our front — with eighty lodges just beyond. Counting four men of fighting age to a lodge, that made a possible three hundred and twenty Indians. Just at sunup an Indian came across the river on a pony. Our Indians down below raised a yell—they always get excited. The Indian heard them—it was very still then. The Indian retreated slowly, and began to ride in a circle. From where I was I could hear him puff like a deer—he was blowing the bullets away from himself—he was a medicine-man. I heard five shots from the Jagers with which my Indians were armed. The painted pony of the medicine-man jumped ten feet in the air, it seemed to me, and fell over on his rider—then five more Jagers went off, and he was dead. I ordered the Tahuahuacans out in front, and kept the Rangers out of sight, because I wanted to charge home and kind of surprise them. Pretty soon I got ready, and gave the word. We charged. At the river we struck some boggy ground and floundered around considerable, but we got through. We raised the Texas yell, and away we went. I never expect again to hear such a noise—I never want to hear it—what with the whoops of the warriors —the screaming of the women and children — our boys yelling — the shooting, and the horses just a-mixin' up and a-stampedin' around," and the Colonel bobbed his head slowly as he continued.

"One of my men didn't know a buck from a squaw. There was an Indian woman on a pony with five children. He shot the pony—it seemed like you couldn't see that pony for little Indians. We went through the camp, and the Indians pulled out—spreading fanlike, and we a-running them. After a long chase I concluded to come back. I saw lots of Indians around in the hills. When I got back, I found Captain Ross had formed my men in line. 'What time in the morning is it?' I asked. 'Morning, hell!' says he—'it's one o'clock!' And so it was. Directly I saw an Indian coming down a hill near by, and then more Indians and more Indians—till it seemed like they wa'n't ever going to get through coming. We had struck a bigger outfit than the first one. That first Indian he bantered my men to come out single-handed and fight him. One after another, he wounded five of my Indians. I

ordered my Indians to engage them, and kind of get them down in the flat, where I could charge. After some running and shooting they did this, and I turned the Rangers loose. We drove them. The last stand they made they killed one of my Indians, wounded a Ranger, but left seven of their dead in a pile. It was now nearly nightfall, and I discovered that my horses were broken down after fighting all day. I found it hard to restrain my men, they had got so heated up; but I gradually withdrew to where the fight commenced. The Indian camp was plundered. In it we found painted buffalo-robes with beads a hand deep around the edges—the finest robes I have ever seen— and heaps of goods plundered from the Sante Fe traders. On the way back I noticed a dead chief, and was for a moment astonished to find pieces of flesh cut out of him; upon looking at a Tahuahuacan warrior I saw a pair of dead hands tied behind his saddle. That night they had a cannibal feast. You see, the Tahuahuacans say that the first one of their race was brought into the world by a wolf. 'How am I to live?' said the Tahuahuacan. 'The same as we do,' said the wolf; and when they were with me, that is just about how they lived. I reckon it's necessary to tell you about the old woman who was found in our lines. She was looking at the sun and making incantations, a-cussing us out generally and elevating her voice. She said the Comanches would get even for this day's work. I directed my Indians to let her alone, but I was informed afterwards that that is just what they didn't do."

At this point the Colonel's cigar went out, and directly he followed; but this is the manner in which he told of deeds which I know would fare better at the hands of one used to phrasing and capable also of more points of view than the Colonel was used to taking. The outlines of the thing are strong, however, because the Deacon and I understood that fights were what the old Colonel had dealt in during his active life, much as other men do in stocks and bonds or wheat and corn. He had been a successful operator, and only recalled pleasantly the bull quotations. This type of Ranger is all but gone. A few may yet be found in outlying ranches. One of the most celebrated resides near San Antonio—"Big-foot Wallace" by name. He says he doesn't mind

"WE STRUCK SOME BOGGY GROUND."

being called "Big-foot," because he is six feet two in height, and is entitled to big feet. His face is done off in a nest of white hair and beard, and is patriarchal in character. In 1836 he came out from Virginia to "take toll" of the Mexicans for killing some relatives of his in the Fannin Massacre, and he considers that he has squared his accounts; but they had him on the debit side for a while. Being captured in the Meir expedition, he walked as a prisoner to the city of Mexico, and did public work for that country with a ball-and-chain attachment for two years. The prisoners overpowered the guards and escaped on one occasion, but were overtaken by Mexican cavalry while dying of thirst in a desert. Santa Anna ordered their "decimation," which meant that every tenth man was shot, their lot being determined by the drawing of a black bean from an earthen pot containing a certain proportion of white ones. "Big-foot" drew a white one. He was also a member of Captain Hayes's company, afterwards a captain of Rangers, and a noted Indian-fighter. Later he carried the mails from San Antonio to El Paso through a howling wilderness, but always brought it safely through—if safely can be called lying thirteen days by a water-hole in the desert waiting for a broken leg to mend, and living meanwhile on one prairie-wolf, which he managed to shoot. Wallace was a professional hunter, who fought Indians and hated "greasers"; he belongs to the past, and has been "outspanned" under a civilization in which he has no place, and is to-day living in poverty.

The civil war left Texas under changed conditions. That and the Mexican wars had determined its boundaries, however, and it rapidly filled up with new elements of population. Broken soldiers, outlaws, poor immigrants living in bull-wagons, poured in. "Gone to Texas" had a sinister significance in the late sixties. When the railroad got to Abilene, Kansas, the cow-men of Texas found a market for their stock, and began trailing their herds up through the Indian country. Bands of outlaws organized under the leadership of desperadoes like Wes Hardin and King Fisher. They rounded up cattle regardless of their owners' rights, and resisted interference with force. The poor man pointed to his brand in the stolen herd and protested. He was shot. The big

owners were unable to protect themselves from loss. The property right was established by the six-shooter, and honest men were forced to the wall. In 1876 the property-holding classes went to the Legislature, got it to appropriate a hundred thousand dollars a year for two years, and the Ranger force was reorganized to carry the law into the chaparral. At this time many judges were in league with bandits; sheriffs were elected by the outlaws, and the electors were cattle-stealers.

The Rangers were sworn to uphold the laws of Texas and the United States. They were deputy sheriffs, United States marshals—in fact, were often vested with any and every power, even to the extent of ignoring disreputable sheriffs. At times they were judge, jury, and executioner, when the difficulties demanded extremes. When a band of outlaws was located, detectives or spies were sent among them, who openly joined the desperadoes, and gathered evidence to put the Rangers on their trail. Then, in the wilderness, with only the soaring buzzard or prowling coyote to look on, the Ranger and the outlaw met to fight with tigerish ferocity to the death. Shot, and lying prone, they fired until the palsied arm could no longer raise the six-shooter, and justice was satisfied as their bullets sped. The captains had the selection of their men, and the right to dishonorably discharge at will. Only men of irreproachable character, who were fine riders and dead-shots, were taken. The spirit of adventure filled the ranks with the most prominent young men in the State, and to have been a Ranger is a badge of distinction in Texas to this day. The display of anything but a perfect willingness to die under any and all circumstances was fatal to a Ranger, and in course of time they got the *moral* on the bad man. Each one furnished his own horse and arms, while the State gave him ammunition, "grub," one dollar a day, and extra expenses. The enlistment was for twelve months. A list of fugitive Texas criminals was placed in his hands, with which he was expected to familiarize himself. Then, in small parties, they packed the bedding on their mule, they hung the handcuffs and leather thongs about its neck, saddled their riding-ponies, and threaded their way into the chaparral.

On an evening I had the pleasure of

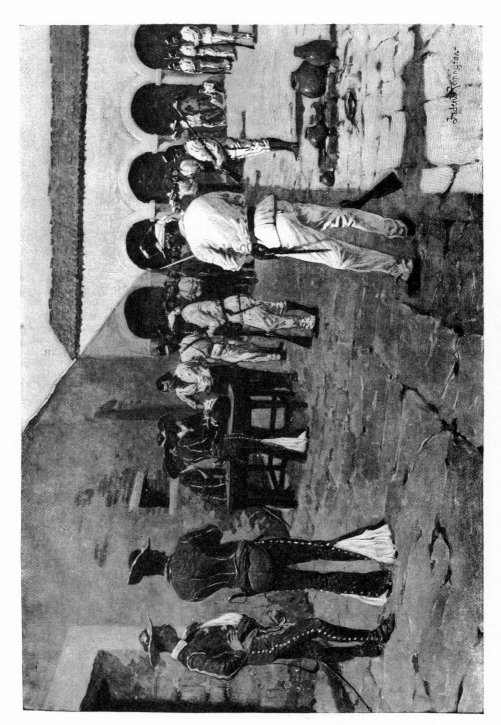

PRISONERS DRAWING THEIR BEANS.

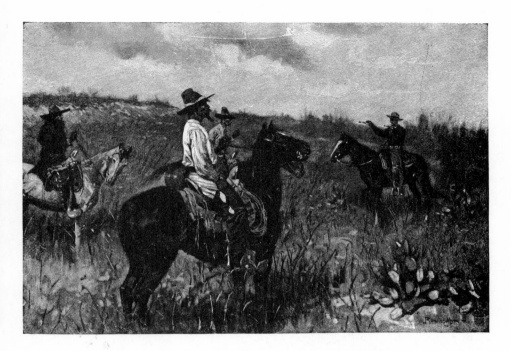

TEXAS RANGERS HOLDING UP CHAPARRAL BANDITS.

meeting two more distinguished Ranger officers — more modern types — Captains Lea Hall and Joseph Shely. Both of them big, forceful men, and loath to talk about themselves. It was difficult to associate the quiet gentlemen who sat smoking in the Deacon's rooms with what men say; for the tales of their prowess in Texas always ends, "and that don't count Mexicans, either." The bandit never laid down his gun but with his life; so the "la ley de fuga"* was in force in the chaparral, and the good people of Texas were satisfied with a very short account of a Ranger's fight.

The most distinguished predecessor of these two men was a Captain McNally, who was so bent on carrying his raids to an issue that he paid no heed to national boundary-lines. He followed a band of Mexican bandits to the town of La Cueva, below Ringgold, once, and surrounding it, demanded the surrender of the cattle which they had stolen. He had but ten men, and yet this redoubtable warrior surrounded a town full of bandits and Mexican soldiers. The Mexican soldiers attacked the Rangers, and forced them back

* Mexican law of shooting escaped or resisting prisoners.

under the river-banks, but during the fight the *jefe politico* was killed. The Rangers were in a fair way to be overcome by the Mexicans, when Lieutenant Clendenin turned a Gatling loose from the American side and covered their position. A parley ensued, but McNally refused to go back without the cattle, which the Mexicans had finally to surrender.

At another time McNally received word through spies of an intended raid of Mexican cattle-thieves under the leadership of Cammelo Lerma. At Resaca de la Palma, McNally struck the depredators with but sixteen men. They had seventeen men and five hundred head of stolen cattle. In a running fight for miles McNally's men killed sixteen bandits, while only one escaped. A young Ranger by the name of Smith was shot dead by Cammelo Lerma as he dismounted to look at the dying bandit. The dead bodies were piled in ox-carts and dumped in the public square at Brownsville. McNally also captured King Fisher's band in an old log house in Dimmit County, but they were not convicted.

Showing the nature of Ranger work, an incident which occurred to my acquaintance Captain Lea Hall will illus-

trate. In De Witt County there was a feud. One dark night sixteen masked men took a sick man, one Dr. Brazel, and two of his boys, from their beds, and, despite the imploring mother and daughter, hanged the doctor and one son to a tree. The other boy escaped in the green corn. Nothing was done to punish the crime, as the lynchers were men of property and influence in the country. No man dared speak above his breath about the affair.

Captain Hall, by secret-service men, discovered the perpetrators, and also that they were to be gathered at a wedding on a certain night. He surrounded the house and demanded their surrender, at the same time saying that he did not want to kill the women and children. Word returned that they would kill him and all his Rangers. Hall told them to allow their women and children to depart, which was done; then, springing on the gallery of the house, he shouted, "Now, gentlemen, you can go to killing Rangers; but if you don't surrender, the Rangers will go to killing you." This was too frank a willingness for midnight assassins, and they gave up.

Spies had informed him that robbers intended sacking Campbell's store in Wolfe City. Hall and his men lay behind the counters to receive them on the designated night. They were allowed to enter, when Hall's men, rising, opened fire —the robbers replying. Smoke filled the room, which was fairly illuminated by the flashes of the guns—but the robbers were all killed, much to the disgust of the lawyers, no doubt, though I could never hear that honest people mourned.

The man Hall was himself a gentleman of the romantic Southern soldier type, and he entertained the highest ideals, with which it would be extremely unsafe to trifle, if I may judge. Captain Shely, our other visitor, was a herculean black-eyed man, fairly fizzing with nervous energy. He is also exceedingly shrewd, as befits the greater concreteness of the modern Texas law, albeit he too has trailed bandits in the chaparral, and rushed in on their camp-fires at night, as two big bullet-holes in his skin will attest. He it was who arrested Polk, the defaulting treasurer of Tennessee. He rode a Spanish pony sixty-two miles in six hours, and arrested Polk, his guide, and two private detectives, whom Polk had bribed to set him over the Rio Grande.

When the land of Texas was bought up and fenced with wire, the old settlers who had used the land did not readily recognize the new régime. They raised the rallying-cry of "free grass and free water"—said they had fought the Indians off, and the land belonged to them. Taking nippers, they rode by night and cut down miles of fencing. Shely took the keys of a county jail from the frightened sheriff, made arrests by the score, and lodged them in the big new jail. The country-side rose in arms, surrounded the building, and threatened to tear it down. The big Ranger was not deterred by this outburst, but quietly went out into the mob, and with mock politeness delivered himself as follows:

"Do not tear down the jail, gentlemen —you have been taxed for years to build this fine structure—it is yours—do not tear it down. I will open the doors wide —you can all come in—do not tear down the jail; but there are twelve Rangers in there, with orders to kill as long as they can see. Come right in, gentlemen—but come fixed."

The mob was overcome by his civility.

Texas is to-day the only State in the Union where pistol-carrying is attended with great chances of arrest and fine. The law is supreme even in the lonely *jacails* out in the rolling waste of chaparral, and it was made so by the tireless riding, the deadly shooting, and the indomitable courage of the Texas Rangers.

OLD COLT'S REVOLVER, 1838.

3.
Stubble and Slough in Dakota

STUBBLE AND SLOUGH IN DAKOTA.

BY FREDERIC REMINGTON.

NOW I am conscious that all my life I have seen men who owned shot-guns and setter-dogs, and that these persons were wont at intervals to disappear from their usual haunts with this paraphernalia. Without thinking, I felt that they went to slay little birds, and for them I entertained a good-natured contempt. It came about in this wise that I acquired familiarity with "mark," and "hie-on," and "No. 6 vis No. 4's": By telegram I was invited to make one of a party in Chicago, bound West on a hunting expedition. It being one of my periods of unrest, I promptly packed up my Winchester, boots, saddle, and blankets, wired "All right—next train," and crawled into the "Limited" at Forty-second Street.

"West" is to me a generic term for that country in the United States which lies beyond the high plains, and this will account for my surprise when I walked into the private car at the St. Paul depot in Chicago and met my friends contesting the rights of occupancy with numerous setter-dogs, while all about were shot-gun cases and boxes labelled "Ammunition." After greetings I stepped to the station platform and mingled with the crowd—disgusted, and disposed to desert.

A genial young soldier who appreciated the curves in my character followed me out, and explained, in the full flush of his joyous anticipation, that we were going to North Dakota to shoot ducks and prairie-chicken, and that it would be the jolliest sort of a time; besides, it was a party of good friends. I hesitated, yielded, and enlisted for the enterprise. Feeling now that I was this far it would be good to go on and learn what there was in the form of sport which charmed so many men whose taste I respected in other matters, and once embarked I summoned my enthusiasm, and tried to "step high, wide, and handsome," as the horsemen say.

The happiness of a hunting party is like that of a wedding, so important is it that true love shall rule. The *pièce de résistance* of our car was two old generals, who called each other by an abbreviation of their first names, and interrupted conversations by recalling to each other's memory where some acres of men were slain. "A little more of the roast beef, please—yes, that was where I was shot in this side;" and at night, when quiet reigned and we sought sleep, there would be a waving of the curtains, and a voice, "Oh, say, Blank, do you remember that time my horse was hit with the twelve-

A DAKOTA CHICKEN-WAGON.

25

pounder?" and it banished dreams. There was a phlebotomist from Pittsburg who had shot all over the earth. He was a thorough sportsman, with a code of rules as complicated as the common law, and he "made up tough" in his canvas shooting-clothes. There was a young and distinguished officer of the regular army who had hunted men, which excused him in the paltry undertaking before him; and, finally, three young men who were adding the accumulated knowledge of Harvard to their natural endowments. For my-

ON THE EDGE OF A SLOUGH.

self, I did not see how jack-boots, spurs, and a Winchester would lend themselves to the stubble and slough of Dakota, but a collection was taken, and by the time we arrived in Valley City, Dakota, I was armed, if not accoutred, in the style affected by double-barrel men. All I now needed was an education, and between the Doctor, who explained, expostulated, and swore, and a great many "clean misses," I wore on to the high-school stage. Like the obliging person who was asked if he played on the violin, I said to myself, "I don't know, but I'll try."

In the early morning three teams drove up where our car was side-tracked, and we embarked in them. The shot-gun man affects buck-colored canvas clothes, with many pockets, and carries his cartridges in his shirt fronts, like a Circassian Cossack. He also takes the shells out of his gun before he climbs into a wagon, or he immediately becomes an object of derision and dread, or, what's worse, suddenly friendless and alone. He also refrains from pointing his gun at any fellow-sportsman, and if he inadvertently does it, he receives a fusillade such as an Irish drill-sergeant throws into a recruit when he does amiss. This day was cool

and with a wind blowing, and the poor dogs leaped in delirious joy when let out from their boxes, in which they had travelled all the way from Chicago. After running the wire edge off their nerves they were gotten to range inside a township site, and we jogged along. The first thing which interested me was to hear the Doctor indicate to the driver that he did not care to participate in the driver's knowledge of hunting, and that in order to save mental wear he only had to drive the team, and stand fast when we got out, in order that from the one motionless spot on the prairie sea we could "mark down" the birds.

The immensity of the wheat-fields in Dakota is astonishing to a stranger. They begin on the edge of town, and we drive all day and are never out of them, and on either side they stretch away as far as one's eye can travel. The wheat had been cut and "shocked," which left a stubble some eight inches high. The farm-houses are far apart, and, indeed, not often in sight, but as the threshing was in progress, we saw many groups of men and horses, and the great steam-threshers blowing clouds of black smoke, and the flying straw as it was belched from the bowels of the monsters.

During the heat of the day the chickens lie in the cover of the grass at the sides of the fields, or in the rank growth of some slough-hole, but at early morning and evening they feed in the wheat stubble. As we ride along, the dogs range out in front, now leaping gracefully along, now stopping and carrying their noses in the air to detect some scent, and finally—"There's a point! Stop, driver!" and we pile out, breaking our guns and shoving in the cartridges.

"No hurry—no hurry," says the Doctor; "the dog will stay there a month." But, fired with the anticipations, we move briskly up. "You take the right and I'll take the left. Don't fire over the dog," adds the portly sportsman, with an admonishing frown. We go more slowly, and suddenly, with a "whir," up get two chickens and go sailing off. Bang! bang! The Doctor bags his and I miss mine. We load and advance, when up

A CONFERENCE IN THE MUD.

comes the remainder of the covey, and the bewildering plenty of the flying objects rattles me. The Doctor shoots well, and indeed prairie-chickens are not difficult, but I am discouraged. As the great sportsman Mr. Soapy Sponge used to say, "I'm a good shooter, but a bad hitter." It was in this distressful time that I remembered the words of the old hunter who had charge of my early education in .45 calibres, which ran, "Take yer time, sonny, and always see your hind sight," and by dint of doing this I soon improved to a satisfactory extent. The walking over the stubble is good exercise, and it becomes fascinating to watch the well-trained Lewellen setters "make game," or stand pointing with their tails wagging violently in the nervous thrill of their excitement, then the shooting, and the marking down of the birds who escape the fire, that we may go to them for another "flush." With care and patience one can bag at last the whole covey.

At noon we met the other wagons in a green swale, and had lunch, and seated in a row under the shadow side of a straw stack, we plucked chickens, while the phlebotomist did the necessary surgery to prepare them for the cook. At three o'clock the soldier, a couple of residents, and myself started together for the evening shooting. We banged away at 1000-yards range at some teal on a big marsh, but later gave it up, and confined ourselves to chicken. In the midst of a covey and a lot of banging I heard the Captain uttering distressful cries. His gun was leaning on a wheat "shock," and he was clawing himself wildly. "Come, help me—I am being eaten alive." Sure enough he was, for in Dakota there is a little insect which is like a winged ant, and they go in swarms, and their bite is sharp and painful. I attempted his rescue, and was attacked in turn, so that we ended by a precipitous retreat, leaving the covey of chickens and their protectors, the ants, on the field.

We next pushed a covey of grouse into some standing oats, and were tempted to go in a short way, but some farmers who were thrashing on the neighboring hill blew the engine whistle and made a "sortie," whereat we bolted. At a slough which we were tramping through

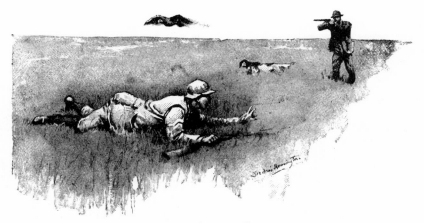

"DON'T SHOOT!"

to kick up some birds "marked down," one suddenly got up under our feet and flew directly over the Captain, who yelled "Don't shoot!" as he dropped to the ground. It was a well-considered thing to do, since a flying bird looks bigger than a man to an excited and enthusiastic sportsman. We walked along through the stubble until the red sunset no longer gave sufficient light, and then got into our wagon to do the fourteen miles to our car and supper. Late at night we reached our car, and from it could hear "the sound of revelry." The cook did big Chicago beefsteaks by the half-dozen, for an all day's tramp is a sauce which tells.

After some days at this place we were hauled up to Devil's Lake, on the Great Northern road, which locality is without doubt the best for duck-shooting in Dakota. We were driven some sixteen miles to a spur of the lake, where we found a settler. There were hundreds of teal in the water back of his cabin, and as we took position well up the wind and fired, they got up in clouds, and we had five minutes of shooting which was gluttony. We gave the "bag" to the old settler, and the Doctor admonished him to "fry them," which I have no doubt he did.

It was six miles to a pond said to be the best evening shooting about there, and we drove over. There we met our other two teams and another party of sportsmen. The shallow water was long and deeply fringed with rank marsh grass. Having no wading-boots can make no difference to a sportsman whose soul is great, so I floundered in and got comfortably wet. After shooting two or three

mud-hens, under the impression that they were ducks, the Doctor came along, and with a pained expression he carefully explained what became of people who did not know a teal from a mud-hen, and said further that he would let it pass this time. As the sun sank, the flight of ducks began, and from the far corners of the marsh I saw puffs of smoke and heard the dull slump of a report.

"Mark—left," came a voice from where

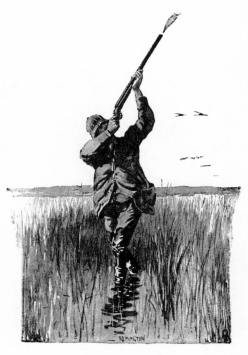

"MARK—LEFT."

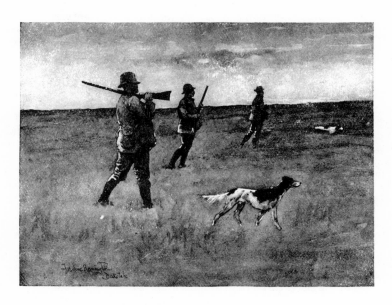

TROOPING HOMEWARD IN THE AFTER-GLOW.

the young Harvard man with the peach complexion and the cream hair had ensconced himself in the grass, and, sure enough, a flight was coming toward my lair. I waited until it was nearly over, when I rose up and missed two fine shots, while the Harvard man scored. The birds fell well out in the pond, and he waded out to retrieve them.

As I stood there the soft ooze of the marsh gradually swallowed me, and when in answer to the warning "mark" of my fellows I squatted down in the black water to my middle, and only held my gun and cartridges up, I began to realize that when a teal-duck is coming down wind you have got to aim somewhere into the space ahead of it, hoping to make a connection between your load of shot and the bird. This I did, and after a time got my first birds. The air was now full of flying birds—mallards, spoon-bills, pintails, red-heads, butter-balls, gadwalls, widgeon, and canvasbacks—and the shooting was fast and furious. It was a perfect revelry of slaughter. "Mark—mark." Bang—bang. "What's the matter of that shot?" The sun has set, and no longer bathes the landscape in its golden light, and yet I sit in the water and mud and indulge this pleasurable taste for gore, wondering why it is so ecstatic, or if my companions will not give over shooting presently. There is little prob-

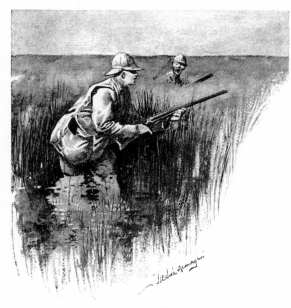

"MARK!"

ability of that, however. Only darkness can end the miseries of the poor little teal coming home to their marsh, and yet with all my sentimental emotions of sympathy I deplore a miss. If slough-shooting has a drawback, it is its lack of action—it is a calm, deliberate shedding of blood, and a wounding of many birds, who die in the marshes, or become easy prey for the hawks, and it's as cold-blooded as sitting in water can make it.

We give over at last, and the fortunates change their wet clothes, while those who have no change sit on the seat knee-deep in dead birds and shiver while we rattle homeward. Our driver gets himself lost, and we bring up against a wire fence. Very late at night we struck the railroad, and counted telegraph poles and travelled east until the lights of the town twinkled through the gloom. Once in the car, we find the creature comfort which reconciles one to life, and we vote the day a red-letter one. The goose-shooting came later than our visit, but the people tell marvellous tales of their numbers. They employ special guns in their pursuit, which are No. 4 gauge, single-barrelled, and very long. They throw buckshot point-blank two hundred yards, and are, indeed, curious-looking arms. The chicken-shooting is not laborious, since one rides in a wagon, and a one-lunged, wooden-legged man is as good as a four-mile athlete at it. He must know setter-dogs, who are nearly as complicated as women in their temper and ways; he must have a nose for cover, and he can be taught to shoot; he can keep statistics if he desires, but his first few experiences behind the dogs will not tempt him to do that unless his modesty is highly developed. If he become a shot-gun enthusiast he will discover a most surprising number of fellows — doctors, lawyers, butchers, farmers, and Indians not taxed—all willing to go with him or to be interested in his tales.

The car was to be attached to an express train bound west that night, to my intense satisfaction, and I crawled into the upper berth to dream of bad-lands elk, soldiers, cowboys, and only in the haze of fleeting consciousness could I distinguish a voice—

"Remington, I hope you are not going to fall out of that upper berth again to-night."

4.
Black Water
and Shallows

BLACK WATER AND SHALLOWS.

BY FREDERIC REMINGTON.

THE morning broke gray and lowering, and the clouds rolled in heavy masses across the sky. I was sitting out on a log washing a shirt, and not distinguishing myself as a laundryman either, for one shirt will become excessively dirty in a week, and no canoeist can have more than that, as will be seen when you consider that he has to carry every thing which he owns on his back. My guide had packed up our little "kit" and deposited it skilfully in the *Necoochee*—a sixteen-foot canoe of the Rice Lake pattern.

We were about to start on a cruise down a river which the lumbermen said could not be "run," as it was shallow and rocky. We could find no one who had been down it, and so, not knowing anything about it, we regarded it as a pleasant prospect. "Harrison," being a professional guide and hunter, had mostly come in contact with people—or "sports," as he called them—who had no sooner entered the woods than they were overcome with a desire to slay. No fatigue or exertion was too great when the grand purpose was to kill the deer and despoil the trout streams, but to go wandering aimlessly down a stream which by general consent was impracticable for boats, and then out into the clearings where the mountain spring was left behind, and where logs and mill-dams and agriculturists took the place of the deer and the trout, was a scheme which never quite got straightened out in his mind. With many misgivings, and a very clear impression that I was mentally deranged, "Has" allowed that "we're all aboard."

33

We pushed out into the big lake and paddled. As we skirted the shores the wind howled through the giant hemlocks, and the ripples ran away into white-caps on the far shore. As I wielded my double-blade paddle and instinctively enjoyed the wildness of the day, I also indulged in a conscious calculation of how long it would take my shirt to dry on my back. It is such a pity to mix a damp shirt up with the wild storm, as it hurries over the dark woods and the black water, that I felt misgivings; but, to be perfectly accurate, they divided my attention, and, after all, man is only noble by fits and starts.

We soon reached the head of the river, and a water-storage dam and a mile of impassable rapids made a "carry" or "portage" necessary. Slinging our packs and taking the seventy-pound canoe on our shoulders, we started down the trail. The torture of this sort of thing is as exquisitely perfect in its way as any ever devised. A trunk-porter in a summer hotel simply does for a few seconds what we do by the hour, and as for reconciling this to an idea of physical enjoyment, it cannot be done. It's a subtle mental process altogether indefinable; but your enthusiast is a person who would lose all if he reasoned any, and to suffer like an anchorite is always a part of a sportsman's programme. The person who tilts back in a chair on the veranda of a summer hotel, while he smokes cigars and gazes vacantly into space, is your only true philosopher; but he is not a sportsman. The woods and the fields and the broad roll of the ocean do not beckon to him to come out among them. He detests all their sensations, and believes nothing holy except the dinner hour, and with his bad appetite that too is flat, stale, and unprofitable. A real sportsman, of the nature-loving type, must go tramping or paddling or riding about over the waste places of the earth, with his dinner in his pocket. He is alive to the terrible strain of the "carry," and to the quiet pipe when the day is done. The camp-fire contemplation, the beautiful quiet of the misty morning on the still water, enrapture him, and his eye dilates, his nerves tingle, and he is in a conflagration of ecstasy. When he is going—going—faster—faster into the boil of the waters, he hears the roar and boom ahead, and the black rocks crop up in thickening masses to dispute his way. He is fighting a game battle with the elements, and they are remorseless. He may break his leg or lose his life in the tip-over which is imminent, but the fool is happy—let him die.

But we were left on the "carry," and it is with a little thrill of joy and the largest sigh of relief possible when we again settle the boat in the water. Now you should understand why it is better to have one shirt and wash it often. My

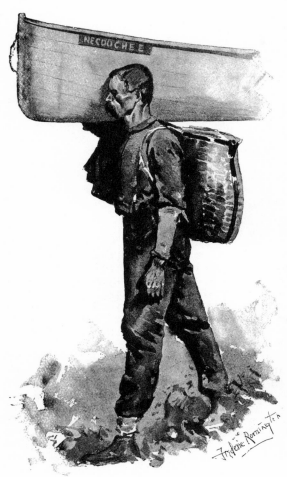

THE PORTAGE.

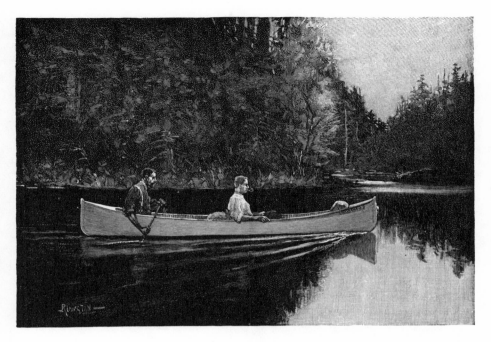

BLACK WATER.

"canoe kit" is the best arranged and the most perfect in the world, as no other canoeist will possibly admit, but which is nevertheless a fact. One blanket, a light shelter-tent, a cooking outfit, which folds up in a sort of Japanese way, a light axe, two canvas packs, and tea, bacon, and flour. This does not make long reading, but it makes a load for a man when it's all packed up, and a canoeist's baggage must be cut to the strength of his back. It is a great piece of confidence in which I will indulge you when I caution you not to pick out invalids for canoe companions. If a burro would take kindly to backwoods navigation, I should enjoy the society of one, though it would not be in the nature of a burro to swing an axe, as indeed there are many fine gentlemen who cannot do a good job at that; and if one at least of the party cannot, the camp-fires will go out early at nights, and it is more than probable that the companions will have less than twenty toes between them at the end of the cruise.

All these arrangements being perfected, you are ready to go ahead, and in the wilderness you have only one anxiety, and that is about the "grub." If the canoe turn over, the tea, the sugar, and the flour will mix up with the surrounding elements, and only the bacon will remain to nourish you until you strike the clearings, and there are few men this side 70° north latitude who will gormandize on that alone.

The long still water is the mental side of canoeing, as the rapid is the life and movement. The dark woods tower on either side, and the clear banks, full to their fat sides, fringed with trailing vines and drooping ferns, have not the impoverished look of civilized rivers. The dark water wells along, and the branches droop to kiss it. In front the gray sky is answered back by the water reflection, and the trees lie out as though hung in the air, forming a gateway, always receding. Here and there an old monarch of the forest has succumbed to the last blow and fallen across the stream. It reaches out ever so far with its giant stems, and the first branch had started sixty feet from the ground. You may have to chop a way through, or you may force your canoe through the limbs and gather a crowd of little broken branches to escort you along the stream. The original forest tree has a character all its own, and I never see one but I think of the artist

who drew second-growth timber and called it " the forest primeval." The quietness of the woods, with all their solemnity, permitting no bright or over-dressed plant to obtrude itself, is rudely shocked by the garish painted thing as the yellow polished *Necoochee* glides among them. The water-rat dives with a tremendous splash as he sees the big monster glide by his sedge home. The kingfisher springs away from his perch on the dead top with loud chatterings when we glide into his notice. The crane takes off from his grassy " set back " in a deliberate manner, as though embarking on a tour to Japan, a thing not to be hurriedly done. The mink eyes you from his sunken log, and grinning in his most savage little manner, leaps away. These have all been disturbed in their wild homes as they were about to lunch off the handiest trout, and no doubt they hate us in their liveliest manner; but the poor trout under the boat compensate us with their thanks. The mud-turtle is making his way up stream, as we can tell by the row of bub-

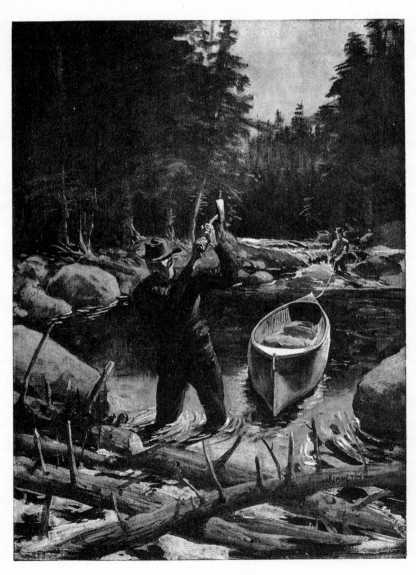

BREAKING A JAM.

bles which arise in his wake; and the "skaters," as I call the little insects which go skipping about like a lawyer's point in an argument, part as we go by. The mosquitoes, those desperate little villains who dispute your happiness in the woods, are there, but they smell the tar and oil of our war-paint, and can only hum in their anger. A stick cracks in the brush, and with all the dash and confidence of a city girl as she steps from her front door, a little spotted fawn walks out on a sedge bank from among the alders. He does not notice us, but in his stupid little way looks out the freshest water-grass, and the hunter in the stern of the boat cuts his paddle through the water, and the canoe glides silently up until right under his nose. We are still and silent. The little thing raises its head and looks us full in the eye, and then continues to feed as before. I talk to him quietly, and say, "Little man, do not come near the ponds or the rivers, for you will not live to have five prongs on your antlers if any one but such good people as we see you." He looks up, and seems to say, "You are noisy, but I do not care." "Now run; and if you ever see anything in the forest which resembles us, run for your life;" and with a bound the little innocent has regained the dark aisles of the woods. You loll back on your pack, your pipe going lazily; your hat is off; you moralize, and think thoughts which have dignity. You drink in the spell of the forest, and dream of the birch barks and the red warriors who did this same thing a couple of centuries since. But as thoughts vary so much in individuals, and have but an indirect bearing on canoeing, I will proceed without them. The low swamp, with its soft timber, gives place to hills and beech ridges, and the old lord of the forest for these last hundred years towers up majestically. The smaller trees fight for the sunlight, and thus the ceaseless war of nature goes on quiet-

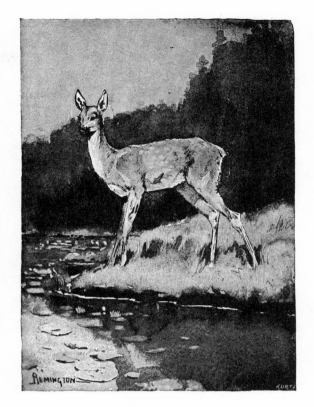

THE FAWN.

ly, silently, and alone. The miserable "witch-hoppel" leads its lusty plebeian life, satisfied to spring its half-dozen leaves, and not dreaming to some day become an oak. The gentle sigh of the forest, the hum of insects, and the chatter and peal of the birds have gone into harmony with a long, deep, swelling sound, becoming louder and louder, until finally it drowns all else.

The canoe now glides more rapidly. The pipe is laid one side. The paddle is grasped firmly, and with a firm eye I regard the "grub" pack which sits up in the bow, and resolve to die if necessary in order that it may not sink if we turn over. The river turns, and the ominous growl of the rapids is at hand.

"Hold her—hold her now—to the right of the big rock; then swing to the far shore: if we go to the right, we are gone."

"All right; let her stern come round," and we drop away.

No talking now, but with every nerve and muscle tense, and your eye on the

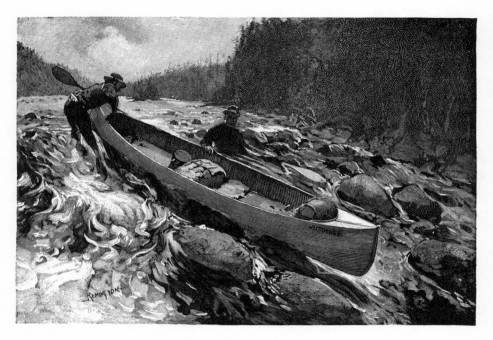

HUNG UP.

boil of the water, you rush along. You back water and paddle, the stern swings, she hangs for an instant, she falls in the current, and with a mad rush you take it like a hunting-man a six-bar gate. Now paddle, paddle, paddle. It looks bad—we cannot make it—yes—all right, and we are on the far shore, with the shallows on the other side. This little episode was successful, but, as you well know, it cannot last. The next rift, and with a bump she is hung upon a sunken rock, and—jump! jump!—we both flounder overboard in any way possible, so it is well and quickly done. One man loses his hold, the other swings the boat off, and kicking and splashing for a foothold, the demoralized outfit shoots along. At last one is found, and then at a favorable rock we embark again.

You are now wet, but the tea and sugar are safe, so it's a small matter. A jam of logs and tops is "hung up" on a particularly nasty place, and you have a time getting the boat around it. You walk on rotten tops while the knots stick up beneath you like sabres. "Has" floats calmly out to sea as it were on a detached log which he is cutting, and with a hopeless look of despair he tot-

ters, while I yell, "Save the axe, —— you—save the axe!" and over he goes, only to get wet and very disgusted, both of which will wear off in time. For a mile the water is so shallow that the boat will not run loaded, and we lead her along as we wade, now falling in over our heads, sliding on slippery stones, hurting our feet, wondering why we had come at all. The boat gets loose, and my heart stands still as the whole boat-load of blankets and grub with our pipes and tobacco started off for the settlements—or "drifting to thunder," as Bret Harte said of Chiquita. There was a rather lively and enthusiastic pursuit instituted then, the details of which are forgotten, as my mind was focussed on the grub-pack, but we got her. About this time the soles let go on my tennis shoes, and my only pair of trousers gave way. These things, however, become such mere details as to be scarcely noticed when you have travelled since sunrise up to your waist in water, and are tired, footsore, and hungry. It is time to go ashore and camp.

You scrape away a rod square of dirt, chunks, witch-hoppel, and dead leaves, and make a fire. You dry your clothes while you wear the blanket and the guide

the shelter-tent, and to a casual observer it would look as though the savage had come again; but he would detect a difference, because a white man in a blanket is about as inspiring a sight as an Indian with a plug-hat.

Finally the coffee boils, the tent is up, and the bough bed laid down. You lean against the dead log and swap lies with the guide; and the greatest hunters I have ever known have all been magnificent liars. The two go together. I should suspect a man who was deficient. Since no one ever believes hunters' yarns, it has come to be a pleasurable pastime, in which a man who has not hunted considerably can't lie properly without offending the intelligence of that part of his audience who have.

The morning comes too soon, and after you are packed up and the boat loaded, if you are in a bad part of the river you do this: you put away your pipe, and with a grimace and a shudder you step out into the river up to your neck and get wet. The morning is cold, and I, for one, would not allow a man who was perfectly dry to get into my boat, for fear he might have some trepidation about getting out promptly if the boat was "hung up" on a rock; and in the woods all nature is subservient to the "grub."

Hour after hour we waded along. A few rods of still water and "Has" would cut off large chews of tobacco, and become wonderfully cynical as to the caprices of the river. The still water ends around the next point. You charge the thing nobly, but end up in the water up to your neck with the "grub" safe, and a mile or so more of wading in prospect.

Then the river narrows, and goes tumbling off down a dark cañon cut through the rocks. We go ashore and "scout the place," and then begin to let the boat down on a line. We hug the black sides like ants, while the water goes to soapsuds at our feet. The boat bobs and rocks, and is nearly upset in a place where we cannot follow it through. We must take it up a ledge about thirty feet high, and after puffing and blowing and feats of maniacal strength, we at last have it again in the water. After some days of this thing we found from a statistician we had dropped 1100 feet in about fifty-one miles, and with the well-known propensity of water to flow down hill, it can be seen that difficulties were encountered. You cannot carry a boat in the forest, and you will discover enough reasons why in a five-minute trail to make their enumeration tiresome. The zest of the whole thing lies in not knowing the difficulties beforehand, and then, if properly equipped, a man who sits at a desk the year through can find no happier days than he will in his canoe when the still waters run through the dark forests and the rapid boils below.

5.
Billy's
Tearless
Woe

BILLY'S TEARLESS WOE
by FREDERIC REMINGTON

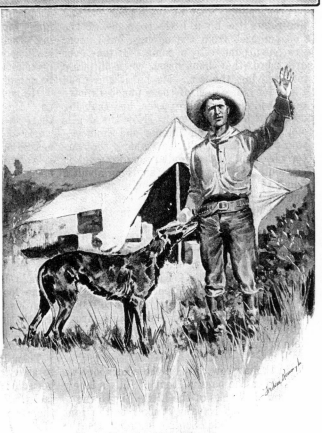

MR BOLETTE, ranch-man, sat with me on the corral fence looking away at the yellow meadows— seeing them through our squinted eyelids, as they rolled one plain into another—growing pink and more cold, losing themselves in blue hills, until one had to squint the more to distinguish what was finally land and what was cloud form. When a mortal looks on these things he ceases to think—it does him so little good. As a mental proposition it is too exhausting. Like the ocean lying quiet at mid-day, it is only fit for brown study.

Presently our vision came back to the vicinity of the corral fence, where was passing a cow-puncher on a pony with a small basket on his arm.

"Good-by, Billy," sung out Bolette.

The individual addressed simply turned his solemn brown face to us, and broke away into a gentle lope.

"That basket is full of pie," exclaimed the ranch owner.

"Pie?"

"Yes; it's the only bait that will draw Billy off the range, 'cept medicine for a dog."

"Medicine for a dog?"

"Oh, yes; Billy's all snarled up with a Scotch stag-hound. He just is naturally in love with the beast—won't let us put out wolf poison on account of him."

The receding Billy was a handsome figure on a horse; bronzed, saturnine, silent. This might in no way distinguish him among his kind, except that it did. He was pronouncedly more so than others. His mission with the Coon Skin outfit was horse-wrangler and rider of the western fence.

He lived in a tent miles away in a small horse pasture on the banks of the Little Big Horn, and only came up to the ranch buildings at long intervals to report matters, and petition for pie. One of Billy's few weaknesses lay strong on the fat pastries fabricated by the Coon Skin *chef*. He rarely stayed longer than was necessary to tell Mr. Bolette that "Brindle Legs" got cut up in some wire which had been carried down by the flood, that "Sloppy Weather" had a sore back, and to recommend the selling of "Magpie" before time set too strong against him, and to acquire the pie.

As Billy grew smaller on the rolling grass,

43

Mr. Bolette observed: "That puncher don't come here often, and he don't stay long, but his dog is sick now, and he can't stay at all. It beats all how that boy hooks up to that dog. He don't appear to care for anything or anybody in the world but Keno. I don't believe that Billy has a brand on anything but that pup. Most of these punchers and line-riders tie up a little to some of the Pocahontases from the agency, but I never saw one around Billy's camp. If they ever are there, they hunt brush when they see me cleaving the air. Maybe it's a good thing for me. Most of these punchers have got a bad case of the gypsies, and that dog seems to hold Billy level. Now the dog is sick. He is getting thinner and thinner—won't eat, and I don't know what's the matter with him. Dogs don't round up much in cow-outfits. Do you know anything about a dog? Can you feel a dog's pulse and figure out what is going on under his belt?"

I admitted my helplessness in the matter.

"Taps, chaps, and ladigo straps—if that dog don't get well my horses can look after themselves, and if he dies, Billy will make the Big Red Medicine. I lose anyway," and Mr. Bolette slid off the fence.

"I reckon we had better go over to Billy's pasture to-morrow, and shove some drugs into Keno. If it don't do any good it may help bring things to a head—so that's what we'll do."

On the morrow, late in the afternoon, we took down the bars in front of Billy's lonely tent on the banks of the Little Big Horn.

On a bright Navajo blanket in the tent lay a big, black, Scotch stag-hound—the sick Keno—Billy's idol. He raised his eyelids at us, but closed them again wearily.

"Don't touch him," sharply said Bolette. "I wouldn't touch him with a shovel in his grave when Billy wasn't around. He's a holy terror. When one of these Injuns about here wants to dine with Billy, he gets off on that hill and sings bass at Billy, till Billy comes out in front and rides the peace-sign; otherwise he wouldn't come into camp at all. An Injun would just as soon go against a ghost as this dog. Keno never did like anything about Injuns except the taste, and it's a good thing for a line-rider to have some safeguard on his mess-box. These Injuns calculate that a cow-puncher is a pretty close relation, and Injuns don't let little matters like grub stand between kinfolks. Then again there are white men who cut this range that need watching, and

Keno never played favorites. He was always willing to hook onto anybody that showed up, and say, when that dog was in good health you wouldn't want to mix up with him much."

Over the hills from the south came a speck—a horseman—Billy himself, as the ranchman said. Slowly the figure drew on—now going out of sight in the wavy plains—moving steadily toward the tent by the river. He dismounted at the bars with the stiff drop peculiar to his species, and, coming in, began to untackle his horse.

He never bowed to us, nor did he greet us. He never cast his eyes on us sitting there so far from any other people in that world of his. In the guild of riders politeness in any form is not an essential—indeed, it is almost a sign of weakness to their minds, because it must necessarily display emotion of a rather tender sort. Odds Fish! Zounds! Away with it. It is not of us. Suffice it to Billy that he could see us for the last three miles sitting there, and equally we were seeing him. What more?

Untying two Arctic hares from his saddle, he straddled on his horseman's legs to Keno's bed and patted him on the head. Keno looked up and licked his hand, and then his face, as he bent toward him. For a little time they looked at each other, while Bolette and I pared softly at two sticks with our jack-knives.

Then Billy got up, came out, and began to skin his rabbits. As he slit one down, he said: "I had to work for these two jacks. When Keno was well he thinned them out round here. Whenever he got after a rabbit it was all day with him. I'm going to make some soup for him. He won't stand for no tin grub," said Billy, as he skinned away.

"Have you any idea what's the matter with the dog?" was asked.

"No, I don't savvy his misery. I'd give up good if there was a doctor within wagon-shot of this place. I'd bring him out here if I had to steal him. I'm afraid the dog has got 'to Chicago.'* He can't eat, and he's got to eat to live, I reckon. I've fixed up all kinds of hash for him—more kinds than Riley's Chinaman can make over to the station, and Keno won't even give it a smell. I lay out to shoot a little rabbit soup into him about once a day, but it's like fillin' ole ca'tridge shells. Been sort of hopin' he might take a notion to come again. Seen a man once that far gone that the boys built

* To die.

a box for him. And that man is a-ridin' somewhere in the world to-day.''

Billy made his soup, and we put aconite and cowtownie whiskey in it. The troubled puncher poured it down Keno's resisting throat with a teaspoon until the patient fell back on the blanket exhausted. After this the poor fellow went around to the far side of the tent, and, sitting down, gazed vacantly into the woods across the Big Horn. A passing word from us met with no response. The man himself would not show his emotions, though the listless melancholy was an emotion, but the puncher did not recognize it as such. The fierce and lonely mind was being chastened, but so long as we were the other side of the canvas there could be no weakness; at least he would not have permitted that—not for an instant—had he known.

Night came on, and, with supper finished, we turned into our blankets. My eyes were opened several times during the night by the flashes of a light, and I could distinguish that it was Billy with a candle, looking over his dog.

In the morning Bolette and I rode the range in pursuit of his details of business

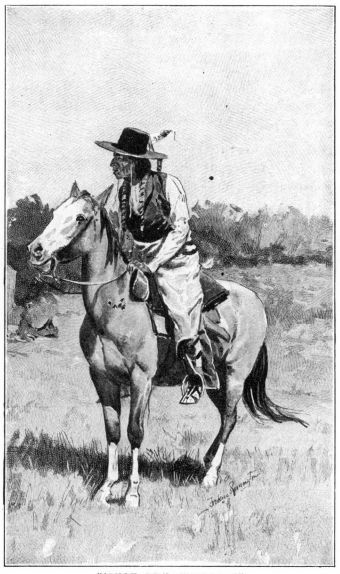

"'BILLY, I FIND HIM DOG...'"

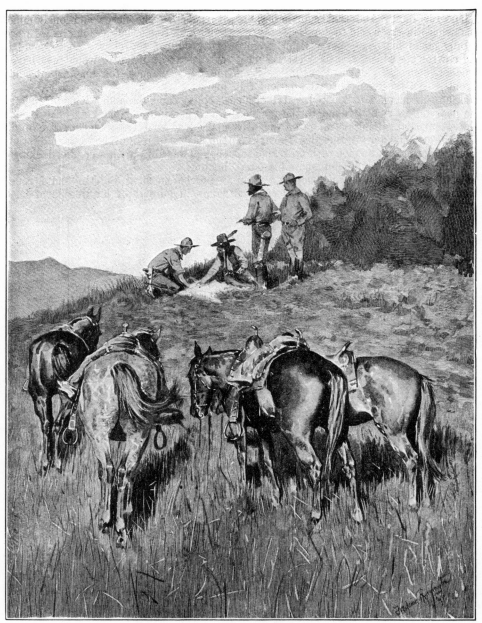

THE BURIAL OF KENO.

management—fences and washouts, the new Texan two-year-olds, and the sizing up of the beef steers fit for Chicago, and then back to Billy's on the second day.

As we jogged up the river, we saw several Indians trailing about in the brush by the river—weird and highly colored figures—leading their ponies and going slowly. They were looking for a lost object, a trail possibly.

"What are they doing?" I asked.

"Don't you put in your time worrying what Injuns are doing," said Bolette. "When they are doing anything, it's worse than when they ain't doing anything. An Injun is all right when he is doing nothing. I like him laying down better than standing up."

"Oh! I say, old 'One Feather,' what you do, hey?" shouted Bolette, and "One Feather," thus addressed, came slowly forward to us.

"Ugh—Billy's dog he cow-eek—he go die—get fi' dollar mabeso we find um."

Bolette turned in his saddle to me, and with a wide, open-eyed wonderment slowly told off the words, "Billy's—kettle—is full—of mud," and I savvied.

This time we approached the camp from down the river, through a brush trail, and Bolette pulled up his horse on the fringe, pointing and saying in a whisper, "Look at Billy."

Sure enough, by the tent on a box sat the bent-over form of the puncher who despised his own emotions. His head was face downward in his hands. He was drawing on the reserve of his feelings, no doubt.

We rode up, and Bolette sang out: "Hello, Billy; hear Keno's passed it up. Sorry 'bout that, Billy. Had to go, though, I suppose. That's life, Billy. We'll all go that way, sooner or later. Don't see any use of worrying."

Billy got up quickly, saying: "Sure thing. Didn't see anything of the pup, did you?" His face was dry and drawn.

"No. Why?"

"Oh, d—n him, he pulled out on me!" and Billy started for his picketed horse.

In chorus we asked, "What do you mean—he pulled out on you?"

Turning quickly, raising his chin, and with the only arm gesture I ever saw him make, he said quickly: "He left me—he went away from me—he pulled out—savvy? Now what do you suppose he wanted to do that for? To me!"

We explained that it was a habit of animals to take themselves off on the approach of death—that they seem to want to die alone; but the idea took no grip on Billy's mind, for he still stood facing us, saying: "But he shouldn't have gone away from me —I would never have deserted him. If I was going to die for it I wouldn't have left him."

Saddling his horse, he took a pan of cooked food and started away down the river, returning after some hours with the empty tin. "I put out fresh grub every day so Keno can get something to eat if he finds it. I put little *caches* of corn-beef every few rods along the river, enough to give him strength to get back to me. He may be weak, and he may be lost. It's no use to tell me that Keno wouldn't come back to me if he could get back. I don't give a d—n what dogs do when they die. Keno wouldn't do what any ordinary dog would."

We sat about under the shadow of the great trouble, knowing better than to offer weak words to one whose rugged nature would find nothing but insult in them, when an Indian trotted up, and, leaning over his horse's neck, said, "Billy, I find him dog —he in de river—drown—you follar me."

In due time we trotted in single file after the blanketed form of Know-Coose. For five miles down the Little Big Horn we wended our way, and the sun was down on the western hills when the Indian turned abruptly into some long sedge-grass and stopped his horse, pointing.

We dismounted, and, sure enough, there lay Keno—not a lovely thing to look at after two days of water and buzzards and sun.

"He must have gone to the river and fallen in from weakness," was ventured.

"No, there was water in the tent," snapped the surly cow-boy in response, for this implied a lack of attention on his part. As there was clearly no use for human comfort in Billy's case, we desisted.

The cow-puncher and the Indian went back on the dry ground, and, with their gloved hands and knives, dug a shallow grave. The puncher took a fine Navajo blanket from his saddle, and in it he carefully wrapped remains of Keno were deposited in the hole. A fifty-dollar blanket was all that Billy could render up to Keno now, excepting the interment in due form, and the rigid repression of all unseemly emotion.

"I wouldn't have pulled out on him. I don't see what he wanted to go pull out on me for," Billy said softly, as we again mounted and took up our backward march.

When we reached camp there was no Billy. After supper he did not come, and for hours there was no Billy, and in the morning there was no Billy.

"I have got it put up," soliloquized Bolette, "that Billy is making medicine over in Riley's saloon at the station, and I reckon I can get a new horse-wrangler, because if I understand the curves of that puncher's mental get-up, New Mexico or Arizona will see William Fling about ten days from now, or some country as far from Keno as he can travel on what money Riley don't get."

So it was that Keno and Billy passed without tears from the knowledge of men.

6.
A Rodeo
at Los Ojos

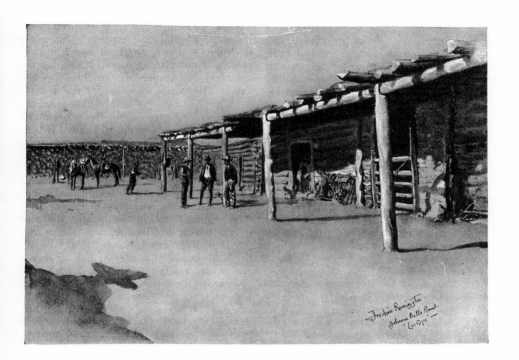

A RODEO AT LOS OJOS.

BY FREDERIC REMINGTON.

THE sun beat down on the dry grass, and the "punchers" were squatting about in groups in front of the straggling log and *adobe* buildings which constituted the outlying ranch of Los Ojos.

Mr. Johnnie Bell, the *capitan* in charge, was walking about in his heavy *chaparras*, a slouch hat, and a white "biled" shirt. He was chewing his long yellow mustache, and gazing across the great plain of Bavicora with set and squinting eyes. He passed us and repassed us, still gazing out, and in his long Texas drawl said, "Thar's them San Miguel fellers."

I looked, but I could not see any San Miguel fellows in the wide expanse of land.

"Hyar, crawl some horses, and we'll go out and meet 'em," continued Mr. Bell; and suiting the action, we mounted our horses and followed him. After a time I made out tiny specks in the atmospheric wave which rises from the heated land, and in half an hour could plainly make out a cavalcade of horsemen. Presently breaking into a gallop, which movement was imitated by the other party, we bore down upon each other, and only

stopped when near enough to shake hands, the half-wild ponies darting about and rearing under the excitement. Greetings were exchanged in Spanish, and the peculiar shoulder tap, or abbreviated embrace, was indulged in. Doubtless a part of our outfit was as strange to Governor Terraza's men — for he is the *patron* of San Miguel — as they were to us.

My imagination had never pictured before anything so wild as these leather-clad *vaqueros*. As they removed their hats to greet Jack, their unkempt locks blew over their faces, back off their foreheads, in the greatest disorder. They were clad in terra-cotta buckskin, elaborately trimmed with white leather, and around their lower legs wore heavy cowhide as a sort of legging. They were fully armed, and with their jingling spurs, their flapping ropes and buckskin strings, and with their gay *serapes* tied behind their saddles, they were as impressive a cavalcade of desert-scamperers as it has been my fortune to see. Slowly we rode back to the corrals, where they dismounted.

Shortly, and unobserved by us until at hand, we heard the clatter of hoofs, and

leaving in their wake a cloud of dust, a dozen "punchers" from another outfit bore down upon us as we stood under the *ramada* of the ranch-house, and pulling up with a jerk, which threw the ponies on their haunches, the men dismounted and approached, to be welcomed by the master of the *rodeo*.

A few short orders were given, and three mounted men started down to the springs, and after charging about, we could see that they had roped a steer, which they led, bawling and resisting, to the ranch, where it was quickly thrown and slaughtered. Turning it on its back, after the manner of the old buffalo-hunters, it was quickly disrobed and cut up into hundreds of small pieces, which is the method practised by the Mexican butchers, and distributed to the men.

In Mexico it is the custom for the man who gives the "round-up" to supply fresh beef to the visiting cow-men; and on this occasion it seemed that the pigs, chickens, and dogs were also embraced in the bounty of the *patron*, for I noticed one piece which hung immediately in front of my quarters had two chickens roosting on the top of it, and a pig and a dog tugging vigorously at the bottom.

The horse herds were moved in from the *llano* and rounded up in the corral, from which the "punchers" selected their mounts by roping, and as the sun was westering they disappeared, in obedience to orders, to all points of the compass. The men took positions back in the hills and far out on the plain; there, building a little fire, they cook their beef, and, enveloped in their *serapes*, spend the night. At early dawn they converge on the ranch, driving before them such stock as they may.

In the morning we could see from the ranch-house a great semicircle of gray on the yellow plains. It was the thousands of cattle coming to the *rodeo*. In an hour more we could plainly see the cattle, and behind them the *vaqueros* dashing about, waving their *serapes*. Gradually they converged on the *rodeo* ground, and, enveloped in a great cloud of dust and with hollow bellowings, like the low pedals of a great organ, they begin to mill, or turn about a common centre, until gradually quieted by the enveloping cloud of horsemen. The *patron* and the captains of the neighboring ranches, af-

ter an exchange of long-winded Spanish formalities, and accompanied by ourselves, rode slowly from the ranch to the herd, and entering it, passed through and through and around in solemn procession. The cattle part before the horsemen, and the dust rises so as to obscure to unaccustomed eyes all but the silhouettes of the moving thousands. This is an important function in a cow country, since it enables the owners or their men to estimate what numbers of the stock belong to them, to observe the brands, and to inquire as to the condition of the animals and the numbers of calves and "mavericks," and to settle any dispute which may arise therefrom.

All controversy, if there be any, having been adjusted, a part of the "punchers" move slowly into the herd, while the rest patrol the outside, and hold it. Then a movement soon begins. You see a figure dash at about full speed through an apparently impenetrable mass of cattle; the stock becomes uneasy and moves about, gradually beginning the milling process, but the men select the cattle bearing their brand, and course them through the herd; all becomes confusion, and the cattle simply seek to escape from the ever-recurring horsemen. Here one sees the matchless horsemanship of the "punchers." Their little ponies, trained to the business, respond to the slightest pressure. The cattle make every attempt to escape, dodging in and out and crowding among their kind; but right on their quarter, gradually forcing them to the edge of the herd, keeps the "puncher," until finally, as a last effort, the cow and the calf rush through the supporting line, when, after a terrific race, she is turned into another herd, and is called "the cut."

One who finds pleasure in action can here see the most surprising manifestations of it. A huge bull, wild with fright, breaks from the herd, with lowered head and whitened eye, and goes charging off indifferent to what or whom he may encounter, with the little pony pattering in his wake. The cattle run at times with nearly the intensity of action of a deer, and whip and spur are applied mercilessly to the little horse. The process of "tailing" is indulged in, although it is a dangerous practice for the man, and reprehensible from its brutality to the cattle. A man will pursue a bull at top speed, will reach over and grasp the tail

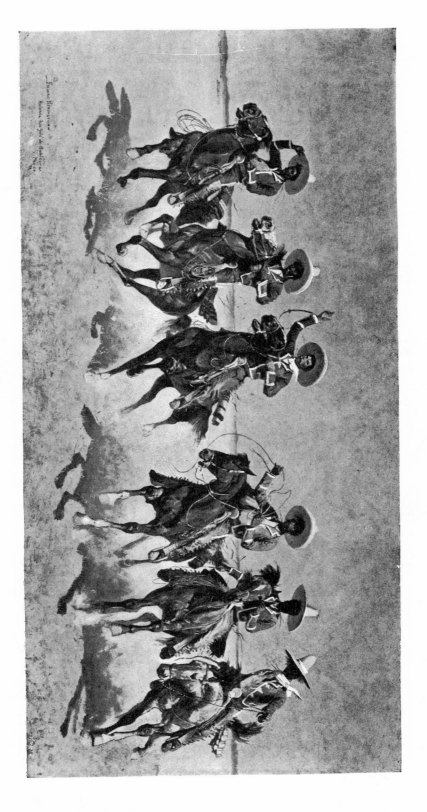

COMING TO THE RODEO.

of the animal, bring it to his saddle, throw his right leg over the tail, and swing his horse suddenly to the left, which throws the bull rolling over and over. That this method has its value I have seen in the case of pursuing "mavericks," where an unsuccessful throw was made with the rope, and the animal was about to enter the thick timber; it would be impossible to coil the rope again, and an escape would follow but for the wonderful dexterity of these men in this accomplishment. The little calves become separated from their mothers, and go bleating about; their mothers respond by bellows, until pandemonium seems to reign. The dust is blinding, and the "puncher" becomes grimy and soiled; the horses lather; and in the excitement the desperate men do deeds which convince you of their faith that "a man can't die till his time comes." At times a bull is found so skilled in these contests that he cannot be displaced from the herd; it is then necessary to rope him and drag him to the point desired;

The whole scene was inspiring to a degree, and well merited Mr. Yorick's observation that "it is the sport of kings; the image of war, with twenty-five per cent. of its danger."

Fresh horses are saddled from time to time, but before high noon the work is done, and the various "cut-offs" are herded in different directions. By this time the dust had risen until lost in the sky above, and as the various bands of cowboys rode slowly back to the ranch, I observed their demoralized condition. The economy *per force* of the Mexican people prompts them to put no more cotton into a shirt than is absolutely necessary, with the consequence that, in these cases, their shirts had pulled out from their belts and their *serapes*, and were flapping in the wind; their mustaches and their hair were perfectly solid with dust, and one could not tell a bay horse from a black.

Now come the cigarettes and the broiling of beef. The bosses were invited to sit at our table, and as the work of cutting and branding had yet to be done, no time was taken for ablutions. Opposite me sat a certain individual who, as he engulfed his food, presented a grimy waste of visage only broken by the rolling of his eyes and the snapping of his teeth.

We then proceeded to the corrals, which were made in stockaded form from gnarled and many - shaped posts set on an end. The cows and calves were bunched on one side in fearful expectancy. A fire was built just outside of the bars, and the branding-irons set on.

A MEXICAN STEER.

and I noticed "punchers" ride behind recalcitrant bulls and, reaching over, spur them. I also saw two men throw simultaneously for an immense creature, when, to my great astonishment, he turned tail over head and rolled on the ground. They had both sat back on their ropes together.

Into the corrals went the "punchers," with their ropes coiled in their hands. Selecting their victims, they threw their ropes, and, after pulling and tugging, a bull calf would come out of the bunch, whereat two men would set upon him and

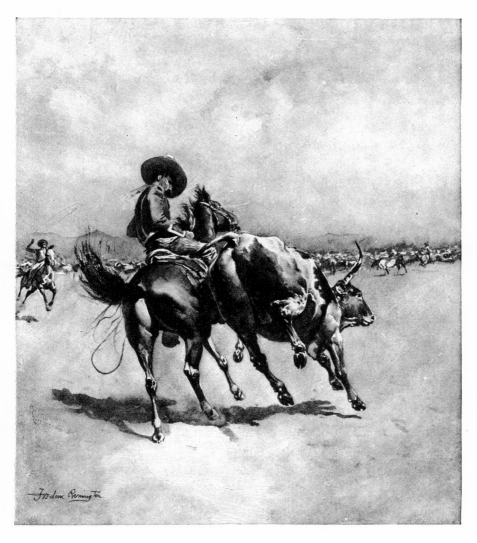

TAILING A BULL.

"rastle" him to the ground. It is a strange mixture of humor and pathos, this mutilation of calves—humorous when the calf throws the man, and pathetic when the man throws the calf. Occasionally an old cow takes an unusual interest in her offspring, and charges boldly into their midst. Those men who cannot escape soon enough throw dust in her eyes, or put their hats over her horns. And in this case there were some big steers which had been "cut out" for purposes of work at the plough and turned in with the young stock; one old grizzled veteran manifest-ed an interest in the proceedings, and walked boldly from the bunch, with his head in the air and bellowing; a wild scurry ensued, and hats and *serapes* were thrown to confuse him. But over all this the "punchers" only laugh, and go at it again. In corral roping they try to catch the calf by the front feet, and in this they become so expert that they rarely miss. As I sat on the fence, one of the foremen, in play, threw and caught my legs as they dangled.

When the work is done and the cattle are again turned into the herd, the men re-

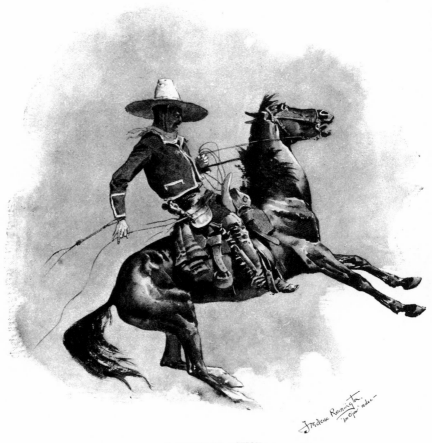

A STUDY OF ACTION.

pair to the *casa* and indulge in games and pranks. We had shooting matches and hundred-yard dashes; but I think no records were broken, since "punchers" on foot are odd fish. They walk as though they expected every moment to sit down. Their knees work outward, and they have a decided "hitch" in their gait; but once let them get a foot in a stirrup and a grasp on the horn of the saddle, and a dynamite cartridge alone could expel them from the saddle. When loping over the plain the "puncher" is the epitome of equine grace, and if he desires to look behind him he simply shifts his whole body to one side and lets the horse go as he pleases. In the pursuit of cattle at a *rodeo* he leans forward in his saddle, and with his arms elevated to his shoulders he "plugs" in his spurs and makes his pony fairly sail. While going

at this tremendous speed he turns his pony almost in his stride, and no matter how a bull may twist and swerve about, he is at his tail as true as a magnet to the pole. The Mexican "punchers" all use the "ring bit," and it is a fearful contrivance. Their saddle-trees are very short, and as straight and quite as shapeless as a "saw-buck pack-saddle." The horn is as big as a dinner plate, and taken altogether it is inferior to the California tree. It is very hard on horses' backs, and not at all comfortable for a rider who is not accustomed to it.

They all use hemp ropes which are imported from some of the southern states of the republic, and carry a lariat of hair which they make themselves. They work for from eight to twelve dollars a month in Mexican coin, and live on the most simple diet imaginable. They are mostly

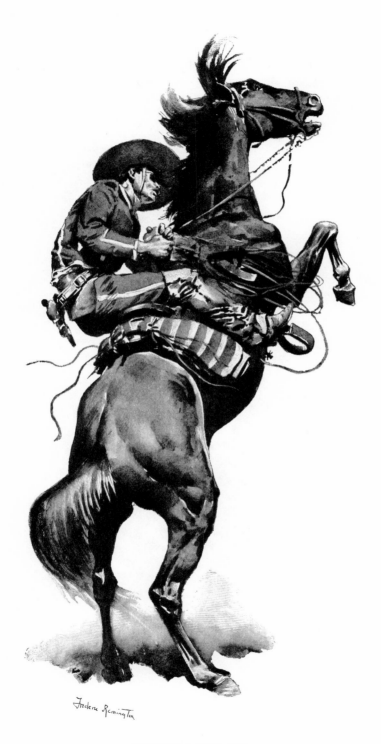

MOUNTING A WILD ONE.

peoned, or in hopeless debt to their *patrons*, who go after any man who deserts the range and bring him back by force. A "puncher" buys nothing but his gorgeous buckskin clothes, and his big silver-mounted straw hat, his spurs, his riata, and his *cincha* rings. He makes his *teguas* or buckskin boots, his heavy leggings, his saddle, and the *patron* furnishes his arms. On the round-up, which lasts about half of the year, he is furnished beef, and also kills game. The balance of the year he is kept in an outlying camp to turn stock back on the range. These camps are often the most simple things, consisting of a pack containing his "grub," his saddle, and *serape*, all lying under a tree, which does duty as a house. He carries a flint and steel, and has a piece of sheet-iron for a stove,

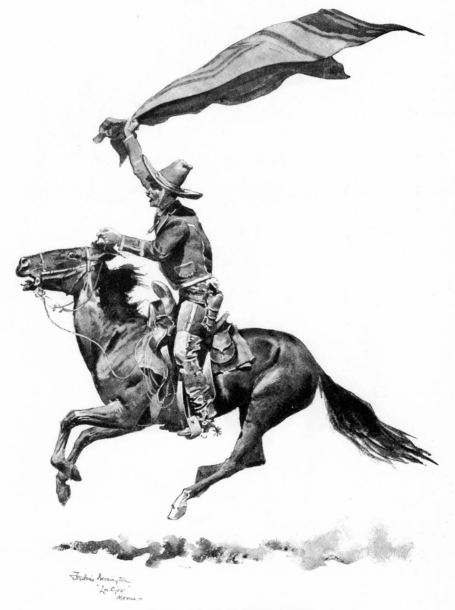

WAVING SERAPE TO DRIVE CATTLE.

and a piece of pottery for boiling things in. This part of their lives is passed in a long siesta, and a man of the North who has a local reputation as a lazy man should see a Mexican "puncher" loaf, in order to comprehend that he could never achieve distinction in the land where *poco tiempo* means forever. Such is the life of the *vaquero*—a brave fellow—a fatalist, with less wants than the pony he rides, a rather thoughtless man who lacks many virtues, but when he mounts his horse or casts his riata, all men must bow and call him master.

The *baile*—the song—the man with the guitar—and under all this *dolce far niente* are their little hates and bickerings, as thin as cigarette smoke and as enduring as time. They reverence their parents, they honor their *patron*, and love their *compadre*. They are grave, and grave even when gay; they eat little, they think less, they meet death calmly, and it's a terrible scoundrel who goes to hell from Mexico.

The Anglo-American foremen are another type entirely. They have all the rude virtues.

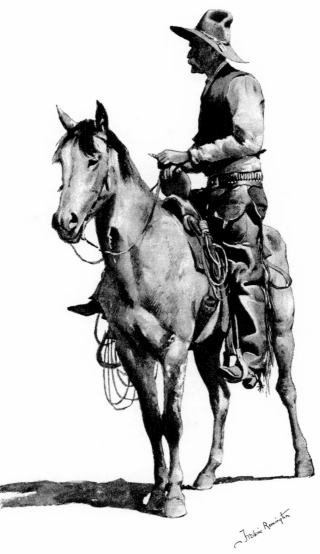

JOHNNIE BELL OF LOS OJOS.

The intelligence which is never lacking and the perfect courage which never fails are found in such men as Tom Bailey and Johnnie Bell—two Texans who are the superiors of any cowmen I have ever seen. I have seen them chase the "mavericks" at top speed over a country so difficult that a man could hardly pass on foot out of a walk. On one occasion Mr. Bailey, in hot pursuit of a bull, leaped a tremendous fallen log at top speed, and in the next instant "tailed" and threw the bull as it was about to enter the timber. Bell can ride a pony at a gallop while standing up on his saddle, and while Cossacks do this trick they are enabled to accomplish it easily from the superior adaptability of their saddles to the purpose. In my association with these men of the frontier I have come to greatly respect their moral fibre and their character. Modern civilization, in the process of educating men beyond their capacity, often succeeds in vulgarizing them, but these natural men possess minds which, though lacking all embellishment, are chaste and simple, and utterly devoid of a certain

flippancy which passes for smartness in situations where life is not so real. The fact that a man bolts his food or uses his table-knife as though it were a deadly weapon counts very little in the game these men play in their lonely range life. They are not complicated, these children of nature, and they never think one thing and say another. Mr. Bell was wont to squat against a fireplace—à la Indian—and dissect the peculiarities of the audience in a most ingenuous way. It never gave offence either, because so guileless. Mr. Bailey, after listening carefully to a theological tilt, observed that "he believed he'd be religious if he knowed how."

The jokes and pleasantries of the American "puncher" are so close to nature often, and so generously veneered with heart-rending profanity, as to exclude their becoming classic. The cow-men are good friends and virulent haters, and, if justified in their own minds, would shoot a man instantly, and regret the necessity, but not the shooting, afterwards.

Among the dry, saturnine faces of the cow "punchers" of the Sierra Madre was one which beamed with human instincts, which seemed to say, "Welcome, stranger!" He was the first impression my companion and myself had of Mexico, and as broad as are its plains and as high its mountains, yet looms up William on a higher pinnacle of remembrance.

We crawled out of a Pullman in the early morning at Chihuahua, and fell into the hands of a little black man, with telescopic pantaloons, a big sombrero with the edges rolled up, and a grin on his good-humored face like a yawning *barranca*.

"Is you frens of Mista Jack's?"

"We are."

"Gimme your checks. Come dis way," he said; and without knowing why we should hand ourselves and our property over to this uncouth personage, we did it, and from thence on over the deserts and in the mountains, while shivering in the snow by night and by day, there was Jack's man to bandage our wounds, lend us tobacco when no one else had any, to tuck in our blankets, to amuse us, to comfort us in distress, to advise and admonish, until the last *adios* were waved from the train as it again bore us to the border-land.

On our departure from Chihuahua to meet Jack out in the mountains the stage was overloaded, but a proposition to leave William behind was beaten on the first ballot; it was well vindicated, for without William the expedition would have been a "march from Moscow." There was only one man in the party with a sort of bass-relief notion that he could handle the Spanish language, and the relief was a very slight one—almost imperceptible—the politeness of the people only keeping him from being mobbed. But William could speak German, English, and Spanish, separately, or all at once.

William was so black that he would make a dark hole in the night, and the top of his head was not over four and a half feet above the soles of his shoes. His legs were all out of drawing, but forty-five winters had not passed over him without leaving a mind which, in its sphere of life, was agile, resourceful, and eminently capable of grappling with any complication which might arise. He had personal relations of various kinds with every man, woman, and child whom we met in Mexico. He had been thirty years a cook in a cow camp, and could evolve banquets from the meat on a bull's tail, and was wont to say, "I don' know so much 'bout dese yar stoves, but gie me a camp-fire an' I can make de bes' thing yo' ever threw your lip ober."

When in camp, with his little cast-off English tourist cap on one side of his head, a short black pipe tipped at the other angle to balance the effect, and two or three stripes of white corn meal across his visage, he would move round the camp-fire like a cub bear around a huckleberry bush, and in a low, authoritative voice have the Mexicans all in action, one hurrying after water, another after wood, some making *tortillas*, or cutting up venison, grinding coffee between two stones, dusting bedding, or anything else. The British Field-Marshal air was lost in a second when he addressed "Mister Willie" or "Mister Jack," and no fawning courtier of the Grand Monarch could purr so low.

On our coach ride to Bavicora, William would seem to go up to any ranch-house on the road, when the sun was getting low, and after ten minutes' conversation with the grave Don who owned it, he would turn to us with a wink, and say:

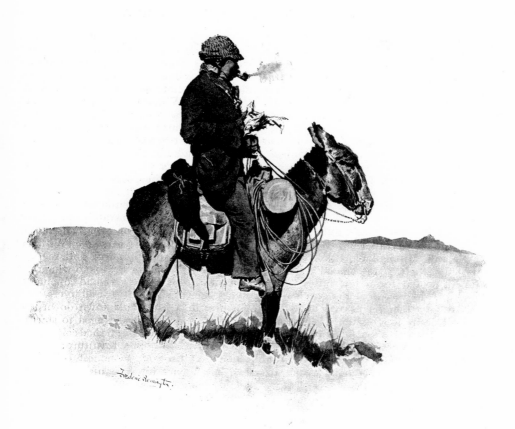

A MODERN SANCHO PANZA.

"Come right in, gemmen. Dis ranch is yours." Sure enough, it was. Whether he played us for major-generals or governors of states I shall never know, but certainly we were treated as such.

On one occasion William had gotten out to get a hat blown off by the wind, and when he came up to view the wreck of the turn-over of the great Concord coach, and saw the mules going off down the hill with the front wheels, the ground littered with boxes and débris, and the men all lying about, groaning or fainting in agony, William scratched his wool, and with just a suspicion of humor on his face he ventured, "If I'd been hyar, I would be in two places 'fore now, shuah," which was some consolation to William, if not to us.

In Chihuahua we found William was in need of a clean shirt, and we had gotten one for him in a shop. He had selected one with a power of color enough to make the sun stand still, and with great glass diamonds in it. We admonished him that when he got to the ranch the "punchers" would take it away from him.

"No, sah; I'll take it off 'fore I get thar."

William had his commercial instincts developed in a reasonable degree, for he was always trying to trade a silver watch, of the Captain Cuttle kind, with the Mexicans. When asked what time it was, William would look at the sun and then deftly cant the watch around, the hands of which swung like compasses, and he would show you the time within fifteen minutes of right, which little discrepancy could never affect the value of a watch in the land of *mañana*.

That he possessed tact I have shown, for he was the only man at Bavicora whose relations with the *patron* and the smallest, dirtiest Indian "kid," were easy and natural. Jack said of his popularity, "He stands 'way in with the Chinese cook;

gets the warm corner behind the stove."
He also had courage, for didn't he serve
out the ammunition in Texas when his
"outfit" was in a life and death tussle
with the Comanches? did he not hold a
starving crowd of Mexican teamsters off
the grub-wagon until the boys came
back?

There was only one feature of Western
life with which William could not assim-
ilate, and that was the horse. He had
trusted a bronco too far on some remote
occasion, which accounted partially for
the kinks in his legs; but after he had re-
covered fully his health he had pinned
his faith to *burros*, and forgotten the glo-
ries of the true cavalier.

"No, sah, Mister Jack, I don' care for
to ride dat horse. He's a good horse, but
I jes hit de flat for a few miles 'fore I
rides him," he was wont to say when the
cowboys gave themselves over to án irre-
sponsible desire to see a horse kill a man.
He would then go about his duties, utter-
ing gulps of suppressed laughter, after the
negro manner, safe in the knowledge that
the *burro* he affected could "pack his
freight."

One morning I was taking a bath out
of our wash-basin, and William, who was
watching me and the coffee-pot at the
same time, observed that "if one of dese
people down hyar was to do dat dere,
dere'd be a funeral 'fo' twelve o'clock."

William never admitted any social af-
finity with Mexicans, and as to his own
people, he was wont to say: "Never have
went with people of my own color. Why,
you go to Brazos to-day, and dey tell you
dere was Bill, he go home come night,
an' de balance of 'em be looking troo de
grates in de morning." So William lives
happily in the "small social puddle," and
always reckons to "treat any friends of
Mister Jack's right." So if you would
know William, you must do it through
Jack.

It was on rare occasions that William,
as master of ceremonies, committed any
indiscretion, but one occurred in the town
of Guerrero. We had gotten in rather late,
and William was sent about the town to
have some one serve supper for us. We
were all very busy when William "blew
in" with a great sputtering, and said, "Is
yous ready for dinner, gemmen?" "Yes,
William," we answered, whereat William
ran off. After waiting a long time, and
being very hungry, we concluded to go

and "rustle" for ourselves, since William
did not come back and had not told us
where he had gone. After we had found
and eaten a dinner, William turned up,
gloomy and dispirited. We inquired as to
his mood. "I do declar', gemmen, I done
forget dat you didn't know where I had or-
dered dat dinner; but dere's de dinner an'
nobody to eat it, an' I's got to leave dis
town 'fore sunup, pay for it, or die." Un-
less some one had advanced the money,
William's two other alternatives would
have been painful.

The romance in William's life even
could not be made mournful, but it was
the "mos' trouble" he ever had, and it
runs like this: Some years since William
had saved up four hundred dollars, and
he had a girl back in Brazos to whom he
had pinned his faith. He had concluded
to assume responsibilities, and to create a
business in a little mud town down the
big road. He had it arranged to start a
travellers' eating-house; he had contracted
for a stove and some furniture; and at
about that time his dishonest employer
had left Mexico for parts unknown, with
all his money. The stove and furniture
were yet to be paid for, so William enter-
ed into hopeless bankruptcy, lost his girl,
and then attaching himself to Jack, he
bravely set to again in life's battle. But
I was glad to know that he had again
conquered, for before I left I overheard a
serious conversation between William and
the *patron*. William was cleaning a
frying-pan by the camp-fire light, and the
patron was sitting enveloped in his *se-
rape* on the other side.

"Mist' Jack, I's got a girl. She's a
Mexican."

"Why, William, how about that girl
up in the Brazos?" inquired the *patron*, in
surprise.

"Don' care about her now. Got a new
girl."

"Well, I suppose you can have her, if
you can win her," replied the *patron*.

"Can I, sah? Well, den, I's win her
already, sah—dar!" chuckled William.

"Oh! very well, then, William, I will
give you a wagon, with two yellow po-
nies, to go down and get her; but I don't
want you to come back to Bavicora with
an empty wagon."

"No, sah; I won't, sah," pleasedly re-
sponded the lover.

"Does that suit you, then?" asked the
patron.

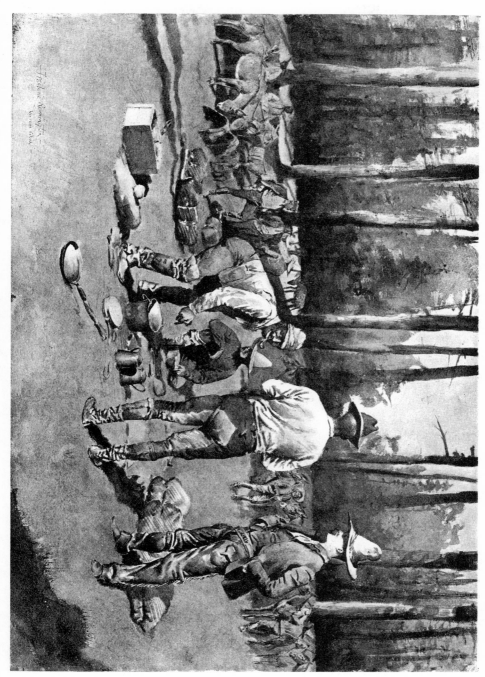

WILLIAM IN ACTION.

"Yes, sah; but, sah, wonder, sah, might I have the two old whites?"

"All right! You can have the two old white ponies;" and, after a pause, "I will give you that old *adobe* up in La Pinta, and two speckled steers; and I don't want you to come down to the ranch except on *baile* nights, and I want you to slide in then just as quiet as any other outsider," said the *patron*, who was testing William's loyalty to the girl.

"All right! I'll do that."

"William, do you know that no true Mexican girl will marry a man who don't know how to ride a charger?" continued the *patron*, after a while.

"Yes; I's been thinking of dat; but dar's dat Timborello, he's a good horse what a man can 'pend on," replied William, as he scoured at the pan in a very wearing way.

"He's yours, William; and now all you have got to do is to win the girl."

After that William was as gay as a robin in the spring; and as I write this I suppose William is riding over the pass in the mountains, sitting on a board across his wagon, with his Mexican bride by his side, singing out between the puffs of his black pipe, "Go on, dar, you muchacos; specks we ever get to Bavicora dis yar gait?"

7.
A Desert Romance

A DESERT ROMANCE.

A TALE OF THE SOUTHWEST.

BY FREDERIC REMINGTON.

WITH PICTURES BY THE AUTHOR.

CHOA water-hole is in no way re- markable, and not regarded as such by people in Arizona, but if the waters could speak and tell about what happened at their sides in the long ago, men would listen. Three gen- erations of white men and Mexicans have fought Apaches since then, and one genera- tion of Apaches has walked in the middle of the big road. There have been stories enough in the meantime. Men have struggled in crowds over similar water-holes throughout the Southwest, and Ochoa has been forgotten.

With the coming of the great war, the regular soldiers were withdrawn to partici-

pate in it. The Apaches redoubled their hostilities. This was in Cochise's day, and he managed well for them.

Volunteers entered the United States ser- vice to take the places of the departed sol- diers, to hold the country, and to protect the wagon-trains then going to California. A regiment of New Mexican volunteer in- fantry, Colonel Simms commanding, was sta- tioned at Fort Bowie, and was mostly engaged in escorting the caravans. There was a mili- tary order that such trains should leave the posts only on the 1st of every month, when the regular soldier escort was available; but in enterprising self-reliance the pioneers often violated this.

One lazy summer day a Texan came plod-

ding through the dust to the sentries at Bowie. He was in a state of great exhaustion, and when taken to Colonel Simms he reported that he had escaped from a Texas emigrant caravan, which was rounded up by Apaches at Ochoa water-hole, about forty-five miles east and south of this point, and that they were making a fight against great odds. If help was not quickly forthcoming, it was death for all.

Immediately the colonel took what of his command could be spared, together with a small cavallard of little hospital mules, and began the relief march.

These Americo-Mexican soldiers were mountain men and strong travelers. All during the remainder of the day they shuffled along in the dust—brown, blue-bearded men, shod in buckskin moccasins, of their own construction, and they made the colonel's pony trot. There are many hills and many plains in forty-five miles, and infantry is not a desert whirlwind. Night settled over the command, but still they shuffled on. Near midnight they could hear the slumping of occasional guns. The colonel well knew the Apache fear of the demons of the night, who hide under the water and earth by day, but who stalk at dark, and are more to be feared than white men, by long odds. He knew that they did not go about except under stress, and he had good hope of getting into the beleaguered wagons without much difficulty. He knew his problem would come afterward.

Guided by the guns, which the white men fired more to show their wakefulness than in hopes of scoring, the two companies trod softly in their buckskin foot-gear; but the mules struck flinty hard against the wayside rocks, and then one split the night in friendly answer to the smell of a brother mule somewhere out in the dark. But no opposition was encountered until occasional bullets came whistling over there from the wagons. "Hold on, pardners!" shouted the colonel. "This is United States infantry; let us in."

This noise located the command, and bullets and arrows began to seek them out in the darkness from all sides, but with a rush they passed into the packed wagons and dropped behind the intrenchments. The poor people of the train were greatly cheered by the advent. By morning the colonel had looked about him, and he saw a job of unusual proportions before him. They were poor emigrants from Texas, their wagons piled with common household goods, and with an unusual proportion of women and children—dry, care-worn women in calico shifts, which the clinging wind blew close about their wasted and unlovely frames. In the center stood a few skeletons of horses, destined to be eaten, and which had had no grass since the train had been rounded up. What hairy, unkempt men there were lay behind their bales, long rifles in hand, bullets and powder-horns by their elbows—tough customers, who would "sell out" dearly.

Presently a very old man came to the colonel, saying he was the head person of the train, and he proposed that the officer come to his wagon, where they could talk over the situation seriously.

The colonel was at the time a young man. In his youth he had been afflicted with desk-work in the great city of New York. He could not see anything ahead but a life of absolute regularity, which he did not view complacently. He was book-taught along the lines of construction and engineering, which in those days meant anything from a smoke-house to a covered bridge. Viewed through the mist of years he must, in his day, have been a fair prospect for feminine eyes. The West was fast eating up the strong young men of the East, and Simms found his way with the rest to the uttermost point of the unknown lands, and became a vagrant in Taos. Still, a man who knew as much as he did, and who could get as far West as Taos, did not have to starve to death. There were merchants there who knew the fords of the Cimarron and the dry crossings of the Mexican custom-house, but who kept their accounts by cutting notches on a stick. So Simms got more writing to do, a thing he had tried to escape by the long voyage and muling of previous days. Being young, his gaze lingered on the long-haired, buckskin men of Taos, and he made endeavor to exchange the quill for the rifle and the trap, and shortly became a protégé of Kit Carson. He succeeded so well that in the long years since he has been no nearer a pen than a sheep-corral would be.

He succumbed to his Mexican surroundings, and was popular with all. When the great war came he remembered New York and declared for the Union. Thus by hooks which I do not understand he became a colonel in the situation where I have found him.

As he approached the old man's part of the train he observed that he was richer and much better equipped than his fellows. He had a tremendous Conestoga and a spring-wagon of fine workmanship. His family consisted of a son with a wife and children, and

a daughter who looked at the colonel until his mind was completely diverted from the seriousness of their present position. The raw, wind-blown, calico women had not seemed feminine to the officer, but this young person began to make his eyes pop, and his blood go charging about in his veins.

She admitted to the officer in a soft Southern voice that she was very glad he had gotten in, and the colonel said he was very glad indeed that he was there, which statement had only become a fact in the last few seconds. Still, a bullet-and-arrow-swept wagon-park was quite as compelling as the eyes of Old Man Hall's daughter, for that was her father's name. The colonel had a new interest in rescue. The people of the train were quite demoralized, and had no reasonable method to suggest as a way out, so the colonel finally said: "Mr. Hall, we must now burn all this property to prevent its falling into the hands of the enemy. I will take my hospital mules and hook them up to a couple of your lightest wagons, on which will be loaded nothing but provisions, old women, small children, and what wounded we have, and then we will fight our way back to the post."

Mr. Hall pleaded against this destruction, but the officer said that the numbers of the investing enemy made it imperative that they go out as lightly as possible, as he had no more mules and could spare no more men to guard the women. It seemed hard to burn all that these people had in the world, but he knew of no other way to save their lives.

He then had two wagons drawn out, and after a tussle got his unbroken pack-mules hooked up. Then the other stuff was piled into the remaining wagons and set on fire. The soldiers waited until the flames were beyond human control, when they sprang forward in skirmish formation, followed out of bow-shot by the wagons and women. A rear-guard covered the retreat.

As the movement began, Colonel Simms led his pony up to the daughter of Mr. Hall, and assisted her to mount. Simms was a young man, and it seemed to him more important that a beautiful young woman

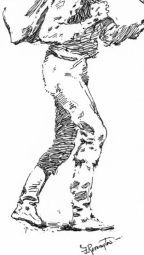

THE OLD TEXAN.

should be saved than some sisters who carried the curbs and collar-marks of an almost spent existence. This may not be true judgment, but Simms had little time to ponder the matter.

Now the demons of the Arizona deserts began to show themselves among the brush and rocks, and they came in boldly, firing from points of vantage at the moving troops. A few went down, but the discipline told, and the soldiers could not be checked. Scurrying in front ran the Indians, on foot and on horseback. They had few guns, and their arrows were not equal to the muzzle-loading muskets of the troops or the long rifles of the Texans. A few of the savages were hit, and this caused them to draw off. The wounded soldiers were loaded into the wagons, which were now quite full.

What with having to stop to ram the charges home in their guns, and with the slow progress of the women on foot, the retreat dragged its toilsome way. There were bad places in the back trail — places which Simms knew the Apaches would take advantage of; but there was nothing for it but to push boldly on.

After a couple of hours the command drew near a line of bluffs up which the trail led. There was no way around. Simms halted his wagons at the foot of the coulée leading up, and sent his men in extended order on each flank to carry the line of the crest, intending to take the wagons and women up afterward. This they did after encountering some opposition, and when just in the act of reaching the level of the mesa, a score of mounted warriors dashed at the line and rode over it, down the coulée in a whirl of dust, and toward the women, who had no protection which could reach them in time to save. The men on the hill, regardless of the enemy in front, turned their muskets on the flying bunch, as did the rear-guard; but it was over with a shot, and the soldiers saw the warriors ride over the women and wagons, twanging their bows and thrusting with their lances. The mules turned, tangled in their harness, and lay kicking in a con-

fused heap. The women ran scurrying about like quail. The cloud of dust and racing-ponies passed on, receiving the fire of the rear-guard again, and were out of range. With them went the colonel's horse and Old Man Hall's daughter, stampeded—killed by the colonel's kindness. No arm could save.

When the dust settled, several women and children lay on the sand, shot with arrows or cut by lances. The mules were rearranged, the harness was patched, and the retreat was resumed.

Old Man Hall was hysterical with tears, Simms was dumb beyond speech, as they marched along beside the clanking wagons, with their moaning loads. On all sides strode the gallant New Mexicans and Texans, shooting and loading. The Apaches, encouraged by success, plied them with arrows and shots from every *arroyo* which afforded safe retreat. The colonel ran from one part of the line to another, directing and encouraging his men. By afternoon every one was much exhausted, Colonel Simms particularly so from his constant activity and distress of mind.

Old Man Hall had calmed down and had become taciturn, except for the working of his hollow jaws as he talked to himself. Going to the rear wagon, he took out a cotton bag, which he swung across his shoulders, and trudged along with it. "Some valuables he cherishes," thought Simms; "but to add such weight in this trying march seems strange. Demented by the loss of his daughter, probably."

Slower and slower moved the old man with his sack, falling back until he mingled with the rear-guard, and then even dropping behind that.

"Come, come, camarado, stir yourself! The Indios are just behind!" they called.

"I don't care," he replied.

"Throw away the sack. Why do you carry that? Is your sack more precious than your blood?"

"Yes, it is now," he said almost cheerfully.

"What does it contain, señor? Paper money, no doubt."

"No; it is full of pinole and pemochie and

COLONEL SIMMS.

strychnine—for the wolves behind us"; and Old Man Hall trod slower and slower, and was two hundred yards in the rear before Simms noticed him.

"Halt! We will go back and get the old man, and have him put in the wagons," he said.

The soldiers turned to go back, when up from the brush sprang the Apaches, and Hall was soon dead.

"Come on; it is of no use now," signaled Simms.

"The old man is loco," said a soldier. "He had a sack of poisoned meal over his shoulder. He is after revenge."

"Poisoned meal!"

"Yes, señor; that is as he said," replied the soldier.

But under the stress Simms's little column toiled along until dusk, when they were forced to stop and intrench in a dry camp. There was no water in those parts, and the Indians had no doubt drawn off for the night—gone to the Ochoa spring, it was thought, and would be back in the morning. By early dawn the retreat started on its weary way, but no Indians appeared to oppose them. All day long they struggled on, and that night camped in the post. They had been delivered from their peril: at little cost, when the situation was considered, so men said—all except Hall's son and the young commanding officer. The caravan had violated the order of the authorities in traveling without escort, and had been punished. Old Man Hall, who had been responsible, was dead, so the matter rested.

II.

The people who had so fortunately come within the protecting lines of Bowie were quite exhausted after their almost ceaseless exertions of the last few days, and had disposed themselves as best they could to make up their lost sleep. Some of the soldiers squeezed the *tequela* pigskin pretty hard, but they had earned it.

Colonel Simms tossed uneasily on his rude bunk for some time before he gained oblivion. Something in the whole thing had been incomplete. He had had soldiers killed and

soldiers wounded—that was a part of the game. Some emigrants had suffered—that could not be helped. It was the good-looking girl, gone swirling off into the unknown desert, in the dust of the Apache charge, which was the rift in the young colonel's lute, and he had begun to admit it to himself. What could be done? What was his duty in the matter? His inclination was to conduct an expedition in quest of her. He knew his Apache so well that hope died out of his mind. Even if she could get away on the colonel's swift pony, an Apache on foot could trail and run down a horse. But the tired body and mind gave over, and he knew nothing until the morning light opened his eyes. Sitting opposite him on a chair was the brother of Hall's daughter, with his chin on his hands, and his long rifle across his knees.

"Good morning, Mr. Hall," he said.

"Mornin', colonel," replied Hall. "Ah 'm goin' back after my sista, colonel. Ah 'm goin' back, leastwise, to whar she was."

"So am I," spoke up Simms, like a flash, as he swung himself to his feet, "and right now." With men like Simms to think was to act.

He was refreshed by his rest, and was soon bustling about the post. The day before two companies of his regiment had come into the post on escort duty. They were pony-mounted, despite their being infantry, and were fresh. These he soon rationed, and within an hour's time had them trailing through the dust on the back track. Hall's sad-faced son rode by his side, saying little, for both felt they could not cheer each other with words.

Late in the afternoon, when coming across the mesa which ended at the bluff where the misfortune had overtaken the girl, they made out mounted figures at the very point where they had brought up the wagons.

"If they are Apaches, we will give them a fight now; they won't have to chase us to get it, either," said the colonel, as he broke his command into a slow lope.

Steadily the two parties drew together. More of the enemy showed above the bluffs. They formed in line, which was a rather singular thing for Apaches to do, and presently a horseman drew out, bearing a white flag on a lance.

"Colonel, those are lanceros of Mexico," spoke up the orderly sergeant behind the officer.

"Yes, yes; I can see now," observed Simms. "Trot! March! Come on, bugler." Saying which, the colonel, attended by his man, rode

forth rapidly, a white handkerchief flapping in his right hand.

So they proved to be, the irregular soldiers of distracted Mexico—wild riders, gorgeous in terra-cotta buckskin and red serapes, bent on visiting punishment on Apache Indians who ravaged the valleys of Chihuahua and Sonora, and having, therefore, much in common with the soldiers on this side of the line.

In those days the desert scamperers did not know just where the international boundary was. It existed on paper, no doubt, but the bleak sand stretches gave no sign. Every man or body of men owned the land as far on each side of them as their rifles would carry, and no farther. Both Mexico and the United States were in mighty struggles for their lives. Neither busied themselves about a few miles of cactus, or the rally and push of their brown-skinned irregulars.

Shortly the comandante of the lancers came up. He was a gay fellow with a brown face, set with liquid black eyes, and togged out in the rainbows of his national costume. Putting out his hand to Simms, he spoke: "Buenos dios, señor. Is it you who have killed all the Apaches?"

"Si, capitan," replied Simms. "I had the honor to command, but I do not think we killed so many."

"Madre de Dios! you call that not many! Ha, you are a terrible soldier!" And the lancer slapped him on the back. "I saw the battle-ground; I rode among the bodies as far as I could make my horse go. I saw all the burned wagons, and the Indios lying around the water-hole, as thick as flies in a kitchen. It smelled so that I did not stop to count them; they were as many as a flock of sheep. I congratulate you. Did you lose many *soldados?*"

"No, capitan. I did not lose many men, but I lost a woman—just down below the bluffs. Did you see her body there?"

In truth, the poisoned sack of meal had come only slowly into Simms's mind when he thought of the dead Indians about the water-hole, and he did not care to enlighten a foreign officer in a matter so difficult of explanation.

"No," answered the Mexican; "they were all naked Apaches—I made note of that. We looked for others, but there were none. You are a terrible soldier. I congratulate you; you will have promotion, and go to the great war in the East."

"Oh, it is nothing, I assure you," grunted Simms, as he trotted off to get away from

his gruesome glories. "Come, señor; we will look at the girl's trail below the bluffs."

"Was she mounted well?" inquired the lancer, full of a horseman's instinct.

"Yes; she had a fast horse, but he had been ridden far. He was my own."

"She was of your family?"

"No, no; she was coming through with the wagon-train from Texas."

flanker who waved his hat, and toward him rode the officer. Nearing, he recognized the man, who was a half-breed American, well known as a trailer of great repute.

"Colonel, here are the prints of the Apache ponies; I know by their bare feet and the rawhide shoes. Your pony is not among them; he was shod with iron. These ponies were very tired; they step short and stumble

THE TRAILER.

"She was a beautiful señorita?" ventured the lancer, with a sharp smile.

"Prettiest filly from Taos to New Orleans," spoke our gallant, in his enthusiasm, and then they dismounted at the wagon place, which was all beaten up with the hoof-marks of the lancers.

The best trailers among the mountain men of the command were soon on the track of the horsed Indians who had driven off the girl, and this they ran until quite dark. The enemy had gone in full flight.

Simms made his camp, and the Mexican lancer pushed on ahead, saying he would join him again in the morning.

By early light Simms had his troops in motion; but the trail was stamped up by the lancer command, and he could follow only this. He was in a broken country now, and rode far before he began to speculate on seeing nothing of his friend of yesterday. Some three hours later he did find evidence that the lancers had made a halt, but without unsaddling. Simms had run the trail carefully, and had his flankers out on the sides, to see that no one cut out from the grand track. Soon he was summoned by a

among the bushes," said the man, as he and the colonel rode along, bending over in their saddles. "See that spot on the ground. They had run the stomachs out of their horses. They stopped here and talked. They dismounted." Both the colonel and the trailer did the same. "There is no print of her shoe here," the trailer continued slowly. "See where they walked away from their horses and stood here in a bunch. They were talking. Here comes a pony-track back to them from the direction of the chase. This pony was very tired. His rider dismounted here and walked to the group. The moccasins all point toward the way they were running. They were talking. Colonel, the girl got away. I may be mistaken, but that is what the trail says. All the Indians are here. I have counted twenty ponies."

There is nothing to do in such places but believe the trail. It often lies, but in the desert it is the only thing which speaks. Taking his command again, the colonel pushed on as rapidly as he dared, while feeling that his flanking trailers could do their work. They found no more sign of the Indians, who had evidently given up the

chase, thinking, probably, the wagons more important than the fast horse-girl.

All day long they progressed, the colonel wondering why he did not come up with the lancer command. Why was the Mexican in such a hurry? He did not relish the idea of this man's rescuing the girl, if that was to be fate. Long he speculated, but time brought only more doubt and suspicion. At places the Mexican had halted, and the ground was tramped up in a most meaningless way. Again the trailer came to him.

"Colonel," he said, "these people were blinding a trail. It 's again' nature for humans to walk around like goats in a corral. I think they have found where the girl stopped, but I can't run my eye on her heel."

The colonel thought hard, and being young, he reached a rapid conclusion. He would follow the Mexican to the end of his road. Detailing a small body of picked trailers to follow slowly on the sides of the main trail, he mounted, and pushed on at a lope. Darkness found the Mexicans still going. While his command stopped to feed and rest, the colonel speculated. He knew the Mexicans had a long start; it was unlikely that they would stop. He thought, "I will sleep my command until midnight, and follow the trail by torch-light. I will gain the advantage they did over me last night."

After much searching on the mountain-side in the gloom, some of his men found a pitch-tree, which they felled and slivered. At the appointed time the command resumed its weary way. Three hundred yards ahead, a small party followed the trail by their firelight. This would prevent, in a measure, an ambuscade. A blanket was carried ahead of the flaming stick—a poor protection from the eyes of the night, but a possible one. So, until the sky grayed in the east, the soldiers stumbled bitterly ahead on their relentless errand. It was a small gain, perhaps, but it made for success. When the torches were thrown away, they grazed for an hour, knowing that horses do not usually do that in the dark, and by day they had watered and were off. The trail led straight for Mexico.

Whatever enthusiasm the poor soldiers and horses might have, we know not, but there was a fuel added to Simms's desire, quite as great as either the pretty face of Adele Hall or his chivalric purpose kindled —it was jealousy of the lancer officer. When hate and love combine against a young man's brain, there is nothing left but the under jaw and the back of his head to guide him. The spurs chugged hard on the lathering sides,

as the pursuers bore up on the flying wake of the treacherous man from Mexico.

At an eating halt which the lancers made, the trailers sought carefully until, standing up together, they yelled for the colonel. He came up, and pointing at the ground, one of the men said: "Señor, there is the heel of the white girl."

Bending over, Simms gazed down on the telltale footprint, saying, "Yes, yes; it is her shoe—I even remember that. Is it not so, Hall?" The girl's brother, upon examination, pronounced it to be his sister's shoe. Simms said: "We will follow that lancer to hell. Come on."

There were, in those days, few signs of human habitation in those parts. The hand of the Apache lay heavy on the land. The girl-stealer was making in the direction of Magdalena, the first important Mexican town en route. This was a promise of trouble for Simms. Magdalena was populous and garrisoned. International complications loomed across Simms's vision, but they grew white in the shadow of the girl, and, come what would, he spurred along, the brother always eagerly at his side.

By mid-afternoon they came across a dead horse, and soon another. The flat-soled tegua-tracks of the dismounted riders ran along in the trail of the lancer troop. The country was broken, yet at times they could see long distances ahead. Shortly the trailers found the tegua-prints turned away from the line of march, and men followed, and found their owners hidden in the mesquit-bush. These, being captured, were brought to Colonel Simms, who dismounted and interrogated them, as he gently tapped their lips with the muzzle of his six-shooter to break their silence. He developed that the enemy was not far ahead; that the girl was with them, always riding beside Don Gomez, who was making for Magdalena. Further, the prisoners said they had found the white woman asleep beside her worn-out pony, which they had taken aside and killed.

This was enough. The chase must be pushed to a blistering finish. As they drew ahead they passed exhausted horses standing head down by the wayside, their riders being in hiding, doubtless. On a rise they saw the troop of lancers jogging along in their own dust, not three hundred yards ahead, while in the valley, a few miles beyond, was an adobe ranch, for which they were making. With a yell from the United States soldiers, they broke into the best run to be got out of their jaded ponies. The enemy, too,

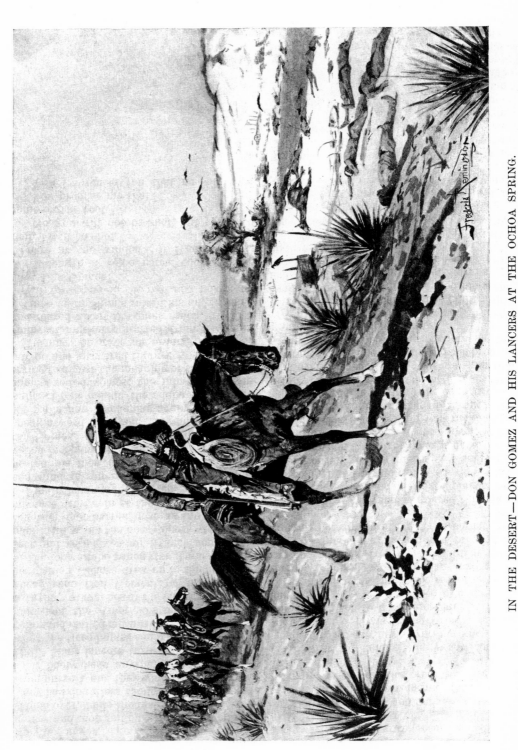

IN THE DESERT—DON GOMEZ AND HIS LANCERS AT THE OCHOA SPRING.

spurred up, but they were even more fatigued, and it was not many minutes before the guns began to go. A few of the enemy's horses and men fell out, wounded, and were ridden over, while the rest fled in wild panic. They had doubtless thought themselves safe from pursuit, and they would have been, had their booty been anything less than Adele Hall. Many lancers turned and surrendered when the tired horses could go no more. The commands tailed out in a long line, the better horses of the Americans mixing gradually with the weaker ones of the lancers. Still well ahead rode Don Gomez and his reluctant companion. These drew up to the blue walls of the long adobe ranch (for it was now sunset), and were given admittance, some dozen men in all, when the heavy doors were swung together and barred, just as the American advance drew rein at their portals.

Finally having all collected,—both Americans and prisoners,—and having carefully posted his men around the ranch, Simms yelled in Spanish: "Come to the wall, Capitan Gomez. I am Colonel Simms. I would speak a word with you." Again he spoke to the walls, now blackening against the failing light. From behind the adobe battlements came excited voices; the inhabitants were trying to digest the meaning of this violence, but no one answered Simms.

Turning, he gave an order. Instantly a volley of musketry started from near him, and roared about the quiet ranch.

Once more Simms raised his angry voice: "Will you come on the roof and talk to me now, Don Gomez?"

At length a voice came back, saying, "There are no windows; if I come on the roof, I will be shot."

"No, you will not be shot, but you must come on the roof."

"You promise me that?"

"Yes, I promise you that no soldier of mine will shoot at you," and in loud military language Simms so gave the order.

Slowly a dark figure rose against the greenish light of the west.

"Don Gomez, I ask you truly, has one hair of that girl's head been harmed? If you lie to me, I swear on the cross to burn you alive."

"I swear, my colonel; she is the same as when you last saw her. I did not know you were coming. I was trying to save her. I was taking her to my commander at Magdalena."

"You lie!" was the quick response from Simms, followed by a whip-like snap peculiar to the long frontier rifles. The dark form of Don Gomez turned half round, and dropped heavily out of sight on the flat roof of the adobe.

"Who fired that shot?" roared Simms.

"Ah did, sah," said Hall, stepping up to the colonel and handing him his rifle. "Ah am not one of yer soldiers, sah—I am Adele Hall's brother, and Mr. Gomez is dead. You can do what you please about it, sah."

While this conversation was making its quick way, a woman sprang up through the hole in the roof, and ran to the edge, crying: "Help, Colonel Simms! Oh, help me!"

"Cover the roof with your guns, men," ordered Simms, and both he and the brother sprang forward, followed by a general closing in of the men on the building.

As they gained the side wall, Simms spoke. "Don't be scared, Miss Hall; jump. I will catch you," and he extended his arms. The girl stepped over the foot-high battlement, grasped one of the projecting roof-timbers, and dropped safely into Colonel Simms's arms. She was sobbing, and Simms carried her away from the place. She was holding tightly to the neck of her rescuer, with her face buried in a week's growth of beard.

THE ADOBE RANCH WHERE THE FIGHT TOOK PLACE.

8.
Cracker Cowboys of Florida

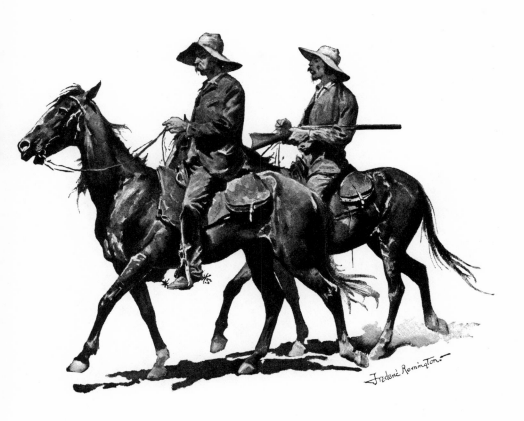

CRACKER COWBOYS OF FLORIDA.

BY FREDERIC REMINGTON.

ONE can thresh the straw of history until he is well worn out, and also is running some risk of wearing others out who may have to listen, so I will waive the telling of who the first cowboy was, even if I knew; but the last one who has come under my observation lives down in Florida, and the way it happened was this: I was sitting in a "sto' do'," as the "Crackers" say, waiting for the clerk to load some "number eights," when my friend said, "Look at the cowboys!" This immediately caught my interest. With me cowboys are what gems and porcelains are to some others. Two very emaciated Texas ponies pattered down the street, bearing wild-looking individuals, whose hanging hair and drooping hats and generally bedraggled appearance would remind you at once of the Spanish-moss which hangs so quietly and helplessly to the limbs of the oaks out in the swamps. There was none of the bilious fierceness and rearing plunge which I had associated with my friends out West, but as a fox-terrier is to a yellow cur, so were these last. They had on about four dollars' worth of clothes between them, and rode McClellan saddles, with saddle-bags, and guns tied on before. The only things they did which were conventional were to tie their ponies up by the head in brutal disregard, and then get drunk in about fifteen minutes. I could see that in this case, while some of the tail feathers were the same, they would easily classify as new birds.

"And so you have cowboys down here?" I said to the man who ran the meat-market.

He picked a tiny piece of raw liver out of the meshes of his long black beard, tilted his big black hat, shoved his arms into his white apron front, and said,

"Gawd! yes, stranger; I was one myself."

The plot thickened so fast that I was losing much, so I became more deliber-

ate. "Do the boys come into town often?"
I inquired further.

"Oh yes, 'mos' every little spell," replied the butcher, as he reached behind his weighing-scales and picked up a double-barrelled shot-gun, sawed off. "We-uns

me of the banker down the street. Bankers are bound to be broad-gauged, intelligent, and conservative, so I would go to him and get at the ancient history of this neck of woods. I introduced myself, and was invited behind the counter. The look

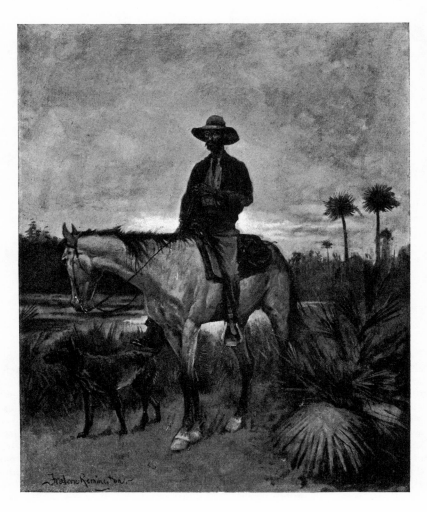

A CRACKER COWBOY.

are expectin' of they-uns to-day." And he broke the barrels and took out the shells to examine them.

"Do they come shooting?" I interposed.

He shut the gun with a snap. "We split even, stranger."

Seeing that the butcher was a fragile piece of bric-à-brac, and that I might need him for future study, I bethought

of things reminded me of one of those great green terraces which conceal fortifications and ugly cannon. It was boards and wire screen in front, but behind it were shot-guns and six-shooters hung in the handiest way, on a sort of disappearing gun-carriage arrangement. Shortly one of the cowboys of the street scene floundered in. He was two-thirds drunk,

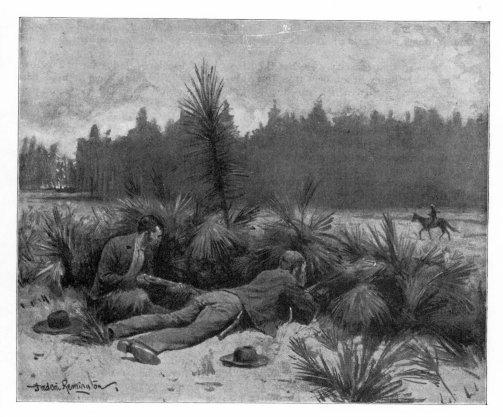

IN WAIT FOR AN ENEMY.

with brutal shifty eyes and a flabby lower lip.

"I want twenty dollars on the old man. Ken I have it?"

I rather expected that the bank would go into "action front," but the clerk said, "Certainly," and completed this rather odd financial transaction, whereat the bull-hunter stumbled out.

"Who is the old man in this case?" I ventured.

"Oh, it's his boss, old Colonel Zuigg, of Crow City. I gave some money to some of his boys some weeks ago, and when the colonel was down here I asked him if he wanted the boys to draw against him in that way, and he said, 'Yes—for a small amount; they will steal a cow or two, and pay me that way.'"

Here was something tangible.

"What happens when a man steals another man's brand in this country?"

"He mustn't get caught; that's all. They all do it, but they never bring their troubles into court. They just shoot it out there in the bresh. The last time old Colonel Zuigg brought Zorn Zuidden in here and had him indicted for stealing cattle, said Zorn: 'Now see here, old man Zuigg, what do you want for to go and git me arrested fer? I have stole thousands of cattle and put your mark and brand on 'em, and jes because I have stole a couple of hundred from you, you go and have me indicted. You jes better go and get that whole deal nol prossed;' and it was done."

The argument was perfect.

"From that I should imagine that the cow-people have no more idea of law than the 'gray apes,'" I commented.

"Yes, that's about it. Old Colonel Zuigg was a judge fer a spell, till some feller filled him with buckshot, and he had to resign; and I remember he decided a case aginst me once. I was hot about it, and the old colonel he saw I was. Says he, 'Now yer mad, ain't you?' And I allowed I was. 'Well,' says he, 'you hain't got no call to get mad. I have decided the last eight cases in yer favor, and you

kain't have it go yer way all the time; it wouldn't look right;' and I had to be satisfied."

The courts in that locality were but the faint and sickly flame of a taper offered at the shrine of a justice which was traditional only, it seemed. Moral forces having ceased to operate, the large owners began to brand everything in sight, never realizing that they were sowing the wind. This action naturally demoralized the cowboys, who shortly began to brand a little on their own account—and then the deluge. The rights of property having been destroyed, the large owners put strong outfits in the field, composed of desperate men armed to the teeth, and what happens in the lonely pine woods no one knows but the desperadoes themselves, albeit some of them never come back to the little fringe of settlements. The winter visitor from the North kicks up the jack-snipe along the beach or tarponizes in the estuaries of the Gulf, and when he comes to the hotel for dinner he eats Chicago dressed beef, but out in the wilderness low-browed cow-folks shoot and stab each other for the possession of scrawny creatures not fit for a pointer-dog to mess on. One cannot but feel the force of Buckle's law of "the physical aspects of nature" in this sad country. Flat and sandy, with miles on miles of straight pine timber, each tree an exact duplicate of its neighbor tree, and underneath the scrub palmettoes, the twisted brakes and hammocks, and the gnarled water-oaks festooned with the sad gray Spanish-moss —truly not a country for a high-spirited race or moral giants.

The land gives only a tough wiregrass, and the poor little cattle, no bigger than a donkey, wander half starved and horribly emaciated in search of it. There used to be a trade with Cuba, but now that has gone; and beyond the supplying of Key West and the small fringe of settlements they have no market. How well the cowboys serve their masters I can only guess, since the big owners do not dare go into the woods, or even to their own doors at night, and they do not keep a light burning in the houses. One, indeed, attempted to assert his rights, but some one pumped sixteen buckshot into him as he bent over a spring to drink, and he left the country. They do tell of a late encounter between two rival foremen, who rode on to each other in the woods, and drawing, fired,

and both were found stretched dying under the palmettoes, one calling deliriously the name of his boss. The unknown reaches of the Everglades lie just below, and with a half-hour's start a man who knew the country would be safe from pursuit, even if it were attempted; and, as one man cheerfully confided to me, "A boat don't leave no trail, stranger."

That might makes right, and that they steal by wholesale, any cattle-hunter will admit; and why they brand at all I cannot see, since one boy tried to make it plain to me, as he shifted his body in drunken abandon and grabbed my pencil and a sheet of wrapping-paper: "See yer; ye see that?" And he drew a circle ⭕. and then another ring around it, thus: ◎. "That brand ain't no good. Well, then—" And again his knotted and dirty fingers essayed the brand **IO**. He laboriously drew upon it and made **EO**, which of course destroyed the former brand.

"Then here," he continued, as he drew **13**, "all ye've got ter do is this—**313**." I gasped in amazement, not at his cleverness as a brand-destroyer, but at his honest abandon. With a horrible operatic laugh, such as is painted in "the Cossack's Answer," he again laboriously drew ⊕ (the circle cross), and then added some marks which made it look like this: ⬡ And again breaking into his devil's "ha, ha!" said, "Make the damned thing whirl."

I did not protest. He would have shot me for that. But I did wish he was living in the northwest quarter of New Mexico, where Mr. Cooper and Dan could throw their eyes over the trail of his pony. Of course each man has adjusted himself to this lawless rustling, and only calculates that he can steal as much as his opponent. It is rarely that their affairs are brought to court, but when they are, the men come *en masse* to the room, armed with knives and rifles, so that any decision is bound to be a compromise, or it will bring on a general engagement.

There is also a noticeable absence of negroes among them, as they still retain some *ante bellum* theories, and it is only very lately that they have "reconstructed." Their general ignorance is "mi-

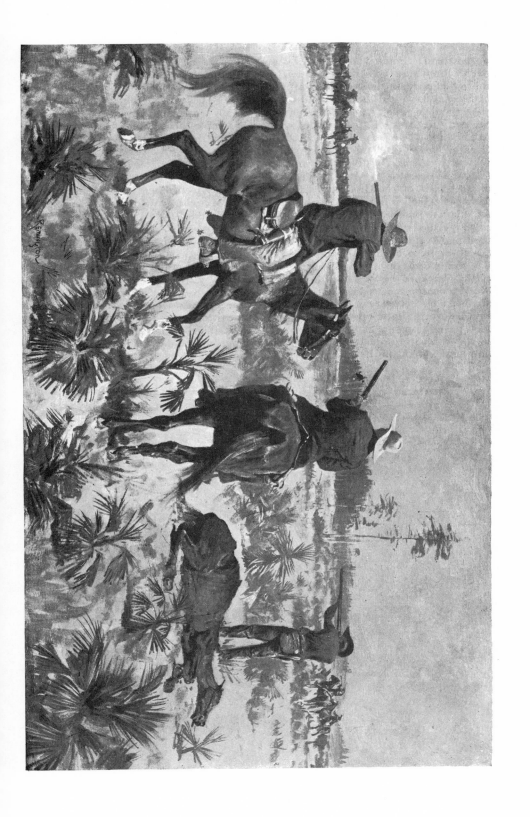

raculous," and quite mystifying to an outside man. Some whom I met did not even know where the Texas was which furnishes them their ponies. The railroads of Florida have had their ups and downs with them in a petty way on account of the running over of their cattle by the trains; and then some long-haired old Cracker drops into the nearest station with his gun and pistol, and wants the telegraph operator to settle immediately on the basis of the Cracker's claim for damages, which is always absurdly high. At first the railroads demurred, but the cowboys lined up in the "bresh" on some dark night and pumped Winchesters into the train in a highly picturesque way. The trainmen at once recognized the force of the Crackers' views on cattle-killing, but it took some considerable "potting" at the more conservative superintendents before the latter could bestir themselves and invent a "cow-attorney," as the company adjuster is called, who now settles with the bushmen as best he can. Certainly no worse people ever lived since the big killing up Muscleshell way, and the romance is taken out of it by the cowardly assassination which is the practice. They are well paid for their desperate work, and always eat fresh beef or "razor-backs," and deer which they kill in the woods. The heat, the poor grass, their brutality, and the pest of the flies kill their ponies, and, as a rule, they lack dash and are indifferent riders, but they are picturesque in their unkempt, almost unearthly wildness. A strange effect is added by their use of large, fierce cur-dogs, one of which accompanies each cattle-hunter, and is taught to pursue cattle, and to even take them by the nose, which is another instance of their brutality. Still, as they only have a couple of horses apiece, it saves them much extra running. These men do not use the rope, unless to noose a pony in a corral, but work their cattle in strong log corrals, which are made at about a day's march apart all through the woods. Indeed,

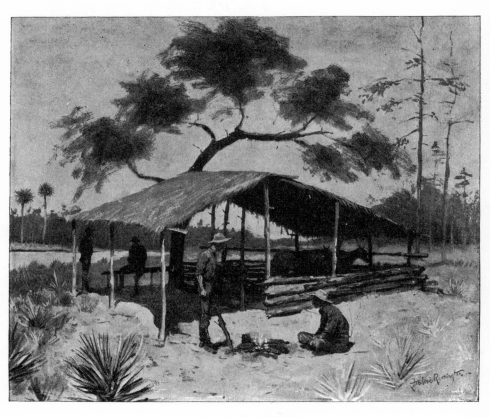

A BIT OF COW COUNTRY.

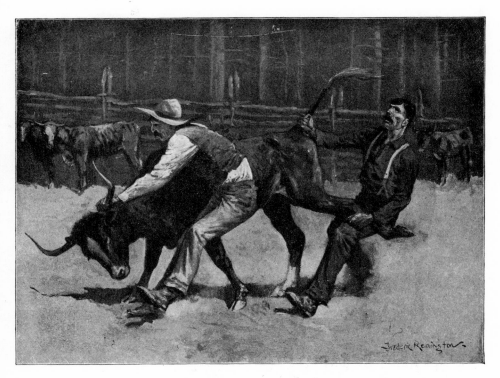

COWBOYS WRESTLING A BULL.

ropes are hardly necessary, since the cattle are so small and thin that two men can successfully "wrestle" a three-year-old. A man goes into the corral, grabs a cow by one horn, and throwing his other arm over her back, waits until some other man takes her hind leg, whereat ensues some very entertaining Græco-Roman style.

When the cow is successful, she finds her audience of Cracker cowboys sitting on the fence awaiting another opening, and gasping for breath. The best bull will not go over three hundred pounds, while I have seen a yearling at a hundred and fifty—if you, O knights of the riata, can imagine it! Still, it is desperate work. Some of the men are so reckless and active that they do not hesitate to encounter a wild bull in the open. The cattle are as wild as deer, they race off at scent; and when "rounded up" many will not drive, whereupon these are promptly shot. It frequently happens that when the herd is being driven quietly along a bull will turn on the drivers, charging at once. Then there is a scamper and great shooting. The bulls often become so mad-dened in these forays that they drop and die in their tracks, for which strange fact no one can account, but as a rule they are too scrawny and mean to make their handling difficult.

So this is the Cracker cowboy, whose chief interest would be found in the tales of some bushwhacking enterprise, which I very much fear would be a one-sided story, and not worth the telling. At best they must be revolting, having no note of the savage encounters which used to characterize the easy days in West Texas and New Mexico, when every man tossed his life away to the crackle of his own revolver. The moon shows pale through the leafy canopy on their evening fires, and the mists, the miasma, and the mosquitoes settle over their dreary camp talk. In place of the wild stampede, there is only the bellowing in the pens, and instead of the plains shaking under the dusty air as the bedizened vaqueros plough their fiery broncos through the milling herds, the cattle-hunter wends his lonely way through the ooze and rank grass, while the dreary pine trunks line up and shut the view.

9.
Bear-Chasing
in the
Rocky
Mountains

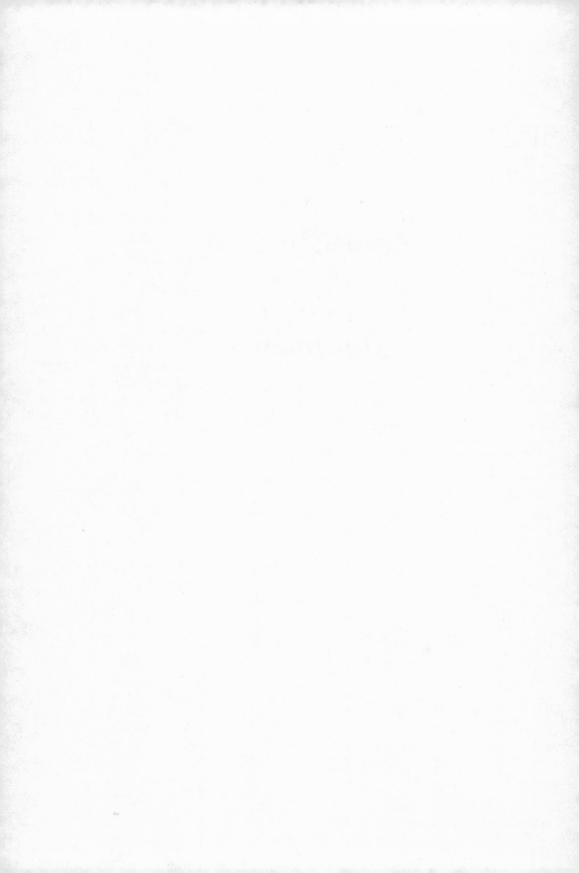

BEAR–CHASING IN THE ROCKY MOUNTAINS.

BY FREDERIC REMINGTON.

MR. MONTAGUE STEVENS is an Englishman who for the most part attends to the rounding up of his cattle, which are scattered over the northwestern quarter of New Mexico; but he does not let that interfere with the time which all Englishmen set duly apart to be devoted to sport. His door-yard is some hundreds of miles of mountain wilderness and desolate mesa—a more gorgeous preserve than any king ever dreamed of possessing for his pleasure—with its plains dotted with antelope, and its mountains filled with cougar, deer, bear, and wild turkeys. The white race has given up the contest with nature in those parts, and it has reverted to the bear, the Navajo, and Mr. Stevens, land grants, corrals, cabins, brands, and all else.

General Miles was conducting a military observation of the country, which is bound to be the scene of any war which the Apaches or Navajos may make, and after a very long day's march, during which we had found but one water, and that was a pool of rain-water, stirred into mud and full of alkali, where we had to let our horses into the muddy stuff at the ends of our lariats, we had at last found a little rivulet and some green grass. The coffee-pot bubbled and the frying-pan hissed, while I smoked, and listened to a big escort-wagon-driver who was repairing his lash, and saying, softly, "Been drivin' a bloody lot of burros for thirty years, and don't know enough to keep a whip out of a wheel; guess I'll go to jack-punchin', 'nen I kin use a dry club."

Far down the valley a little cloud of dust gleamed up against the gray of the mountains, and presently the tireless stride of a pony shone darkly in its luminous midst. Nearer and nearer it grew—the flying tail, the regular beating of the hoofs, the swaying figure of the rider, and the left sleeve of the horseman's coat flapping purposelessly about. He crossed the brook with a splash, trotted, and, with a jerk, pulled up in our midst. Mr. Stevens is a tall, thin young man, very much bronzed, and with the set, serious face of an Englishman. He wore corduroy clothes, and let himself out of his saddle with one hand, which he also presented in greeting, the other having

been sacrificed to his own shot-gun on some previous occasion. Mr. Stevens brought with him an enthusiasm for bear which speedily enveloped 'the senses of our party, and even crowded out from the mind of General Miles the nobler game which he had affected for thirty years.

The steady cultivation of one subject for some days is bound to develop a great deal of information, and it is with difficulty that I refrain from herein setting down facts which can doubtless be found in any good encyclopædia or natural history; but the men in the mountains never depart from the consideration of that and one other subject, which is brands, and have reached some strange conclusions, the strangest being that the true Rocky Mountain grizzly is only seen once in a man's lifetime, and that the biggest one they ever heard of leaves his tracks in this district, and costs Mr. Stevens, roughly estimating, about $416 a year to support, since that about covers the cattle he kills.

At break of day the officers, cavalrymen, escort wagons, and pack-train toiled up the Cañon Largo to Mr. Stevens's camp, which was reached in good time, and consisted of a regular ranchman's grub-wagon, a great many more dogs of more varieties than I could possibly count, a big Texan, who was cook, and a professional bear-hunter by the name of Cooper, who had recently departed from his wonted game for a larger kind, with the result that after the final deal a companion had passed a .45 through Mr. Cooper's face and filled it with powder, and brought him nigh unto death, so that even now Mr. Cooper's head was swathed in bandages, and his mind piled with regrets that he had on at the time an overcoat, which prevented him from drawing his gun with his usual precision. Our introduction to the outfit was ushered in by a most magnificent free-for-all dog-fight; and when we had carefully torn the snarling, yelling, biting mass apart by the hind legs and staked them out to surrounding trees, we had time to watch Mr. Cooper draw diagrams of bear paws in the dust with a stick. These tracks he had just discovered up the Largo Cañon, and he averred that the bear was a grizzly, and weighed

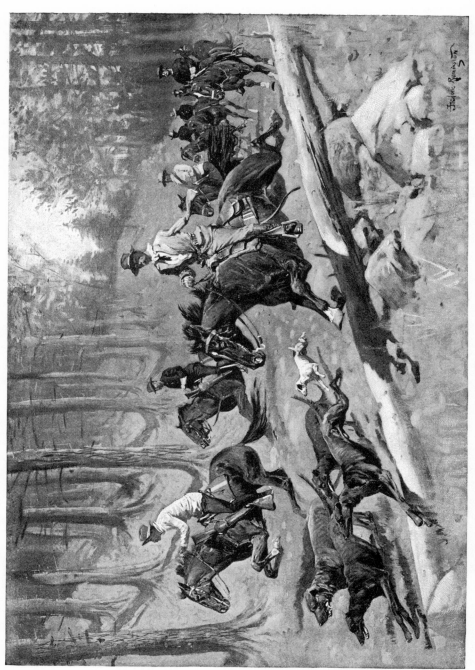

"GONE AWAY"

eighteen hundred pounds, and that he had been there two years, and that all the boys had hunted him, but that he was a sad old rascal.

After lunch we pulled on up the cañon and camped. The tents were pitched and Mr. Cooper, whose only visible eye rolled ominously, and Dan, the S. U. foreman, with another puncher.

"He's usin' here," said Cooper. "That's his track, and there's his work," pointing up the hill-side, where lay the dead body

CROSSING A DANGEROUS PLACE.

the cooks busy, when I noticed three cow-boys down the stream and across the ca-ñon who were alternately leading their horses and stooping down in earnest con-sultation over some tracks on the ground. We walked over to them. There were of a five-year-old cow. We drew near her, and there was the tale of a mighty struggle all written out more eloquently than pen can do. There were the deep furrows of the first grapple at the top; there was the broad trail down the steep

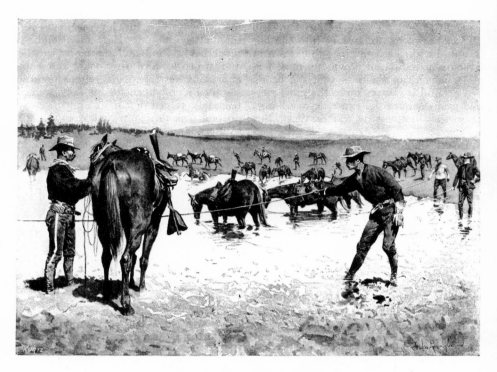

WATERING HORSES IN A 'DOBE HOLE.

hill for fifty yards, with the stones turned over, and the dust marked with horn and hoof and claw; and there was the stump which had broken the roll down hill. The cow had her neck broken and turned under her body; her shoulder was torn from the body, her leg broken, and her side eaten into; and there were Bruin's big telltale footprints, rivalling in size a Gladstone bag, as he had made his way down to the stream to quench his thirst and continue up the cañon. The cow was yet warm—not two hours dead.

"We must pull out of here; he will come back to-night," said Cooper. And we all turned to with a will and struck the tents, while the cooks threw their tins, bags, and boxes into the wagons, whereat we moved off down wind for three miles, up a spur of the cañon, where we again camped. We stood around the fires and allowed Mr. Cooper to fill our minds with hope. "He'll shore come back; he's usin' here; an' cow outfits—why, he don't consider a cow outfit nothin'; he's been right on top of cow outfits since he's been in these parts, and thet two years gone now when he begun to work this yer

range and do the work you see done yonder. In the mornin' we'll strike his trail, and if we can git to him you'll shore see a bar-fight."

We turned in, and during the night I was awakened twice, once by a most terrific baying of all the dogs, who would not be quieted, and later by a fine rain beating in my face. The night was dark, and we were very much afraid the rain would kill the scent. We were up long before daylight, and drank our coffee and ate our meat, and as soon as "we could see a dog a hundred yards," which is the bear-hunter's receipt, we moved off down the creek. We found that the cow had been turned over twice, but not eaten; evidently Bruin had his suspicions. The dogs cut his trail again and again. He had run within sight of our camp, had wandered across the valley hither and yon, but the faithful old hounds would not "go away." Dan sat on his pony and blew his old cow's horn, and yelled, "Hooick! hooick! get down on him, Rocks; hooick! hooick!" But Rocks could not get down on him, and then we knew that the rain had killed the scent,

We circled a half-mile out, but the dogs were still; and then we followed up the Cañon Largo for miles, and into the big mountain, through juniper thickets and over malpais, up and down the most terrible places, for we knew that the bear's bed-ground is always up in the most rugged peaks, where the rim-rock overhangs in serried battlements, tier on tier. But no bear.

Rocks, the forward hound, grew weary of hunting for things which were not, and retired to the rear for consultation with his mates; and Dan had to rope him, and with some irritation started the pony, and Rocks kept the pace by dint of legging it, and by the help of a tow from nine hundred pounds of horseflesh. Poor Rocks! He understood his business, but in consequence of not being able to explain to the men what fools they were, he suffered.

The hot mid-day sun of New Mexico soon kills the scent, and we were forced to give over for the day. A cavalry sergeant shot three deer, but we, in our superior purpose, had learned to despise deer. Later than this I made a good two-hundred-yard centre on an antelope, and though I had not been fortunate enough in years to get an antelope, the whole sensation was flat in view of this new ambition.

On the following morning we went again to our dead cow, but nothing except the jackals had been at the bear's prey, for the wily old fellow had evidently scented our camp, and concluded that we were not a cow outfit, whereat he had discreetly "pulled his freight."

We sat on our horses in a circle and raised our voices. In consideration of the short time at our disposal, we concluded that we could be satisfied with taking eighteen hundred pounds of bear on the instalment plan. The first instalment was a very big piece of meat, but was, I am going to confess, presented to us in the nature of a gift; but the whole thing was so curious I will go into it.

We hunted for two days without success, unless I include deer and antelope; but during the time I saw two things which interested me. The first was a revelation of the perfect understanding which a mountain cow-pony has of the manner in which to negotiate the difficulties of the country which is his home.

Dan, the foreman, was the huntsman.

He was a shrewd-eyed little square-built man, always very much preoccupied with the matter in hand. He wore a sombrero modelled into much character by weather and time, a corduroy coat, and those enormous New Mexican "chaps," and he sounded a cow-horn for his dogs, and alternately yelped in a most amusing way. So odd was this yelp that it caught the soldiers, and around their camp-fire at night you could hear the mimicking shouts of, "Oh Rocks! eh-h-h! hooick! get down on him, Rocks; tohoot! to-hoot!" We were sitting about on our horses in a little *sienneca*, while Dan was walking about, leading his pony and looking after his dogs.

When very near me he found it necessary to cross an *arroyo* which was about five feet deep and with perfectly perpendicular banks. Without hesitating, he jumped down into it, and, with a light bound, his pony followed. At the opposite side Dan put up his arms on the bank and clawed his way up, and still paying no attention to his pony, he continued on. Without faltering in the least, the little horse put his fore feet on the bank, clawed at the bank, once, twice, jumped, scratched, clawed, and, for all the world like a cat getting into the fork of a tree, he was on the bank and following Dan.

Later in the day, when going to our camp, we followed one of Dan's short-cuts through the mountains, and the cowboys on their mountain ponies rode over a place which made the breath come short to the officers and men behind. Not that they could not cross themselves, being on foot, but that the cavalry horses could they had their solemn doubts, and no one but an evil brute desires to lead a game animal where he may lose his life. Not being a geologist, I will have to say it was a blue clay in process of rock formation, and in wet times held a mountain torrent. The slope was quite seventy degrees. The approach was loose dirt and malpais, which ran off down the gulch in small avalanches under our feet. While crossing, the horses literally stood on their toes to claw out a footing. A slip would have sent them, belly up, down the toboggan slide, with a drop into an unknown depth at the end. I had often heard the cavalry axiom "that a horse can go anywhere a man can if the man will not use his hands," and a little recruit murmured it to reassure himself,

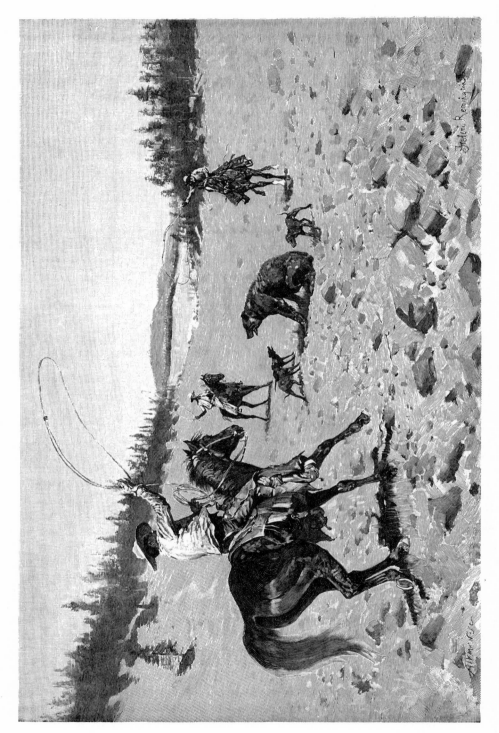

THE BEAR AT BAY.

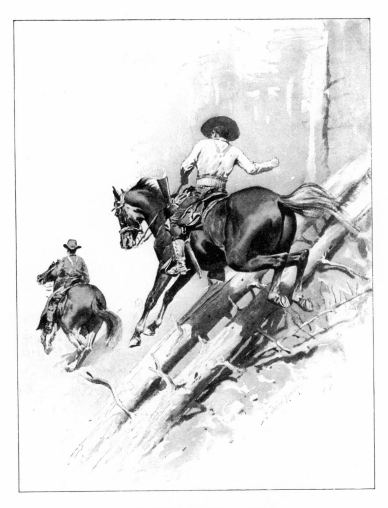

TIMBER-TOPPING IN THE ROCKIES.

I passed with the loss of a quarter of the skin on my left hand, and later asked a quaint old veteran of four enlistments if he thought it was a bad place, and he said, "It's lizards, not harses, what ought te go thar."

Riding over the rough mountains all day sows poppy seeds in a man's head, and when the big medical officer opens your tent flaps in the morning, and fills the walls with his roars to "get up; it's four o'clock," it is with groans that you obey. You also forego washing, because you are nearly frozen stiff, and you go out and stand around the fire with your companions, who are all cheerfully miserable as they shiver and chaff each other. It

seems we do not live this life on a cold calculating plane of existence, but on different lines, the variation of which is the chief delight of the discriminating, and I must record a distinct pleasure in elbowing fellows around a camp-fire when it is dark and cold and wet, and when you know that they are oftener in bed than out of it at such hours. You drink your quart of coffee, eat your slice of venison, and then regard your horse with some trepidation, since he is all of a tremble, has a hump on his back, and is evidently of a mind to "pitch."

The eastern sky grows pale, and the irrepressible Dan begins to "honk" on his horn, and the cavalcade moves off through

the grease-wood, which sticks up thickly from the ground like millions of Omaha war-bonnets.

The advance consists of six or eight big blood-hounds, which range out in front, with Dan and Mr. Cooper to blow the horn, look out for "bear sign," and to swear gently but firmly when the younger dogs take recent deer trails under consideration. Three hundred yards behind come Scotch stag-hounds, a big yellow mastiff, fox-terriers, and one or two dogs which would not classify in a bench show, and over these Mr. Stevens holds a guiding hand, while in a disordered band come General Miles, his son, three army officers, myself, and seven orderlies of the Second Cavalry. All this made a picture, but, like all Western canvases, too big for a frame. The sun broke in a golden flash over the hills, and streaked the plain with gold and gray-greens. The spirit of the thing is not hunting but the chase of the bear, taking one's mind back to the buffalo, or the nobles of the Middle Ages, who made their "image of war" with bigger game than red foxes.

Leaving the plain, we wound up a dry creek, and noted that the small oaks had been bitten and clawed down by bear to get at the acorns. The hounds gave tongue, but could not get away until we had come to a small glade in the forest, where they grew wildly excited. Mr. Cooper here showed us a very large bear track, and also a smaller one, with those of two cubs by its side. With a wild burst the dogs went away up a cañon, the blood went into our heads, and our heels into the horses, and a desperate scramble began. It is the sensation we have travelled so long to feel. Dan and Cooper

CONVERSATION AT 4 A.M.

"Do you think the pony is going to buck?"
"He does look a little hostile."

sailed off through the brush and over the stones like two old crows, with their coat tails flapping like wings. We follow at a gallop in single file up the narrow dry watercourse. The creek ends, and we take to the steep hill-sides, while the loose stones rattle from under the flying hoofs. The rains have cut deep furrows on their way to the bed of the cañon, and your horse scratches and scrambles for a foothold. A low gnarled branch bangs you across the face; and then your breath fairly stops as you see a horse go into the air and disappear over a big log

yelling dogs goes straight up, amid scraggly cedar and juniper, with loose malpais underfoot. We arrive at the top only to see Cooper and Dan disappear over a precipice after the dogs, but here we stop. Bears always seek the very highest peaks, and it is better to be there before them if possible. A grizzly can run down hill quicker than a horse, and all hunters try to get above them, since if they are big and fat they climb slowly; besides, the mountain-tops are more or less flat and devoid of underbrush, which makes good running for a horse.

THE FINALE.

fallen down a hill of seventy degrees' slope. The "take off and landing" is yielding dust, but the blood in your head puts the spur in your horse, and over you go. If you miss, it is a two-hundred-foot roll, with a twelve-hundred-pound horse on top of you. But the pace soon tells, and you see nothing but good honest climbing ahead of you. The trail of the

We scatter out along the cordon of the range. The bad going on the rimrock of the mountain-tops, where the bear tries to throw off the dogs, makes it quite impossible to follow them at speed, so that you must separate, and take your chances of heading the chase.

I selected Captain Mickler — the immaculate — the polo-player — the epitome

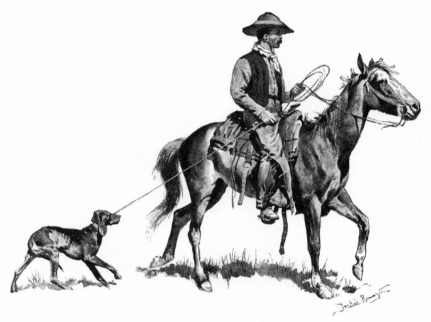

DAN AND ROCKS.

of staff form—the trappiest trooper in the Dandy Fifth, and, together with two orderlies, we started. Mickler was mounted on a cow-pony which measured one chain three links from muzzle to coupling. Mickler had on English riding-togs—this is not saying that the pony could not run, or that Mickler was not humorous. But it was no new experience for him, this pulling a pony and coaxing him to attempt breakneck experiments, for he told me casually that he had led barefooted cavalrymen over these hills in pursuit of Apaches at a date in history when I was carefully conjugating Latin verbs.

We were making our way down a bad formation, when we heard the dogs, and presently three shots. A strayed cavalry orderly had, much to his disturbance of mind, beheld a big silver-tip bearing down on him, jaws skinned, ears back, and red-eyed, and he had promptly removed himself to a proper distance, where he dismounted. The bear and dogs were much exhausted, but the dogs swarmed around the bear, thus preventing a shot. But Bruin stopped at intervals to fight the dogs, and the soldier fired, but without effect. If men do not come up with the dogs in order to encourage them, many will draw off, since the work of

chasing and fighting a bear without water for hours is very trying. The one now running was an enormous silver-tip, and could not "tree." The shots of the trooper diverted the bear, which now took off down a deep cañon next to the one we were in, and presently we heard him no more. After an hour's weary travelling down the winding way we came out on the plain, and found a small cow outfit belonging to Mr. Stevens, and under a tree lay our dead silver-tip, while a half-dozen punchers squatted about it. It appeared that three of them had been working up in the foot-hills, when they heard the dogs, and shortly discovered the bear. Having no guns, and being on fairly good ground, they coiled their *riatas* and prepared to do battle.

The silver-tip was badly blown, and the three dogs which had staid with him were so tired that they sat up at a respectful distance and panted and lolled. The first rope went over Bruin's head and one paw. There lies the danger. But instantly number two flew straight to the mark, and the ponies surged, while Bruin stretched out with a roar. A third rope got his other hind leg, and the puncher dismounted and tied it to a tree. The roaring, biting, clawing mass of hair was

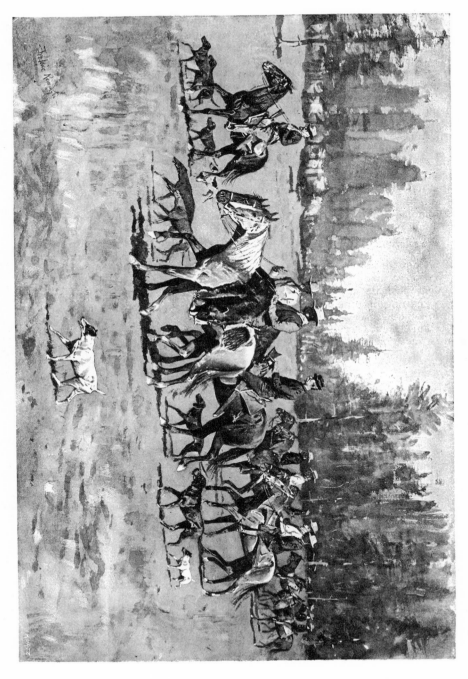

THE RETURN OF THE HUNTERS

practically helpless, but to kill him was an undertaking.

"Why didn't you brand him and turn him loose?" I asked of the cowboy.

"Well," said the puncher, in his Texan drawl, "we could have branded him all right, but we might have needed some help in turning him loose."

They pelted him with malpais, and finally stuck a knife into a vital part, and then, loading him on a pony, they brought him in. It was a daring performance, but was regarded by the "punchers" as a great joke.

Mickler and I rode into camp, thinking on the savagery of man. One never heard of a bear which travelled all the way from New Mexico to Chicago to kill a man, and yet a man will go three thousand miles to kill a bear—not for love, or fear, or hate, or meat; for what, then? But Mickler and I had not killed a bear, so we were easy.

One by one the tired hunters and dogs straggled into camp, all disappointed, except the dogs, which could not tell us what had befallen them since morning. The day following the dogs started a big black bear, which made a good run up a bad place in the hills, but with the hunters scrambling after in full cry. The bear treed for the dogs, but on sighting the horsemen he threw himself backward from the trunk, and fell fifteen feet among the dogs, which latter piled into him *en masse*, the little fox-terriers being particularly aggressive. It was a tremendous shake-up of black hair and pups of all colors, but the pace was too fast for Bruin, and he sought a new tree. One little foxie had been rolled over, and had quite a job getting his bellows mended. This time the bear sat on a limb very high up,

and General Miles put a .50-calibre ball through his brain, which brought him down with a tremendous thump, when the pups again flew into him, and "wooled him," as the cowboys put it, to their hearts' content.

While our bear-hunting is not the thing we are most proud of, yet the method is the most sportsmanlike, since nothing but the most desperate riding will bring one up with the bear in the awful country which they affect. The anticipation of having a big silver-tip assume the aggressive at any moment is inspiriting. When one thinks of the enormous strength of the "silver-tip," which can overpower the mightiest steer, and bend and break its neck or tear its shoulder from its body at a stroke, one is able to say, "Do not hunt a bear unless thy skin is not dear to thee." Then the dogs must be especially trained to run bear, since the country abounds in deer, and it is difficult to train dogs to ignore their sight and scent. The cowboys account for the number of the bear in their country from the fact that it is the old Apache and Navajo range, and the incoherent mind of the savage was impressed with the rugged mass of fur and the grinning jaws of the monster which crossed his path, and he was awed by the dangers of the encounter—arrow against claw. He came to respect the apparition, and he did not know that life is only sacred when in the image of the Creator. He did not discriminate as to the value of life, but, with his respect for death, there grew the speculation, which to him became a truth, that the fearsome beast was of the other world, and bore the lost souls of the tribe. He was a vampire; he was sacred. Oh Bear!

10.
Artist Wanderings Among the Cheyennes

ARTIST WANDERINGS AMONG THE CHEYENNES.

WRITTEN AND ILLUSTRATED BY FREDERIC REMINGTON.

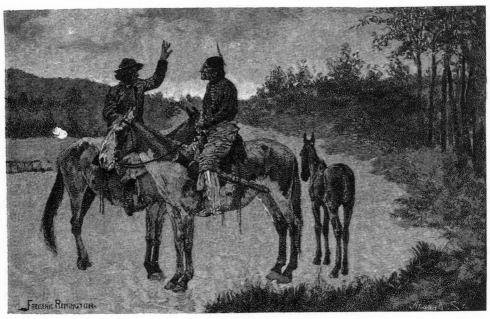

A CHEYENNE.

AFTER a hard pull we came to a beautiful creek heavily timbered with post-oak, black-jack, and pecan trees. Taking our well-worn ponies from the pole we fed and curried them, hoping that by careful nursing they might be gotten through to Fort Reno. I wasted some anxiety on myself as I discovered that my cowboy driver unrolled from a greasy newspaper the provisions which he had assured me before starting was a matter which had been attended to. It was "poor picking" enough, and I did not enjoy my after-dinner smoke when I realized that the situation was complicated by the fact that we had eaten everything for dinner and were then miles from Reno, with a pair of played-out ponies.

Hooking up again, we started on. On a little hill one jaded beast "set back in the breeching" and we dismounted to push the wagon and coax him along. The road was heavy with sand and we lost a parallel trail made by the passage of the Eighth Cavalry some weeks before. We hoped to discover the "breaks"[1] of the South Canadian River before darkness set in; but the land rose steadily away in front, and we realized that something must be done. At last coming suddenly upon a group of miserable pole cabins, we saw two Caddoes reclining on a framework of poles. I conceived the idea of hiring one of these to guide us through in the darkness. The wretches refused to understand us, talk English, sign language, or what we would. But after a hard bargain one saddled his pony and consented to lead the way through the darkness. On we traveled, our valuable guide riding so far ahead that we could not see him, and at last we came suddenly in sight of the bright surface of the

THE SIGN LANGUAGE.

South Canadian. The sun was fast sinking, and by the time we had crossed the wide sand-bars and the shallow water of the river bottom a great red gleam was all that remained on the western horizon. About a mile to the left flickered the camp-fires about a group of lodges

1 The lowering of the land, cut by streams tending towards the basin of a large river.

AN ARAPAHO SCOUT.

of Arapahoes. We fed our team and then ourselves crunched kernels of "horse-trough corn" which were extracted from the feed box. Our Caddo sat on his horse while we lay stretched on the grassy bank above the sand flats. A dark-skinned old Arapaho rode up, and our Caddo saluted him. They began to converse in the sign language as they sat on their ponies, and we watched them with great interest. With graceful gestures they made the signs and seemed immediately and fully to comprehend each other. As the old Arapaho's face cut dark against the sunset I thought it the finest Indian profile I had ever seen. He was arrayed in the full wild Indian costume of these latter days, with leggings, beaded moccasins, and a sheet wrapped about his waist and thighs. The Caddo, on the contrary, was a progressive man. His hair was cropped in Cossack style; he wore a hat, boots, and a great "slicker," or cowboy's oil-skin coat. For the space of half an hour they thus interested each other. We speculated on the meaning of the signs, and could often follow them; but they abbreviated so much and did it all so fast that we missed the full meaning of their conversation. Among other things the Caddo told the Arapaho who we were, and also made arrangements to meet him at the same place at about 10 o'clock on the following day.

Darkness now set in, and as we plunged into the timber after the disappearing form of our guide I could not see my companions on the seat beside me. I think horses can make out things better than men can under circumstances like these; and as the land lay flat before us, I had none of the fears which one who journeys in the mountains often feels.

The patter of horses' hoofs in the darkness behind us was followed by a hailing cry in the guttural tone of an Indian. I could just make out a mounted man with a led horse beside the wagon, and we exchanged inquiries in English and found him to be an acquaint-

ance of the morning, in the person of a young Cheyenne scout from Fort Reno who had been down to buy a horse of a Caddo. He had lived at the Carlisle school, and although he had been back in the tribe long enough to let his hair grow, he had not yet forgotten all his English. As he was going through to the post, we dismissed our Caddo and followed him.

Far ahead in the gloom could be seen two of the post lights, and we were encouraged. The little ponies traveled faster and with more spirit in the night, as indeed do all horses. The lights did not come nearer, but kept at the indefinite distance peculiar to lights on a dark night. We plunged into holes, and the old wagon pitched and tipped in a style which insured keeping its sleepy occupants awake. But there is an end to all things, and our tedious trail brought us into Fort Reno at last. A sleepy boy with a lamp came to the door of the post-trader's and wanted to know if I was trying to break the house down, which was a natural conclusion on his part, as sundry dents in a certain door of the place will bear witness to this day.

On the following morning I appeared at the headquarters office, credentials in hand. A smart, well-gotten up "non-com." gave me a chair and discreetly kept an eye on the articles of value in the room, for the hard usage of my recent travels had so worn and soiled my clothing that I was more picturesque than assuring in appearance. The colonel came soon, and he too eyed me with suspicious glances until he made out that I was not a Texas horse thief nor an Oklahoma boomer. After finding that I desired to see his protégés of the prairie, he sent for the interpreter, Mr. Ben. Clark, and said, "Seek no farther; here is the best Cheyenne in the country."

Mr. Clark I found to be all that the colonel had recommended, except that he did not look like a Cheyenne, being a perfect type of the frontier scout, only lacking the long hair, which to his

BEN. CLARK, INTERPRETER.

practical mind a white man did not seem to require. A pair of mules and a buckboard were provided at the quartermaster's corral, and Mr. Clark and I started on a tour of observation.

We met many Cheyennes riding to some place or another. They were almost invariably tall men with fine Indian features. They wore the hair caught by braids very low on the shoulders, making a black mass about the ears, which at a distance is not unlike the aspect of an Apache. All the Indians now use light "cow-saddles," and ride with the long stirrups peculiar to Western Americans, instead

back, although I have never heard any one with enough temerity to question his ability. I always like to dwell on this subject of riding, and I have an admiration for a really good rider which is altogether beyond his deserts in the light of philosophy. In the Eastern States the European riding-master has proselyted to such an extent that it is rather a fashionable fad to question the utility of the Western method. When we consider that for generations these races of men who ride on the plains and in the Rocky Mountains have been literally bred on a horse's back, it seems reasonable to suppose they ought to be riders; and when

A CHEYENNE CAMP.

of "trees" of their own construction with the short stirrup of the old days. In summer, instead of a blanket, a white sheet is generally worn, which becomes dirty and assumes a very mellow tone of color. Under the saddle the bright blue or red Government cloth blanket is worn, and the sheet is caught around the waist, giving the appearance of Zouave trousers. The variety of shapes which an Indian can produce with a blanket, the great difference in wearing it, and the grace and naturalism of its adjustment, are subjects one never tires of watching. The only criticism of the riding of modern Indians one can make is the incessant thumping of the horse's ribs, as though using a spur. Outside of the far South-west, I have never seen Indians use spurs. With the awkward old "trees" formerly made by the Indians, and with the abnormally short stirrup, an Indian was anything but graceful on horse-

one sees an Indian or a cowboy riding up precipices where no horses ought to be made to go, or assuming on horseback some of the grotesque positions they at times affect, one needs no assurance that they do ride splendidly.

As we rattled along in the buckboard, Mr. Clark proved very interesting. For thirty odd years he has been in contact with the Cheyennes. He speaks the language fluently, and has discovered in a trip to the far North that the Crees use almost identically the same tongue. Originally the Cheyennes came from the far North, and they are Algonquin in origin. Though their legend of the famous "medicine arrow" is not a recent discovery, I cannot forbear to give it here.

A long time ago, perhaps about the year 1640, the Cheyennes were fighting a race of men who had guns. The fighting was in the vicinity of the Devil's Lake country, and

the Cheyennes had been repeatedly worsted in combat and were in dire distress. A young Horatius of the tribe determined to sacrifice himself for the common weal, and so wandered away. After a time he met an old man, a mythical personage, who took pity on him. Together they entered a great cave, and the old man gave him various articles of "medicine" to choose from, and the young man selected the "medicine arrows." After the old man had performed the proper incantations, the hero went forth with his potent fetish and rejoined the tribe. The people regained courage, and in the fight which soon followed they conquered and obtained guns for the first time. Ever since the tribe has kept the medicine arrows, and they are now in the Indian Territory in the possession of the southern Cheyennes. Years ago the Pawnees captured the arrows and in ransom got vast numbers of ponies, although they never gave back all of the arrows, and the Cheyennes attribute all their hard experiences of later days to this loss. Once a year, and oftener should a situation demand it, the ceremony of the arrows takes place. No one has ever witnessed it except the initiated priests.

The tribal traditions are not known thoroughly by all, and of late years only a very few old men can tell perfectly the tribal stories. Why this is so no one seems to know, unless the Indians have seen and heard so much through the white men that their faith is shaken.

Our buckboard drew gradually nearer the camp of the Cheyennes. A great level prairie of waving green was dotted with the brown toned white canvas lodges, and standing near them were brush "ramadas," or sheds, and also wagons. For about ten years they have owned wagons, and now seldom use the *travaux.* In little groups all over the plain were scattered pony herds, and about the camp could be seen forms wearing bright blankets or wrapped in ghostlike cotton sheets. Little columns of blue smoke rose here and there, and gathered in front of one lodge was squatted a group of men. A young squaw dressed in a bright calico gown stood near a ramada and bandied words with the interpreter while I sketched. Presently she was informed that I had made her picture, when she ran off, laughing at what she considered an unbecoming trick on the part of her entertainer. The women of this tribe are the only squaws I have ever met, except in some of the tribes of the northern plains, who have any claim to be considered good looking. Indeed, some of them are quite as I imagine Pocahontas, Minnehaha, and the rest of the heroines of the race appeared. The female names are conventional, and have been borne by the women ever since the oldest man can remember. Some of them have the pleasant sound which we occasionally find in the Indian tongues: "Mut-say-yo," "Wau-hi-yo," "Mo-ka-is," "Jok-ko-ko-me-yo," for instance, are examples; and with the soft guttural of their Indian pronunciation I found them charming. As we entered the camp all the elements which make that sort of scene interesting were about. A medicine-man was at work over a sick fellow. We watched him through the opening of a lodge and our sympathies were not aroused, as the patient was a young buck who seemed in no need of them. A group of young men were preparing for a clan dance. Two young fellows lay stretched on the grass in graceful attitudes. They were what we call "chums." Children were playing with dogs; women were beading moccasins; a group of men lay under a wagon playing monte; a very old man, who was quite naked, tottered up to our vehicle and talked with Mr. Clark. His name was Bull Bear, and he was a strange object with his many wrinkles, gray hair, and toothless jaws.

From a passing horseman I procured an old "buck saddle" made of elk horn. They are now very rare. Indian saddlery is interesting, as all the tribes had a different model, and the women used one differing from that of the men.

We dismounted at the lodge of Whirlwind, a fine old type who now enjoys the prestige of head chief. He was dignified and reserved, and greeted us cordially as he invited us to a seat under the ramada. He refused a cigar, as will nearly all Indians, and produced his own cigarettes.

Through the interpreter we were enabled to converse freely. I have a suspicion that the old man had an impression that I was in some way connected with the Government. All Indians somehow divide the white race into three parts. One is either a soldier, a Texas cowboy, or a "big chief from Washington," which latter distinction I enjoyed. I explained that I was not a "big chief," but an artist, the significance of which he did not grasp. He was requested to put on his plumage, and I then proceeded to make a drawing of him. He looked it over in a coldly critical way, grunted several times, and seemed more mystified than ever; but I do not think I diminished in his estimation. In his younger days Whirlwind had been a war chief; but he traveled to Washington and there saw the power and numbers of the white man. He advised for peace after that, and did not take the war-path in the last great outbreak. His people were defeated, as he said they would be, and confidence in his judgment was restored. I asked him all sorts of questions to draw on

his reminiscences of the old Indian life before the conquest, all of which were answered gravely and without boasting. It was on his statesmanlike mind, however, to make clear to me the condition of his people, and I heard him through. Though not versed in the science of government, I was interested in the old man's talk. He had just returned from a conference of the tribes which had been held in the Cherokee country, and was full of the importance of the conclusions there evolved. The Indians all fear that they will lose their land, and the council advised all Indians to do nothing which would interfere with their tenure of the land now held by them. He told with pride of the speech he made while there and of the admiration with which he was regarded as he stood, dressed in the garb of the wild Indian, with his tomahawk in hand. However, he is a very progressive man, and explained that while he was too old to give up the methods of life which he had always observed, yet his son would be as the civilized Cherokees are. The son was squatted near,

and have failed, and are now very properly discouraged. Stock-raising is the natural industry of the country, and that is the proper pursuit of these people. They are only now recovering by natural increase from the reverses which they suffered in their last outbreak. It is hard for them to start cattle herds, as their ration is insufficient, and one scarcely can expect a hungry man to herd cattle when he needs the beef to appease his hunger. Nevertheless, some men have respectable herds and can afford to kill an animal occasionally without taking the stock cattle. In this particular they display wonderful forbearance, and were they properly rationed for a time and given stock cattle, there is not a doubt but in time they would become self-supporting. The present scheme of taking a few boys and girls away from the camps to put them in school where they are taught English, morals, and trades has nothing reprehensible about it, except that it is absolutely of no consequence so far as solving the Indian problem is concerned. The few boys return to the camps with their English, their school clothes, and their short hair. They know a trade also, but have no opportunity to be employed in it. They loaf about the forts for a time with nothing to do, and the white men talk pigeon English to them and the wild Indians sneer at them. Their virtues are unappreciated, and, as a natural consequence, the thousands of years of barbarism which is bred in their nature overcome the three little seasons of school training. They go to the camps, go back to the blanket, let their hair grow, and forget their English. In a year one cannot tell a school-

FREDERIC REMINGTON.
AFTER PHOTOGRAPH.

CHEYENNE AGENCY.

and I believed his statement, as the boy was large of stature and bright of mind, having enjoyed some three years' schooling at a place which I have now forgotten. He wore white men's clothes and had just been discharged from the corps of scouts at Reno. When I asked the boy why he did not plow and sow and reap, he simply shrugged his shoulders at my ignorance, which, in justice to myself, I must explain was only a leading question, for I know that corn cannot be raised on this reservation with sufficient regularity to warrant the attempt. The rainfall is not enough; and where white men despair, I, for one, do not expect wild Indians to continue. They have tried it

boy from any other little savage, and in the whole proceeding I see nothing at all strange.

The camp will not rise to the school-boy, and so Mahomet goes to the mountain. If it comes to pass that the white race desires to aid these Indians to become a part of our social system instead of slowly crushing them out of it, there is only one way to do it. The so-called Indian problem is no problem at all in reality, only that it has been made one by a long succession of acts which were masterly in their imbecility and were fostered by political avarice. The sentiment of this nation is in favor of no longer regarding the aborigines of this country as a conquered race; and except

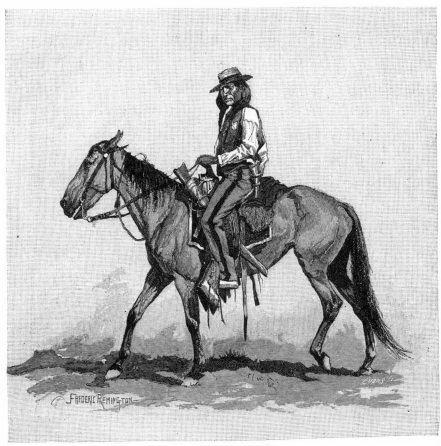

AN AGENCY POLICEMAN.

that the great body of our citizens are apathetic of things so remote as these wards of the Government, the people who have the administration of their destinies would be called to account. No one not directly interested ever questioned that the Indian Department should have been attached to the War Department; but that is too patent a fact to discuss. Now the Indian affairs are in so hopeless a state of dry-rot that practical men, in political or in military circles, hesitate to attempt the rôle of reformers. The views which I have on the subject are not original, but are very old and very well understood by all men who live in the Indian countries. They are current among army officers who have spent their whole lives on the Indian frontier of the far West, but are not often spoken, because all men realize the impotency of any attempt to overcome the active work of certain political circles backed by public apathy and a lot of theoretical Indian regenerators. If anything is done to relieve the condition of the Indian tribes it must be a scheme which begins at the bottom and takes the "whole outfit," as a Western man would

say, in its scope. If these measures of relief are at all tardy, before we realize it the wild Indian tribes will be, as some writer has said, "loafers and outcasts, contending with the dogs for kitchen scraps in Western villages." They have all raised stock successfully when not interfered with or not forced by insufficient rations to eat up their stock cattle to appease their hunger, and I have never heard that Indians were not made of soldier stuff. A great many Western garrisons have their corps of Indian scouts. In every case they prove efficient. They are naturally the finest irregular cavalry on the face of this globe, and with an organization similar to the Russian Cossacks they would do the United States great good and become themselves gradually civilized. An irregular cavalry is every year a more and more important branch of the service. Any good cavalry officer, I believe, could take a command of Indians and ride around the world without having a piece of bacon, or a cartridge, or a horse issued by his Government. So far as effective police work in the West is concerned, the corps of Indian scouts do nearly all of that

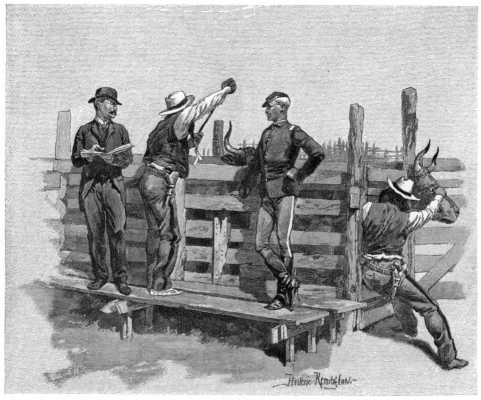

THE BRANDING CHUTE AT THE BEEF ISSUE.

service now. They all like to be enlisted in the service, universally obey orders, and are never disloyal. But nothing will be done; so why continue this?

For hours we sat in the ramada of the old chief and conversed, and when we started to go I was much impressed by the discovery that the old Indian knew more about Indians, Indian policy, and the tendencies and impulses of the white men concerning his race than any other person I had ever met.

The glories of the reign of an Indian chieftain are past. As his people become more and more dependent on the Government his prestige wanes. For instance, at the time of our visit to this camp the people were at loggerheads regarding the locality where the great annual Sun Dance, or, more literally, "The Big Medicine," should be held. The men of the camp that I visited wanted it at one place, and those of the "upper camp" wanted it at another. The chief could not arrange the matter, and so the solution of the difficulty was placed in the hands of the agent.

The Cheyenne agency buildings are situated about a mile and a half from Fort Sill. The great brick building is imposing. A group of stores and little white dwelling-houses sur-round it, giving much the effect of a New England village. Wagons, saddled ponies, and Indians are generally disposed about the vicinity and give life to the scene. Fifteen native policemen in the employ of the agency do the work and take care of the place. They are uniformed in cadet gray, and with their beaded white moccasins and their revolvers are neat and soldierly looking. A son of old Bent, the famous frontiersman, and an educated Indian do the clerical work, so that the agent is about the only white man in the place. The goods which are issued to the Indians have changed greatly in character as their needs have become more civilized. The hatchets and similar articles of the old traders are not given out, on the ground that they are barbarous. Gay colored clothes still seem to suit the esthetic sense of the people, and the general effect of a body of modern Indians is exceeding brilliant. Arabs could not surpass them in this respect.

They receive flour, sugar, and coffee at the great agency building, but the beef is issued from a corral situated out on the plain at some distance away. The distribution is a very thrilling sight, and I made arrangements to see it by procuring a cavalry horse from Colonel Wade at the fort and by following the ambu-

lance containing an army officer who was detailed as inspector. We left the post in the early morning, and the driver "poured his lash into the mules" until they scurried along at a speed which kept the old troop-horse at a neat pace.

The heavy dew was on the grass, and clouds lay in great rolls across the sky, obscuring the sun. From the direction of the target range the "stump" of the Springfields came to our ears, showing that the soldiers were hard at their devotions. In twos, and threes, and groups, and crowds, came Indians, converging on the beef corral. The corral is a great ragged fence made of an assortment of boards, poles, scantling, planks, old wagons, and attached to this is a little house near which the weighing scales are placed. The crowd collected in a great mass near the gate and branding-chute. A fire was burning, and the cattle contractors (cowboys) were heating their branding-irons to mark the "I. D." on the cattle distributed, so that any Indian having subsequently a hide in his possession would be enabled to satisfy roving cattle inspectors that they were not to be suspected of killing stock.

The agent came to the corral and together with the army officer inspected the cattle to be given out. With loud cries the cowboys in the corral forced the steers into the chute, and crowding and clashing they came through into the scales. The gate of the scales was opened and a half-dozen frightened steers crowded down the chute and packed themselves in an unyielding mass at the other end. A tall Arapaho policeman seized a branding-iron, and mounting the platform of the chute poised his iron and with a quick motion forced it on the back of the living beast. With a wild but useless plunge and a loud bellow of pain the steer shrunk from the hot contact; but

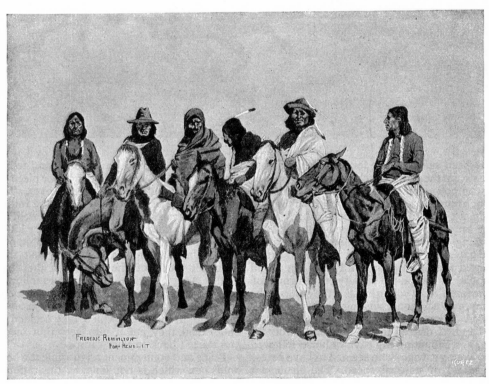

WAITING FOR THE BEEF ISSUE.

it was all over, and a long black "I. D." disfigured the surface of the skin.

Opposite the branding-chute were drawn up thirty young bucks on their ponies, with their rifles and revolvers in hand. The agent shouted the Indian names from his book, and a very engaging lot of cognomens they were. A policeman on the platform designated a particular steer which was to be the property of each man as his name was called. The Indian came forward and marked his steer by reaching over the fence and cutting off an ear with a sharp knife, by severing the tail, or by tying some old rag to some part of the animal. The cold-blooded mutilation was perfectly shocking, and I turned away in sickened disgust. After all

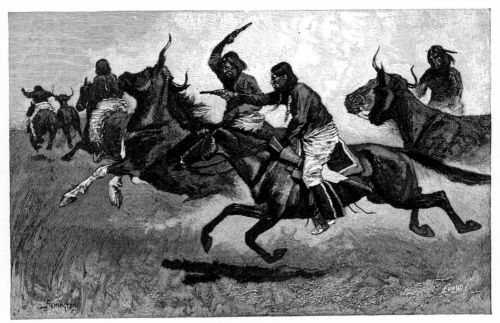

STEER-HUNTING.

had been marked, the terrified brutes found the gate at the end of the chute suddenly opened by the police guard; but before this had been done a frantic steer had put his head half through the gate, and in order to force him back a red-hot branding-iron was pushed into his face, burning it horribly. The worst was over; the gates flew wide, and the maddened brutes poured forth, charging swiftly away in a wild impulse to escape the vicinity of the crowd of humanity. The young bucks in the group broke away, and each one, singling out his steer, followed at top speed, with rifle or six-shooter in hand. I desired to see the whole proceeding, and mounting my cavalry horse followed two young savages who seemed to have a steer possessed of unusual speed. The lieutenant had previously told me that the shooting at the steers was often wild and reckless, and advised me to look sharp or I might have to "pack a bullet." Puffs of smoke and the "pop! pop!" of the guns came from all over the plain. Now a steer would drop, stricken by some lucky shot. It was buffalo-hunting over again, and was evidently greatly enjoyed by the young men. My two fellows headed their steer up the hill on the right, and when they had gotten him far enough away they "turned loose," as we say. My old cavalry horse began to exhibit a lively interest in the smell of gunpowder, and plunged away until he had me up and in front of the steer and the Indians, who rode on each side. They blazed away at the steer's head, and I could hear a misdirected bullet "sing" by uncomfortably near. Seeing me in front, the steer

dodged off to one side, and the young fellow who was in his way, by a very clever piece of horsemanship, avoided being run over. The whole affair demonstrated to me that the Indian boys could not handle the revolver well, for they shot a dozen rounds before they killed the poor beast. Under their philosophic outward calm I thought I could see that they were not proud of the exhibition they had made. After the killing, the squaws followed the wagons and proceeded to cut up the meat. After it had been divided among themselves, by some arrangement which they seemed to understand, they cut it into very thin pieces and started back to their camps.

Peace and contentment reign while the beef holds out, which is not long, as the ration is insufficient. This is purposely so, as it is expected that the Indians will seek to increase a scant food supply by raising corn. It does not have that effect, however. By selling ponies, which they have in great numbers, they manage to get money; but the financial future of the Cheyennes is not flattering.

Enlistment in the scouting corps at Reno is a method of obtaining employment much sought after by the young men. The camp is on a hill opposite the post, where the white tepees are arranged in a long line. A wall tent at the end is occupied by two soldiers who do the clerical work. The scouts wear the uniform of the United States army, and some of them are strikingly handsome in the garb. They are lithe and naturally "well set up," as the soldiers phrase it. They perform all the duties of sol-

diers; but at some of the irksome tasks, like standing sentry, they do not come out strong. They are not often used for that purpose, however, it being found that Indians do not appreciate military forms and ceremonies.

Having seen all that I desired, I procured passage in the stage to a station on the Santa Fc Railroad. In the far distance the train came rushing up the track, and as it stopped I boarded it. As I settled back in the soft cushions of the sleeping-car I looked at my dirty clothes and did not blame the negro porter for regarding me with the haughty spirit of his class.

11.
On the
Indian
Reservations

ON THE INDIAN RESERVATIONS.

I WAS camping with a couple of prospectors one night some years ago on the south side of the Pinal Range in Arizona Territory. We were seated beside our little cooking fire about 9 o'clock in the evening engaged in smoking and drowsily discussing the celerity of movement displayed by Geronimo, who had at last been heard of down in Sonora, and might be already far away from there, even in our neighborhood. Conversation lapsed at last, and puffing our pipes and lying on our backs we looked up into the dark branches of the trees above. I think I was making a sluggish calculation of the time necessary for the passage of a far-off star behind the black trunk of an adjacent tree when I felt moved to sit up. My breath went with the look I gave, for, to my unbounded astonishment and consternation, there sat three Apaches on the opposite side of our fire with their rifles across their laps. My comrades also saw them, and, old, hardened frontiersmen as they were, they positively gasped in amazement.

"Heap hungry," ejaculated one of the savage apparitions, and again relapsed into silence.

As we were not familiar with Mr. Geronimo's countenance we thought we could see the old villain's features in our interlocutor's, and we began to get our artillery into shape.

APACHE SOLDIER, OR SCOUT.

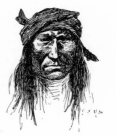

APACHE.

115

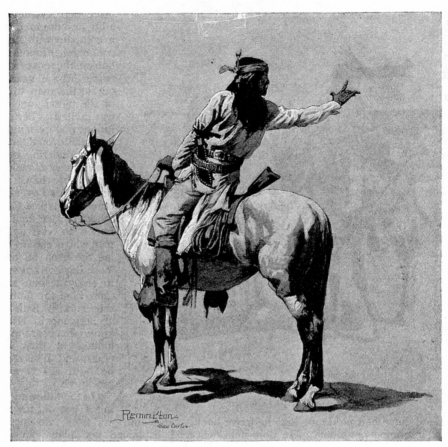

YUMA APACHE.

The savages, in order to allay the disturbance which they had very plainly created, now explained.

"We White Mountain. No want fight — want flour."

They got the flour in generous quantities, it is needless to add, and although we had previously been very sleepy, we now sat up and entertained our guests until they stretched themselves out and went to sleep. We pretended to do the same. During that night I never closed my eyes, but watched, momentarily expecting to see more visitors come gliding out of the darkness. I should not have been surprised even to see an Apache drop from a branch above me.

They left us in the morning, with a blessing couched in the style of forcible speech that my Rocky Mountain friends affected on unusual occasions. I mused over the occurrence; for while it brought no more serious consequences than the loss of some odd pounds of bacon and flour, yet there was a warning in the way those Apaches could usurp the prerogatives of ghosts, and ever after that I used to mingle undue proportions of discretion with my valor.

Apaches are wont to lurk about in the rocks and *chaparral* with the stealth of coyotes, and they have always been the most dangerous of all the Indians of the Western country. They are not at all valorous in their methods of war, but are none the less effective. In the hot desert and vast rocky ranges of their country no white man can ever catch them by direct pursuit. Since railroads and the telegraph have entered their territory, and military posts have been thoroughly established, a very rigorous military system has kept them in the confines of the San Carlos reservation, and there is no longer the same fear that the next dispatches may bring news of another outbreak. But the troopers under General Miles always had their cartridge-belts filled and their saddle-pockets packed, ready at any hour of the day to jump out on a hostile trail.

The affairs of the San Carlos agency are administered at present by an army officer, Captain Bullis of the Twenty-fourth Infantry. As I have observed him in the discharge of

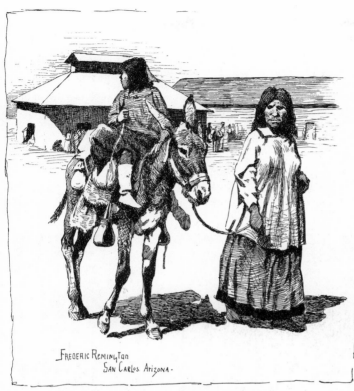

FREDERIC REMINGTON
SAN CARLOS. ARIZONA.

APACHE WOMAN WITH RATIONS.

place one evening, after a hot and tiresome march, in company with a cavalry command. I found a good bunk in the tent of an army officer whose heart went out to the man in search of the picturesque, and I was invited to destroy my rations that evening at the long table of the officers' mess, wondering much at the culinary miracles performed by the Chinamen who presided over its destinies. The San Carlos is a hotter place than I ever intend to visit again. A man who is used to breathing the fresh air of New York Bay is in no condition to enjoy at one and the same time the dinner and the Turkish bath which accompanies it. However, army officers are as entertaining in their way as poets, and I managed to be both stoical and appreciative.

On the following morning I got out my sketch-book, and taking my host into my confidence, I explained my plans for action. The captain discontinued brushing his hair and looked me over with a humorous twinkle in his eyes. "Young man," he said, "if you desire to wear a long, gray beard you must make away with the idea that you are in Venice."

I remembered that the year before a Blackfoot upon the Bow River had shown a desire to tomahawk me because I was endeavoring to immortalize him. After a long and tedious course of diplomacy it is at times possible to get one of these people to gaze in a defiant and fearful way down the mouth of a camera; but to stand still until a man draws his picture on paper or canvas is a proposition which no Apache will entertain for a moment. With the help of two officers, who stood up close to me, I was enabled to make rapid sketches of the scenes and people; but my manner at last aroused suspicion, and my game would vanish like a covey of quail. From the parade in front of our tent I could see the long lines of horses, mules, and burros trooping into the agency from all quarters. Here was my feast. Ordinarily the Indians are scattered for forty miles in every direction; but this was ration-day, and they all were together. After breakfast

his duties I have had no doubt that he pays high life insurance premiums. He does not seem to fear the beetle-browed pack of murderers with whom he has to deal, for he has spent his life in command of Indian scouts, and not only understands their character, but has gotten out of the habit of fearing anything. If the deeds of this officer had been done on civilized battlefields instead of in silently leading a pack of savages over the desert waste of the Rio Grande or the Staked Plain, they would have gotten him his niche in the temple of fame. Alas! they are locked up in the gossip of the army mess-room, and end in the soldiers' matter-of-fact joke about how Bullis used to eat his provisions in the field, opening one can a day from the packs, and, whether it was peaches or corned-beef, making it suffice. The Indians regard him as almost supernatural, and speak of the "Whirlwind" with many grunts of admiration as they narrate his wonderful achievements.

The San Carlos reservation, over which he has supervision, is a vast tract of desert and mountain, and near the center of it, on the Gila River, is a great flat plain where the long, low adobe buildings of the agency are built. Lines of white tents belonging to the cantonment form a square to the north. I arrived at this

we walked down. Hundreds of ponies, caparisoned in all sorts of fantastic ways, were standing around. Young girls of the San Carlos tribe flitted about, attracting my attention by the queer ornaments which, in token of their virginity, they wear in their hair. Tall Yuma bucks galloped past with their long hair flying out behind. The squaws crowded around the exit and received the great chunks of beef which a native butcher threw to them. Indian scouts in military coats and armed with rifles stood about to preserve order. Groups of old women sat on the hot ground and gossiped. An old chief, with a very respectable amount of adipose under his cartridge-belt, galloped up to our group and was introduced as Esquimezeu. We shook hands.

to the guard-house, granted absolute divorces, and probated wills with a bewildering rapidity. The interpreter struggled with his English; the parties at law eyed one another with villainous hate, and knives and rifles glistened about in a manner suggestive of the fact that the court of last resort was always in session. Among these people men are constantly killing one another, women are carried off, and feuds are active at all times. Few of these cases come before the agent if the parties think they can better adjust their own difficulties by the blood-atonement process, but the weak and the helpless often appeal.

After leaving the office and going some distance we were startled by a gun-shot from the direction of the room we had just left. We

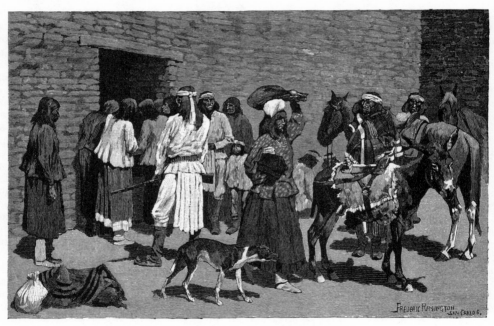

DISTRIBUTION OF BEEF AT SAN CARLOS AGENCY.

These Indians have natural dignity, and it takes very little knowledge of manners for them to appear well. The Apaches have no expression for a good-bye or a greeting, and they never shake hands among themselves; but they consider handshaking an important ceremony among white men, and in their intercourse with them attach great importance to it. I heard an officer say that he had once seen an Apache come home after an absence of months: he simply stepped into the jicail, sat down without a word, and began rolling a cigarette.

The day was very hot, and we retired to the shade of Captain Bullis's office. He sat there with a big sombrero pulled over his eyes and listened to the complaints of the Indians against one another. He relegated certain offenders

started back. The negro soldiers of the guard came running past; the Indians became excited; and every one was armed in a minute. A giant officer of infantry, with a white helmet on his head, towered above the throng as he forced his way through the gathering mass of Indians. Every voice was hushed, and every one expected anything imaginable to happen. The Indians began to come out of the room, the smoke eddying over their heads, and presently the big red face and white helmet of the infantry officer appeared. "It's nothing, boys —only an accidental discharge of a gun." In three minutes things were going on as quietly as before.

Captain Bullis sauntered up to us, and tipping his hat on one side meditatively scratched

his head as he pointed to an old wretch who sat wrapped in a sheet against the mud wall of the agency.

"There's a problem. That old fellow's people won't take care of him any longer, and they steal his rations. He's blind and old and can't take care of himself." We walked up and regarded the aged being, whose parchment skin reminded us of a mummy. We recoiled at the filth, we shuddered at his helplessness, and we pitied this savage old man so steeped in misery; but we could do nothing. I know not how the captain solved his problem. Physical suffering and the anguish of cast-off old age are the compensations for the self-reliant savage warrior who dozes and dreams away his younger days and relegates the toil to those within his power.

We strolled among the horses and mules. They would let me sketch them, though I thought the half-wild beasts also shrunk away from the baleful gaze of the white man with his bit of paper. Broncos, mules, and burros stood about, with bags of flour tied on their saddles and great chunks of meat dripping blood over their unkempt sides. These woe-begone beasts find scant pasture in their desert home, and are banged about by their savage masters until ever-present evils triumph over equine philosophy. Fine navy blankets and articles of Mexican manufacture were stretched over some of the saddles, the latter probably obtained in a manner not countenanced by international law.

The Apaches have very little native manufacture. They rely on their foraging into Mexico for saddlery, serapes, and many other things; but their squaws make wicker-work, some of which I have never seen surpassed. *Allas*, or water-jars, of beautiful mold and unique design, are sold

METHOD OF SKETCHING AT SAN CARLOS.

to any one who desires to buy them at a price which seems absurdly mean when the great labor expended on them is considered. But Apache labor is cheap when Apaches will work at all. The women bring into the cantonment great loads of hay on their backs, which is sold to the cavalry. It is all cut with a knife from bunches which grow about six inches apart, and is then bound up like wheat and carried for miles.

By evening all the Indians had betaken themselves to their own rancherias, and the agency was comparatively deserted for another week.

I paused for a day on the Gila, some miles from the agency, to observe the methods of agriculture practiced by the San Carlos Indian tribe. The Gila River bottoms are bounded on each side by bluffs, and on these the Indians build their brush jicails. High above the stifling heat of the low ground the hot winds from the desert blow through the leafy bowers which they inhabit. As they wear no clothing except breech-cloth and moccasins, they enjoy comparative comfort. The squaws go back and forth between their

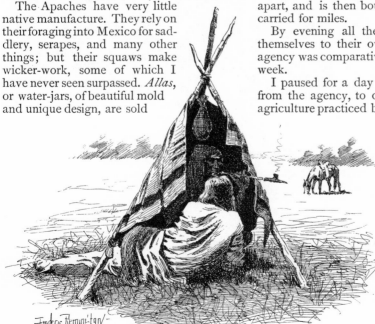

WICHITAS SMOKING THEIR MEDICINE.

jicails and the river carrying wicker allas filled with muddy water, and the whole people seek the river and the system of irrigating ditches at evening time to turn the water over the parched ground and nourish the corn, wheat, and vegetables which grow there. Far up the valley the distant *stump* of a musket-shot reaches our ears; then another comes from a nearer point, and still another. Two or three women begin to take away the boards of an acequia dam near as the water rises to their knees, and with a final tug the deepening water rushes through. "Bang!" goes the Springfield carbine of an Indian standing at my elbow, and after some moments another gun-shot comes to our ears from below. As the minutes pass the reports come fainter and fainter, until we are

I bethink ourselves to go back to the camps of these people to spend an evening; so, leaving the troopers about their fires, we take our way in company with an old Government Indian scout to his own jicail. The frugal evening meal was soon disposed of, and taking our cigarettes we sat on the bluffs and smoked. A traveler in the valley looking up at the squatting forms of men against the sky would have remembered the great strength of chiaroscuro in some of Doré's drawings and to himself have said that this was very like it.

I doubt if he would have discerned the difference between the two white men who came from the bustling world so far away and the dark-skinned savages who seemed a sympathetic part of nature there, as mute as any of

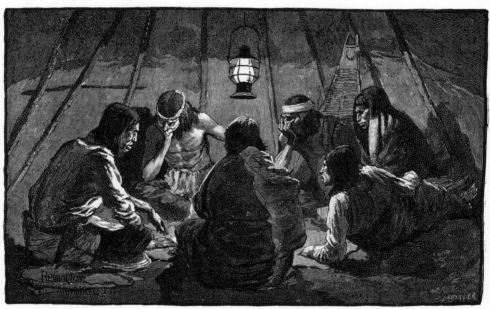

INDIAN TERRITORY APACHES PLAYING MONTE.

just conscious of the sounds far off down the valley.

The pile of straw round which a mounted Indian has been driving half a dozen horses all day in order to stamp out the grain has lowered now until he will have but an hour's work more in the morning. He stops his beasts and herds them off to the hills to graze. The procession of barefooted men and of women bearing jars comes winding over the fields towards their humble habitations on the bluffs. The sun sinks behind the distant Sierras, and the beautiful quiet tones of the afterglow spread over the fields and the water. As I stand there watching the scene I can almost imagine that I see Millet's peasants; but, alas! I know too well the difference.

My companion, a lieutenant of cavalry, and

its rocks and as incomprehensible to the white man's mind as any beast which roams its barren wastes.

It grew dark, and we forbore to talk. Presently, as though to complete the strangeness of the situation, the measured "thump, thump, thump" of the tom-tom came from the vicinity of a fire some short distance away. One wild voice raised itself in strange discordant sounds, dropped low, and then rose again, swelling into shrill yelps, in which others joined. We listened, and the wild sounds to our accustomed ears became almost tuneful and harmonious. We drew nearer, and by the little flickering light of the fire discerned half-naked forms huddled with uplifted faces in a small circle around the tom-tom. The fire cut queer lights on their rugged outlines, the waves of sound

rose and fell, and the "thump, thump, thump, thump" of the tom-tom kept a binding time. We grew in sympathy with the strange concert, and sat down some distance off and listened for hours. It was more enjoyable in its way than any trained chorus I have ever heard.

The performers were engaged in making medicine for the growing crops, and the concert was a religious rite, which, however crude to us, was entered into with a faith that was attested by the vigor of the performance. All savages seem imbued with the religious feeling, and everything in nature that they do not comprehend is supernatural. Yet they know so much about her that one often wonders why they cannot reason further.

The one thing about our aborigines which interests me most is their peculiar method of thought. With all due deference to much scientific investigation which has been lavished upon them, I believe that no white man can ever penetrate the mystery of their mind or explain the reason of their acts.

The red man is a mass of glaring incongruities. He loves and hates in such strange fashions, and is constant and inconstant at such unusual times, that I often think he has no mental process, but is the creature of impulse. The searching of the ethnologist must not penetrate his thoughts too rapidly, or he will find that he is reasoning for the Indian, and not with him.

THE COMANCHES.

COMANCHE.

AFTER coming from the burning sands of Arizona the green stretches of grass and the cloud-flecked sky of northern Texas were very agreeable. At a little town called Henrietta I had entered into negotiations with a Texas cowboy to drive me over certain parts of the Indian Territory. He rattled up to my quarters in the early morning with a covered spring-wagon drawn by two broncos so thin and small and ugly that my sympathies were aroused, and I protested that they were not able to do the work.

The driver, a smart young fellow with his hat brim knocked jauntily back in front, assured me that "They can pull your freight, and you can bet on it." I have learned not to trust to appearances regarding Western ponies, and so I clambered in and we took up our way.

The country was a beautiful rolling plain, covered with rank, green grass and dotted with dried flowers. Heavily timbered creeks interlaced the view and lessened its monotony. The sun was hot, and the driver would nod, go fast asleep, and nearly fall out of the wagon. The broncos would quiet down to a walk, when he would suddenly awake, get out his black snake whip, and roar "mule language" at the lazy creatures. He was a good fellow and full of interest, had made the Montana trail three times with the Hash Knife outfit, and was full of the quaint expressions and pointed methods of reasoning peculiar to Western Americans. He gave me volumes of information concerning Comanches and Indians in general; and while his point of view was too close for a philosophical treatment of the case, he had a knowledge of details which carried him through. Speaking of their diet, he "allowed anything 's grub to an Injun, jus' so it hain't pisen."

We came at last to the Red River, and I then appreciated why it was called red, for its water is absolutely the reddest thing I ever saw in nature. The soil thereabouts is red, and the water is colored by it. We forded the river, and the little horses came so near sticking fast in the middle that my cowboy jumped out up to his waist and calmly requested me to do the same. I did, but to the ruin of a pair of white corduroys. We got through, however, and were in the Territory. Great quantities of plums, which the Indians gather, grow near the river.

In due course of time we came in sight of Fort Sill, which is built of stone, in a square around a parade of grass, and perched on rising ground. The plains about were dotted with the skulls of cattle killed for ration day. Sheds of poles covered with branches dotted the plains, and on our right the "big timber" of Catch Creek looked invitingly cool.

At Fort Sill I became acquainted with Mr. Horace P. Jones the Comanche interpreter, who has lived with that tribe for thirty-one years. He is an authority on the subject of Indians, and I tried to profit by his knowledge. He spoke of one strange characteristic of the Comanche language which makes their speech almost impossible to acquire. Nearly all Comanches are named after some object in nature, and when one dies the name of the object after which he was named is changed and the old word is never spoken again. Mr. Jones often uses one of the words which a recent death has made obsolete, and is met with muttered protestations from his Indian hearers. He therefore has to skirmish round and find the substitute for the outlawed word.

The Comanches are great travelers, and

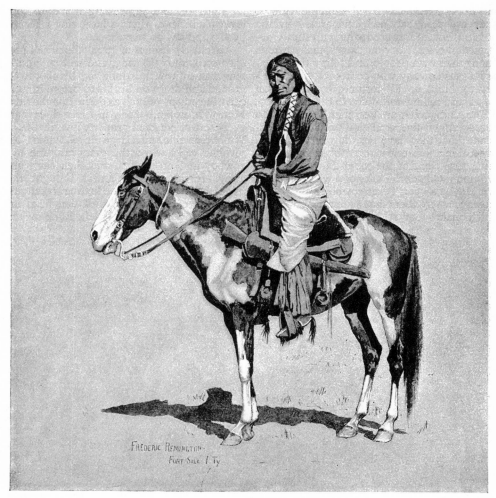

A COMANCHE.

wander more than any other tribe. Mr. Jones has known Comanches to go to California, and as far south as Central America, on trips extending over years. They are a jolly, round-faced people, who speak Spanish, and often have Mexican blood in their veins—the result of stolen Mexican women, who have been ingrafted into the tribe.

The Comanches are less superstitious than Indians are generally. They apply an amount of good sense to their handling of horses which I have never seen among Indians elsewhere. They breed intelligently, and produce some of the most beautiful "painted" ponies imaginable. They take very good care of them, and in buying and selling have no lessons to learn from Yankee horse-traders. They still live in lodges, but will occupy a good house if they can obtain one. About this thing they reason rather well; for in their visits to the Caddoes and the Shawnees they observe the squalid huts in the damp woods, with razor-back hogs contesting the rights of occupancy with their masters, and they say that the tepee is cleaner, and argue that if the Shawnees represent civilization, their own barbarism is the better condition of the two. However, they see the good in civilization and purchase umbrellas, baby-carriages, and hats, and of late years leave the Winchester at home; although, like the Texan, a Comanche does not feel well dressed without a large Colt strapped about his waist. Personal effects are all sacrificed at the death of their owners, though these Indians no longer destroy the horses, and they question whether the houses which are built for them by the Government should be burned upon the death of the tenant. Three or four have been allowed to stand, and if no dire results follow the matter will regulate itself.

The usual corps of Indian scouts is camped under the walls of Fort Sill, and is equally di-

vided between the Comanches and the Kiowas. They are paid, rationed, and armed by the Government, and are used to hunt up stray Government horses, carry messages, make arrests among their own people, and follow the predatory Texas cowboy who comes into the Territory to build up his fortunes by driving off horses and selling corn-juice to the Indians.

The Comanches are beginning to submit to arrests without the regulation exchange of fusillade; but they have got the worst of Texas law so long that one cannot blame them for being suspicious of the magistracy. The first question a Comanche asks of a white stranger is, "Maybe so you Texas cowboy?" to which I always assure them that I am a Kansas man, which makes our relations easy. To a Co-

for the race, and the throng moves to some level plain near, where a large ring is formed by the Indians on horseback.

An elderly Indian of great dignity of presence steps into the ring, and with a graceful movement throws his long red blanket to the ground and drops on his knees before it, to receive the wagers of such as desire to make them. Men walk up and throw in silver dollars and every sort of personal property imaginable. A Winchester rifle and a large nickel-plated Colt's revolver are laid on the grass near me by a cowboy and an Indian, and then each goes away. It was a wager, and I thought they might well have confidence in their stakeholder —mother earth. Two ponies, tied head and head, were led aside and left, horse against

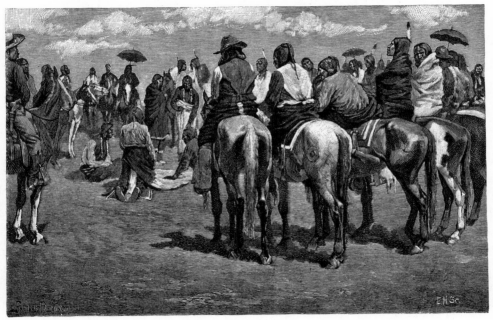

IN THE BETTING-RING.

manche all bad men are "Texas cowboys," and all good people are "Kansas men."

At the scout camp I was allowed to sketch to my heart's content, and the people displayed great interest in the proceedings.

The morning of the Fourth of July found Mr. Jones and me in the saddle and on the way to the regulation celebration at the agency below the post. The Fourth of July and Christmas are the "white man's big Sundays" to the Indians, and they always expect the regular horse-race appropriations. The cavalrymen contribute purses and the Indians run their ponies. Extra beeves are killed, and the red men have always a great regard for the "big Sundays."

As we approach the agency it is the hour

horse. No excitement seemed to prevail. Near me a little half-Mexican Comanche boy began to disrobe until he stood clad only in shirt and breech-cloth. His father addressed some whispered admonition and then led up a roan pony, prancing with impatience and evidently fully conscious of the work cut out for him that day. With a bound the little fellow landed on the neck of the pony only half way up; but his toes caught on the upper muscles of the pony's leg, and like a monkey he clambered up and was in his seat. The pony was as bare as a wild horse except for a bridle, and loped away with his graceful little rider sitting like a rock. No, not like a rock, but limp and unconcerned, and as full of the motion of the horse as the horse's tail or any other part of him.

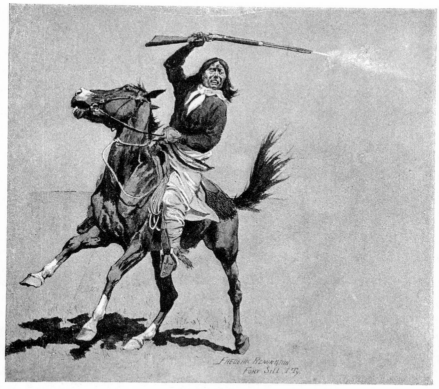

KIOWA BUCK STARTING A RACE.

A Kiowa with loose hair and great coarse face broke away from the group and galloped up the prairie until he stopped at what was to be the starting-point, at the usual distance of "two arrow flights and a pitch." He was followed by half a dozen ponies at an easy lope, bearing their half-naked jockeys. The Indian spectators sat about on their ponies, as unmoved in countenance as oysters, being natural gamblers, and stoical as such should be, while the cowboys whispered among themselves.

"That's the bay stallion there," said one man to me, as he pointed to a racer, "and he's never been beaten. It's his walk-over, and I've got my gun up on him with an Injun."

It was to be a flying start, and they jockeyed a good deal and could not seem to get off. But presently a puff of smoke came from the rifle held aloft by the Kiowa starter, and his horse reared. The report reached us, and with a scurry the five ponies came away from the scratch, followed by a cloud of dust. The *quirts* flew through the air at every jump. The ponies bunched and pattered away at a nameless rate, for the quarter-race pony is quick of stride. Nearer and nearer they came, the riders lying low on their horses' necks, whipping and ki-yi-yi-ing. The dust in their wake

swept backward and upward, and with a rush they came over the scratch, with the roan pony ahead and my little Mexican fellow holding his quirt aloft, and his little eyes snapping with the nervous excitement of the great event. He had beaten the invincible bay stallion, the pride of this Comanche tribe, and as he rode back to his father his face had the settled calm which nothing could penetrate, and which befitted his dignity as a young runner.

Far be it from these quaint people ever to lose their blankets, their horses, their heroism, in order to stalk behind a plow in a pair of canvas overalls and a battered silk hat. Now they are great in their way; but then, how miserable! But I have confidence that they will not retrograde. They can live and be successful as a pastoral people, but not as sheep herders, as some great Indian department reformer once thought when he placed some thousands of these woolly idiots at their disposal.

The Comanches travel about too much and move too fast for sheep; but horses and cattle they do have and can have so long as they retain possession of their lands. But if the Government sees fit to consecrate their lands to the "man with the hoe," then, alas! good-bye to all their greatness.

Bidding adieu to my friends at Fort Sill, I

REMINGTON.

INDIAN HORSE-RACE — COMING OVER THE SCRATCH.

"pulled out" for Anadarko on the Washita, where the head agency of the Comanches, Kiowas, and Wichitas is located. The little ponies made bad work of the sandy roads. Kiowa houses became more numerous along the road, and there is evidence that they farm more than the brother tribe, but they are not so attractive a people. Of course the tepee is pitched in the front yard and the house is used as a kind of out-building. The medicine-bags were hanging from the tripod of poles near by, and an occasional buck was lying on his back "smoking his medicine"—a very comfortable form of devotion.

We saw the grass houses of the Wichitas, which might be taken for ordinary haystacks. As they stand out on the prairie surrounded by wagons, agricultural implements, and cattle, one is caught wondering where is the remainder of the farm which goes with this farm-yard.

These Territory Apaches are very different from their brothers of the mountains. They are good-looking, but are regarded contemptuously by other Indians and also by the traders. They are treacherous, violent, and most cunning liars and thieves. I spent an evening in one of their tepees watching a game of monte, and the gambling passion was developed almost to insanity. They sat and glared at the cards, their dark faces gleaming with avarice, cunning, and excitement. I thought then that the good white men who would undertake to make Christian gentlemen and honest tillers of the soil out of this material would contract for a job to subvert the process of nature.

Our little ponies, recuperated by some grain and rest, were once more hooked up, and the cowboy and I started for Fort Reno to see the Arrapahoes and the Cheyennes, hoping to meet them far along on "the white man's road."

12.
In the
Sierra Madre
with the
Punchers

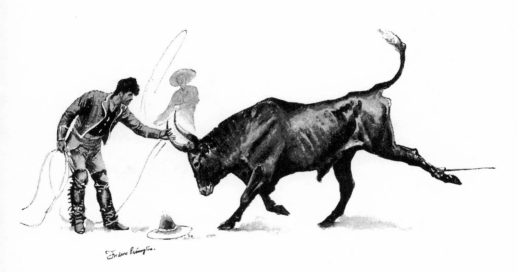

IN THE SIERRA MADRE WITH THE PUNCHERS.

BY FREDERIC REMINGTON.

ON a chill black morning the cabins of Los Ojos gave up their inmates at an early hour. The ponies, mules, and *burros* were herded up, and stood shivering in an angle, while about them walked the men, carefully coiling their hair lariats, and watching for an opportunity to jerk them over the heads of the selected ones. The *patron's* black pet walked up to him, but the mounts of my companion and self sneaked about with an evident desire not to participate in the present service. Old *Cokomorachie* and Jim were finally led forth, protesting after the manner of their kind. I carefully adjusted my Whitman's officer-tree over a wealth of saddle blanketing, and slung my Winchester 45–70 and my field-glasses to it. The "punchers," both white and brown,

and two or three women, regarded my new-fangled saddle with amused glances; indeed, Mr. Bell's Mexican wife laughed at it outright, and Tom Bailey called it "a d—— rim-fire." Another humorist thought that "it would give the chickens the pip if they got onto it"; all of which I took good-humoredly, since this was not the first time "your Uncle Samuel" had been away from home; and after some days, when a lot of men were carefully leading sore-backed horses over the mountains, I had cause to remark further on the subject. A Mexican cow-saddle is a double-barrelled affair; it will eat a hole into a horse's spine and a pair of leather breeches at the same time. If one could ask "Old Jim" about that saddle of mine, I think he would give it an autograph

recommend, for he finished the trip with the hide of his back all there.

Leaving the "burro men" to haul and pull at their patient beasts as they bound on their loads, our outfit "pulled out" on what promised to be plenty of travelling. We were to do the rounds of the ranch, explore the mountains, penetrate to the old Apache strongholds, shoot game, find cliff-dwellers' villages, and I expect the dark minds of the punchers hoped for a sight at the ever-burning fire which should discover the lost mine of Tiopa. We were also promised a fight with the "Kid" if we "cut his trail"; and if he "cuts ours," we may never live to regret it. Some tame Indians, just in from a hunt in the Rio Chico, had seen three fires, but they had "rolled their tails"* for Bavicora so promptly that they had not ascertained whether they were Apache or not. The same men we were in the company of had run the "Kid's" band in to the States only two months before, but on our trip that very elusive and very "bad Injun" was not encountered. Much as I should like to see him, I have no regrets, since it is extremely likely that he would have seen me first.

Our little band was composed of the patron, Don Gilberto; my travelling companion from New York city, who had never before been west of the Elysian Fields of New Jersey; Bailey and Bell, ranch foremen, and as dauntless spirits as ever the Texas border nurtured; the ranch bookkeeper, a young man "short" on experiences and "long" on hope; Epitacio, an Indian hunter, since outlawed; William, the colored cook; four buckskin Mexican "punchers"; an old man who was useless for practical purposes, but who was said to be "funny" in Spanish; and two "burro men." We were that day to go to the farthest outlying ranch, called the Casa Camadra, and then to stop for a short hunt and to give the punchers time to "gentle" some steers for work-cattle. The puncher method of doing this is beautifully simple, for any animal undergoing this is gentle or dead after it. After scouring the plain for antelope until late, we followed up a creek toward the cabin where we expected to find the punchers and the burro men with their loads of creature comforts, and as we rode in, it was raining a cold sleet. The little log cabin was low,

* Cowboy for travelling rapidly.

MY COMRADE.

small, and wonderfully picturesque. It was a typical "shack," such as one used to see in the Northwest when the hunters were there. Out in the rain sat two punchers, enveloped in their serapes, engaged in watching a half-dozen big steers eat grass. Inside of the cabin was William by a good fire in a most original fireplace, glowing with heat and pride over his corn cakes and "marrow-gut." Between various cigarettes, the last drink of *tequela*, and the drying of our clothes,

flew in. The expression and the food were both good. Outside, the cold rain had turned into a wet snow, and we all crowded into the little place and squatted or lay about on the floor. With fingers and hunting-knives we carved and tore at the mountain of beef. The punchers consume enormous quantities of meat, and when satiated they bring forth their cornhusks and tobacco-pouches and roll their long thin cigarettes, which burn until they draw their serapes about their heads and sink back in dreamless sleep. It is all beautifully primitive, and as I rise on my elbow to look across the blanketed forms packed like mackerel in a cask, to hear their heavy breathing, and see the fire glow, and hear the wind howl outside, I think how little it takes to make men happy. Tom Bailey and Johnnie Bell, the ranch foremen, had faces which would have been in character under a steel headpiece at Cressy, while the wildest blood of Spain, Morocco, and the American Indian ran in the veins of the punchers; and all these men were untainted by the enfeebling influences of luxury and modern life. A chunk of beef, a cigarette, an enveloping serape, with the Sierras for a bedroom, were the utmost of their needs.

The sunlight streamed down the big chimney, and William's "Goodmo'nin', sah," brought back my senses. Beyond his silhouette, as he crouched before the fireplace, I could hear the sputtering of the broiling steak. I repaired to the brook and smashed the ice for a rub-down. It was still drizzling, and the landscape lay under a heavy fog. Outside the cabin lay the dead body of a skinned wolf, and about a small fire crouched the punchers.

Breakfast over, the men rode off by twos into the fog, and as Tom Bailey and I jogged along together we reasoned that if we were to strike the point of the mountains and then keep well in the timber we might catch a bunch of antelope which we had "jumped" the day before on the plain below. So all day long we rode over the wet rocks, under the drip and drizzle of the mountain pines, up hill and down dale, and never "cut a sign." It was our luck; for on riding up to the "shack" we saw the bodies of deer, antelope, a

PORPHYRY ROCK.

we passed the time until William had put the "grub" on a pack-saddle blanket and said, "Now, gemmen, fly in."

"Fly in" is vulgar, but it is also literal, for we did that: we did not dine—we

THE CASA CAMADRA.

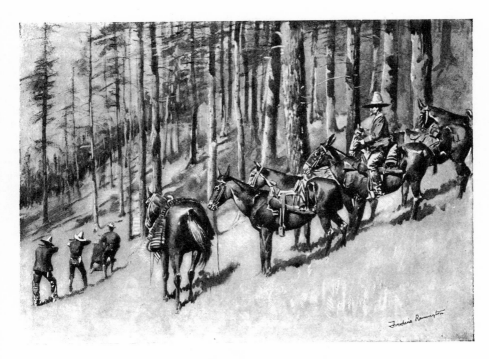

SHOOTING IN THE SIERRA MADRE.

big gray wolf, and the skin of a mountain-lion. We were requested to view the game, and encouraged to comment on it; but Tom and I sought a dark corner of the cabin to consume our coffee and cigarettes in silence.

At the Casa Camadra are two other log houses, and in them live some squalid, yellow-hided humans who are to farm a little stretch of bottom-land this year. They require work-steers to do their ploughing, and Mr. Bell has brought up half a dozen vicious old "stags," which are both truculent and swift of foot. The Mexicans insist that they are not able to handle them; and Mr. Bell orders his punchers into action. I strolled out to the corrals to see the bulls "gentled." After a lot of riding and yelling they were herded and dragged into the enclosure, where they huddled while seven punchers sat on their ponies at the gate. I was standing at one corner of the corral, near the men, when out from the midst of the steers walked a big black bull, which raised its head and gazed directly at me. The bull had never before in his stupid life observed a man on foot, and I comprehended immediately what he would

do next, so I "led out" for the casa at a rate of speed which the boys afterwards never grew weary of commending. No spangled *torero* of the bull-ring ever put more heart and soul into his running than did I in my great-coat and long hunting-spurs. The bull made a "fo'-lorn hope" for the gate, and the gallant punchers melted away before the charge.

The diversion of the punchers made the retreat of the infantry possible, and from an intrenched position I saw the bulls tear over the hill, with the punchers "rolling their tails" behind. After an hour of swearing and hauling and bellowing, the six cattle were lugged back to the pen, and the bars put up. The punchers came around to congratulate me on my rapid recovery from a sprained ankle, when they happened to observe the cattle again scouring off for the open country. Then there was a grunting of ponies as the urs went in, some hoarse oaths, and for a third time they tore away after the "gentle work-oxen." The steers had taken the bars in their stride. Another hour's chase, and this time the animals were thrown down, trussed up like turkeys for the baking, and tied to posts, where they

lay to kick and bellow the night through in impotent rage. The punchers coiled their ropes, lit their cigarettes, and rode off in the gathering gloom. The morning following the steers were let up, and though wet and chilled, they still roared defiance. For agricultural purposes a Mexican "stag" would be as valuable as a rhinoceros or a Bengal tiger, and I await with interest the report of the death rate at the Casa Camadra during spring ploughing.

In the handling of these savage animals the punchers are brave to recklessness, but this is partly because it seems so. In reality they have a thorough knowledge of bull nature, and can tell when and where he is going to strike as quickly as a boxer who knows by the "skim on the eye" of his opponent. But still they go boldly into the corral with the maddened brutes, seeming to pay no heed to the imminent possibilities of a trip to the moon. They toss their ropes and catch the bull's feet, they skilfully avoid his rush, and in a spirit of bravado they touch the horns, pat him on the back, or twist his tail.

After hunting for another day, with more success, we packed up and "pulled out" up the Varras Creek toward the mountains, leaving the last house behind us. Beyond was the unknown country. For many miles it had been ridden by some of the punchers, but the country is large, covered with vast mountain ranges, with wastes of stony foot-hills at the bases, while *barrancas* yawn at your feet, and for a great many years the policy of the Apaches has been not to encourage immigration. In 1860 a heavy band of

Mexican prospectors undertook to penetrate this part in the quest of Tiopa, but they were driven out. It is now possible for strong outfits to travel its wilds with only a small chance of encountering Apache renegades, but very few have attempted it as yet. It is so remote that prospectors for silver or gold could hardly work a mine if they found one, and for other purposes it has little value. The most magnificent pine timber covers its slopes, but it would take a syndicate to deliver one log at the railroad. As we wound

ON THE MOUNTAINS.

our way up the Varras Creek we passed beetling crags and huge pillars of porphyry rock cut into fantastic shapes by water and frost, resplendent in color, and admirably adapted for the pot-hunting of humans as affected by gentry temporarily stopping at San Carlos.

In a dell in the forest we espied some "mavericks," or unbranded stock. The punchers are ever alert for a beef without half its ears gone and a big HF burned in its flank, and immediately they perceive one they tighten their *cincha*, slip the rope from the pommel, put their hats on the back of their heads, and "light out." A cow was soon caught, after desperate riding over rocks and fallen timber, thrown down, and "hog-tied," which means all four feet together. A little fire is built, and one side of a *cincha* ring is heated red-hot, with which a rawhide artist paints HF in the sizzling flesh, while the cow kicks and bawls. She is then unbound, and when she gets back on her feet the vaqueros stand about, serape in hand, after the bull-fighter method, and provoke her to charge. She charges, while they avoid her by agile springs and a flaunting of their rags. They laugh, and cry "Bravo toro!" until she, having overcome her indignation at their rudeness, sets off down the cañon with her tail in the air.

Thus we journeyed day by day over the hills and up the cañons, camping by night under the pines in mountain glades or deep ravines, where the sun sets at four o'clock, while it is light above. The moon was in the full and the nights were frosty, and many times we awoke to think it morning when only our heads had become uncovered by the blankets and the big white moon shone fair upon us. Getting up in the night to poke the fire and thaw the stiffening out of one's legs is called by the boys "playing freeze-out," and we all participate in the game. A cigarette at two o'clock in the morning, with one's back to the fire, while the moon looks down on you, your comrades breathing about you, a wolf howling mournfully from a neighboring hill, the mountains towering on every side, and the tall pines painting inky shadows across the ghostly grass, is a mild sensation and rather pleasant. Some of the men are on foot, from soring their horses' backs, and their buckskin boots are wearing out, so they sit about the fire and stitch. We are all very dirty, and I no longer take comfort in watching the cook who makes the bread, for fear I may be tempted to ask him if he will not wash his hands, whereat the boys may indicate that I am a "dude," and will look down on me. The flour is nearly gone, and shortly it will not matter whether the cook's hands are rusty or not. The coffee and sugar promise to hold out. When William can no longer serve "bull gravy" with his fried meat I shall have many regrets, but they are swamped by the probabilities of a tobacco famine, which is imminent. We get deer every day, but to one not used to a strictly meat diet it begins to pall. The Indian hunter takes the stomach of a deer, fills it with meat, and deposits it under the coals. We roast it in slices and chunks, but I like it better when "jerked" brown, as it then affords somewhat more mystery to a taste already jaded with venison. In travelling with pack animals it is the custom to make a day's march before halting, and a day's march ends about four o'clock, or when water is found. Ten hours' march will loosen one's cartridge-belt five or six holes, for venison and coffee is not a strong food. By 12 M. we acquire a wolfish yearning for the "flesh-pots," but that shortly is relieved by the contraction of the stomach, or three or four quarts of mountain water will afford some relief. By nightfall one can "fly into" a venison steak, while cigarettes, coffee, and a desire to lie down restore one's equanimity.

We have passed some small ranges and worm our way down bottomless pits, but at last there rises ahead the main range of the Sierra Madre. From the depths of a great *barranca* we begin the climb. Never have I seen hills as sideling as these. It is terrible work for one not used to mountain-climbing and the short allowance of air one finds to subsist on. The feeling of exhaustion is almost impossible to overcome. The horses are thin, and Old Jim is developing more ribs than good condition calls for, so I walk to ease the old fellow. There are snow fields to cross, which intensifies the action. The journey is enlivened at times by shots at deer, and the rifles echo around the mountains, but being long shots they are misses. We passed the *cordon* of the mountains, and stopped

THE INDIAN'S STORY.

THE CLIFF-DWELLINGS:

on a knifelike ridge where the melting snows under one's foot ran east and west to the two great oceans. The climb from here over the main range was a bellows-bursting affair, but as we pulled on to the high *mesa* our drooping nerves were stiffened by shots, and presently deer came bounding down the ravine to our left. Jack made a bully flying shot, and the stricken deer rolled many yards, until caught by a fallen log. My companion, who was in advance, had fired into some deer, and had shot a buck which was lying down, and he was much puffed

up with pride over this achievement in still-hunting. From there on we passed through the most wonderful natural deer park. The animals did not fear man, and stood to be fired at, though the open timber and absence of underbrush made the shots long-range ones. After killing all we could carry, we sat down to wait for the burro train.

That night we camped on a jutting crag, with the water running in the *barranca* 200 feet below us. For a hundred miles the mountain and plain lay at our feet—a place more for an eagle's eyry than a camp for a caravan. The night set very cold, and from out in space the moon threw its mellow light down upon us. Before the camp-fire our Indian hunter told the story of the killing of Victoria's band, where he had been among the victors, and as he threw his serape down, and standing forth with the firelight playing on his harsh features, he swayed his body and waved his hands, while with hoarse voice and in a strange language he gave the movement of the fight. The legend of the lost mine of Tiopa was narrated by a vaquero in the quiet manner of one whose memory goes far back, and to whom it is all real— about the Jesuits, the iron door over the mouth of the mine, its richness, the secrecy enjoined by the fathers on the people when they fled before the Apache devils, and how there is always a light to be kept burning at its entrance to guide them back. It was a grand theatre and an eerie scene.

On the other side of the mountain we found the trail most difficult. I would never have believed that a horse could traverse it. To say that it was steep is commonplace, and yet I cannot be believed if I say that it was perpendicular; but a man could toss his hat a mile at any moment if he pleased. Then, underfoot, it was all loose lava rock, and the little ponies had to jump and dance over the bowlders. When we had finally arrived on a grassy *mesa* I concluded that if ever again I did the like of that, it would most certainly be the result of a tremendous error in my calculations. The pack-train was here detached and sent to water, but we followed Jack to see his "discovery." After miles of travel through the dry yellow grass we came out on a high bluff, with a *barranca* at its foot the bottom of which we could

not see. On the overhanging wall opposite were Jack's cliff-dwellings, perched like dove-cots against the precipice. It was only a quarter of a mile to them, but it took two days to get there, so we did not go. There are also holes in the cliffs, and underground passages. The paths up to them are washed away, but Jack and some of his men have invaded the silent village. They climbed up with lariats, and he was let down over the cliff, but they found nothing left but dust and cobwebs.

We could not get down to water, and as our horses were thirsty and foot-sore, we "mogged along." On our ride we "cut the trail" of a big band of mustangs, or wild horses, but did not see them, and by late afternoon we found the camp, and William busy above his fire. After hunting down the valley for a few days for "burro deer" and wild turkey, we found that the tobacco was promptly giving out, according to calculations, and being all inveterate smokers, we "made trail fast" for the Neuearachie ranch. Our ponies were jaded and sore; but having "roped" a stray pony two days before, which was now fresh, the lightest vaquero was put on his back, and sent hot-foot in the night to the ranch for tobacco. He made the long ride and returned at noon the next day on a fresh mount, having been thirty-six hours in the saddle. This fellow was a rather remarkable man, as it was he who, on the beginning of the trip, had brought some important mail to us one hundred and seventy miles, and after riding down two ponies he followed our trail on foot through the mountains, and overtook us as we sat resting on a log in the woods.

How we at last pulled into the ranch at Neuearachie, with its log buildings and irrigated fields, and how we "swooped down" on Mr. John Bailey, and ate up all his eggs and bread and butter at the first onset, I will not weary you with; but I believe that a man should for one month of the year live on the roots of the grass, in order to understand for the eleven following that so-called necessities are luxuries in reality. Not that I would indiscriminately recommend such a dietary abasement as ours, yet will I insist that it has killed less men than gluttony, and should you ever make the Sierra trails with the punchers, you will get rather less than more.

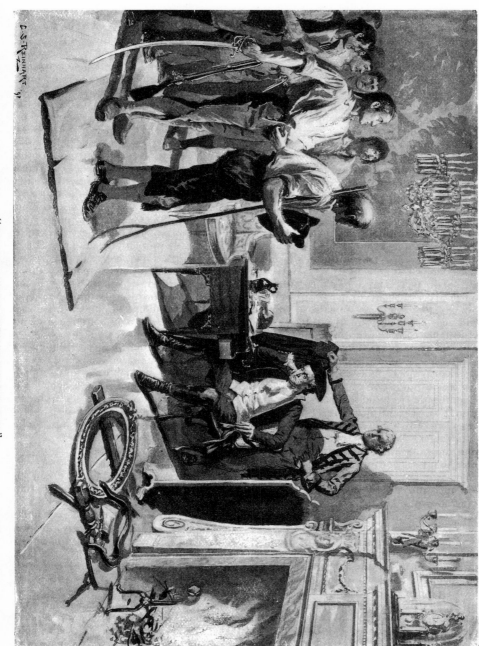

13.
Natchez's
Pass

NATCHEZ'S PASS

BY FREDERIC REMINGTON

WHAT I have in mind occurred in the days when the government expected the army to fight successfully both the wild Indians and the Department of the Interior. A military career thrives on opposition. It is the natural development of a soldier. Captain Bill Summers had buffeted through the great war, and all in all had sixteen years of formulation. He was rugged, red, fearless, and short-winded in his speech. He had found that the flag and Washington were often at odds, but he did not attempt to understand. The agency and Fort McDowell were as much at war as well could be.

There was at this time a demon in charge of the Apache agency whose name shall be Mr. Marshall East. He may have since died in a penitentiary, or have gotten through the net which justice has always set across the dark waters of opportunity: I do not know. He was a well-looking man, educated, and resourceful. Morally he liked a dirty dollar—even a bloody one, I think. He was a tool used by what was then called the "Indian Ring"—a scurvy band of political pirates, the thought of whom will always make Americans blush. Its reckless operations made a hell of the frontier. The army protested, the settlers pleaded pathetically, but the Interior Department kept its mercenaries at their posts.

The politicians grew fat, the army, the settlers, and the Indians grew thin. General Crook was in charge of the military operations against the Indians and the Interior Department. Savages constantly left the agencies on passes, when they murdered and stole. Crook's soldiers rode after them, and the government had a real war on its hands, between two of its greatest departments.

One hot day Captain Bill Summers rode into the agency at the head of his troop. After making camp he stalked into the office of Mr. Marshall East, and opened fire. "Mr. Marshall East, we have found the dead bodies of three white men over on the Rio Verde—killed by Indians, whose trail we have followed into this agency. What are you going to do about it?"

"Humph!—won't you sit down?" nodded the agent, as he fumbled some papers before him on the table.

"No, thank you. I didn't come here to sit down. I came here to arrest murderers, and I demand your aid."

"Well—arrest murderers, and don't bother me," retorted the agent.

"See here, Mr. Marshall East, you know that it is your duty to assist me by the use of your Indian police to identify these outlaws. You know, or should know, what Indians are away from the agency, or have been away, with or without passes," rejoined the Captain, now becoming alarmingly red in the face.

"I thought you came here to arrest murderers?"

"I did."

Coolly the man behind the table continued, "Well—what are you standing there for?"

The Captain was no longer standing, but striding, heavy heeled, across the room and back to his place, where he slapped his sombrero on his head, pulling it down defiantly about his ears. "You are a scoundrel, Mr. Marshall East! You are accessory after the fact to murder!"

The agent in his turn took fire. He sprang to his feet. "You call me a scoundrel! What do you mean by coming into my office and calling me such a name? Get out of here instantly," and half turning to a long-haired, sombreroed Indian factotum, he said, "Sanchez!" Sergeant McCollough's rifle came from an "order" to a "carry" with a snap.

"Steady, sergeant," muttered the Captain. Thus the scene was arrested in its development, and all in the room stood regarding each other nervously. Pres-

ently the Captain's mustache spread, and he burst into a loud laugh. "Oh, you old dog! I know you won't bite. You would abet murder, but you would not do it with your right arm. I am going to leave this room, but not until you sit down—if I have to get my striker to pitch my dog-tent here."

Slowly the desk-man resumed his chair. Continuing, the Captain said, "Before going, I want to state carefully that you are one of the worst scoundrels I ever saw, and before I am through I will run the brand—Scoundrel—on your thick hide." Going to the door, where he stopped, with his hand on the knob, he half turned and said, "Sanchez," followed by a sneering laugh. Then he passed out, followed by the sergeant.

"I will make you pay for this!" came a muffled roar of the agent's voice through the closed door.

"Oh, I guess we will split even," mumbled the departing officer, though of a truth he did not see how.

Walking to the troop camp, the Captain took possession of an abandoned *ramada* some little distance from his men, and here he sat on his blankets, trying to soothe his disgusting thoughts with a pipe. The horses and mules and soldiers made themselves comfortable, and rested after their hard marching of the previous days. It was to ease his command that determined the officer to stay "one smoke" at the place.

Immediately after dark, "Peaches," one of the Indian scouts of the command, slipped, ghostlike, to the opening of the *ramada,* saying, "Nan-tan!"

"What is it, Peaches?"

The ghost glided from the moonlight into the shadow, addressing his officer: "Say, Nan-tan—Injun bad—agent bad—no like you hombres. Say—me tink kill you. Tink you go make de vamoose. Sabe?"

"Oh, nonsense! Apaches won't attack me at night. Too many ghosts, Peaches."

Peaches replied, with a deprecatory turn of the hand: "No, no, Nan-tan—no *brujas*—too near agency. You vamoose —sabe?"

The Captain had an all-abiding faith in Peaches's knowledge of villany. He was just at present a friendly scout, but liable at any time to have a rush of blood to the head which would turn his hand against any man. He had been among the agency Indians all day, talking with them, and was responsive to their moods. It isn't at all necessary to beat an Indian on the head with a rock to impress his mind. He is possessed of a subtlety of understanding which is Oriental. So the Captain said, "Go, Peaches—tell Sergeant McCollough to come here."

In a few minutes the alert non-com. stood across the moonlight saluting.

"Sergeant, Peaches here has heard some alarming talk among the Indians. I don't think there is anything in it, but 'Injuns is Injuns,' you know. Tie and side-line your horses, and have your men sleep, skirmish formation, twenty-five paces out from the horses. Double your sentries. You might send a man or two up here to divide a watch over me. I want a good sleep. Understand?"

"Yes, sir. May I be one of them? It ain't far to the troop, and I can see them in the moonlight well enough."

"You had better stay with the troop. Why do you want to come up here? You can manage some sleep?" queried Summers.

"Been sleeping all afternoon, sir. Been talking to Peaches. Don't quite make it all out. Like to come up, sir."

"Oh, well—all right, then—do as you please, but secure your horses well." Saying which, the Captain turned on his blankets to sleep.

In a half-hour's time the sergeant had arranged his troop to his satisfaction— told the old "bucks" to mind their eyes, judiciously scared the "shave-tails" into wakefulness, and with Peaches and Trooper "Long Jack" O'Brien—champion fist-mixer of the command—he stole into the Captain's *ramada*. The officer was snoring with honest, hard-going vigor.

"This do be a rale da-light," murmured Long Jack.

"Shut up—you'll wake the old man!" whispered the non-com. Silence becoming the moonlight and desert soon brooded over the plains of the agency. There was no sound save the snoring, stamping of horses on picket, and the doleful coyotes out beyond baying the mysterious light.

Through long hours Long Jack and

the sergeant nodded their heads by turns. The moon was well down in the west when Peaches came over and poked the sergeant in the back with his carbine. The punched one stood up in sleepy surprise, but comprehending, shook O'Brien awake, and stepped over to where Peaches was scanning through the dead leaves which draped the *ramada*.

"Injun," whispered Peaches, almost inaudibly.

For a long time they sat gazing out at the dusky blur of the sage-brush. The sergeant, with white man's impatience, had about concluded that the faculties of Peaches were tricking him.

"Humph!" he grunted. The hand of the Indian scout tightened like nippers of steel around his arm and opened his eyes anew. Presently he made out a sage-brush which had moved slowly several feet, when it stopped. The hand of Peaches gave another squeeze when the brush made farther progress toward the *ramada*. The sergeant stole over to the door and put a tourniquet on Long Jack's arm which brought him in sympathy with the mysterious situation. That worthy's heart began to thump in unison with the others. A man under such circumstances can hear his own heart beat, but it is so arranged that others cannot. The sergeant pulled Long Jack's ear to his mouth, as a mother might about to kiss her infant. "Don't shoot—give them the butt." Cautiously the two Springfields were reversed. Long Jack was afraid to spit on his hands, but in lieu he ran his tongue over both before he bull-dogged them about the carbine barrel. With feet spread, the two soldiers waited, and Peaches, like a black shadow, watched the brush. The minutes passed slowly, but the suspense nerved them. After ages of time had passed they were conscious of the low rustle of a bush alongside the *ramada*—ever so faint, but they were coming. Slowly a sage-bush came around the corner, followed by the head of an Indian.

The eyes of the crawling assassin could not contract from the moonlight to meet the gloom of the interior of the house of boughs. It is doubtless true that he never had a sense of what happened, but the silence was shattered by a crash, and the soldiers sprang outside.

"Then I broake both ye un me goon."

"What in hell is the matter?" came from the awakened Captain, as he made his way out of the blankets.

A little group formed around the body, while Peaches rolled it over on its back, face upward. "Sanchez," he said, quietly. "Say, Nan-tan, maybeso you sabe Peaches. You go vamoose now?"

The Captain scratched his bare head, he gave his breeches a hitch, he regarded the moon carefully, as though he had never seen it before, then he looked at the dead Indian.

"Yes, Peaches, I think I sabe. Say, sergeant, it's 'boots and saddles' on the jump. Don't say a word to the men, but bring a pack-mule up here and we'll load this carrion on it. Peaches, you blind this man's trail. I reckon you are Injun enough to do that. O'Brien, don't leave the stock of that rifle lying there."

The camp was soon bustling. The horses were led out, blankets smoothed, and saddles swung across. A pack-mule was led up to the Captain's *ramada* by McCollough, O'Brien, and Peaches. All four men helped to wrap up their game in a canvas. Though the mule protested vigorously, he was soon under his grewsome burden, circled tight with the diamond hitch. Having finished, the Captain spoke: "Promise me, men, that you won't talk about this. I want time to think about it. I don't know the proper course to take until I consult with the military authorities. If the Indians found this out now, there would be a fight right here. If they don't, one may be averted."

"'Twas a foine bit av woork to me credit, which will be a dead loss to me, boot I promise," replied Long Jack, and so did the others.

"Have you blinded his trail, Peaches?"

"Si, Nan-tan; Injun no see a ting," said that imp of the night.

The little command took their thudding, clanking way over the ghostly hills, trotting steadily until the sun was high, when they made an eating halt. A few days brought them into McDowell, where the Captain reported the affair. Officially his comrades did not know what to do; personally they thought he did right. They expected nothing from the Indian

Ring but opposition, and they were not as strong in Washington as the politicians. But shortly time served them, as it does many who wait.

A great drought had raged in the Southwest, and many sheep-men from San Diego were driving their flocks into the Tonto Basin. One day a Mexican Indian came into Fort McDowell, stark naked and nearly exhausted. He reported that the small sheep outfit to which he belonged had been attacked by Apaches, and all murdered but himself.

Captain Summers was again ordered out with his troop to the scene of the outrage. He made forty-five miles the first day, yet with such travelling it was ten days before he came in sight of the camp. There were three tents, wind-blown and flapping. In front of the middle one lay three dead Indian bucks. The canvas walls were literally shot full of holes. As the Captain pulled back the flap of the centre tent he saw a big, blond-bearded white man sitting bolt-upright on a bed made of poles, with one arm raised in the act of ramming down a charge in a muzzle-loading rifle. He was dead, having been shot through the head. He was the owner, and a fine-looking man. His herders lay dead in the other tents, and his flocks were scattered and gone. The story of that desert combat will never be known. It was a drawn battle, because the Indians had not dared to occupy the field. The man who escaped was out in the hills, and fled at the firing.

On burying the dead the troopers found passes signed, " Marshall East, Agt.," under the belts of the dead Apaches. At last here was something tangible. Identifying each head with its attendant pass, the Indian scouts decapitated them, stowing them in grain-bags. Back to McDowell wound the command, where a council of war was held. This resulted in the Captain's being sent to the agency, accompanied by four troops as safe-escort.

Arriving, Summers again passed the unwelcome portals of the agent's office, followed by his staff, consisting of a Lieutenant, McCollough, Long Jack, and Peaches bearing a grain-bag.

" Good-day, Mr. Marshall East. I come to reassure you that you are a great scoundrel," vouchsafed the sombreroed officer, as he lined up his picturesque company. " I see Sanchez is not here to-day. Away on a pass, I presume."

" I don't know how that concerns you. I have other men here, and I will not be bulldozed by you; I want you to understand that. I intend to see if there are not influences in the world which will effectually prevent such a ruffian as you invading my office and insulting both myself and the branch of the government to which I belong."

" My dear sir," quoth the Captain, " you sign passes which permit these Indians of yours to go into white men's territory, where they every day murder women and men, and run off stock. When we run them back to your agency, you shield and protect them, because you know that if we were allowed to arrest them for their crimes, it might excite the tribe, send them on the war-path, resulting in a transfer of their responsibility to the War Department. That would interfere with your arrangements. A few dead settlers or soldiers count for little against that."

" Captain Summers, I am running this agency. I am responsible for this agency. Indians do go off this reservation at times without doubt, but seldom without a pass from me, and then with a specific object. When Indians are found outside without passes, it then becomes the duty of the army to return them to me."

In reply: " I suppose it is our duty to bring you tarantulas and Gila monsters also; it is our duty to wear our horses' shoes off in these mountains chasing your passes with their ' specific objects.' Would you give up an Indian who we could prove had murdered, or who had tried to murder, a white man ?"

" Yes—I might—under certain circumstances, with exceptional proofs," answered Mr. East.

Quickly asked the officer, " Where is Sanchez now ?"

With a searching query in his eyes, the agent continued his defensive of not seeing how that concerned the Captain.

The warrior's voice rose. " Yes, sir. I will tell you how it interests me. He tried to murder me, to stab me at night—right here on this agency. Will you send your Indian police to arrest him for me ?"

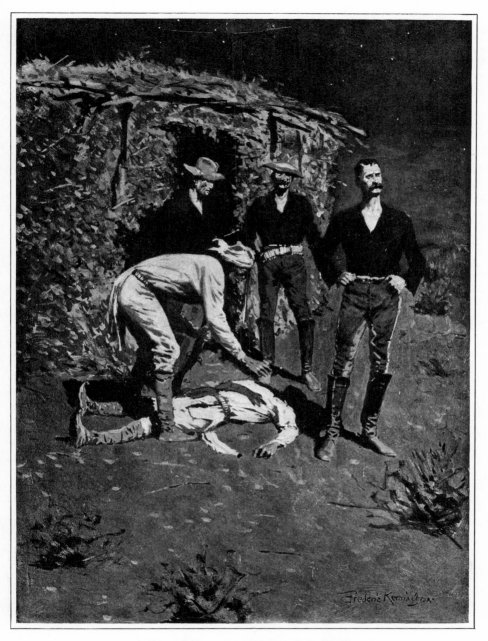

THE CAPTAIN . . . LOOKED AT THE MOON

"Humph! — rather startling. Pray where and when did he try to murder you? What proofs have you?"

"I have three men standing here before you who saw him crawl to my *ramada* in the night with a drawn knife."

"What became of him?" drawled the agent, betraying an increasing interest.

"Will you arrest him?" insisted Summers, with his index finger elevated against the chairman.

"Not so fast, my dear Captain. He might prove an alibi. Your evidence might not be conclusive."

The Captain permitted his rather severe countenance to rest itself. McCollough

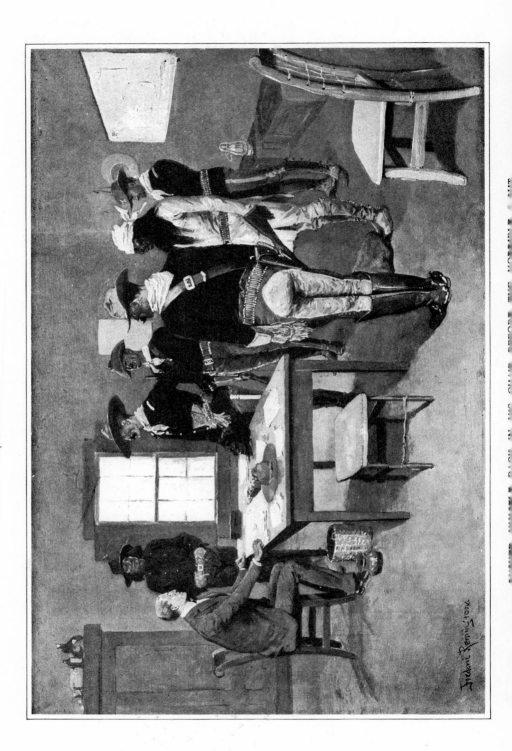

ALMOST WITHIN A REACH OF HIS CHAIR BEFORE THE MONEY WAS UP

and O'Brien guarded their "four aces" with a "deuce-high" lack of interest. Peaches might have been a splendid mummy from an aged tomb standing there with the sack at his feet.

Again becoming sober of mien, the Captain continued, in a voice which might have been the slow beginning of a religious service: "You are a scoundrel—you are to blame for dozens of murders in this country! Men and even women are being butchered every day because you fear to lose the opportunity to steal the property which belongs to these poor savages. I have soldier comrades lying in desert graves who would be alive if you were not a coward and a thief. Only the other day Indians bearing your 'specific object' passes killed five sheep-men in the Tonto Basin."

"I have issued no passes lately."

Here the Captain pulled out all the stops in his organ. "You are a liar, and I am going to prove it."

The agent, who had been sitting lazily behind his desk, leaned forward and made the ink-bottles, pens, and erasers dance fast as he smote the table with his fist. "Leave the room—leave the room, or I will call my police!"

"Where is Sanchez?"

"I don't know," and the fist ceased to beat as he looked up sharply. "Do you?"

The Captain turned rigidly. "Peaches, show the gentleman where Sanchez is."

With a suggestion of that interest which a mender of cane-bottomed chairs might display in business, Peaches pawed in his grain-sack—peered into its dark folds—until suddenly, having assured himself, he straightened up, holding in his right hand, by its long locks, a dead head depending therefrom. Taking it gingerly, the Captain set it on the table directly before Mr. Marshall East, and arranged it squarely. With dropping jaw, the agent pushed himself back in his chair before the horrible sight.

"Yes—I know where Sanchez is. He is looking at you. Were you an accessory before the fact of his intentions? Does he seem to reproach you?" spoke the Captain.

"God!" burst from the lips of the man as he eyeballed his attendant.

"Oh—well—you recognize him, then. Here also is one of your passes. It calls for Chief Natchez, a one-eyed man, who 'specifically murdered sheep-herders with an object.' Peaches, produce Natchez!"

Again fumbling the keeper of the bag got the desired head by the hair and handed it over. It was more recent, and not so well preserved. The eyes were more human, and his grin not so sweet. This, too, was arranged to gaze on the author of passes.

"You see he has one eye—he answers the pass. I suppose his 'specific object' was sheep."

The agent breathed heavily—not from moral shock, but at the startling exhibit. His chickens had come home to roost. His imagination had never taken him so far afield. The smooth amenities of the business world could not assert themselves before such unusual things. The perspiration rolled down his forehead. He held on to the table with both hands.

Again producing a dirty paper, the Captain read, "Pass Guacalotes" (with some description. Signed, "Marshall East. Agt., etc." Peaches dug up the deceased from the sack, handing it solemnly to the Nan-tan.

"Now, you murderer, you see your work. I wish you could see the faces of the dead sheep-herders too," and with hot impulse he rolled the head across the table. It fell into the agent's lap, and then to the floor. With a loud exclamation of "Oh—o—o!" the affrighted man bolted for the door.

Turning with the quickness of a fish, the soldier said, "Peaches, numero tres," and the third head came out of the bag like a shot.

"Murderer! Stop! Here is another 'specific object!'" but the agent was rapidly making for the door. With a savage turn the Captain hurled the dead head after him. It struck him on the back of the neck, and fell to the floor.

With a cry of fear, which cannot be interpreted on paper, the agent got through the door, followed by a chorus of "Murderer!" It was a violent scene —such as belonged to remote times, seemingly. No one knows what became of the agent. What I wonder at is why highly cultivated people in America seem to side with savages as against their own soldiers.

14.
The
Blue Quail
of the
Cactus

OCTOBER, 1896

THE BLUE QUAIL OF THE CACTUS.

BY FREDERIC REMINGTON.

THE Quartermaster and I both had trouble which the doctors could not cure — it was January, and it would not do for us to sit in a "blind"; besides, I do not fancy that. There are ever so many men who are comfortable all over when they are sitting in a blind waiting on the vagrant flying of the ducks; but it is solemn, gloomy business, and, I must say, sufficient reason why they take a drink every fifteen minutes to keep up their enthusiasm. We both knew that the finest winter resort for shot-gun folks was in the Southwest— down on the Rio Grande in Texas—so we journeyed to Eagle Pass. As we got down from the train we saw Captain Febiger in his long military cloak by a lantern-light.

"Got any quail staked out for us, Feb?" asked the Quartermaster.

"Oodles," said Febiger; "get into my trap," and we were rattled through the unlighted street out to the camp, and brought up by the Captain's quarters.

In the morning we unpacked our trunks, and had everything on the floor where we could see it, after the fashion with men. Captain Febiger's baby boy came in to help us rummage in the heaps of canvas clothes, ammunition, and what not besides, finally selecting for his amusement a loaded Colt's revolver and a freshly honed razor. We were terrorized by the possibilities of the combination. Our trying to take them away from the youngster only made him yell like a cavern of demons. We howled for his mother to come to our aid, which she finally did, and she separated the kid from his toys.

I put on my bloomers, when the Captain came in and viewed me, saying: "Texas bikes; but it doesn't bloom yet. I don't know just what Texas will do if you parade in those togs — but you can try."

As we sauntered down the dusty main street, Texas lounged in the doorways or stood up in its buggy and stared at me. Texas grinned cheerfully, too, but I did not care, so long as Texas kept its hand out of its hip pocket. I was content to help educate Texas as to personal comfort, at no matter what cost to myself. We passed into Mexico over the Long Bridge to call on Señor Muños, who is the local czar, in hopes of getting permits to be let alone by his chaparral-rangers while we shot quail on their soil. In Mexico when the people observe an Americano they simply shrug their shoulders; so our bloomers attracted no more contempt than would an X ray or a trolley-car. Señor Muños gave the permits, after much stately compliment and many subtle ways, which made us feel under a cloud of obligation.

The next morning an ambulance and escort-wagon drove up to the Captain's quarters, and we loaded ourselves in— shot-guns, ammunition, blankets, and the precious paper of Señor Muños; for, only the week before, the custom-house rangers had carefully escorted an American hunting party a long distance back to the line for lack of the little paper and red seals. We rattled over the bridge, past the Mexican barrack, while its dark-skinned soldiery—who do not shoot quails —lounged in the sunshine against the whitewashed wall.

At the first outpost of the customs a little man, whose considerable equatorial

proportions were girted with a gun, examined our paper, and waved us on our way. Under the railroad bridge of the International an engineer blew his whistle, and our mules climbed on top of each other in their terror. We wound along the little river, through irrigating ditches, past dozens of those deliciously quaint adobe houses, past the inevitable church, past a dead pony, ran over a chicken, made the little seven-year-old girls take their five-year-old brothers up in their arms for protection, and finally we climbed a long hill. At the top stretched an endless plain. The road forked; presently it branched; anon it grew into twigs of white dust on the gray levels of the background. The local physician of Eagle Pass was of our party, and he was said to know where a certain tank was to be found, some thirty miles out in the desert, but no man yet created could know which twig of the road to take. He decided on one—changed his mind—got out of the ambulance, scratched his head, pondered, and finally resolution settled on his face. He motioned the driver to a certain twig, got in, and shut his mouth firmly, thus closing debate. We smoked silently, waiting for the doctor's mind to fog. He turned uneasily in his seat, like the agitated needle of a compass, and even in time hazarded the remark that something did not look natural; but there was nothing to look at but flat land and flat sky, unless a hawk sailing here and there. At noon we lunched at the tail of the ambulance, and gently "jollied" the doctor's topography. We pushed on. Later in the afternoon the thirsty mules went slowly. The doctor had by this time admitted his doubts—some long blue hills on the sky-line ought to be farther to the west, according to his remembrance. As no one else had any ideas on the subject, the doctor's position was not enviable. We changed our course, and travelled many weary miles through the chaparral, which was high enough to stop our vision, and stiff enough to bar our way, keeping us to narrow roads. At last the bisecting cattle trails began to converge, and we knew that they led to water—which they did; for shortly we saw a little broken adobe, a tumbled brush corral, the plastered gate of an *acéquia*, and the blue water of the tank.

To give everything its due proportion at this point, we gathered to congratulate the doctor as we passed the flask. The camp was pitched within the corral, and while the cook got supper, we stood in the after-glow on the bank of the tank and saw the ducks come home, heard the mud-hens squddle, while high in the air flew the long line of sand-hill cranes with a hoarse clangor. It was quite dark when we sat on the "grub" chests and ate by the firelight, while out in the desert the coyotes shrilled to the monotonous accompaniment of the mules crunching their feed and stamping wearily. To-morrow it was proposed to hunt ducks in their morning flight, which means getting up before daylight, so bed found us early. It seemed but a minute after I had sought my blankets when I was being abused by the Captain, being pushed with his foot—fairly rolled over by him—he even standing on my body as he shouted: "Get up, if you are going hunting. It will be light directly—get up!" And this, constantly recurring, is one reason why I do not care for duck-shooting.

But, in order to hunt, I had to get up, and file off in the line of ghosts, stumbling, catching on the chaparral, and splashing in the mud. I led a setter-dog, and was presently directed to sit down in some damp grass, because it was a good place—certainly not to sit down in, but for other reasons. I sat there in the dark, petting the good dog, and watching it grow pale in the east. This is not to mention the desire for breakfast, or the damp, or the sleepiness, but this is really the larger part of duck-hunting. Of course if I later had a dozen good shots it might compensate—but I did not have a dozen shots.

The day came slowly out of the east, the mud-hens out in the marsh splashed about in the rushes, a sailing hawk was visible against the gray sky overhead, and I felt rather insignificant, not to say contemptible, as I sat there in the loneliness of this big nature which worked around me. The dog dignified the situation—he was a part of nature's belongings—while I somehow did not seem to grace the solitude. The grays slowly grew into browns on the sedge-grass, and the water to silver. A bright flash of fire shot out of the dusk far up in the gloom, and the dull report of a shot-gun came over the tank. Black objects fled across the sky — the ducks were flying. I missed one or two, and grew weary—none came near enough to

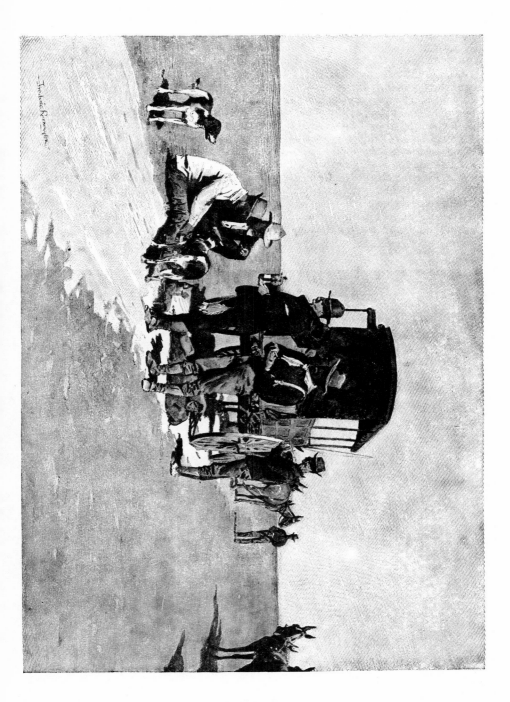

my lair. Presently it was light, and I got a fair shot. My bird tumbled into the rushes out in front of me, and the setter bounded in to retrieve. He searched vehemently, but the wounded duck dived in front of him. He came ashore shortly, and lying down, he bit at himself and pawed and rolled. He was a mass of cockle burs. I took him on my lap and laboriously picked cockle burs out of his hair for a half-hour; then, shouldering my gun, I turned tragically to the water and anathematized its ducks—all ducks, my fellow-duckers, all thoughts and motives concerning ducks—and then strode into the chaparral.

"Hie on! hie on!" I tossed my arm, and the setter began to hunt beautifully—glad, no doubt, to leave all thoughts of

the cockle burs and evasive ducks behind. I worked up the shore of the tank, keeping back in the brush, and got some fun. After chasing about for some time I came out near the water. My dog pointed. I glided forward, and came near shooting the Quartermaster, who sat in a bunch of sedge-grass, with a dead duck by his side. He was smoking, and was disgusted with ducks. He joined me, and shortly, as we crossed the road, the long Texas doctor, who owned the dog, came striding down the way. He was ready for quail now, and we started.

This quail-hunting is active work. The dog points, but one nearly always finds the birds running from one prickly-pear bush to another. They do not stand, rarely flush, and when they do get up it

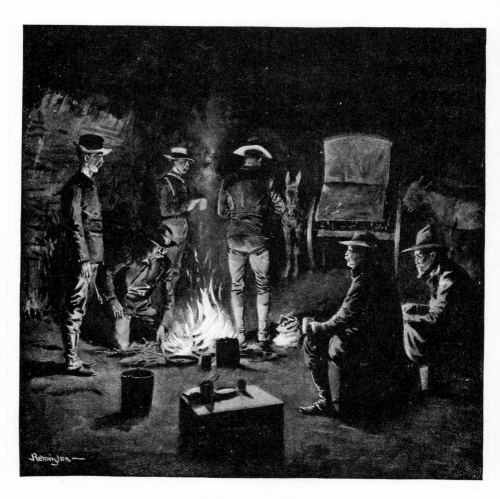

SUPPER IN THE CORRAL.

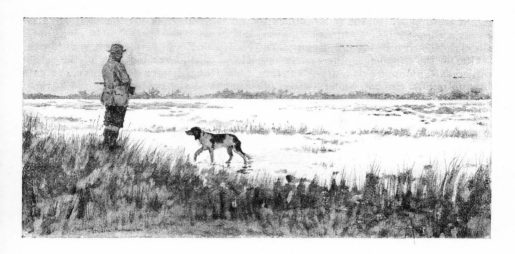

ON THE SHORE OF THE TANK—MORNING.

is only to swoop ahead to the nearest cover, where they settle quickly. One must be sharp in his shooting—he cannot select his distance, for the cactus lies thick about, and the little running bird is only on view for the shortest of moments. You must overrun a dog after his first point, since he works too close behind them. The covey will keep together if not pursued with too much haste, and one gets shot after shot; still, at last you must run lively, as the frightened covey scurry along at a remarkable pace. Heavy shot are necessary, since the blue quail carry lead like Marshal Masséna, and are much harder to kill than the bob-white. Three men working together can get shooting enough out of a bunch—the chase often continuing for a mile, when the covey gradually separate, the sportsmen following individual birds.

Where the prickly-pear cactus is thickest, there are the blue quail, since that is their feed and water supply. This same cactus makes a difficulty of pursuit, for it bristles with spines, which come off on your clothing, and when they enter the skin make most uncomfortable and persistent sores. The Quartermaster had an Indian tobacco-bag dangling at his belt, and as it flopped in his progress it gathered prickers, which it shortly transferred to his luckless legs, until he at last detected the reason why he bristled so fiercely. And the poor dog—at every covey we had

to stop and pick needles out of him. The haunts of the blue quail are really no place for a dog, as he soon becomes useless. One does not need him, either, since the blue quail will not flush until actually kicked into the air.

Jack and cotton-tail rabbits fled by hundreds before us. They are everywhere, and afford good shooting between coveys, it being quick work to get a cotton-tail as he flashes between the network of protecting cactus. Coyotes lope away in our front, but they are too wild for a shot-gun. It must ever be in a man's mind to keep his direction, because it is such a vastly simple thing to get lost in the chaparral, where you cannot see a hundred yards. Mexico has such a considerable territory that a man on foot may find it inconvenient to beat up a town in the desolation of thorn-bush.

There is an action about blue-quail shooting which is next to buffalo shooting —it's run, shoot, pick up your bird, scramble on in your endeavor to keep the skirmish-line of your two comrades; and at last, when you have concluded to stop, you can mop your forehead—the Mexican sun shines hot even in midwinter.

Later in the afternoon we get among bob-white in a grassy tract, and while they are clean work—good dog-play, and altogether more satisfactory shooting than any other I know of—I am yet much inclined to the excitement of chasing after

game which you can see at intervals. Let it not be supposed that it is less difficult to hit a running blue quail as he shoots through the brush than a flying bob-white, for the experience of our party has settled that, and one gets ten shots at the blue to one at the bob-white, because of their number. As to eating, we could

tle which threaded their way to water, and it makes one nervous. It is of no use to say "Soo-bossy," or to give him a charge of No. 6; neither is it well to run. If the *matadores* had any of the sensations which I have experienced, the gate receipts at the bull-rings would have to go up. When a big long-horn fastens a

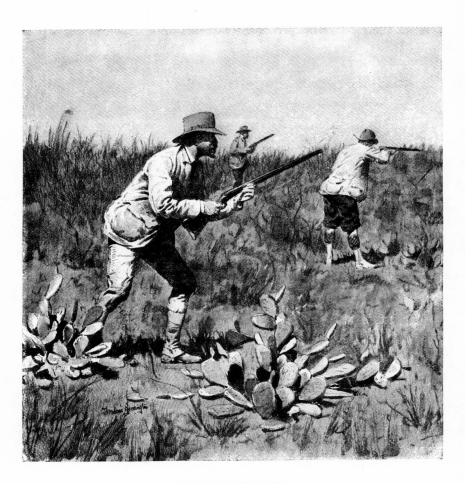

RUNNING BLUE QUAIL.

not tell the difference; but I will not insist that this is final. A man who comes in from an all day's run in the brush does not care whether the cook gives him boiled beans, watermelon, or crackers and jam; so how is he to know what a bird's taste is when served to a tame appetite?

At intervals we ran into the wild cat-

quail-shooter with his great open brown eye in a chaparral thicket, you are not inclined to "call his hand." If he will call it a misdeal, you are with him.

We were banging away, the Quartermaster and I, when a human voice began yelling like mad from the brush ahead. We advanced, to find a Mexican—rather well gotten up—who proceeded to wave

TOO BIG GAME FOR NUMBER SIX.

his arms like a parson who had reached "sixthly" in his sermon, and who proceeded thereat to overwhelm us with his eloquence. The Quartermaster and I "*buenos dias-ed*" and "*si, señor-ed*" him in our helpless Spanish, and asked each other, nervously, "What de'll." After a long time he seemed to be getting through with his subject, his sentences became separated, he finally emitted monosyllables only along with his scowls, and we tramped off into the brush. It was a pity he spent so much energy, since it could only arouse our curiosity without satisfying it.

In camp that night we told the Captain of our excited Mexican friend out in the brush, and our cook had seen sinister men on ponies passing near our camp. The Captain became solicitous, and stationed a night-guard over his precious govern-

ment mules. It would never do to have a bandit get away with a U. S. brand. It never does matter about private property, but anything with U. S. on it has got to be looked after, like a croupy child.

We had some good days' sport, and no more formidable enterprise against the night-guard was attempted than the noisy approach of a white jackass. The tents were struck and loaded when it began to rain. We stood in the shelter of the escort-wagon, and the storm rose to a hurricane. Our corral became a tank; but shortly the black clouds passed north, and we pulled out. The twig ran into a branch, and the branch struck the trunk near the bluffs over the Rio Grande, and in town there stood the Mexican soldiers leaning against the wall as we had left them. We wondered if they had moved meanwhile.

15.
The
Strange Days
that Came to
Jimmy Friday

THE STRANGE DAYS THAT CAME TO JIMMIE FRIDAY.

BY FREDERIC REMINGTON.

THE "Abwee-chemun"* Club was organized with six charter members at a heavy lunch in the Savarin restaurant—one of those lunches which make through connections to dinner without change. One member basely deserted, while two more lost all their enthusiasm on the following morning, but three of us stuck. We vaguely knew that somewhere north of the Canadian Pacific and south of Hudson Bay were big lakes and rapid rivers—lakes whose names we did not know; lakes bigger than Champlain, with unnamed rivers between them. We did not propose to be boated around in a big birch-bark by two voyagers among blankets and crackers and ham, but each provided himself a little thirteen-foot cedar canoe, twenty-nine inches in the beam, and weighing less than forty pounds. I cannot tell you precisely how our party was sorted, but one was a lawyer with eye-glasses and settled habits, loving nature, though detesting canoes; the other was nominally a merchant, but in reality an atavic Norseman of the wolf and raven kind; while I am not new. Together we started.

Presently the Abwees sat about the board of a lumbermen's hotel, filled with house-flies and slatternly waiter-girls, who talked familiarly while they served greasy food. The Abwees were yet sore in their minds at the thoughts of the smelly beds upstairs, and discouragement sat deeply on their souls. But their time was not yet.

After breakfast they marched to the Hudson Bay Company's store, knowing as they did that in Canada there are only two places for a traveller to go who wants anything—the great company or the parish priest; and then, having explained to the factor their dream, they were told "that beyond, beyond some days' journey"—oh! that awful beyond, which for centuries has stood across the path of the pioneer, and in these latter days confronts the sportsman and wilderness-lover—"that beyond some days' journey to the north was a country such as they had dreamed — up Temiscamingue and beyond."

The subject of a guide was considered.

* Algonquin for "paddle and canoe."

Jimmie Friday always brought a big toboggan-load of furs into Fort Tiemogamie every spring, and was accounted good in his business. He and his big brother trapped together, and in turn followed the ten days' swing through the snow-laden forest which they had covered with their dead-falls and steel-jawed traps; but when the ice went out in the rivers, and the great pines dripped with the melting snows, they had nothing more to do but cut a few cords of wood for their widowed mother's cabin near the post. Then the brother and he paddled down to Bais des Pierres, where the brother engaged as a deck hand on a steamboat, and Jimmie hired himself as a guide for some bush-rangers, as the men are called who explore for pine lands for the great lumber firms. Having worked all summer and got through with that business, Jimmie bethought him to dissipate for a few days in the bustling lumber town down on the Ottawa River. He had been there before to feel the exhilaration of civilization, but beyond that clearing he had never known anything more inspiring than a Hudson Bay post, which is generally a log store, a house where the agent lives, and a few tiny Indian cabins set higgledy-piggledy in a sunburnt gash of stumps and bowlders, lost in the middle of the solemn, unresponsive forest. On this morning in question he had stepped from his friend's cabin up in the Indian village, and after lighting a perfectly round and rather yellow cigar, he had instinctively wandered down to the Hudson Bay store, there to find himself amused by a strange sight.

The Abwees had hired two French-Indian voyagers of sinister mien, and a Scotch-Canadian boy bred to the bush. They were out on the grass, engaged in taking burlaps off three highly polished canoes, while the clerk from the store ran out and asked questions about "how much bacon," and, "will fifty pounds of pork be enough, sir?"

The round yellow cigar was getting stubby, while Jimmie's modest eyes sought out the points of interest in the new-comers, when he was suddenly and sharply addressed:

"Can you cook?"

Jimmie couldn't do anything in a hur-

ry, except chop a log in two, paddle very
fast, and shoot quickly, so he said, as was
his wont,

"I think—I dun'no'—"

"Well—how much?" came the query.

"Two daul—ars—" said Jimmie.

The transaction was complete. The
yellow butt went over the fence, and Jim-
mie shed his coat. He was directed to
lend a hand by the bustling sportsmen,
and requested to run and find things of
which he had never before in his life
heard the name.

After two days' travel the
Abwees were put ashore—box-
es, bags, rolls of blankets, ca-
noes, Indians, and plunder
of many sorts—on a pebbly
beach, and the steamer backed
off and steamed away. They
had reached the "beyond" at
last, and the odoriferous little
bedrooms, the bustle of the
preparation, the cares of their
lives, were behind. Then

"THE LAWYER HAD BECOME A VOYAGER."

"IT IS STRANGE HOW ONE CAN ACCUSTOM
HIMSELF TO 'PACK.'"

there was a girding up of the loins, a get-
ting out of tump-lines and canvas packs,
and the long portage was begun.

The voyagers carried each two hundred
pounds as they stalked away into the wil-
derness, while the attorney-at-law "heft-
ed" his pack, wiped his eye-glasses with
his pocket-handkerchief, and tried cheer-
fully to assume the responsibilities of "a
dead game sport."

"I cannot lift the thing, and how I am
going to carry it is more than I know;
but I'm a dead game sport, and I am going
to try. I do not want to be dead game,
but it looks as though I couldn't help it.
Will some gentleman help me to adjust
this cargo?"

The night overtook the outfit in an
old beaver meadow half-way through the
trail. Like all first camps, it was tough.
The lean-to tents went up awkwardly.
No one could find anything. Late at
night the Abwees lay on their backs un-
der the blankets, while the fog settled over
the meadow and blotted out the stars.

On the following day the stuff was all
gotten through, and by this time the law-
yer had become a voyager, willing to car-

ry anything he could stagger under. It is strange how one can accustom himself to " pack." He may never use the tump-line, since it goes across the head, and will unseat his intellect if he does, but with shoulder - straps and a tump - line a man who thinks he is not strong will simply amaze himself inside of a week by what he can do. As for our little canoes, we could trot with them. Each Abwee car-ried his own belongings and his boat, which entitled him to the distinction of " a dead game sport," whatever that may mean, while the Indians portaged their larger canoes and our mass of supplies, making many trips backward and for-ward in the process.

At the river everything was parcelled out and arranged. The birch-barks were repitched, and every man found out what he was expected to portage and do about camp. After breaking and making camp three times, the outfit could pack up, load the canoes, and move inside of fifteen minutes. At the first camp the lawyer essayed his canoe, and was cautioned that the delicate thing might flirt with him. He stepped in and sat gracefully down in about two feet of water, while the " deli-cate thing " shook herself saucily at his side. After he had crawled dripping ashore and wiped his eye-glasses, he en-gaged to sell the " delicate thing " to an Indian for one dollar and a half on a promissory note. The trade was sup-pressed, and he was urged to try again. A man who has held down a cane-bottom chair conscientiously for fifteen years looks askance at so fickle a thing as a canoe twenty-nine inches in the beam. They are nearly as hard to sit on in the water as a cork; but once one is in the bottom they are stable enough, though they do not submit to liberties or palsied movements. The staid lawyer was filled with horror at the prospect of another go at his polished beauty; but remember-ing his resolve to be dead game, he aban-doned his life to the chances, and got in this time safely.

So the Abwees went down the river on a golden morning, their double-blade paddles flashing the sun and sending the drip in a shower on the glassy water. The smoke from the lawyer's pipe hung behind him in the quiet air, while the note of the reveille clangored from the little buglette of the Norseman. Jimmie and the big Scotch backwoodsman swayed their bodies in one boat, while the two sinister voyagers dipped their paddles in the big canoe.

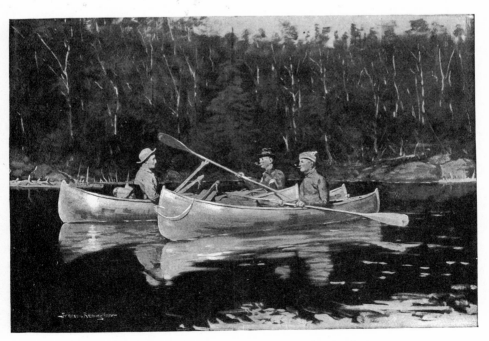

"DOWN THE RIVER ON A GOLDEN MORNING."

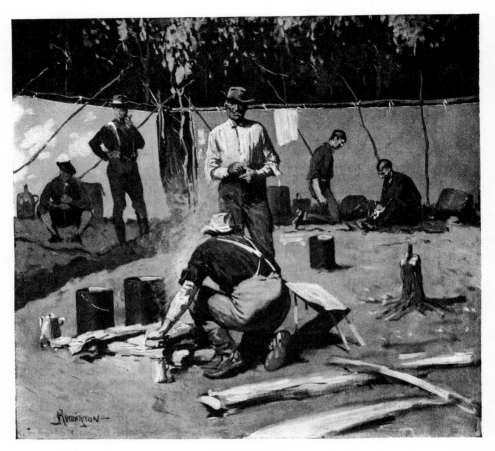

A REAL CAMP.

The Norseman's gorge came up, and he yelled back: "Say! this suits me. I am never going back to New York."

Jimmie grinned at the noise; it made him happy. Such a morning, such a water, such a lack of anything to disturb one's peace! Let man's better nature revel in the beauties of existence; they inflate his soul. The colors play upon the senses—the reddish-yellow of the birch-barks, the blue of the water, and the silver sheen as it parts at the bows of the canoes; the dark evergreens, the steely rocks with their lichens, the white trunks of the birches, their fluffy tops so greeny green, and over all the gold of a sunny day. It is my religion, this thing, and I do not know how to tell all I feel concerning it.

The rods were taken out, a gang of flies put on and trolled behind—but we have all seen a man fight a five-pound bass for twenty minutes. The waters fairly swarmed with them, and we could always get enough for the "pot" in a half-hour's fishing at any time during the trip. The Abwees were canoeing, not hunting or fishing; though, in truth, they did not need to hunt spruce-partridge or fish for bass in any sporting sense; they simply went out after them, and never staid over half an hour. On a point we stopped for lunch: the Scotchman always struck the beach a-cooking. He had a "kit," which was a big camp-pail, and inside of it were more dishes than are to be found in some hotels. He broiled the bacon, instead of frying it, and thus we were saved the terrors of indigestion. He had many luxuries in his commissary, among them dried apples, with which he filled a camp-pail one day and put them on to boil. They subsequently got to be about a foot deep all over the camp, while Furguson stood

around and regarded the black-magic of the thing with overpowering emotions and Homeric tongue. Furguson was a good genius, big and gentle, and a woodsman root and branch. The Abwees had intended their days in the wilderness to be happy singing flights of time, but with grease and paste in one's stomach what may not befall the mind when it is bent on nature's doings?

And thus it was that the gloomy Indian Jimmie Friday, despite his tuberculosis begotten of insufficient nourishment, was happy in these strange days — even to the extent of looking with wondrous eyes on the nooks which we loved — nooks which previously for him had only sheltered possible "dead-falls" or not, as the discerning eye of the trapper decided the prospects for pelf.

Going ashore on a sandy beach, Jimmie wandered down its length, his hunter mind seeking out the footprints of his prey. He stooped down, and then beckoned me to come, which I did.

Pointing at the sand, he said, "You know him?"

"Wolves," I answered.

"Yes — first time I see 'em up here — they be follerin' the deers — bad — bad. No can trap 'em — verrie smart."

A half-dozen wolves had chased a deer into the water; but wolves do not take to the water, so they had stopped and drank, and then gone rollicking together up the beach. There were cubs, and one great track as big as a mastiff might make.

"See that — moose track — he go by yesterday;" and Jimmie pointed to enormous footprints in the muck of a marshy place. "Verrie big moose — we make call at next camp — think it is early for call."

At the next camp Jimmie made the usual birch-bark moose-call, and at evening blew it, as he also did on the following morning. This camp was a divine spot on a rise back of a long sandy beach, and we concluded to stop for a day. The Norseman and I each took a man in our canoes and started out to explore. I wanted to observe some musk-rat hotels

down in a big marsh, and the Norseman was fishing. The attorney was content to sit on a log by the shores of the lake, smoke lazily, and watch the sun shimmer through the lifting fog. He saw a canoe approaching from across the lake. He gazed vacantly at it, when it grew strange and more unlike a canoe. The paddles did not move, but the phantom craft drew quickly on.

"Say, Furguson—come here—look at that canoe."

The Scotchman came down, with a pail in one hand, and looked. "Canoe—hell —it's a moose—and there ain't a pocket-pistol in this camp," and he fairly jumped up and down.

"You don't say—you really don't say!" gasped the lawyer, who now began to exhibit signs of insanity.

"Yes—he's going to be d——d sociable with us—he's coming right bang into this camp."

The Indian too came down, but he was long past talking English, and the gutturals came up in lumps, as though he was trying to keep them down.

The moose finally struck a long point of sand and rushes about two hundred yards away, and drew majestically out of the water, his hide dripping, and the sun glistening on his antlers and back.

The three men gazed in spellbound admiration at the picture until the moose was gone. When they had recovered their senses they slowly went up to the camp on the ridge—disgusted and dumfounded.

"I could almost put a cartridge in that old gun-case and kill him," sighed the backwoodsman.

"I have never hunted in my life," mused the attorney, "but few men have seen such a sight," and he filled his pipe.

"Hark—listen!" said the Indian. There was a faint cracking, which presently became louder. "He's coming into camp;" and the Indian nearly died from excitement as he grabbed a hatchet. The three unfortunate men stepped to the back of the tents, and as big a bull moose as walks the lonely woods came up to within one hundred and fifty feet of the camp, and stopped, returning their gaze.

Thus they stood for what they say was a minute, but which seemed like hours. The attorney composedly admired the unusual sight. The Indian and Furguson swore softly but most viciously until

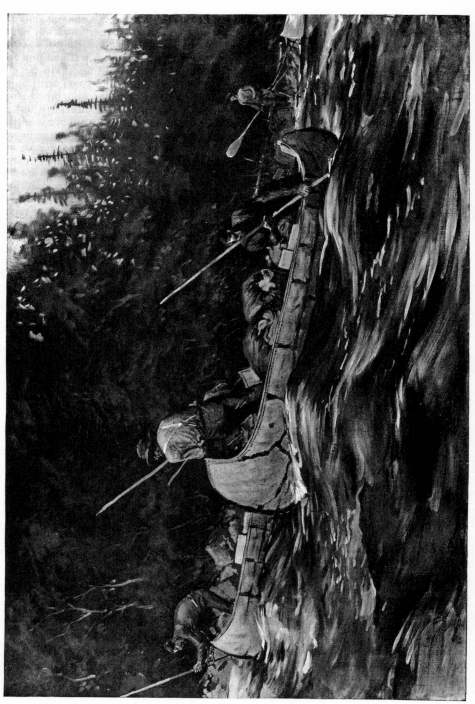

"THE INDIAN (USED KNIFE AND SPEAR)"

the moose moved away. The Indian hurled the hatchet at the retreating figure, with a final curse, and the thing was over.

"Those fellows who are out in their canoes will be sick abed when we tell them what's been going on in the camp this morning," sighed Mr. Furguson, as he scoured a cooking-pot.

I fear we would have had that moose on our consciences if we had been there: the game law was not up at the time, but I should have asked for strength from a higher source than my respect for law.

The golden days passed and the lake grew great. The wind blew at our backs. The waves rolled in restless surges, piling the little canoes on their crests and swallowing them in the troughs. The canoes thrashed the water as they flew along, half in, half out, but they rode like ducks. The Abwees took off their hats, gripped their double blades, made the water swirl behind them, howled in glee to each other through the rushing storm. To be five miles from shore in a seaway in kayaks like ours was a sensation. We found they stood it well, and grew contented. It was the complement to the golden lazy days when the water was glass, and the canoes rode upside down over its mirror surface. The Norseman grinned and shook his head in token of his pleasure, much as an epicure might after a sip of superior Burgundy.

"How do you fancy this?" we asked the attorney-at-law.

"I am not going to deliver an opinion until I get ashore. I would never have believed that I would be here at my time of life, but one never knows what a —— fool one can make of one's self. My glasses are covered with water, and I can hardly see, but I can't let go of this paddle to wipe them," shrieked the man of the office chair, in the howl of the weather.

But we made a long journey by the aid of the wind, and grew a contempt for it. How could one imagine the stability of those little boats until one had tried it?

That night we put into a natural harbor and camped on a gravel beach. The tents were up and the supper cooking, when the wind hauled and blew furiously into our haven. The fires were scattered and the rain came in blinding sheets. The tent-pegs pulled from the sand. We sprang to our feet and held on to the poles, wet to the skin. It was useless; the rain blew right under the canvas. We laid the tents on the "grub" and stepped out into the dark. We could not be any wetter, and we did not care. To stand in the dark in the wilderness, with nothing to eat, and a fire-engine playing a hose on you for a couple of hours—if you have imagination enough, you can fill in the situation. But the gods were propitious. The wind died down. The stars came out by myriads. The fires were relighted, and the ordinary life begun. It was late in the night before our clothes, blankets, and tents were dry, but, like boys, we forgot it all.

Then came a river—blue and flat like the sky above — running through rushy banks, backed by the masses of the forest; anon the waters rushed upon us over the rocks, and we fought, plunk-plunk-plunk, with the paddles, until our strength gave out. We stepped out into the water, and getting our lines, and using our long double blades as fenders, "tracked" the canoes up through the boil. The Indians in their heavier boats used "setting-poles" with marvellous dexterity, and by furious exertion were able to draw steadily up the grade — though at times they too "tracked," and even portaged. Our largest canoe weighed two hundred pounds, but a little voyager managed to lug it, though how I couldn't comprehend, since his pipe-stem legs fairly bent and wobbled under the enormous ark. None of us by this time were able to lift the loads which we carried, but, like a Western pack-mule, we stood about and had things piled on to us, until nothing more would stick. Some of the backwoodsmen carry incredible masses of stuff, and their lore is full of tales which no one could be expected to believe. Our men did not hesitate to take two hundred and fifty pounds over short portages, which were very rough and stony, though they all said if they slipped they expected to break a leg. This is largely due to the tump-line, which is laid over the head, while persons unused to it must have shoulder-straps in addition, which are not as good, because the "breastbone," so called, is not strong enough.

We were getting day by day farther into "the beyond." There were no traces here of the hand of man. Only Jimmie knew the way—it was his trapping-ground. Only once did we encounter people. We were blown into a little

board dock, on a gray day, with the waves piling up behind us, and made a difficult landing. Here were a few tiny log houses—an outpost of the Hudson Bay Company. We renewed our stock of provisions, after laborious trading with the stagnated people who live in the lonely place. There was nothing to sell us but a few of the most common necessities; however, we needed only potatoes and

The loneliness of this forest life is positively discouraging to think about. What the long winters must be in the little cabins I cannot imagine, and I fear the traders must be all avarice, or have none at all; for there can certainly be absolutely no intellectual life. There is undoubtedly work, but not one single problem concerning it. The Indian hunters do fairly well in a financial way, though

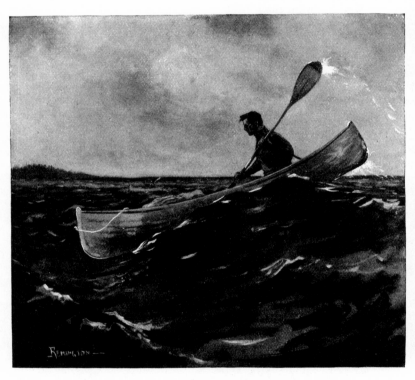

ROUGH WATER.

sugar. This was Jimmie's home. Here we saw his poor old mother, who was being tossed about in the smallest of canoes as she drew her nets. Jimmie's father had gone on a hunting expedition and had never come back. Some day Jimmie's old mother will go out on the wild lake to tend her nets, and she will not come back. Some time Jimmie too will not return—for this Indian struggle with nature is appalling in its fierceness.

There was a dance at the post, which the boys attended, going by canoe at night, and they came back early in the morning, with much giggling at their gallantries.

their lives are beset with weakening hardships and constant danger. Their meagre diet wears out their constitutions, and they are subject to disease. The simplicity of their minds makes it very difficult to see into their life as they try to narrate it to one who may be interested.

From here on was through beautiful little lakes, and the voyagers rigged blanket sails on the big canoes, while we towed behind. Then came the river and the rapids, which we ran, darting between rocks, bumping on sunken stones—shooting fairly out into the air, all but turning over hundreds of times. One day the Abwees glided out in the big lake Tes-

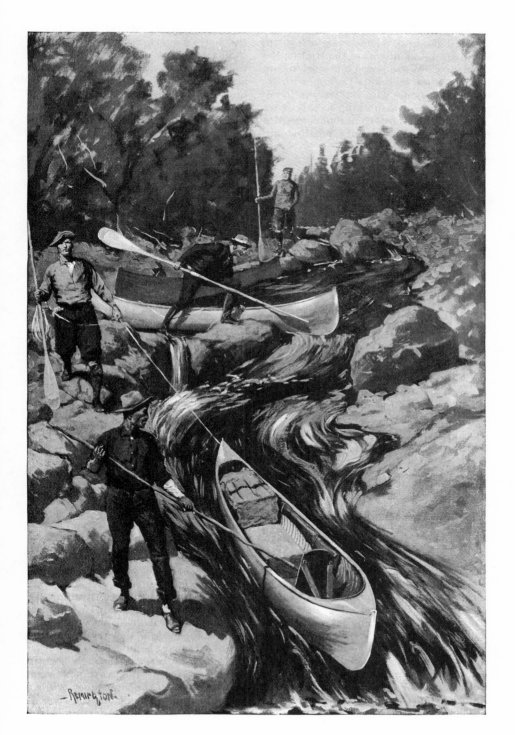

TRYING MOMENTS.

miaquemang, and saw the steamer going to Bais des Pierres. We hailed her, and she stopped, while the little canoes danced about in the swell as we were loaded one by one. On the deck above us the passengers admired a kind of boat the like of which had not before appeared in these parts.

At Bais des Pierres we handed over the residue of the commissaries of the Abwee-Chemun to Jimmie Friday, including personally many pairs of well-worn golf-breeches, sweaters, rubber coats, knives which would be proscribed by law in New York. If Jimmie ever parades his solemn wilderness in these garbs, the owls will laugh from the trees. Our simple forest friend laid in his winter stock—traps, flour, salt, tobacco, and pork, a new

axe—and accompanied us back down the lake again on the steamer. She stopped in mid-stream, while Jimmie got his bundles into his "bark" and shoved off, amid a hail of "good-byes."

The engine palpitated, the big wheel churned the water astern, and we drew away. Jimmie bent on his paddle with the quick body-swing habitual to the Indian, and after a time grew a speck on the reflection of the red sunset in Temiscamingue.

The Abwees sat sadly leaning on the after-rail, and agreed that Jimmie was "a lovely Injun." Jimmie had gone into the shade of the overhang of the cliffs, when the Norseman started violently up, put his hands in his pockets, stamped his foot, said, "By George, fellows, any D. F. would call this a sporting trip!"

16.
A Scout
with the
Buffalo-Soldiers

A SCOUT WITH THE BUFFALO-SOLDIERS.

WRITTEN AND ILLUSTRATED BY FREDERIC REMINGTON.

THE GOVERNMENT PACK.

I SAT smoking in the quarters of an army friend at Fort Grant, and through a green lattice - work was watching the dusty parade and congratulating myself on the possession of this spot of comfort in such a disagreeably hot climate as Arizona Territory offers in the summer, when in strode my friend the lieutenant, who threw his cap on the table and began to roll a cigarette.

"Well," he said, "the K. O. has ordered me out for a two-weeks' scouting up the San Carlos way, and I 'm off in the morning. Would you like to go with me?" He lighted the cigarette and paused for my reply.

I was very comfortable at that moment, and knew from some past experiences that marching under the summer sun of Arizona was real suffering and not to be considered by one on pleasure bent; and I was also aware that my friend the lieutenant had a reputation as a hard rider, and would in this case select a few picked and seasoned cavalrymen and rush over the worst possible country in the least possible time. I had no reputation as a hard rider to sustain, and, moreover, had not backed a horse for the year past. I knew too that Uncle Sam's beans, black coffee, and the bacon which every old soldier will tell you about would fall to the lot of any one who scouted

175

stable-call and pick out a mount? You are one of the heavies, but I think we can outfit you," he said; and together we strolled down to where the bugle was blaring.

At the adobe corral the faded coats of the horses were being groomed by black troopers in white frocks; for the 10th United States Cavalry is composed of colored men. The fine alkaline dust of that country is continually sifting over all exposed objects, so that grooming becomes almost as hopeless a task as sweeping back the sea with a house-broom. A fine old veteran cavalry-horse, detailed for a sergeant of the troop, was select-ed to bear me on the trip. He was a large horse of a pony build, both strong and sound except that he bore a healed-up saddle-gall, gotten, probably, dur-ing some old march up-on an endless Apache trail. His temper had been ruined, and a grinning soldier said, as he stood at a respect-ful distance, "Leouk out, sah. Dat ole hoss shore kick youh head off, sah."

The lieutenant as-sured me that if I could ride that animal through and not start the old gall I should be covered with glory; and as to the rest,

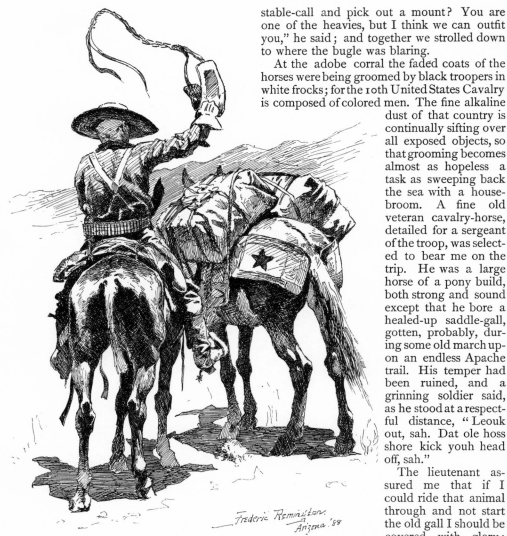

A PACKER AND MULES.

with the 10th Dragoons. Still, I very much de-sired to travel through the country to the north, and in a rash moment said, "I'll go."

"You quite understand that you are amena-ble to discipline," continued the lieutenant with mock seriousness, as he regarded me with that soldier's contempt for a citizen which is not openly expressed but is tacitly felt.

"I do," I answered meekly.

"Put you afoot, citizen; put you afoot, sir, at the slightest provocation, understand," pur-sued the officer in his sharp manner of giving commands.

I suggested that after I had chafed a Gov-ernment saddle for a day or two I should un-doubtedly beg to be put afoot, and, far from being a punishment, it might be a real mercy.

"That being settled, will you go down to

"What you don't know about cross-country riding in these parts that horse does. It 's lucky there is n't a hole in the ground where his hoofs trod, for he 's pounded up and down across this Territory for the last five years."

Well satisfied with my mount, I departed. That evening numbers of rubber-muscled cav-alry officers called and drew all sorts of hor-rible pictures for my fancy, which greatly amused them and duly filled me with dismal forebodings. "A man from New York comes out here to trifle with the dragoon," said one facetious chap, addressing my lieutenant; "so now, old boy, you don't want to let him get away with the impression that the cavalry don't ride." I caught the suggestion that it was the purpose of those fellows to see that I was "ridden down" on that trip; and though I

got my resolution to the sticking-point, I knew that "a pillory can outpreach a parson," and that my resolutions might not avail against the hard saddle.

On the following morning I was awakened by the lieutenant's dog-rubber,[1] and got up to array myself in my field costume. My old troop-horse was at the door, and he eyed his citizen rider with malevolent gaze. Even the dumb beasts of the army share that quiet contempt for the citizen which is one manifestation of the military spirit, born of strength, and as old as when the first man went forth with purpose to conquer his neighbor man.

Together at the head of the little cavalcade rode the lieutenant and I, while behind, in single file, came the five troopers, sitting loosely in their saddles with the long stirrup of the United States cavalry seat, forage-hats set well over the eyes, and carbines, slickers, canteens, saddle-pockets, and lariats rattling at their sides. Strung out behind were the four pack-mules, now trotting demurely along, now stopping to feed, and occasionally making a solemn and evidently well-considered attempt to get out of line and regain the post which we were leaving behind. The packers brought up the rear, swinging their "blinds" and shout-

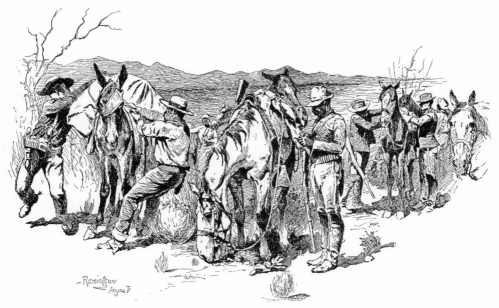

A HALT TO TIGHTEN THE PACKS.

Down in front of the post-trader's was gathered the scouting party. A tall sergeant, grown old in the service, scarred on battlefields, hardened by long marches,—in short, a product of the camp,—stood by his horse's head. Four enlisted men, picturesquely clad in the cavalry soldier's field costume, and two packers, mounted on diminutive bronco mules, were in charge of four pack-mules loaded with *apperajos* and packs. This was our party. Presently the lieutenant issued from the headquarters' office and joined us. An orderly led up his horse. "Mount," said the lieutenant; and swinging himself into his saddle he started off up the road. Out past the groups of adobe houses which constitute a frontier military village or post we rode, stopping to water our horses at the little creek, now nearly dry,— the last water for many miles on our trail,— and presently emerged upon the great desert.

ing at the lagging mules in a manner which evinced a close acquaintance with the character and peculiarities of each beast.

The sun was getting higher in the heavens and began to assert its full strength. The yellow dust rose about our horses' hoofs and settled again over the dry grass and mesquite bush. Stretching away on our right was the purple line of the Sierra Bonitas, growing bluer and bluer until lost in the hot scintillating atmosphere of the desert horizon. Overhead stretched the deep blue of the cloudless sky. Presently we halted and dismounted to tighten the packs, which work loose after the first hour. One by one the packers caught the little mules, threw a blind over their eyes, and "Now, Whitey! Ready! eve-e-e-e—gimme that loop," came from the men as they heaved and tossed the circling ropes in the mystic movements of the diamond hitch. "All fast, Lieutenant," cries a packer, and mounting we move on up the long

[1] Soldier detailed as officer's servant.

slope of the mesa towards the Sierras. We enter a break in the foothills, and the grade becomes steeper and steeper, until at last it rises at an astonishing angle.

The lieutenant shouts the command to dismount, and we obey. The bridle-reins are tossed over the horses' heads, the carbines thrown butt upwards over the backs of the troopers, a long drink is taken from the canteens, and I observe that each man pulls a plug of tobacco about a foot long from one of the capacious legs of his troop-boots and wrenches off a chew. This greatly amused me, and as I laughed I pondered over the fertility of the soldier mind; and while I do not think that the original official military board which evolved the United States troop-boot had this idea in mind, the adaptation of means to an end reflects great credit on the intelligence of some one.

Up the ascent of the mountain we toiled, now winding among trees and brush, scrambling up precipitous slopes, picking a way across a field of shattered rock, or steadying our horses over the smooth surface of some bowlder, till it seemed to my uninitiated mind that cavalry was not equal to the emergencies of such a country. In the light of subsequent experiences, however, I feel confident that any cavalry officer who has ever chased Apaches would not hesitate a moment to lead a command up the Bunker Hill Monument. The slopes of the Sierra Bonitas are very steep, and as the air became more rarified as we toiled upward I found that I was panting for breath. My horse—a veteran mountaineer—grunted in his efforts and drew his breath in a long and labored blowing; consequently I felt as though I was not doing anything unusual in puffing and blowing myself. The resolutions of the previous night needed considerable nursing, and though they were kept alive, at times I reviled myself for being such a fool as to do this sort of thing under the delusion that it was an enjoyable experience. On the trail ahead I

TROOPER IN TOW.

saw the lieutenant throw himself on the ground. I followed his example, for I was nearly "done for." I never had felt a rock that was as soft as the one I sat on. It was literally downy. The old troop-horse heaved a great sigh, and dropping his head went fast asleep, as every good soldier should do when he finds the opportunity. The lieutenant and I discussed the climb, and my voice was rather loud in pronouncing it "beastly." My companion gave me no comfort, for he was "a soldier, and unapt to weep," though I thought he might have used his official prerogative to grumble. The negro troopers sat about, their black skins shining with perspiration, and took no interest in the matter in hand. They occupied such time in joking and in merriment as seemed fitted for growling. They may be tired and they may be hungry, but they do not see fit to augment their misery by finding fault with everybody and everything. In this particular they are charming men with whom to serve. Officers have often confessed to me that when they are on long and monotonous field service and are troubled with a depression of spirits, they have only to go about the campfires of the negro soldier in order to be amused and cheered by the clever absurdities of the men. Personal relations can be much closer between white officers and colored soldiers than in the white regiments without breaking the barriers which are necessary to army discipline. The men look up to a good officer, rely on him in trouble, and even seek him for advice in their small personal affairs. In barracks no soldier is allowed by his fellows to "cuss out" a just and respected superior. As to their bravery, I am often asked, "Will they fight?" That is easily answered. They have fought many, many times. The old sergeant sitting near me, as calm of feature as a bronze statue, once deliberately walked over a Cheyenne rifle-pit and killed his man. One little fellow near him once took charge of a lot of stampeded cavalry-horses when Apache bullets were flying loose and no one knew from what point to expect them next. These little episodes prove the sometimes doubted self-reliance of the negro.

After a most frugal lunch we resumed our journey towards the clouds. Climbing many weary hours, we at last stood on the sharp ridge of the Sierra. Behind us we could see the great yellow plain of the Sulphur Spring Valley, and in front, stretching away, was that of the Gila, looking like the bed of a sea with the water gone. Here the lieutenant took observations and busied himself in making an itinerary of the trail. In obedience to an order of the department commander, General Miles, scouting parties like ours are constantly being sent out from the chain of forts

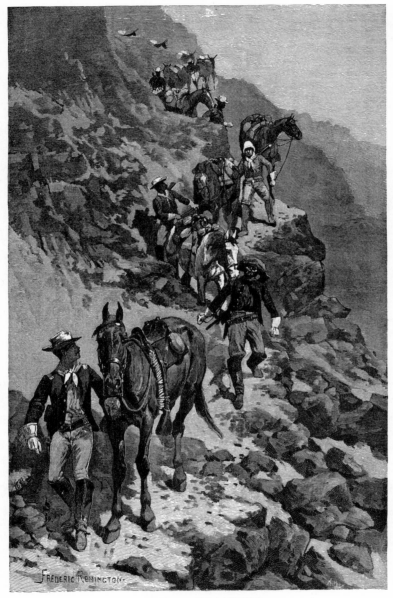

MARCHING ON THE MOUNTAINS.

which surround the great San Carlos reservation. The purpose is to make provision against Apache outbreaks, which are momentarily expected, by familiarizing officers and soldiers with the vast solitude of mountain and desert. New trails for the movement of cavalry columns across the mountains are threaded out, waterholes of which the soldiers have no previous knowledge are discovered, and an Apache band is at all times liable to meet a cavalry command in out-of-the-way places. A salutary effect on the savage mind is then produced.

Here we had a needed rest, and then began the descent on the other side. This was a new experience. The prospect of being suddenly overwhelmed by an avalanche of horseflesh as the result of some unlucky stumble makes the recruit constantly apprehensive. But the trained horses are sure of foot, understand the business, and seldom stumble except when treacherous ground gives way. On the crest the prospect was very pleasant, as the pines there obscured the hot sun; but we suddenly left them for the scrub mesquite which bars your passage and reaches forth for you with its thorns when you attempt to go around.

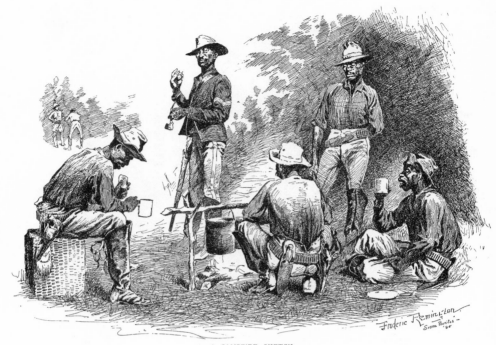

A CAMPFIRE SKETCH.

We wound downward among the masses of rock for some time, when we suddenly found ourselves on a shelf of rock. We sought to avoid it by going up and around, but after a tiresome march we were still confronted by a drop of about a hundred feet. I gave up in despair; but the lieutenant, after gazing at the unknown depths which were masked at the bottom by a thick growth of brush, said, "This is a good place to go down." I agreed that it was if you once got started; but personally I did not care to take the tumble.

Taking his horse by the bits, the young officer began the descent. The slope was at an angle of at least sixty degrees, and was covered with loose dirt and bowlders, with the mask of brush at the bottom concealing awful possibilities of what might be beneath. The horse hesitated a moment, then cautiously put his head down and his leg forward and started. The loose earth crumbled, a great stone was precipitated to the bottom with a crash, the horse slid and floundered along. Had the situation not been so serious it would have been funny, because the angle of the incline was so great that the horse actually sat on his haunches like a dog. "Come on!" shouted the redoubtable man of war; and as I was next on the ledge and could not go back or let any one pass me, I remembered my resolutions. They prevailed against my better judgment, and I started. My old horse took it unconcernedly, and we came down all right, bringing our share of dirt

and stones and plunging through the wall of brush at the bottom to find our friend safe on the lower side. The men came along without so much as a look of interest in the proceeding, and then I watched the mules. I had confidence in the reasoning powers of a pack-mule, and thought that he might show some trepidation when he calculated the chances; but not so. Down came the mules, without turning an ear, and then followed the packers, who, to my astonishment, rode down. I watched them do it, and know not whether I was more lost in admiration or eager in the hope that they would meet with enough difficulty to verify my predictions.

We then continued our journey down the mountains through a box-cañon. Suffice it to say that, as it is a cavalry axiom that a horse can go wherever a man can if the man will not use his hands, we made a safe transit.

Our camp was pitched by a little mountain stream near a grassy hillside. The saddles, packs, and *apperajos* were laid on the ground and the horses and mules herded on the side of the hill by a trooper, who sat perched on a rock above them, carbine in hand. I was thoroughly tired and hungry, and did my share in creating the famine which it was clearly seen would reign in that camp ere long. We sat about the fire and talked. The genial glow seems to possess an occult quality: it warms the self-confidence of a man; it lulls his moral nature; and the stories which circulate about a

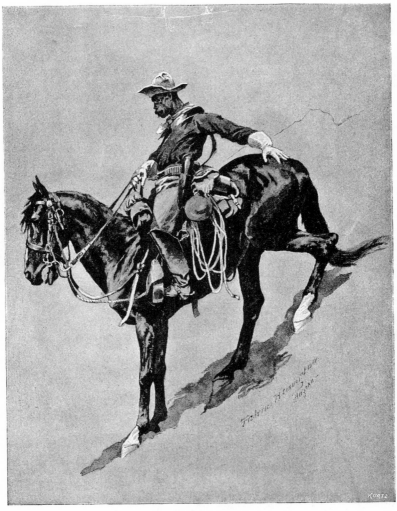

A STUDY OF ACTION.

campfire are always more interesting than authentic. One old packer possessed a wild imagination, backed by a fund of experiences gathered in a life spent in knocking about everywhere between the Yukon River and the City of Mexico, and he rehearsed tales which would have staggered the Baron. The men got out a pack of Mexican cards and gambled at a game called " Coon-can " for a few nickels and dimes and that other soldier currency— tobacco. Quaint expressions came from the card party. " Now I 'se a-goin' to scare de life outen you when I show down dis han'," said one man after a deal. The player addressed looked at his hand carefully and quietly rejoined, " You might scare *me*, pard, but you can't scare de fixin's I 'se got yere." The utmost good-nature seemed to prevail. They discussed the little things which make their lives. One man suggested that " De big jack

mule, he behavin' hisself pretty well dis trip ; he hain't done kick nobody yet." Pipes were filled, smoked, and returned to that cavalryman's grip-sack, the boot-leg, and the game progressed until the fire no longer gave sufficient light. Soldiers have no tents in that country, and we rolled ourselves in our blankets and, gazing up, saw the weird figure of the sentinel against the last red gleam of the sunset, and beyond that the great dome of the sky, set with stars. Then we fell asleep.

When I awoke the next morning the hill across the cañon wall was flooded with a golden light, while the gray tints of our camp were steadily warming up. The soldiers had the two black camp-pails over the fire and were grooming the horses. Every one was good-natured, as befits the beginning of the day. The tall sergeant was meditatively combing his hair with a currycomb ; such delight-

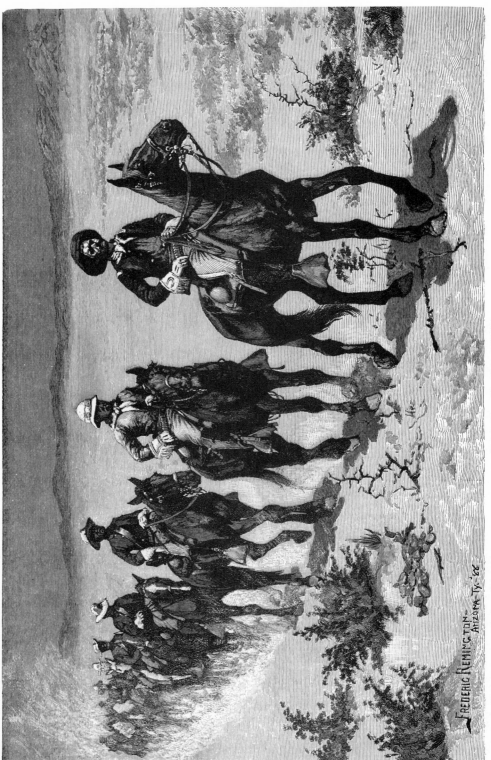

MARCHING IN THE DESERT.

ful little unconventionalities are constantly observed about the camp. The coffee steamed up in our nostrils, and after a rub in the brook I pulled myself together and declared to my comrade that I felt as good as new. This was a palpable falsehood, as my labored movements revealed to the hard-sided cavalryman the sad evidence of the effeminacy of the studio. But our respite was brief, for almost before I knew it I was again on my horse, following down the cañon after the black charger bestrided by the junior lieutenant of K troop. Over piles of rocks fit only for the touch and go of a goat, through the thick mesquite which threatened to wipe our hats off or to swish us from the saddle, with the air warming up and growing denser, we rode along. A great stretch of sandy desert could be seen, and I foresaw hot work.

In about an hour we were clear of the descent and could ride along together, so that conversation made the way more interesting. We dismounted to go down a steep drop from the high mesa into the valley of the Gila, and then began a day warmer even than imagination had anticipated. The awful glare of the sun on the desert, the clouds of white alkaline dust which drifted up until lost above, seemingly too fine to settle again, and the great heat cooking the ambition out of us, made the conversation lag and finally drop altogether. The water in my canteen was hot and tasteless, and the barrel of my carbine, which I touched with my ungloved hand, was so heated that I quickly withdrew it. Across the hot-air waves which made the horizon rise and fall like the bosom of the ocean we could see a whirlwind or sand-storm winding up in a tall spiral until it was lost in the deep blue of the sky above. Lizards started here and there; a snake hissed a moment beside the trail, then sought the cover of a dry bush; the horses moved along with downcast heads and drooping ears. The men wore a solemn look as they rode along, and now and then one would nod as though giving over to sleep. The pack-mules no longer sought fresh feed along the way, but attended strictly to business. A short halt was made, and I alighted. Upon remounting I threw myself violently from the saddle, and upon examination found that I had brushed up against a cactus and gotten my corduroys filled with thorns. The soldiers were overcome with great glee at this episode, but they volunteered to help me pick them from my dress. Thus we marched all day, and with canteens empty we "pulled into" Fort Thomas that afternoon. I will add that forageless cavalry commands with pack-animals do not halt until a full day's march is completed, as the mules cannot be kept too long under their burdens.

At the fort we enjoyed that hospitality which is a kind of freemasonry among army officers. The colonel made a delicious concoction of I know not what, and provided a hammock in a cool place while we drank it. Lieutenant F—— got cigars that were past praise, and another officer had provided a bath. Captain B—— turned himself out of doors to give us quarters, which graciousness we accepted while our consciences pricked. But for all that Fort Thomas is an awful spot, hotter than any other place on the crust of the earth. The siroccos continually chase each other over the desert, the convalescent wait upon the sick, and the thermometer persistently reposes at the figures 125° F. Soldiers are kept in the Gila Valley posts for only six months at a time before they are relieved, and they count the days.

On the following morning at an early hour we waved adieus to our kind friends and took our way down the valley. I feel enough interested in the discomforts of that march to tell about it, but I find that there are not resources in any vocabulary. If the impression is abroad that a cavalry soldier's life in the South-west has any of the lawn-party element in it, I think the impression could be effaced by doing a march like that. The great clouds of dust choke you and settle over horse, soldier, and accouterments until all local color is lost and black man and white man wear a common hue. The "chug, chug, chug" of your tired horse as he marches along becomes infinitely tiresome, and cavalry soldiers never ease themselves in the saddle. That is an army axiom. I do not know what would happen to a man who "hitched" in his saddle, but it is carefully instilled into their minds that they must " ride the horse " at all times and not lounge on his back. No pains are spared to prolong the usefulness of an army horse, and every old soldier knows that his good care will tell when the long forced march comes some day, and when to be put afoot by a poor mount means great danger in Indian warfare. The soldier will steal for his horse, will share his camp bread, and will moisten the horse's nostrils and lips with the precious water in the canteen. In garrison the troop-horses lead a life of ease and plenty; but it is varied at times by a pursuit of hostiles, when they are forced over the hot sands and up over the perilous mountains all day long, only to see the sun go down with the rider still spurring them on amid the quiet of the long night.

Through a little opening in the trees we see a camp and stop in front of it. A few mesquite trees, two tents, and some sheds made of boughs beside an *acequia* make up the background. By the cooking-fire lounge two or three rough frontiersmen, veritable pirates in appearance, with rough flannel shirts, slouch hats, brown canvas overalls, and an unkempt

THE SIGN LANGUAGE.

air; but suddenly, to my intense astonishment, they rise, stand in their tracks as immovable as graven images, and salute the lieutenant in the most approved manner of Upton. Shades of that sacred book the "Army Regulations," then these men were soldiers! It was a camp of instruction for Indians and a post of observation. They were nice fellows, and did everything in their power to entertain the cavalry. We were given a tent, and one man cooked the army rations in such strange shapes and mysterious ways that we marveled as we ate. After dinner we lay on our blankets watching the groups of San Carlos Apaches who came to look at us. Some of them knew the lieutenant, with whom they had served and whom they now addressed as "Young Chief." They would point him out to others with great zest, and babble in their own language. Great excitement prevailed when it was discovered that I was using a sketch-book, and I was forced to disclose the half-finished visage of one villainous face to their gaze. It was straightway torn up, and I was requested, with many scowls and grunts, to discontinue that pastime, for Apaches more than any other Indians dislike to have portraits made. That night the "hi-ya-ya-hi-ya-hi-yo-o-o-o-o" and the beating of the tom-toms came from all

parts of the hills, and we sank to sleep with this grewsome lullaby.

The following day, as we rode, we were never out of sight of the brush huts of the Indians. We observed the simple domestic processes of their lives. One naked savage got up suddenly from behind a mesquite bush, which so startled the horses that quicker than thought every animal made a violent plunge to one side. No one of the trained riders seemed to mind this unlooked-for movement in the least beyond displaying a gleam of grinning ivories. I am inclined to think that it would have let daylight upon some of the "English hunting-seats" one sees in Central Park.

All along the Gila Valley can be seen the courses of stone which were the foundations of the houses of a dense population long since passed away. The lines of old irrigating ditches were easily traced, and one is forced to wonder at the changes in Nature, for at the present time there is not water sufficient to irrigate land necessary for the support of as large a population as probably existed at some remote period. We "raised" some foothills, and could see in the far distance the great flat plain, the buildings of the San Carlos agency, and the white canvas of the cantonment. At the ford of the Gila we saw a company of "doughboys" wade through the stream as our own troop-horses splashed across. Nearer and nearer shone the white lines of tents until we drew rein in the square where officers crowded around to greet us. The jolly post-commander, the senior captain of the 10th, insisted upon my accepting the hospitalities of his "large hotel," as he called his field tent, on the ground that I too was a New Yorker. Right glad have I been ever since that I accepted his courtesy, for he entertained me in the true frontier style.

Being now out of the range of country known to our command, a lieutenant in the same regiment was detailed to accompany us beyond. This gentleman was a character. The best part of his life had been spent in this rough country, and he had so long associated with Apache scouts that his habits while on a trail were exactly those of an Indian. He had acquired their methods and also that instinct of locality so peculiar to red men. I jocosely insisted that Lieutenant Jim only needed breech-clout and long hair in order to draw rations at the agency. In the morning, as we started under his guidance, he was a spectacle. He wore shoes and a white shirt, and carried

absolutely nothing in the shape of canteens and other "plunder" which usually constitute a cavalryman's kit. He was mounted on a little runt of a pony so thin and woe-begone as to be remarkable among his kind. It was insufferably hot as we followed our queer guide up a dry cañon, which cut off the breeze from all sides and was a veritable human fry-

ing one; nevertheless, by the exercise of self-denial, which is at times heroic, he manages to pull through. They say that he sometimes fills an old meat-tin with water in anticipation of a long march, and stories which try credulity are told of the amount of water he has drunk at times.

Yuma Apaches, miserable wretches, come

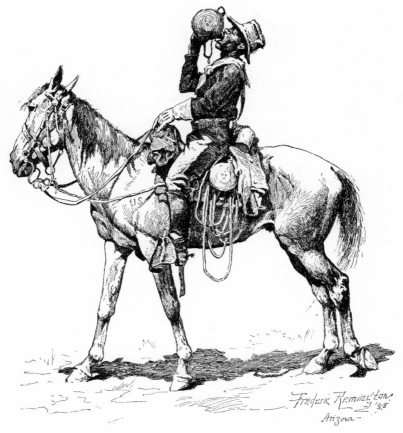

A PULL AT THE CANTEEN.

ing-pan. I marched next behind our leader, and all day long the patter, patter of that Indian pony, bearing his tireless rider, made an aggravating display of insensibility to fatigue, heat, dust, and climbing. On we marched over the rolling hills, dry, parched, desolate, covered with cactus and loose stones. It was Nature in one of her cruel moods, and the great silence over all the land displayed her mastery over man. When we reached water and camp that night our ascetic leader had his first drink. It was a long one and a strong one, but at last he arose from the pool and with a smile remarked that his "canteens were full." Officers in the regiment say that no one will give Lieutenant Jim a drink from his canteen, but this does not change his habit of not carry-

into camp, shake hands gravely with every one, and then in their Indian way begin the inevitable inquiries as to how the coffee and flour are holding out. The campfire darts and crackles, the soldiers gather around it, eat, joke, and bring out the greasy pack of cards. The officers gossip of army affairs, while I lie on my blankets, smoking and trying to establish relations with a very small and very dirty little Yuma Apache, who sits near me and gazes with sparkling eyes at the strange object which I undoubtedly seem to him. That "patroness of rogues," the full moon, rises slowly over the great hill while I look into her honest face and lose myself in reflections. It seems but an instant before a glare of sun strikes my eyes and I am awake for another day. I am mentally quar-

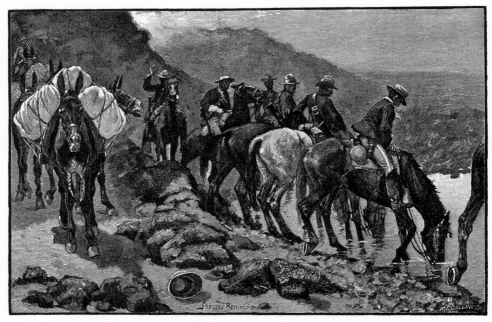

A POOL IN THE DESERT.

reling with that insane desire to march which I know possesses Lieutenant Jim; but it is useless to expostulate, and before many hours the little pony constantly moving along ahead of me becomes a part of my life. There he goes. I can see him now—always moving briskly along, pattering over the level, trotting up the dry bed of a stream, disappearing into the dense chapparal thicket that covers a steep hillside, jumping rocks, and doing everything but "halt."

We are now in the high hills, and the air is cooler. The chapparal is thicker, the ground is broken into a succession of ridges, and the volcanic bowlders pile up in formidable shapes. My girth loosens and I dismount to fix it, remembering that old saddle-gall. The command moves on and is lost to sight in a deep ravine. Presently I resume my journey, and in the meshwork of ravines I find that I no longer see the trail of the column. I retrace and climb and slide down hill, forcing my way through chapparal, and after a long time I see the pack-mules go out of sight far away on a mountain slope. The blue peaks of the Pinals tower away on my left, and I begin to indulge in mean thoughts concerning the indomitable spirit of Lieutenant Jim, for I know he will take us clear over the top of that pale blue line of far-distant mountains. I presume I have it in my power to place myself in a more heroic light, but this kind of candor is good for the soul.

In course of time I came up with the command, which had stopped at a ledge so steep that it had daunted even these mountaineers. It

was only a hundred-foot drop, and they presently found a place to go down, where, as one soldier suggested, "there is n't footing for a lizard." On, on we go, when suddenly with a great crash some sandy ground gives way, and a collection of hoofs, troop-boots, ropes, canteens, and flying stirrups goes rolling over in a cloud of dust and finds a lodgment in the bottom of a dry watercourse. The dust settles and discloses a soldier and his horse. They rise to their feet and appear astonished, but as the soldier mounts and follows on we know he is unhurt. Now a coyote, surprised by our cavalcade and unable to get up the ledge, runs along the opposite side of the cañon wall. "Pop, pop, pop, pop" go the six-shooters, and then follow explanations by each marksman of the particular thing which made him miss.

That night we were forced to make a "dry camp"; that is, one where no water is to be found. There is such an amount of misery locked up in the thought of a dry camp that I refuse to dwell upon it. We were glad enough to get upon the trail in the morning, and in time found a nice running mountain-brook. The command wallowed in it. We drank as much as we could hold and then sat down. We arose and drank some more, and yet we drank again, and still once more, until we were literally water-logged. Lieutenant Jim became uneasy, so we took up our march. We were always resuming the march when all nature called aloud for rest. We climbed straight up impossible places. The air grew chill, and in a gorge a cold wind blew briskly down to supply the hot air rising from sands

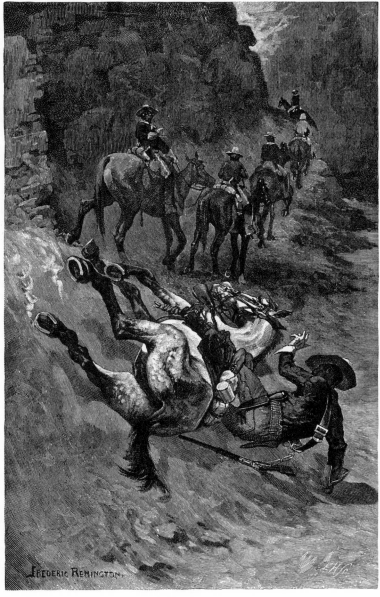

A TUMBLE FROM THE TRAIL.

of the mesa far below. That night we made a camp, and the only place where I could make my bed was on a great flat rock. We were now among the pines, which towered above us. The horses were constantly losing one another in the timber in their search for grass, in consequence of which they whinnied, while the mules brayed, and made the mountain hideous with sound.

By another long climb we reached the extreme peaks of the Pinal range, and there before us was spread a view which was grand enough to compensate us for the labor. Be-

ginning in " gray reds," range after range of mountains, overlapping each other, grow purple and finally lose themselves in pale blues. We sat on a ledge and gazed. The soldiers were interested, though their remarks about the scenery somehow did not seem to express an appreciation of the grandeur of the view which impressed itself strongly upon us. Finally one fellow, less æsthetic than his mates, broke the spell by a request for chewing-tobacco, so we left off dreaming and started on.

That day Lieutenant Jim lost his bearings, and called upon that instinct which he had

acquired in his life among the Indians. He "cut the signs" of old Indian trails and felt the course to be in a certain direction—which was undoubtedly correct, but it took us over the highest points of the Mescal range. My shoes were beginning to give out, and the troop-boots of several soldiers threatened to disintegrate. One soldier, more ingenious than the rest, took out some horse-shoe nails and cleverly mended his boot-gear. At times we wound around great slopes where a loose stone or the giving way of bad ground would have precipitated horse and rider a thousand feet below. Only the courage of the horses brings one safely through. The mules suffered badly, and our weary horses punched very hard with their foreparts as they went down hill. We made the descent of the Mescals through a long cañon where the sun gets one in chancery, as it were. At last we reached the Gila, and nearly drowned a pack-mule and two troopers in a quicksand. We began to pass Indian huts, and saw them gathering wheat in the river bottoms, while they paused to gaze at us and doubtless wondered for what purpose the buffalo-soldiers were abroad in the land. The cantonment appeared, and I was duly gratified when we reached it. I hobbled up to the "Grand Hotel" of my host the captain, who laughed heartily at my floundering movements and observed my nose and cheeks, from which the sun had peeled the skin, with evident relish at the thought of how I had been used by his lieutenant. At his suggestion I was made an honorary member of the cavalry, and duly admonished "not to trifle again with the 10th Nubian Horse if I expected any mercy."

In due time the march continued without particular incident, and at last the scout "pulled in" to the home post, and I again sat in my easy-chair behind the lattice-work, firm in the conviction that soldiers, like other men, find more hard work than glory in their calling.

17.
Horses
of the
Plains

HORSES OF THE PLAINS.

WRITTEN AND ILLUSTRATED BY FREDERIC REMINGTON.

TO men of all ages the horse of northern Africa has been the standard of worth and beauty and speed. It was bred for the purpose of war and reared under the most favorable climatic conditions, and its descendants have infused their blood into all the strains which in our day are regarded as valuable. The Moors stocked Spain with this horse, and the so-called Spanish horse is more Moorish than otherwise. It is fair to presume that the lightly armored cavaliers of the sixteenth century, or during the Spanish conquests in Amer- ica, rode this animal, which had been so long domesticated in Spain, in preference to the inferior northern horse. To this day the pony of western America shows many points of the Barbary horse to the exclusion of all other breeding. His head has the same facial line; and that is a prime point in deciding ancestry in horses. Observe, for instance, the great dissimilarity in profile displayed by old plates of the Godolphin Arabian and the Darley Arabian, two famous sires, kings of their races, the one a Barb and the other an Arabian.

In contemplating the development of the horse, or rather his gradual adjustment to his

191

THE FIRST OF THE RACE.

environment, no period more commends itself than that of the time from the Spanish invasion of Mexico to the present day. The lapse of nearly four centuries and the great variety of dissimilar conditions have so changed the American "bronco" from his Spanish ancestor that he now enjoys a distinctive individuality. This individuality is also subdivided; and as all types come from a common ancestry, the reasons for this varied development are sought with interest, though I fear not always with accuracy. Cortes left Cuba on his famous expedition with "sixteen horses," which were procured from the plantations of that island at great expense.

As a matter of course these horses did not contribute to the stocking of the conquered country, for they all laid down their lives to make another page of military history in the annals of the Barbary horse. Subsequent importations must have replenished the race. Possibly the dangers and expense attendant on importation did not bring a very high grade of horses from Spain, though I am quite sure that no sane don would have preferred a coarse-jointed great Flemish weight-carrier for use on the hot sands of Mexico to a light and supple Barb, which would recognize in the sand and heat of his new-world home an exact counterpart of his African hills. As the Spaniards worked north in their explorations, they lost horses by the adverse fortunes of war and by their straying and being captured by Indians. At a very early date the wild horse was encountered on the plains of Mexico, but a long time elapsed before the

that this assertion has its foundation in the vanity of their cavalier souls, for the Cheyenne legend runs very smoothly, and has paleface corroboration back to a period when we know that they could not have had horses.

Only on the plains has the horse reached his most typical American development. The range afforded good grass and they bred indiscriminately, both in the wild state and in the hands of the Indians, who never used any discretion in the matter of coupling the best specimens, as did the Indians of the mountains, because of the constant danger of their being lost or stolen, thus making it unprofitable. Wild stallions continually herded off the droves of the Indians of the southern plains, thus thwarting any endeavor to improve the stock by breeding. It is often a question whether the "pinto,"[1] or painted pony of Texas, is the result of a pinto ancestry, or of a general coupling of horses of all colors. The latter, I think, is the case, for the Barb

AN OLD-TIME MOUNTAIN MAN WITH HIS PONIES.

horse was found in the north. La Salle found the Comanches with Spanish goods and also horses in their possession, but on his journey to Canada it was with great difficulty that he procured horses from the Indians farther north. In 1680, or contemporaneously with La Salle's experience in the south, Father Hennepin lived with the Sioux and marched and hunted the buffalo on foot. At a much later day a traveler heard the Comanches boast that they "remembered when the Arapahoes to the north used dogs as beasts of burden." That horses were lost by the Spaniards and ran in a wild state over the high, dry plains of Mexico and Texas at an early day is certain; and as the conditions of life were favorable, they must have increased rapidly. How many years elapsed before the northern Indians procured these animals, with which they are so thoroughly identified, is not easily ascertainable. Cheyenne Indians who were well versed in that tribal legend which is rehearsed by the lodge fire in the long winter nights have told me gravely that they always have had horses. I suspect

was a one-color horse, and the modern horse-breeder in his science finds no difficulty in producing that color which he deems the best. The Comanches, Wichitas, and Kiowas hold that stallion in high esteem which is most bedecked and flared by blotches of white hair on the normal color of his hide. The so-called Spanish horse of northern Mexico is less apt to show this tendency towards a parti-colored coat, and his size, bone, and general development stamp him as the best among his kind, all of which qualities are the result of some consideration on the part of man with a view to improve the stock. The Mexicans on their Indian-infested frontier kept their horses close herded; for they lived where they had located their ranches, desired good horses, and took pains to produce them. The sires were well selected, and the growing animals were not subjected to the fearful setbacks attendant on passing a winter on the cold plains, which is one of the reasons why all wild horses are stunted in size. Therefore we

[1] Parti-colored "calico," as sometimes called.

must look to the Spanish horse of northern Mexico for the nearest type to the progenitors of the American bronco. The good representatives of this division are about fourteen and a half hands in stature; of large bone, with a slight tendency to roughness; generally bay in color; flat-ribbed, and of great muscular development; and, like all the rest, have the Barbary head, with the slightly oval face and fine muzzle.

Nearly identical with this beast is the mustang of the Pacific coast—a misnomer, by the bye, which for a generation has been universally applied by fanciful people to any horse bearing a brand. This particular race of horses, reared under slightly less advantageous circumstances than the Spanish horse of old Mexico, was famous in early days; but they are now so mixed with American stock as to lose the identity which in the days of the Argonauts was their pride.

The most inexperienced horseman will not have to walk around the animal twice in order to tell a Texas pony; that is, one which is full bred, with no admixture. He has fine deer-like legs, a very long body, with a pronounced roach just forward of the coupling, and possibly a "glass eye" and a pinto hide. Any old cowboy will point him out as the only creature suitable for his purposes. Hard to break, because he has any amount of latent devil in his disposition, he does not break his legs or fall over backwards in the "pitching" process as does the "cayuse" of the North-west. I think he is small and shriveled up like a Mexican because of his dry, hot habitat, over which he has to walk many miles to get his dinner. But, in compensation, he can cover leagues of his native plains, bearing a seemingly disproportionately large man, with an ease both to himself and to his rider which is little short

of miraculous. I tried on one occasion to regenerate a fine specimen of the southern plains sort, and to make a pretty little cob of the wild, scared bundle of nerves and bones which I had picked out of a herd. I roached his mane and docked his tail, and put him in a warm stall with half a foot of straw underneath. I meted out a ration of corn and hay which was enough for a twelve-hundred work-horse in the neighboring stall. I had him combed and brushed and wiped by a good-natured man, who regarded the proceeding with as much awe as did the pony. After the animal found out that the corn was meant to be eaten, he always ate it; but after many days he was led out, and, to my utter despair, he stood there the same shy, perverse brute which he always had been. His paunch was distended to frightful proportions, but his cat hams, ewe neck, and thin little shoulders were as dry and hard as ever. Mentally he never seemed to make any discrimination between his newly found masters and the big timber wolves that used to surround him and keep him standing all night in a bunch of fellows. On the whole it was laughable, for in his perversity he resisted the regenerating process much as

A TEXAN PONY.

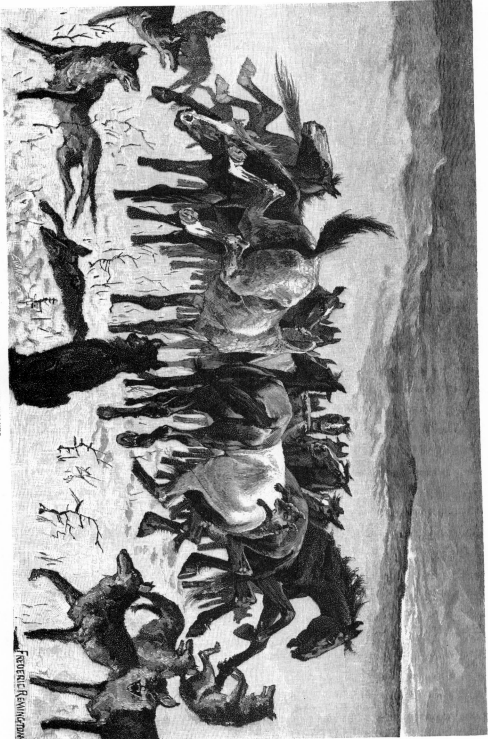

BRONCOS AND TIMBER WOLVES.

FREDERIC REMINGTON

any other wild beast might. For all that, these animals are " all sorts of a horse " in their own particular field of usefulness, though they lack the power of the Spanish horse. Once in Arizona I rode one of the latter animals, belonging to Chief Ascension Rios of the Papagoes, at a very rapid gallop for twenty-four miles, during the middle of the day, through the des-

of the best specimens of the horse and rider which I have ever had occasion to admire were Mexican *vaqueros*, and I have often thought the horses were more worthy than the men.

The golden age of the bronco was ended some twenty years ago when the great tidal wave of Saxonism reached his grassy plains. He was rounded up and brought under the

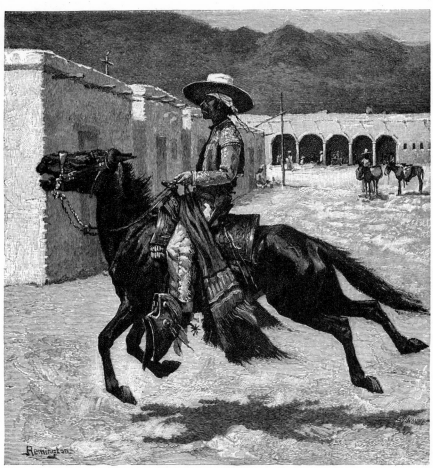

SPANISH HORSE OF NORTHERN MEXICO.

ert sand. The thermometer stood as high as you please in the shade, and the hot sun on the white sand made the heat something frightful; and personally I am not noted for any of the physical characteristics which distinguish a fairy. At the end of the journey I was confirmed in the suspicion that he was a most magnificent piece of horse-flesh for a ride like that, and I never expect to see another horse which can make the trip and take it so lightly to heart. He stood there like a rock, and was as good as at starting, having sweat only a normal amount. The best test of a horse is, not what he can do, but how easily he can do it. Some

yoke by the thousand, and his glories departed. Here and there a small band fled before man, but their freedom was hopeless. The act of subjugation was more implied than real, and to this day, as the cowboy goes out and drives up a herd of broncos to the corral, there is little difference between the wild horse of old and his enslaved progeny. Of course the wild stallion is always eliminated, and he alone was responsible for the awe which a wild horse inspired. As I have before remarked, the home of the Simon-pure wild horse is on the southern plains, and when he appears elsewhere he has been transported there by man and found

his freedom later on. I have found food for reflection in tracing the causes of the varied development of these broncos under different conditions. A great many of the speculations in which I indulge may be faulty, as they deal with a subject not widely investigated by any more learned savants than one is apt to find about the fires of the cow-camps in the far West. One must not forget, also, that the difficulty increases as years pass, because the horses are driven about from one section to another, and thus crossed with the stock of the country until in a very few years they became a ho-

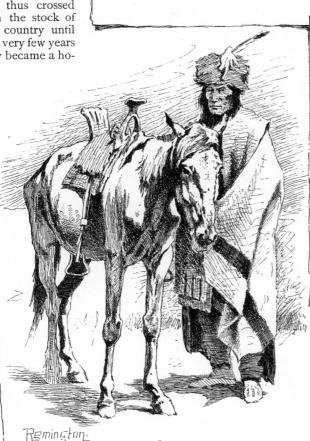

THE INDIAN PONY.

glorify his reign in America there will be none more worthy than his horse. This proposition I have heard combated, however, by a person who had just been "bucked" violently from the back of a descendant of the Barbs. He insisted that the Spaniards had left little to glorify their reign in America, least of all their miserable scrubby ponies. Nevertheless, the Spaniard's horses may be found to-day in countless thousands, from the city of the Montezumas to the regions of perpetual snow; they are grafted into our equine wealth and make an important impression on the horse of the country.

There is a horse in the Indian Territory, Arkansas, and Missouri, called the Cherokee pony, which is a peculiar animal. Of low stature, he is generally piebald, with a great profusion of mane and tail. He is close set, with head and

mogeneous type. The solutions to these problems must always be personal views, and in no sense final. One thing is certain: of all the monuments which the Spaniard has left to

legs not at all of the bronco type, and I know that his derivation is from the East, though some insist on classing him with our Western ponies; but he is a handsome little beast,

easily adapts himself to surroundings, and is in much favor in the Eastern markets as a saddle pony for boys and for ladies' carts.

The most favorable place to study the pony is in an Indian camp, as the Indians rarely defeat the ends of nature in the matter of natural selection; and further, the ponies are allowed to eat the very greenest grass they can find in the summer time, and to chew on a cottonwood saw-log during the winter, with perfect indifference on the part of their owners. The pony is thus a reflex of nature, and, coupled with his surroundings, is of quite as much interest as the stretch of prairie grass, the white lodges, and the blanketed forms. The

pist should he look along the humpy ribs and withered quarters. But alack! when the young grass does shoot, the pony scours the trash which composes his winter diet, sheds his matted hair, and shines forth another horse. In a month " Richard 's himself again," ready to fly over the grassy sward with his savage master or to drag the *travaux* and pack the buxom squaw. Yet do not think that at this time the Indian pony is the bounding steed of romance; do not be deluded into expecting the arched neck, the graceful lines, and the magnificent limbs of the English hunter, for, alas! they are not here. They have existed only on paper. He may be all that the wildest en-

PONIES PAWING IN THE SNOW.

savage red man in his great contest with nature has learned, not to combat nature, but to observe her moods and to prepare a simple means of escape. He puts up no fodder for the winter, but relies on the bark of the cottonwood. Often he is driven to dire extremity to bring his stock through the winter. I have been told that in the Canadian North-west the Blackfeet have bought grain for their ponies during a bad spell of weather, which act implies marvelous self-denial, as the cost of a bushel of oats would bring financial ruin on any of the tribe. Before the early grass starts in the spring the emaciated appearance of one of these little ponies in the far North-west will sorely try the feelings of an equine philanthro-

thusiast may claim in point of hardihood and power, as indeed he is, but he is not beautiful. His head and neck join like the two parts of a hammer, his legs are as fine as a deer's, though not with the flat knee-cap and broad cannon-bone of the English ideal. His barrel is a veritable tun, made so by the bushels of grass which he consumes in order to satisfy nature. His quarters are apt to run suddenly back from the hips, and the rear view is decidedly mulish about the hocks. The mane and the tail are apt to be light, and I find that the currycomb of the groom has a good deal to do in deciding on which side of the horse's neck the mane shall fall; for on an Indian pony it is apt to drop on the right and the left, or stand up in the

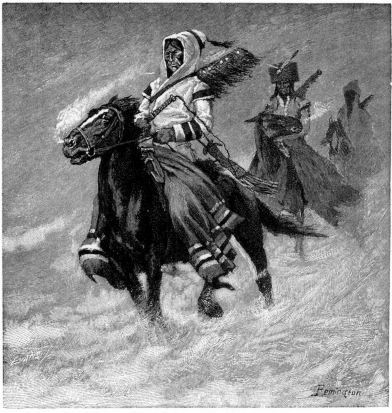

HORSE OF THE CANADIAN NORTH-WEST.

middle in perfect indecision. The Indian never devotes any stable-work to his mount, although at times the pony is bedecked in savage splendor. Once I saw the equipment of a Blackfoot war pony, composed of a mask and bonnet gorgeous with red flannel, brass-headed tacks, silver plates, and feathers, which was art in its way.

As we go very far into the Canadian Northwest we find that the interminable cold of the winters has had its effect, and the pony is small and scraggy, with a disposition to run to hair that would be the envy of a goat. These little fellows seem to be sadly out of their reckoning, as the great northern wastes were surely not made for horses; however, the reverse of the proposition is true, for the horses thrive after a fashion and demonstrate the toughness of the race. Unless he be tied up to a post, no one ever knew an Indian pony to die of the cold. With his front feet he will paw away the snow to an astonishing depth in order to get at the dry herbage, and by hook or by crook he will manage to come through the winter despite the wildest prophecies on the part of the uninitiated that he cannot live ten days in such a storm. The Indian

pony often finds to his sorrow that he is useful for other purposes than as a beast of burden, for his wild masters of the Rocky Mountains think him excellent eating. To the Shoshonees the particular use of a horse was for the steaks and the stews that were in him; but the Indian of the plains had the buffalo, and could afford, except in extreme cases, to let his means of transportation live. The Apaches were never "horse Indians," and always readily abandoned their stock to follow the mountains on foot. In early times their stock-stealing raids into Mexico were simply foraging expeditions, as they ate horses, mules, cattle, and sheep alike. In the grassy valleys of the northern Rocky Mountains, walled in as they are by the mountain ranges, horse-breeding was productive of good, and was followed. Thus the "cayuse," a fine strain of pony stock, took its name from a tribe, though it became disseminated over all that country. As it was nearly impossible for the Indians to steal each other's horses on every occasion, the people were encouraged to perpetuate the good qualities of their favorite mounts.

The cayuse is generally roan in color, with always a tendency this way, no matter how

slight. He is strongly built, heavily muscled, and the only bronco which possesses square quarters. In height he is about fourteen hands; and while not possessed of the activity of the Texas horse, he has much more power. This native stock was a splendid foundation for the horse-breeders of Montana and the North-west to work on, and the Montana horse of commerce rates very high. This condition is not, however, all to the credit of the cayuse, but as a thoroughbred, with his structural points corrected, and fit for many purposes. He has about the general balance of the French ponies of Canada or perhaps a Morgan, which for practical purposes were the best horses ever developed in America. At this stage of the development of the bronco he is no longer the little narrow-shouldered, cat-hammed brute of his native plains, but as round and square and arched as "anybody's horse," as a Texan

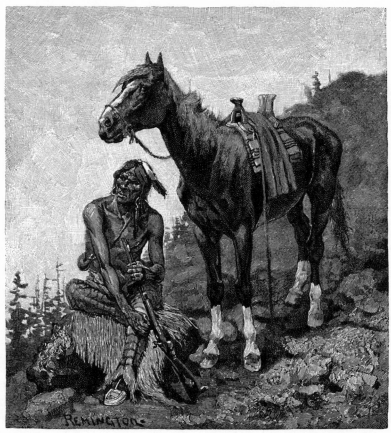

A "CAYUSE."

to a strain of horses early imported into Montana from the West and known as the Oregon horse, which breed had its foundation in the mustang.

In summing up for the bronco I will say that he is destined to become a distinguished element in the future horse of the continent, if for no other reason except that of his numbers. All over the West he is bred into the stock of the country, and of course always from the side of the dam. The first one or two crosses from this stock are not very encouraging, as the blood is strong, having been bred in and in for so many generations. But presently we find an animal of the average size, as fine almost

would express it. In this shape I see him ridden in Central Park, and fail to see but that he carries himself as gallantly as though his name were in the "Stud-Book." I often see a pair of these horses dragging a delivery wagon about on the pavements, and note the ease with which they travel over many miles of stone-set road in a day. I have also a particular fad which I would like to demonstrate, but will simply say that this horse is the *ne plus ultra* for light cavalry purposes. In the Department of Arizona they have used many Californian horses, and while some officers claim that they are not as desirable as pure American stock, I venture to think that they

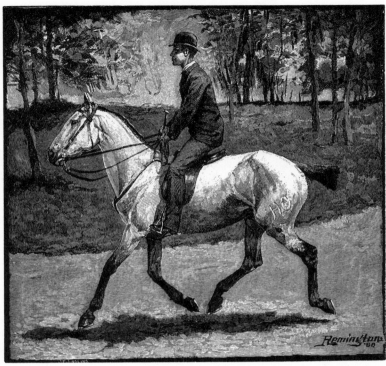

A BRONCO IN CENTRAL PARK.

would be if they were used by light cavalry and not by dragoons.

In intelligence the bronco has no equal, unless it is the mule, though this comparison is inapt, as that hybrid has an extra endowment of brains, as though in compensation for the beauty which he lacks. I think that the wild state may have sharpened the senses of the bronco, while in domestication he is remarkably docile. It would be quite unfair to his fellows to institute anything like a comparison without putting in evidence the peculiar method of defense to which he resorts when he struggles with man for the mastery. Every one knows that he "bucks," and familiarity with that characteristic never breeds contempt. Only those who have ridden a bronco the first time it was saddled, or have lived through a railroad accident, can form any conception of the solemnity of such experiences. Few Eastern people appreciate the sky-rocket bounds, and grunts, and stiff-legged striking, because the "bucking" process is entered into with great spirit by the pony but once, and that is when he is first under the saddle-tree. If that "scrape" is "ridden out" by his master the bronco's spirit is broken; and while he may afterwards plunge about, he has intelligence enough not to "kick against the pricks."

His greatest good quality is the ease with which he stands any amount of hard riding over the trail; and this is not because of any particular power which he has over the thoroughbred, for instance, but because of his "hard stomach." He eats no grain in the growing stages of his life, and his stomach has not been forced artificially to supply a system taxed beyond the power of the stomach to fill. The same general difference is noted between an Indian and a white man. You may gallop the pony until your thoroughbred would "heave and thump" and "go wrong" in a dozen vital places, and the bronco will cool off and come through little the worse for the experience.

Some years ago I drove up to a stage station in the San Pedro Valley in Arizona, and the Mexican stock tender had had a hard time in rounding up his stage stock. His herd pony had been run until, as he stood there under the shade of a brush corral, covered with foam and dust, with his belly drawn up almost to his spine and gasping occasionally as though it was his last, I felt sure I should see him die before I left the station. I was afterwards told by the stage boss in a bluff, matter-of-course way, in answer to my inquiry, that he had "pulled through all right: you can't kill them critters"; and now I am perfectly positive that you cannot.

As a saddle animal simply, the bronco has no superior. The "lope" is a term which should never be applied to that motion in any other

breed of horses. I have watched a herd of cow-ponies being driven over the prairie where the undulations of the backs in the moving throng were as regular and easy as the rise and fall of the watery waves. The fox-trot, which is the habitual gait of all plainsmen, cowboys, and Indians, is easily cultivated in him, and his light, supple frame accommodates itself naturally to the motion.

This particular American horse lays claim to another quality, which in my estimation is not least, and that is his wonderful picturesqueness. He graces the Western landscape, not because he reminds us of the equine ideal, but because he comes of the soil, and has borne the heat and burden and the vicissitudes of all that pale of romance which will cling about the Western frontier. As we see him hitched to the plow or the wagon he seems a living protest against utilitarianism; but, unlike his red master, he will not go. He has borne the Moor, the Spanish conqueror, the red Indian, the mountain-man, and the vaquero through all the glories of their careers; but they will soon be gone, with all their heritage of gallant deeds. The pony must meekly enter the new régime. He must wear the collar of the new civilization and earn his oats by the sweat of his flank. There are no more worlds for him to conquer; now he must till the ground.

18.
The Way
of an
Indian

The Way of an Indian

BY FREDERIC REMINGTON

I

WHITE OTTER'S OWN SHADOW

WHITE OTTER'S heart was bad. He sat alone on the rim-rocks of the bluffs overlooking the sunlit valley. To an unaccustomed eye from below he might have been a part of nature's freaks among the sand rocks. The yellow grass sloped away from his feet mile after mile to the timber, and beyond that to the prismatic mountains. The variegated lodges of the Chis-chis-chash village dotted the plain near the sparse woods of the creek-bottom; pony herds stood quietly waving their tails against the flies or were driven hither and yon by the herdboys—giving variety to the tremendous sweep of the Western landscape.

This was a day of peace—such as only comes to the Indians in contrast to the fierce troubles which nature stores up for the other intervals. The enemy, the pinch of the shivering famine, and the Bad Gods were absent, for none of these things care to show themselves in the white light of a midsummer's day. There was peace with all the world except with him. He was in a fierce dejection over the things which had come to him, or those which had passed him by. He was a boy—a fine-looking, skillfully modeled youth—as beautiful a thing, doubtless, as God ever created in His sense of form; better than his sisters, better than the four-foots, or the fishes, or the birds, and he meant so much more than the inanimate things, in so far as we can see. He had the body given to him and he wanted to keep it, but there were the mysterious demons of the darkness, the wind and the flames; there were the monsters from the shadows, and from under the waters; there were the machinations of his enemies, which he was not proof against alone, and there was yet the strong hand of the Good God, which had not been offered as yet to help him on with the simple things of life; the women, the beasts of the fields, the ponies and the war-bands. He could not even protect his own shadow, which was his other and higher self.

His eyes dropped on the grass in front of his moccasins—tiny dried blades of yellow grass, and underneath them he saw the dark traceries of their shadows. Each had its own little shadow—its soul—its changeable thing—its other life—just as he himself was cut blue-black beside himself on the sandstone. There were millions of these grass-blades, and each one shivered in the wind, maundering to itself in the chorus, which made the prairie sigh, and all for fear of a big brown buffalo wandering by, which would bite them from the earth and destroy them.

White Otter's people had been strong warriors in the Chis-chis-chash; his father's shirt and leggins were black at the seams with the hair of other tribes. He, too, had stolen ponies, but had done no better than that thus far, while he burned to keep the wolf-totem red with honor. Only last night, a few of his boy companions, some even younger than himself, had gone away to the Absaroke for glory and scalps, and ponies and women—a war-party—the one thing to which an Indian pulsed with his last drop.

He had thought to go also, but his father had discouraged him, and yesterday presented him with charcoal-ashes in his right hand, and two juicy buffalo-ribs with his left. He had taken the charcoal. His father said it was good—that it was not well for a young man to go to the enemy with his shadow uncovered before the Bad Gods.

Now his spirits raged within his tightened belly, and the fierce Indian brooding had driven him to the rim-rock, where his soul rocked and pounced within him. He looked at the land of his people, and he hated all vehemently, with a rage that nothing stayed but his physical strength.

Old Big Hair, his father, sitting in the shade of his tepee, looked out across at his son on the far-off sky-line, and he hid his head in his blanket as he gazed into his

medicine-pouch. "Keep the enemy and the Bad Gods from my boy; he has no one to protect him but you, my medicine."

Thus hour after hour there sat the motionless tyro, alone with his own shadow on the hill. The shades of all living nature grew great and greater with the declining sun. The young man saw it with satisfaction. His heart swelled with brave thoughts, as his own extended itself down the hillside —now twenty feet long—now sixty—until the western sun was cut by the bluffs, when it went out altogether. The shadow of White Otter had been eaten up by the shadow of the hill. He knew now that he must go to the westward—to the western mountains, to the Inyan-kara, where in the deep recesses lay the shadows which had eaten his. They were calling him, and as the sun sank to rest, White Otter rose slowly, drew his robe around him, and walked away from the Chis-chis-chash camp.

The split sticks in Big Hair's lodge snapped and spit gleams of light on the old warrior as he lay back on his resting-mat. He was talking to his sacred symbols. "Though he sleeps very far off, though he sleeps even on the other side, a spirit is what I use to keep him. Make the bellies of animals full which would seek my son; make the wolf and the bear and the panther go out of their way. Make the buffalo herds to split around my son, Good God! Be strong to keep the Bad God back, and all his demons—lull them to sleep while he passes; lull them with soft sounds."

And the Indian began a dolorous chanting, which he continued throughout the night. The lodge-fires died down in the camp, but the muffled intone came in a hollow sound from the interior of the tepee until the spirit of silence was made more sure, and sleep came over the bad and good together.

Across the gray-greens of the moonlit plains bobbed and flitted the dim form of the seeker of God's help.

Now among the dark shadows of the pines, now in the gray sage-brush, lost in the coulees, but ceaselessly on and on, wound this figure of the night. The wolves sniffed along on the trail, but came no nearer.

All night long he pursued his way, his muscles playing tirelessly to the demands of a mind as taut as bowstring.

Before the morning he had reached the Inyan-kara, a sacred place, and begun to ascend its pine-clad slopes. It had repulsion for White Otter, it was sacred— full of strange beings not to be approached except in the spiritual way, which was his on this occasion, and thus he approached it. To this place the shadows had retired, and he was pursuing them. He was in mortal terror—every tree spoke out loud to him; the dark places gave back groans, the night-winds swooped upon him, whispering their terrible fears. The great underground wildcat meowed from the slopes, the red-winged moon-birds shrilled across the sky, and the stone giants from the cliffs rocked and sounded back to White Otter, until he cried aloud:

"O Good God, come help me. I am White Otter. All the bad are thick around me; they have stolen my shadow; now they will take me, and I shall never go across to live in the shadow-land. Come to White Otter, O Good God!"

A little brown bat whirled round and round the head of the terror-stricken Indian, saying: "I am from God, White Otter. I am come to you direct from God. I will take care of you. I have your shadow under my wings. I can fly so fast and crooked that no one can catch up with me. No arrow can catch me, no bullet can find me, in my tricky flight. I have your shadow and I will fly about so fast that the spirit-wildcats and the spirit-birds and the stone giants cannot come up with me or your shadow, which I carry under my wings. Sit down here in the dark place under the cliffs and rest. Have no fear."

White Otter sat him down as directed, muffled in his robe. "Keep me safe, do not go away from me, ye little brown bat. I vow to keep you all my life, and to take you into the shadow-land hereafter, if ye will keep me from the demons now, O little brown bat!" And so praying, he saw the sky pale in the east as he lay down to sleep. Then he looked all around for his little brown bat, which was no more to be seen.

The daylight brought quiescence to the fasting man, and he sank back, blinking his hollow eyes at his shadow beside him. Its possession lulled him, and he paid the debt of nature, lying quietly for a long time.

Consciousness returned slowly. The hot sun beat on the fevered man, and he moved uneasily. To his ears came the far-away

HE LOOKED ON THE LAND OF HIS PEOPLE AND HE HATED ALL VEHEMENTLY

beat of a tom-tom, growing nearer and
nearer until it mixed with the sound of
bells and the hail-like rattle of gourds.
Soon he heard the breaking of sticks under
the feet of approaching men, and from
under the pines a long procession of men
appeared—but they were shadows, like
water, and he could see the landscape be-
yond them. They were spirit-men. He
did not stir. The moving retinue came up,
breaking now into the slow side-step of the
ghost-dance, and around the form of White
Otter gathered these people of the other
world. They danced "the Crazy Dance"
and sang, but the dull orbs of the faster gave
no signs of interest.

"He-eye, he-eye! we have come for you
—come to take you to the shadow-land.
You will live on a rocky island, where there
are no ponies, no women, no food, White
Otter. You have no medicine, and the
Good God will not protect you. We have
come for you—hi-ya, hi-ya, hi-yah!"

"I have a medicine," replied White
Otter. "I have the little brown bat which
came from God."

"He-eye, he-eye! Where is your little
brown bat? You do not speak the truth—
you have no little brown bat from God.
Come with us, White Otter." With this
one of the spirit-men strode forward and
seized White Otter, who sprang to his feet
to grapple with him. They clinched and
strained for the mastery, White Otter and
the camp-soldier of the spirit-people.

"Come to me, little brown bat," shouted
the resisting savage, but the ghostly crowd
yelled, "Your little brown bat will not come
to you, White Otter."

Still he fought successfully with the spirit-
soldier. He strained and twisted, now
felling the ghost, now being felled in
turn, but they staggered again to their feet.
Neither was able to conquer. Hour after
hour he resisted the taking of his body from
off the earth to be deposited on the in-
glorious desert island in the shadow-land.
At times he grew exhausted and seemed to
lie still under the spirit's clutches, but reviv-
ing, continued the struggle with what
energy he could summon. The westering
sun began lengthening the shadows on the
Inyan-kara, and with the cool of evening
his strength began to revive. Now he
fought the ghost with renewed spirit, calling
from time to time on his medicine-bat, till
at last when all the shadows had merged

and gone together, with a whir came the
little brown bat, crying "Na-hoin [I come]."

Suddenly all the ghost-people flew away,
scattering over the Inyan-kara, screaming,
"Hoho, hoho, hoho!" and White Otter sat
up on his robe.

The stone giants echoed in clattering
chorus, the spirit-birds swished through the
air with the whis-s-s-tling noise, and the
whole of the bad demons came back to
prowl, since the light had left the world,
and they were no longer afraid. They all
sought to circumvent the poor Indian, but
the little brown bat circled around and
around his head, and he kept saying:
"Come to me, little brown bat. Let White
Otter put his hand on you; come to my hand."

But the bat said nothing, though it con-
tinued to fly around his head. He waved
his arms widely at it, trying to reach it.
With a fortunate sweep it struck his hand,
his fingers clutched around it, and as he
drew back his arm he found his little
brown bat dead in the vise-like grip. White
Otter's medicine had come to him.

Folding himself in his robe, and still
grasping the symbol of the Good God's
protection, he lay down to sleep. The
stone giants ceased their clamors, and all
the world grew still. White Otter was
sleeping.

In his dreams came the voice of God,
saying: "I have given it, given you the little
brown bat. Wear it always on your scalp-
lock, and never let it away from you for a
moment. Talk to it, ask of it all manner
of questions, tell it the secrets of your
shadow-self, and it will take you through
battle so fast that no arrow or bullet can
hit you. It will steal you away from the
spirits which haunt the night. It will
whisper to you concerning the intentions
of the women, and your enemies, and it
will make you wise in the council when
you are older. If you adhere to it and
follow its dictation, it will give you the white
hair of old age on this earth, and bring you
to the shadow-land when your turn comes."

The next day when the sun had come
again, White Otter walked down the moun-
tain, and at the foot met his father with
ponies and buffalo-meat. The old man
had followed on his trail, but had gone no
farther.

"I am strong now, father. I can protect
my body and my shadow—the Good God
has come to Wo-pe-ni-in."

THE WOLVES SNIFFED ALONG ON THE TRAIL, BUT CAME NO NEARER

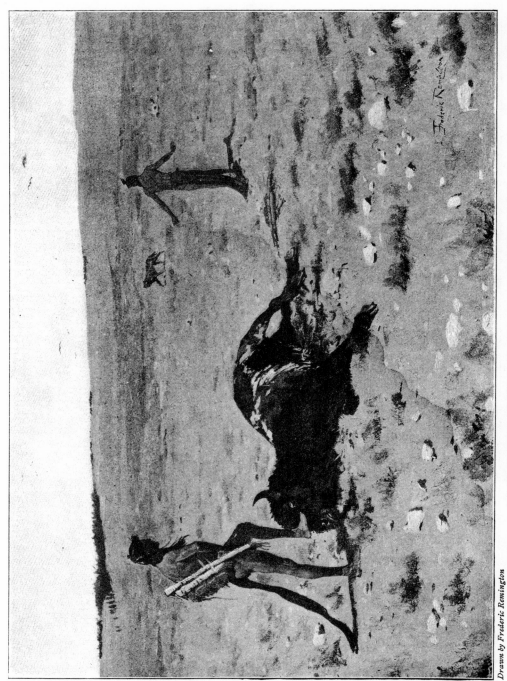

Drawn by Frederic Remington

"O GRAY WOLF OF MY CLAN—SHALL WE HAVE FORTUNE?"

II

Big Hair and his son, White Otter, rode home slowly, back through the coulees and the pines and the sage-brush to the camp of the Chis-chis-chash. The squaws took their ponies when they came to their lodge.

Days of listless longing followed the journey to the Inyan-kara in search of the offices of the Good God, and the worn body and fevered mind of White Otter recovered their normal placidity. The red warrior on his resting-mat sinks in a torpor which a sunning mud-turtle on a log only hopes to attain to, but he stores up energy, which must sooner or later find expression in the most extended physical effort.

Thus during the days did White Otter eat and sleep, or lie under the cottonwoods by the creek with his chum, the boy Red Arrow—lying together on the same robe and dreaming as boys will, and talking also, as is the wont of youth, about the things which make a man. They both had their medicine—they were good hunters, whom the camp soldiers allowed to accompany the parties in the buffalo-surround. They both had a few ponies, which they had stolen from the Absaroke hunters the preceding autumn, and which had given them a certain boyish distinction in the camp. But their eager minds yearned for the time to come when they should do the deed which would allow them to pass from the boy to the warrior stage, before which the Indian is in embryo.

Betaking themselves oft to deserted places, they each consulted his own medicine. White Otter had skinned and dried and tanned the skin of the little brown bat, and covered it with gaudy porcupine decorations. This he had tied to his carefully cultivated scalplock, where it switched in the passing breeze. People in the camp were beginning to say "the little brown bat boy" as he passed them by.

But their medicine conformed to their wishes, as an Indian's medicine mostly has to do, so that they were promised success in their undertaking.

Old Big Hair, who sat blinking, knew that the inevitable was going to happen, but he said no word. He did not advise or admonish. He doted on his son, and did not want him killed, but that was better than no eagle-plume.

Still the boys did not consult their relatives in the matter, but on the appointed evening neither turned up at the ancestral tepee, and Big Hair knew that his son had gone out into the world to win his feather. Again he consulted the medicine-pouch and sang dolorously to lull the spirits of the night as his boy passed him on his war-trail.

Having traveled over the table-land and through the pines for a few miles, White Otter stopped, saying: "Let us rest here. My medicine says not to go farther, as there is danger ahead. The demons of the night are waiting for us beyond, but my medicine says that if we build a fire the demons will not come near, and in the morning they will be gone."

They made a small fire of dead pine sticks and sat around it wrapped in the skins of the gray wolf, with the head and ears of that fearful animal capping theirs—unearthly enough to frighten even the monsters of the night.

Old Big Hair had often told his son that he would send him out with some war-party under a chief who well knew how to make war, and with a medicine-man whose war-medicine was strong; but no war-party was going then and youth has no time to waste in waiting. Still he did not fear pursuit.

Thus the two human wolves sat around the snapping sticks, eating their dried buffalo-meat.

"To-morrow, Red Arrow, we will make the war-medicine. I must find a gray spider, which I am to kill, and then if my medicine says go on, I am not afraid, for it came direct from the Good God, who told me I should live to wear white hair."

"Yes," replied Red Arrow, "we will make the medicine. We do not know the mysteries of the great war-medicine, but I feel sure that my own is strong to protect me. I shall talk to a wolf. We shall find a big gray wolf, and if as we stand still on the plain he circles us completely around, we can go on, and the Gray Horned Thunder-Being and the Great Pipe-Bearing Wolf will march on our either side. But if the wolf does not circle us, I do not know what to do. Old Bear-Walks-at-Right, who is the strongest war-medicine-maker in the Chis-chis-chash, says that when the Gray Horned Thunder-Being goes

with a war-party, they are sure of counting their enemies' scalps, but when the Pipe-Bearing Wolf also goes, the enemy cannot strike back, and the Wolf goes only with the people of our clan."

Thus the young men talked to each other, and the demons of the night joined in their conversation from among the tree-tops, but got no nearer because the fire shot words of warning up to them, and the hearts of the boys were strong to watch the contest and bear it bravely.

With the first coming of light they started on—seeking the gray spider and the gray wolf. After much searching through the rotting branches of the fallen trees, White Otter was heard calling to Red Arrow: "Come! Here is the gray spider, and as I kill him, if he contains blood I shall go on, but if he does not contain blood my medicine says there is great danger, and we must not go on."

Over the spider stooped the two seekers of truth, while White Otter got the spider on the body of the log, where he crushed it with his bow. The globular insect burst into a splash of blood, and the young savage threw back his shoulders with a haughty grunt, saying, "My medicine is strong—we shall go to the middle of the Absaroke village," and Red Arrow gave his muttered assent.

"Now we must find a wolf," continued Red Arrow, and they betook themselves through the pines to the open plains, White Otter following him but a step in rear.

In that day wolves were not hard to find in the buffalo country, as they swarmed around the herds and they had no enemies. Red Arrow arrogated to himself the privilege of selecting the wolf. Scanning the expanse, it was not long before their sharp eyes detected ravens hovering over a depression in the plain, but the birds did not swoop down. They knew that there was a carcass there and wolves, otherwise the birds would not hover, but drop down. Quickly they made their way to the place, and as they came in range they saw the body of a half-eaten buffalo surrounded by a dozen wolves. The wolves betook themselves slowly off, with many wistful looks behind, but one in particular, more lately arrived at the feast, lingered in the rear.

Selecting this one, Red Arrow called: "O gray wolf of my clan, answer me this question. White Otter and I are going to

the Absaroke for scalps—shall we have fortune, or is the Absaroke medicine too strong?"

The wolf began to circle as Red Arrow approached it and the buffalo carcass. Slowly it trotted off to his left hand, whereat the anxious warrior followed slowly.

"Tell me, pretty wolf, shall White Otter's and my scalps be danced by the Absaroke? Do the enemy see us coming now—do they feel our presence?" And the wolf trotted around still to the left.

"Come, brother. Red Arrow is of your clan. Warn me, if I must go back." And as the Indian turned, yet striding after the beast, it continued to go away from him, but kept an anxious eye on the dead buffalo meanwhile.

"Do not be afraid, gray wolf; I would not rise my arm to strike. See, I have laid my bow on the ground. Tell me not to fear the Absaroke, gray wolf, and I promise to kill a fat buffalo-cow for you when we meet again."

The wolf had nearly completed his circle by this time, and once again his follower spoke.

"Do you fear me because of the skin of the dead wolf you see by my bow on the ground? No, Red Arrow did not kill thy brother. He was murdered by a man of the dog clan, and I did not do it. Speak to me—help me against my fears." And the wolf barked as he trotted around until he had made a complete circle of the buffalo, whereat Red Arrow took up his bow and bundle, saying to White Otter, "Now we will go."

The two then commenced their long quest in search of the victims which were to satisfy their ambitions. They followed up the depression in the plains where they had found the buffalo, gained the timber, and walked all day under its protecting folds. They were a long way from their enemies' country, but instinctively began the cautious advance which is the wild-animal nature of an Indian.

The old buffalo-bulls, elk and deer fled from before them as they marched. A magpie mocked at them. They stopped while White Otter spoke harshly to it: "You laugh at us, fool-bird, because we are boys, but you shall see when we come back that we are warriors. We will have a scalp to taunt you with. Begone now, before I pierce you with an arrow, you chattering

"PRETTY MOTHER OF THE NIGHT—WHITE OTTER IS NO LONGER A BOY"

woman-bird." And the magpie fluttered away before the unwonted address.

In the late afternoon they saw a band of wolves pull down and kill a fawn, and ran to it, saying, "See, the Pipe-Bearing Wolf is with us; he makes the wolves to hunt for us of his clan," and they despoiled the prey.

Coming to a shallow creek, they took off their moccasins and waded down it for a mile, when they turned into a dry water-course, which they followed up for a long distance, and then stopped in some thick brush which lined its sides. They sat long together on the edge of the bushes, scanning with their piercing eyes the sweep of the plains, but nothing was there to rouse their anxiety. The wild animals were feeding peacefully, the sun sank to rest, and no sound came to them but the cry of the night-birds.

When it was quite dark, they made a small fire in the depths of the cut, threw a small quantity of tobacco into it as a sacrifice, cooked the venison and went to sleep.

It was more than mere extension of interest with them; it was more than ambition's haughtiest fight; it was the sun-dried, wind-shriveled, tried-out ata-vistic blood-thirst made holy by the ap-proval of the Good God they knew.

The miniature war-party got at last into the Absaroke country. Before them lay a big camp—the tepees scattering down the creek-bottom for miles, until lost at a turn of the timber. Eagerly they studied the cut and sweep of the land, the way the tepees dotted it, the moving of the pony herds and the coming and going of the hunters, but most of all the mischievous wanderings of the restless Indian boys. Their telescopic eyes penetrated everything. They understood the movements of their foes, for they were of kindred nature with their own.

Their buffalo-meat was almost gone, and it was dangerous to kill game now for fear of attracting the ravens, which would circle overhead and be seen from the camp. These might attract an investigation from idle and adventurous boys and betray them.

"Go now; your time has come," said the little brown bat on White Otter's scalplock.

"Go now," echoed Red Arrow's charm.

When nothing was to be seen of the land but the twinkle of the fires in the camp, they were lying in a deep washout under a bluff, which overlooked the hostile camp. Long and silently they sat watching the fires and the people moving about, hearing their hum and chanting as it came to them on the still air, together with the barking of dogs, the nickering of ponies, and the hollow pound-ing on a log made by old squaws hacking with their hatchets.

Slowly before the drowse of darkness, the noises quieted and the fires died down. Red Arrow felt his potent symbols whisper-ing to him.

"My medicine is telling me what to do, White Otter."

"What does it say?"

"It says that there is a dangerous mystery in the blue-and-yellow tepee at the head of the village. It tells me to have great care," replied Red Arrow.

"Hough, my medicine says go on; I am to be a great warrior," replied White Otter.

After a moment Red Arrow exclaimed: "My medicine says go with White Otter, and do what he says. It is good."

"Come, then; we will take the war-ponies from beside the blue-and-yellow tepee. They belong to a chief and are good. We will strike an Absaroke if we can. Come with me." White Otter then glided forward in the darkness toward the camp. When quite near, they waited for a time to allow the dogs to be still, and when they ceased to tongue, they again approached with greater caution.

Slowly, so as not to disturb the animals of the Indians, they neared the blue-and-yellow tepee, squatting low to measure its gloom against the sky-line. They were among the picketed ponies, and felt them all over carefully with their hands. They found the clip-maned war-ponies and cut the ropes. The Indian dogs made no trouble, as they walked their booty very slowly and very quietly away, as though they wandered in search of food. When well out of hearing, they sprang on their backs and circled back to the creek-bottom.

Nearing this, they heard the occasional inharmonious notes of an Indian flute-horn among the trees. Instantly they recognized it as an Indian lover calling for his sweetheart to come out from the lodges to him.

"Hold the ponies, Red Arrow. My medicine tells me to strike," and White Otter slid from his horse. He passed

among the tepees at the end of the village, then quickly approached the direction of the noise of the flute.

The lover heard his approaching footsteps, for White Otter walked upright until the notes stopped, when he halted to await their renewal. Again the impatient gallant called from the darkness to his hesitating one, and our warrior advanced with bared knife in one hand, and bow in the other with an arrow notched.

When quite near, the Absaroke spoke in his own language, but White Otter, not understanding, made no reply, though advancing rapidly. Alas for the surging blood which burns a lover's head, for his quick advance to White Otter discovered for him nothing until, with a series of lightning-like stabs, the knife tore its way into his vitals—once, twice, three times, when, with a wild yell, he sank under his deluded infatuation.

He doubtless never knew, but his yell had found its response from the camp. Feeling quickly, White Otter wound his hand among the thick black hair of his victim's head, and though it was his first, he made no bad work of the severance of the prize, whereat he ran fast to his chum. Attracted by the noise, Red Arrow rode up, and they were mounted. Cries and yells and barking came from the tepees, but silently they loped away from the confusion —turning into the creek, blinding the trail in the water for a few yards and regaining the hills from a much-tracked-up pony and buffalo crossing. Over the bluffs and across the hills they made their way, until they no longer heard the sounds of the camp behind them.

Filled with a great exultation, they trotted and loped along until the moon came up, when White Otter spoke for the first time, addressing it: "Pretty Mother of the Night—time of the little brown bat's flight—see what I have done. White Otter is no longer a boy." Then to his pony: "Go on quickly now, pretty little war-pony. You are strong to carry me. Do not lame yourself in the dog-holes. Carry me back to the Chis-chis-chash, and I promise the Mother of the Night, now and here, where you can hear me speak, that you shall never carry any man but White Otter, and that only in war."

For three days and nights they rode as rapidly as the ponies could travel, resting an hour here and there to refresh themselves. Gradually relaxing after this, they assumed the fox-trot of the plains pony; but they looked many times behind and doubled often in their trail.

Seeing a band of wolves around a buffalo-bull which was fighting them off, they rode up and shot arrows into it—the sacrifice to the brother of the clan who had augured for them. Red Arrow affected to recognize his old acquaintance in the group.

As they rode on, White Otter spoke: "I shall wear the eagle-feather standing up in my scalplock, for I struck him with a hand-weapon standing up. It shall wave above the bat and make him strong. The little brown bat will be very brave in the time to come. We took the clipped and painted war-ponies from under the chief's nose, Red Arrow."

"Yes, I did that—but my medicine grew weak when it looked at the great camp of the Absaroke. Your medicine was very strong, White Otter; there is no old warrior in the Chis-chis-chash whose is stronger. I shall take the charcoal again, and see if the Good God won't strengthen my medicine."

Time brought the victors in sight of their village, which had moved meanwhile, and it was late in the evening.

"Stay here with the ponies, Red Arrow, and I will go into my father's lodge and get red paint for us. We will not enter until to-morrow."

So White Otter stole into his own tepee by night—told his father of his triumph— got a quantity of vermilion and returned to the hills. When he and Red Arrow had bedaubed themselves and their ponies most liberally, they wrapped the scalp to a lance which he had brought out, then moved slowly forward in the morning light on their jaded ponies to the village, yelling the long, high notes of the war-whoop. The people ran out to see them come, many young men riding to meet them. The yelling procession came to the masses of the people, who shrilled in answer, the dogs ki-yied, and old trade-guns boomed. White Otter's chin was high, his eyes burned with a devilish light through the red paint, as he waved the lance slowly, emitting from time to time above the din his battle-cry.

It was thus that White Otter became a man.

THE CEREMONY OF THE FASTEST HORSE

The Way of an Indian

BY FREDERIC REMINGTON

SYNOPSIS.---*White Otter, a boy of the Chis-chis-chash, is in deep dejection. He has had no help from the Good Gods in his efforts to become a man. He has no "medicine." He cannot even protect his own shadow. He has done no better than steal ponies, while he longs to keep the wolf-totem red with honor. He knows he must go westward to the mountains and hunt the shadow he has lost. Arriving there, a little brown bat hovers over him, tells him it has his shadow and has been sent by God to protect him. The bat bids him sit and rest. In a vision, the spirit-men approach to take him to shadow-land, but he fights them off. He calls for the bat and grasps it as it again hovers over his head. He draws back his hand and finds the bat dead in his grip. White Otter has found his "medicine." The voice of God now speaks, telling the boy to wear the bat always on his scalplock. It will protect him and be his guide through life. White Otter returns to Big Hair, his father, and says he can now protect his body and his shadow. He longs to do the deed that will make him a warrior.*

White Otter, with the dried bat-skin in his scalplock, sets out with his chum, Red Arrow, to win the eagle-plume (sign of the warrior). Their "medicines" and the omens promise success. The two boys reach the Absaroke country and stealthily approach a village. The bat urges White Otter on. Red Arrow's "medicine" tells him to follow his friend. The boys steal two war-ponies, and returning at night to the village, come upon an Absaroke lover calling to his sweetheart on the flute-horn. Him, White Otter stabs to death and scalps. The two friends return home, bedaub themselves with vermilion paint and enter their village in triumph. White Otter has become a man.

III

THE BAT DEVISES MISCHIEF AMONG THE YELLOW-EYES

HITE OTTER, the boy, had been superseded by the man with the upright eagle-feather, whom people now spoke of as Ho-to-kee-mat-sin, the Bat. The young women of the Chis-chis-chash threw approving glances after the Bat as he strode proudly about the camp. He was possessed of all desirable things conceivable to the red mind. Nothing that ever bestrode a horse was more exquisitely supple than the well-laid form of this young Indian man; his fame as a hunter was great, but the taking of the Absaroke scalp was transcendent. Still, it was not possible to realize any matrimonial hopes which he was led to entertain, for his four ponies would buy no girl fit for him. The captured war-pony, too, was one of these, and not to be transferred for any woman.

The Bat had conjured with himself and conceived the plan of a trip to the far south —to the land of many horses—but the time was not yet.

As the year drew on, the Chis-chis-chash moved to the west—to the great fall buffalo-hunt—to the mountains where they could gather fresh tepee-poles, and with the hope of trade with the wandering trapper bands. To be sure, the Bat had no skins or ponies to barter with them, but good fortune is believed to stand in the path of every young man, somewhere, some time, as he wanders on to meet it. Delayed ambition did not sour the days for the Indian. He knew that the ponies and the women and the chieftainship would come in the natural way; besides which, was he not already a warrior worth pointing at?

He accompanied the hunters when they made the buffalo-surround, where the bellowing herds shook the dusty air and made the land to thunder while the Bat flew in swift spirals like his prototype. Many a carcass lay with his arrows driven deep, while the squaws of Big Hair's lodge sought the private mark of the Bat on them.

The big moving camp of the Chis-chis-chash was strung over the plains—squaws, dogs, fat little boys toddling after possible prairie dogs, tepee ponies, pack-animals with gaudy squaw trappings, old chiefs stalking along in their dignified buffalo-robes—and a swarm of young warriors riding far on either side.

The Bat's and Red Arrow's lusty fire had carried them far in the front, and as they slowly raised the brow of a hill they saw in the shimmer of the distance a cavalcade with many two-wheeled carts—all dragging wearily over the country.

"The Yellow-Eyes!" said the Bat.

"Yes," replied Red Arrow. "They always march in the way the wild ducks fly—going hither and yon to see what is happening in the land. But their medicine is very strong; I have heard the old men say it."

"Hough! it may be, but is not the medicine of the Chis-chis-chash also strong? Why do we not strike them, Red Arrow? That I could never understand. They have many guns, blankets, paints, many strong ponies and the strong water, which we might take," added the Bat, in perplexity.

"Yes, true, we might take all, but the old men say that the Yellow-Eyes would not come again next green grass—we would make them afraid. They would no more bring us the powder and guns or the knives. What could we do without iron arrow-heads? Do you remember how hard it was to make bone arrow-heads, when we were boys and could not get the iron? Then, the Yellow-Eyes are not so many as the Chis-chis-chash, and they are afraid of us. No, we must not make them more timid," replied the wise Red Arrow.

"But we may steal a gun or a strong pony when they do not look," continued the indomitable Bat.

"Yes—we will try."

"I will go down the hill, and make my pony go around in a circle so that the camp may send the warriors out to us," saying which, the Bat rode the danger-signal, and the Chis-chis-chash riders came scurrying over the dry grass, leaving lines of white dust in long marks behind them. Having assembled to the number of a hundred or so, the chiefs held a long consultation, each talking loudly from his horse, with many gestures. After some minutes, the head war-chief declared in a high, rough voice that the man must go to the Yellow-Eyes with the peace-sign, and that they must not do anything to make the Yellow-Eyes afraid. The white men had many guns, and if they feared the Indians they would fire on them, when it would be impossible to get near the powder and paints and knives which were in the carts.

The warriors took each from a little bag his paints and plumes. Sitting in the grass, they decorated themselves until they assumed all hues—some red, and others half white or red across the face, while the ponies came in for streaks and daubs, grotesque as tropic birds.

So over the hill rode the line of naked men, their ponies dancing with excitement, while ahead of them a half-breed man skimmed along bearing a small bush over his head. The cavalcade of the Yellow-Eyes had halted in a compact mass, awaiting the oncoming Indians. They had dismounted and gone out on the sides away from the carts, where they squatted quietly in the grass. This was what the Yellow-Eyes always did in war.

A warrior of the Yellow-Eyes came to meet them, waving a white cloth from his gun-barrel after the manner of his people, and the two peace-bearers shook hands. Breaking into a run, the red line swept on, their ponies' legs beating the ground in a vibratory whirl, their plumes swishing back in a rush of air, and with yelps which made the white men draw their guns into a menacing position.

At a motion of the chief's arm, the line stopped. The Yellow-Eyed men rose slowly from the grass and rested on their long rifles, while their chief came forward.

For a long time the two head men sat on their ponies in front of the horsemen, speaking together with their hands. Not a sound was to be heard but the occasional stamp of a pony's hoof on the hard ground. The beady eyes of the Chis-chis-chash beamed malevolently on the white chief—the blood-thirst, the warrior's itch, was upon them.

After an understanding had been arrived at, the Indian war-chief turned to his people and spoke. "We will go back to our village. The Yellow-Eyes do not want us among their carts—they are afraid. We will camp near by them to-night, and to-morrow we will exchange gifts. Go back,

Chis-chis-chash, or the white chief says it is war. We do not want war."

The two camps were pitched that night two miles apart; ,the Yellow-Eyes intrenched behind their packs and carts, while the Indians, being in overwhelming strength, did much as usual, except that the camp-soldiers drove the irrepressible boys back, not minding to beat their ponies with their whips when they were slow to go. There was nothing that a boy could do except obey when the camp-soldier spoke to him. He was the one restraint they had, the only one.

But as a mark of honor, the Bat and Red Arrow were given the distinguished honor of observing the Yellow-Eye camp all night, to note its movements if any occurred, and with high hearts they sat under a hill-top all through the cold darkness, and their souls were much chastened by resisting the impulses to run off the white man's ponies, which they conceived to be a very possible undertaking.

Nothing having cccurred, they returned before daylight to their own camp to so inform the war-chief.

That day the Chis-chis-chash crowded around the barricade of the Yellow-Eyes, but were admitted only a few at a time. They received many small presents of coffee and sugar, and traded what ponies and robes they could. At last it became the time for the Bat to go into the trappers' circle. He noted the piles of bales and boxes as he passed in, a veritable mountain of wealth; he saw the tall white men in their buckskin and white blanket suits, befringed and beribboned; their long, light hair, their bushy beards, and each carrying a well-oiled rifle. Ah, a rifle! That was what the Bat wanted; it displaced for the time all other thoughts of the young warrior. He had no robes and came naked among the traders—they noted him—only an Indian boy, and when all his group had bartered what they had, the half-breed who had ridden with the peace-branch spoke to him, interpreting: "The white chief wants to know if you want to buy anything."

"Yes. Tell the white chief that I must have a gun, and some powder and ball."

"What has the boy to give for a gun?" asked a long-bearded leader.

"A pony—a fast buffalo-pony," replied our hero through the half-breed.

"One pony is not enough for a gun; he must give three ponies. He is too young to have three ponies," replied the trader.

"Say to the Yellow-Eye that I will give him two ponies," risked the Bat.

"No, no; he says three ponies, and you will not get them for less."

"Let me see the gun," demanded the boy. A gun was necessary for the Bat's future progression.

A subordinate was directed to show a gun to him, which he did by taking him one side and pulling one from a cart. It was a long, yellow-stocked smoothbore, with a flintlock. It had many brass tacks driven into the stock, and was bright in its cheap newness. As the Bat took it in his hand, he felt a nervous thrill, such as he had not experienced since the night he had pulled the dripping hair from the Absaroke. He felt it all over, smoothing it with his hand; he cocked and snapped it; and the little brown bat on his scalplock fairly yelled, "Get your ponies, get your ponies—you must have the gun."

Returning the gun, the Bat ran out, and after a time came back with his three ponies, which he drove up to the white man's pen, saying in Chis-chis-chash: "Here are my ponies. Give me the gun."

The white chief glanced at the boy as he sat there on a sturdy little clip-maned war-pony—the one he had stolen from the Absaroke. He spoke, and the interpreter continued: "The trader says he will take the pony you are riding as one of the three."

"Tell him that I say I would not give this pony for all the goods I see. Here are my three ponies; now let him give me the gun before he makes himself a liar," and the boy warrior wore himself into a frenzy of excitement as he yelled: "Tell him if he does not give me the gun he will feel this war-pony in the dark, when he travels; tell him he will not see this war-pony, but he will feel him when he counts his ponies at daylight. He is a liar."

"The white chief says he will take the war-pony in place of three ponies, and give you a gun, with much powder and many balls."

"Tell the Yellow-Eye he is a liar, with the lie hot on his lips," and the Bat grew quiet to all outward appearance.

After speaking to the trader, the interpreter waved at the naked youth, sitting

there on his war-pony: "Go away—you are a boy, and you keep the warriors from trading."

With a few motions of the arms, so quickly done that the interpreter had not yet turned away his eye, the Bat had an arrow drawn to its head on his leveled bow and covering the white chief.

Indians sprang between; white men cocked their rifles; two camp-soldiers rushed to the enraged Bat, and led his pony quietly away, driving the three ponies after him.

The trading progressed throughout the day, and at night the Indians all came home, but no one saw the Bat in his father's lodge, and also Red Arrow was missing. All the Indians had heard of how the white trader had lied to the boy, and they knew the retribution must come. The trading was over; the white men had packed up their goods; had shaken hands with the chiefs and head men, promising to come again when the grass was green.

The Chis-chis-chash were busy during the ensuing days following the buffalo, and their dogs grew fat on the leavings of the carcasses. The white traders drew their weary line over the rolling hills, traveling as rapidly as possible to get westward of the mountains before the snows encompassed them. But by night and by day, on their little flank, in rear or far in front, rode two vermilion warrior-boys, on painted ponies, and one with an eagle-plume upright in his scalplock.

Old Delaware hunters in the caravan told the white chief that they had seen swift pony-tracks as they hunted through the hills; and that, too, many times. The tracks showed that the ponies were strong and went quickly—faster than they could follow on their jaded mounts. The white chief must not trust the solitude.

But the trailing buffalo soon blotted out the pony-marks; the white men saw only the sailing hawks, and heard only bellowing and howling at night. Their natures responded to the lull, until two horse-herders grew eager in a discussion, and did not notice that the ponies and mules were traveling rapidly away to the bluffs. Two ponies ran hither and thither behind the horses. There was method in their movements—were they wild stallions? As the white men moved out toward the herd, still gazing ardently, they saw one of these

ponies turn quickly, and as he did so a naked figure shifted from one side to the other of his back.

"Indians! Indians!" A pistol was fired —the herders galloped after.

The horse-thieves sat upon their ponies, and the long, tremulous notes of the war-whoop were faintly borne on the wind to the camp of the Yellow-Eyes. Looking out across the plains, they saw the herd break into a wild stampede, while behind them sped the Bat and Red Arrow, waving long-lashed whips to the ends of which were suspended blown-up buffalo-bladders, which struck the hard ground with sharp, explosive thumps, rebounding and striking again. The horses were terrorized, but, being worn down, could not draw away from the swift and supple war-steeds. There were more than two hundred beasts, and the white men were practically afoot.

Many riders joined the pursuit; a few lame horses fell out of the herd and out of the race—but it could have only one ending with the long start. Mile by mile the darkness was coming on, so that when they could no longer see, the white pursuers could hear the beat of hoofs, until that, too, passed—and their horses were gone.

That night there was gloom and dejection around the camp-fires inside the ring of carts. Some recalled the boy on the war-pony with the leveled bow; some even whispered that Mr. McIntish had lied to the boy, but no one dared say that out loud. The factor stormed and damned, but finally gathered what men he could mount and prepared to follow next day.

Follow he did, but the buffalo had stamped out the trail, and at last, baffled and made to go slow by the blinded sign, he gave up the trail to hunt for the Chis-chis-chash village.

After seven days' journey he struck the carcasses left in the line of the Indians' march, and soon came up with their camp, which he entered with appropriate ceremony, followed by his seven retinues— half-breed interpreter, Delaware trailers, French horse-herders, and two real Yellow-Eyed men—white Rocky Mountain trappers, rifle-bearing and born in Kentucky.

He sought the head chief, and they all gathered in the council tepee. There they smoked and passed the pipe. The squaws brought kettles of buffalo-meat, and the eager youngsters crowded the door until a

camp-soldier stood in the way to bar them back. The subchiefs sat in bronze calm, with their robes drawn in all dignity about them.

When all was ready, Mr. McIntish stood in the middle of the lodge and spoke with great warmth and feeling, telling them that Chis-chis-chash warriors had stolen his horse-herd—that he had traced it to their camp and demanded its· return. He accused them of perfidy, and warned them that from thence on no more traders would ever come into their country, but would give their guns to the Absaroke, who would thus be able to overwhelm them in war.

When he had finished and sat down, the head chief arose slowly, and stepping from the folds of his robe, he began slowly to talk, making many gestures. "If the white chief had tracked the stolen ponies to his camp, let him come out to the Indian pony-herds and point them out. He could take his horses."

The face of the trader grew hard as he faced the snare into which the chief had led him, and the lodge was filled with silence.

The camp-soldier at the entrance was brushed aside, and with a rapid stride a young Indian gained the center of the lodge, and stood up very straight in his nakedness. He began slowly, with senatorial force made fierce by resolve. "The white chief is a liar. He lied to me about the gun; he has come into the council tepee of the Chis-chis-chash and lied to all the chiefs. He did not trail the stolen horses to this camp. He will not find them in our pony-herds. I—the boy—I stole all the white chief's ponies, in the broad daylight, with his whole camp looking at me. I did not come in the dark. He is not worthy of that.· He is a liar, and there is a shadow across his eyes. The ponies are not here. They are far away—where the poor blind Yellow-Eyes cannot see them even in dreams. There is no man of the Chis-chis-chash here who knows where the horses are. Before the liar gets his horses again, he will have his mouth set on straight," and the Bat turned slowly around, sweeping the circle with his eyes to note the effect of his first speech, but there was no sound.

Again the trader ventured on his wrongs —charged the responsibility of the Bat's actions on the Chis-chis-chash, and pleaded for justice.

The aged head chief again rose to reply, saying he was sorry for what had occurred, but he reminded McIntish that the young warrior had convicted him of forged words. What would the white chief do to recompense the wrong if his horses were returned? He also stated that it was not in his power to find the horses, and that only the young man could do that.

Springing again to his feet, with all the animation of resolution, the Bat's voice clicked in savage gutturals. "Yes, it is only with myself that the white liar can talk. If the chiefs and warriors of my tribe were to take off my hide with their knives—if they were to give me to the Yellow-Eyes to be burnt with fire—I would not tell where the ponies lie hidden. My medicine will blind your eyes as does the north wind when he comes laden with snow.

"I will tell the white man how he can have his ponies back. He can hand over to me now the bright new gun which lies by his side. It is a pretty gun, better than any Indian has. With it, his powder-horn and his bullet-bag must go. If he does this, he can have back all his horses, except those I choose to keep. Is it good? I will not say it again. I have spoken."

The boy warrior stood with arms dropped at his sides, very straight in the middle of the tent, the light from the smokehole illumining the top of his body while his eye searched the traders.

McIntish gazed through his bushy eyebrows at the victor. His burnt skin turned an ashen-green; his right hand worked nervously along his gun-barrel. Thus he sat for a long time, the boy standing quietly, and no one moved in the lodge.

With many arrested motions, McIntish raised the rifle until it rested on its butt; then he threw it from himself, and it fell with a .crash across the dead ashes of the fire, in front of the Bat. Stripping his powder-horn and pouch off his body, violently he flung them after, and the Bat quickly rescued them from among the ashes.

Gathering the tokens and girding them about his body, the Bat continued: "If the white liar will march up this river one day and stop on the big meadows by the log house, which has no fire in it; if he will keep his men quietly by the log house,

where they can be seen at all times; if he will stay there one day, he will see his ponies coming to him. I am not a boy; I am not a man with two tongues; I am a warrior. Go, now—before the camp-soldiers beat you with sticks."

IV

THE NEW LODGE

The Yellow-Eyes had departed, and at the end of four days the Bat and Red Arrow drove a band of thirty ponies and mules onto the herd-grounds, where they proceeded to cut them into two bunches—fifteen horses for each young man. This was not a bad beginning in life, where ponies and robes were the things reckoned. The Bat got down from his horse and tossed a little brother onto it, telling him to look after them. The copper-colored midget swelled perceptibly as he loped away after the Bat's nineteen horses, for the twentieth, which was the war-pony, was taken to be picketed by Big Hair's Lodge.

As the Bat stalked among the Chis-chis-chash, he was greeted often—all eyes turned to him. No mere boys dared longer to be familiar; they only stood modestly, and paid the tribute to greatness· which much staring denotes. The white man's new rifle lay across his left arm, his painted robe dragged on the ground, his eagle-feather waved perpendicularly above the dried bat's skin, the sacred red paint of war bloodied his whole face, and a rope and a whip—symbols of his success with horses—dangled in his right hand, while behind him followed the smart war-pony, covered with vermilion hand-prints as thickly as the spots on a brook-trout. The squaws ran from their fleshing, their chopping or their other work to look at the warrior who made all the camp talk. Wisdom mellowed by age, in the forms of certain old men, sat back and thought disturbedly of the future, as is the wont of those who have little time to live. They feared for the trade with the Yellow-Eyes, for no Chis-chis-chash could forge iron into guns and knives, which were the arbiter between the tribes. This the Bat had brought upon them. But still they thought more than they said; warriors as promising as this young one did not often appear.

There was a feast at the lodge. The Bat told his exploits to the warriors, as he strode about the night-fire in the tepee, waving his arms, giving his war-yell until he split the air and made his listeners' ears ring.

On the morrow, men from the military order of the "red lodges," the "miayuma," came to the Bat with charcoal, and he fasted many days before undergoing his initiation. The sacred symbols of the body, their signs and ceremonies, were given him, and he had become a pillar in the Chis-chis-chash social structure.

The nights were growing cold, and occasional bleak winds blew down from the great mountains, warning the tribe to be about its mission. The loads of dry meat made the horses weary, when the camp was broken; the tepee-poles were bright and new, and the hair began to grow on the ponies.

One day, as they moved, they could see far ahead on the plains the colorless walls of Fort Laramie, and the wise-men feared for their reception, but the pillage of the traders' horses sat lightly on the people. The Yellow-Eyes should have a care how they treated the Chis-chis-chash. It was in their power to put out the white man's fires. The Bat's people were an arrogant band, and held their heads high. in the presence of aliens. Their hands were laid heavily and at once on anyone who stood in their path. All the plains tribes, the French Indians at the posts and the Yellow-Eyed trapper-bands stood in awe of them. With the exception of the chief, the people had never been inside of the second gate at Laramie. They traded through a hole in the wall, and even then the bourgeois Papin thought he played with fire. Their haughty souls did not brook refusal when the trader denied them the arrangement of the barter.

The tribe encamped, and got rid of what ponies, robes and meats it could dispose of for guns and steel weapons, and "made whisky." The squaws concealed the arms while the warriors raged, but the Chis-chis-chash in that day were able to withstand the new vices of the white men better than most people of the plains.

On one occasion, the Bat was standing with a few chiefs before the gateway of the fort. Papin opened the passage and invited them to enter. Proudly the tall tribesmen walked among the engagés—

THE INTERPRETER WAVED AT THE YOUTH, SITTING THERE ON HIS WAR-PONY

seeming to pay no heed, but the eye of an Indian misses nothing. The surroundings were new and strange to the young man. The thick walls seemed to his vagabond mind to be built to shield cowards. The white men were created only to bring goods to the Indians. They were weak, but their medicine was wonderful. It could make the knives and guns, which God had denied to the Bat's people. They were to be tolerated; they were few in number— he had not seen over a hundred of them in all his life. Scattered here and there about the post were women, who consorted with the *engagés*—half-breeds from the Mandans and Delawares, Sioux and many other kinds of squaws; but the Chis-chis-chash had never sold a woman to the traders. That was a pride with them.

The sisterhood of all the world will look at a handsome man and smile pleasantly; so nothing but cheerful looks followed the Bat as he passed the women who sat working by the doorways. They were not ill-favored, these comforters of the workmen, and were dressed in bright calicoes and red strouding, plentifully adorned with bright beads. The boy was beginning to feel a subtle weakening in their presence. His fierce barbarism softened, and he began to think of taking one. But he put it aside as a weakness—this giving of ponies for these white men's cast-offs. That thought was unworthy of him—a trade was not his wild way of possessing things.

He stood quietly leaning against a door on Papin's balcony, observing the men laboring about the enclosure, his lip curling upward with fine contempt. The "dogs" were hewing with axes about some newly made carts, or rushing around on errands as slaves are made to do. Everyone was busy and did not notice him in his brown study.

From within the room near by he heard a woman sing a few notes in an unknown tongue. Without moving a facial muscle, he stepped inside the room, and when his eye became accustomed to the light, saw a young squaw, who sat beading, and wore a dress superior to that of the others. She stared a moment and then smiled. The Bat stood motionless for a long time regarding her, and she dropped her gaze to her needlework.

"I' nisto' niwon [You were humming]," spoke the statued brave, but she did not understand.

Again came the clicking gutturals of the harsh Chis-chis-chash tongue: "Whose squaw are you?"—which was followed by the sign-talk familiar to all Indians in those days.

The woman rose, opening her hand toward him and hissing for silence. Going to the door, she looked into the sunlighted court, and, pointing to the factor who was directing workmen, replied, "Papin." He understood.

She talked by signs as she drew back, pointing to the Bat, and then ran her hand across her own throat as though she held a knife, and then laughed while her eyes sparkled.

Again he understood, and for the first time that day he smiled. There are no preliminaries when a savage warrior concludes to act. The abruptness of the Bat's love-making left room for few words, and his attentions were not repulsed except that the fear of her liege lord out by the carts made her flutter to escape that she might reassure herself. She was once again covered by the sweep of the warrior's robe, and what they whispered there, standing in its folds, no man can tell. The abrupt entrance of Papin drowned all other thoughts, and filled the quiet fort with a whirl of struggles and yells, in which all joined, even to the dogs.

The outcome was that the Bat found himself thrown ignominiously into the dust outside the walls, and the gate slammed after him. He gathered himself together and looked around. His humiliation was terrible—complete. Nothing like this had occurred before. Cowardly French half-breeds had laid their hands on the warrior's body, even on his sacred bat and eagle-plume; and they had been content to throw him away as though he were a bone—merely to be rid of him. His rage was so great that he was in a torpor; he did not even speak, but walked away hearing the shrieks of the squaw being beaten by Papin.

Going to the camp, he got a pony and rode to the hills, where he dismounted and sat down. The day passed, the night came, and morning found the Bat still sitting there.

He seemed not to have moved. His eye burned with the steady glare of the great cats until, allowing his robe to fall away, he brought out his firebag and lighted his

Drawn by Frederic Remington

"I WILL TELL THE WHITE MAN HOW HE CAN HAVE HIS PONIES BACK"

NOTHING BUT CHEERFUL LOOKS FOLLOWED THE BAT

pipe. Standing up, he blew a mouthful of smoke to each of the four corners of the world; then lowered his head in silence for a long while. He had recovered himself now.

Presently he mounted and rode toward camp; his eyes danced the devil's dance as they wandered over the battlements of Fort Laramie. He wanted a river of blood—he wanted to break the bones of the whites with stone hatchets—he wanted to torture with fire. He would have the girl now at any cost.

After eating at Big Hair's lodge, he wandered over to the Fort. He said not a word to anyone as he passed. An old chief came out of the gate, turned the corner, saw the Bat, and said: "The white chief says you tried to steal his squaw. His heart is cold toward our people. He will no longer trade with us. What have you done?"

The Bat's set eyes gazed at the old man, and he made no reply, but stood leaning against the walls while the chief passed on.

No one noticed him, and he did not move for hours. He was under that part of the wall behind which was the room of the woman, and not unexpectedly he heard a voice from above in the strange language which he did not understand. Looking up, he saw that she was on the roof. He motioned her to come down to him, at the same time taking his rifle from under his robe.

The distance was four times her height, but she quickly produced a rawhide lariat, which she began to adjust to a timber that had been exposed in the roof, dirt having been washed away. Many times she looked back anxiously, fearful of pursuit, until, testing the knot and seeming satisfied, she threw her body over the edge and slid down.

The Bat patted her on the back, and instinctively they fled as fast as the woman could run until out of rifle-shot, when her new brave stayed her flight and made her go slowly that they might not attract attention. They got at last to the pony-herds, where the Bat found his little brother with his bunch of ponies. Taking the cherished war-pony and two others, he mounted his new woman on one, while he led the other beside his own. They galloped to the hills. Looking back over the intervening miles of plain, their sharp eyes could see people running about like ants, in great perplexity and excitement. Papin had discovered his woes, and the two lovers laughed loud and long. He had made his slaves lay violent hands on the Bat, and he had lashed the girl Seet-se-be-a (Mid-day Sun) with a pony-whip, but he had lost his woman.

Much as the Bat yearned to steep his hands in the gore of Papin, yet the exigencies of the girl's escape made it impossible now, as he feared pursuit. On the mountain-ridge they stopped, watching for the pursuing party from the Fort, but the Cheyennes swarmed around and evidently Papin was perturbed.

So they watched and talked, and fondled each other, the fierce Cheyenne boy and Minataroe girl—for she proved to be of that tribe—and they were married by the ancient rites of the ceremony of the Fastest Horse.

Shortly the tribe moved away to its wintering-grounds, the young couple following after. The Bat lacked the inclination to stop long enough to murder Papin; he deferred that to the gray future, when the "Mid-day Sun" did not warm him so.

As they entered the lodges, they were greeted with answering yells, and the sickening gossip of his misadventure at Laramie was forgotten when they saw his willing captive. The fierce old women swarmed around, yelling at Seet-se-be-a in no complimentary way, but the fury of possible mothers-in-law stopped without the sweep of the Bat's elkhorn pony-whip.

Before many days there was a new tepee among the "red lodges," and every morning Seet-se-be-a set a lance and shield up beside the door, so that all people should know by the devices that the Bat lived there.

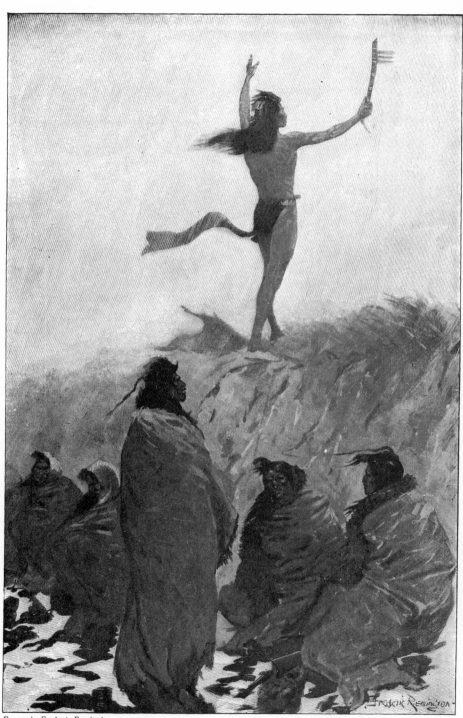

THE FIRE EATER RAISED HIS ARMS TO THE THUNDER BIRD

The Way of an Indian

BY FREDERIC REMINGTON

SYNOPSIS.—The opening instalments narrate the growth and development of White Otter, a Chis-chis-chash boy. He finds his fetich or "medicine" in a little brown bat, and sets forth with his friend, Red Arrow, to win the eagle-plume of the warrior, which he does by the wanton murder of an Absaroke. In his new estate he is known, from his "medicine," as the Bat. Despite his cruelty, the young Indian shows a fine sense of honor in a deal with some white traders, by which he obtains possession of a long-coveted rifle. But the baser instincts again assert themselves when he steals Seet-se-be-a, a Minataroe girl, wife of the half-breed Papin, at Fort Laramie, and marries her according to the ancient Indian rites.

V

"THE KITES AND THE CROWS"

THE Bat had passed the boy stage. He was a Chis-chis-chash warrior now, of agile body and eager mind. No man's medicine looked more sharply after his physical form and shadow-self than did the Bat's; no young man was quicker in the surround; no war-pony could scrabble to the lariat ahead of his in the races. He had borne more bravely in the Sun-dance than all others, and those who had done the ceremony of "smoking his shield" had heard the thick bull's-hide promise that no arrow or bullet should ever reach the Bat. He lost the contents of his lodge at the game of the plum-stones—all the robes that Seet-se-be-a had fleshed and softened, but more often his squaw had to bring a packpony down to the gamble and pile it high with his winnings. He was much looked up to in the warrior class of the Red Lodges, which contained the tried-out braves of the Cheyenne tribe; moreover old men—wise ones—men who stood for all there was in the Chis-chis-chash talked to him occasionally out of their pipes, throwing measuring glances from under lowering brows in his direction to feel if he had the secret Power of the Eyes.

The year passed until the snow fell no longer and Big Hair said the medicine chiefs had called it "The Falling Stars Winter" and had painted the sign on the sacred robes. The new grass changed from yellow to a green velvet, while the long hair blew off the horses' hides in bunches and their shrunken flanks filled up with fat. As nature awoke from the chill and began to circulate, the Indians responded to its feel. They stalked among the pony herds, saying to each other, "By the middle of the moon of the new Elk Horns, these big dogs will carry us to war."

The boys of the camp herded the ponies where the grass was strongest, and the warriors watched them grow. It was the policy of the tribe to hang together in a mass against the coming of the enemy, for the better protection of the women and the little ones, but no chiefs or councils were strong enough to stop the yearning of the young Cheyennes for military glory. All self-esteem, all applause, all power and greatness, came only down that fearful road—the war-trail. Despite the pleadings of tribal policy Iron Horn, a noted war- and mystery-man, secretly organized his twenty men for glorious death or splendid triumph. Their orders went forth in whispers. "By the full of the moon at the place where the Drowned Buffalo water tumbles over the rocks one day's pony-travel to the west."

Not even Seet-se-be-a knew why the Bat was not sitting back against his willow-mat in the gray morning when she got up to make the kettle boil, but she had a woman's instinct which made her raise the flap to look out. The two war-ponies were gone. Glancing again behind the robes of his bed she saw, too, that the oiled rifle was missing. Quickly she ran

to the lodge of Red Arrow's father, wailing, "My man has gone, my man has gone—his fast ponies are gone—his gun has gone," and all the dogs barked and ran about in the shadows while Red Arrow's mother appeared in the hole in the tepee, also wailing, "My boy has gone, my boy has gone," and the village woke up in a tumult. Every one understood. The dogs barked, the women wailed, the children cried, the magpies fluttered overhead while the wolves answered back in piercing yells from the plains beyond.

Big Hair sat up and filled his pipe. He placed his medicine-bag on a pole before him and blew smoke to the four sides of the earth and to the top of the lodge saying: "Make my boy strong. Make his heart brave, oh Good Gods—take his pony over the dog-holes—make him see the enemy first!" Again he blew the smoke to the deities and continued to pray thus for an hour until the sunlit camp was quiet and the chiefs sat under a giant cotton-wood, devising new plans to keep the young men at home.

Meanwhile from many points the destined warriors loped over the rolling landscape to the rendezvous. Tirelessly all day long they rose and fell as the ponies ate up the distance to the Drowned Buffalo, stopping only at the creeks to water the horses. By twos and threes they met, galloping together—speaking not. The moon rose big and red over their backs, the wolves stopped howling and scurried one side—the ceaseless thud of the falling hoofs continued monotonously, broken only by the crack of a lash across a horse's flank.

At midnight the faithful twenty men were still seated in a row around Iron Horn while the horses, too tired to eat, hung their heads. The old chief dismissed his war-party saying, "To-morrow we will make the mystery—we will find out whether the Good Gods will go with us to war or let us go alone."

Sunrise found the ponies feeding quietly, having recovered themselves, while the robed aspirants sat in a circle. The grass had been removed from the enclosed space and leveled down.

A young man filled the long medicine-pipe and Iron Horn blew sacrificial puffs about him, passing it in, saying: "Let no man touch the pipe who has eaten meat since the beginning of the last sun. If there are any such he must be gone—the Good Gods do not speak to full men." But the pipe made its way about the ring without stopping.

Iron Horn then walked behind the circle sticking up medicine-arrows in the earth—arrows made sacred by contact with the great medicine of the Chis-chis-chash and which would hold the Bad Gods in check while the Good Gods counseled.

Resuming his seat, he spoke in a harsh, guttural clicking: "What is said in this circle must never be known to any man who does not sit here now. The Bad Gods will hear what the Good Gods say in such an event and the man who tells against them will be deserted by the Good Gods forever. Every man must tell all his secrets—all the things he has thought about his brothers since the last war-medicine; all that the gods have whispered in his dreams. He must tell all and forever say no more," and Iron Horn rested on his words for a moment before continuing his confession:

"Brothers, I am a great medicine-man—no arrow can touch me—I do not fear men. I am too old for the women to look upon. I did not say it at the time, but when the sun was low on the land last winter, I made it turn blue for a time. I made it cold in the land. Our horses were poor, and when I made the sun blue we crusted the buffalo and killed many with our lances. Brothers, it was I who made the sun blue in the winter.

"Brothers, I love you all—I shall say no more," and Iron Horn threw tobacco on the earth in front of him.

A young man next to him dropped his robe from about his body and with fierce visage spoke excitedly, for it was his first confession and his Indian secretiveness was straining badly under the ordeal. It was mostly about gallantries and dreams—all made like the confessions which followed. They were the deeds and thoughts common to young Indian men.

The men now began to paint themselves and to take their paraphernalia from their war-bags and put it on. Iron Horn said: "Brothers—when it is dark I will put a medicine-arrow into the ground where my feet are now, and if in the morning it has not moved, we will go back to the lodges, but if it has moved, we will go in the direction in which it points.

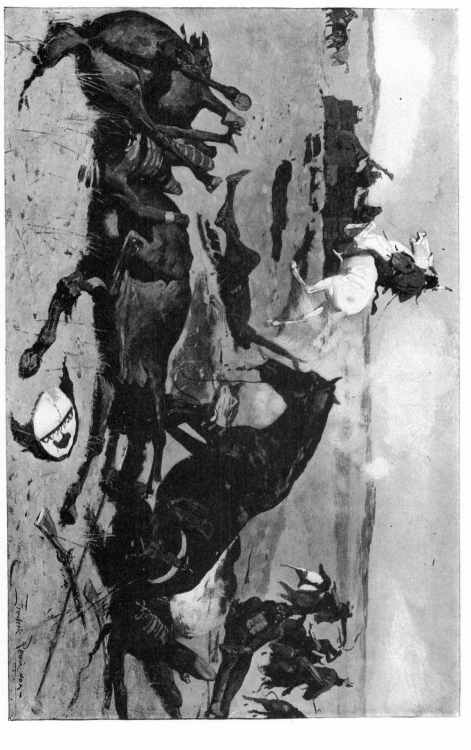

HE RUSHED THE PONY RIGHT TO THE BARRICADE

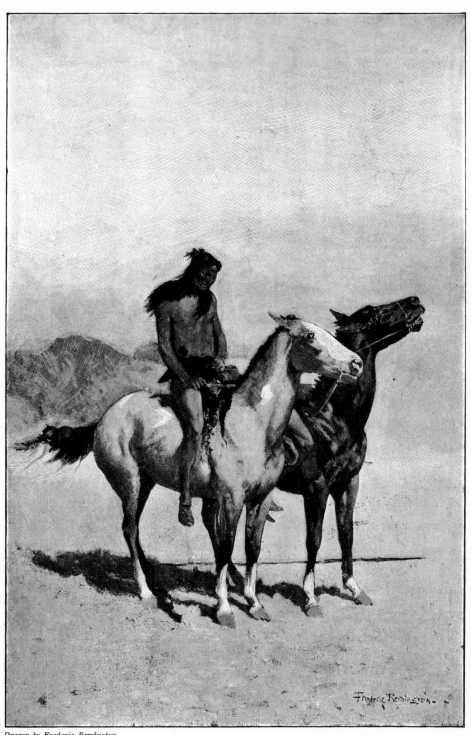

Drawn by Frederic Remington

THE FIRE EATER SLUNG HIS VICTIM ACROSS HIS PONY, TAKING HIS SCALP

"When we start toward the enemy no man must eat, drink or sit down by day, no matter how long or fatiguing the march; if he halts for a moment he must turn his face toward his own country so that the gods may see that it is his wish to return there. We must sleep with our own faces toward our village. No two men must lie covered by the same robe. We must not ride or walk in a beaten path lest the spirit of the path go running on ahead of us to warn the enemy, and if by chance we do, we must come to the big medicine and rub it on the horses' legs to ward off the danger."

This said, Iron Horn said much more to his young braves—all the demon fears which the savage mind conjures in its contact with the supernatural, together with stated forms of decorations to be painted on the ponies, and then he dismissed them, saying, "Come to the circle before the moon rises while it is yet dark, but meanwhile sit each man alone and in silence and we will see what the Good Gods do with the arrows."

The warriors led their ponies off to various points in the savage gorge and sat motionless the livelong day while the river rushed ceaselessly over the wild rocks and the ravens soared in the blue heavens.

By night they came gliding back, picking their way among the rocks, and stood by the bared earth of the mystery place. The chief struck a light and, bending over, saw the arrow lying out in the middle of the space many feet away from where he had placed it. The smooth earth was dotted by the tracks of coyotes, but the arrow pointed nearly southwest and it was the way they must take. Rising, he pointed, saying: "The Good Gods say we must go this way—where they point. The medicine is strong—the gods sent their little medicine-wolves to show us."

They struck a pole in the center of the circle, and when the moon rose each warrior approached it and either hung some piece of rag or buckskin on it or put various implements at its foot, muttering meanwhile prayers for protection and success and rubbing the pole with his weapons to vitalize them spiritually.

By the full light of the moon the mounted men, each leading a horse, rode slowly off, one after the other, into the hills, and they did not halt until nearly morning when they again sat in a magic circle and took heed of the medicine-arrows before lying down to sleep in a long row, facing toward the village.

The day following found the small war-party advancing cautiously, preceded far in advance on its flanks by watchful scouts. They were all eyes for any hunting bands of Utes or Shoshones and might see the Yellow-Eyes trooping along in a line as the ducks fly.

For days marched the band, winding through the lands or splashing through the flat rivers until early one morning they observed one of the scouts far in advance, flashing a looking-glass from a hilltop. Lashing their horses they bore on toward him, dashing down the cut banks at reckless speed or clambering up them helter-skelter. No inequalities of ground opposed their desperate speed.

Arriving at the place, they rode boldly up to the mounted scout and far down on the plains saw three Yellow-Eyes driving twelve pack animals heavily loaded. They paused to repaint their faces and put the sacred war-marks on the ponies, not forgetting to tie up their tails before continuing the mad charge. The poor beaver-hunters saw the on-coming, knew their danger, and instantly huddled their horses and began dropping their packs. They had selected a slight knoll of the prairie and before many minutes had a rude barricade constructed with their packages. Dropping behind this they awaited the Indians with freshly primed rifles and pistols.

The Chis-chis-chash rode in a perfect line and when within a hundred yards gave shrill "ki-yi's," lashed their whips and the ponies clattered through the dust. It would be all over with the three luckless trappers in an instant. When nearly half the distance had been consumed three rifles cracked. Iron Horn and another warrior reeled on their mounts but clung desperately, stopping in no way the rush. In an instant, when it seemed as if the Indians were about to trample the Yellow-Eyes, a thin trail of fire ran along the grass from the barricade and with a blinding flash a keg of powder exploded with terrific force right under the front feet of the rushing ponies. Pistols cracked from behind the pile of roped goods. Four ponies lay kicking on the grass together with six writhing men, all blackened, bleeding

and scorched. The other ponies reeled away from the shock—running hopelessly from the scene. All but one, for the Bat pulled desperately at his hair lariat which was tied to the under jaw of the horse. Striking his pony across the head with his elk-horn whip and, lashing fiercely, he rushed the pony right to the barricade. Firing his rifle into it swerving, he struck the bunch of trapper-horses which had already begun to trot away from the turbulent scene, and drove them off in triumph. He alone had risen superior to the shock of the white man's fire trap.

Four of the wounded Indians got slowly to their feet, one after the other, and walked painfully away. The whites had reloaded meanwhile and fatally shot the last man as he was nearly out of range.

When the defeated party came together, it made a mystic circle in the turf of open prairie, not over three arrow flights from the Yellow-Eyes, and there sat down. In the center lay the Indian dead and three more sightless with their hair singed off and their bodies horribly scorched, while Iron Horn was stretched on a blanket, shot through the body and singing weakly his death-song.

"Let the Bat take the medicine—he is a strong warrior—the bursting fire did not stop him. He ate the fire. I am a great warrior—I am a great medicine-man, but I could not eat the fire. Brothers, the scalps of the beaver-hunters must dry in the Red Lodges." Then the dying warrior became incoherent and scarcely mumbled. The Bat took black paint from his fire bag and rubbed it on the face of the dying man while the decreased circle of warriors yelped the death-cry dolorously. For an hour this continued, rising and rising in scales until the sadness had changed to fury. The Bat held the medicine toward the sun saying: "Mia-yu-ma—nis heva—la ma—nih. Nis tako navero nao' hiko' no hi. (Red Lodges—he has taken pity on us. He will make you strong—I am strong.)"

They took the dead and wounded and deposited them near where the led-horses were kept. The injured men were attended to, and the dead buried carefully in robes.

"One warrior lies dead near the feet of Yellow-Eyes; if they get his scalp he will go to the hungry islands in the middle of the Big Water and we shall never see him in the spirit-land. We must not let them touch his hair, brothers. If the Yellow-Eyes come from behind their packs we must charge—we must eat the flying fire or all be rubbed out. If they do not come out the ravens will not have to wait long for the feast." Thus said the Bat. He had kept his word about going farther toward the enemy than any other and was now moved to resort to strategy. He did not martial his warriors in a line but deployed them about the citadel of the plains. That place, robbed of its horrors, gave no sign of life except a burned and injured pony which raised itself and slowly moved its head from side to side in its agony. But behind it there was promise of deadly rifles and the bursting fire.

The warriors stood like vultures on the plains, by twos and threes, smoking and feeding their ponies from their lariats. They spoke of the chief no longer as the Bat but called him "Fire Eater" or "The Man who eats the Flying Fire." The ravens hovered about the place and wise, gray wolves sat haunched in a still larger ring without. Slowly the sun moved across the heavens. The scene was quiet and pitiful.

Night came on but nothing happened. Before the moon rose out of the darkness a rifle flashed behind the bales, when again the quiet became intensified by the explosion. The wolves sung their lullaby of death, but on the prairie that was as the ceaseless, peaceful surging of the waves on the ocean sand.

When the warriors returned in small parties to their camp for refreshment they saw the dead body of Owl Bear—he who had fallen outside the barricade of the Yellow-Eyes. The Fire Eater had brought it in during the night—having approached and carried it away—drawing the fire of the rifle but saving the hair and shadow-self of his brother.

For seven days the Chis-chis-chash stood about the doomed place. Twice they had approached it and had lost another warrior, shot by the fatal rifle of the beaver-men. Then they had drawn off and given up in the face of the deadly shooting—concluding to let nature work for the victory.

At last, becoming eager and restless, the Fire Eater's war-party galloped out to-

ward the fort. His brothers, seeing this rashness, closed in with him, but no sign of life came from the stronghold.

Boldly he rode up to the edge of the bales of goods, and glancing over saw the swelled and blackened bodies of the three beaver-men and knew by the skinned lips and staring eyes that thirst had done its work. The braves gathered, but no man dismounted and one by one they turned and rode away. "The bad spirits of the dead may get into our bodies—come away—come away—the sun shines now, but we must be far away when the night sets in. Our medicine-arrows will keep them off after that," said the Fire Eater.

Much cast down the Red Lodge warriors gathered up their dead and rode slowly back toward the village.

On the morning of the second day the Cheyennes awoke to find the Fire Eater gone, but he had left his horses on their hands. "The young chief's heart is sad. He has gone away by himself. He will not want us to follow him. He cannot go into the village with our dead and wear the mourning paint," whispered they, one to another.

This was true—for the fierce spirit of the young man could not brook defeat. The Chis-chis-chash should never see blackened ashes on a cheek which was only fitted for the red paint. The shield of the Fire Eater should never face to the lance—the little brown bat flapped fiercely in the wind and screamed for blood and scalp braids. The warrior traveled lazily on his journey—light-hearted and fiercely resolved.

After many days of wolfish travel he saw signs of the vicinage of the Shoshone Indians. They were a hungry band who had come out of the mountains and were hunting the buffalo. He followed the pony tracks where they were not lost in the buffalo trails, finding picked bones, bits of castaway clothing and other signs, until he saw the scouts of the enemy riding about the hills. Approaching carefully in the early night and morning he found the camp and lay watching for depressions in the fall of some bluffs. But the young men were ceaselessly active, and he did not see an opportunity to approach. During the night he withdrew to a pine-clad rocky fortress which promised better concealment, and his surprise was great in the

morning to see the Shoshones preparing to make a buffalo-surround in the valley immediately in front of him. From all directions they came and encompassed the buffalo below.

The Fire Eater carefully pressed down the tuft of loose hair which sat upright on the crown of his head after the manner of his people, and leaving his rifles he walked down toward the seething dust-blown jumble where the hunters were shearing their bewildered game. No one noticed him and the dust blew over him from the herd. Presently a riderless pony came by and seizing its lariat he sprang on its back. He rode through the whirling dust into the surround, and approaching an excited and preoccupied Shoshone, stabbed him repeatedly in the back. The Indian yelled, but no one paid any attention in the turmoil. The Fire Eater slung his victim across his pony, taking his scalp. He seized his lance and pony and rode slowly away toward the bluffs. . After securing his rifle he gained the timber and galloped away.

On his road he met a belated scout of the enemy coming slowly on a jaded horse. This man suspected nothing until the Fire Eater raised his rifle when he turned away to flee. It was too late and a second scalp soon dangled at the victor's belt. He did not take the tired horse for it was useless.

Swiftly he rode now for he knew that pursuit was sure, but if one was instituted it never came up, and before many days the Cheyennes rode along his own tepee, waving the emblem of his daring, and the camp grew noisy with exultation. The mourning paint was washed from each face and the old pipe-men said, "The Bat will be a great leader in war—his medicine is very strong and he eats fire." The chiefs and council withheld their discipline, and the Fire Eater grew to be a great man in the little world of the Chis-chis-chash, though his affairs proportionately were as the "Battles of the Kites and Crows."

VI

THE FIRE EATER'S BAD MEDICINE.

The Chis-chis-chash had remembered through many "green grasses" that the Fire Eater had proven himself superior

to the wrath of the Bad Gods who haunt the way of the men who go out for what the Good Gods offer—the ponies, the women and the scalps. He had become a sub-chief in the Red Lodge military clan. He had brought many painted war-bands into the big camp with the scalps of their tribal enemies dangling from their lance heads. The village had danced often over the results of his victories. Four wives now dressed and decorated his buffalo robes. The seams of his clothes were black with the hair of his enemies, as he often boasted, and it required four boys to herd his ponies. His gun was reddened, and there were twenty-four painted pipes on his shield indicative of the numbers who had gone down before him in war. In the time of the ceremonies, his chief's war-bonnet dragged on the ground and was bright with the painted feathers which belonged to a victor. He hated the Yellow-Eyes—not going often to their posts for trade, and like a true Indian warrior he despised a beaver trap. It was conceded by old men that time would take the Fire Eater near to the head chieftainship, while at all times the young men were ready to follow him to the camp of the foe.

One day in the time of the yellow-grass the Fire Eater had sat for hours, without moving, beside his tepee, looking vacantly out across the hills and speaking to no human being. His good squaws and even his much cherished children went about the camping space quietly, not caring to disturb the master. He was tired of the lazy sunshine of home; the small cackle of his women, one to another, annoyed him; he was strong with the gluttony of the kettle which was ever boiling; the longing for fierce action and the blood-thirst had taken possession of him. Many times he reached up with his hand to the crown of his head and patted the skin of the little brown bat, which was his medicine. This constantly talked to him in his brown study, saying: "Look—look at the war-ponies—the big dogs are fat and kick at each other as they stand by the wooden pins. They are saying you are too old for them. They think that the red hands will no more be painted on their flanks."

But the warrior, still with his sleepy dog-stare fixed on the vacant distance, answered the bat-skin: "We will seek the help of the Good Gods to-night; we will see if the path is clear before us. My shadow is very black beside me here—I am strong." Thus the Indian and his medicine easily agreed with each other in these spiritual conversations —which thing gave the Fire Eater added respect for the keeper of his body and his shadow-self.

Far into the night the preoccupied Indian leaned against his resting-mat watching the little flames leaping from the split sticks as his youngest squaw laid them on the fire.

After a time he sprang to his feet and drove the woman out of the lodge. Untying his war-bags he produced a white buffalo-robe and arranged it to sit on. This was next to the bat-skin his strongest protector. When seated on it he lost contact with the earth—he was elevated above all its influences. Having arranged his gun, shield and war-bonnet over certain medicine-arrows, the sacred bat-skin was placed on top. This last had, in the lapse of years, been worn to a mere shred and was now contained in a neat buckskin bag highly ornamented with work done by squaws. Lighting his medicine-pipe, after having filled it in the formal manner due on such occasions, he blew the sacrificial whiffs to the four corners of the world, to the upper realms and to the lower places, and then addressed the Good Gods. All the mundane influences had departed—even his body had been left behind. He was in communion with the spirit-world—lost in the expectancy of revelation. He sang in monotonous lines, repeating his extemporizations after the Indian manner and was addressing the Thunder Bird—the great bird so much sought by warriors. He sat long before his prayers were heeded, but at last could hear the rain patter on the dry sides of the tepee, and he knew that the Thunder Bird had broken through the air to let the rain fall. A great wind moaned through the encampment and in crashing reverberations the Thunder Bird spoke to the Fire Eater: "Go—go to the Absaroke—take up your pony-whip—your gun wants to talk to them —your ponies squeal on the ropes—your bat says no arrow or bullet can find him— you will find me over your head in time of danger. When you hear me roar across the sky and see my eyes flash fire, sit down and be still; I am driving your enemies back. When you come again back to the village you must sacrifice many robes and ponies to me." Lower and lower spoke the great bird as he passed onward—the rain ceased

to beat—the split sticks no longer burned—
the Fire Eater put up the sacred things and
was alone in the darkness.

In the early morning the devotee stalked
over to the great war-prophet—a mystery-
man of the tribe who could see especially far
on a contemplated war-path. The sun was
bright when they were done with their con-
versation, but the signs were favorable to
the spirit of war. The Thunder Bird had
on the preceding night also told the war-
prophet that the Chis-chis-chash had sat too
long in their lodges, which was the reason
why he had come to urge activity.

Accordingly—without having gone near
the boiled meat—the Fire Eater took the
war-pipe around the Red Lodges and
twenty young men gladly smoked it. In
council of the secret clan the war-prophet
and the sub-chief voiced for war. The old
chiefs and the wise men, grown stiff from
riding and conservative toward a useless
waste of young warriors, blinked their beady
eyes in protest, but they did not imperil their
popularity by advice to the contrary. The
young men's blood-thirst and desire for dis-
tinction could not be curbed.

So the war-prophet repaired to his secret
lodge to make the mystery, while the war-
riors fasted until it was done. Everything
about the expedition had been faithfully
attended to; all the divinities had been duly
consulted; the council had legitimatized it;
the Fire Eater had been appointed leader;
the war-prophet had the secret protection
forthcoming, and no band had lately gone
forth from the village with so many assur-
ances of success.

For many days the little streak of ponies
wound over the rolling brown land toward
the north. Each man rode a swift horse
and led another alongside. Far ahead
ranged the cautious spies; no sailing hawk,
no wailing coyote, no blade of grass did
anything which was not reasoned out by
mind or noted by their watchful eyes.

The Absaroke were the friends of the
Yellow-Eyes who had a little fort at the
mouth of the Muscleshell, where they gave
their guns and gauds in great quantities.
The Chis-chis-chash despised the men who
wore hats. They barely tolerated and half
protected their own traders. Nothing
seemed so desirable as to despoil the Absa-
roke traders. They had often spied on the
fort but always found the protecting
Absaroke too numerous. The scouts of the

Fire Eater, however, found immense trace
of their enemy's main camp as it had
moved up the valley of the Yellowstone.
They knew that the Absaroke had finished
their yellow-grass trading and had gone to
hunt the buffalo. They hoped to find the
little fort unprotected. Accordingly they
sped on toward that point, which upon
arrival they found sitting innocently alone
in the grand landscape. Not a tepee was to
be seen.

Having carefully reconnoitered and con-
sidered the place, they left their horses in a
dry washout and crawled toward it through
the sagebrush. As the sky grew pale
toward the early sun there was no sign of
discovery from its silent pickets. When
within a hundred yards, in response to the
commanding war-cry of the Fire Eater, they
rose like ghosts from the sage and charged
fast on the stockade. The gray logs stood
stiffly unresponsive and gave no answering
shots or yells as the Indians swept toward it.
The gate was high, but the attacking force
crept up on one another's bent backs as they
strove for the interior. A tremendous com-
motion arose; rifles blazed inside and out.
Two or three Indians sprang over but were
shot down. Hatchets hacked at the timbers;
gun-muzzles and drawn arrows sought the
crevices in the logs; piercing yells rose above
the hoarse shouts of the besieged, for the
stockade was full of white men.

The savages had not noticed a great
number of Mackinaw boats drawn up on
the river bank and concealed by low bushes.
These belonged to a brigade of freighters who
were temporarily housed in the post. As
the surprised whites and creoles swarmed
to the defense, the Indians found themselves
outnumbered three to one. The Fire
Eater, seeing several braves fall before the
ever-increasing fire from the palisades and
knowing he could not scale the barrier,
ordered a withdrawal. The beaten band
drew slowly away carrying the stricken
brothers.

The medicine was bad—the war-prophet
had not had free communication with the
mystery of the Good Gods. Some one had
allowed himself to walk in a beaten path or
had violated the sacred rights of the war-
path. The skin of the little brown bat
did not comfort the Fire Eater in his fallen
state. He cast many burning glances back
at the logs now becoming mellowed by the
morning light. The sun had apparently

thrown its protection over them, and the omen struck home to the wondering, savage mind. He remembered that the old men had always said that the medicine of the Yellow-Eyes was very strong and that they always fought insensibly, like the gray bears. The flashing rifles which had blown their bodies back from the fort had astonished these Indians less by their execution, than the indication they gave that the powers of darkness were not with them. They looked askance at the Fire Eater for their ill-success. He was enraged—a sudden madness had overpowered and destroyed his sense of the situation. One of those moods had come upon the savage child-mind when the surging blood made his eyes gleam vacantly like the great cat's.

Slowly the dismayed band withdrew to the washout—casting backward glances at the walls which had beaten down their ambitions and would paint the tribes with ashes and blood-sacrifices for the lost. When there, they sat about dejectedly, finding no impulse to do more. From out of the west, in response to their blue despondency, the clouds blew over the plains —the thunder rumbled—the rain came splashing and beating and then came in blinding sheets. The Fire Eater arose and standing on the edge of the bank raised his arms in thanks to the Thunder Bird for his interposition in their behalf saying: "Brothers, the Thunder Bird has come to his poor warriors to drive our enemies back as was promised to the prophet. He will put out the fires of the Yellow-Eyes, behind their medicine-logs. We are not afraid—our medicine is strong."

The rain poured for a time but abated gradually as the crashing Thunder Bird hurried away to the rising sun, and with a final dash it separated into drops, letting the sunlight through the departing drizzle. The warriors began drying their robes and their weapons—preoccupied with the worries so much dampness had wrought to their powder and bowstrings. Suddenly one of them raised his head, deerlike, to listen. As wild things they all responded, and the group of men was statuesque as it listened to the beat of horses' hoofs. As a flock of blackbirds leave a bush—with one motion— the statuary dissolved into a kaleidoscopic twinkle of movement as the warriors grabbed and ran and gathered. They sought their ponies' lariats, but before they

could mount a hundred mounted Yellow-Eyes swept down upon them, circling away as the Indians sowed their shots among them. But they were surrounded. The Thunder Bird had lied to the Chis-chis-chash—he had chosen to sacrifice the Fire Eater and the twenty Red Lodge braves. There was now no thought of arresting the blow—there was but to die as their people always did in war. The keepers of the Red Lodge counting robes might cross the red pipes out with black, but they should not wash them out entirely.

The beaver-men—the traders—the creoles and the half-breeds slid from their horses and showered their bullets over the washout, throwing clouds of wet dirt over the braves crowding under its banks. The frightened Indian ponies swarmed out of one end of the cut, but were soon brought back and herded together in the sagebrush by the moccasin-boys of the Yellow-Eyes.

In maddened bewilderment the Fire Eater leaped upon the flat plain, made insulting gestures and shouted defiant words in his own language at the flashing guns. Above the turmoil could be heard the harsh, jerky voice which came from the bowels of the warrior rather than from his lips. No bullet found him as he stepped back into cover, more composed than when he had gone out. The nervous thrill had expended itself in the speech. To his own mind the Fire Eater was a dead man, his medicine had departed; his spiritual protection was gone. He recognized that to live his few remaining hours was all—he had only to do the mere act of dying and that he would do as his demon nature willed it. His last sun was looking down upon him.

The Yellow-Eyes knew their quarry well. They recognized of old the difference between an Indian cooped up in a hole in a flat plain and one mounted on a swift war-pony, with a free start and the whole plain for a race track. They advanced with all caution—crawling, sneaking through sage and tufted grass. Occasionally as an Indian exposed himself for fire, a swift bullet from a beaver-man's long rifle crashed into his head, rolling him back with oozing brains. The slugs and ounce-balls slapped into the dirt from the muskets of the creole engagés and they were losing warrior after warrior. By cutting the dirt with their knives the Indians dug into the banks and, avoiding a fire which raked the

washout and by throwing the dirt up on either side, they protected their heads as they raised to fire.

A man walking over the flats by midday would have seen nothing but feeding ponies and occasional flashes of fire close to the grass, but a flying raven would have gloated over a scene of many future gorges. It would have seen many lying on their backs in the ditch—lying quite still and gazing up at his wheeling flight with stony gaze. Still there were others, rolling over on their backs to load their guns and again turning on their bellies to fire them.

The white men had no means of knowing how successful had been their rifle-fire and they hesitated to crawl closer. Each party in turn taunted the other in unknown tongue, but they well knew that the strange voices carried fearful insult from the loud defiance of the intonation. The gray bears or the mountain cats were as merciful as any there. As the sun started on its downward course the nature of the Gothic blood asserted itself. The white men had sat still until they could sit still no longer. They had fasted too long. They talked to each other through the sagebrush and this is what happened when they cast the dice between death and dinner.

A tall, long-haired man, clad in the fringed buckskin of a Rocky Mountain trapper of the period, passed slowly around the circle of the siege, shouting loudly to those concealed among the brush and grasses. What he said the Chis-chis-chash did not know, but they could see him pointing at them continually.

The Fire Eater raised his voice: "Brothers, keep your guns full of fire; lay all your arrows beside you; put your war-ax under you. The Yellow-Eyes are going to kill us as we do the buffalo in a surround. Brothers, if the Thunder Bird does not come, our fires will go out now. We will take many to the spirit-land."

Having completed the circle the tall white man waved a red blanket and started on a run toward the place where the Indians lay. From all sides sprang the besiegers, converging with flying feet. When nearly in contact the Indians fired their guns, killing and wounding. The whites, in turn, excitedly emptied theirs and through the smoke with lowered heads charged like the buffalo. The bowstrings twanged and the ravens could only see the lightning

sweep of axes and furious gun-butts going over the pall of mingled dust and powder smoke. If the ravens were watching they would have seen nothing more except a single naked Indian run out of the turmoil, and, after a quick glance backward, speed away through the sagebrush. He could not fight for victory now; he sought only to escape; he was deserted by his gods; he ran on the tightened muscles of a desperate hope.

A bunch of horses had been left huddled by a squad of the enemy who had gone in with the charge on post, and for these the Fire Eater made. No one seemed to notice the lone runner until a small herds-boy spied him, whereat he raised his childish treble, but it made no impression. The Fire Eater picked up a dropped pony-whip and leading two ponies out of the bunch, mounted and lashed away. He passed the screaming boy within killing distance, but it was an evil day.

Before the small herder's voice asserted itself he was long out of rifle-shot but not out of pony-reach. A dozen men dashed after him. The warrior plied his whip mercilessly in alternate slaps on each pony-quarter and the bareback savage drew steadily away to the hills. For many miles the white men lathered their horses after, but one by one gave up the chase. The dice doubtless said dinner as against an Indian with a double mount, and many will think they gave a wise choice.

On flew the Fire Eater. Confusion had come to him. The bat on his scalp-lock said never a word. His heart was upside down within him. His shadow flew away before him. The great mystery of his tribe had betrayed and bewitched him. The Yellow-Eyed medicine would find him yet.

From a high divide the fugitive stopped beside a great rock to blow his horses, and he turned his eyes on the scene of ill-fate. He saw the Yellow-Eyes ride slowly back to their medicine-logs. For a long time he stood—not thinking, only gazing heavy-headed and vacant.

After a time he pulled his ponies' heads up from the grass and trotted them away. Growing composed with his blood stilled, thoughts came slowly. He thanked the little brown bat when it reminded him of his savior. A furious flood of disappointment overcame him when he thought of his

lifelong ambitions as a warrior—now only dry white ashes. Could he go back to the village and tell all? The council of the Red Lodges would not listen to his voice as they had before. When he spoke they would cast their eyes on the ground in sorrow. The Thunder Bird had demanded a sacrifice from him when he returned. He could not bear the thoughts of the wailing women and the screaming children and the old men smoking in silence as he passed through the camp. He would not go back. He had died with his warriors.

When the lodges lay covered with snow the Chis-chis-chash sang songs to the absent ones of the Fire Eater band. Through the long, cold nights the women sat rocking and begging the gods to bring them back their warriors. The green-grass came and the prophet of the Red Lodges admitted that the medicine spoke no more of the absent band. By yellow-grass hope grew cold in the village and socially they had read-justed themselves. It had happened in times past that even after two snows had come and gone warriors had found the path back to the camp, but now men saw the ghost of the Fire Eater in dreams, together with his lost warriors.

Another snow passed and still another. The Past had grown white in the shadows of an all-enduring Present when the Chis-chis-chash began to hear vague tales from their traders of a mighty war-chief who had come down to the Shoshones from the clouds. He was a great "wakan" and he spoke the same language as the Chis-chis-chash. This chief said he had been a Cheyenne in his former life on earth, but had been sent back to be a Shoshone for another life. The Indians were overcome by an insatiate curiosity to see this being and urged the traders to bring him from the Shoshones—promising to protect and honor him.

The traders, dominated by avarice, hoping to better their business, humored the stories and enlarged upon them. They half under-stood that the mystery of life and death is inextricably mixed in savage minds—that they come and go, passing in every form from bears to inanimate things or living in ghosts which grow out of a lodge fire. So for heavy considerations in beaver skins they sent representatives to the Shoshones, and there, for an armful of baubles, they pre-vailed upon those people to allow their supernatural war-chief to visit his other race out on the great meadows.

"If, in the time of the next green-grass," said the trader, "the Chis-chis-chash have enough beaver—we will bring their brother who died back to their camp. We will lead him into the tribal council. If, on the other hand, they do not have enough skins, our medicine will be weak."

In the following spring the tribe gathered at the appointed time and place, camp-ing near the post. The big council-lodge was erected, the great ceremonial-pipe filled and the council-fire kept smoldering.

When the pipe had passed slowly and in form, the head-chief asked the trader if he saw beaver enough outside his window. This one replied that he did and sent for the man who had been dead.

The council sat in silence with its eyes upon the ground. From the commotion outside they felt an awe of the strange ap-proach. Never before had the Chis-chis-chash been so near the great mystery. The door-flap was lifted and a fully painted, gorgeously arrayed warrior stepped into the center of the circle and stood silently with raised chin.

There was a loud murmur on the outside that the lodge was like a grave. A loud grunt came from one man—followed by another until the hollow walls gave back like a hundred tom-toms. They recognized the Fire Eater, but no Indian calls another by his name.

Raising his hand with the dignity which Indians have in excess of all other men, he said: "Brothers, it makes my heart big to look at you again. I have been dead, but I came to life again. I was sent back by the gods to complete another life on earth. The Thunder Bird made the Yellow-Eyes kill all my band when we went against the Absaroke. My medicine grew weak before the white man's medicine. Brothers, they are very strong. Always beware of the medicine of the traders and the beaver-men. They are fools and women themselves, but the gods give them guns and other medicine things. He can make them see what is to happen long before he tells the Indians. They have brought me back to my people, and my medicine says I must be a Chis-chis-chash until I die again. Brothers, I have made my talk."

The Way of an Indian

BY FREDERIC REMINGTON

SYNOPSIS : White Otter, a Chis-chis-chash boy grows to manhood and wins the eagle-plume of the warrior. From his fetich or "medicine," he is known as the Bat. His character shows itself as a strange mixture of base instincts and a somewhat fine sense of honor. He steals an Indian girl, wife of a half-breed, and marries her. On a raiding expedition the Bat and his followers come across a small body of white traders and annihilate it. From this success the Bat is now called the Fire Eater, and becomes a great man among his people. He believes himself invincible until, miscalculating the strength of a party of freighters and Absaroke Indians, the whole of his attacking band is wiped out. The Fire Eater aione survives, and he flees to the Shoshones rather than face a return to his people. After two years the fame of a mysterious warrior among the Shoshones reaches the Chis-chis-chash, and they ask the white traders to bring him to them. The Fire Eater is recognized. He tells his people he has been dead, but has been sent back by the gods to complete another life on earth.

VII

AMONG THE PONY-SOLDIERS

THE burial scaffold of the Fire Eater's father had rotted and fallen down with years. Time had even bent his own shoulders, filled his belly and shrunk his flanks. He now had two sons who were of sufficient age to have forgotten their first sun-dance medicine, so long had they been warriors of distinction. He also had boys and girls of less years, but a child of five snows was the only thing which could relax the old man's features, set hard with thought and time and toil.

Evil days had come to the Buffalo Indians. The Yellow-Eyes swarmed in the Indian country, and although the red warriors rode their ponies thin in war, they could not drive the invaders away. The little bands of traders and beaver-men who came to the camps of the Fire Eater's boyhood with open hands were succeeded by immense trains of wagons, drawn by the white man's buffalo. The trains wound endlessly toward the setting sun—paying no heed to the Indians. Yellow-Eyes came to the mountains where they dug and washed for the white man's great medicine, the yellow iron. The fire boats came up the great river with a noise like the Thunder Bird—firing big medicine-guns which shot twice at one discharge.

The Fire Eater, with his brothers of the Chis-chis-chash, had run off with the horses and buffalo of these helpless Yellow-Eyes until they wanted no more. They had knocked them on the head with battle-axes in order to save powder. They had burned the grass in front of the slow-moving trains and sat on the hills laughing at the discomfiture caused by the playful fires. Notwithstanding, all their efforts did not check the ceaseless influx and a vague feeling of alarm began to pervade them.

Talking-men came to them and spoke of their Great Father in Washington. It made them laugh. These talking-men gave them enough blankets and medicine-goods to make the travvis poles squeak under the burden. When these men also told them that they must live like white men, the secret council lost its dignity ·entirely and roared long and loud at the quaint suggestion.

Steadily flowed the stream of wagons over the plains though the Indians plied them with ax and rifle and fire. Sober-minded old chiefs began to recall many prophecies of the poor trappers who told how their people swarmed behind them and would soon come on.

Then began to appear great lines of the Great Father's warriors—all dressed alike and marching steadily with their wagons drawn along by half-brothers to the horse. These men built log forts on the Indian lands and they had come to stay.

The time for action had come. Runners went through the tribes calling great councils which made a universal peace between the red brothers. Many and fierce were the fights with these blue soldiers of the Great Father. The Indians slew them by hun-

THE RUSHING RED LODGES PASSED THROUGH THE LINE OF THE BLUE SOLDIERS

dreds at times and were slain in turn. In a grand assault on some of these which lay behind medicine-wagons and shot medicine-guns, the Indian dead blackened the grass and the white soldiers gave them bad dreams for many days.

The talking-wives and the fire wagon found their way, and the white hunters slew the buffalo of the Indians by millions, for their hides.

Every year brought more soldiers who made more log forts from which they emerged with their wagons, dragging after the trace of the Chis-chis-chash camp, and disturbing the buffalo and the elk. To be sure, the soldiers never came up because the squaws could move the travvis more rapidly than the others could their wagons, but it took many young men to watch their movements and keep the grass burning before them. Since the Indians had made the wagon fight, they no longer tried to charge the soldiers, thinking it easier to avoid them. The young men were made to run their ponies around the Yellow-Eyes before it was light enough in the morning for them to shoot, and they always found the Yellow-Eyes heavy with sleep; but they did not grapple with the white soldiers because they found them too slow to run away and enemies who always fought wildly, like bears. Occasionally the Indians caught one of them alive, staked him out on a hill, and burned him in sight of his camp. These Yellow-Eyes were poor warriors, for they always whined and yelled under the torture. Half-breeds who came from the camp of the Yellow-Eyes said that this sight always made the white soldiers' blood turn to water. Still the invaders continued to crawl slowly along the dusty valleys. The buffalo did not come up from the south—from the caves of the Good Gods where they were made—in such numbers as they once did and the marching soldiers frightened those which did and kept them away. The young warriors never wearied of the excitement of these times, with its perpetual war-party, but old men remembered the prophecies of the beaver-men and that the times had changed.

The Fire Eater as he talked to old Weasel Bear over their pipes and kettles said:

"Brother—we used to think Yellow Horse had lost the Power of his Eyes when he came from his journey with the talking white man. We thought he had been made to dream by the Yellow-Eyes. We have seen the talking-wives and we have seen fire wagons. We have seen the white men come until there are as many as all the warriors in this camp. All the foolish half-breeds say it is as the talking-men say. Brother, I have seen in my dreams that there are more of them than the buffalo. They have their caves to the east as the buffalo do to the south, and they come out of them in the time of the green-grass just as the buffalo do. The Bad Gods send the Yellow-Eyes and the Good Gods send the buffalo. The gods are fighting each other in the air."

Weasel Bear smoked in silence until he had digested the thoughts of his friend when he replied.

"Your talk is good. Two grasses ago I was with a war-party and we caught a white man between the bends of the Tois-ta-to-e-o. He had four eyes and also a medicine-box which we did not touch. All the hair on his head and face was white as the snow. While we were making the fire to burn him with he talked much strong talk. Before we could burn him he sank down at our feet and died a medicine-death. We all ran away. Bad Arm, the half-breed who was with us, said the man had prophesied that before ten snows all our fires would be put out by his people. Brother, that man hath the Power of the Eyes. I looked at him strong while he talked. I have seen him in my dreams—I am afraid."

The Fire Eater continued:

"You hear our young scouts who come in tell us how the white soldiers are coming in droves this grass. There are walking-soldiers, pony-soldiers, big guns on wheels and more wagons than they can count. Many of their scalps shall dry in our lodges, but, brother, we cannot kill them all."

In accordance with the tribal agreements, the Chis-chis-chash joined their camp with the Dakota, and together both tribes moved about the buffalo range. Every day the scouts came on reeking ponies to the chiefs. The soldiers were everywhere marching toward the camps. The council fire was always smoldering. The Dakota and Chis-chis-chash chiefs sat in a dense ring while Sitting Bull, Gull, Crazy Horse and all the strong men talked. They regarded the menace with awe; they feared for the camp with its women and children, but each voice was for war. It was no longer poor beaver-men or toiling bull-wagons; it was crowds of soldiers coming up every valley toward the

villages which before had been remote and unmolested. If any soothsayer could penetrate the veil of the future he held his peace in the councils. The Indians tied up their ponies' tails for the struggle and painted for war. Three cartridges were all a fine buffalo robe would bring from a trader and even then it was hard to get them, but, if the lodges had few robes, many brass-bound bullets reposed in the war-bags.

The old thrill came over the Fire Eater in these agitated times. He could no longer leap upon his pony at full gallop but rode a saddle. The lodge chafed him until he gathered up a few young men who had been acting as spies and trotted forth on a coyote prowl. For many days they made their way toward the south. One day as he sat smoking by a small fire on a mountain-top, somewhat wearied with travel—the restless young men came trotting softly back over the pine needles, saying,

"Come out and you will see the white soldiers." He mounted and followed and, sitting there amid the mountain tangle, he saw his dreams come true. The traders and the talking-men had not lied about the numbers of their people, for his eye did not come to the rear of the procession which wound up the valley like a great snake. There were pony-soldiers, walking-soldiers, guns on wagons, herds of the white men's buffalo, and teams without end. The Fire Eater passed his hands across his eyes before another gaze reassured him, and having satisfied himself he asked a young man, "Brother, you say there are as many more soldiers up north by the Yellowstone?"

"There are as many more—I saw them with my own eyes and Blow Cloud over there has seen as many to the east. He could not count them."

For an hour the spies watched the white columns before the Fire Eater turned his pony and, followed by his young men, disappeared in the timber.

Upon his arrival at the big camp the Fire Eater addressed the council:

"I have just come five smokes from the south, and I saw the white soldiers coming. I could not count them. They crawl slowly along the valley and they take their wagons to war. They cannot travel as fast as our squaws, but they will drive the buffalo out of the land. We must go out and fight them while our villages lie here close to the mountains. The wagon-soldiers cannot follow the women's pack-horses into the mountains."

The council approved this with much grunting, and the warriors swarmed from the villages—covering the country until the coyotes ran about continually to get out of their way. No scout of the enemy could penetrate to the Indian camps. The Indians burned the grass in front of the oncoming herds; they fired into the enemy's tents at night, and as the pony-soldiers bathed naked in the Yellowstone, ran their horses over them. They would have put out many white soldiers' fires if the wagon-guns had not fired bullets which burst among them.

But it was all to no purpose. Slowly the great snakes crawled through the valleys and the red warriors went riding back to the village to prepare for flight.

One morning the Fire Eater sat beside his lodge fire playing with his young son—a thing which usually made his eyes gleam. Now he looked sadly into the little face of the boy who stood holding his two great scalp-braids in his chubby hands. He knew that in a day or two the camp must move and that the warriors must try to stop the Yellow-Eyes. Taking from his scalp a buckskin bag which contained his bat-skin medicine he rubbed it slowly over the boy's body and it made the boy laugh. The sun was barely stronger than the lodge fire when from far away on the hills beyond the river came a faint sound borne on the morning wind, yet it electrified the camp, and, from in front of the Fire Eater's tent, a passing man split the air with the wolfish war-yell of the Chis-chis-chash. As though he had been a spiral spring released from pressure, the Fire Eater regained his height. The little boy sat briskly down in the ashes, adding his voice to the confusion which now reigned in the great camp in most disproportionate way. The old chief sprang to his doorway in time to see a mounted rider cut by who shrieked, "The pony-soldiers are coming over the hills," and disappeared among the tepees.

With intense fingers the nerved warrior readjusted his life treasure, the bat-skin, to his scalp-lock, then opening his war-bags, which no other person ever touched on pain of death, he quickly daubed the war-paint on his face. These two important things having been done, he filled his ammunition bag with a double handful of cartridges, tied

his chief's war-bonnet under his chin, and grasping his rifle, war-ax and whip, he slid out of the tepee. An excited squaw hastily brought his best war-pony with its tail tied up, as it always was in these troublesome times. The Fire Eater slapped his hand violently on its quarters and, when he raised it, there was the red imprint of the hand of war. The frightened animal threw back its head and backed away, but, with a bound like a panther, the savage was across its back, a thing which, in tranquil times, the old man was not able to do.

This was the first time in years that the warrior had a chance to wear his war-bonnet in battle. Rapidly adjusting his equipment as he sat his plunging horse, he brought his quirt down with a full-arm swing and was away. By his side many sturdy war-ponies spanked along. At the ford of the river they made the water foam, and the far side muddy, with their drip. They were grotesque demons, streaked and daubed, on their many-colored ponies. Rifles clashed, pony-whips cracked, horses snorted and blew, while the riders emitted the wild yelps which they had learned from the wolves. Back from the hills came their scouts sailing like hawks, scarcely seeming to touch the earth as they flew along. "The pony-soldiers are coming—they are over the hill," they cried. The crowded warriors circled out and rode more slowly as their chiefs marshaled them. Many young Red Lodge braves found the Fire Eater place, boys who had never seen the old man in war, but who had listened in many winter lodges where his deeds were "smoked." As they looked at him now they felt the insistency of his presence—felt the nervous ferocity of the wild man; it made them eager and reckless, and they knew that such plumes as the Fire Eater wore were carried in times like these.

The view of the hill in front was half cut by the right bank of the coulee up which they were going, when they felt their hearts quicken. One, two, a half dozen, and then the soldiers of the Great Father broke in a flood across the ridge, galloping steadily in column, their yellow flags snapping. The Fire Eater turned and gave the long yell and was answered by the demon chorus—all whipping along. The whole valley answered in kind. The rifles began to pop. A bugle rang on the hill, once, twice, and the pony-soldiers were on their knees, their front a blinding flash, with the blue smoke

rolling down upon the Indians or hurried hither and thither by the vagrant winds. Several followers of the Fire Eater reeled on their ponies or waved from side to side or clung desperately to their ponies' necks, sliding slowly to the ground as life left them. Relentless whips drove the maddened charge into the pall of smoke, and the fighting men saw everything dimly or not at all.

The rushing Red Lodges passed through the line of the blue soldiers, stumbling over them and striking downward with their axes. Dozens of riderless troop-horses mingled with them, rushing aimlessly and tripping on dangling ropes and reins. Soon they were going down the other side of the hill and out of the smoke; not all, for some had been left behind. Galloping slowly, the red warriors crowded their cartridges into their guns while over their heads poured the bullets of the soldiers who, in the smoke, could no longer be seen. On all sides swarmed the rushing warriors mixed inextricably with riderless troop-horses mad with terror. As the clouds of Indians circled the hill, the smoke blew slowly away from a portion of it, revealing the kneeling soldiers. Seeing this the Fire Eater swerved his pony and, followed by his band, charged into and over the line. The whole whirling mass of horsemen followed. The scene was now a mass of confusion which continued for some time, but the frantic Fire Eater, as he dashed about, could no longer find any soldiers. As the tumult quieted and the smoke gave back, they all seemed to be dead. Dismounting, he seized a soldier's hair and drew his knife, but was not able to wind his fingers into it. He desisted and put back his knife muttering, "A dog—he had not the hair of a warrior—I will not dance such a scalp."

The Fire Eater looked around him and saw the warriors hacking and using their knives, but the enemy had been wiped out. Horses lay kicking and struggling, or sat on their haunches like dogs with the blood pouring from their nostrils. He smiled at the triumph of his race, mounted his pony and with his reeking war-ax moved through the terrible scene. The hacking and scalping was woman's work—anyone could count a *coup* here. As for the Fire Eater, his lodge was full of trophies, won in single combat. Slowly he made his way down the line of horror until he came to the end—to the place where the last

soldier lay dead, and he passed on to a neighboring hill to view the scene. As he stood looking, he happened to cast his eyes on the ground and there saw a footprint. It was the track of a white man's moccasins with the iron nails showing, and it was going away from the scene of action. Turning his pony, he trotted along beside the trail. Over the little hills it ran through the sagebrush. Looking ahead, the Fire Eater saw a figure in a red blanket moving rapidly away. Putting his pony to speed, he bore down with his rifle cocked upon the man. The figure increased its gait, and the red blanket fell from the shoulders revealing a blue soldier. It was but an instant before the pony drew up alongside and the white man stood still, breathing heavily. The Fire Eater saw that his enemy had no gun, the thought of which made him laugh—"A naked warrior; a man without even a knife; does the man with the iron moccasins hope to outrun my war-pony?"

The breathless and terrified white man held out his hand and spoke excitedly, but the Fire Eater could not understand. With menacing rifle he advanced upon his prey, whereat the white man, suspecting his purpose, quickly picked up a loose stone and threw it at him but only hit the pony. The Fire Eater straightway shot the soldier in the thigh and the latter sat down in the dirt. The old chief got off his horse, chuckling while he advanced, and sat down a few yards from the stricken man. He talked to him saying: "Brother I have you now. You are about to die. Look upon the land for the last time. You came into my country to kill me, but it is you who are to be killed."

The white soldier could not make out the intention of the Indian for the language was mild and the face not particularly satanic. He pleaded for his life, but it had no effect upon the Fire Eater, who shortly arose and approached him with his battle-ax. The men saw clearly now what was to happen and buried his face in his hands. Too often had the hunter-warrior stood over his fallen quarry to feel pity; he knew no more of this than a bird of prey, and he sank his three-pronged battle-ax into the soldier's skull and wiped it on his pony's shoulder saying: "Another dog's head; I will leave him for the women and the boys. If he had thrown away his iron moccasins his fire would not be out. I give the meat to the little gray wolves and to the crowd which bring us messages from the spirit-world," and he resumed his mount.

Riding back, he saw the squaws swarming over the battlefield, but the warriors had gone. Men that he met in the valley told him that they had more soldiers surrounded in the bluffs up the valley, but that the white-faces could not get away and that the Indians were coming back for fresh ponies. Enough men had been left to hold the besieged.

Coming to his lodge he got a new pony, and, as he mounted, said to his youngest wife: "Wan-ha-ya, give me my little boy; put him up behind me on my pony. I will show him war."

The squaw held the chubling and put him on the desired place where he caught on like a burr. The Fire Eater made his way to the battle ground. There the squaws were stripping and mutilating. Finding a dead soldier who was naked, he dismounted, setting the boy on the ground. Pulling his great knife from its buckskin sheath, he curled the fat little hand around its shaft and led him to the white body. "Strike the enemy, little son, strike like a warrior," and the Fire Eater, simulating a blow, directed the small arm downward on the corpse. Comprehending the idea, the infant drew up and drove down, doing his best to obey the instructions, but his arm was far too weak to make the knife penetrate. The fun of the thing made him scream with pleasure, and the old Fire Eater chuckled at the idea of his little warrior's first *coup*. Then he rode back to the lodge.

The Way of an Indian

BY FREDERIC REMINGTON

SYNOPSIS: White Otter, a Chis-chis-chash boy grows to manhood and wins the eagle-plume of the warrior. From his fetich, or "medicine," he is known as the Bat. His character shows itself as a strange mixture of base instincts and a somewhat fine sense of honor. He steals an Indian girl, wife of a half-breed, and marries her. On a raiding expedition the Bat and his followers come across a small body of white traders and annihilate it. From this success the Bat is now called the Fire Eater, and becomes a great man among his people. He believes himself invincible until, miscalculating the strength of a party of freighters and Absaroke Indians, the whole of his attacking band is wiped out. The Fire Eater alone survives, and he flees to the Shoshones rather than face a return to his people. After two years the fame of a mysterious warrior among the Shoshones reaches the Chis-chis-chash, and they ask the white traders to bring him to them. The Fire Eater is recognized. He tells his people he has been dead, but has been sent back by the gods to complete another life on earth. The white men are now coming in large numbers to the Indian country. The redskins harass them continually, but are unable to drive them out. They resent and deride the government's attempt to make them live like the whites, and troops of soldiers put in an appearance.

VIII

THE MEDICINE-FIGHT OF THE CHIS-CHIS-CHASH

 HITHER and yon through the valleys dragged the wagon-soldiers, while the Indians laughed at them from the hills. In the time of the yellow-grass the tribe had made a successful hunt and the sides of their lodges were piled high with dry meat. Their kettles would boil through this snow.

As the tops of the mountains grew white, the camp was moved into a deep gorge of the Big Horn Mountains out of the way of the trailing Yellow-Eyes. For a thousand feet the rock walls rose on either side. A narrow brook wound down between their narrow ways. Numerous lateral cañons crossed the main one, giving grass and protection to their ponies. As it suited the individual tastes of the people, the lodges were placed in cozy places.

They felt secure in their eerie home, though the camp-crier frequently passed shouting, "Do not let your ponies wander down the cañon and make trails for the Yellow-Eyes to see." The women worked the colored beads and porcupine quills, chatted with one another, or built discreet romances, as fancy dictated. The men gambled, or made smoke-talks by the night fires. It was the Indian time of social enjoyment.

Restless young men beat up the country in search of adventure; and only this day a party had arrived with Absaroke scalps which they were dancing after the sun had gone. The hollow beat of the tom-toms multiplied against the sides of the cañon, together with wild shrieking and yelling of the rejoicers; but the old Fire Eater had grown weary of dancing scalps. He had danced his youthful enthusiasm away. Thus he sat on this wild, whooping night with old Big Hand by his side to smoke his talk, and with his son asleep across his lap.

"Where did the war-party leave its trail as it came to the lodges?" he asked.

Big Hand in reply said: "The man who strikes said they came over the mountains —that the snow lay deep. They did not lead up from the plains. They obeyed the chiefs. If it was not so, the camp-soldiers would have beaten them with sticks. You have not heard the women or the dogs cry."

"It is good," continued the Fire Eater. "The wagon-soldiers will not find a trail on the high hills. The snow would stop their wheels. They will dream that the Chis-chis-chash were made into birds and have flown away."

Then Big Hand: "I have heard, brother, that ponies passed the herders at the mouth of the cañon last smoke. It was cold,

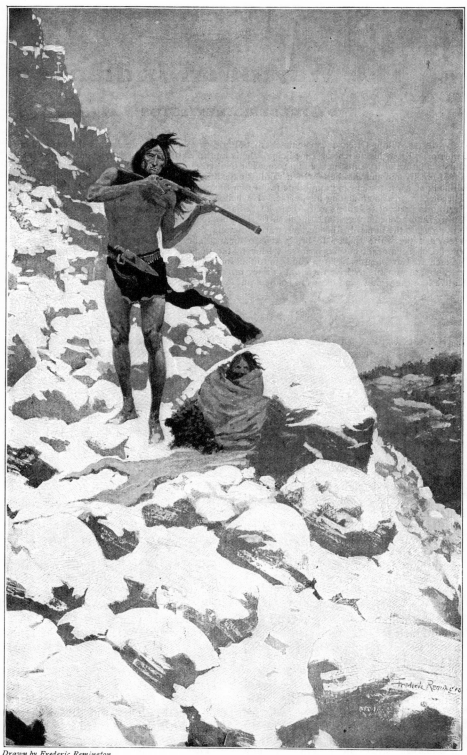

Drawn by Frederic Remington

HE MADE HIS MAGAZINE GUN BLAZE UNTIL EMPTY

and they had their robes tight over their heads. It is bad."

"Yes, you talk straight. It is bad for the pony trails to show below where the land breaks. Some dog of an Absaroke who follows the gray fox may see them. Ponies do not go to live in the hills in the time of snow. The ponies will not travel straight, as the herders drive them back. They will understand. With another sun, I shall call the council. It will talk the herders' eyes open. The young men have closed ears in these days. The cold makes their bones stiff. Brother, when we were young we could see a horse pass in the night. We could smell him. We could tell if he had a man on his back."

Big Hand gave wise consideration to his companion's statement, saying it was as he spoke. "Brother, those big horses which we took from the pony-soldiers run badly in the herd. They gather in a bunch and run fast. They go over the herders when they see the valley. They will do nothing unless you strike them over the head. They are fools like their white riders were."

So the old men gravely passed the pipe over the little things of life, which to them bore all their interest in the world. The squaw combed her hair and put fresh sticks on the fire from time to time. After a time the boy woke up and stretched himself cubbishly across his father's knees. The ancient one gave him a piece of fresh meat, which he held in both hands as he gnawed it, smearing his chubby face with grease. Having devoured his morsel he blinked sleepily, and the old Indian tucked him away in the warm recesses of his old buffalo-robe couch, quite naked, as was their custom to sleep during the winter nights. Long sat the smokers, turning their tongues over youthful remembrances, until Big Hand arose and drawing his robe about him, left the lodge.

The Fire Eater removed the small buckskin bag which contained his little brown bat's skin from his scalp-lock and smoked to it saying, "Keep the big horses from running down the cañon—keep the eyes of the herders open while I sleep—keep the little boy warm—keep the bad spirits outside the lodge after the fire can no longer see them." With these devotions concluded, he put the relic of the protection of the Good Gods in his war-bag which hung on his resting-mat over his head.

Undressing, he buried himself in his buffalo robes. The fire died down, the tom-toms and singing in the adjoining lodges quieted gradually, and the camp slept.

In the ceaseless round of time the night was departing to the westward when, as though it were in a dream, the old warrior was conscious of noise. His waking sense was stirred. Rapid, frosty cracking of snow ground by horse-hoofs came through the crevices of his covering. All unusual, he sat up with a savage bang, as it were, and bent a stiff ear to the darkness. His senses were electric, but the convolutions of his brain were dead. A rifle shot, far away but unmistakable. Others followed; they came fast, but not until the clear notes of a bugle blazed their echoing way up the rock walls did he, the Fire Eater, think the truth. He made the lodge shake with the long yell of war. He did the things of a lifetime now and he did them in a trained, quick way. He shoveled his feet into his moccasins and did no more because of the urgency of the case; then he reached for his rifle and belt and stood in the dark lodge aroused. His sleep was gone but he did not comprehend. Listening for the briefest of moments, he heard amid the yelping of his own people the dull, resonant roar which he knew was the white man's answer.

Fired into a maddened excitement, he snatched up his precious boy and seizing a robe, ran out of the lodge followed by his squaw. Overhead the sky was warming but the cañon was blue dark. Every moment brought the shots and roar nearer. Plunging through the snow with his burden, the Fire Eater ran up a rocky draw which made into the main cañon. He had not gone many arrow-flights of distance before the rushing storm of the pony-soldiers swept past his deserted lodge. Bullets began to whistle about him, and, glancing back, he saw the black form of his squaw stagger and lie slowly down in the snow. He had, by this time, quite recovered the calm which comes to the tired-out man when tumult overtakes him. Putting the boy down on a robe behind a rock, and, standing naked in the frosty air, he made his magazine gun blaze until empty. Resuming his burden, he ran on higher up the rocks until he was on the table-land of the top of the cañon. Here he resumed his shooting, but the darkness and distance

made it difficult to see. Other Indians joined him and they poured their bullets into the pony-soldiers.

The Bad God had whispered to the Yellow-Eyes; they had made them see under the snow. The Chis-chis-chash were dead men, but they would take many with them to the spirit-land. The Fire Eater felt but a few cartridges in his belt and knew that he must use them sparingly. The little boy sat crying on the buffalo robe. Holding his smoking rifle in one hand, he passed the other over his scalp-lock. The bat-skin medicine was not there. For the first time since the Good Gods had given it to him, back in his youth, did he find himself without it. A nameless terror overcame him. He was a truly naked man in the snow, divested of the protection of body and soul.

Shoving cartridges into his magazine, he made his way down, the light snow flying before him. Rounding the rocks he could see down into the main cañon; see the pony-soldiers and their Indian allies tearing down and burning the lodges. The yellow glare of many fires burned brightly in contrast with the cold blue of the snow. He scanned narrowly the place where his own lodge had been and saw it fall before many hands to be taken to their fires. The bat-skin—the hand of the Good Gods—was removed from him; his shadow was as naked as his back.

In the snow a hundred yards below him lay his young squaw, the mother of his boy; and she had not moved since she lay down.

As the pony-soldiers finally saw the stark figure of the Indian among the rocks they sent a shower of bullets around him. He had no medicine; the Bad Gods would direct the bullets to his breast. He turned and ran frantically away.

The last green-grass had seen the be-plumed chief with reddened battle-ax leading a hundred swift warriors over the dying pony-soldiers, but now the cold, blue snow looked on a naked man running before bullets, with his medicine somewhere in the black smoke which began to hang like a pall over the happy winter-camp of the bravest Indians. The ebb and flow of time had fattened and thinned the circumstances of the Fire Eater's life many times, but it had never taken his all before. It had left him nothing but his boy and a nearly empty gun. It had placed him

between the fire of the soldiers' rifles and the cruel mountain winds which would pinch his heart out.

With his boy at his breast he flew along the rim-rock like a crow, hunting for shelter from bullets and wind. He longed to expend his remaining cartridges where each would put out a white man's fire. Recovering from their surprise, the Indians gathered thickly on inaccessible heights and fought stiffly back. Being unable to follow them, the pony-soldiers drew back; but, as they retreated, they left the village blazing, which the Chis-chis-chash could not prevent. Their rifles had only handed them over to the hungry winter.

The Fire Eater sat muffled on a ledge, firing from time to time, and anxiously scanning his shots. The cold made him shake and he could not hold his rifle true. His old, thin blood crept slowly through his veins, and the child cried piteously. His fires were burning low; even the stimulus of hate no longer stirred him as he looked down on the white men who had burned his all and shot his wife and were even then spattering his den in the rocks with lead. He gave up, overpowered by the situation. With infinite difficulty he gathered himself erect on his stiffened joints and took again his burden in his trembling arms. Standing thus on the wind-swept height, with the bullets spotting the rocks around him, he extended his right hand and besought the black, eddying smoke to give him back his bat-skin; he begged the spirits of the air to bring it to him. He shouted his harsh pathos at a wild and lonely wind, but there was no response.

Then off through the withering cold and powdery snow moved the black figure of despair tottering slowly away from the sound of rifles which grew fainter at each step. He chattered and mumbled, half to himself, half to the unseen influences of nature, while the child moaned weakly under his clutched robe. When he could but barely hear the noises of the fight, he made his way down into the cañon where he shortly came upon a group of his tribesmen who had killed a pony and were roasting pieces over a log fire. They were mostly women and children or old, old men like himself. More to note than their drawn and leathery faces was the speechless terror brooding over all. Their minds had not digested their

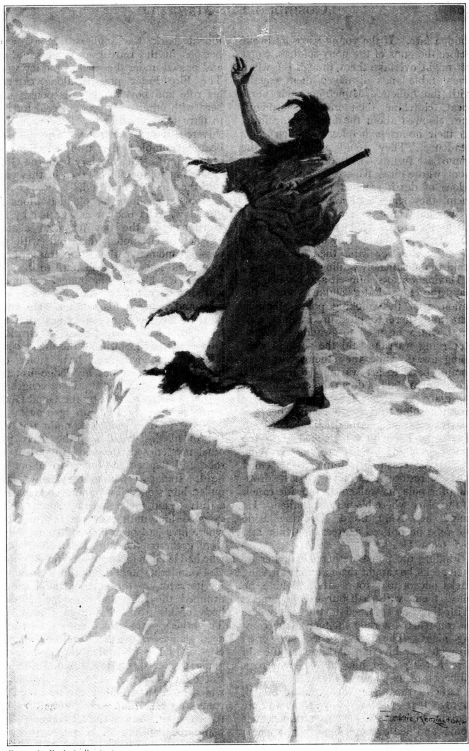

Drawn by Frederic Remington

HE SHOUTED HIS HARSH PATHOS AT A WILD AND LONELY WIND, BUT THERE WAS
NO RESPONSE

sudden fate. If the young warriors broke before the guns of the pony-soldiers, worse yet might overtake them, though the wind-swept table-lands dismayed them equally with the bullets. Munching their horse meat, clutching their meager garments, they elbowed about the fires, saying little. In their homeless helplessness their souls deadened. They could not divine the immediate future. Unlike the young war-riors whose fires flashed brighter as the talons of death reached most fiercely for them, they shuddered and crouched.

Warriors came limping back from the battle, their robes dyed with a costly vermil-ion. They sat about doing up their wounds in filthy rags, or sang their death-songs amid the melancholy wailing of the squaws.

Having warmed himself and quieted the boy, the Fire Eater stalked down the cañon, past the smoking poles, stopping here and there to pick up fragments of skins which he used to swaddle the boy. Returning warriors said the soldiers were going away, while they themselves were coming back to get warm. Hearing this, the old man stalked down the creek toward the place where his lodge had been. He found nothing but a smoldering heap of charred robes and burnt dried meat. With a piece of lodge pole he poked away the ashes, searching for his precious medicine and never ceasing to implore the Good Gods to restore it to him. At last, drop-ping the pole, he walked up the side cañon to the place where his wife had fallen. He found her lying there. Drawing aside the robe he noticed a greenish pallor and fled from Death.

Finding the ponies tethered together by their necks, he caught them and improvising packs out of old robes and rawhide, he filled them with half-burnt dried meat. With these he returned to the fires where he constructed a rude shelter for the com-ing night. The boy moaned and cried through the shivering darkness as the old Fire Eater rocked him in his arms to a gibberish of despairing prayer.

Late in the night, the scouts came in, saying that the walking-soldiers were coming, whereat the Indians gathered their ponies and fled over the snow. The young men stayed where from the cliffs they fought back the soldiers. Many weak persons in the retreating band sat down and passed under the spell of the icy wind. The Fire Eater pressed along, carrying his rifle and boy, driving his ponies in a herd with others. It was too cold for him to dare to ride a horse. The crying boy shivered under the robe. The burden-bearer mumbled the troubled thoughts of his mind: "My mystery from the Good Gods is gone; they have taken it; they gave it to the fire. I am afraid."

Hour after hour he plodded along in the snow. His body was warmed by his exertions and the boy felt cold against his flesh. He noted this, but with the passing moments the little frame grew more rigid and more cold until to the Fire Eater it felt like a stone image. Stopping with his back to the wind, he undid the robe and fingered his burden. He knew that the shadow had gone; knew that the bad spirits had taken it away. "Oh, Bad Gods! Oh, Evil Spirits of the night, come take my shadow! You have stolen my boy, you have put out my lodge-fire; put out the fire of my body! Take vengeance on me! I am deserted by the Good Gods! I am ready to go! I am waiting!"

Thus stood in the bleak night this vic-tim of his lost medicine; the fierce and cruel mysteries of the wind tugged at his robe and flapped his long hair about his head. Indians coming by pushed and pulled him along. Two young men made it a duty to aid the despairing chief. They dragged him until they reached a cañon where fires had been lighted around which were gathered the fugitives. The people who had led him had supposed that his mind was wandering under suffering or wounds. As he sank by the side of the blaze he dropped the robe and laid the stiffened body of his frozen boy across his knees. The others peered for a time with fright-ened glances at the dead body, when with cries of "Dead, dead!" they ran away, going deeper down the cañon. The Fire Eater sat alone, waiting for the evil spirits which lurked out among the pine trees, to come and take him. He wanted to go to the spirit-land where the Cheyennes of his home and youth were at peace in warm valleys, talking and eating.

(The End)

19.
How
Order No. 6
Went Through

HOW ORDER NO. 6 WENT THROUGH.

AS TOLD BY SUN-DOWN LEFLARE.

BY FREDERIC REMINGTON.

WE were full of venison and coffee as we gathered close around the camp fire, wiping the fitful smoke out of our eyes alternately as it came our way.

"It's blowing like the devil," said the sportsman, as he turned up his face to the pine-trees.

"Yees, sair. Maybeso dar be grass fire secon' ting we know," coincided Sun-Down Leflare.

Silver-Tip, the one who drove the wagon, stood with his back to us, gazing out across the mountain to an ominous red glare far to the south. "Ef that forest fire gets into Black Canyon, we'll be straddlin' out of yer all sorts of gaits before mornin'," he remarked.

"Cole night," observed Bear - Claw, which having exhausted his stock of English, he spoke further to Fire-Bear, but his conversation was opaque to us.

"Look at the stars!" continued the sportsman.

"Yes—pore critters—they have got to stay out all night; but I am going to turn in. It's dam cold," and Silver-Tip patted and mauled at his blankets.

"What was the coldest night you ever saw?" I asked.

He pulled off his boots, saying: "Seen heap of cold nights—dun'no' what was the coldest—reckon I put in one over on the Bull Mountains, winter of '80, that I ain't going to forget. If nex' day hadn't been a Chinook, reckon I'd be thar now."

"You have been nearly frozen, I suppose, Sun-Down?" I added.

"Yees, sair—I was cole once all right."

"Ah—the old coffee-cooler, he's been cold plenty of times. Any man what lives in a tepee has been cold, I reckon; they've been that way six months for a stretch," and having made this good-natured contribution, Silver-Tip pulled his blanket over his head.

Sun-Down's French nervousness rose. "Ah—dat mule-skinner, what she know 'bout cole?—she freeze on de green grass. I freeze seex day in de middle of de wintar over dar Buford. By gar, dat weare freeze too! Come dam near put my light out. Um-m-m!" and I knew that Sun-Down was my prey.

"How was that?"

"Over Fort Keough—I was scout for Ewers—she was chief scout for Miles," went on Leflare.

"Yas, I was scout too—over Keough—

255

same time," put in Ramon, the club-foot-ed Mexican.

"Yees, Ramon was scout too. Say—Miles she beeg man Eas'—hey? I see her come troo agency—well, fall of '90. Ah, she ole man; don' look like she use be sebenty-seben. Good-lookin' den."

"Wall—what you spect?" sighed his congener Ramon, in a harsh interruption. "I was good-lookin' mon myselef—sebenty-seben."

"You weare buy more squaw dan you weare eber steal—you ole frog. Dat Miles she was mak heap of trouble up dees way. I was geet sebenty dollar a month. She not trouble my people, but she was no good for Cheyenne un Sioux. Dey was nevar have one good night sleep af'er she was buil' de log house on de Tongue Rivière. Ah, ha, we was have hell of a time dem day'—don' we, Wolf-Voice?" and that worthy threw up his head quick-ly, and said, "Umph!"

"Well—I was wid my ole woman set in de lodge one day. Eet was cole. Lieu-tent Ewers she send for me. I was know I was got for tak eet or lose de sebenty. Well, I tak eet. Eet was cole.

"I was tink since, it weare dam good ting I lose dat sebenty. I was geet two pony, un was go to log house, where de officier she write all time in de book. Lieutent was say I go to Buford. I was say eet dam cole weddar for Buford. Lieutent was say I dam coffee-cooler. Well—I was not. Sitts-on-the-Point and Dick, she white man, was order go Buford wid me. Lieutent was say, when she han' me beeg lettair wid de red button, 'You keep eet clean, Leflare, un you go troo.' I tole heem I was go troo, eef eet was freeze de steamboat.

"We was go out of de fort on our pony—wid de led horse. We was tak nothin' to eat, 'cause we was eat de buf-falo. I was look lak de leetle buffalo —all skin. Skin hat—skin robe—skin leggin—you shoot me eef you see me. Eet was cole. We weare ride lak hell. When we was geet to Big Dry, Dick she say, 'Your pony no good; your pony not have de oat; you go back. He says he mak Buford to-morrow night. I say, 'Yees, we go back to-morrow.'

"We mak leetle sleep, un Sitts-on-the-Point he go back Keough; but I geets crazy, un say I brave man; I weel not go back; I weel go Buford, or give de dinner to de dam coyote. I weel go.

"My pony he was not able for run, un Dick she go over de heel—I was see her no more. I was watch out for de buffalo —all day was watch. I was hungry; dar was nothin' een me. All right, I was go top of de heel—I was not see a buffalo. All deese while I was head for de Moun-tain-Sheep Buttes, where I know Gros Ventre camp up by Buford. Eet was blow de snow, un I was walk heap for keep warm. I was tink, eef no buffalo, no Gros Ventre camp for Leflare, by gar. I was marry Gros Ventre woman once, un eef I was geet dar I be all right. De snow she blow, un I could see not a ting. When eet geet dark, I was not know where I was go, un was lay down een de willow bush. Oh, de cole—how de hell you spect I sleep?—not sleep one wink, 'cept one. Well, my pony was try break away, but I was watch 'im, 'cept dat one wink. De dam pony what was led horse, she geet off een de one wink. I see her track een de mornin', but I was not able for run him wid de order pony. He was geet clean away. 'Bout dat I was sorry, for een de daytime I was go keel heem eef no buffalo.

"Een de mornin' de win' she blow; de snow she blow too. Eet was long time 'fore I untie my lariat, un couldn't geet on pony 'tall—all steef—all froze. I walk long—walk long;" and Sun-Down shrugged up his shoulders and eyebrows, while he shut down his eyes and mouth in a most forlorn way. He had the quick, nervous French delivery of his father, coupled with the harsh voice of his Ind-ian mother. There was also much of the English language employed by this waif of the plains which, I know, you will forgive me if I do not introduce.

"I deedn't know where I was—I was los'—couldn't see one ting. Was keep under cut bank for dodge win'. De snow she bank up een plass, mak me geet out on de win' she mak me hump. Pony he was heavy leg for punch troo de snow. All time I was watch out for buffalo, but dar was no buffalo;" and Sun-Down's voice rose in sympathy with the frightful condition which haunted his memory.

"Begin tink my medicin' was go plumb back on me. Den I tink Ewers—wish she out here wid dam ole order. Eet mak me mad. Order—all time order— by gar, order soldier to change hees shirt —scout go two hundred miles. My belly

she draw up like tomtom, un my head go roun', roun', lak ting Ramon was mak de hair rope wid; my han' she shake lak de leaf de plum-tree. I was fall down under cut bank, wid pony rope tie roun' me. Pony he stay, or tak me wid heem. How long I lay—well, I dun'no', but I was cole un wak up. Eet was steel—de star she shine; de win' she stop blow. Long time I was geet up slow. I was move leetle—move leetle—den I was move queek —move leetle—move queek. All right— you eat ten deer reebs while I was geet up un stan' on my feet. Pony he was white wid de snow un de fros'. Buffalo-robe she steef lak de wagon box. Long time I was move my finger—was try mak fire, un after while she blaze up. Ah, good fire—she steek in my head. Me un pony we geet thaw out one side, den oder side. I was look at pony—pony was look at me. By gar—I tink he was 'fraid I eat heem; but I was say no—I eat him by-un-by. I was melt de snow een my tin cup—was drink de hot water—eet mak me strong. Den come light I was ride to beeg butte, look all roun'—all over, but couldn't tell where I was. Den I was say, no buffalo I go Missouri Rivière.

"Long time, I was come to de buffalo. Dey was all roun'—oh, everywhere—well, hundred yard. When I was geet up close, I was aim de gun for shoot. I couldn't hole dat gun—she was wabble lak de pony tail een de fly-time. All right, I shoot un shoot at de dam buffalo, but I neber heet eem 'tall—all run off. My head she swim; my han' she shake; my belly she come up een my neck un go roun' lak she come untie. I almos' cry.

"Well—I dun'no' jus' what den. 'Pears lak my head she go plumb off. I was wave my gun; was say I not afraid of de Sioux. Dam de Sioux!—I was fight all de Sioux in de worl'. I was go over de snow fight dem, un I was yell terrible. Eet seem lak all de Sioux, all de Cheyenne, all de Assiniboine, all de bad Engun een de worl', she come out of de sky, all run dar pony un wave dar gun. I could hear dar pony gallop ovar my head. I was fight 'em all, but dey went 'way.

"A girl what I was use know she come drop—drop out of de sky. She had keetle of boil meat, but she was not come right up—was keep off jus' front of my pony. I was run after de girl, but she was float 'long front of me—I could not catch her. Den I don' know nothin'.

"Black George un Flyin' Medicin' was two scout come to Keough from Fort Peck. Dey saw me un follow me—dey was go to keel me, but dey see I was Leflare, so dey rope my pony, tak me een brush, mak fire, un give me leetle meat. By come night I was feel good—was geet strong.

"We was 'fraid of de Assiniboine— 'cause de order fellers had seen beeg sign. I sais let us go 'way mile or so un leave fire burn here.

"Black George he sais he no dam ole woman—he brav man—fight dem— no care dam for Assiniboine.

"I say to myself, all right — Assiniboine been foller you. I go.

"Flyin' Medicin' he want for go, but George he sais Assiniboine scare woman wid hees pony track — umph! un Flyin' Medicin' she sais she no ole woman. I say, by gar, I am woman; I have got sense. You wan' stay here you be dead. Den I tak my pony un I go 'way een de dark, but I look back dar un see Medicin', she lie on de robe, Black George she set smoke de pipe, un a gray dog he set on de order side, all een de firelight. I sais dam fools.

"Well, I got for tell what happen. When I was go 'bout mile I was lay down. 'Bout one hour I hear hell of shootin'. I geet up queek, climb pony, run lak hell. I was ole woman, un I was dam glad for be ole woman. Eet was dark; pony was very thin; all same I mak heap of trail 'fore mornin' bes' I could."

I asked Sun-Down what made the shooting.

"Oh—Black George camp—course I deedn't know, but I was tink strong eet be hees camp all right 'nough. Long time after I hear how 'twas. Well—dey lay dar by de fire—Medicin' on hees back —George she set up—dog he set up order side—Assiniboine come on dar trail. I was ole woman—eef not, maybeso I was set by de fire too—humph!

"George he geet no chance fight Assiniboine. Dey fire on hees camp, shoot Flyin' Medicin' five time—all troo chest, all troo leg, all troo neck—all shoot up. Black George she was shot t'ree time troo lef' arm; un, by gar, gray dog she keel too. Black George grab hees gun un was run jump down de cut bank. Assiniboine was rush de camp un run off de pony, but George she was manage wid

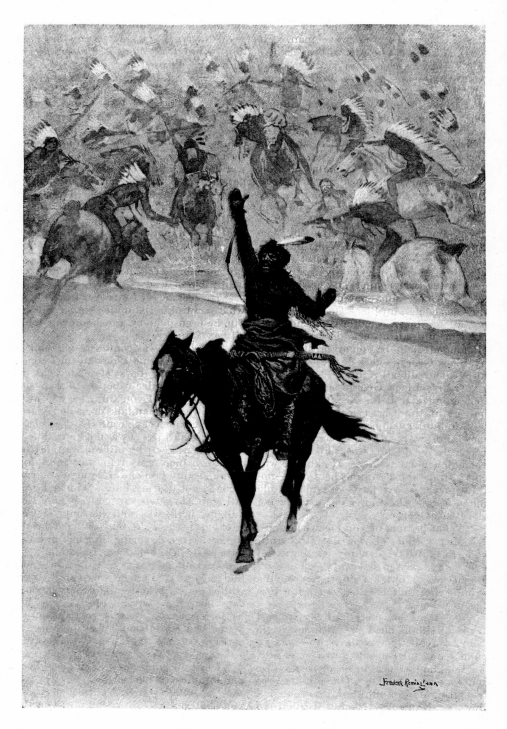

"UN I WAS YELL TERRIBLE."

her lef' han' to shoot over cut bank, un dey was not dare tak Medicin's hair. Black George he was brave man. He was talk beeg, but he was as beeg as hees talk. He was scout roun', un was see no Assiniboine; he was come to Flyin' Medicin', who was go gurgle, gurgle—oh, he was all shot—all blood "—and here Sun-Down made a noise which was awfully realistic and quite unprintable, showing clearly that he had seen men who were past all surgery.

"George she raise Medicin' up, was res' hees head on hees arm, un den Medicin' was give heem hell. He was say: 'Deedn't I tole you? By gar, you dam brave man; you dam beeg fool! You do as I tole you, we be 'live, by gar. Now our time has come.' When he could speak again—when he had speet out de blood—he sais, 'Go geet my war-bag—geet out my war-bonnet—my bead shirt—my bead moccasins—put 'em on me—my time has come'; un Black George she geet out all de fine war-clothes, un she dress Medicin' up—all up een de war-clothes. 'Put my medicin'-bag on my breas'—good-by, Black George—keek de fire—good-by;' un Medicin' die all right.

"Course Black George she put out a foot un mak trail for Keough. He was haf awful time; was seex day geet to buffalo-hunter camp, where she was crawl mos' of de way. De hunter was geeve heem de grub, un was pull heem to Keough een dar wagon. Reckon he was cole—all de blood run out hees arm—nothin' to eat — seex day — reckon dat ole mule-skinner she tink she was cole eef she Black George."

"What became of you meanwhile?"

"Me? Well—I was not stop until come bright day; den my pony was go deese way, was go dat way"—here Sun-Down spread out his finger-tips on the ground and imitated the staggering fore feet of a horse.

"I was res' my pony half day, un was try keel buffalo, but I was weak lak leetle baby. My belly was draw up—was go roun'—was turn upside down—was hurt me lak I had wile-cat inside my reebs. De buffalo was roun' dar. One minute I see 'em all right, nex' minute dey go roun' lak dey was all drunk. No use—I could not keel buffalo. Eet was Gros Ventre camp or bus' Leflare wid me den. All time eet very cole; fros' go pop, pop under pony feet. Guess I look lak dead man—guess

I feel dam sight worse. Dat seex day she mak me very ole man.

"I was haf go slow—pony he near done — jus' walk 'long. I deedn't care dam for Assiniboine now. De gray wolf he was follow 'long behin' — two—t'ree—four wolf. I deedn't care dam for wolf. All Sioux, all Assiniboine, all wolf een de worl'—she go to hell now; I no care. I was want geet to Gros Ventre camp 'fore I die. I was walk 'long slow—was feed my pony; my feet, my han's was get cold, hard lak knife-blade. I was haf go to cut bank for fall on my pony's back—no crawl up no more. I was ride all night, slow, slow. Was sit down; wolf was come up look at me. I was tell wolf to go to hell.

"Nex' day same ting—go 'long slow. Pony he was dead; he no care for me. I can no more keek heem; I cannot use whip; I was dead.

"You ask me eef I was ever froze—hey, what you tink? Dat mule-skinner, Silver-Tip, he been dar—by gar, he nevair melt all nex' summer.

"Jus' dark I was come een big timber by creek. I was tink I die dar, for I could not mak de fire. I was stan' steel lak de steer een de coulee when de blizzair she blow. Den what you tink? I was hear Gros Ventre woman talk 'cross de rivière. She was come geet de wattair. I was lead de pony on de hice. I was not know much, but I was wake up by fall een wattair troo crack een hice. My rein was roun' my shoulder; my gun she cross my two arm. I could not use my han'. When I was fall, gun she catch 'cross hice—pony was pull lak hell—was pull me out. I was wet, but I was wake up. Eef dat bridle she break, een de spring-time dey fine Leflare een wheat-fiel' down Dakotah.

"De woman she was say, 'Go below—you find de ford.' Den he was run. After while I get 'cross ford—all hice. Was come dam near die standin' up. I was see leetle log house, un was go to door un pound wid my elbow. 'Let me een—let me een—I froze,' sais I, een Gros Ventre.

"Dey say, 'Who you are?'

"I sais, 'I am Leflare—I die een 'bout one minute—let me een.'

"'You talk Gros Ventre; maybeso you bad Engun. How we know you Leflare?' sais de woman.

"'Eef I not Leflare, shoot when you open de door,' un dey open de door. I tink dey was come near shoot me—I was

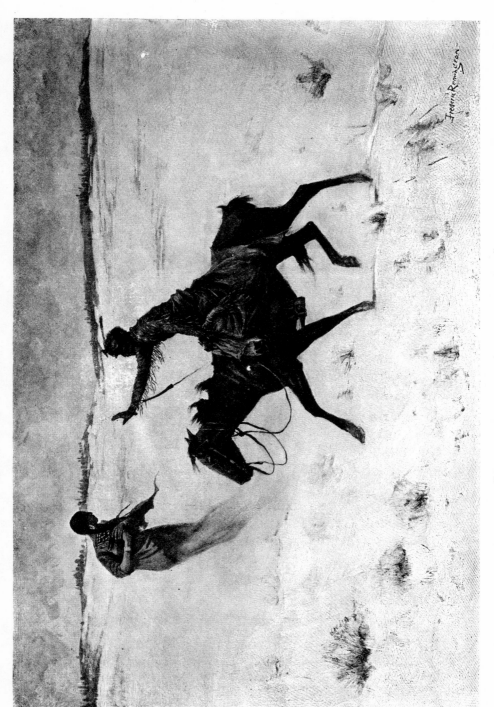

"SHE WAS KEEP OFF JUS' FRONT OF MY PONY."

look terrible—dey was 'fraid. I grab de fire, but dey was pull me 'way. Dey was sit on me un tak off my clothes un rub me wid de snow. Well, dey was good; I dun'no' what dey do, but I was eat, eat, leetle at a time, till I was fall 'sleep.

"I lay een dat log house t'ree day 'fore I geet out, un den I go Buford. Dey sais de order she was all right. Den dey want me go back Keough wid order. I sais, 'Dam glad go back,' for de weddar she was fine den. 'You geeve me pony.'

SUN-DOWN LEFLARE, WASHED AND DRESSED UP.

When I was wake up I was say, 'Tak dam ole order to Buford,' un I was tole de man what was tak eet I was keel heem eef he not tak eet.

"'Why geeve you pony?' sais de officier.

"'By gar, de las' order she keel my pony,' I sais."

20.
The
Essentials
at Fort Adobe

THE ESSENTIALS AT FORT ADOBE.

BY FREDERIC REMINGTON.

HE Indian suns himself before the door of his tepee, dreaming of the past. For a long time now he has eaten of the white man's lotos—the bi-monthly beef-issue. I looked on him and wondered at the new things. The buffalo, the war-path, all are gone. What of the cavalrymen over at Adobe—his Nemesis in the stirring days—are they, too, lounging in barracks, since his lordship no longer leads them trooping over the burning flats by day and through the ragged hills by night? I will go and see.

The blistered faces of men, the gaunt horses dragging stiffly along to the cruel spurring, the dirty lack-lustre of campaigning—that, of course, is no more.

Will it be parades, and those soul-deadening "fours right" and "column left" affairs? Oh, my dear, let us hope not.

Nothing is so necessary in the manufacture of soldiers, sure enough, but it is not hard to learn, and once a soldier knows it I can never understand why it should be drilled into him until it hurts. Besides, from another point of view, soldiers in rows and in lines do not compose well in pictures. I always feel, after seeing infantry drill in an armory, like Kipling's light-house keeper, who went insane looking at the cracks between the boards—they were all so horribly alike.

Then Adobe is away out West in the blistering dust, with no towns of any importance near it. I can understand why men might become listless when they are at field-work, with the full knowledge that nothing but their brothers are look-

265

ing at them save the hawks and coyotes. It is different from Meyer, with its traps full of Congressmen and girls, both of whom are much on the minds of cavalrymen.

In due course I was bedded down at Adobe by my old friend the Captain, and then lay thinking of this cavalry business. It is a subject which thought does not simplify, but, like other great things, makes it complicate and recede from its votaries. To know essential details from unessential details is the study in all arts. Details there must be; they are the small things which make the big things. To apply this general order of things to this arm of the service kept me awake. There is first the riding—simple enough if they catch you young. There are bits, saddles, and cavalry packs. I know men who have not spoken to each other in years because they disagree about these. There are the sore backs and colics —that is a profession in itself. There are judgment of pace, the battle tactics, the use of three very different weapons; there is a world of history in this, in forty languages. Then an ever-varying *terrain* tops all. There are other things not confined to cavalry, but regarded by all soldiers. The crowning peculiarity of cavalry is the rapidity of its movement, whereby a commander can lose the carefully built up reputation of years in about the time it takes a schoolboy to eat a marsh-mallow. After all, it is surely a hard profession—a very blind trail to fame. I am glad I am not a cavalryman; still, it is the happiest kind of fun to look on when you are not responsible; but it needs some cultivation to understand and appreciate.

I remember a dear friend who had a taste for out-of-doors. He penetrated deeply into the interior not long since to see these same troopers do a line of heroics, with a band of Bannocks to support the rôle. The Indians could not finally be got on the centre of the stage, but made hot-foot for the agency. My friend could not see any good in all this, nor was he satisfied with the first act even. He must needs have a climax, and that not forth-coming, he loaded his disgust into a trunk line and brought it back to his club corner here in New York. He there narrated the failure of his first night; said the soldiers were not even dusty as advertised; damned the Indians

keenly, and swore at the West by all his gods.

There was a time when I, too, regarded not the sketches in this art, but yearned for the finished product. That, however, is not exhibited generally over once in a generation.

At Adobe there are only eight troops —not enough to make a German nursegirl turn her head in the street, and my friend from New York, with his Napoleonic largeness, would scoff out loud. But he and the nurse do not understand the significance; they have not the eyes to see. A starboard or a port horseshoe would be all one to them, and a crease in the saddle-blanket the smallest thing in the world, yet it might spoil a horse.

When the trumpets went in the morning I was sorry I had thought at all. It was not light yet, and I clung to my pillow. Already this cavalry has too much energy for my taste.

"If you want to see anything, you want to lead out," said the Captain, as he pounded me with a boot.

"Say, Captain, I suppose Colonel Hamilton issues this order to get up at this hour, doesn't he?"

"He does."

"Well, he has to obey his own order, then, doesn't he?"

"He does."

I took a good long stretch and yawn, and what I said about Colonel Hamilton I will not commit to print, out of respect to the Colonel. Then I got up.

This bitterness of bed-parting passes. The Captain said he would put a "cook's police" under arrest for appearing in my make-up; but all these details will be forgotten, and whatever happens at this hour should be forgiven. I had just come from the North, where I had been sauntering over the territory of Montana with some Indians and a wild man from Virginia, getting up before light—tightening up on coffee and bacon for twelve hours in the saddle to prepare for more bacon and coffee; but at Adobe I had hoped for, even if I did not expect, some repose.

In the east there was a fine green coming over the sky. No one out of the painter guild would have admitted it was green, even on the rack, but what I mean is that you could not approach it in any other way. A nice little adjutant went jangling by on a hard-trotting thoroughbred, his shoulders high and his seat low.

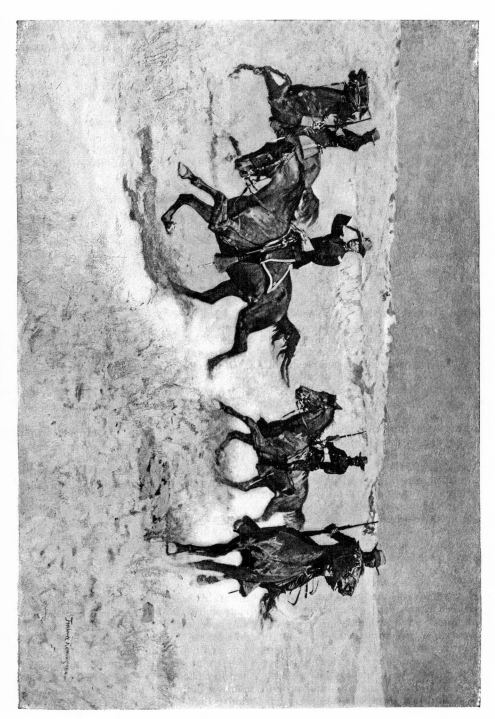

THE ADVANCE.

A TAME HORSE.

My old disease began to take possession of me; I could fairly feel the microbes generate. Another officer comes clattering, with his orderly following after. The fever has me. We mount, and we are off, all going to stables.

Out from the corrals swarm the troopers, leading their unwilling mounts. The horses are saying, "Damn the Colonel!" One of them comes in arching bounds; he is saying worse of the Colonel, or maybe only cussing out his own recruit for pulling his *cincha* too tight. They form troop lines in column, while the Captains throw open eyes over the things which would not interest my friend from New York or the German nurse-girl.

The two forward troops are the enemy, and are distinguished by wearing brown canvas stable-frocks. These shortly move out through the post, and are seen no more.

Now comes the sun. By the shades of Knickerbocker's *History of New York* I seem now to have gotten at the beginning; but patience, the sun is no detail out in the arid country. It does more things than blister your nose. It is the despair of the painter as it colors the minarets of the Bad Lands which abound around Adobe, and it dries up the company gardens if they don't watch the *acequias* mighty sharp. To one just out of bed it excuses existence. I find I begin to soften toward the Colonel. In fact it is possible

that he is entirely right about having his old trumpets blown around garrison at this hour, though it took the Captain's boot to prove it shortly since.

The command moves out, trotting quickly through the blinding clouds of dust. The landscape seems to get right up and mingle with the excitement. The supple, well-trained horses lose the scintillation on their coats, while Uncle Sam's blue is growing mauve very rapidly. But there is a useful look about the men, and the horses show condition after their long practice march just finished. Horses much used to go under saddle have well-developed quarters and strong stifle action. Fact is, nothing looks like a horse with a harness on. That is a job for mules, and these should have a labor organization and monopolize it.

The problem of the morning was that we as an advance were to drive the two troops which had gone on ahead. These in turn were to represent a rapidly retiring rear-guard. This training is more that troops may be handled with expedition, and that the men may gather the thing, rather than that officers should do brilliant things, which they might undertake on their own responsibility in time of war, such as pushing rapidly by on one flank and cutting out a rear-guard.

Grievous and very much to be commiserated is the task of the feeling historian who writes of these paper wars. He may see possibilities or calamities which do not signify. The morning orders provide against genius, and who will be able to estimate the surgical possibilities of blank cartridges? The sergeant-major cautioned me not to indicate by my actions what I saw as we rode to the top of a commanding hill. The enemy had abandoned the stream because their retreat would have been exposed to fire. They made a stand back in the hills. The

advance felt the stream quickly, and passed, fanning out to develop. The left flank caught their fire, whereat the centre and right came around at top speed. But this is getting so serious.

The scene was crowded with little pictures, all happening quickly — little dots of horsemen gliding quickly along the yellow landscape, leaving long trails of steely dust in their wake. A scout comes trotting along, his face set in an expect-

JUMPING ON TO A HORSE.

HORSE GYMNASTICS.

cially when a gun and sabre are attached. When both living equations are young, full of oats and bacon, imbued with military ideas, and trained to the hour, it always seems to me that the ghost of a tragedy stalks at their side. This is why the polo-player does not qualify sentimentally. But what is one man beside two troops which come shortly in two solid chunks, with horses snorting and sending the dry landscape in a dusty pall for a quarter of a mile in the rear? It is good —ah! it is worth any one's while; but stop and think, what if we could magnify that? Tut, tut! as I said

ant way, carbine advanced. A man on a horse is a vigorous, forceful thing to look at. It embodies the liveliness of nature in its most attractive form, espe-before, that only happens once in a generation. Adobe doesn't dream; it simply does its morning's work.

The rear-guard have popped at our

advance, which exchanges with them. Their fire grows slack, and from our vantage we can see them mount quickly and flee.

After two hours of this we shake hands with the hostiles and trot home to breakfast.

These active, hard-riding, straight-shooting, open-order men are doing real work, and are not being stupefied by drill-ground routine, or rendered listless by file-closer prompting or sleepy reiteration.

By the time the command dismounts in front of stables we turn longingly to the thoughts of breakfast. Every one has completely forgiven the Colonel, though I have no doubt he will be equally unpopular to-morrow morning.

But what do I see—am I faint? No; it has happened again. It looks as though I saw a soldier jump over a horse. I moved on him.

"Did I see you—" I began.

"Oh yes sir—you see," returned a little soldier, who ran with the mincing steps of an athlete toward his horse, and landed standing up on his hind quarters, whereupon he settled down quietly into his saddle.

Others began to gyrate over and under their horses in a dizzy way. Some had taken their saddles off and now sat on their horses' bellies, while the big doglike animals lay on their backs, with their feet in the air. It was circus business, or what they call "short and long horse" work—some not understandable phrase. Every one does it. While I am not unaccustomed to looking at cavalry, I am being perpetually surprised by the lengths to which our cavalry is carrying this Cossack drill. It is beginning to be nothing short of marvellous.

In the old days this thing was not known. Between building mud or log forts, working on the bull-train, marching or fighting, a man and a gun made a soldier; but it takes an education along with this now before he can qualify.

The regular work at Adobe went on during the day—guard mount, orders, inspection, and routine.

At the club I was asked, "Going out this afternoon with us?"

"Yes, he is going; his horse will be up at 4.30; he wants to see this cavalry," answered my friend the Captain for me.

"Yes; it's fine moonlight. The Colonel is going to do an attack on Cossack posts out in the hills," said the adjutant.

So at five o'clock we again sallied out in the dust, the men in the ranks next me silhouetting one after the other more dimly until they disappeared in the enveloping cloud. They were cheerful, laughing and wondering one to another if Captain Garrard, the enemy, would get in on their pickets. He was regarded in the ranks as a sharp fellow, one to be well looked after.

At the line of hills where the Colonel stopped, the various troops were told off in their positions, while the long cool shadows of evening stole over the land, and the pale moon began to grow bolder over on the left flank.

I sat on a hill with a sergeant who knew history and horses. He remembered "Pansy," which had served sixteen years in the troop—and a first-rate old horse then; but a damned inspector with no soul came browsing around one day and condemned that old horse. Government got a measly ten dollars—or something like that. This ran along for a time; when one day they were trooping up some lonely valley, and, behold, there stood "Pansy," as thin as a snake, tied by a wickieup. He greeted the troop with joyful neighs. The soldiers asked the Captain to be allowed to shoot him, but of course he said no. I could not learn if he winked when he said it. The column wound over the hill, a carbine rang from its rear, and "Pansy" lay down in the dust without a kick. Death is better than an Indian for a horse. The thing was not noticed at the time, but made a world of fuss afterwards, though how it all came out the sergeant did not develop, nor was it necessary.

Night settled down on the quiet hills, and the dark spots of pickets showed dimly on the gray surface of the land. The Colonel inspected his line, and found everybody alert and possessed of a good working knowledge of picket duties at night—one of the most difficult duties enlisted men have to perform. It is astonishing how short is the distance at which we can see a picket even in this bright night on the open hills.

I sat on my horse by a sergeant at a point in the line where I suspected the attack would come. The sergeant thought he saw figures moving in a dry bottom

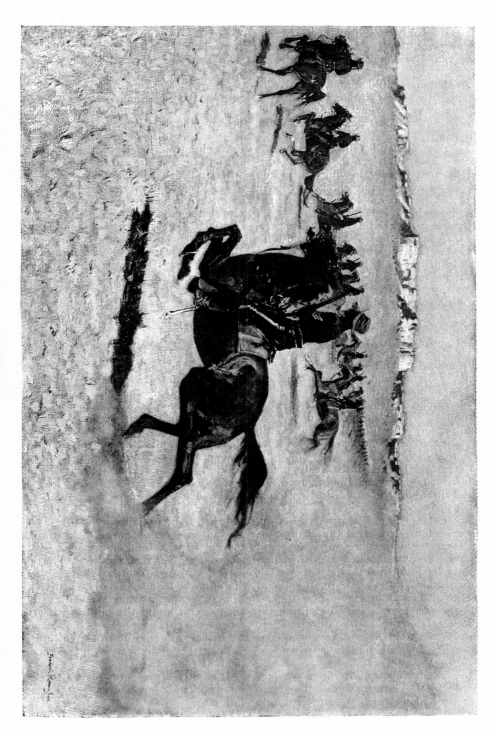

THE PURSUIT.

before us. I could not see. A column of dust off to the left indicated troops, but we thought it a ruse of Garrard's. My sergeant, though, had really seen the enemy, and said, softly, "They are coming."

The bottom twinkled and popped with savage little yellow winks; bang! went a rifle in my ear; "whew," snorted my big horse; and our picket went to the supports clattering.

The shots and yells followed fast. The Colonel had withdrawn the supports toward the post rapidly, leaving his picket-line in the air—a thing which happens in war; but he did not lose much of that line, I should say.

It was an interesting drill. Pestiferous little man disturbed nature, and it all seemed so absurd out there on those quiet gray hills. It made me feel, as I slowed down and gazed at the vastness of things, like a superior sort of bug. In the middle distance several hundred troops are of no more proportion than an old cow bawling through the hills after her wolf-eaten calf. If my mental vision were not distorted I should never have seen the manœuvre at all—only the moon and the land doing what they have done before for so long a time.

We reached Adobe rather late, when I found that the day's work had done wonders for my appetite. I reminded the Captain that I had broken his bread but once that day.

"It is enough for a Ninth Cavalry man," he observed. However, I out-flanked this brutal disregard for established customs, but it was "cold."

In the morning I resisted the Captain's boot, and protested that I must be let alone; which being so, I appeared groomed and breakfasted at a Christian hour, fully persuaded that as between an Indian and a Ninth Cavalry man I should elect to be an Indian.

Some one must have disciplined the Colonel. I don't know who it was. There is only one woman in a post who can, generally; but no dinners were spoiled at Adobe by night-cat affairs.

Instead, during the afternoon we were to see Captain Garrard, the hostile, try to save two troops which were pressed into

the bend of a river by throwing over a bridge, while holding the enemy in check. This was as complicated as putting a baby to sleep while reading law; so clearly my point of view was with the hostiles. With them I entered the neck. The horses were grouped in the brush, leaving some men who were going underground like gophers out near the entrance. The brown-canvas-covered soldiers grabbed their axes, rolled their eyes toward the open plain, and listened expectantly.

The clear notes of a bugle rang; whackety, bang—clack—clack, went the axes. Trees fell all around. The forest seemed to drop on me. I got my horse and fled across the creek.

"That isn't fair; this stream is supposed to be impassable," sang out a Lieutenant, who was doing a Blondin act on the first tree over, while beneath him yawned the chasm of four or five feet.

In less than a minute the whole forest got up again and moved toward the bridge. There were men behind it, but the leaves concealed them. Logs dropped over, brush piled on top. The rifles rang in scattered volleys, and the enemy's fire rolled out beyond the brush. No bullets whistled—that was a redeeming feature.

Aside from that it seemed as though every man was doing his ultimate act. They flew about; the shovels dug with despair; the sand covered the logs in a shower. While I am telling this the bridge was made.

The first horse came forward, led by his rider. He raised his eyes like St. Anthony; he did not approve of the bridge. He put his ears forward, felt with his toes, squatted behind, and made nervous side steps. The men moved on him in a solid crowd from behind. Stepping high and short he then bounded over, and after him in a stream came the willing brothers. Out along the bluffs strung the troopers to cover the heroes who had held the neck, while they destroyed the bridge.

Then they rode home with the enemy, chaffing each other.

It is only a workaday matter, all this; but workaday stuff does the business nowadays.

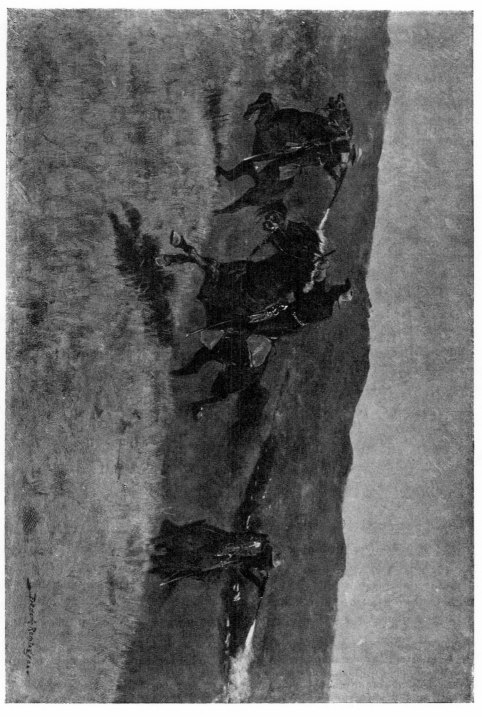

Frederic Remington

21.
Massai's
Crooked
Trail

MASSAI'S CROOKED TRAIL.

BY FREDERIC REMINGTON.

IT is a bold person who will dare to say that a wilder savage ever lived than an Apache Indian, and in this respect no Apache can rival Massai.

He was a *bronco* Chiricahua whose *tequa* tracks were so long and devious that all of them can never be accounted for. Three regiments of cavalry, all the scouts—both white and black —and Mexicans galore had their hack, but the ghostly presence appeared and disappeared from the Colorado to the Yaqui. No one can tell how Massai's face looks, or looked, though hundreds know the shape of his footprint.

The Seventh made some little killings, but they fear that Massai was not among the game. There surely is or was such a person as Massai. He developed himself slowly, as I will show by the Sherlock Holmes methods of the chief of scouts, though even he only got so far, after all. Massai manifested himself like the dust-storm or the morning mist—a shiver in the air, and gone. The chief walked his horse slowly back on the lost trail in disgust, while the scouts bobbed along behind perplexed. It was always so. Time has passed, and Massai, indeed, seems gone, since he appears no more. The hope in the breasts of countless men is nearly blighted; they no longer expect to see Massai's head brought into camp done up in an old shirt and dropped triumphantly on the ground in front of the chief of scouts' tent, so it is time to preserve what trail we can.

Three troops of the Tenth had gone into camp for the night, and the ghostly Montana landscape hummed with the murmur of many men. Supper was over, and I got the old Apache chief of scouts behind his own ducking, and demanded what he knew of an Apache Indian down in Arizona named Massai. He knew all or nearly all that any white man will ever know.

"All right," said the chief, as he lit a cigar and tipped his sombrero over his left eye, "but let me get it straight. Massai's trail was so crooked, I had to study nights to keep it arranged in my

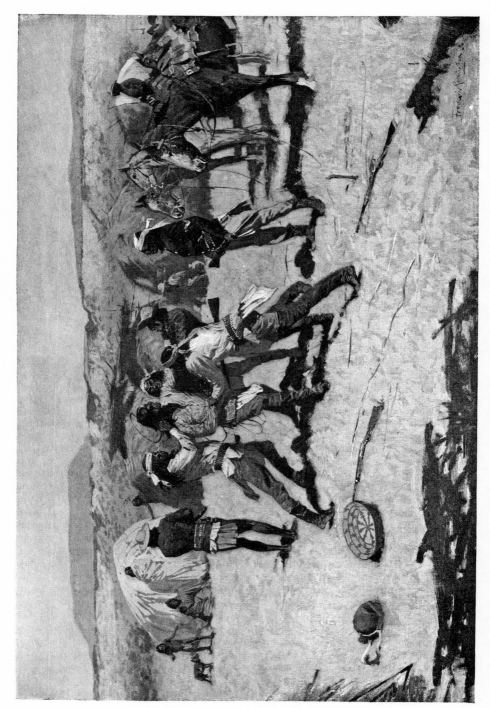

THE ARREST OF THE SCOUT.

head. He didn't leave much more trail than a buzzard, anyhow, and it took years to unravel it. But I am anticipating.

"I was chief of scouts at Apache in the fall of '90, when word was brought in that an Indian girl named Natastale had disappeared, and that her mother was found under a walnut-tree with a bullet through her body. I immediately sent Indian scouts to take the trail. They found the tracks of a mare and colt going by the spot, and thinking it would bring them to the girl, they followed it. Shortly they found a moccasin track where a man had dismounted from the mare, and without paying more attention to the horse track, they followed it. They ran down one of my own scouts in a *tiswin** camp, where he was carousing with other drinkers. They sprang on him, got him by the hair, disarmed and bound

* An intoxicating beverage made of corn.

THE CHIEF OF SCOUTS.

him. Then they asked him what he had done with the girl, and why he had killed the mother, to which he replied that 'he did not know.' When he was brought to me, about dark, there was intense excitement among the Indians, who crowded around demanding Indian justice on the head of the murderer and ravisher of the women. In order to save his life I took him from the Indians and lodged him in the post guard-house. On the following morning, in order to satisfy myself positively that this man had committed the murder, I sent my first sergeant, the famous Mickey Free, with a picked party of trailers, back to the walnut-tree, with orders to go carefully over the trail and run down the mare and colt, or find the girl, dead or alive, wherever they might.

In two hours word was sent to me that the trail was running to the north. They had found the body of the colt with its throat cut, and were following the mare. The trail showed that a man afoot was driving the mare, and the scouts thought the girl was on the mare. This proved that we had the wrong man in custody. I therefore turned him loose, telling him he was all right. In return he told me that he owned the mare and colt, and that when he passed the tree the girl was up in its branches, shaking down nuts which her old mother was gathering. He had ridden along, and about an hour afterwards had heard a shot. He turned his mare loose, and proceeded on foot to the *tiswin* camp, where he heard later that the old woman had been shot and the girl 'lifted.' When arrested, he knew that the other scouts had trailed him from the walnut-tree; he saw the circumstances against him, and was afraid.

"On the night of the second day Mickey Free's party returned, having run the trail to within a few hundred yards of the camp of Alcashay in the Forestdale country, between whose band and the band to which the girl belonged there was a blood feud. They concluded that the murderer belonged to Alcashay's camp, and were afraid to engage him.

"I sent for Alcashay to come in immediately, which he did, and I demanded that he trail the man and deliver him up to me, or I would take my scout corps, go to his camp, and arrest all suspicious characters. He stoutly denied that the

man was in his camp, promised to do as I directed, and, to further allay any suspicions, he asked for my picked trailers to help run the trail. With this body of men he proceeded on the track, and they found that it ran right around his camp, then turned sharply to the east, ran within two hundred yards of a stage-ranch, thence into some rough mountain country, where it twisted and turned for forty miles. At this point they found the first camp the man had made. He had tied the girl to a tree by the feet,

NATASTALE.

which permitted her to sleep on her back; the mare had been killed, some steaks taken out, and some meat 'jerked.' From thence on they could find no trail which they could follow. At long intervals they found his moccasin mark between rocks, but after circling for miles they gave it up. In this camp they found and brought to me a fire-stick—the first and only one I had ever seen—and they told me that the fire-stick had not been used by Apaches for many years. There were only a few old men in my camp who were familiar with its use, though one managed to light his cigarette with it. They reasoned from this that the man was a bronco Indian who had been so long 'out' that he could not procure matches, and also that he was a much wilder one than any of the Indians then known to be outlawed.

"In about a week there was another Indian girl stolen from one of my hay-camps, and many scouts thought it was the same Indian, who they decided was one of the well-known outlaws; but older and better men did not agree with them; so there the matter rested for some months.

"In the spring the first missing girl rode into Fort Apache on a fine horse, which was loaded down with buckskins and other Indian finery. Two cowboys followed her shortly and claimed the pony,

which bore a C C C brand, and I gave it up to them. I took the girl into my office, for she was so tired that she could hardly stand up, while she was haggard and worn to the last degree. When she had sufficiently recovered she told me her story. She said she was up in the walnut-tree when an Indian shot her mother, and coming up, forced her to go with him. He trailed and picked up the mare, bound her on its back, and drove it along. The colt whinnied, whereupon he cut its throat. He made straight for Alcashay's camp, which he circled, and then turned sharply to the east, where he made the big twisting through the mountains which my scouts found. After going all night and the next day, he made the first camp. After killing and cooking the mare, he gave her something to eat, tied her up by the feet, and standing over her, told her that he was getting to be an old man, was tired of making his own fires, and wanted a woman. If she was a good girl he would not kill her, but would treat her well and always have venison hanging up. He continued that he was going away for a few hours, and would come back and kill her if she tried to undo the cords; but she fell asleep while he was talking. After daylight he returned, untied her, made her climb on his back, and thus carried her for a long

SCOUTS.

distance. Occasionally he made her alight where the ground was hard, telling her if she made any 'sign' he would kill her, which made her careful of her steps.

"After some miles of this blinding of the trail they came upon a white horse that was tied to a tree. They mounted double, and rode all day as fast as he could lash the pony, until, near nightfall, it fell from exhaustion, whereupon he killed it and cooked some of the carcass. The *bronco* Indian took himself off for a couple of hours, and when he returned, brought another horse, which they mounted, and sped onward through the moonlight all night long. On that morning they were in the high mountains, the poor pony suffering the same fate as the others.

"They staid here two days, he tying her up whenever he went hunting, she being so exhausted after the long flight that she lay comatose in her bonds. From thence they journeyed south slowly, keeping to the high mountains, and only once did he speak, when he told her that a certain mountain pass was the home of the Chiricahuas. From the girl's account she must have gone far south into the Sierra Madre of Old Mexico, though of course she was long since lost.

"He killed game easily, she tanned the hides, and they lived as man and wife. Day by day they threaded their way through the deep canyons and over the Blue Mountain ranges. By this time he had become fond of the White Mountain girl, and told her that he was Massai, a Chiricahua warrior; that he had been arrested after the Geronimo war and sent East on the railroad over two years since, but had escaped one night from the train, and had made his way alone back to his native deserts. Since then it is known that an Indian did turn up missing, but it was a big band of prisoners, and some births had occurred, which made the checking off come straight. He was not missed at the time. From what the girl said, he must have got off east of Kansas City and travelled south and then west, till at last he came to the lands of the Mescalero Apaches, where he staid for some time. He was over a year making this journey, and told the girl that no human eye ever saw him once in that time. This is all he ever told the girl Natastale, and she was afraid to ask him more. Beyond these mere facts, it is still a midnight prowl of a human coyote through a settled country for twelve hundred miles, the hardihood of the undertaking being equalled only by the instinct which took him home.

"Once only while the girl was with him did they see sign of other Indians, and straightway Massai turned away—his wild nature shunning even the society of his kind.

"At times 'his heart was bad,' and once he sat brooding for a whole day, finally telling her that he was going into a bad country to kill Mexicans, that women were a burden on a warrior, and that he had made up his mind to kill her. All through her narrative he seemed at times to be overcome with this bloodthirst, which took the form of a homicidal melancholia. She begged so hard for her life that he relented; so he left her in the wild tangle of mountains while he raided on the Mexican settlements. He came back with horses and powder and lead. This last was in Winchester bullets, which he melted up and recast into .50-calibre balls made in moulds of cactus sticks. He did not tell how many murders he had committed during these raids, but doubtless many.

"They lived that winter through in the Sierras, and in the spring started north, crossing the railroad twice, which meant the Guaymas and the Southern Pacific. They sat all one day on a high mountain and watched the trains of cars go by; but 'his heart got bad' at the sight of them, and again he concluded to kill the girl. Again she begged off, and they continued up the range of the Mogollons. He was unhappy in his mind during all this journey, saying men were scarce up here, that he must go back to Mexico and kill some one.

"He was tired of the woman, and did not want her to go back with him, so, after sitting all day on a rock while she besought him, the old wolf told her to go home in peace. But the girl was lost, and told him that either the Mexicans or Americans would kill her if she departed from him; so his mood softened, and telling her to come on, he began the homeward journey. They passed through a small American town in the middle of the night—he having previous-

ly taken off the Indian rawhide shoes from the ponies. They crossed the Gila near the Nau Taw Mountains. Here he stole two fresh horses, and loading one with all the buckskins, he put her on and headed her down the Eagle Trail to Black River. She now knew where she was, but was nearly dying from the exhaustion of his fly-by-night expeditions. He halted her, told her to 'tell the white officer that she was a pretty good girl, better than San Carlos woman, and that he would come again and get another.' He struck her horse and was gone.

"Massai then became a problem to successive chiefs of scouts, a bugbear to the reservation Indians, and a terror to Arizona. If a man was killed or a woman missed, the Indians came galloping and the scouts lay on his trail. If he met a woman in the defiles, he stretched her dead if she did not please his errant fancy. He took pot-shots at the men ploughing in their little fields, and knocked the Mexican bull-drivers on the head as they plodded through the blinding dust of the Globe Road. He even sat like a vulture on the rim rock and signalled the Indians to come out and talk. When two Indians thus accosted did go out, they found themselves looking down Massai's .50-calibre, and were tempted to do his bidding. He sent one in for sugar and coffee, holding the brother, for such he happened to be, as a hostage till the sugar and coffee came. Then he told them that he was going behind a rock to lie down, cautioning them not to move for an hour. That was an unnecessary bluff, for they did not wink an eye till sundown. Later than this he stole a girl in broad daylight in the face of a San Carlos camp and dragged her up the rocks. Here he was attacked by fifteen or twenty bucks, whom he stood off until darkness. When they reached

his lair in the morning, there lay the dead girl, but Massai was gone.

"I never saw Massai but once, and then it was only a piece of his G string flickering in the brush. We had followed his trail half the night, and just at daylight, as we ascended a steep part of the mountains, I caught sight of a pony's head looking over a bush. We advanced rapidly, only to find the horse grunting from a stab wound in the belly, and the little camp scattered around about him. The shirt tail flickering in the brush was all of Massai. We followed on, but he had gone down a steep bluff. We went down too, thus exposing ourselves to draw his fire so that we could locate him, but he was not tempted.

"The late Lieutenant Clark had much the same view of this mountain outlaw, and since those days two young men of the Seventh Cavalry, Rice and Averill, have on separate occasions crawled on his camp at the break of day, only to see Massai go out of sight in the brush like a blue quail.

"Lieutenant Averill, after a forced march of eighty-six miles, reached a hostile camp near morning, after climbing his detachment, since midnight, up the almost inaccessible rocks, in hopes of surprising the camp. He divided his force into three parts, and tried, as well as possible, to close every avenue of escape, but as the camp was on a high rocky hill at the junction of four deep canyons, this was found impracticable. At daylight the savages came out together, running like deer, and making for the canyons. The soldiers fired, killing a buck and accidentally wounded a squaw, but Massai simply disappeared.

"That's the story of Massai. It is not as long as his trail," said the chief of scouts.

22.
They
Bore
a Hand

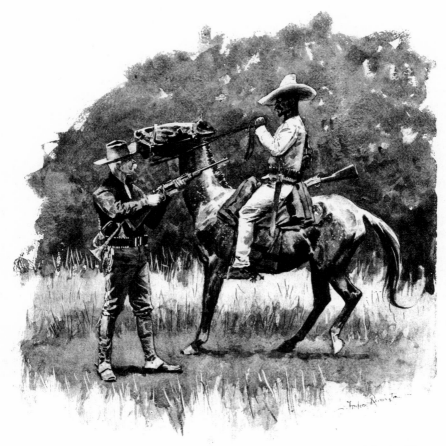

"Get down!"

THEY BORE A HAND

BY FREDERIC REMINGTON

WHEN Mrs. Kessel with the two children saw the troops pack up and entrain their horses, she had plenty of things to do for the Major besides control her feelings. It had appened so many times before that it was not a particularly distinct sensation; but the going forth of an armed man i always thrilling—yes, even after twenty years of it. She did not think, I imagine, but she knew many wives of regular army officers whom Congress had forgotten, after the dead heroes had been heralded up and down the land and laid away. The "still small voice" of the army widow doesn't make the halls of Congress yell with rage at the stern facts. But she was accustomed, since the year of their marriage, to the departure of her besabred husband, and that was the "worse" for which she married him. The eldest girl was as near twenty as I can tell about such things. They were excited by the fast moving of events, and the flash of steel had benumbed their reflective quality, but papa was a soldier, and Spain had to be licked. Who could do it better than papa, Oestreicher, his orderly trumpeter, and the gallant Third, those nimble athletes who took the three bareback horses over the hurdles in the riding-hall? Who could withstand the tearing charge

287

down the parade with the white blades flashing? Nothing but Oestreicher with his trumpet could stop that.

Oestreicher had told them a thousand times that papa could lick any one under any conceivable circumstances. They very well knew that he had followed the flying Arapaho village far into the night, until he had captured everything; they were familiar with the niceties of the Apache round-up at San Carlos, because Oestreicher had handed the Major a six-shooter at the particular instant; and the terrible ten days' battle with the revengeful Cheyennes, when the snow was up to the horses' bellies, had been done to death by the orderly. Papa had been shot before, but it hadn't killed him, and they had never heard of "yellow-jack" on the high plains. Papa did all this with Oestreicher to help him, to be sure, for the orderly always declared himself a full partner in the Major's doings, and divided the glory as he thought best.

Oestreicher, orderly trumpeter, was white and bald. He never stated any recollections of the time before he was a soldier. He was a typical German of the soldier class ; a fierce red in the face, illuminated by a long yellowish-white mustache, but in body becoming a trifle wobbly with age. He had been following the guidon for thirty-seven years. That is a long time for a man to have been anything, especially a trooper.

Oh yes, it cannot be denied that Oestreicher got drunk on pay-days and state occasions; but he was too old to change; in his day that thing was done. Also, he had love-affairs, of no very complex nature. They were never serious enough for the girls to hear of. Also, he had played the various financial allurements of the adjoining town, until his "final statement" would be the month's pay then due. But this bold humanity welled up in Oestreicher thoroughly mixed with those soft virtues which made every one in trouble come to him. He was a professional soldier, who knew no life outside a Sibley or a barrack, except the Major's home, which he helped the Major to run. On the drill-ground the Major undoubtedly had to be taken into account, but at the Major's quarters Oestreicher had so close an alliance with madam and the girls that the "old man" made a much smaller impression. A home always should be a pure democracy.

The Kessel outfit was like this: It was "military satrap" from the front door out, but inside it was "the most lovable person commands," and Oestreicher often got this assignment.

In the barracks Oestreicher was always "Soda"—this was an old story, which may have related to his hair, or his taste, or an episode—but no man in the troop knew why. When they joined, Oestreicher was "Soda," and traditions were iron in the Third.

Oestreicher and the Major got along without much friction. After pay-day the Major would say all manner of harsh things about the orderly because he was away on a drunk, but in due time Oestreicher would turn up smiling. Madam and the girls made his peace, and the Major subsided. He had got mad after this manner at this man until it was a mere habit, so the orderly trumpeter never came up with the court-martialling he so frequently courted, for which that worthy was duly grateful, and readily forgave the Major his violent language.

For days Oestreicher and the women folks had been arranging the Major's field-kit. The Major looked after the troops, and the trumpeter looked after the Major, just as he had for years and years before. When the train was about to pull out, the Major kissed away his wife's tears and embraced his children, while Oestreicher stood by the back door of the Pullman, straight and solemn.

"Now look out for the Major," solicited the wife, while the two pretty girls pulled the tall soldier down and printed two kisses on his red burnt cheeks, which he received in a disciplined way.

"Feed Shorty and Bill [dogs] at four o'clock in the afternoon, and see that they don't get fed out of mess hours," said the orderly to the girls, and the women got off the cars.

And Oestreicher never knew that madam had told the Major to look out well for the orderly, because he was old, and might not stand things which he had in the earlier years. That did not matter, however, because it was all a day's work to the toughened old soldier. The dogs, the horses, the errands, the girls, the Major, were habits with him, and as for the present campaign—he had been on many before. It gave only a slight titillation.

Thus moved forth this atom of human-

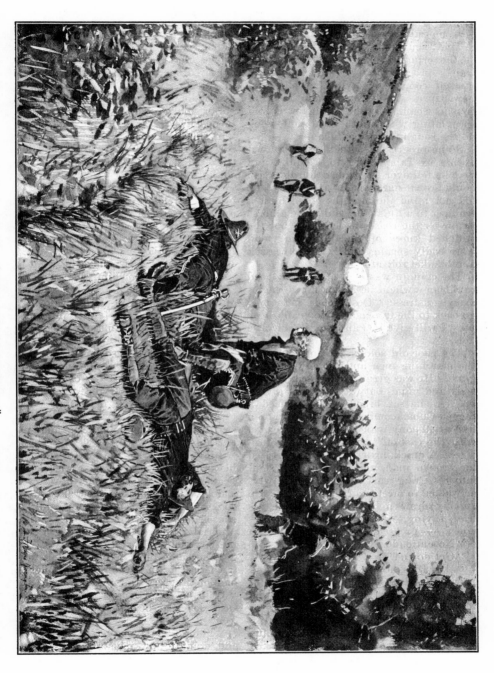

"THERE WAS NOTHING TO DO."

ity with his thousands of armed country-men to do what had been done before—set the stars and stripes over the frontier and hold them there. Indians, greasers, Spaniards—it was all the same, just so the K troop guidon was going that way.

The "shave-tails" could kick and cuss at the criminal slowness of the troop-train's progress, but Oestreicher made himself comfortable with his pipe and newspaper, wondering what kind of cousins Spaniards were to Mexicans, and speculating with another old yellow-leg on the rough forage of Cuba.

So he progressed with the well-known events to Tampa and to Daiquiri, and here he fell over a very bad hurdle. He could brown hardtack in artful ways, he did not mind the mud, he could blow a trumpet to a finish, he could ride a horse as far as the road was cut out, but the stiffened knees of the old cavalryman were badly sprung under the haversack and blanket roll afoot.

The column was well out on the road to Siboney when the Major noted the orderly's distress: "Oestreicher, fall out—go back to the transport. You can't keep up. I will give you an order," which he did.

The poor old soldier fell to the rear of the marching men and sat down on the grass. He was greatly depressed, both in body and mind, but was far from giving up. As he sat brooding he noticed a ragged Cuban coming down the road on a flea-bitten pony, which was heavily loaded with the cast-off blankets of the volunteers. A quick lawless thought energized the broken man, and he shoved a shell into his Craig carbine. Rising slowly, he walked to meet the ragged figure. He quickly drew a bead on the sable patriot, saying, "Dismount—get down—you d—— greaser!"

"No entiendo."

"Get down!"

"¿Por Dios, hombre, que va hacer?" and at this juncture Oestreicher poked the Cuban in the belly with his carbine, and he slid off on the other side.

"Now run along—vamose—underlay —get a gait on you!" sang out the blue soldier, while the excited Cuban backed up the road, waving his hands and saying, "¡Bandolero, ladron, sin verguenza! ¿Porque me roba el caballo?"

To which Oestreicher simply said, "Oh hell!"

Not for a second did Oestreicher know that he was a high agent of the law. Be it known that any man who appropriates property of your Uncle Samuel can be brought to book. It is hard to defend his action when one considers his motive and the horse.

The final result was that Oestreicher appeared behind the Third Cavalry, riding nicely, with his blanket roll before his saddle. The troops laughed, and the Major looked behind; but he quickly turned away, grinning, and said to Captain Hardier: "Look at the d—— old orderly! If that isn't a regular old-soldier trick! I'm glad he has a mount; you couldn't lose him."

"Yes," replied the addressed, "you can order Oestreicher to do anything but get away from the Third. Can't have any more of this horse-stealing; it's demoralizing;" and the regiment plodded along, laughing at old "Soda," who sheepishly brought up the rear, wondering what justice had in store for him.

Nothing happened, however, and presently Oestreicher sought the Major, who was cursing his luck for having missed the fight at Las Guasimas. He condoled with the Major in a tactful way he had, which business softened things up. While the Major was watching him boil the coffee in the tin cups over a little "Indian fire," he put the order in the flames, and it went up in smoke.

"You old rascal!" was all the Major said, which meant that the incident was closed.

Right glad was the Major to have his orderly during the next week. The years had taught Oestreicher how to stick a dog-tent and make a bed, and how to cook and forage. Oestreicher's military conscience never vibrated over misappropriated things to eat, and Fagin could not have taught him any new arts.

Then came the fateful morning when the Third lay in the long grass under the hail of Mausers and the sickening sun. "Will the Major have some water?" said Oestreicher, as he handed over one canteen.

"You go lie down there with the men and don't follow me around—you will get shot," commanded Kessel; but when he looked around again, there was Oestreicher stalking behind. He could fool away no more energy on the man.

Then came the forward movement,

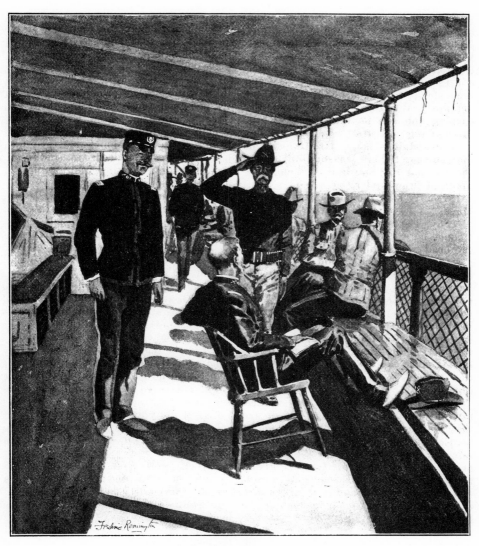

"I HOPE THE COLONEL WON'T GET MAD—"

the firing, and the falling men, and ahead strode the officer, waving his sword and shouting fiercely. Behind followed the jaded old trumpeter, making hard going of it, but determined to keep up. His eye was not on the blazing heights, but on the small of the Major's back, when the officer turned, facing him, and ran into his arms. Down over the Major's face came gushes of blood. He reeled—would have fallen but for the supporting arms of the soldier. The rush of men passed them.

They lay down in the grass. The or-derly brushed the blood from the pale face, while he cut up a "first-aid" band-age and bound the wound. Then he gave him water; but the Major was far gone, and the orderly trumpeter was very miserable. Oestreicher replaced the Ma-jor's sword in its scabbard. Men came tottering back, holding on to their wounds.

"Say, Johnson," sung out Oestreicher to a passing soldier, "you ain't hit bad; gimme a lift with the Major here." The soldier stopped, while they picked up the unconscious officer and moved heavily off toward the Red Cross flag. Suddenly they

lurched badly, and all three figures sank in the pea-green grass. A volley had found them. Johnson rolled slowly from side to side and spat blood. He was dying. Oestreicher hung on to one of his arms, and the bluish-mauve of the shirt sleeve grew slowly to a crimson lake. He sat helplessly turning his eyes from the gasping Johnson to the pale Major and the flaming hill-crest. He put his hat over the Major's face. He drank from his canteen. There was nothing to do. The tropical July sun beat on them until his head swam under the ordeal.

Presently a staff-officer came by on a horse.

"Say, Captain," yelled the soldier, "come here. Major Kessel is shot in the head. Take him, won't you?"

"Oh, is that you?" said the one addressed as he rode up, for he remembered Kessel's orderly. Dismounting, the two put the limp form on the horse. While Oestreicher led the animal, the Captain held the nearly lifeless man in the saddle, bent forward and rolling from side to side. Thus they progressed to the blood-soaked sands beside the river, where the surgeons were working grimly and quickly.

It was a month before two pale old men got off the train at Burton, one an officer and the other a soldier, and many people in the station had a thrill of mingled pity and awe as they looked at them. Two very pretty girls kissed them both, and people wondered the more. But the papers next morning told something about it, and no policeman could be induced to arrest Oestreicher that day when he got drunk in Hogan's saloon, telling how he and the Major took San Juan hill.

Time wore on, wounds healed, and the troops came back from Montauk to the yelling multitudes of Burton, the home station. The winter chilled the fever out of their blood. The recruits came in and were pulled into shape, when the long-expected order for the Philippines came, and the old scenes were re-enacted just as they had happened in the Kessel household so many times before, only with a great difference : Oestreicher was detached and ordered to stay in the guard of the post. This time the Major, who was a Colonel now, settled it so it would stay settled. An order is the most terrible and potent thing a soldier knows.

Oestreicher shed tears, he pleaded, he got the women to help him, but the Major stamped his foot and became ossified about the mouth.

Clearly there was only one thing left for Oestreicher to do in this case, and he did it with soldierly promptness. He got drunk—good and drunk—and the Third Cavalry was on its way to Manila. When the transport was well at sea from Seattle, the Colonel was reading a novel on the after-deck. A soldier approached him saluting, and saying, "I hope the Colonel won't get mad—"

The Colonel looked up; his eyes opened; he said, slowly, "Well—I—will—be—d——!" and he continued to stare helplessly into the cheerful countenance of Oestreicher, orderly trumpeter, deserter, stowaway, soft food for courts martial. "How did you get here, anyway?"

Then the Colonel had a military fit. He cussed Oestreicher long and loud. Told him he was a deserter, said his long-service pension was in danger ; and true it is that Oestreicher was long past his thirty years in the army, and could retire at any time. But through it all the Colonel was so astonished that he could not think—he could only rave at the tangle of his arrangements in the old orderly's interest.

"How did you get here, anyhow?

"Came along with the train, sir—same train you were on, sir," vouchsafed the veteran.

"Well, well, well!" soliloquized the Colonel as he sat down and took up his novel. "Get out—I don't want to see you—go away," and Oestreicher turned on his heel.

Other officers gathered around and laughed at the Colonel.

"What am I to do with that old man? I can't court-martial him. He would get a million years in Leavenworth if I did. D—these old soldiers, anyhow! They presume on their service. What can I do?"

"Don't know," said the junior Major. "Reckon you'll have to stay home yourself if you want to keep Oestreicher there."

It was plain to be seen that public sentiment was with the audacious and partly humorous orderly.

"Well—we will see—we will see!" testily jerked the old man, while the young ones winked at each other—long broad winks, which curled their mouths far up one side.

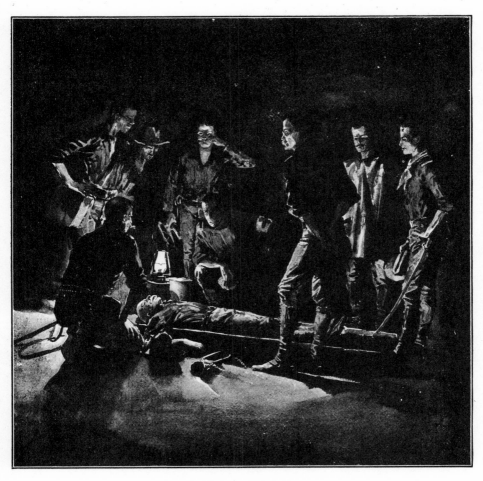

THE DEATH OF OESTREICHER.

The Colonel has been seeing ever since. I have only just found out what he "saw," by a letter from an old friend of mine out in the Philippines, which I shall quote:

"You remember Colonel Kessel's old orderly—Oestreicher? Was with us that time we were shooting down in Texas. He was ordered to stay at Jackson Barracks, but he deserted. The men hid him under their bunks on the railroad train, and then let him on the transport at Seattle. Soldiers are like boys: they will help the wicked. One day he presented himself to the old man. Oh, say—you ought to have heard the old Nantan cuss him out—it was the effort of the 'old man's' life! We sat around and enjoyed it, because Oestreicher is a habit with the Colonel. We knew he wouldn't do anything about it after he had blown off steam.

"Well, the night after our fight at Cabanatuan it was dark and raining. What do you suppose I saw? Saw the 'old man' in a nipa hut with a doctor, and between them old Oestreicher, shot through the head and dying. There was the Colonel sitting around doing what he could for his old dog-soldier. I tell you it was a mighty touching sight. Make a good story that—worked up with some blue lights and things. He sat with him until he died. Many officers came in and stood with their hats off, and the Colonel actually boohooed. As you know, boo-hooing ain't the 'old man's' long suit by a d—— sight!"

23.
A Failure
of Justice

A FAILURE OF JUSTICE

BY FREDERIC REMINGTON

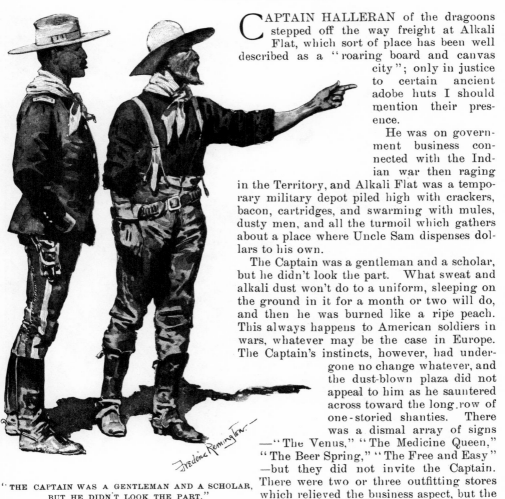

CAPTAIN HALLERAN of the dragoons stepped off the way freight at Alkali Flat, which sort of place has been well described as a "roaring board and canvas city"; only in justice to certain ancient adobe huts I should mention their presence.

He was on government business connected with the Indian war then raging in the Territory, and Alkali Flat was a temporary military depot piled high with crackers, bacon, cartridges, and swarming with mules, dusty men, and all the turmoil which gathers about a place where Uncle Sam dispenses dollars to his own.

The Captain was a gentleman and a scholar, but he didn't look the part. What sweat and alkali dust won't do to a uniform, sleeping on the ground in it for a month or two will do, and then he was burned like a ripe peach. This always happens to American soldiers in wars, whatever may be the case in Europe. The Captain's instincts, however, had undergone no change whatever, and the dust-blown plaza did not appeal to him as he sauntered across toward the long row of one-storied shanties. There was a dismal array of signs —"The Venus," "The Medicine Queen," "The Beer Spring," "The Free and Easy" —but they did not invite the Captain. There were two or three outfitting stores which relieved the business aspect, but the

"THE CAPTAIN WAS A GENTLEMAN AND A SCHOLAR, BUT HE DIDN'T LOOK THE PART."

297

simple bed and board which the Captain wanted was not there, unless with its tin-pan piano or gambling-chip accompaniment.

He met a man who had the local color, and asked if there was not in the town a hotel run somewhat more on the ancient lines.

"Sure there is, Cap, right over to the old woman's," said he, pointing. "They don't have no hell round the old woman's. That's barred in this plaza; and she can cook jes like mother. That's the old woman's over thar whar yu' see the flowers in front and the two green trees—jes nex' the Green Cloth Saloon."

The Captain entered the place, which was a small bar-room with a pool table in the centre, and back of this a dining-room. Behind the bar stood a wholesome-looking woman in a white calico dress, far enough this side of middle age to make "old woman" libellous as applied to her.

"Good-evening, madam," ventured the Captain, feeling that such a woman could not escape matrimony at the Flat.

"Good-evening, Captain. Want some supper?"

"Yes, indeed, and I guess I will take a drink—a cocktail, if you please," as he leaned on the bar.

"Captain, the boys say I am a pretty bad bartender. I'll jes give yu' the stuff, and you can fix it up to your taste. I don't drink this, and so I don't know what men like. It's grub and beds I furnish mostly, but you can't exactly run a hotel without a bar. My customers sort of come in here and tend bar for themselves. Have a lemon-peel, Captain?"

The Captain comprehended, mixed and drank his cocktail, and was ushered into the dining-room. It was half full of picturesque men in their shirt sleeves, or in canvas and dusty boots. They were mostly red-faced, bearded, and spiked with deadly weapons. They were quiet and courteous.

Over his bottle the American is garrulous, but he handles his food with silent earnestness.

Chinamen did the waiting, and there was no noise other than the clatter of weapons, for the three-tined fork must be regarded as such. The Captain fell to with the rest, and found the food an improvement on field rations. He present-ly asked a neighbor about the hostess—how she managed to compete with the more pretentious resorts. Was not the Flat a hard place for a woman to do business?

"Yes, pard, yu' might say it is rough on some of the ladies what's sportin' in this plaza, but the old woman never has no trouble." And his new acquaintance leaned over and whispered: "She's on the squar', pard; she's a plumb good woman, and this plaza sort of stands for her. She's as solid as a brick church here."

The Captain's friend and he, having wrestled their ration, adjourned to the sidewalk, and the friend continued: "She was wife to an old sergeant up at the post, and he went and died. The boys here wanted a eatin'-joint, bein' tired of the local hash, which I honest can tell yu' was most dam bad; so they gets her down here to ride herd on this bunch of Chinamen top-side. She does pretty well for herself, gives us good grub, and all that, but she gets sort of stampeded at times over the goin's on in this plaza, and the committee has to go out and hush 'em up. Course the boys gets tangled up with their irons, and then they are packed in here, and if the old woman can't nurse 'em back to life, they has to go. There is quite a little bunch of fellers here what she has set up with nights, and they got it put up that she is about the best dam woman on the earth. They sort of stand together when any alcoholic patient gets to yellin' round the old woman's, or some sportin' lady goes after the old woman's hair. About every loose feller round yer has asked the old woman to marry him, which is why she ain't popular with the ladies. She plays 'em all alike, and don't seem to marry much, and this town makes a business of seein' she always lands feet first, so when any one gets to botherin', the committee comes round and runs him off the range. It sure is unhealthy fer any feller to get loaded and go jumpin' sideways round this 'dobie. Sabe?"

The Captain did his military business at the quartermaster's, and then repaired to the old woman's bar-room to smoke and wait for the down freight. She was standing behind the bar, washing the glasses.

A customer came in, and she turned to him.

"Brandy, did yu' say, John?"

"Yes, madam; that's mine."

"I don't know brandy from whiskey, John; you jes smell that bottle."

John put the bottle to his olfactories, and ejaculated, "Try again; that ain't brandy, fer sure."

Madam produced another bottle, which stood the test, and the man poured his portion and passed out.

Alkali Flat was full of soldiers, cowmen, prospectors, who had been chased out of the hills by the Apaches, government freighters who had come in for supplies, and the gamblers and whiskey-sellers who kindly helped them to sandwich a little hilarity into their business trips.

As the evening wore on the blood of Alkali Flat began to circulate. Next door to the old woman's the big saloons were in a riot. Glasses clinked, loud-lunged laughter and demoniac yells mixed with the strained piano, over which untrained fingers banged and pirouetted. Dancers bounded to the snapping fiddle tones of "Old Black Jack." The chips on the faro table clattered, the red-and-black man howled, while from the streets at times came drunken whoops, mingled with the haw-haws of mules over in the quartermaster's corral.

Madam looked toward the Captain, saying, "Did you ever hear so much noise in your life?"

"Not since Gettysburg," replied the addressed. "My tastes are quiet, but I should think Gettysburg the more enjoyable of the two. But I suppose these people really think this kind of thing is great fun."

"Yes; they live so quiet out in the hills that they like to get into this bedlam when they are in town. It sort of stirs them up," explained the hostess.

"Do they never trouble you, madam?"

"No—except for this noise. I have had bullets come in here, but they wasn't meant for me. They get drunk outside and shoot wild sometimes. I tell the boys plainly that I don't want none of them to come in here drunk, and I don't care to do any business after supper. They don't come around here after dark much. I couldn't stand it if they did. I would have to pull up."

A drunken man staggered to the door of the little hotel, saw the madam behind the bar, received one look of scorn, and backed out again with a muttered, "Scuse me, lady; no harm done."

Presently in rolled three young men, full of the confidence which far too much liquor will give to men. They ordered drinks at the bar roughly. Their Derby hats proclaimed them Easterners: railroad tramps or some such rubbish, thought the Captain. Their conversation had the glib vulgarity of the big cities, with many of their catch-phrases, and they proceeded to jolly the landlady in a most offensive way. She tried to brave it out, until one of them reached over the bar and chucked her under the chin. Then she lifted her apron to her face and began to cry.

The wise mind of the Captain knew that society at Alkali Flat worked like a naphtha-engine—by a series of explosions. And he saw a fearful future for the small bar-room.

Rising, he said, "Here, here, young men, you had better behave yourselves, or you will get killed."

Turning with a swagger, one of the hoboes said, "Ah! whose 'll kill us, youse —— ——?"

"No, he won't!" This was shouted in a resounding way into the little room, and all eyes turned to the spot from which the voice came. Against the black doorway stood Dan Dundas—the gambler who ran the faro lay-out next door, and in his hands were the Colts levelled at the toughs, while over them gleamed steadily two bright blue eyes like planetary stars against the gloom of his complexion. "No, he won't kill yu'; he don't have to kill yu'. I will do that."

With a hysterical scream the woman flew to her knight-errant. "Stop—stop that, Dan! Don't you shoot—don't you shoot, Dan! If you love me, Dan, don't, don't!"

With the quiet drawl of the Southwest the man in command of the situation replied: "Well, I reckon I'll sure have to, little woman. Please don't put your hand on my guns. Maybeso I won't shoot, but, Helen—but I ought to, all right. Hadn't I, Captain?"

Many heads lighted up the doorway back of the militant Dan, but the Captain blew a whiff of smoke toward the ceiling and said nothing.

The three young men were scared rigid.

They held their extremities as the quick situation had found them. If they had not been scared, they would still have failed to understand the abruptness of things; but one of them found tongue to blurt:

"Don't shoot! We didn't do nothin', mister."

Another resounding roar came from Dan—"Shut up!" And the quiet was opaque.

"Yes," said the Captain, as he leaned on the billiard table, "you fellows have got through your talking. Any one can see that;" and he knocked the ash off his cigar.

"What did they do, Helen?" And Dan bent his eyes on the woman for the briefest of instants.

Up went the apron to her face, and through it she sobbed, "They chucked me under the chin, Dan, and—and one of them said I was a pretty girl—and—"

"Oh, well, I ain't sayin' he's a liar, but he 'ain't got no call fer to say it. I guess we had better get the committee and lariat 'em up to a telegraph pole—sort of put 'em on the Western Union line—or I'll shoot 'em. Whatever you says goes, Helen," pleaded justice amid its perplexities.

"No, no, Dan! Tell me you won't kill 'em. I won't like you any more if you do."

"Well, I sure ought to, Helen. I can't have these yer hoboes comin' round here insultin' of my girl. Now you allow that's so, don't yu'?"

"Well, don't kill 'em, Dan; but I'd like to tell 'em what I think of them, though."

"Turn her loose, Helen. If yu' feel like talkin', just you talk. You're a woman, and it does a woman a heap of good to talk; but if yu' don't want to talk, I'll turn these guns loose, or we'll call the committee without no further remarks—jes as yu' like, Helen. It's your play."

The Captain felt that the three hoboes were so taken up with Dan's guns that Helen's eloquence would lose its force on them. He also had a weak sympathy for them, knowing that they had simply applied the low street customs of an Eastern city in a place where customs were low enough, except in the treatment of decent women.

While Dan had command of the situation, Helen had command of Dan, and she began to talk. The Captain could not remember the remarks—they were long and passionate—but as she rambled along in her denunciation, the Captain, who had been laughing quietly, and quizzically admiring the scene, became suddenly aware that Dan was being more highly wrought upon than the hoboes.

He removed his cigar, and said, in a low voice, "Say, Dan, don't shoot; it won't pay."

"No?" asked Dan, turning his cold, wide-open blue eyes on the Captain.

"No; I wouldn't do it if I were you; you are mad, and I am not, and you had better use my judgment."

Dan looked at the hoboes, then at the woman, who had ceased talking, saying, "Will I shoot, Helen?"

"No, Dan," she said, simply.

"Well, then," he drawled, as he sheathed his weapons, "I ain't goin' to trifle round yer any more. Good-night, Helen," and he turned out into the darkness.

"Oh, Dan!" called the woman.

"What?"

"Promise me that no one kills these boys when they go out of my place; promise me, Dan, you will see to it that no one kills them. I don't want 'em killed. Promise me," she pleaded out of the door.

"I'll do it, Helen. I'll kill the first man what lays a hand on the doggoned skunks;" and a few seconds later the Captain heard Dan, out in the gloom, mutter, "Well, I'll be d——!"

A more subdued set of young gentlemen than followed Dan over to the railroad had never graced Alkali Flat.

Dan came back to his faro game, and sitting down, shuffled the pack and meditatively put it in the box, saying to the case-keeper, "When a squar' woman gets in a game, I don't advise any bets."

But Alkali Flat saw more in the episode than the mere miscarriage of justice: the excitement had uncovered the fact that Dan Dundas and Helen understood each other.

24.
A Sketch
by MacNeil

A SKETCH BY MACNEIL.

BY FREDERIC REMINGTON.

WE had to laugh. I chuckled all day, it was all so quaint. But I don't see how I can tell you, because you don't know MacNeil, which is necessary.

In a labored way, MacNeil is an old frontier scout with a well-frosted poll. He is what we all call a "good fellow," with plenty of story, laugh, and shrewd comment; but his sense of humor is so ridiculously healthy, so full-bloodedly crude, that many ceremonious minds would find themselves "off side" when Mac turns on his sense of jollity. He started years ago as a scout for Sheridan down Potomac way, and since then he has been in the Northwest doing similar duty against Indians, so a life spent in the camps and foot-hills has made no "scented darling" out of old man MacNeil. He is a thousand-times hero, but he does not in the least understand this. If he could think any one thought he was such a thing he would opine that such a one was a fool. He has acted all his life in great and stirring events as unconscious of his own force as the heat, the wind, or the turn of tide. He is a pure old warrior, and nothing has come down the years to soften MacNeil. He is red-healthy in his sixties, and has never

seen anything to make him afraid. The influence of even fear is good on men. It makes them reflective, and takes them out of the present. But even this refinement never came to Mac, and he needed it in the worst way.

So that is a bad sketch of MacNeil.

A little bunch of us sat around the hotel one day, and we were drawing Mac's covers of knowledge concerning Indians. As the conversation went on, Mac slapped his leg, and laughing, said, "The most comical thing I ever saw in my life!"

"What was that, Mac?" came a half-dozen voices, and Mac was convulsed with merriment.

"The last time the Piegans raided the Crows I was out with the First Cavalry. We were camped on the Yellowstone, and had gone to bed. I heard an Injun outside askin' about me, and pretty soon Plenty Coups comes in, sayin' the Piegans had got away with a good bunch of their ponies, but that they had found the trail crossing a little way down the river, and Big Horse and a war-band of Crows was layin' on it, and they wanted me to go 'long with them and help run it. I didn't have anything but a big government horse, and they ain't good company for Injun ponies when they are runnin' horse-thieves; besides, I didn't feel called to bust my horse helpin' Injuns out of trouble. There had got to be lots of white folks in the country, and they wa'n't at all stuck on havin' war-bands of Injuns pirootin' over the range. The Injuns wanted me to protect them from the cowboys, 'cause, you see, all Injuns look alike to a cowboy when they are runnin' over his cows. So Plenty Coups says he will give a pony, and I says, 'Mr. Injun, I will go you one.'

"I fixed up sort of warm, 'cause it was late in the fall, and threw my saddle on the pony, and joined the war-band. It was bright moon, and we ran the trail slowly until morning; and when it come day we moved along Injun fashion, which ain't slow, if you ask me about it. We kept a-pushin' until late afternoon, when we saw the Piegans, about seven miles ahead, just streakin' it over the hills. My Injuns got off their ponies, and, Injun fashion, they stripped off every rag they had on except the G-string and moccasins. This is where them Injuns is light-minded, for no man has got any call to go

flirtin' with Montana weather at that time of the year in his naked hide. Old man Mac stands pat with a full set of jeans. And then we got on them ponies and we ran them Piegans as hard as we could lather till plumb dark, when we had to quit because we couldn't see. We were in an open sage-brush country. Well, it got darker and darker, and then it began to rain. I sat on my saddle and put my saddle-blanket over my head, and I was pretty comfortable. Then it began to rain for fair. Them Injuns stamped and sung and near froze to death, and I under the blanket laughing at them. 'Long 'bout midnight it began to snow, and them Injuns turned on the steam. The way they sung and stomped round in a ring tickled me near to death. The snow settled round my blanket and kept out the cold in great shape. I only had my nose out, and when it began to get gray morning I had to just yell to see them Injuns out there in five inches of snow, without a rag on, hoppin' for all they was worth. You talk about shootin' up a fellow's toes to make him dance; it wa'n't a circumstance. Them Injuns had to dance or 'cash in.' I have seen plenty of Injun dances, but that dance had a swing to it that they don't get every time.

"We got on the ponies and started back through the falling snow, tryin' to locate them annuity goods of theirn. 'Course we lost the Piegans. We lost ourselves, and we didn't find them clothes till afternoon, 'most eighteen miles back, and then we had to dig them up, and they was as stiff as *par-flèche*. Them was a funny bunch of warriors, I tell you.

"We found an old big-jaw* steer which some punchers had killed, and them Injuns eat that all right; but I wasn't hungry enough yet to eat big-jaw steer, so I pulled along down to the railroad. I got a piece of bread from a sheep-man, and when I got to Gray Cliffs, on the N. P., I was 'most frozen. My feet and knees were all swollen up.

"Whenever I gets to thinkin' 'bout them bucks jumpin' around out there in the snow all that night, and me a-settin' there under the blanket, I has to laugh. She was sure a funny old revel, boys."

And we listeners joined him, but we were laughing at MacNeil, not with him.

* A cattle disease.

25.
The
White
Forest

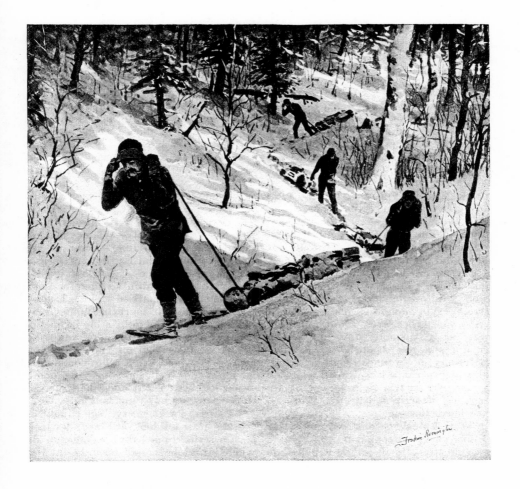

THE WHITE FOREST.

BY FREDERIC REMINGTON.

FROM the mid-winter mist and mush of New York it was a transformation to us standing there in the smoking-room of the Château Frontenac at Quebec, looking down across the grand reaches of the St. Lawrence, where the ice ran in crashing fields through the steaming water of the flood-tide. It was a cheerful view from a cheerful place, though the frost was on the pane, and the wood-work popped with the cold. Down in the street the little Canadian horses, drawing their loads, were white with rime, while their irrepressible French drivers yelled at each other until we could hear them through the double windows. There is energy in this fierce Northern air.

"Why Florida in winter? Why not Quebec?" said the old Yale stroke.

"Yes, why not?" reiterated the Essex trooper.

But the coziness of the château did not suggest the seriousness of our purpose. We wanted to get out on the snow—to get in the snow—to tempt its moods and feel its impulses. We wanted to feel the

nip of that keen outside air, to challenge a contest with our woollens, and to appropriate some of its energy. Accordingly we consulted a wise mind who sold snow-shoes, blankets, moccasins, and socks, and he did a good business.

"Shall we dress at St. Raymond or in the château?" said my companion, mindful of the severity of convention in New York, as he gazed on the litter of his new garments spread out on the floor of our room.

"We will dress here, and leave so early that Quebec will not be out of bed until we are away; but if Quebec were awake and on the streets, Quebec would not turn its head to honor our strangeness with a glance, because it would see nothing new in us;" and dress we did. We only put on three pairs of socks and one pair of flannel-lined moccasins, but we were taught later to put on all we had. As the rich man said to the reporter, when trying to explain the magnitude of his coming ball, "There will be ten thousand dollars' worth of ice-cream," so I say to you we had forty dollars' worth of yarn socks.

We had bags of blankets, hunks of fresh beef and pork, which had to be thawed for hours before cooking, and potatoes in a gunny sack, which rattled like billiard-balls, so hard were they frozen. We found great amusement on the train by rattling the bag of potatoes, for they were the hardest, the most dense things known to science.

The French drivers of the burleaus who deposited us at the train took a cheery interest in our affairs; they lashed the horses, yelled like fiends, made the snow fly around the corners, nearly ran down an early policeman, and made us happy with the animation. They are rough children, amazingly polite— a product of paternalism—and comfortable folks to have around, only you must be careful not to let them succeed in their childish endeavor to drive their horses over you. Anyway, they cheered us off through the softly falling snow of that early winter morning, and made us feel less like strangers.

At St. Raymond were the guides and little one-horse burleaus all ready for the trip to the "bush," or at least for the fifteen miles, which was as far as sleighs could go, up to old man O'Shannahan's, which is the first camp of the club. There were nearly four feet of snow on the ground, so that the regular road between the fences was drifted full, compelling the *habitants* to mark out another way with evergreen trees through their fields.

Far apart over the white landscape are set the little French cottages, with their curved roofs. They are so cozily lonely, and the rough hills go up from the valley to further isolate them. Coming along the road we met the low hauling-sleds of the natives, who ran their horses off the road into the snow half-way up their horses' sides; but the sledges were flat, and floated, as it were. Picturesque fellows, with tuques, red sashes, and fur coats, with bronzed faces, and whiskers worn under their chin, after the fashion of the early thirties. The Quebec *habitants* don't bother their heads about the new things, which is the great reason why

THE OLD YALE STROKE.

THE ESSEX TROOPER.

ing, as I do, that all the game in America has in these latter days been forced into them, and realizing that to follow it the hunter must elevate himself over the highest tops, which process never became mixed in my mind with the poetry of mountain scenery.

We essayed the snow-shoes—an art neglected by us three people since our boyhood days. It is like horseback-riding—one must be at it all the time if he is to feel comfortable. Snow-shoes must be understood, or they will not get along with you.

Bebé Larette laughingly said, "Purty soon you mak de snow-shoe go more less lak dey was crazee."

Having arranged to haul the supplies into the "bush" next day, we lay down for the night in the warm cabin, tucked in and babied by our generous French guides. The good old Irishman, Mr. O'Shannahan, was the last to withdraw.

"Mr. O'Shannahan, what do the French say for 'good-night'?"

"Well, som' o' thim says 'Bung-sware,' and som' o' thim says 'Bung way';" but none of them, I imagine, say it just like Mr. O'Shannahan.

With the daylight our hut began to abound with the activities of the coming day. A guide had a fire going, and Mr. O'Shannahan stood warming himself beside it. The Essex trooper, having reduced himself to the buff, put on an old pair of moccasins and walked out into the snow. The New Jersey thermometer which we had brought along may not have as yet gotten acclimated, but it solemnly registered 5° below zero.

"Bebé, will you kindly throw a bucket of water over my back?" he asked; but Bebé might as well have been asked to kindly shoot the Essex trooper with a gun, or to hit him with an axe. Bebé would have neither ice-water, rifle, nor axe on his pious soul.

I knew the stern requirements of the morning bath, and dowsed him with the desired water, when he capered into the cabin and began with his crash towel to rub for the reaction. Seeing that Mr. O'Shannahan was perturbed, I said,

"What do you think of that act?"

"Oi think a mon is ez will aff be the soide av this stove as to be havin' the loikes av yez poor ice-wather down his spoine."

Mr. O'Shannahan reflected and hunched

they are the most contented people in America.

The faithful watch-dog barked at us from every cottage, and, after the manner of all honest house-dogs, charged us, with skinned lips and gleaming eye. We waited until they came near to the low-set burleau, when we menaced them with the whip, whereat they sprang from the hard road into the soft snow, going out of sight in it, where their floundering made us laugh loud and long. Dogs do not like to be laughed at, and it is so seldom one gets even with the way-side pup.

At O'Shannahan's we were put up in the little club cabin and made comfortable. I liked everything in the country except the rough look of the hills, know-

nearer the box-stove, saying: "It's now gaun a year, but oi did say a mon do mooch the loikes av that wan day. He divisted himself av his last stitch, an' day*liberately* wint out an' rowled himsilf in the snow. That before brikfast, moind ye. Oi've no doobt he's long since dead. Av the loikes av this t'ing do be goan an, an' is rayparted down en the Parla-mint, they'll be havin' a law fer it— more's the nade."

After breakfast a hundred pounds of our war material was loaded on each toboggan. We girded on our snow-shoes and started out to break trail for the sledges. I know of no more arduous work. And while the weather was very cold, Mr. O'Shannahan nearly undressed us before he was satisfied at our condi-tion for bush-ranging. We sank from eight to ten inches in the soft snow. The raising of the snow-burdened racket tells on lung and ankle and loin with killing force. Like everything else, one might become accustomed to lugging say ten pounds extra on each set of toes, but he would have to take more than a day at it. The perspiration comes in streams, which showed the good of O'Shannahan's judgment. Besides, before we had gone three miles we began to understand the mistake of not wearing our forty dollars' worth of socks. Also we had our moc-casins on the outside, or next to the snow-shoes. They got damp, froze into some-thing like sheet-iron, and had a fine ice-

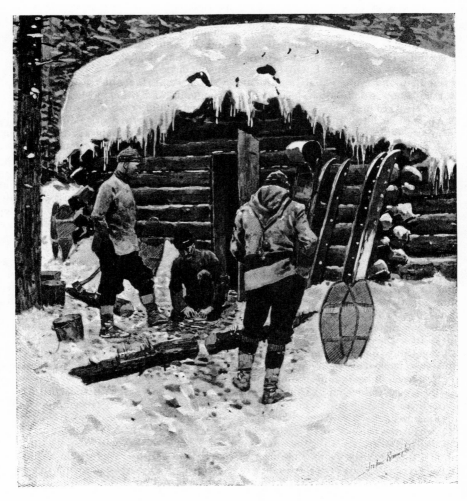

THE CABIN.

glaze on their bottoms, which made them slip and slide backward and forward on the snow-shoes.

After three miles, Bebé readjusted and tied my moccasins, when Oliver, the cook, who was a very intelligent man, mopped his forehead with his shirt sleeve, and observed:

"Excuse me, I t'ink you bettair go back dose cabain—you are not fix hup more propair for dees beesness. Ma dear fren', dose man een Quebec what sol' you dose t'ing"—and here his quiet, patient personality was almost overcome, this human reflection of the long Northern winter could not calm himself, so he blurted, in his peaceful way—"dose man een Quebec dey weare know not'ing."

We were in the light of a great truth —the shoes would not stay on — the thongs cut our toes—we had outlived our usefulness as trail-breakers, and we succumbed. The back track was one of my greatest misfortunes in life, but it was such a measly lot of cold-finger, frozen-toe, slip-down detail that I will forbear. My companions were equally unfortunate; so when we finally fell into the arms of Mr. O'Shannahan, he said:

"Ah, a great hardship. Oi will make that matter plain to yez."

The sledges had deposited their loads half-way up the trail, the guides coming back for the night.

Next morning the remainder of our stuff was loaded, and with renewed faith we strode forth. The snow-shoes were now all right, and, with five pairs of socks apiece — one outside the moccasins — the thongs could not eat our toes. We took photographs of our moccasins—unwholesome, swollen things—and dedicated the plates to Mr. Kipling as "the feet of the young men."

The country of the Little Saguenay is as rough as any part of the Rocky Mountains. It is the custom to dress lightly for travelling, notwithstanding the 20° below zero, and even then one perspires very freely, making it impossible to stop long for a rest, on account of the chill of the open pores. Ice forms on eyebrow, hair, and mustache, while the sweat freezes in scales on the back of one's neck. The snow falls from the trees on the voyager, and melting slightly from the heat of the body, forms cakes of ice. Shades of Nansen and all the arctic men! I do not understand why they are not all pillars

of ice, unless it be that there are no trees to dump snow on them. The spruce and hemlock of these parts all point upwards as straight as one could set a lance, to resist the constant fall of snow. If one leaned ever so little out of the perpendicular, it could not survive the tremendous average of fifty feet of snowfall each winter. Their branches, too, do not grow long, else they would snap under the weight. Every needle on the evergreens has its little burden of white, and without intermission the snow comes sifting down from the sky through the hush of the winter. When we stopped, and the creak of the snow-shoes was still, we could almost hear our hearts beat. We could certainly hear the cracking of the tobacco burning in our pipes. It had a soothing, an almost seductive influence, that muffle of snow. So solemn is it, so little you feel yourself, that it is a consciousness which brings unconsciousness, and the calm white forest is almost deadening in its beauty. The winter forest means death.

Then came the guides dragging their toboggans, and we could hear them pant and grunt and creak and slip; how they manage the fearful work is quite beyond me. Used to it, I suppose. So are pack-mules; but think of the generations of suffering behind this which alone makes it possible. The men of the pack, the paddle, snow-shoe, toboggan, and axe do harder, more exhausting work than any other set of people; they are nearer to the primitive strain against the world of matter than are other men—they are the "wheelers," so to speak.

The last stage up the mountain was a lung-burster, but finally we got to a lake, which was our objective. It was smooth.

"Let us take off these instruments of torture and rest our feet on the smooth going," said we, in our innocence, and we undid a snow-shoe each. The released foot went into the snow up to our middles, and into water besides. We resumed our snow-shoe, but the wet moccasins coming in contact with the chill air became as iron. Our frozen snow-shoe thongs were wires of steel. Our hands were cold with the work of readjustment, our bodies chilled with the waiting. It was a bad half-hour before the cabin was reached. We built a fire, but the provisions had not come up, so we sat around and gazed with glaring eyes at each oth-

THE HOT FINISH IN THE SNOW-SHOE RACE.

er. The Essex trooper and I talked of eating the old Yale stroke, who was our companion, but we agreed he was too tough. I was afraid for a time that a combination might be made against me on those lines, but luckily the toboggans arrived.

The log cabin was seventeen feet square, so what with the room taken by the bunks, box-stove, our provender and dunnage, the lobby of the house was somewhat crowded. There were three Americans and five Frenchmen. The stove was of the most excitable kind, never satisfied to do its mere duty, but threatening a holocaust with every fresh stick of wood. We made what we called "atmospheric cocktails" by opening the door and letting in one part of 20° below zero air to two parts of 165° above zero air, seasoned with French bitters. It had the usual effect of all cocktails; we should much have preferred the "straight goods" at, say, 70°.

In the morning we began a week's work at caribou-hunting. It is proper to state at this interval that this article can have no "third act," for success did not crown our efforts. We scoured the woods industriously behind our India-rubber, leather-lunged guides, with their expert snow-shoeing, and saw many caribou; but they saw us first, or smelled us, or heard us, and, with the exception of two "clean misses," we had no chance. It may be of interest to tell what befalls those who "miss," according to the rough law of the cabin. The returning hunter may deny it vigorously, but the grinning of the guide is ample testimony for conviction. The hunter is led to the torture tree. All the men, cook included, pour out of the cabin and line up. The "misser" is required to assume a very undignified posture, when all the men take a hack at him with a frozen moccasin. It is rude fun, but the howls of laughter ring through the still forest, and even the unfortunate sportsman feels that he has atoned for his deed.

Bebé Larette killed a young caribou, which was brought into camp for our observation. It was of a color different from what we had expected, darker on the back, blacker on the muzzle, and more the color of the tree trunks among which it lives. Indeed, we had it frozen and set up in the timber to be photographed and painted. Standing there, it was almost invisible in its sameness.

Its feet were the chief interest, for we had all seen and examined its tracks. If one puts his hand down into the track, he will find a hard pillar of snow which is compressed by their cuplike feet; and more striking still is it that the caribou does not sink in the snow as far as our big snowshoes, not even when it runs, which it is able to do in four feet of snow with the speed of a red deer on dry ground. In these parts the caribou has no enemy but man: the wolf and the panther do not live here, though the lynx does,

THE SERIOUSNESS OF FOUR FEET OF SNOW.

CARIBOU TRACK.

but I could not learn that he attacks the caribou.

From Mr. Whitney's accounts, I was led to believe the caribou was a singularly stupid beast, which he undoubtedly is in the Barren Grounds. For sportsmen who hunt in the fall of the year he is not regarded as especially difficult—he is easily shot from boats around ponds; but to kill a caribou in the Laurentian Mountains in midwinter is indeed a feat. This is due to the deathly stillness of the winter forest, and the snow-shoeing difficulties which beset even the most clever sportsman.

This brings to my mind the observation that snow-shoeing, as a hunter is required to do it when on the caribou track, has the same relationship to the "club snow-shoe run," so called, that "park riding" does to "punching cows." The men of the "bush" have short and broad oval shoes, and they must go up and down the steepest imaginable places, and pass at good speed and perfect silence through the most dense spruce and tamarack thickets, for there the caribou leads. The deep snow covers up the small evergreen bushes, but they resist it somewhat, leaving a soft spot, which the hunter is constantly falling into with fatal noise. If he runs against a tree, down comes an

avalanche of snow, which sounds like thunder in the quiet.

I was brought to a perfectly fresh track of three caribou by two guides, and taking the trail, we found them not alarmed, but travelling rapidly. So "hot" was the trail that I removed the stocking from my gun-breech. We moved on with as much speed as we could manage in silence. The trees were cones of snow, making the forest dense, like soft-wood timber in summer. We were led up hills, through dense hemlock thickets, where the falling snow nearly clogged the action of my rifle and filled the sights with ice. I was forced to remove my right mitten to keep them ice-clear by warming with the bare hand. The snow-shoeing was difficult and fatiguing to the utmost, as mile after mile we wound along after those vagrant caribou. We found a small pond where they had pawed for water, and it had not yet frozen after their drink.

Now is the time when the hunter feels the thrill which is the pleasure of the sport.

Down the sides of the pond led the trail, then twisting and turning, it entered the woods and wound up a little hill. Old man Larette fumbled the snow with his bare hand; he lifted toward us some unfrozen spoor—good, cheerful old soul, his eyes were those of a panther. Now we set our shoes ever so carefully, pressing them down slowly, and shifting our weight cautiously lest the footing be false. The two hunters crouched in the snow, pointing. I cocked my rifle; one snow-shoe sunk slowly under me—the snow was treacherous—and three dark objects flitted like birds past the only opening in the forest, seventy-five yards ahead.

"Take the gun, Con," I said, and my voice broke on the stillness harshly: the game was up, the disappointment keen. The reaction of disgust was equal to the suppressed elation of the second before. "Go to camp the nearest way, Larette."

The country was full of caribou. They travel constantly, not staying in one section. New tracks came every day into our little territory. We stalked and worked until our patience gave out, when we again loaded our toboggans for the back track.

At Mr. O'Shannahan's we got our burleaus, and jingled into St. Raymond by the light of the moon.

ICE-FISHING.

26.
Sun-Down
Leflare's
Warm Spot

SUN-DOWN LEFLARE'S WARM SPOT.

BY FREDERIC REMINGTON.

TOWARDS mid-day the steady brilliancy of the sun had satiated my color sense, and the dust kicked up in an irritating way, while the chug-a-chug, chug-a-chug, of the ponies began to bore me. I wished for something to happen.

We had picked wild plums, which had subdued my six-hour appetite, but the unremitting walk-along of our march had gotten on my nerves. A proper man should not have such fussy things—but I have them, more is the pity. The pony was going beautifully: I could not quarrel with him. The high plains do things in such a set way, so far as weather is concerned, and it is a day's march before you change views. I began to long for a few rocks—a few rails and some ragged trees—a pool of water with some reflections—in short, anything but the horizontal monotony of our surroundings.

To add to this complaining, it could not be expected that these wild men would ever stop until they got there, wherever "there" might happen to be this day. I evidently do not have their purpose, which is "big game," close to my heart. The chickens in this creek-bottom which we are following up would suit me as well.

These people will not be diverted, though I must, so I set my self-considering eye on Sun-Down Leflare. He will answer, for he is a strange man, with his curious English and his weird past. He is a tall person of great physical power, and must in his youth have been a handsome vagabond. Born and raised with the buffalo Indians, still there was white man enough about him for a point of view which I could understand. His great head, almost Roman, was not Indian, for it was too fine; nor was it French; it answered to none of those requirements. His character was so fine a balance between the two, when one considered his environment, that I never was at a loss to place the inflections. And yet he was an exotic, and could never bore a man who had read a little history.

Sombreroed and moccasined, Sun-Down pattered along on his roan pinto, talking seven languages at the pack-ponies, and I drew alongside. I knew he never contributed to the sum of human knowledge gratuitously; it had to be irritated out of him with delicacy. I wondered if he ever had a romance. I knew if he ever had, it would be curious. We bumped along for a time doggedly, and I said,

"Where you living now, Sun-Down?"

Instantly came the reply, "Leevin' here." He yelled at a pack-horse; but, turning with a benignant smile, added, "Well, I weare leeve on dees pony, er een de blanket on de white pack-horse."

"No tepee?" I asked.

"No—no tepee," came rather solemnly for Sun-Down, who was not solemn by nature, having rather too much variety for that.

"I suppose you are a married man?"

"No—no—me not marry," came the heavy response.

"Had no woman, hey?" I said, as I gave up the subject.

"Oh, yees! woman—had seex woman," came the rather overwhelming information.

"Children too, I suppose?"

"Oh, dam, yees! whole tribe. Why, I was have boy old as you aire. He up Canada way; hees mudder he Blackfoot woman. Dat was 'way, 'way back yondair, when I was firs' come Rocky Mountain. I weare a boy."

I asked where the woman was now.

"Dead — long, long time. She got keel by buffalo. She was try for skin buffalo what was not dead 'nough for skin. Buffalo was skin her," and Sun-Down grinned quickly at his pleasantry; but it somehow did not appeal to my humor so much as to my imagination, and it revealed an undomesticated mind.

"Did you never have one woman whom you loved more than all the others?" I went on.

"Yees; twenty year 'go I had Gros Ventre woman. She was fine woman—bes' woman I evair have. I pay twenty-five pony for her. She was dress de robe un

323

paint eet bettair, un I was mak heap of money on her. But she was keel by de Sioux while she was one day pick de wil' plum, un I lose de twenty-five pony een leetle ovair a year I have her. Sacré!

"Eef man was hab seex woman lak dat een dose day, he was not ask de odds of any reech man. He could sell de robe plenty;" and Sun-Down heaved a downright sigh.

I charged him with being an old trader, who always bought his women and his horses; and Sun-Down turned his head to me with the chin raised, while there was the wild animal in his eye.

"Buy my woman! What de 'ell you know I buy my woman?"

And then I could see my fine work. I gave him a contemptuous laugh.

Then his voice came high-pitched: "You ask me de oddar night eef I weare evair cole. Do you tink I was evair cole now? You say I buy my woman. Now I weel tell you I deed not alway buy my woman."

And I knew that he would soon vindicate his gallantry, so I said, softly, "I will have to believe what you tell me about it."

"I don' wan' for dat agent to know 'bout all dees woman beesness. He was good frien' of mine, but he pretty good man back Eas'—maybeso he not lak me eef he know more 'bout me;" and Sun-Down regained his composure.

"Oh, don't you fret — I won't say a word," I assured him. And here I find myself violating his confidence in print; but it won't matter. Neither Sun-Down nor the agent will ever read it.

"'Way back yondair, maybeso you 'bout dees high"—and he leaned down from his pony, spreading his palm about two feet and a half above the buffalo-grass— "I was work for Meestar MacDonnail, what hab trade-pos' on Missouri Reever. I was go out to de Enjun camp, un was try for mak 'em come to Meestar MacDonnail for trade skin. Well, all right. I was play de card for dose Enjun, un was manage for geet some skin myself for trade Meestar MacDonnail. I was know dose Enjun varrie well. I was play de card, was run de buffalo, un was trap de skin.

"I was all same Enjun—fringe, bead, long hair — but I was wear de hat. I was hab de bes' pony een de country,

un I was hab de firs' breech-loadair een de country. Ah, I was reech! Well, I young man, un de squaw she was good frien' for me, but Snow-Owl hab young woman, un he tink terreble lot 'bout her —was watch her all time. Out of de side of her eye she was watch me, un I was watch her out of de side of my eye—we was both watch each oddar, but we deed not speak. She was look fine, by gar! You see no woman at Billings Fair what would speet even wid her. I tink she not straight-bred Enjun woman—I tink she 'bout much Enjun as I be. All time we watch each oddar. I know eet no use for try trade Snow-Owl out of her, so I tink I win her wid de cards. Den I was deal de skin game for Snow-Owl, un was hab heem broke—was geet all hees pony, all hees robe, was geet hees gun; but eet no use. Snow-Owl she not put de woman on de blanket. I tell heem, 'You put de woman on de blanket, by gar I put twenty pony un forty robe on de blanket.'

"No, he sais he weel not put de woman on de blanket. He nevair mind de robe un de pony. He go to de Alsaroke un steal more pony, un he have de robe plenty by come snow.

"Well, he tak some young man un he go off to Alsaroke to steal horse, un I seet roun' un watch dat woman. She watch me. Pretty soon camp was hunt de buffalo, un I was hunt Snow-Owl's woman. Every one was excite, un dey don' tak no 'count of me. I see de woman go up leetle coulie for stray horse, un I follar her. I sais: 'How do? You come be my woman. We run off to Meestar MacDonnail's tradehouse.'

"She sais she afraid. I tole her: 'Your buck no good; he got no robe, no pony; he go leave you to live on de camp. I am reech. Come wid me.' And den I walk up un steek my knife eento de ribs of de old camp pony what she was ride. He was go hough! hough! un was drop down. She was say she weel go wid me, un I was tie her hand un feet, all same cowboy she rope de steer down, un I was leave her dair on de grass. I was ride out een de plain for geet my horse-ban', un was tell my moccasin-boy I was wan' heem go do dees ting, go do dat ting—I was forget now.

"Well, den back I go wid de horseban' to de woman, un was put her on good strong pony, but I was tak off hees

lariat un was tie her feet undar hees belly. I tink maybeso she skin out. Den we mak trail for Meestar MacDonnail, un eet was geet night. I was ask her eef she be my squaw. She sais she will be my squaw; but by gar she was my squaw, anyhow, eef I not tak off de rawhide." Sun-Down here gave himself up to a little merriment, which called crocodiles and hyenas to my mind.

"I was tell you not for doubt I mak dat horse-ban' burn de air dat night. I knew eef dose Enjun peek up dat trail, dey run me to a stan'-steel. Eet was two day to Meestar MacDonnail, un I got dair 'bout dark, un Meestar MacDonnail she sais, 'When dose Enjun was come een?' I sais, 'Dey come pretty queek, I guess.'

"I was glad for geet een dat log fence. My pony she could go no more. Well, I was res' up, un maybeso eet four day when up come de 'vance-guard of dose Enjun, un dey was mad as wolf. Deedn't have nothin' on but de moccasin un de red paint. Dey was crazy. Meestar Mac-Donnail he not let 'em een de log fence. Den he was say, 'What een hell de mattair, Leflare?' I sais, 'Guess dey los' someting.'

"Meestar MacDonnail was geet up on de beeg gate, un was say, 'What you Enjun want?' Dey was say, 'Leflare; he stole chief's wife.' Dey was want heem for geeve me up. Den Meestar MacDonnail he got crazy, un he dam me terreble. He sais I was no beesness steal woman un come to hees house; but I was tol' heem I have no oddar plass for go but hees house. He sais, 'Why you tak woman, anyhow?' I was shrug my shouldair.

"Dose Enjun dey was set roun' on dair ham-bone un watch dat plass, un den pretty soon was come de village—dog, baby, dry meat—whole outfeet. Well, Leflare he was up in a tree, for dey was mak camp all roun' dat log fence. Meestar MacDonnail he was geet on de gate, de Enjun dey was set on de grass, un dey was talk a heap—dey was talk steady for two day. De Enjun was have me or dey was burn de pos'. Meestar MacDonnail sais he was geeve up de woman. De Enjun was say, dam de woman—was want me. I was say I was not geeve up de woman. Dat was fine woman, un I was say eef dey geet dat woman, dey must geet Leflare firs'.

"All night dar was more talk, un de Enjun dey was yell. Meestar MacDonnail was want me for mak run een de night-time, but I was not tink I geet troo. 'Well, den,' he sais, 'you geeve yourself to dose Enjun.' I was laugh at heem, un cock my breech-loadair, un say, 'You cannot mak me.'

"De Enjun dey was shoot dar gun at de log fence, un de white man he was shoot een de air. Eet was war.

"All right. Pretty soon dey was mak de peace sign, un was talk some more. Snow-Owl had come.

"Den I got on de gate un I yell at dem. I was call dem all de dog, all de woman een de worl'. I was say Snow-Owl he dam ole sage-hen. He lose hees robe, hees pony, hees woman, un I leek heem een de bargain eef he not run lak deer when he hear my voice. Den I was yell, bah!" which Sun-Down did, putting all the prairie-dogs into their holes for our day's march.

"Den dey was talk.

"Well, I sais, eef Snow-Owl he any good, let us fight for de woman. Let dose Enjun sen' two beeg chief eento de log fence, un I weel go out eento de plain un fight Snow-Owl for de woman. Eef I leek, dose Enjun was have go 'way; un eef dar was any one strike me but Snow-Owl, de two chief mus' die. Meestar MacDonnail he say de two chief mus' die. De Enjun was talk heap. Was say 'fraid of my gun. I was say eef I not tak my gun, den Snow-Owl mus' not tak hees bow-arrow. Den dey send de two chief eento de log house. We was fight wid de lance un de skin-knife.

"Eet was noon, un was hot. I was sharp my knife, was tie up my bes' pony tail, un was tak off my clothes, but was wear my hat for keep de sun out of my eye. Den I was geet on my pony un go out troo de gate. I was yell, 'Come on, Snow-Owl; I teach you new game;' un I was laugh at dem.

"Dose Enjun weare not to come within rifle-shot of de pos', or de chief mus' die.

"All right. Out come Snow-Owl. He was pretty man — pretty good man, I guess. Oh, eet was long time 'go. I tink he was brav' man, but he was tink too much of dat woman. He was on pinto pony, un was have not a ting on heem but de breech-clout un de bull-hide shiel'. Den we leek our pony, un we went for fight. I dun'no' jes what eet all weare;"

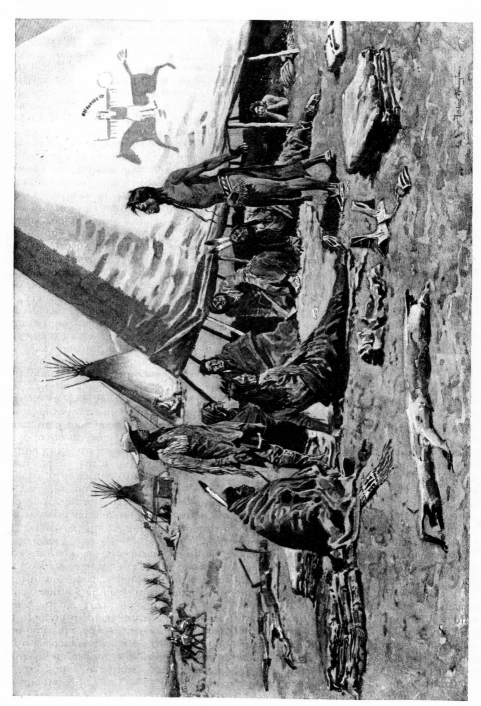

"HE SAIS HE WEEL NOT PUT DE WOMAN ON DE BLANKET."

and Sun-Down began to undo his shirt, hauling it back to show me a big livid scar through the right breast, high up by the shoulder.

"De pony go pat, pat, pat, un lak de light in de mornin' she trabel 'cross de plain we come togaddar. Hees beeg buffalo-lance she go clean troo my shouldar, un br'ak off de blade, un trow me off my pony. Snow-Owl she stop hees pony chuck, chunck, chinck, un was come roun' for run me down. I peeked up a stone un trow eet at heem. You bet my medicine she good; eet heet heem een de back of de head.

"Snow-Owl she go wobble, wobble, un she slide off de pony slow lak, un I was run up for heem. When I was geet dair he was geet on hees feet, un we was go at eet wid de knife. Snow-Owl was bes' man wid de lance, but I was bes' man wid de knife, un hees head was not come back to heem from de stone, for I keel heem, un I took hees hair; all de time de lance she steek out of my shouldar. I was go to de trade-pos', un dose Enjun was yell terreble; but Meestar MacDonnail she was geet on de gate un say dey mus' go 'way or de chief mus' die.

"Nex' morning dey was all go 'way; un Leflare he go 'way too. Meestar Mac-Donnail he did not tink I was buy all my squaw. Sacré!

"Oh, de squaw — well, I sol' her for one hundred dollar to white man on de Yellowstone. 'Twas t'ree year aftair dat fight;" and Sun-Down made a détour into the brushy bottom to head back the kitchen-mare, while I rode along, musing.

This rough plains wanderer is an old man now, and he may have forgotten his tender feelings of long ago. He had never examined himself for anything but wounds of the flesh, and nature had laid rough roads in his path, but still he sold the squaw for whom he had been willing to give his life. How can I reconcile this romance to its positively fatal termination?

Back came Sun-Down presently, and spurring up the cut-bank, he sang out, "You tink I always buy my squaw, hey? —what you tink 'bout eet now?"

Oh, you old land-loper, I do not know what to think about you, was what came

into my head; but I said, "Sun-Down, you are a raw dog," and we both laughed.

So over the long day's ride we bobbed along together, with no more romance than hungry men are apt to feel before the evening meal. We toiled up the hills, driving the pack-horses, while the disappearing sun made the red sand-rocks glitter with light on our left, and about us the air and the grass were cold. Presently we made camp in the canyon, and what with laying our bedding, cooking our supper, and smoking, the darkness had come. Our companions had turned into their blankets, leaving Sun-Down and me gazing into the fire. The dance of the flames was all that occupied my mind until Sun-Down said, "I want for go Buford dees wintair."

"Why don't you go?" I chipped in.

"Oh—leetle baby—so long," and he showed me by spreading his hands about eighteen inches.

"Your baby, Sun-Down?"

"Yees — my little baby," he replied, meditatively.

"Why can't you go to Buford?" I hazarded.

"Leetle baby she no stan' de trip. Eet varrie late een de fall—maybeso snow— leetle baby she no stand dat."

"Why don't you go by railroad?" I pressed; but, bless me, I knew that was a foolish question, since Sun-Down Leflare did not belong to the railroad period, and could not even contemplate going anywhere that way.

"I got de wagon un de pony, but de baby she too leetle. Maybeso I go nex' year eef baby she all right. I got white woman up at agency for tak care of de baby, un eet cos' me t'ree dollar a week. You s'pose I put dat baby een a dam Enjun tepee?" And his voice rose truculently.

As I had not supposed anything concerning it, I was embarrassed somewhat, and said, "Of course not—but where was the mother of the child?"

"Oh, her mudder—well, she was no Enjun. Don' know where she ees now. When de leetle baby was born, her mudder was run off on de dam railroad;" and we turned in for the night.

My romance had arrived.

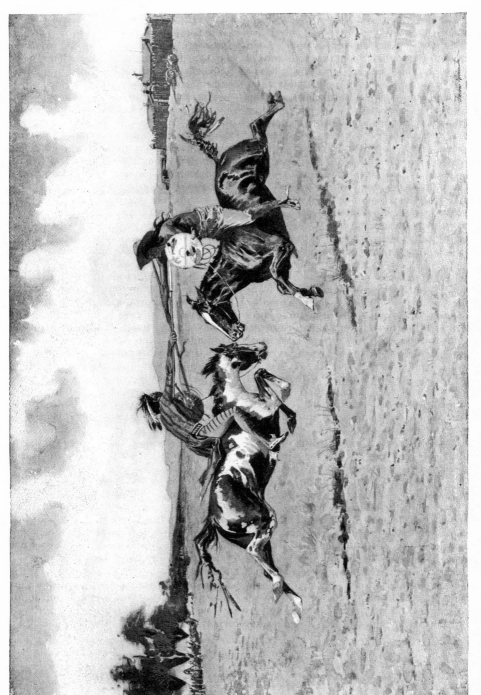

"HEES BEEG BUFFALO-LANCE SHE GO CLEAN TROO MY SHOULDAR"

27.
With the
Fifth Corps

WITH THE FIFTH CORPS.

BY FREDERIC REMINGTON.

"THE BIGGEST THING IN SHAFTER'S ARMY WAS MY PACK."

I APPROACH this subject of the Santiago campaign with awe, since the ablest correspondents in the country were all there, and they wore out lead-pencils most industriously. I know I cannot add to the facts, but I remember my own emotions, which were numerous, interesting, and, on the whole, not pleasant. I am as yet unable to decide whether sleeping in a mud-puddle, the confinement of a troop-ship, or being shot at is the worst. They are all irritating, and when done on an empty stomach, with the object of improving one's mind, they are extravagantly expensive. However, they satisfied a life of longing to see men do the greatest thing which men are called on to do.

The creation of things by men in time of peace is of every consequence, but it does not bring forth the tumultuous energy which accompanies the destruction of things by men in war. He who has not seen war only half comprehends the possibilities of his race. Having thought of this thing before, I got a correspondent's pass, and ensconced myself with General Shafter's army at Tampa.

When Hobson put the cork in Cervera's bottle, it became necessary to send the troops at once, and then came the first shock of the war to me. It was in the form of an order to dismount two squadrons of each regiment of cavalry and send them on foot. This misuse of cavalry was compelled by the national necessities, for there was not at that time sufficient volunteer infantry equipped and in readiness for the field. It is without doubt that our ten regiments of cavalry are the most perfect things of all Uncle Sam's public institutions. More good

honest work has gone into them, more enthusiasm, more intelligence, and they have shown more results, not excepting the new navy or the postal system.

The fires of hatred burned within me. I was nearly overcome by a desire to "go off the reservation." I wanted to damn some official, or all officialism, or so much thereof as might be necessary. I knew that the cavalry officers were to a man disgusted, and thought they had been misused and abused. They recognized it as a blow at their arm, a jealous, wicked, and ignorant stab. Besides, the interest of my own art required a cavalry charge.

General Miles appeared at Tampa about that time, and I edged around toward him, and threw out my "point." It is necessary to attack General Miles with great care and understanding, if one expects any success. "General, I wonder who is responsible for this order dismounting the cavalry?" I ventured.

I think the "old man" could almost see me coming, for he looked up from the reading of a note, and in a quiet manner, which is habitual with him, said, "Why, don't they want to go?" and he had me flat on the ground.

"Oh yes, of course! They are crazy to go! They would go if they had to walk on their hands!" I said, and departed. A soldier who did not want to go to Cuba would be like a fire which would not burn — useless entirely. So no one got cursed for that business; but it is a pity that our nation finds it necessary to send cavalry to war on foot. It would be no worse if some day it should conclude to mount "bluejackets" for cavalry purposes, though doubtless the "bluejackets" would "sit tight." But where is the use of specialization? One might as well ask the nurse-girl to curry the family horse.

So the transports gathered to Port Tampa, and the troops got on board, and the correspondents sallied down to their quarters, and then came a wait. A Spanish war-ship had loomed across the night of some watch-on-deck down off the Cuban coast. Telegrams flew from Washington to "stop where you are." The mules and

the correspondents were unloaded, and the whole enterprise waited.

Here I might mention a series of events which were amusing. The exigencies of the service left many young officers behind, and these all wanted, very naturally, to go to Cuba and get properly shot, as all good soldiers should. They used their influence with the general officers in command; they begged, they implored, and they explained deviously and ingeniously why the expedition needed their particular services to insure success. The old generals, who appreciated the proper spirit which underlay this enthusiasm, smiled grimly as they turned "the young scamps" down. I used to laugh to myself when I overheard these interviews, for one could think of nothing so much as the school-boy days, when he used to beg off going to school for all sorts of reasons but the real one, which was a ball-game or a little shooting-trip.

Presently the officials got the Spanish war-ship off their nerves, and the transports sailed. Now it is so arranged in the world that I hate a ship in a compound, triple-expansion, forced-draught way. Barring the disgrace, give me "ten days on the island." Do anything to me, but do not have me entered on the list of a ship. It does not matter if I am to be the lordly proprietor of the finest yacht afloat, make me a feather in a sick chicken's tail in shore, and I will thank you. So it came about that I did an unusual amount of real suffering in consequence of living on the *Segurança* during the long voyage to Cuba. I used to sit out on the after-deck and wonder why, at my time of life, I could not so arrange my affairs that I could keep off ships. I used to consider seriously if it would not be a good thing to jump overboard and let the leopard-sharks eat me, and have done with a miserable existence which I did not seem to be able to control.

When the first landing was made, General Shafter kept all the correspondents and the foreign military attachés in his closed fist, and we all hated him mightily. We shall probably forgive him, but it will take some time. He did allow us to go ashore and see the famous interview which he and Admiral Sampson held with Garcia, and for the first time to behold the long lines of ragged Cuban patriots, and I was convinced that it was no mean or common impulse which kept up the determination of these ragged, hungry souls.

Then on the morning of the landing at Daiquiri the soldiers put on their blanket rolls, the navy boats and launches lay by the transports, and the light ships of Sampson's fleet ran slowly into the little bay and "turned everything loose" on the quiet, palm-thatched village. A few fires were burning in the town, but otherwise it was quiet. After severely pounding the coast, the launches towed in the long lines of boats deep laden with soldiery, and the correspondents and foreigners saw them go into the overhanging smoke. We held our breath. We expected a most desperate fight for the landing. After a time the smoke rolled away, and our people were on the beach, and not long after some men climbed the steep hill on which stood a block-house, and we saw presently the stars and stripes break from the flag-staff. "They are Chinamen!" said a distinguished foreign soldier; and he went to the other side of the boat, and sat heavily down to his reading of our artillery drill regulations.

We watched the horses and mules being thrown overboard, we saw the last soldiers going ashore, and we bothered General Shafter's aid, the gallant Miley, until he put us all on shore in order to abate the awful nuisance of our presence.

No one had any transportation in the campaign, not even colonels of regiments, except their good strong backs. It was for every man to personally carry all his own hotel accommodations; so we correspondents laid out our possessions on the deck, and for the third time sorted out what little we could take. I weighed a silver pocket-flask for some time, undecided as to the possibility of carriage. It is now in the woods of Cuba, or in the ragged pack of some Cuban soldier. We had finally three days of crackers, coffee, and pork in our haversacks, our canteens, rubber ponchos, cameras, and six-shooter —or practically what a soldier has.

I moved out with the Sixth Cavalry a mile or so, and as it was late afternoon, we were ordered to bivouac. I sat on a hill, and down in the road below saw the long lines of troops pressing up the valley toward Siboney. When our troops got on the sand beach, each old soldier adjusted his roll, shouldered his rifle, and started for Santiago, apparently by individual intuition.

The troops started, and kept marching just as fast as they could. They ran the Spaniards out of Siboney, and the cavalry brigade regularly marched down their retreating columns at Las Guasimas, fought them up a defile, outflanked, and sent them flying into Santiago. I think our army would never have stopped until it cracked into the doomed city in column formation, if Shafter had not discovered this unlooked-for enterprise, and sent his personal aide on a fast horse with positive orders to halt until the "cracker-line" could be fixed up behind them.

In the morning I sat on the hill, and still along the road swung the hard-marching columns. The scales dropped from my eyes. I could feel the impulse, and still the Sixth was held by orders. I put on my "little hotel equipment," bade my friends good-by, and "hit the road." The sides of it were blue with cast-off uniforms. Coats and overcoats were strewn about, while the gray blankets lay in the camps just where the soldiers had gotten up from them after the night's rest. This I knew would happen. Men will not carry what they can get along without, unless they are made to; and it is a bad thing to "make" American soldiers, because they know what is good for them better than any one who sits in a roller-chair. In the tropics mid-day marching under heavy kits kills more men than damp sleeping at night. I used to think the biggest thing in Shafter's army was my pack.

It was all so strange, this lonely tropic forest, and so hot. I fell in with a little bunch of headquarters cavalry orderlies, some with headquarters horses, and one with a mule dragging two wheels, which I cannot call a cart, on which General Young's stuff was tied. We met Cubans loitering along, their ponies loaded with abandoned soldier-clothes. Staff-officers on horseback came back and said that there had been a fight on beyond, and that Colonel Wood was killed and young Fish shot dead—that the Rough Riders were all done to pieces. There would be more fighting, and we pushed forward, sweating under the stifling heat of the jungle-choked road. We stopped and cracked cocoanuts to drink the milk. Once, in a sort of savanna, my companions halted and threw cartridges into their carbines. I saw two or three Spanish soldiers on ahead in some hills and brush.

We pressed on; but as the Spanish soldiers did not seem to be concerned as to our presence, I allowed they were probably Cubans who had taken clothes from dead Spanish soldiers, and so it turned out. The Cubans seem to know each other by scent, but it bothered the Northern men to make a distinction between Spanish and Cuban, even when shown Spanish prisoners in order that they might recognize their enemy by sight. If a simple Cuban who stole Spanish soldier clothes could only know how nervous it made the trigger fingers of our regulars, he would have died of fright. He created the same feeling that a bear would, and the impulse to "pull up and let go" was so instinctive and sudden with our men that I marvel more mistakes were not made.

At night I lay up beside the road outside of Siboney, and cooked my supper by a soldier fire, and lay down under a mango-tree on my rubber, with my haversack for a pillow. I could hear the shuffling of the marching troops, and see by the light of the fire near the road the white blanket rolls glint past its flame— tired, sweaty men, mysterious and silent too, but for the clank of tin cups and the monotonous shuffle of feet.

In the early morning the field near me was covered with the cook-fires of infantry, which had come in during the night. Presently a battery came dragging up, and was greeted with wild cheers from the infantry, who crowded up to the road. It was a great tribute to the guns; for here in the face of war the various arms realized their interdependence. It is a solace for cavalry to know that there is some good steady infantry in their rear, and it is a vast comfort for infantry to feel that their front and flanks are covered, and both of them like to have the shrapnel travelling their way when they "go in."

At Siboney I saw the first wounded Rough Riders, and heard how they had behaved. From this time people began to know who this army doctor was, this Colonel Wood. Soldiers and residents in the Southwest had known him ten years back. They knew Leonard Wood was a soldier, skin, bones, and brain, who travelled under the disguise of a doctor, and now they know more than this.

Then I met a fellow-correspondent, Mr. John Fox, and we communed deeply. We had not seen this fight of the cavalry bri-

"BEFORE THE WARNING SCREAM OF THE SHRAPNEL."

gade, and this was because we were not at the front. We would not let it happen again. We slung our packs and most industriously plodded up the Via del Rey until we got to within hailing distance of the picket posts, and he said: "Now, Frederic, we will stay here. They will pull off no more fights of which we are not a party of the first part." And stay we did. If General Lawton moved ahead, we went up and cultivated Lawton; but if General Chaffee got ahead, we were his friends, and gathered at his mess fire. To be popular with us it was necessary for a general to have command of the advance.

But what satisfying soldiers Lawton and Chaffee are! Both seasoned, professional military types. Lawton, big and long, forceful, and with iron determination. Chaffee, who never dismounts but for a little sleep during the darkest hours of the night, and whose head might have been presented to him by one of William's Norman barons. Such a head! We used to sit around and study that head. It does not belong to the period; it is remote, when the race was young and strong; and it has "warrior" sculptured in every line. It may seem trivial to you, but I must have people "look their part." That so many do not in this age is probably because men are so complicated; but "war is a primitive art," and that is the one objection I had to von Moltke, with his simple student face. He might have been anything. Chaffee is a soldier.

The troops came pouring up the road, reeking under their packs, dusty, and with their eyes on the ground. Their faces were deeply lined, their beards stubby, but their minds were set on "the front"—"on Santiago." There was a suggestion of remorseless striving in their dogged stepping along, and it came to me that to turn them around would require some enterprise. I thought at the time that the Spanish commander would do well to assume the offensive, and marching down our flank, pierce the centre of the straggling column; but I have since changed my mind, because of the superior fighting ability which our men showed. It must be carefully remembered that, with the exception of three regiments of Shafter's army, and even these were "picked volunteers," the whole command was our regular army — trained men, physically superior to any in the

world, as any one will know who understands the requirements of our enlistment as against that of conscript troops; and they were expecting attack, and praying devoutly for it. Besides, at Las Guasimas we got the *moral* on the Spanish.

Then came the "cracker problem." The gallant Cabanais pushed his mules day and night. I thought they would go to pieces under the strain, and I think every "packer" who worked on the Santiago line will never forget it. Too much credit cannot be given them. The command was sent into the field without its proper ratio of pack-mules, and I hope the blame of that will come home to some one some day. That was the *direct* and *only* cause of all the privation and delay which became so notable in Shafter's operations. I cannot imagine a man who would recommend wagons for a tropical country during the rainy season. Such a one should not be censured or reprimanded; he should be spanked with a slipper.

So while the engineers built bridges, and the troops made roads behind them, and until we got "*three days' crackers ahead*" for the whole command, things stopped. The men were on half-rations, were out of tobacco, and it rained, rained, rained. We were very miserable.

Mr. John Fox and I had no cover to keep the rain out, and our determination to stay up in front hindered us from making friends with any one who had. Even the private soldiers had their dog-tents, but we had nothing except our two rubber ponchos. At evening, after we had "bummed" some crackers and coffee from some good-natured officer, we repaired to our neck of woods, and stood gazing at our mushy beds. It was good, soft, soggy mud, and on it, or rather in it, we laid one poncho, and over that we spread the other.

"Say, Frederic, that means my death; I am subject to malaria."

"Exactly so, John. This cold of mine will end in congestion of the lungs, or possibly bronchial consumption. Can you suggest any remedy?"

"The fare to New York," said John, as we turned into our wallow.

At last I had the good fortune to buy a horse from an invalided officer. It seemed great fortune, but it had its drawback. I was ostracized by my fellow-correspondents.

All this time the reconnoissance of the works of Santiago and the outlying post of Caney was in progress. It was rumored that the forward movement would come, and being awakened by the bustle, I got up in the dark, and went gliding around until I managed to steal a good feed of oats for my horse. This is an important truth as showing the demoralization of war. In the pale light I saw a staff-officer who was going to Caney, and I followed him. We overtook others, and finally came to a hill overlooking the ground which had been fought over so hard during the day. Capron's battery was laying its guns, and back of the battery were staff-officers and correspondents eagerly scanning the country with field-glasses. In rear of these stood the hardy First Infantry, picturesquely eager and dirty, while behind the hill were the battery horses, out of harm's way.

The battery opened and knocked holes in the stone fort, but the fire did not appear to depress the rifle-pits. Infantry in the jungle below us fired, and were briskly answered from the trenches.

I had lost my canteen and wanted a drink of water, so I slowly rode back to a creek. I was thinking, when along came another correspondent. We discussed things, and thought Caney would easily fall before Lawton's advance, but we had noticed a big movement of our troops toward Santiago, and we decided that we would return to the main road and see which promised best. Sure enough, the road was jammed with troops, and up the hill of El Poso went the horses of Grimes's battery under whip and spur. Around El Poso ranch stood Cubans, and along the road the Rough Riders— Roosevelt's now, for Wood was a brigadier.

The battery took position, and behind it gathered the foreigners, naval and military, with staff-officers and correspondents. It was a picture such as may be seen at a manœuvre. Grimes fired a few shells toward Santiago, and directly came a shrill screaming shrapnel from the Spanish lines. It burst over the Rough Riders, and the manœuvre picture on the hill underwent a lively change. It was thoroughly evident that the Spaniards had the range of everything in the country. They had studied it out. For myself, I fled, dragging my horse up the hill, out of range of Grimes's inviting guns. Some

as gallant soldiers and some as daring correspondents as it is my pleasure to know did their legs proud there. The tall form of Major John Jacob Astor moved in my front in jack-rabbit bounds. Prussian, English, and Japanese correspondents, artists, all the news, and much high-class art and literature, were flushed, and went straddling up the hill before the first barrel of the Dons. Directly came the warning scream of No. 2, and we dropped and hugged the ground like star-fish. Bang! right over us it exploded. I was dividing a small hollow with a distinguished colonel of the staff.

"Is this thing allowed, Colonel?"

"Oh, yes, indeed!" he said. "I don't think we could stop those shrapnel."

And the next shell went into the battery, killing and doing damage. Following shell were going into the helpless troops down in the road, and Grimes withdrew his battery for this cause. He had been premature. All this time no one's glass could locate the fire of the Spanish guns, and we could see Capron's smoke miles away on our right. Smoky powder belongs with arbalists and stone axes and United States ordnance officers, which things all belong in museums with other dusty rust.

Then I got far up on the hill, walking over the prostrate bodies of my old friends the Tenth Cavalry, who were hugging the hot ground to get away from the hotter shrapnel. There I met a clubmate from New York, and sundry good foreigners, notably the Prussian (Von Goetzen), and that lovely "old British salt" Paget, and the Japanese major, whose name I could never remember. We sat there. I listened to much expert artillery talk, though the talk was not quite so impressive as the practice of that art.

But the heat—let no man ever attempt that after Kipling's "and the heat would make your blooming eyebrows crawl."

This hill was the point of vantage; it overlooked the flat jungle, San Juan hills, Santiago, and Caney, the whole vast country to the mountains which walled in the whole scene. I heard the experts talk, and I love military science, but I slowly thought to myself this is not my art— neither the science of troop movement nor the whole landscape. My art requires me to go down in the road where the human beings are who do these things which science dictates, in the landscape

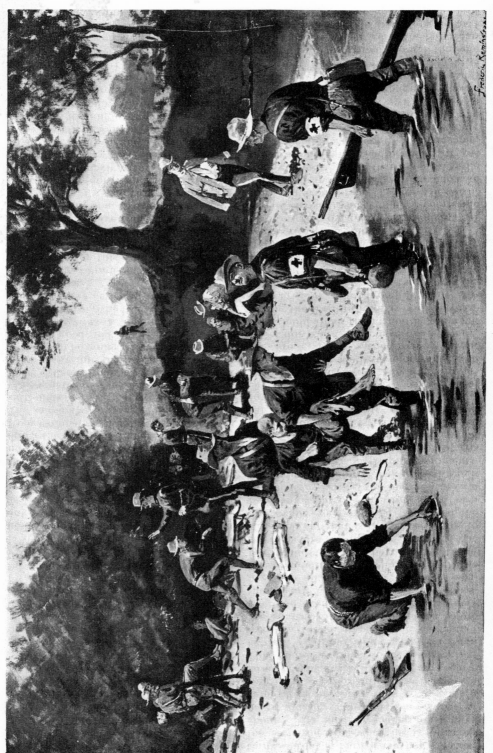

THE HOSPITAL CORPS AT WORK. DRAWN BY FREDERIC REMINGTON

which to me is overshadowed by their presence. I rode slowly, on account of the awful sun. Troops were standing everywhere, lying all about, moving regularly up the jungle road toward Santiago, and I wound my way along with them, saying, "Gangway, please."

War is productive of so many results, things happen so awfully fast, men do such strange things, pictures make themselves at every turn, the emotions are so tremendously strained, that what knowledge I had fled away from my brain, and I was in a trance; and do you know, cheerful reader, I am not going to describe a battle to you.

War, storms at sea, mountains, deserts, pests, and public calamities leave me without words. I simply said "Gangway" as I wormed my way up the fateful road to Santiago. Fellows I knew out West and up North and down South passed their word to me, and I felt that I was not alone. A shrapnel came shrieking down the road, and I got a drink of water from Colonel Garlington, and a cracker. The soldiers were lying alongside and the staff-officers were dismounted, also stopping quietly in the shade of the nearest bush. The column of troops was working its way into the battle-line.

"I must be going," I said, and I mounted my good old mare—the colonel's horse. It was a tender, hand-raised trotting-horse, which came from Colorado, and was perfectly mannered. We were in love.

The long columns of men on the road had never seen this condition before. It was their first baby. Oh, a few of the old soldiers had, but it was so long ago that this must have come to them almost as a new sensation. Battles are like other things in nature—no two the same.

I could hear noises such as you can make if you strike quickly with a small walking-stick at a very few green leaves. Some of them were very near and others more faint. They were the Mausers, and out in front through the jungle I could hear what sounded like a Fourth of July morning, when the boys are setting off their crackers. It struck me as new, strange, almost uncanny, because I wanted the roar of battle, which same I never did find. These long-range, smokeless bolts are so far-reaching, and there is so little fuss, that a soldier is for hours under fire getting into the battle proper, and he has time to

think. That is hard when you consider the seriousness of what he is thinking about. The modern soldier must have moral quality; the guerilla is out of date. This new man may go through a war, be in a dozen battles, and survive a dozen wounds without seeing an enemy. This would be unusual, but easily might happen. All our soldiers of San Juan were for the most part of a day under fire, subject to wounds and death, before they had even a chance to know where the enemy was whom they were opposing. To all appearance they were apathetic, standing or marching through the heat of the jungle. They flattened themselves before the warning scream of the shrapnel, but that is the proper thing to do. Some good-natured fellow led the regimental mascot, which was a fice, or a fox-terrier. Really, the dog of war is a fox-terrier. Stanley took one through Africa. He is in all English regiments, and he is gradually getting into ours. His flag is short, but it sticks up straight on all occasions, and he is a vagabond. Local ties must set lightly on soldiers and fox-terriers.

Then came the light as I passed out of the jungle and forded San Juan River. The clicking in the leaves continued, and the fire-crackers rattled out in front. "Get down, old man; you'll catch one!" said an old alkali friend, and I got down, sitting there with the officers of the cavalry brigade. But promptly some surgeons came along, saying that it was the only safe place, and they began to dig the sand to level it. We, in consequence, moved out into the crackle, and I tied my horse with some others.

"Too bad, old fellow," I thought; "I should have left you behind. Modern rifle fire is rough on horses. They can't lie down. But, you dear thing, you will have to take your chances." And then I looked at the preparation for the field hospital. It was altogether too suggestive. A man came, stooping over, with his arms drawn up, and hands flapping downward at the wrists. That is the way with all people when they are shot through the body, because they want to hold the torso steady, because if they don't it hurts. Then the oncoming troops poured through the hole in the jungle which led to the San Juan River, which was our line of battle, as I supposed. I knew nothing of the plan of battle, and I have an odd conceit that no

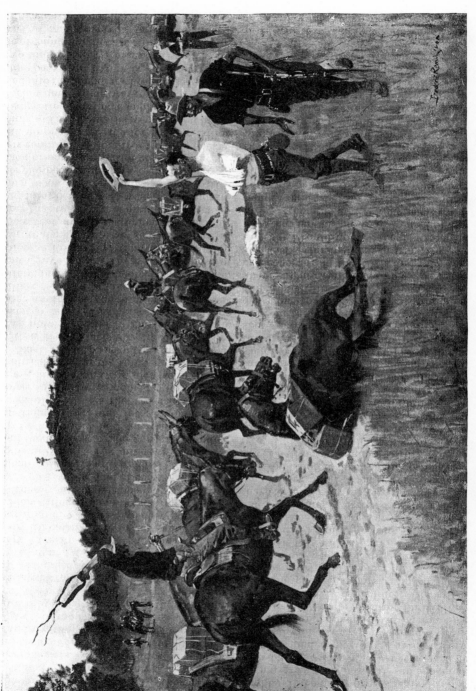

"THE WOUNDED, GOING TO THE REAR, CHEERED THE AMMUNITION."

one else did, but most all the line-officers were schooled men, and they were able to put two and two together mighty fast, and in most instances faster than headquarters. When educated soldiers are thrown into a battle without understanding, they understand themselves.

As the troops came pouring across the ford they stooped as low as they anatomically could, and their faces were wild with excitement. The older officers stood up as straight as on parade. They may have done it through pride, or they may have known that it is better to be "drilled clean" than to have a long ranging wound. It was probably both ideas which stiffened them up so.

Then came the curious old tube drawn by a big mule, and Borrowe with his squad of the Rough Riders. It was the dynamite-gun. The mule was unhooked and turned loose. The gun was trundled up the road and laid for a shot, but the cartridge stuck, and for a moment the cheerful grin left the red face of Borrowe. Only for a moment; for back he came, and he and his men scraped and whittled away at the thing until they got it fixed. The poor old mule lay down with a grunt and slowly died. The fire was now incessant. The bullets came like the rain. The horses lay down one after another as the Mausers found their billets. I tried to take mine to a place of safety, but a sharp-shooter potted at me, and I gave it up. There was no place of safety. For a long time our people did not understand these sharp-shooters in their rear, and I heard many men murmur that their own comrades were shooting from behind. It was very demoralizing to us, and on the Spaniards' part a very desperate enterprise to lie deliberately back of our line; but of course, with bullets coming in to the front by the bucketful, no one could stop for the few tailing shots. The Spaniards were hidden in the mango-trees, and had smokeless powder.

Now men came walking or were carried into the temporary hospital in a string. One beautiful boy was brought in by two tough, stringy, hairy old soldiers, his head hanging down behind. His shirt was off, and a big red spot shone brilliantly against his marblelike skin. They laid him tenderly down, and the surgeon stooped over him. His breath came in gasps. The doctor laid his arms across his breast, and shaking his head, turned

to a man who held a wounded foot up to him, dumbly imploring aid, as a dog might. It made my nerves jump, looking at that grewsome hospital, sand-covered, with bleeding men, and yet it seemed to have fascinated me; but I gathered myself and stole away. I went down the creek, keeping under the bank, and then out into the "scrub," hunting for our line; but I could not find our line. The bullets cut and clicked around, and a sharp-shooter nearly did for me. The thought came to me, what if I am hit out here in the bush while all alone? I shall never be found. I would go back to the road, where I should be discovered in such case; and I ran quickly across a space that my sharp-shooting Spanish friend did not see me. After that I stuck to the road. As I passed along it through an open space I saw a half-dozen soldiers sitting under a tree. "Look out—sharp-shooters!" they sang out. "Wheet!" came a Mauser, and it was right next to my ear, and two more. I dropped in the tall guinea-grass, and crawled to the soldiers, and they studied the mango-trees; but we could see nothing. I think that episode cost me my sketch-book. I believe I lost it during the crawl, and our friend the Spaniard shot so well I wouldn't trust him again.

From the vantage of a little bank under a big tree I had my first glimpse of San Juan hill, and the bullets whistled about. One would "tumble" on a tree or ricochet from the earth, and then they shrieked. Our men out in front were firing, but I could not see them. I had no idea that our people were to assault that hill—I thought at the time such an attempt would be unsuccessful. I could see with my powerful glass the white lines of the Spanish intrenchments. I did not understand how our men could stay out there under that gruelling, and got back into the safety of a low bank.

A soldier said, while his stricken companions were grunting around him, "Boys, I have got to go one way or the other, pretty damn quick." Directly I heard our line yelling, and even then did not suppose it was an assault.

Then the Mausers came in a continuous whistle. I crawled along to a new place and finally got sight of the fort, and just then I could distinguish our blue soldiers on the hill-top, and I also noticed that the Mauser bullets rained no more. Then I started after. The country was

IN THE REAR OF THE BATTLE—WOUNDED ON THE SAN JUAN ROAD.

alive with wounded men—some to die in the dreary jungle, some to get their happy home-draft, but all to be miserable. Only a handful of men got to the top, where they broke out a flag and cheered. "Cheer" is the word for that sound. You have got to hear it once where it means so much, and ever after you will grin when Americans make that noise.

San Juan was taken by infantry and dismounted cavalry of the United States regular army without the aid of artillery. It was the most glorious feat of arms I ever heard of, considering every condition. It was done without grub, without reserves of either ammunition or men, under tropical conditions. It was a storm of intrenched heights, held by veteran troops armed with modern guns, supported by artillery, and no other troops on the earth would have even thought they could take San Juan heights, let alone doing it.

I followed on and up the hill. Our men sat about in little bunches in the pea-green guinea-grass, exhausted. A young officer of the Twenty-fourth, who was very much excited, threw his arms about me, and pointing to twenty-five big negro infantrymen sitting near, said, "That's all—that is all that is left of the Twenty-fourth Infantry," and the tears ran off his mustache.

Farther on another officer sat with his arms around his knees. I knew him for one of these analytical chaps—a bit of a philosopher—too highly organized—so as to be morose. "I don't know whether I am brave or not. Now there is S——; he don't mind this sort of thing. I think—"

"Oh, blow your philosophy!" I interrupted. "If you were not brave, you would not be here."

The Spanish trenches were full of dead men in the most curious attitudes, while about on the ground lay others, mostly on their backs, and nearly all shot in the head. Their set teeth shone through their parted lips, and they were horrible. The life never runs so high in a man as it does when he is charging on the field of battle; death never seems so still and positive.

Troops were moving over to the right, where there was firing. A battery came up and went into position, but was driven back by rifle fire. Our batteries with their smoky powder could not keep guns manned in the face of the Mausers. Then, with gestures much the same as a woman

makes when she is herding chickens, the officers pushed the men over the hill. They went crawling. The Spanish were trying to retake the hill. We were short of ammunition. I threw off my hat and crawled forward to have a look through my glass at the beyond. I could hardly see our troops crouching in the grass beside me, though many officers stood up. The air was absolutely crowded with Spanish bullets. There was a continuous whistle. The shrapnel came screaming over. A ball struck in front of me, and filled my hair and face with sand, some of which I did not get out for days. It jolted my glass and my nerves, and I beat a masterly retreat, crawling rapidly backwards, for a reason which I will let you guess. The small-arms rattled; now and then a wounded man came back and started for the rear, some of them shot in the face, bleeding hideously.

"How goes it?" I asked one.

"Ammunition! ammunition!" said the man, forgetful of his wound.

I helped a man to the field hospital, and got my horse. The lucky mare was untouched. She was one of three animals not hit out of a dozen tied or left at the hospital. One of these was an enormous mule, loaded down with what was probably officers' blanket rolls, which stood sidewise quietly as only a mule can all day, and the last I saw of him he was alive. Two fine officers' chargers lay at his feet, one dead and the other unable to rise, and suffering pathetically. The mule was in such an exposed position that I did not care to unpack him, and Captain Miley would not let any one shoot a horse, for fear of the demoralizing effect of fire in the rear.

A trumpeter brought in a fine officer's horse, which staggered around in a circle. I saw an English sabre on the saddle, and recognized it as Lieutenant Short's, and indeed I knew the horse too. He was the fine thoroughbred which that officer rode in Madison Square military tournament last winter, when drilling the Sixth Cavalry. The trumpeter got the saddle off, and the poor brute staggered around with a bewildered look in his eager eyes, shot in the stifle-joint, I thought; and then he sat down in the creek as a dog would on a hot day. The suffering of animals on a battle-field is most impressive to one who cares for them.

I again started out to the hill, along

with a pack-train loaded with ammunition. A mule went down, and bullets and shell were coming over the hill aplenty. The wounded going to the rear cheered the ammunition, and when it was unpacked at the front, the soldiers seized it like gold. They lifted a box in the air and dropped it on one corner, which smashed it open.

"Now we can hold San Juan hill against them garlics—hey, son!" yelled a happy cavalryman to a doughboy.

"You bet—until we starve to death."

"Starve nothin'—we'll eat them gun-teams."

Well, well, I said, I have no receipt for licking the kind of troops these boys represent. And yet some of the generals wanted to retreat.

Having had nothing to eat this day, I thought to go back to headquarters camp and rustle something. Besides, I was sick. But beyond the hill, down the road, it was very dangerous, while on the hill we were safe. "Wait for a lull; one will come soon," advised an old soldier. It is a curious thing that battle firing comes like a big wind, and has its lulls. Now it was getting dark, and during a lull I went back. I gave a wounded man a ride to the field hospital, but I found I was too weak myself to walk far. I had been ill during the whole campaign, and latterly had fever, which, taken together with the heat, sleeping in the mud, marching, and insufficient food, had done for me.

The sight of that road as I wound my way down it was something I cannot describe. The rear of a battle. All the broken spirits, bloody bodies, hopeless, helpless suffering which drags its weary length to the rear, are so much more appalling than anything else in the world that words won't mean anything to one who has not seen it. Men half naked, men sitting down on the road-side utterly spent, men hopping on one foot with a rifle for a crutch, men out of their minds from sunstroke, men dead, and men dying. Officers came by white as this paper, carried on rude litters made by their devoted soldiers, or borne on their backs. I got some food about ten o'clock and lay down. I was in the rear at headquarters, and there were no bullets and shells cracking about my ears, but I found my nerves very unsettled. During the day I had discovered no particular nervousness in myself, quite contrary to my expecta-

tions, since I am a nervous man, but there in the comparative quiet of the woods the reaction came. Other fellows felt the same, and we compared notes. Art and literature under Mauser fire is a jerky business; it cannot be properly systematized. I declared that I would in the future paint "set pieces for dining-rooms." Dining-rooms are so much more amusing than camps. The novelist allowed that he would be forced to go home and complete "The Romance of a Quart Bottle." The explorer declared that his treatise on the "Flora of Bar Harbor" was promised to his publishers.

Soldiers always joke after a battle. They have to loosen the strings, or they will snap. There was a dropping fire in the front, and we understood our fellows were intrenching. Though I had gotten up that morning at half past three, it was nearly that time again before I went to sleep. The fever and the strong soldier-coffee banished sleep; then, again, I could not get the white bodies which lay in the moonlight, with the dark spots on them, out of my mind. Most of the dead on modern battle-fields are half naked, because of the "first-aid bandage." They take their shirts off, or their pantaloons, put on the dressing, and die that way.

It is well to bear in mind the difference in the point of view of an artist or a correspondent, and a soldier. One has his duties, his responsibilities, or his gun, and he is on the firing line under great excitement, with his reputation at stake. The other stalks through the middle distance, seeing the fight and its immediate results, the wounded; lying down by a dead body, mayhap, when the bullets come quickly; he will share no glory; he has only the responsibility of seeing clearly what he must tell; and he must keep his nerve. I think the soldier sleeps better nights.

The next day I started again for the front, dismounted, but I only got to El Poso Hill. I lay down under a bank by the creek. I had the fever. I only got up to drink deeply of the dirty water. The heat was intense. The re-enforcing troops marched slowly up the road. The shells came railroading down through the jungle, but these troops went on, calm, steady, like true Americans. I made my way back to our camp, and lay there until nightfall, making up my mind and unmaking it as to my physical condition, until I concluded that I had "finished."

28.
Sun-Down's
Higher Self

SUN–DOWN'S HIGHER SELF.

BY FREDERIC REMINGTON.

I SAT in the growing dusk of my room at the agency, before a fire, and was somewhat lonesome. My stay was about concluded, and I dreaded the long ride home on the railroad — an institution which I wish from the bottom of my heart had never been invented.

The front door opened quietly, and shut. The grating or sand-paper sound of moccasined feet came down the hall, my door opened, and Sun-Down Leflare stole in.

"Maybeso you wan' some coal on dees fire—hey?" he observed, looking in at the top of the stove.

"No, thank you—sit down," I replied, which he did, performing forthwith the instinctive act of making a cigarette.

"Sun-Down, I am going home to-morrow."

"Where you was go home?" came the guttural response.

"Back East."

"Ah, yees. I come back Eas' myself —I was born back Eas'. I was come out here long, long time 'go, when I was boy."

"And what part of the East did you come from?"

"Well—Pembina Reever—I was born een dat plass, un I was geet be good chunk of boy een dat plass—un, by gar, I wish I geet be dead man een dat plass. May-beso I weel."

"You think you will go back some day?" I ventured.

"Oh, yees — I tink eet weel all come out dat way. Some day dat leetle baby he geet ole for mak de travel, un I go slow back dat plass. I mak dat baby grow up where dar ees de white woman un de pries'. I mak heem 'ave de farm, un not go run roun' deese heel on de dam pony." Sun-Down threw away his cigarette, and leaned forward on his hands.

"You are a Roman Catholic?" I asked.

"Yees, I am Roman Catholic. Dose pries' ees de only peop' what care de one dam 'bout de poor half-breed Enjun. You good man, but you not so good man lak de pries'. You go run roun' wid de soldier, go paint up deese Enjun, un den go back Eas'; maybeso nevair see you 'gain. Pries' he stay where we stay, un he not all de while wan' hear how I raise de hell ober de country. He keep say, 'You be good man, Sun-Down'; un, by gar, he keep tell me how for be good man.

"I be pretty good man now; maybeso eet 'cause I too ole for be bad man;" and Sun-Down's cynicism had asserted itself, whereat we laughed.

347

It occurred to me that time had fought for the priest and against the medicine-man in these parts, and I so inquired.

"Yees, dey spleet even nowday. Pries' he bes' man for half - breed; but he be white man, un course he not know great many ting what dose Enjun know."

"Why, doesn't he know as much as the medicine-man?" came my infantlike question.

"Oh, well, pries' he good peop'; all time he varrie good for poor Sun-Down; but I keep tell you he ees white man. All time wan' tak care of me when I die. Well, all right, dees Enjun medicine-man she tak care of me when I was leeve sometime. You s'pose I wan' die all time? No; I wan' leeve; un I got de medicine ober een my tepee—varrie good medicine. Eet tak me troo good many plass where I not geet troo maybeso."

"What is your medicine, Sun-Down?"

"Ah, you nevair min' what my medicine ees. You white man; what you know 'bout medicine? I see you 'fraid dat fores' fire out dair een dose mountain. You ask de question how dose canyon run. Well, you not be so 'fraid you 'ave de medicine. De medicine she tak care dose fire.

"White man she leeve een de house; she walk een de road; she nevair go half-mile out of hees one plass; un I guess all de medicine he care 'bout he geet een hees pocket.

"I see deese soldier stan' up, geet keel, geet freeze all up; don' 'pear care much. He die pretty easy, un de pries' he all time talk 'bout die, un dey don't care much 'bout leeve. All time deese die: eet mak me seeck. Enjun she wan' leeve, un, by gar, she look out pretty sharp 'bout eet too.

"Maybeso white man she don' need medicine. White man she don' 'pear know enough see speeret. Humph! white man can't see wagon-track on de grass; don' know how he see wagon-track on de cloud. Enjun he go all ober de snow; he lie een de dark; he leeve wid de win', de tunder—well, he leeve all time out on de grass—night-time—daytime—all de time."

"Yes, yes — certainly, Sun-down. It is all very strange to me, but how can you prove to me that good comes to you which is due to your medicine alone?"

"Ah-h—my medicine—when weare she evair do me any good? Ah-h, firs' time I evair geet my medicine she save my life—what? She do me great deal good, I tell you. Eef dose pries' be dair, she tell me, 'You geet ready for die'; but I no wan' die.

"Well, fellar name Wauchihong un me was trap de bevair ovair by de Souris Reever, un we weare not geet to dat reever one night, un weare lay down for go sleep. We weare not know where we weare. We weare wak up een de middle of dat night, un de plain she all great beeg grass fire. De win' she weare blow hard, un de fire she come 'whew-o-o-o!' We say, where we run? My medicine she tell me run off lef' han', un Wauchihong hees medicine tell heem you run off right-han' way. I weare say my medicine she good; he weare say hees medicine varrie ole—have done de great ting—weare nev-air fail. We follow our medicine, un so we weare part. I run varrie fas', un lee-tle while I fall een de Souris Reever, un den I know dose fire she not geet Leflare. My medicine was good.

"Nex' day I fin' Wauchihong dead. All burn—all black. He was burn up een dose fire what catch heem on de plain. De win' she drove de fire so fas' he could do not'ing, un hees medicine she lie to heem.

"You s'pose de pries' he tole me wheech way for run dat night? No; she tell me behave myself, un geet ready for die right dair. Now what you tink?"

Revelations and truths of this sort were overpowering, and no desire to change a man of Sun-Down's age and rarity came to my mind; but in hopes I said, "Did it ever so happen that your medicine failed you?"

"My medicine she always good, but medicine ees not so good one time as nod-der time. Do you s'pose I geet dat soldier order to Buford eef my medicine bad? But de medicine she was not ac' varrie well dat time.

"Deed you evair lie down alone een de bottom of de Black Canyon for pass de night? I s'pose you tink dair not'ing but bear een dat canyon; but I 'ave 'ear dem speerets dance troo dat canyon, un I 'ave see dem shoot troo dem pine-tree when I was set on de rim-rock. Deed you evair see de top of dose reever een de moon-light? What you know 'bout what ees een dat reever? White man he don't know so much he tink he know. Guess de speeret don' come een de board house,

but she howl roun' de tepee een de win-tair night. Enjun see de speerets dance un talk plenty een de lodge fire; white man he see not'ing but de coffee boil.

"White man mak de wagon, un de seelver dollar, un de dam railroad, un he tink dat ees all dair ees een de country;" and Sun-Down left off with a guttural "humph," which was the midship shot of disaster for me.

"But you don't tell the priest about this medicine?"

"No—what ees de use for tell de pries'? —he ees white man."

I asked Sun-Down what was the greatest medicine he ever knew, and he did not answer until, fired by my doubts, he continued, slowly, "My medicine ees de great medicine."

A critic must be without fear, since he can never fully comprehend the intent of other minds, so I saw that fortune must favor my investigations, for I knew not how to proceed; but knowing that action is life, I walked quickly to my grip-sack and took out my silver pocket-flask, saying: "You know, Sun-Down, very well, that it is dead against the rule to give a redskin a drink on a United States agency, but I am going to give you one if you will promise me not to go out and talk about it in this collection of huts. Are you with me?"

"Long-Spur—we pretty good frien'—hey? I weel say not a ting."

Then the conventionalities were gone through with, and they are doubtless familiar to many of my readers.

"Now I tole you dees ting—what was de great medicine—but I don' wan' you for go out here een de village un talk no more dan I talk—are you me?"

"I am you," and we forgathered.

"Now le's see; I weel tole you 'bout de bigges' medicine," and he made a cigarette.

"You aire young man—I guess maybeso you not born when I was be medicine-man; but eet was bad medicine for Absaroke, un you mus' not say a ting 'bout dees to dem. I am good frien' here now, but een dose day I was good frien' of de Piegan, un dey wan' come down here to de Absaroke un steal de pony. De party was geet ready—eet was ten men, un we come on de foot. We come 'long slow troo de mountain un was hunt for de grub. Aftair long time we was fin' de beeg Crow camp—we was see eet from de top

of de Pryor Mountain. Den we go 'way back up head of de canyon, 'way een dat plass where de timber she varrie tick, un we buil' de leetle log fort, 'bout as beeg as t'ree step 'cross de meddle. We was wan' one plass for keep de dry meat; we weare not wan' any one for see our fire; un we weare put up de beeg fight dair eef de Absaroke she roun' us up.

"Een dose day de Enjun he not come een de mountain varrie much—dey was hunt de buffalo on de flat, but maybeso she come een de mountain, un we watch out varrie sharp. Every night, jus' sun-down, we go out—each man by hees self, un we watch dat beeg camp un de horse ban's. Eet was 'way out on de plain great many mile. White man lak you he see not'ing, but de Enjun he mak out de tepee un de pony. I was always see much bettair dan de odder Enjun—varrie much bettair—un when we come back to de log fort for smoke de pipe, I was tole dose Enjun jus' how de country lay, un where de bes' plass for catch dem pony."

I think one who has ever looked at the Western landscape from a mountain-top will understand what Sun-Down intended by this extensive view. If one has never seen it, words will hardly tell him how it stretches away, red, yellow, blue, in a prismatic way, shaded by cloud forms and ending among them—a sort of topographical map. I can think of nothing else, except that it is an unreal thing to look at.

"Well, for begeen wid, one man she always go alone; nex' night noddair man go. Firs' man she 'ave de bes' chance, un eet geet varrie bad for las' man, 'cause dose Enjun dey catch on to de game un watch un go roun' for cut de trail. But de Enjun horse-t'ief he mak de trail lak de snake—eet varrie hard for peek up.

"I was 'ave de idea I geet be medicine-man, un I tole dem dey don' know not'ing 'cause dey cannot see, un I tole dem I see everyting; see right troo de cloud. I say each dose Enjun now you do jus' what I tole you, den you fin' de pony.

"So de firs' man he was start off een de afternoon, un we see heem no more. When de man was geet de horse, un maybeso de scalp, he skin out for de Piegan camp.

"Nex' night noddair man she go start off late een de afternoon, un I go wid heem, un I sais, 'You stay here, pull your robe ovair your head, un I go een de brush un

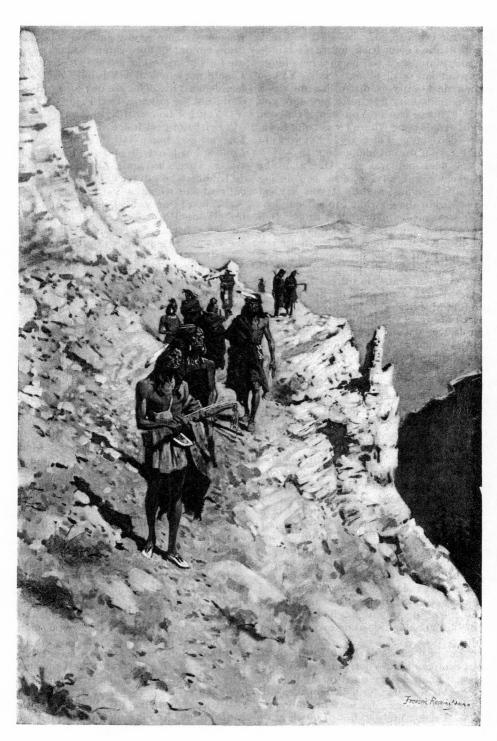

"WE COME 'LONG SLOW TROO DE MOUNTAIN."

mak de medicine for tell where ees good plass for heem to go.' When I was mak de medicine I come back, un we set dair on de mountain, un I tell heem where he go 'way out dair on de plain. I sais: 'You go down dees canyon un follow de creek down, un twenty-five mile out dair you fin' de horse ban'. You can sleep one night een de plass where I was point heem out—den you geet de pony. Eef you not fin' eet so, I am not medicine-man.'

"So dees man was go. One man she go every night, un I was set een de log fort all 'lone las' night. I was say eef deese Enjun she do what I tole heem, I be beeg great medicine-man dees time. Den I geet varrie much scare, for I was las' man, un dose Absaroke dey sure begin see our trail, un I put out de fire een de log fort, un I go off down de mountain for geet 'way from de trail what deese Enjun she mak. I was wan' mak de fire on dees mountain, 'cause she jus' 'live wid dose grizzly-bear. I varrie much 'fraid—I sleep een de tree dat night, un jus' come day I was go down de creek een de canyon. I was walk een de water un walk on de rocks. I was geet big ban' elk to run ovair my trail. I was walk long de rim-rock, un was geet pretty well down een de plain. I was sleep dat night een de old bear-cave, un I was see dees camp pretty well. Eet was good plass, 'bout ten mile out een de uppair valley of de Beeg-Horn Reever, but I was 'ave be careful, for dose Enjun dey weare run all ovair de country hunt deese horse-t'ief tracks. Oh, I see dem varrie well. I see Enjun come up my canyon un pass by me so near I hear dem talk. I was scare.

"Jus' come dark I crawl up on de rim-rock, un eet was rain hard. Enjun she no lak de rain, so I sais: 'I go down now. I keep out een de heel, for I see varrie much bettair dan de Absaroke, un eef I tink dey see me I drop een de sage-bush.'" And here Sun-Down laughed, but I did not think such hide-and-seek was very funny.

"Eet geet varrie dark, un I walk up to dees camp, not more dan ten step from de tepee. I tak de dry meat off de pole un trow eet to dose dog for mak dem keep still while I was hear de Absaroke laugh un talk. De dog he bark not so much at de Enjun as eef I be de white man; jus' same de white man dog he bite de dam leg off de Enjun.

"I cut de rope two fine pony what was

tie up near de lodge, un I know deese weare war-pony or de strong buffalo-horse. I lead dem out of dose camp. Eet was no use for try geet more as de two pony, for I could not run dem een de dark night. I feel dem all ovair for see dey all right. I could not see much. Den I ride off."

"You got home all right, I suppose?"

"Eef I not geet home all right, by gar, I nevair geet home 'tall. Dey chasse me, I guess, but I 'ave de good long start, un I leave varrie bad trail, I tink. Man wid de led horse he can leave blind trail more def'rent dan when he drive de pony.

"When I geet to dat Piegan camp I was fin' all dose Enjun 'cept one: he was nevair come back. Un I sais my medicine she ees good; she see where no one can see. Dey all sais my medicine she varrie strong for steal de pony. I was know ting what no man she see. Dey was all fin' de camp jus' as I say so. I was geet be strong een dat camp, un dey all say I see bes' jus' at sun-down, un dey always call me de sun-down medicine."

I asked, "How did it happen that you could see so much better than the others; was it your medicine which made it possible?"

"No. I was fool dose Enjun. I was 'ave a new pair of de fiel'-glass what I was buy from a white man, un I was not let dose Enjun see dem—dat ees how."

"So, you old fraud, it was not your medicine, but the field-glasses?" and I jeered him.

"Ah, dam white man, she nevair understan' de medicine. De medicine not 'ave anyting to do wid de fiel'-glass; but how you know what happen to me een dat canyon on dat black night? How you know dat? Eef eet not for my medicine, maybeso I not be here. I see dose speeret —dey was come all roun' me—but my medicine she strong, un dey not touch me."

"Have a drink, Sun-Down," I said, and we again forgathered. The wild man smacked his lips.

"I say, Sun-Down, I have always treated you well; I want you to tell me just what that medicine is like, over there in your tepee."

"Ah, dat medicine. Well, she ees leetle bagful of de bird claw, de wolf tooth, t'ree arrow-head, un two bullet what 'ave go troo my body."

"Is that all?"

"Ah, you white man!"

"I SAIS: 'YOU GO DOWN DEES CANYON.'"

29.
An Outpost
of Civilization

AN OUTPOST OF CIVILIZATION.

BY FREDERIC REMINGTON.

UNKNOWN—KILLED BY APACHE

THE hacienda San José de Bavicora lies northwest from Chihuahua 225 of the longest miles on the map. The miles run up long hills and dive into rocky cañons; they stretch over never-ending burnt plains, and across the beds of tortuous rivers thick with scorching sand. And there are three ways to make this travel. Some go on foot—which is best, if one has time—like the Tahuramaras; others take it ponyback, after the Mexican manner; and persons with no time and a great deal of money go in a coach. At first thought this last would seem to be the best, but the Guerrero stage has never failed to tip over, and the company make you sign away your natural rights, and almost your immortal soul, before they will allow you to embark. So it is not the best way at all, if I may judge from my own experience. We had a coach which seemed to choose the steepest hill on the route, where it then struck a stone, which heaved the coach, pulled out the king-pin, and what I remember of the occurrence is full of sprains and aches and general gloom. Guerrero, too, is only three-fourths of the way to Bavicora, and you can only go there if Don Gilberto, the *patron* of the hacienda—or, if you know him well enough, "Jack"—will take you in the ranch coach.

After bumping over the stones all day for five days, through a blinding dust, we were glad enough when we suddenly came out of the tall timber in the mountain pass and espied the great yellow plain of Bavicora stretching to the blue hills of the Sierra. In an hour's ride more,

through a chill wind, we were at the ranch. We pulled up at the entrance, which was garnished by a bunch of cow-punchers, who regarded us curiously as we pulled our aching bodies and bandaged limbs from the Concord and limped into the *patio*.

To us was assigned the room of honor, and after shaking ourselves down on a good bed, with mattress and sheeting, we recovered our cheerfulness. A hot toddy, a roaring fireplace, completed the effect. The floor was strewed with bear and wolf skin rugs; it had pictures and draperies on the walls, and in a corner a wash-basin and pitcher—so rare in these parts— was set on a stand, grandly suggestive of the refinements of luxury we had attained to. I do not wish to convey the impression that Mexicans do not wash, because there are brooks enough in Mexico if they want to use them, but wash-basins are the advance-guards of progress, and we had been on the outposts since leaving Chihuahua.

Jack's man William had been ever-present, and administered to our slightest wish; his cheerful "Good-mo'n'in', gemmen," as he lit the fire, recalled us to life, and after a rub-down I went out to look at the situation.

Jack's ranch is a great straggling square of mud walls enclosing two *patios*, with adobe corrals and out-buildings, all obviously constructed for the purposes of defence. It was built in 1770 by the Jesuits, and while the English and Dutch were fighting for the possession of the Mohawk Valley, Bavicora was an outpost of civilization, as it is to-day. Locked in a strange language, on parchment stored in vaults in Spain, are the records of this enterprise. In 1840 the good fathers were murdered by the Apaches, the country devastated and deserted, and the cattle and horses hurried to the mountain lairs of the Apache devils. The place lay idle and unreclaimed for years, threatening to crumble back to the dust of which it was made. Near by are curious mounds on the banks of a dry *arroyo*. The punchers have dug down into these ruins, and found adobe walls, mud plasterings, skeletons, and bits of woven goods.

EL PATRON.

They call them the "Montezumas." All this was to be changed. In 1882 an American cowboy—which was Jack—accompanied by two companions, penetrated south from Arizona, and as he looked from the mountains over the fair plain of Bavicora, he said, "I will take this." The Apaches were on every hand; the country was terrorized to the gates of Chihuahua. The stout heart of the pioneer was not disturbed, and he made his word good. By purchase he acquired the plain, and so much more that you could not ride round it in two weeks. He moved in with his hardy punchers, and fixed up Bavicora so it would be habitable. He chased the Indians off his ranch whenever he "cut their sign." After a while the Mexican *vaqueros* from below overcame their terror, when they saw the American hold his own with the Apache devils, and by twos and threes and half-dozens they came up to take service, and now there are two hundred who lean on Jack and call him *patron*. They work for him, and they follow him

on the Apache trail, knowing he will never run away, believing in his beneficence, and trusting to his courage.

I sat on a mud bank and worked away at a sketch of the yellow sunlit walls of the mud ranch, with the great plain running away like the ocean into a violet streak under the blue line of the Peña Blanca. In the rear rises a curious broken formation of hills like millions of ruins of Rhine castles. The *lobos** howl by night, and the Apache is expected to come at any instant. The old *criada* or serving-woman who makes the beds saw her husband killed at the front door, and every man who goes out of the *patio* has a large assortment of the most improved artillery on his person. Old carts with heavy wooden wheels like millstones stand about. Brown people with big straw hats and gay *serapes* lean lazily against the gray walls. Little pigs carry on the contest with nature, game-chickens strut, and clumsy puppies tumble over

* Wolves.

each other in joyful play; *burros* stand about sleepily, only indicating life by suggestive movements of their great ears, while at intervals a pony, bearing its lithe rider, steps from the gate, and breaking into an easy and graceful lope, goes away into the waste of land.

I rose to go inside, and while I gazed I grew exalted in the impression that here, in the year of 1893, I had rediscovered a Fort Laramie after Mr. Parkman's well-known description. The foreman, Tom Bailey, was dressed in store clothes, and our room had bedsteads and a wash-basin; otherwise it answered very well. One room was piled high with dried meat, and the great stomachs of oxen filled with tallow; another room is a store full of goods—calicoes, buckskin, *riatas*, yellow leather shoes, guns, and other quaint plunder adapted to the needs of a people who sit on the ground and live on meat and corn meal.

"Charlie Jim," the Chinese cook, has a big room with a stove in it, and he and

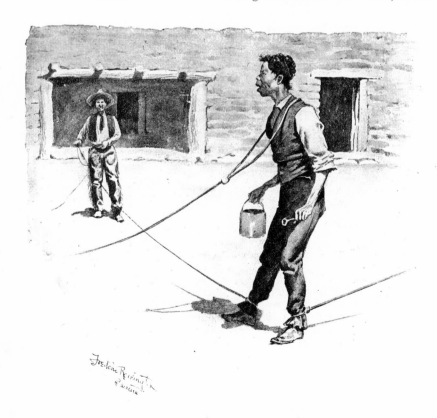

"PUNCHER ROPE MAN ALL SAME HORSE."

the stove are a never-ending wonder to all the folks, and the fame of both has gone across the mountains to Sonora and to the south. Charlie is an autocrat in his curious Chinese way, and by the dignity of his position as Mr. Jack's private cook, and his unknown antecedents, he conjures the Mexicans and d——s the

The *patron* has the state apartment, and no one goes there with his hat on; but the relations with his people are those of a father and children. An old gray man approaches; they touch the left arm with the right — an abbreviated hug — say "Buenos dias, patron!" "Buenos dias, Don Sabino!" and they shake hands. A

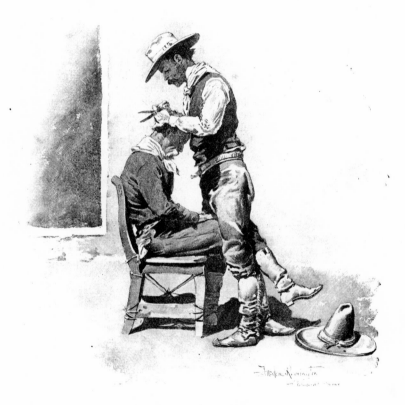

A HAIR-CUT À LA PUNCHER.

Texans, which latter refuse to take him seriously and kill him, as they would a "proper" man. Charlie Jim, in return, entertains ideas of Texans which he secretes, except when they dine with Jack, when he may be heard to mutter, "Cake and pie no good for puncher, make him fat and lazy"; and when he crosses the *patio* and they fling a rope over his foot, he becomes livid, and breaks out, "D—— puncher; d—— rope; rope man all same horse; d—— puncher; no good that way."

California saddle stands on a rack by the desk, and the latter is littered with photographs of men in London clothes and women in French dresses, the latter singularly out of character with their surroundings. The old *criada* squats silently by the fireplace, her head enveloped in her blue *rebozo*, and deftly rolls her cigarette. She alone, and one white bull-dog, can come and go without restraint.

The *administrador*, which is Mr. Tom Bailey, of Texas, moves about in the dis-

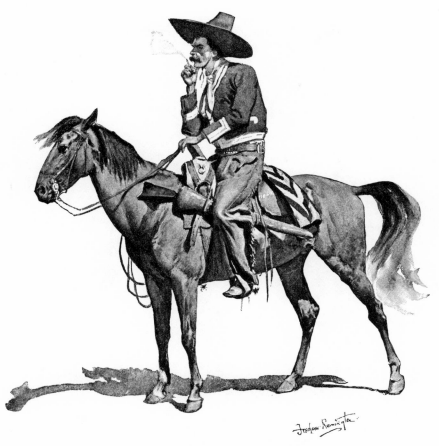

THE ADMINISTRADOR OF SAN JOSÉ DE BAVICORA.

charge of his responsibilities, and they are universal; anything and everything is his work, from the negotiation for the sale of five thousand head of cattle to the "busting" of a bronco which no one else can "crawl."

The clerk is in the store, with his pink boy's face, a pencil behind his ear, and a big sombrero, trying to look as though he had lived in these wilds longer than at San Francisco, which he finds an impossible part. He has acquired the language and the disregard of time necessary to one who would sell a real's worth of cotton cloth to a Mexican.

The forge in the blacksmith's shop is going, and one puncher is cutting another puncher's hair in the sunlight; ponies are being lugged in on the end of lariats, and thrown down, tied fast, and left in a convulsive heap, ready to be shod at the disposition of their riders.

On the roof of the house are two or three men looking and pointing to the little black specks on the plain far away, which are the cattle going into the *lagunas* to drink.

The second *patio*, or the larger one, is entered by a narrow passage, and here you find horses and saddles and punchers coming and going, saddling and unsaddling their horses, and being bucked about or dragged on a rope. In the little doorways to the rooms of the men stand women in calico dresses and blue cotton *rebozos*, while the dogs and pigs lie about, and little brown *vaqueros* are ripening in the sun. In the rooms you find pottery, stone *metates* for grinding the corn, a fireplace, a symbol of the Catholic Church, some *serapes*, some rope, and buckskin. The people sit on a mat on the floor, and make cigarettes out of native tobacco and corn husks, or rolled *tor-*

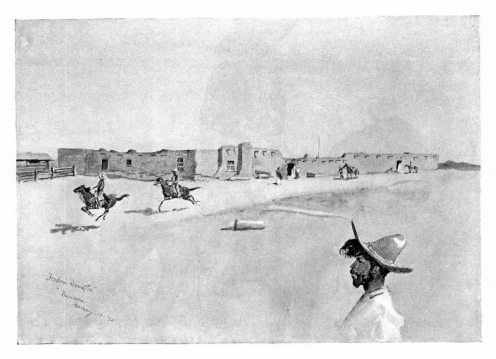

THE HACIENDA SAN JOSÉ DE BAVICORA.

tillas; they laugh and chat in low tones, and altogether occupy the tiniest mental world, hardly larger than the *patio,* and not venturing beyond the little mud town of Temozachic, forty miles over the hills. Physically the men vacillate between the most intense excitement and a comatose state of idleness, where all is quiet and slothful, in contrast to the mad whirl of the roaring *rodeo.*

In the haciendas of old Mexico one will find the law and custom of the feudal days. All the laws of Mexico are in protection of the land-owner. The master is without restraint, and the man lives dependent on his caprice. The *patron* of Bavicora, for instance, leases land to a Mexican, and it is one of the arrangements that he shall drive the ranch coach to Chihuahua when it goes. All lessees of land are obliged to follow the *patron* to war, and, indeed, since the common enemy, the Apache, in these parts is as like to harry the little as the great, it is exactly to his interest to wage the war. Then, too, comes the responsibility of the *patron* to his people. He must feed them in the famine, he must arbitrate their disputes, and he must lead them at all times. If through improvidence their work-cattle die or give out, he must restock them, so that they may continue the cultivation of the land, all of which is not altogether profitable in a financial way, as we of the North may think, where all business is done on the " hold you responsible, sir," basis.

The *vaqueros* make their own saddles and *reatas ;* only the iron saddle-rings, the rifles, and the knives come from the *patron,* and where he gets them from God alone knows, and the puncher never cares. No doctor attends the sick or disabled, old women's nursing standing between life and death. The Creator in His providence has arranged it so that simple folks are rarely sick, and a sprained ankle, a bad bruise from a steer's horn or a pitching horse, are soon remedied by rest and a good constitution. At times instant and awful death overtakes the puncher—a horse in a gopher-hole, a mad steer, a chill with a knife, a blue hole where the .45 went in, a quicksand closing overhead, and a cross on a hillside are all.

Never is a door closed. Why they were put up I failed to discover. For

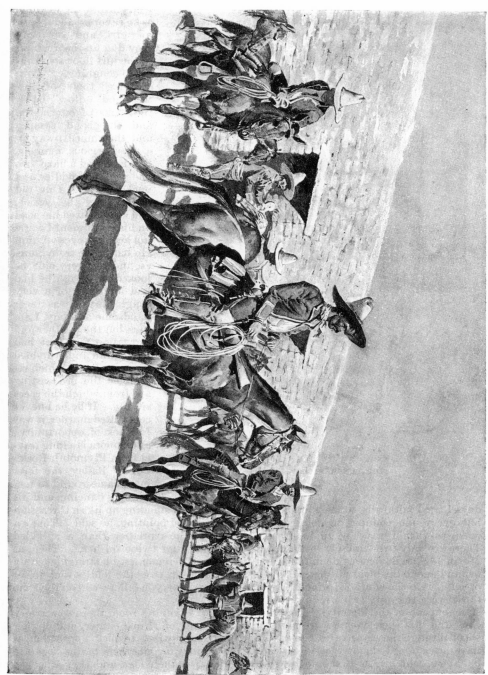

PUNCHERS SADDLING IN THE PATIO.

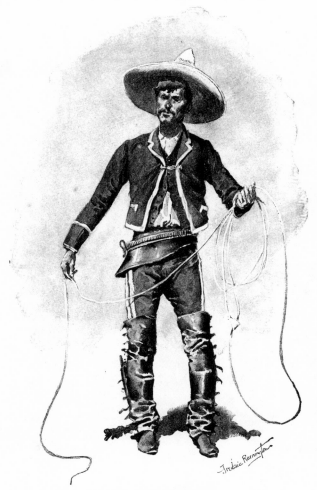

THE PUNCHER COSTUME.

observed the man who wears the big hat and who throws the rawhide as he cavorted about with his girl, and the way they dug up the dust out of the dirt floor soon put me to coughing. "Candles shed their soft lustre—and tallow" down the backs of our necks, and the band scraped and thrummed away in a most serious manner. One man had a harp, two had primitive fiddles, and one a guitar. One old fiddler was the leader, and as he bowed his head on his instrument I could not keep my eyes off him. He had come from Sonora, and was very old; he looked as though he had had his share of a very rough life; he was never handsome as a boy, I am sure, but the weather and starvation and time had blown him and crumbled him into a ruin which resembled the pre-existing ape from which the races sprung. If he had never committed murder, it was for lack of opportunity; and Sonora is a long travel from Plymouth Rock.

Tom Bailey, the foreman, came round to me, his eyes dancing, and his shock of hair standing up like a Circassian beauty's, and pointing, he said, "Thar's a woman who's prettier than a speckled pup; put your twine on her." Then, as master of ceremonies, he straightened up and sang out over the fiddles and noise: "Dance, thar, you fellers, or you'll git the gout."

In an adjoining room there was a very heavy jug of strong-water, and thither the men repaired to pick up, so that as the night wore on their brains began to whirl after their legs, and they whooped at times in a way to put one's nerves on edge. The band scraped the harder and the dance waxed fast, the spurs clinked, and *bang, bang, bang* went the Winchester rifles in the *patio*, while the cho-

days I tried faithfully to keep mine shut, but every one coming or going left it open, so that I gave it up in despair. There are only two windows in the ranch of San José de Bavicora, one in our chamber and one in the blacksmith's shop, both opening into the court. In fact, I found those were the only two windows in the state, outside of the big city. The Mexicans find that their enemies are prone to shoot through these apertures, and so they have accustomed themselves to do without them, which is as it should be, since it removes the temptation.

One night the *patron* gave a *baile*. The *vaqueros* all came with their girls, and a string band rendered music with a very dancy swing. I sat in a corner and

rus "Viva el patron" rang around the room—the Old Guard was in action.

We sat in our room one evening when in filed the *vaqueros* and asked to be allowed to sing for the *patron*. They sat on my bed and on the floor, while we occupied the other; they had their hats in their hands, and their black dreamy eyes were diverted as though overcome by the magnificence of the apartment. They hemmed and coughed, until finally one man, who was evidently the leader, pulled himself together and began, in a high falsetto, to sing; after two or three words the rest caught on, and they got through the line, when they stopped; thus was one leading and the others following to the end of the line. It was strange, wild music—a sort of general impression of a boys' choir with a wild discordance, each man giving up his soul as he felt moved. The refrain always ended, for want of breath, in a low expiring howl, leaving the audience in suspense;

but quickly they get at it again, and the rise of the tenor chorus continues. The songs are largely about love and women and doves and flowers, in all of which nonsense punchers take only a perfunctory interest in real life.

These are the amusements—although the puncher is always roping for practice, and everything is fair game for his skill; hence dogs, pigs, and men have become as expert in dodging the rope as the *vaqueros* are in throwing it. A mounted man, in passing, will always throw his rope at one sitting in a doorway, and then try to get away before he can retaliate by jerking his own rope over his head. I have seen a man repair to the roof and watch a doorway through which he expected some comrade to pass shortly, and watch for an hour to be ready to drop his noose about his shoulders.

The ranch fare is very limited, and at intervals men are sent to bring back a steer from the water-holes, which is

THE MUSIC AT THE "BAILE."

SHOEING A BRONCO.

dragged to the front door and there slaughtered. A day of feasting ensues, and the doorways and the gutter-pipes and the corral fences are festooned with the beef left to dry in the sun.

There is the serious side of the life. The Apache is an evil which Mexicans have come to regard as they do the meteoric hail, the lightning, the drought, and any other horror not to be averted. They quarrel between themselves over land and stock, and there are a great many men out in the mountains who are proscribed by the government. Indeed, while we journeyed on the road and were stopping one night in a little mud town, we were startled by a fusillade of shots, and in the morning were informed that two men had been killed the night before, and various others wounded. At another time a Mexican, with his followers, had invaded our apartment and expressed a disposition to kill Jack, but he found Jack was willing to play his game, and gave up the enterprise. On the ranch the men had discovered some dead stock which had been killed with a knife. Men were detailed to roam the country in search of fresh trails of these cattle-killers. I asked the foreman what would happen in case they found a trail which could be followed, and he said, "Why, we would follow it until we came up, and then kill them." If a man is to "hold down" a big ranch in northern Mexico he has got to be "all man," because it is "a man's job," as Mr. Bailey of Los Ojos said—and he knows.

Jack himself is the motive force of the enterprise, and he disturbs the quiet of

this waste of sunshine by his presence for about six months in the year. With his strong spirit, the embodiment of generations of pioneers, he faces the Apache, the marauder, the financial risks. He spurs his listless people on to toil, he permeates every detail, he storms, and greater men than he have sworn like troopers under less provocation than he has at times; but he has snatched from the wolf and the Indian the fair land of Bavicora, to make it fruitful to his generation.

There lies the hacienda San José de Bavicora, gray and silent on the great plain, with the mountain standing guard against intruders, and over it the great blue dome of the sky, untroubled by clouds, except little flecks of vapor, which stand, lost in immensity, burning bright like opals, as though discouraged from seeking the mountains or the sea from whence they came. The marvellous color of the country beckons to the painter; its simple natural life entrances the blond barbarian, with his fevered brain; and the gaudy *vaquero* and his trappings and his pony are the actors on this noble stage. But one must be appreciative of it all, or he will find a week of rail and a week of stage and a week of horseback all too far for one to travel to see a shadow across the moon.

30.
The
Spirit
of Mahongui

THE SPIRIT OF MAHONGUI.

BY FREDERIC REMINGTON.

IT is so I have called this old document, which is an extract from the memoirs of le Chevalier Bailloquet, a Frenchman living in Canada, where he was engaged in the Indian fur trade, about the middle of the seventeenth century, and as yet they are unpublished. It is written in English, since the author lived his latter life in England, having left Canada as the result of troubles with the authorities.

He was captured by the Iroquois, and after living with them some time, made his escape to the Dutch.

My Chevalier rambles somewhat, although I have been at pains to cut out extraneous matter. It is also true that many will not believe him in these days, for out of their puny volition they will analyze, and out of their discontent they will scoff. But to those I say, Go to your microbes, your statistics, your volts, and your bicycles, and leave me the truth of other days.

The Chevalier was on a voyage from Quebec to Montreal; let him begin:

The next day we embarqued, though not wthout confufion, becaufe many weare not content, nor fatiffied. What a pleafure ye two fathers to fee them trott up and downe ye rocks to gett their manage into ye boat. The boats weare fo loaded that many could not proceed if foul weather fhould happen. I could not perfuade myfelf to ftay wth this concourfe as ye weather was faire for my journie. Wthout adoe, I gott my fix wild men to paddle on ye way.

This was a fatal embarquation, butt I did not miftruft that ye Iriquoits weare abroad in ye foreft, for I had been at ye Peace. Neverthelefs I find that thefe wild men doe naught butt what they refolve out of their bloodie mindednefs. We paffed the Point going out of ye Lake St. Peter, when ye Barbars appeared on ye watter-fide difcharging their mufkets at us, and embarquing for our purfuit.

"Kohe — kohe!" — came nearer ye fearfome warre cry of ye Iriquoit, making ye hearts of ye poore Hurron & ffrench alike to turn to water in their breafts. 2 of my favages weare ftrook downe at ye firft difcharge & an other had his paddle cutt in twain, befides fhott holes through wᶜʰ the watter poured apace. Thus weare we diminifhed and could not draw off.

The Barbars weare daubed wᵗʰ paint, wᶜʰ is ye figne of warre. They coming againft our boat ftruck downe our Hurrons wᵗʰ hattchetts, fuch as did not jump into the watter, where alfo they weare in no wife faved.

But in my boat was a Hurron Captayne, who all his life-time had killed many Iriquoits & by his name for vallor had come to be a great Captayne att home and abroad. We weare refolved fome execution & wᵗʰ our gunns dealt a difcharge & drew our cuttlaffes to ftrike ye foe. They environed us as we weare finking, and one fpake, faying, "Brothers, cheere up and affure yourfelfe you fhall not be killed; thou art both man and Captayne, as I myfelf am, and I will die in thy defenfe." And ye afforefaid crew fhewed fuch a horrid noife, of a fudden ye Iriquoit Captayne took hold about me—"Thou fhalt not die by another hand than mine."

The favages layd bye our armes & tyed us faft in a boat, one in one boat and one in another. We proceeded up ye river, rather fleeping than awake, for I thought never to efcape.

Att near funfett we weare taken on ye fhore, where ye wild men encamped bye making cottages of rind from off ye trees. They tyed ye Hurron Captayne to a trunk, he refolving moft bravely but deffparred to me, and I too defparred. Neverthelefs he fang his fatal fong though ye fire made him as one wᵗʰ the ague. They tooke out his heart and cut off fome of ye fleafh of ye miferable, boyled it and eat it. This they wifhed not to doe att this time, but that ye Hurron had been fhott wᵗʰ a ball under his girdle where it was not feen, though he would have died of his defperate wound. That was the miferable end of that wretch.

Whilft they weare bufy wᵗʰ ye Hurron, they having ftripped me naked, tyed me above ye elbows, and wrought a rope about my middle. They afked me feveral queftions, I not being able to anfwer, they gave me great blows wᵗʰ their fifts, then pulled out one of my nails. Having loft all hopes, I refolved altogether to die, itt being folly to think otherwife.

I could not fleep, butt was flung into a boat att daylight. The boats went all abreaft, ye wild men finging fome of their fatal fongs, others their howls of victory, ye wild "Kohes," beating giens & parchments, blowing whiftles, and all manner of tumult.

Thus did we proceed wᵗʰ these ravening wolves, God having delivered a Chriftian into ye power of Satan.

I was nott ye only one in ye claws of thefe wolves, for we fell in wᵗʰ 150 more of thefe cruels, who had Hurron captyves to ye number of 33 victims, wᵗʰ heads alfoe ftuck on poles, of thofe who in God's mercie weare gone from their miferies. As for me, I was put in a boat wᵗʰ one who had his fingers cutt & bourned. I afked him why ye Iriquoit had broak ye Peace, and he faid they had told him ye ffrench had broak ye Peace; that ye ffrench had fet their pack of doggs on an olde Iriquoit woman who was eat up alive, & that ye Iriquoits had told ye Hurron wild men that they had killed ye doggs, alfoe Hurrons and ffrench, faying that as to ye captyves, they would boyl doggs, Hurrons, and ffrench in ye fame kettle.

A great rain arofe, ye Iriquoits going to ye watter-fide did cover themfelvs wᵗʰ their boats, holding ye captyves ye meanwhile bye ropes bound about our ancles, while we ftood out in ye ftorm, wᶜʰ was near to caufing me death from my nakednefs. When ye rain had abated, we purfued our way killing ftaggs, & I was given fome entrails, wᶜʰ before I had only a little parched corne to ye extent of my hand full.

At a point we mett a gang of ye head hunters all on ye fhore, dancing about a tree to wᶜʰ was tyed a fine ffrench maftiff dogg, wᶜʰ was ftanding on its hinder leggs, being lafhed up againft a tree by its middle. The dogg was in a great terror, and frantic in its bonds. I knew him for a dogg from ye fort att Mont-royal, kept for to give warnings of ye Ennemys approach. It was a ftrange fight for to fee ye Heathen rage about ye noble dogg, but he itt was neverthelefs wᶜʰ brought ye Barbars againft us. He was only gott wᵗʰ great difficulty, having killed one Barbar, and near to ferving others likewife.

They untied ye dogg, holding him one fide and ye other, wᵗʰ cords they brought and tyed him in ye bow of a boat wᵗʰ 6 warriors to paddle him. The dogg boat was ye Head, while ye reft came on up ye river, finging fatal fongs, triumph fongs, piping, howling, & ye dogg above all wᵗʰ his great noife. The Barbars weare more delight-

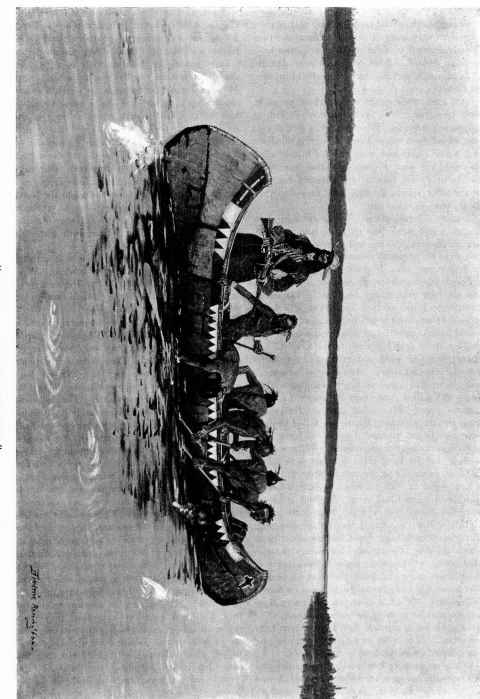

"THIS WAS A FATAL EMBARQUATION."

ed att ye captyve dogg than at all of us poore Chriftians, for that they did fay he was no dogg. The doggs w^ch ye wild men have are nott fo great as wolves, they being little elfe & fmall att that. The maftiff was confidered as a confequence to be a great intereft. This one had near defeated their troupe, & now was to be horridly killed after ye bloody way of ye wild men.

Att camp they weare fleep moft of ye night, they being aweary w^th ye torture of ye Hurron Captaine previoufly. The dogg was tyed & layd nott far off from where I was alfoe tyed, butt over him weare 2 olde men, who guarded him of a fear he would eat away his ropes. Thefe men weare Elders or Priefts, fuch as are efteemed for their power over fpirits, & they did keep up their devil's fong ye night thro.

I made a vertue of neceffity & did fleep, butt was early caft into a boat to go on toward ye Ennemy's countrie, tho we had raw meat given us, w^th blows on ye mouth to make us ye more quickly devour itt. An Iriquoit who was the Captayne in our boat bade me to be of a good courage, as they would not hurt me. The small knowledge I had of their fpeech made a better hope, butt one who could have underftood them would have been certainly in a great terror.

Thus we journied 8 days on ye Lake Champlaine, where ye wind and waves did fore befet our endeavors att times. As for meate we wanted none, as we had a ftore of ftaggs along ye watterfide. We killed fome every day, more for fport than for need. We finding them on Ifles, made them go into ye watter, & after we killed above a fcore, we clipped ye ears of ye reft & hung bells on them, and then lett them loofe. What a fport to fee ye reft flye from them that had ye bells!

There came out of ye vaft foreft a multitude of bears, 300 at leaft together, making a horrid noife, breaking ye fmall trees. We fhott att them, butt they ftirred not a ftep. We weare much frightened that they ftirred nott att our fhooting. The great ffrench dogg would fain encounter them notwithftanding he was tyed. He made ye watterfide to ring w^th his heavy voife, & from his eyes came flames of fyre & clouds from out his mouth. The bears did ftraightway fly, w^ch much cheered ye Iriquoits. One faid to me they weare refolved nott to murder ye dogg, w^ch was a ftone-God in ye dogg fhape, or a witch, butt I could nott fully underftand. The wild men faid they had never heard their fathers fpeak of fo many bears.

When we putt ye kettle on, ye wild man who had captured me gave me of meate to eat, & told me a ftory. "Brother," fays he, "itt is a thing to be admired to goe afar to travell. You muft know that tho I am olde, I have always loved ye ffrench for their goodnefs, but they fhould have

given us to kill ye Algonkins. We fhould not warre againft ye ffrench, butt trade w^th them for Caftors, who are better for traffic than ye Dutch. I was once a Captayne of 13 men against ye Altignaonanton & ye ffrench. We ftayed 3 whole winters among ye Ennemy, butt in ye daytime durft nott marche nor ftay out of ye deep foreft. We killed many, butt there weare devils who took my fon up in ye air fo I could never again get him back. Thefe devils weare as bigg as horriniacs,* & ye little blue birds w^ch attend upon them faid itt was time for us to go back to our people, w^ch being refolved to do, we came back, butt nott of a fear of ye Ennemy. Our warre fong grew ftill on our lipps, as ye fnow falling in ye foreft. I have nott any more warred to the North, until I was told by ye fpirits to go to ye ffrench & recover my fon. My friend, I have dreamed you weare my fon;" and henceforth I was not hurted nor ftarved for food.

We proceeded thro rivers & lakes & thro forefts where I was made to support burdens. When we weare come to ye village of ye Iriquoits we lay in ye woods becaufe that they would nott go into ye village in ye night time.

The following day we weare marched into ye brought of ye Iriquoits. When we came in fight we heard nothing butt outcryes from one fide as from ye other. Then came a mighty hoft of people & payd great heed to ye ffrench dogg, w^ch was ledd bye 2 men, while roundabout his neck was a girdle of porcelaine. They tormented ye poore Hurrons w^th violence, butt about me was hung a long piece of porcelaine—ye girdle of my captor, & he ftood againft me. In ye mean while many of ye village came about us, among w^ch a goode olde woman & a boy w^th a hattchett came neere me. The olde woman covered me, & ye boy took me by my hand and led mee out of ye companie. What comforted me was that I had efcaped ye blowes. They brought me into ye village, where ye olde woman showed me kindnefs. She took me into her cottage & gave me to eat, butt my great terror took my ftumack away from me. I had ftayed an hour when a great companie came to fee me, of olde men w^th pipes in their mouths. For a time they fat about, when they did lead me to another cabbin, w^re they smoked & made me apprehend they fhould throw me into ye fyre. Butt itt proved otherwife, for ye olde woman followed me, fpeaking aloud, whome they anfwered w^th a loud Ho, then fhee tooke her girdle, and about me fhe tyed itt, fo brought me to her cottage & made me to fitt downe.

Then fhe gott me Indian corne toafted, & took away ye paint ye fellows had ftuck to my face. A

* Moose. † Borough.

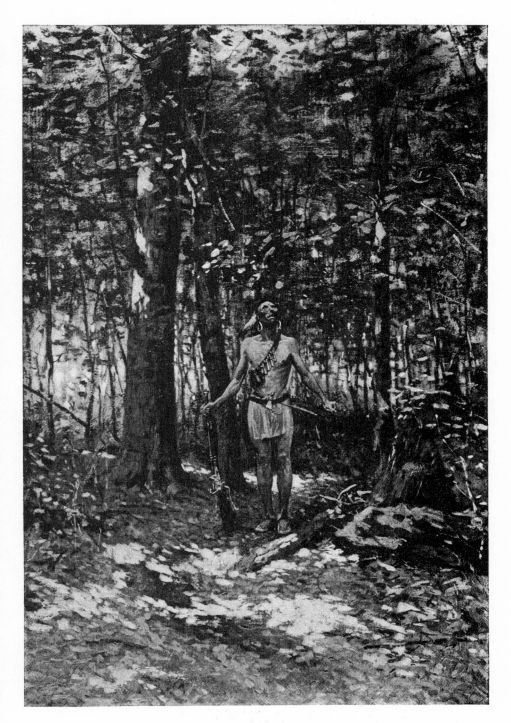

THE OMEN OF THE LITTLE BLUE BIRDS.

maide greafed & combed my haire, & ye olde woman danced and fung, while my father bourned tobacco on a ftone. They gave me a blew coverlitt, ftockings, and fhoes. I layed w^th her fon & did w^t I could to get familiarity w^th them, and I fuffered no wrong, yet I was in a terror, for ye fatal fongs came from ye poore Hurrons. The olde man inquired whether I was Afferony, a ffrench. I affured him no, faying I was Panugaga, that is, of their nation, for w^ch he was pleafed.

My father feafted 200 men. My fifters made me clean for that purpofe, and greafed my haire. They tyed me w^th 2 necklaces of porcelaine & garters of ye fame. My father gave me a hattchett in my hand.

My father made a fpeech, fhowing many demonstrations of vallor, broak a kettle of cagamite w^th a hattchett. So they fung, as is their ufual cuftom. The banquette being over, all cryed to me "Shagon, Orimha!"—that is, "Be hearty!" Every one withdrew to his quarters.

Here follows a long account of his daily life among the Indians, his hunting, and observations which our space forbids. He had become meanwhile more familiar with the language. He goes on:

My father came into ye cabbin from ye grand caftle & he fat him downe to fmoke. He said ye Elders had approved after much debate, & that ye ffrench dogg was not a witch, but ye great warrior Mahongui, gone before, whofe fpirit had rofe up into ye ffrench dogg & had fpyed ye ffrench. Att ye council even foe ye dogg had walked into ye centre of ye great cabbin, there faying loudly to ye Elders what he was & that he muft be heard. His voice muft be obeyed. His was not ye mocking cryes of a witch from under an olde fnakefkin, butt a chief come from Paradife to comfort his own people. My father afked me if I was agreed. I faid that witches did not battile as openly as ye dogg, butt doe their evil in ye dark.

Thefe wild men are fore befet w^th witches and devils—more than Chriftians, as they deferve to be, for they are of Satan's own belonging.

My father dreamed att night, & fang about itt, making ye fire to bourne in our cabbin. We fatt to liften. He had mett ye ffrench dogg in ye foreft path bye night—he ftanding accrofs his way, & ye foreft was light from ye dogg's eyes, who fpake to my father, faying, "I belong to ye dead folks—my hattchett is ruft—my bow is mould—I can no longer battile w^th our Ennemy, butt I hover over you in warre—I direct your arrows to their breafts—I fmoothe ye little dry fticks & wett ye leaves under ye fhoes—I draw ye morning mift

accrofs to fhield you—I carry ye 'Kohes' back and fore to bring your terror—I fling afide ye foeman's bulletts—go back and be ftrong in council."

My father even in ye night drew ye Elders in ye grand cabbin. He faid what he had feen and heard. Even then the great ffrench dogg gott from ye darknefs of ye cabin, & ftrode into ye fyre. He roared enough to blow downe caftles in his might, & they knew he was faying what he had told unto my father.

A great Captayne fent another night & had ye Elders for to gather at ye grande cabbin. He had been paddling his boat upon ye river when ye dogg of Mahongui had walked out on ye watter thro ye mift. He was taller than ye foreft. So he fpake, faying, "Mahongui fays—go tell ye people of ye Panugaga, itt is time for warre—ye corne is gathered—ye deer has changed his coat—there are no more Hurrons for me to eat. What is a Panugaga village w^th no captyves? The young men will talk as women doe, & ye Elders will grow content to watch a fnow-bird hopp. Mahongui fays itt is time."

Again att ye council fyre ye fpirit dogg ftrode from ye darknefs & faid itt was time. The tobacco was bourned by ye Priefts. In ye fmoke ye Elders beheld ye Spirit of Mahongui. "Panugaga—Warre."

Soe my father faw ye ghoft of ye departed one. He fmoked long bye our cabbin fyre. He fang his battile fong. I afked him to goe myfelf, even w^th a hattchett, as I too was Panugaga. Butt he would in no wife liften. "You are nott meet," he fays; "you faye that your God is above. How will you make me believe that he is as goode as your black coats say? They doe lie, & you fee ye contrary; ffor firft of all, ye Sun bournes us often, ye rain wetts us, ye winde makes us have fhipwrake, ye thunder, ye lightening bournes & kills us, & all comes from above, & you fay that itt is goode to be there. For my part, I will nott go there. Contrary they fay that ye reprobates & guilty goeth downe & bourne. They are miftaken; all is goode heare. Do nott you fee that itt is ye Earthe that nourifhes all living creatures, ye watter, ye fifhes & ye yus, and that corne & all other fruits come up, & that all things are nott foe contrary to us as that from above? The devils live in ye air, & they took my fon. When you fee that ye Earthe is our Mother, then you will fee that all things on itt are goode. The Earthe was made for ye Panugaga, & ye fouls of our warriors help us againft our Ennemy. The ffrench dogg is Mahongui's fpirit. He tells us to goe to warre againft ye ffrench. Would a ffrench dogg doe that? You are nott yett Panugaga to follow your father in warre."

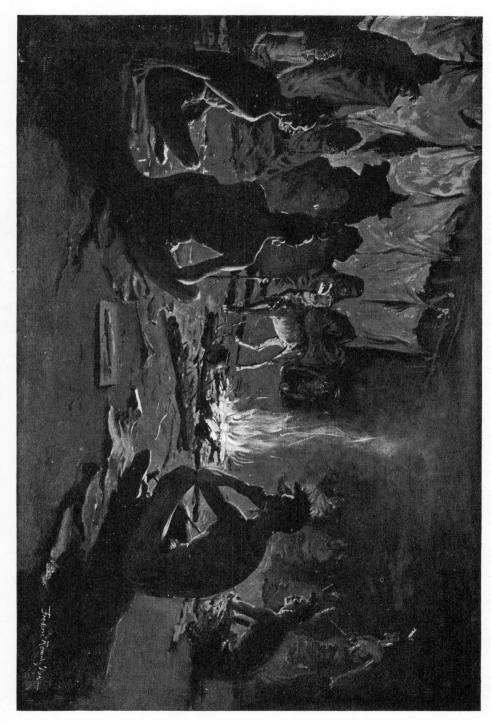

"YE SPIRIT DOGG STRODE FROM YE DARKNESS & SAID IT WAS TIME"

31.
The
Great
Medicine-Horse

THE GREAT MEDICINE–HORSE.

AN INDIAN MYTH OF THE THUNDER.

BY FREDERIC REMINGTON.

"ITSONEORRATSEAHOOS," or Paint, as the white men called him, had the story, and had agreed to tell it to me. His tepee was not far, so "Sun-Down La Flare" said he would go down and interpret.

Sun-Down was cross-bred, red and white, so he never got mentally in sympathy with either strain of his progenitors. He knew about half as much concerning Indians as they did themselves, while his knowledge of white men was in the same proportion. I felt little confidence that I should get Paint's mysterious musings transferred to my head without an undue proportion of dregs filtered in from Sun-Down's lack of appreciation. While the latter had his special interest for me, the problem in this case was how to eliminate "Sun-Down" from "Paint." So much for interpreters.

We trudged on through the soft gray-blues of the moonlight, while drawing near to some tepees grouped in the creek bottom. The dogs came yelling; but a charge of Indian dogs always splits before an enemy which does not recoil, and recovers itself in their rear. There they may become dangerous. Sun-Down lifted the little tepee flap, and I crawled through. A little fire of five or six split sticks burned brightly in the centre, illumining old Paint as he lay back on his resting-mat. He grunted, but did not move; he was smoking. We shook hands, and Sun-Down made our peace-offering to the squaw, who sat at her beading. We reclined about the tepee and rolled cigarettes. There is a solemnity about the social intercourse of old Indian warriors which reminds me of a stroll through a winter forest. Every one knows by this how the interior of an Indian tepee looks, though every one cannot necessarily know how it feels; but most people who have wandered much have met with fleas. Talk came slow; but that is the Indian of it: they think more than they talk. Sun-Down explained something at length to Paint, and back came the heavy guttural clicking of the old warrior's words, accompanied by much subtle sign language.

"He sais he will tell you 'bout de horse. Now you got for keep still and wait; he'll talk a heap, but you'll get de story eef you don' get oneasy."

"Now, Sun-Down, remember to tell me just what Paint says. I don't care what you think Paint means," I admonished.

"I step right in hees tracks."

Paint loaded his long red sandstone pipe with the utmost deliberation, sat up on his back-rest, and puffed with an exhaust like a small stationary engine. The squaw put two more sticks on the fire, which spitted and fluttered, lighting up the broad brown face of the old Indian, while it put a dot of light in his fierce little left eye. He spoke slowly, with clicking and harsh gutturals, as though he had an ounce of quicksilver in his mouth which he did not want to swallow. After a time Sun-Down raised his hand to enjoin silence.

"He sais dat God—not God, but dat is bess word I know for white man; I have been school, and I know what he want for say ees what you say medicin', but dat ees not right. What he want for say ees de ding what direct heem un hees people what is best for do; et ees de speret what tell de ole men who can see best when dey sleep. Well—anyhow, it was long, long time ago, when hees fader was young man, and 'twas hees fader's fader what it all happened to. The Absarokees deedn't have ponies 'nough—de horses ware new in de country—dey used for get 'em out of a lac,* 'way off somewhere—dey come out of de water, and dese Enjun† lay in the bulrush for rope 'em, but dey couldn't get 'nough; besides, de Enjun from up north she use steal 'em from Absarokee. Well—anyhow, de medicin' tole hees fader's fader dat he would get plenty horses eef he go 'way south. So small party went 'long wid heem—dey was on foot—dey was

* Lake.　　　　† Indian.

379

travel for long time, keepin' in de foot-hill. Dey was use for travel nights un lay by daytime, 'cept when dey was hunt for de grub. De country was full up wid deir enemies, but de medicin' hit was strong, and de luck was wid 'em. De medicin' hit keep tellin' 'em for go 'long —go on—on—on—keep goin' long, long time. He's been tellin' me de names of revers dey cross, but you wouldn't know dem plass by what he call 'em. Dey keep spyin' camps, but de medicin' he keep tellin' 'em for go on, go on, un not bodder dem camp, un so dey keep goin'."

Here Sun-Down motioned Paint, and he started his strange high-pitched voice —winking and moving his hands at Sun-Down, who was rolling a cigarette, though keeping his eyes on the old Indian. Presently the talking ceased.

"He sais—dey went on—what he is tryin' for say ees dey went on so far hit was heap hot, un de Enjun dey was deef-erent from what dees Enjun is. He's tryin' for to get so far off dat I don' know for tell you how far he ees."

"Never mind, Sun-Down; you stick to Paint's story," I demanded.

"Well—anyhow—he's got dees outfit hell of a long way from home, un dey met up wid a camp un heap of pony. He was try tell how many pony — like de buffalo use be—more pony dan you see ober, by Gar. Den de medicin' say dey was for tac dose pony eef dey can. Well, den de outfit lay roun' camp wid de wolf-skin on—de white wolf. De En-jun he do jus' same as wolf, un fool de oder Enjun, you see; well, den come one night dey got de herds whar dey wanted 'em, un cut out all dey could drive. Et was terrible big bunch, 'cording as Paint say. Dey drive 'em all night un all nex' day, wid de horse-guides ahead, un de oders behin', floppin' de wolf-robe, un Paint say de grass will nevar grow where dey pass 'long; but I dink, by Gar, Paint ees talk t'ro' hees hat."

"Never mind—I don't want you to think—you just freeze to old Paint's talk, Mr. Sun-Down," I interlarded.

"Well, den—damn 'em, after dey had spoil de grass for 'bout night un day de people what dey had stole from come a-runnin'. Et was hard for drive such beeg bunch fas'—dey ought for have tac whole outfit un put 'em foot; but Paint say—un he's been horse-tief too hisself,

by Gar—he say dey natu'lly couldn't; but I say—"

"Never mind what you say."

"Well, anyhow, I say—"

"Never mind, Sun-Down!"

"Well, ole Paint he say same t'ing. De oder fellers kim up wid 'em, so just natu'lly dey went fightin'; but dey had extra horses, un de oder fellers dey didn't, 'cep' what was fall out of bunch, dem be-in' slow horses, un horses what was no 'count, noway. Dey went runnin' un fightin' 'way in de night; but de herd split on 'em, un hees fader's fader went wid one bunch, un de oder fellers went wid de 'split,' which no one neber heard of no more. De men what had loss de horses all went after de oder bunch. Hees fader's fader rode all dat night, all nex' day, un den stopped for res'. Dar was only 'bout ten men for look after de herd, which was more horses dan you kin see een dees valley to-day; what ees more horses dan ten men kin wrangle, 'cordin' to me."

"Never mind, Sun-Down."

"Let 'er roll, Paint," said La Flare, be-ginning a new cigarette.

"He sais," interrupted Sun-Down, "dey was go 'long slowly, slowly—goin' tow-ard de villages—when one day dey was jump by Cheyenne. Dey went runnin' and fightin' till come night, un couldn't drive de herd rightly. Dey loss heap of horses, but as dey come onto divide, dey saw camp right in front of dem. It was 'mos' night, so four or five of hees fader's fader's men dey cut out a beeg bunch, un split hit off down a coulie. De Enjun foller de oder bunch, which ram right eento de village, whar de 'hole outfit went for fight lac hell. Paint's fader's fader she saw dees as she rode ober de hill. Dey was loss heap of men dat day by bein' kill un by run eento dose camp— lesewise none of dem ever show up no more. Well, den, Paint say dey was keep travellin' on up dees way—hit was tac heem d—— long story for geet hees fader's fader's outfit back here, wheech ees hall right, seein' he got 'em so far 'way for begin wid."

Then Paint continued his story:

"He sais de Sioux struck 'em one day, un dey was have hell of a fight—runnin' deir pony, shootin' deir arrow. One man he was try mount fresh horse, she stan' steel un buck, buck, buck, un dees man he was not able for geet on; de Sioux dey

come run, run, un dey kiell* heem. You see, when one man he catch fresh horse, he alway' stab hees played-out horse, 'cause he do not want eet for fall eento hand of de Enjun follerin'. Den White Bull's horse she run slow; he 'quirt' heem, but eet was do no good—ze horse was done; de Sioux dey was shoot de horse, un no one know whatever becom' of heem, but I dink he was kiell all right 'nough. Den 'noder man's horse she was stick hees foot in dog-hole, un de Sioux dey shoot las' man 'cept hees fader's fader. Den he was notice a beeg red horse what had alway' led de horse ban' since dey was stole. Dese Enjun had try for rope dees horse plenty times, but dey was never been able, but hees fader's fader was ride up to de head of de ban', un jus' happen for rope de red horse. He jump from hees pony to dees red horse jus' as Sioux was 'bout to run heem down. De big red horse was run—run lac† hell—ah! He was run, by Gar, un de Sioux dey was—aah!—de Sioux dey couldn't run wid de big red horse nohow.

"He was gone now half-year, un he deed not know where he find hees people. He was see coyote runnin' 'head, un he was say 'good medicin'.' He foller after leetle wolf—he was find two buffalo what was kiell by lightnin', what show coyote was good medicin'. He was give coyote some meat, un nex' day he was run on some Absarokee, who was tell him whar hees people was, wheech was show how good de coyote was. When he got camp de Enjun was terrible broke up, un dey had nevar before see red horse. All of deir horses was black, gray, spotted, roan, but none of dem was red—so dees horse was tac to de big medicin' in de medicin'-lodge, un he was paint up. He got be strong wid Absarokee, un hees fader's fader was loss horse because he was keep in medicin'-tepee, un look after by big medicin'-chiefs. Dey was give out eef he was loss eet would be bad, bad for Absarokee, un dey was watch out mighty close—by Gar, dey was watch all time dees red horse. When he go out for graze, t'ree warriors was hole hees rope un t'ree was sit on deir pony 'longside. No one was ride heem."

Then, talking alternately, the story came: "He sais de horse of de Absarokee was increase—plenty pony—un de mare he was all red colts; de big horse was strong.

De buffalo dey was come right to de camp—by Gar, de horse was good. De Sioux sent Peace Commission for try buy de horse—dey was do beesness for Enjun down whar de summer come from, what want for geet heem back—for he was a medicin'-horse. De Absarokee dey was not sell heem. Den a big band of de Ogalalas, Brulés, Minneconjous, Sans Arcs, Cheyennes, was come for tac de red horse, dey was kiell one village, but dare was one man 'scape, what was come to red horse, un de Absarokee dey was put de red paint on deir forehead. Ah! de Sioux dey was not get de red horse—dey was haf to go 'way. Den some time de beeg medicin'-horse was have hell of a trouble wid de bigges' medicin'-chief, right in de big medicin'-lodge. Dees word medicin' don't mean what de Enjun mean; de tent whar de sperets come for tell de people what for do, ees what dey mean; all same as Fader Lacomb he prance 'roun' when he not speak de French—dat's what dey mean. All right, he have dees trouble wid de head chief, un he keek heem een de head, un he kiell him dead. After dat he was get for be head medicin'-chief hisself, un he tole all de oder medicin'-chief what for do. He was once run 'way from de men what was hol' hees rope when he was graze—dey was scared out of deir life of heem eef dey was mak' heem mad, un he was go out een herd un kiell some horse. No one was dare go after heem. De medicin'-men dey was go out wid de big medicin'—dey was talk come back to heem; but he wouldn't come. Den de virgin woman of de tribe—she was kind of medicin'-man herself—she was go out un make a talk; she was tell red horse to go off—dat's de way for talk to people when deir minds not lac oder people's minds—un de horse she was let heem bring heem back. After dat all de Absarokee women had for behave preety well, or de medicin'-men kiell dem, 'cause dey say de medicin'-horse she was want de woman for be better in de tribe. Be d—— good t'ing eef dat horse she 'roun' here now."

"Oh, you reptile! will you never mind this thinking—it is fatal," I sighed.

"Well, anyhow, he sais de woman dey was have many pappoose, un de colts was red, un was not curly hair, un de 'yellow eyes'* was come wid de gun for trade skin. De buffalo she was stay late; de winter was mile; de enemy no steal de

* Kill. † Like. * White men.

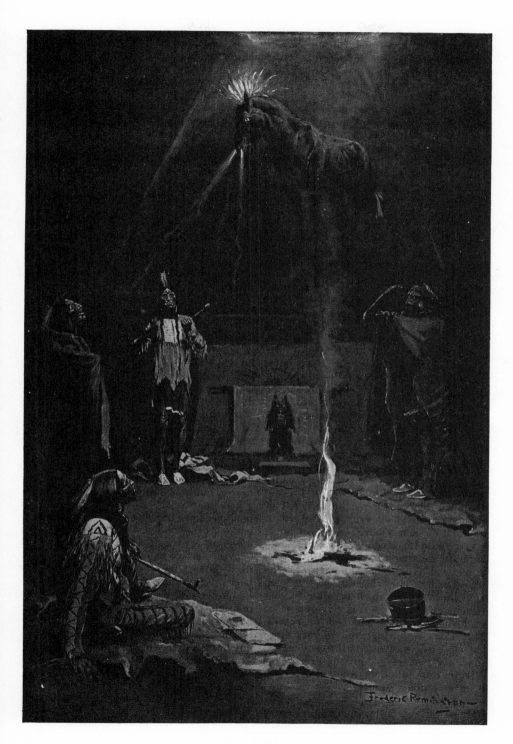

THE GOING OF THE MEDICINE-HORSE.

pony, un de Absarokee he tac heap scalp —all dese was medicin'-horse work. But in de moon een which de geese lay deir eggs de great horse he was rise up een de curl of de smoke of de big lodge—he was go plum' t'ro' de smoke-hole. De chief ask him for not go, but he was say he was go to fight de T'under-Bird. He say he would come back. Dey could keep his ghost. So he went 'way, un since den he has nevar come back no more. But Paint say lots of ole men use for see heem go t'ro' air wid de lightnin' comin' out of his nose, de T'under-Bird always runnin' out of hees way; he was always lick de t'under. Paint say dese Enjun have not see de medicin'-horse nowday; eef dey was see heem more, dey see no 'yellow eyes' een dees country. He sais he has seen de medicin'-horse once. He was hunt over een de mountain, but he was not have no luck; he was hungry, un was lay down by leetle fire een cañon. He was see de beeg medicin'-horse go 'long de ridge of de

hill 'gainst de moon—he was beeg lac de new school-house. Paint got up un talked loud to de horse, askin' heem eef he was nevar come back. De horse stop un sais —muffled, lac man talk t'ro' blanket— 'Yes, he was come back from speret-land, when he was bring de buffalo plenty; was roll de lan' over de white men; was fight de north wind. He sais he was come back when de Absarokee was not wear pants, was ride widout de saddle; when de women was on de square—un, by Gar, I t'ink he not come varrie soon."

"What does Paint say?"

"Ah, Paint he sais hit weel all come some day."

"Is that all?"

"Yes—dat ees all," said Sun-Down.

To be sure, there is quite as much Sun-Down in this as Paint—but if you would have more Paint, it will be necessary to acquire the Crow language, and then you might not find Paint's story just as I have told it.

32.
The
Trouble
Brothers

THE TROUBLE BROTHERS

BILL AND THE WOLF

BY FREDERIC REMINGTON

SADNESS comes when we think of how long ago things happened. Let us not bother ourselves about time, though we cannot cease to remember that it took youth to sit up all night in the club and ride all next day, or sleep twenty-four hours on a stretch, as the situation demanded. The scene, as I recall it, demanded exactly that. The ambulances of Fort Adobé brought a party of rank-ing military men, sundry persons of sub-stance, lesser mortals of much enthusiasm, and Colonel William Cody—the Great Unknown—up the long thirty miles of dusty plains from the railroad. The yel-low country in the autumn is dry riding and hard work. The officers stationed at the post took a brotherly interest in the new-comers because they were also sportsmen. You could not drive an iron wedge between the plains type of officer and a sportsman without killing both. There were dinners of custom and such a gathering at the club as was unusual, where the hunting plans were keenly discussed—so keenly, in fact, that it was nearer morning than midnight when it was considered desirable to go to bed.

There were dogs which the sportsmen had brought along—fierce wolf-hounds from Russia—and Buffalo Bill had two malignant pups in which he took a fine interest. The officers at Adobé were pos-sessed of a pack of rough Scotch hounds, besides which, if every individual soldier at the post did not have his individual doggie, I must have made a miscount. It was arranged that we consolidate the col-lection and run a wolf on the morrow.

When sport was in prospect, *reveille* was the usual hour, regardless of bed-time. Morning found us all mounted, and the throng of horses started up the road. The dogs were kept together; the morning was of the golden, frosty Adobé type, and the horses could feel the run which was coming to them.

Everything was ready but the wolf. It was easy to find wolves in that country, however. We had slow dogs to trail them with. But our wolf came to us in the way money comes to a modern politician.

Bill, the chief of sports, as we called him, was riding ahead, when we saw him stop a wagon. It was driven by an old "prairie-dog,"* and on the bed of the wagon was a box made of poles and slats. Inside of this was a big gray wolf, which the man had caught in a trap without in-juring it in the least. He hoped to be able to sell it at the post, but he realized his hope and his price right there. "Now, boys, we'll have a wolf-hunt; but let us go back to the post, where the ladies and the men can see it."

* Nondescript man of the plains.

"THIS IS THE WAY IT BEGAN."

We could not agree whether it was the colonel's gallantry or his circus habits which prompted this move, but it was the thing which brought a blighting sorrow to Fort Adobé. We turned back, bundling Mr. Wolf down the road. He sat behind the slats, gazing far away across his native hills, silent and dignified as an Indian warrior in captivity.

The ladies were notified, and came out in traps. The soldiers joined us on horseback and on foot, some hundred of them, each with his pet *fice** at his heels.

The domestic servants of the line came down back of the stables. The sentries on post even walked sidewise, that they might miss no details. Adobé was out for a race. I had never supposed there were so many dogs in the world. As pent-up canine animosities displayed themselves, they fell to taking bites at each other in the dense gathering; but their owners policed and soothed them.

Every one lined up. The dogs were arranged as best might. The wagon was driven well out in front, and Colonel William Cody helped the driver to turn the wolf loose, a matter which gave no trouble at all. They removed two slats, and if there had been a charge of melinite behind that wolf he could not have hit that valley any harder.

The old hounds, which had scented and had seen the wolf, straightway started on his course. With a wild yell the cavalcade sprang forward. Many curdogs were ridden screaming under foot. The two bronco ponies of the man who had brought the wolf turned before the rush and were borne along with the charge. Everything was going smoothly.

Of the garrison curs many were left behind. They knew nothing about wolves or field-sports, but, addled by the excitement, fell into the old garrison feuds.

At a ravine we were checked. I looked behind, and the intervening half-mile was dotted here and there with dog-fights of various proportions. Some places there were as high as ten in a bunch, and at others only couples. The infantry soldiers came running out to separate them, and, to my infinite surprise, I saw several of the dough-boys circling each other in the well-known attitudes of the prizering. Officers started back to pull them apart. Our dogs were highly excited. Two of them flew at each other; more

* Cur-dog.

sprang into the jangle. The men yelled at them and got off their horses. One man kicked another man's dog, whereat the aggrieved party promptly swatted him on the eye. This is the way it began. While you read, over a hundred and fifty men were pounding each other with virility, while around and underfoot fought each doggie with all possible vim. Greyhounds cut red slices on quarter-bred bulls; fox-terriers hung on to the hind legs of such big dogs as were fully engaged in front. Fangs glistened; they yelled and bawled and growled, while over them struggled and tripped the men as they swung for the knock-out blow. If a man went down he was covered with biting and tearing dogs. The carnage became awful—a variegated foreground was becoming rapidly red. The officers yelled at the men, trying to assert their authority, but no officer could yell as loud as the acre of dogs. By this time the men were so frenzied that they could not tell a shoulder-strap from a bale of hay. One might as well have attempted to stop the battle of Gettysburg.

Naturally this could not last forever, and gradually the men were torn apart and the dogs unhooked their fangs from their adversaries. During the war I looked toward the fort, hoping for some relief, but the half-mile was dotted here and there with individuals thumping and pounding each other, while their dogs fought at their heels. Where, where had I seen this before, thought came. Yes, yes —in Cæsar's Commentaries. They did things just this way in his time. Bare legs and short swords only were needed here.

Things gradually quieted, and the men started slowly back to the post nursing their wounds. Most of the horses had run away during the engagement. It was clear to be seen that plaster and liniment would run short at Adobé that day.

Colonel Cody sat on his horse, thinking of the destruction he had wrought.

The commanding officer gathered himself and sang out: "Say, Bill, there is your doggoned old wolf sitting there on the hill looking at you. What do you reckon he thinks?"

"I reckon he thinks we have made trouble enough for to-day. Next time we go hunting, colonel, I think you had better leave your warriors at home," was Bill's last comment as he turned his horse's tail toward the wolf.

33.
When a
Document is
Official

WHEN A DOCUMENT IS OFFICIAL.

BY FREDERIC REMINGTON.

WILLIAM or "Billy" Burling had for these last four years worn three yellow stripes on his coat sleeve with credit to the insignia. Leading up to this distinction were two years when he had only worn two, and back of that were yet other annums when his blue blouse had been severely plain except for five brass buttons down the front. This matter was of no consequence in all the world to any one except Burling, but the nine freezing, grilling, famishing years which he had so successfully contributed to the cavalry service of the United States were the "clean-up" of his assets. He had gained distinction in several pounding finishes with the Indians; he was liked in barracks and respected on the line; and he had wrestled so sturdily with the books that when his name came up for promotion to an officer's commission he had passed the examinations. On the very morning of which I speak, a lieutenant of his company had quietly said to him: "You need not say anything about it, but I heard this morning that your commission had been signed and is now on the way from Washington. I want to congratulate you."

"Thank you," replied William Burling as the officer passed on. The sergeant sat down on his bunk and said, mentally, "It was a damn long time coming."

There is nothing so strong in human nature as the observance of custom, especially when all humanity practises it, and the best men in America and Europe, living or dead, have approved of this one. It has, in cases like the sergeant's, been called "wetting a new commission." I suppose in Mohammedan Asia they buy a new wife. Something outrageous must be done when a military man celebrates his "step"; but be that as it may, William Burling was oppressed by a desire to blow off steam. Here is where the four years of the three stripes stood by this hesitating mortal and overpowered the exposed human nature. Discipline had nearly throttled custom, and before this last could catch its breath again the or-

derly came in to tell Burling that the colonel wanted him up at headquarters.

It was early winter at Fort Adobe, and the lonely plains were white with a new snow. It certainly looked lonely enough out beyond the last buildings, but in those days one could not trust the plains to be as lonely as they looked. Mr. Sitting-Bull or Mr. Crazy-Horse might pop out of any *coulee* with a goodly following, and then life would not be worth living for a wayfarer. Some of these high-flavored romanticists had but lately removed the hair from sundry buffalo-hunters in Adobe's vicinity, and troops were out in the field trying to "kill, capture, or destroy" them, according to the ancient and honorable form. All this was well known to Sergeant Burling when he stiffened up before the colonel.

"Sergeant, all my scouts are out with the commands, and I am short of officers in post. I have an order here for Captain Morestead, whom I suppose to be at the juncture of Old Womans Fork and Lightning Creek, and I want you to deliver it. You can easily find their trail. The order is important, and must go through. How many men do you want?"

Burling had not put in nine years on the plains without knowing a scout's answer to that question. "Colonel, I prefer to go alone." There was yet another reason than "he travels the fastest who travels alone" in Burling's mind. He knew it would be a very desirable thing if he could take that new commission into the officers' mess with the prestige of soldierly devotion upon it. Then, too, nothing short of twenty-five men could hope to stand off a band of Indians.

Burling had flipped a mental coin. It came down heads for him, for the colonel said: "All right, sergeant. Dress warm and travel nights. There is a moon. Destroy that order if you have bad luck. Understand?"

"Very well, sir," and he took the order from the colonel's hand.

The old man noticed the figure of the young cavalryman, and felt proud to command such a man. He knew Burling was

an officer, and he thought he knew that Burling did not know it. He did not like to send him out in such weather through such a country, but needs must.

As a man Burling was at the ripe age of thirty, which is the middle distance of usefulness for one who rides a government horse. He was a light man, trim in his figure, quiet in manner, serious in mind. His nose, eyes, and mouth denoted strong character, and also that there had been little laughter in his life. He had a mustache, and beyond this nothing can be said, because cavalrymen are primitive men, weighing no more than one hundred and sixty pounds. The horse is responsible for this, because he cannot carry more, and that weight even then must be pretty much on the same ancient lines. You never see long, short, or odd curves on top of a cavalry horse — not with nine years of field service.

Marching down to the stables, he gave his good bay horse quite as many oats as were good for him. Then going to his quarters, he dressed himself warmly in buffalo coat, buffalo moccasins, fur cap and gloves, and he made one saddle pocket bulge with coffee, sugar, crackers, and bacon, intending to fill the opposite side with grain for his horse. Borrowing an extra six-shooter from Sergeant McAvoy, he returned to the stables and saddled up. He felt all over his person for a place to put the precious order, but the regulations are dead set against pockets in soldiers' clothes. He concluded that the upper side of the saddle-bags, where the extra horseshoes go, was a fit place. Strapping it down, he mounted, waved his hand at the fellow-soldiers, and trotted off up the road.

It was getting toward evening, there was a fine brisk air, and his horse was going strong and free. There was no danger until he passed the Frenchman's ranch where the buffalo-hunters lived; and he had timed to leave there after dark and be well out before the moon should discover him to any Indians who might be viewing that log house with little schemes of murder in expectance.

He got there in the failing light, and tying his horse to the rail in front of the long log house, he entered the big room where the buffalo-hunters ate, drank, and exchanged the results of their hard labor with each other as the pasteboards should indicate. There were about fifteen men in the room, some inviting the bar, but mostly at various tables guessing at cards. The room was hot, full of tobacco smoke and many democratic smells, while the voices of the men were as hard as the pounding of two boards together. What they said, for the most part, can never be put in your library, neither would it interest if it was. Men with the bark on do not say things in their lighter moods which go for much; but when these were behind a sage-bush handling a Sharps, or skinning among the tailing buffaloes on a strong pony, what grunts were got out of them had meaning!

Buffalo-hunters were men of iron endeavor for gain. They were adventurers; they were not nice. Three buckets of blood was four dollars to them. They had thews, strong-smelling bodies, and eager minds. Life was red on the buffalo-range in its day. There was an intellectual life—a scientific turn—but it related to flying lead, wolfish knowledge of animals, and methods of hide-stripping.

The sergeant knew many of them, and was greeted accordingly. He was feeling well. The new commission, the dangerous errand, the fine air, and the ride had set his blood bounding through a healthy frame. A young man with an increased heart action is going to do something besides standing on one foot leaning against a wall: nature arranged that long ago.

Without saying what he meant, which was "let us wet the new commission," he sang out: "Have a drink on the army. Kem up, all you hide-jerkers," and they rallied around the young soldier and "wet." He talked with them a few minutes, and then stepped out into the air—partly to look at his horse, and partly to escape the encores which were sure to follow. The horse stood quietly. Instinctively he started to unbuckle the saddle pocket. He wanted to see how the "official document" was riding, that being the only thing that oppressed Burling's mind. But the pocket was unbuckled, and a glance showed that the paper was gone.

His bowels were in tremolo. His heart lost three beats; and then, as though to adjust matters, it sent a gust of blood into his head. He pawed at his saddle-bags; he unbuttoned his coat and searched with nervous fingers everywhere through his clothes; and then he stood still, looking with fixed eyes at the nigh front foot of the cavalry horse. He did not stand mooning long; but he thought

through those nine years, every day of them, every minute of them; he thought of the disgrace both at home and in the army; he thought of the lost commission, which would only go back the same route it came. He took off his overcoat and threw it across the saddle. He untied his horse and threw the loose rein over a post. He tugged at a big sheath-knife until it came from the back side of his belt to the front side, then he drew two big army revolvers and looked at the cylinders—they were full of gray lead. He cocked both, laid them across his left arm, and stepped quickly to the door of the Frenchman's log house. As he backed into the room he turned the key in the lock and put it under his belt. Raising the revolvers breast-high in front of him, he shouted, "Attention!" after the loud, harsh habit of the army. An officer might talk to a battalion on parade that way.

No one had paid any attention to him as he entered. They had not noticed him, in the preoccupation of the room, but every one quickly turned at the strange word.

"Throw up your hands instantly, every man in the room!" and with added vigor, "Don't move!"

Slowly, in a surprised way, each man began to elevate his hands—some more slowly than others. In settled communities this order would make men act like a covey of quail, but at that time at Fort Adobe the six-shooter was understood both in theory and in practice.

"You there, bartender, be quick! I'm watching you." And the bartender exalted his hands like a practised saint.

"Now, gentlemen," began the soldier, "the first man that bats an eye or twitches a finger or moves a boot in this room will get shot just that second. Sabe?"

"What's the matter, Mr. Soldier? Be you *loco?*" sang out one.

"No, I am not *loco.* I'll tell you why I am not." Turning one gun slightly to the left, he went on: "You fellow with the long red hair over there, you sit still if you are not hunting for what's in this gun. I rode up to this shack, tied my horse outside the door, came in here, and bought the drinks. While I was in here some one stepped out and stole a paper—official document—from my saddle pockets, and unless that paper is returned to me, I am going to turn both of these

guns loose on this crowd. I know you will kill me, but unless I get the paper I want to be killed. So, gentlemen, you keep your hands up. You can talk it over; but remember, if that paper is not handed me in a few minutes, I shall begin to shoot." Thus having delivered himself, the sergeant stood by the door with his guns levelled. A hum of voices filled the room.

"The soldier is right," said some one.

"Don't point that gun at me; I hain't got any paper, pardner. I can't even read paper, pard. Take it off; you might git narvous."

"That sojer's out fer blood. Don't hold his paper out on him."

"Yes, give him the paper," answered others. "The man what took that paper wants to fork it over. This soldier means business. Be quick."

"Who's got the paper?" sang a dozen voices. The bartender expostulated with the determined man—argued a mistake—but from the compressed lips of desperation came the word "Remember!"

From a near table a big man with a gray beard said: "Sergeant, I am going to stand up and make a speech. Don't shoot. I am with you." And he rose quietly, keeping an inquisitive eye on the Burling guns, and began:

"This soldier is going to kill a bunch of people here; any one can see that. That paper ain't of no account. What ever did any fool want to steal it for? I have been a soldier myself, and I know what an officer's paper means to a de-spatch-bearer. Now, men, I say, after we get through with this mess, what men is alive ought to take the doggone paper-thief, stake the feller out, and build a slow fire on him, if he can be ridden down. If the man what took the paper will hand it up, we all agree not to do anything about it. Is that agreed?"

"Yes, yes, that's agreed," sang the chorus.

"Say, boss, can't I put my arms down?" asked a man who had become weary.

"If you do, it will be forever," came the simple reply.

Said one man, who had assembled his logistics: "There was some stompin' around yar after we had that drink on the sojer. Whoever went out that door is the feller what got yer document; and ef he'd a-tooken yer horse, I wouldn't think much—I'd be lookin' fer that play,

"NO, I AM NOT LOCO."

stranger. But to go *cincha* a piece of paper! Well, I think you must be plumb *loco* to shoot up a lot of men like we be fer that yar."

"Say," remarked a natural observer—one of those minds which would in other places have been a head waiter or some other highly sensitive plant—"I reckon that Injun over thar went out of this room. I seen him go out."

A little French half-breed on Burling's right said, "Maybe as you keel de man what 'ave 'and you de papier—hey?"

"No, on my word I will not," was the promise, and with that the half-breed continued: "Well, de papier ees een ma pocket. Don't shoot."

The sergeant walked over to the abomination of a man, and putting one pistol to his left ear, said, "Give it up to me with one fist only—mind, now!" But the half-breed had no need to be admonished, and he handed the paper to Burling, who gathered it into the grip of his pistol hand, crushing it against the butt.

Sidling to the door, the soldier said, "Now I am going out, and I will shoot any one who follows me." He returned one gun to its holster, and while covering the crowd, fumbled for the key-hole, which he found. He backed out into the night, keeping one gun at the crack of the door until the last, when with a quick spring he dodged to the right, slamming the door.

The room was filled with a thunderous roar, and a dozen balls crashed through the door.

He untied his horse, mounted quickly with the overcoat underneath him, and galloped away. The hoof-beats reassured the buffalo-hunters; they ran outside and blazed and popped away at the fast-receding horseman, but to no purpose. Then there was a scurrying for ponies, and a pursuit was instituted, but the grain-fed cavalry horse was soon lost in the darkness. And this was the real end of Sergeant William Burling.

The buffalo-hunters followed the trail next day. All night long galloped and trotted the trooper over the crunching snow, and there was no sound except when the moon-stricken wolves barked at his horse from the gray distance.

The sergeant thought of the recent occurrence. The reaction weakened him. His face flushed with disgrace; but he knew the commission was safe, and did not worry about the vengeance of the buffalo-hunters, which was sure to come.

At daylight he rested in a thick timbered bottom, near a cut bank, which in plains strategy was a proper place to make a fight. He fed himself and his horse, and tried to straighten and smooth the crumpled order on his knee, and wondered if the people at Adobe would hear of the unfortunate occurrence. His mind troubled him as he sat gazing at the official envelope; he was in a brown study. He could not get the little sleep he needed, even after three hours' halt. Being thus preoccupied, he did not notice that his picketed horse from time to time raised his head and pricked his ears toward his back track. But finally, with a start and a loud snort, the horse stood eagerly watching the bushes across the little opening through which he had come.

Burling got on his feet, and untying his lariat, led his horse directly under the cut bank in some thick brush. As he was in the act of crawling up the bank to have a look at the flat plains beyond, a couple of rifles cracked and a ball passed through the soldier's hips. He dropped and rolled down the bank, and then dragged himself into the brush.

From all sides apparently came Indians' "Ki-yis," and "coyote yelps." The cavalry horse trembled and stood snorting, but did not know which way to run. A great silence settled over the snow, lasting for minutes. The Sioux crawled closer, and presently saw a bright little flare of fire from the courier's position, and they poured in their bullets, and again there was quiet. This the buffalo-hunters knew later by the "sign" on the trail. To an old hunter there is no book so plain to read as footprints in the snow.

And long afterwards, in telling about it, an old Indian declared to me that when they reached the dead body they found the ashes of some paper which the soldier had burned, and which had revealed his position. "Was it his medicine which had gone back on him?"

"No," I explained, "it wasn't his medicine, but the great medicine of the white man, which bothered the soldier so."

"Hump! The great Washington medicine maybeso. It make dam fool of soldiers lots of time I know 'bout," concluded "Bear-in-the-Night," as he hitched up his blanket around his waist.

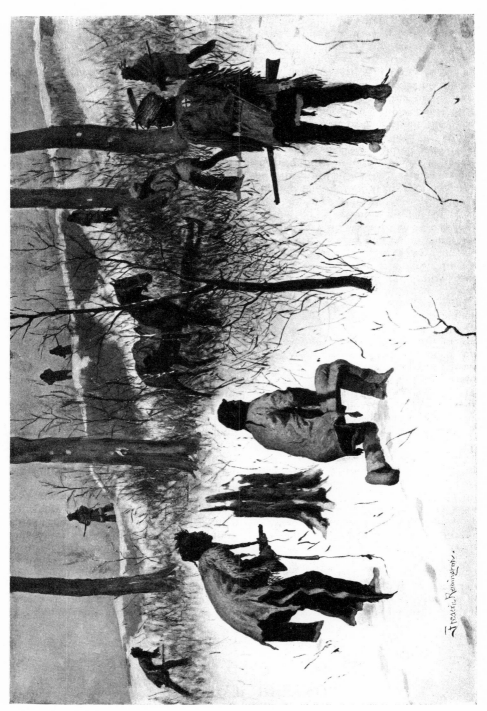

"THE BUFFALO-HUNTERS KNEW BY THE 'SIGN' ON THE TRAIL."

34.
The
Sorrows of
Don Tomas Pidal
Reconcentrado

THE SORROWS OF DON TOMAS PIDAL, RECONCENTRADO.

BY FREDERIC REMINGTON.

I WAS driving lately with the great Cuban "war special" Sylvester Scovel along a sun-blazoned road in the Havana province, outside of Marnion: we were away beyond the patrols of the Seventh Corps. The native soldiers pattered along the road on their ratlike ponies. To them Scovel was more than a friend: he was a friend of the great chief Gomez, and that is more than enough for a Cuban.

He pointed to a ditch and to a hill, saying he had been in fights in those places—back in Maceo's time; hot little skirmishes, with no chance to put your hat on your sword. But he had always managed to get away from the Spanish; and so had Maceo—all but the one time.

Beside the road there were fine old mansions — stuccoed brick, with open windows, and with the roofs fallen in. The rank tropic vegetation was fast growing up around them, even now choking the doorways and gravel walks. And the people who lived in them? God knows!

The day grew into noon. We were hungry, and the ardent sun suggested stopping at a village which we were passing through. There was a fonda, so we got down from our carriage, and going in, sat down at a table in a little side room.

One is careful about the water in Cuba, and by no chance can a dirty cook get his hands on a boiled egg. We ordered coffee and eggs. A rural Cuban fonda is very close to the earth.

Through the open window could be seen the life of the village—men sitting at tables across the way, drinking, smoking, and lazing about. It was Sunday. Little children came to the window and opened their eyes at us, and we pitied their pale anæmic faces and little puffed bellies, for that terrible order of Weyler's had been particularly hard on children. There were men hanging about who looked equally hollow, but very few women.

"Reconcentrados — poor devils," observed my friend.

This harmless peasantry had suffered all that people could suffer. To look at them and to think of them was absolutely saddening. Still, the mass of suffering which they represented also deadened one's sensibilities somewhat, and for an ordinary man to put out his hand in help seemed a thing of no importance.

"I should like to know the personal experiences of one individual of this fallen people, Scovel. I can rise to one man, but two or three hundred thousand people is too big for me."

"All right," replied the alert "special." "We will take that Spanish-looking man over there by the cart. He has been starved, and he is a good type of a Cuban peasant." By the arts of the finished interviewer, Scovel soon had the man sitting at our table, with brandy and water before him. The man's eyes were like live coals, which is the most curious manifestation of starvation. His forehead was wrinkled, the eyebrows drawn up in the middle. He had the greenish pallor which comes when the blood is thin behind a dark coarse skin. He did not seem afraid of us, but behind the listlessness of a low physical condition there was the quick occasional movement of a wild animal.

"Reconcentrado?"

"Si, señor. I have suffered beyond counting."

"We are Americans; we sympathize with you; tell us the story of all you have suffered. Your name? Oh! Don Tomas Pidal, will you talk to us?"

"It will be nearly three rains since the King's soldiers burned the thatch over my head and the cavalry shoved us down the road like the beasts.

"I do not know what I shall do. I may yet die—it is a small affair. Everything which I had is now gone. The Americans have come to us; but they should have come long before. At this time we are not worth coming to. Nothing is left but the land, and that the Spaniards could not kill. Señor, they of a surety would have burnt it, but that is to them impossible."

"Are you not a Spaniard by birth?"

"No; my father and mother came from over the sea, but I was born in

sight of this town. I have always lived here, and I have been happy,•until the war came. We did not know what the war was like. We used to hear of it years ago, but it was far to the east. The war never came to Punta Brava. We thought it never would; but it did come; and now you cannot see a thatch house or an ox, and you have to gaze hard to see any people in this country about here. That is what war does, señor, and we people here did not want war.

"Some of the valiant men who used to dwell around Punta Brava took their guns and the machete of war, and they ran away into the manigua. They used to talk in the fonda very loud, and they said they would not leave a Spaniard alive on the island. Of a truth, señor, many of those bravos have gone, they have taken many Spaniards with them to death, and between them both the people who worked in the fields died of the hunger. They ate the oxen, they burned the thatch, and the fields are grown up with bushes. There is not a dog in Punta Brava to-day.

"When the bravos ran away, the King's soldiers came into this land in numbers as great as the flies. This village sheltered many of them—many of the battalion San Quintin—and that is why the houses are not flat with the ground."

"Why did you not go out into the manigua, Don Pidal?" was asked.

"Oh, señores, I am not brave. I never talked loud in the fonda. Besides, I had a wife and five children. I lived perfectly. I had a good house of the palm. I had ten cows of fine milk and two yokes of heavy work-oxen. There were ten pigs on my land, and two hundred chickens laid eggs for me. By the sale of these and my fruit I got money. When I killed a pig to sell in Havana, it was thirty dollars. When I did not choose to sell, we had lard in the house for a month, and I had not to buy. Two of my boys, of fourteen and sixteen years, aided me in my work. We bred the beasts, planted tobacco, corn, sweet-potatoes, and plantains, and I had a field of the pineapples, besides many strong mango-trees. Could a man want for what I did not have? We ate twice a day, and even three times. We could have eaten all day if we had so desired.

"Then, señor, the tax-gatherers never suspected that I had fourteen hundred dollars in silver buried under the floor of my house. We could work as much as we pleased, or as little; but we worked, señor—all the men you see sitting about Punta Brava to-day worked before the war came; not for wages, but for the shame of not doing so. When the yokes were taken from the cattle at night and the fodder was thrown to them, we could divert ourselves. The young men put on their 'guayaberas,'* threw their saddles on their 'caballitos,'† and marched to the girls, where they danced and sang and made love. To get married it was only for the young man to have seventy dollars; the girl had to have only virtue. There was also to go to town to buy, and then the feast-days and the Sunday nights. There was always the work—every day the same, except in the time of tobacco; then we worked into the night. In the house the women washed, they cooked, they looked after the pigs and the chickens, they had the children, and in the time of the tobacco they also went forth into the fields.

"It was easy for any man to have money, if he did not put down much on the fighting-cocks. The Church cost much; there was the *cura*, the *sacristan*—many things to pay away the money for; but even if the goods from Spain did cost a great sum, because the officers of the King made many collections on them, even if the taxes on the land and the annuals were heavy, yet, señor, was it not better to pay all than to have the soldiers come? Ah me, amigo, of all things the worst are the King's soldiers. It was whispered that the soldiers of your people were bad men. It was said that if they ever came to Punta Brava we should all die; but it is not so. Your soldiers do not live in other people's houses. They are all by themselves in tents up the King's road, and they leave us alone. They do nothing but bring us food in their big wagons. They lied about your soldiers. It was the talk in this country, señor, that the great people in the free States of the North wanted to come to us and drive the King's soldiers out of the country, but it was said that your people quarrelled among themselves about coming. The great general who lived in Havana was said to be a friend to all of us, but he did not have the blue

* Fine shirts. † Little horses.

"THIS WAS THE FIRST I FELT OF WAR."

soldiers then. He is down the King's road now—I saw him the other day—and a man cannot see over the land far enough to come to the end of his tents.

"If they had been there one day the King's soldiers would not have come through my land and cut my boy to pieces in my own field. They did that, señor—cut him with the machetes until he was all over red, and they took many canastas of my fruits away. I went to the comandante to see what should be done, but he knew nothing about it.

"Then shortly a column of troops came marching by my house, and the officer said by word of mouth that we must all go to town, so that there would be none but rebels in the country. They burned my house and drove all my beasts away—all but one yoke of oxen. I gathered up some of my chickens and what little I could find about the place and put it on a cart, but I could not get my money from the burning house, because they drove us away. This was the first I felt of war.

"I thought that the King would give us food, now that he had taken us from our fields, but we got nothing from the King's officers. I could even then have lived on the outside of the town, with my chickens and what I could have raised, but it was only a short time before the soldiers of the battalion took even my chickens, and they made me move inside of a wire fence which ran from one stone fort to another. I tried to get a pass to go outside of the wire fence, and for a few weeks I was used to go and gather what potatoes I could find, but so many men were cut to pieces by the guerillas as they were coming from the fields that I no longer dared go out by day.

"We had a little thatch over our heads, but it did not keep out the rain. We became weak with the hunger. We lived in sorrow and with empty bellies. My two young children soon died, and about me many of my friends were dying like dogs. The ox-cart came in the afternoon, and they threw my two children into it like carrion. In that cart, señor, were twenty-two other dead people. It was terrible. My wife never dried her tears after that. If I had five dollars I could have gotten a box, but I did not have it. The priest would not go for less than double the price of the box, which is the custom. So my two little ones went to Guatoco on an ox-cart loaded with dead like garbage—which the Spanish comandante said we were.

"Now came the hard days, señor. Not even a dog could pick up enough in Punta Brava to keep life in his ribs. My people lay on the floor of our thatch hut, and they had not the strength to warm water in the kettle. My other child died, and again the ox-cart came. My oldest boy said he was going away and would not return. He got through the wire fence in the dark of the night, and I went with him. We got a small bunch of bananas, and in the black night out there in the manigua we embraced each other, and he went away into the country. I have not seen him since; I no longer look for him.

"Only the strongest could live, but I had hopes that by going through the fence every few nights I could keep my wife alive. This I did many times, and came back safely; but I was as careful as a cat, señor, as I crawled through the grass, for if a soldier had shot me, my wife would then have but to die. It was hard work to gather the fruit and nuts in the night, and I could not get at all times enough. My wife grew weaker, and I began to despair of saving her. One night I stole some food in a soldier's kettle from near a mess fire, and the men of the battalion fired many shots at me, but without doing me injury. Once a Spanish guerilla, whom I had known before the war came, gave me a piece of fresh beef, which I fed to my wife. I thought to save her with the beef, but she died that night in agony. There was no flesh on her bones.

"Then I ran away through the wire fence. I could not see my wife thrown on the dead wagon, and I never came back until a few days since. I did not care if the guerillas found me. I made my way into Havana, and I got bread from the doorways at times, enough to keep me alive. There was a little work for wages along the docks, but I was not strong to do much. One night I looked between iron bars at some people of your language, señor. They were sitting at a table which was covered with food, and when they saw me they gave me much bread, thrusting it out between the bars. A Spaniard would not do that.

"I was not born in a town, and when the King's soldiers sailed away I came back here to my own country. I did not like to live in Havana.

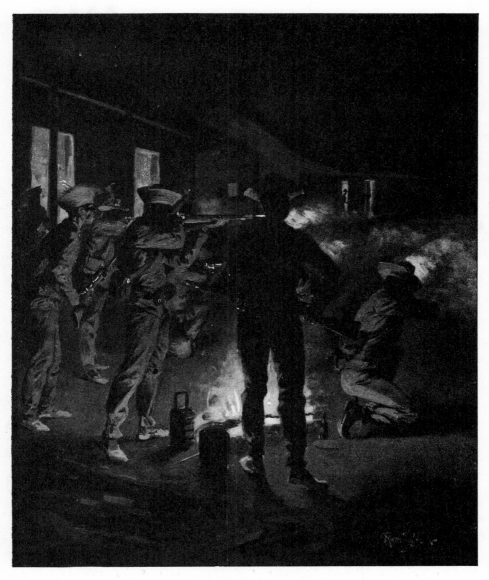

"AND THE SOLDIERS FIRED MANY SHOTS AT ME."

"But now I do not care to live here. I do not see, señor, why people who do not want war should have it. I would have paid my taxes. I did not care if the goods from Spain cost much. There was to get along without them if they were beyond price. It was said by the soldiers that we peasants out in the fields told the men of the manigua what the battalion San Quintin were doing. Señor, the battalion San Quintin did nothing but eat and sleep in Punta Brava. The guerillas roamed about, but I never knew whence they roamed.

"The men of the manigua took my potatoes and my plantains, but, with their guns and machetes, could I make them not to take them? Was it my fault if fifty armed men did what pleased them?

"Señor, why did not the blue soldiers of your language come to us before we died?"

This we were not able to answer.

35.
The
Honor
of the Troop

THE HONOR OF THE TROOP.

BY FREDERIC REMINGTON.

L TROOP in a volunteer regiment might be an unadulterated fighting outfit, but at first off, to volunteers, it would not be the letter L which they would fight for, so much as the mere sake of fighting, and they would never regard the letter L as of more importance than human life. Indeed, that letter would not signify to them any more than the "second set of fours," or the regimental bass drum. Later on it certainly would, but that would take a long time. In the instance of the L Troop of which I speak, it had nearly one hundred years to think about, when any one in the troop cared to think about the matter at all. They were honorable years, and some of the best men living or dead have at one time or another followed that guidon. It had been through the "rifle" and "dragoon" periods of our history, and was now part of the regular cavalry establishment, and its operations had extended from Lake Erie to the city of Mexico.

Long lists of names were on its old rolls—men long since dead, but men who in the snow and on the red sands had laid down all they had for the honor of L Troop guidon. Soldiers—by which is meant the real long‑service military type—take the government very much as a matter of course; but the number of the regiment, and particularly the letter of their troop, are tangible, comparative things with which they are living every day. The feeling is precisely that one has for the Alma Mater, or for the business standing of an old commercial house.

The "old man" had been captain of L for years and years, and for thirty years its first sergeant had seen its rank and file fill up and disappear. Every tenth man was a "buck" soldier, who thought it only a personal matter if he painted a frontier town up after pay-day, but who would follow L Troop guidon to hell, or thump any one's nose in the garrison foolish enough to take L in vain, and I fear they would go farther than this— yes, even farther than men ought to go. Thus the "rookies" who came under the spell of L Troop succumbed to this veneration through either conventional decorum or the "mailed fist."

In this instance L Troop had been threading the chaparral by night and by day on what rations might chance, in hopes to capture for the honor of the troop sundry greasers, outlawed and defiant of the fulminations of the civil order of things. Other troops of the regiment also were desirous of the same thing, and were threading the desolate wastes far on either side. Naturally L did not want any other troop to round up more "game" than they did, so then horses were ridden thin, and the men's tempers were soured by the heat, dust, poor diet, and lack of success.

The captain was an ancient veteran, gray and rheumatic, near his retirement, and twenty‑five years in his grade, thanks to the silly demagogues so numerous in Congress. He had been shot full of holes, bucketed about on a horse, immured in mud huts, frozen and baked and soaked until he should have long since had rank enough to get a desk and a bed or retirement. Now he was chasing human fleas through a jungle—boys'

409

work—and it was admitted in ranks that the "old man" was about ready to "throw a curb." The men liked him, even sympathized with him, but there was that d—— G Troop in the barrack next, and they would give them the merry ha-ha when they returned to the post if L did not do something.

And at noon—mind you, high noon—the captain raised his right hand ; up came the heads of the horses, and L Troop stood still in the road. Pedro, the Mexican trailer, pointed to the ground and said, "It's not an hour old," meaning the trail.

"Dismount," came the sharp order.

Toppling from their horses, the men stood about, but the individuals displayed no noticeable emotion ; they did what L Troop did. One could not imagine their thoughts by looking at their red set faces.

They rested quietly for a time in the scant shade of the bare tangle, and then they sat up and listened, each man looking back up the road. They could hear a horse coming, which meant much to people such as these.

The men "thrown to the rear" would come first or "fire a shot," but with a slow pattering came a cavalry courier into view—a dusty soldier on a tired horse, which stepped stiffly along, head down, and if it were not for the dull kicking of the inert man, he would have stopped anywhere. The courier had ridden all night from the railroad, seventy-five miles away. He dismounted and unstrapped his saddle pocket, taking therefrom a bundle of letters and a bottle, which he handed to the "old man" with a salute.

The captain now had a dog-tent set up for himself, retiring into it with his letters and the bottle. If you had been there you would have seen a faint ironical smile circulate round the faces of L Troop.

A smart lieutenant, beautifully fashioned for the mounted service, and dressed in field uniform, with its touches of the "border" on the "regulations," stepped up to the dog-tent, and stooping over, saluted, saying, "I will run this trail for a few miles if the captain will give me a few men."

"You will run nothing. Do you not see that I am reading my mail? You will retire until I direct you—"

The lieutenant straightened up with a snap of his lithe form. His eyes twinkled merrily. He was aware of the mail, he realized the bottle, and he had not been making strategic maps of the captain's vagaries for four years to no purpose at all ; so he said, "Yes, sir," as he stepped out of the fire of future displeasure.

But he got himself straightway into the saddle of a horse as nearly thoroughbred as himself, and riding down the line, he spoke at length with the old first sergeant. Then he rode off into the brush. Presently six men whose horses were "fit" followed after him, and they all trotted along a trail which bore back of the captain's tent, and shortly they came back into the road. He had arranged so as to avoid another explosion from the "old man."

Then Pedro Zacatin ran the trail of three ponies—no easy matter through the maze of cattle paths, with the wind blowing the dust into the hoof-marks. He only balked at a turn, more to see that the three did not "split out" than at fault of his own. In an opening he stopped, and pointing, said in the harsh gutturals which were partly derived from an Indian mother, and partly from excessive cigarette-smoking: "They have stopped and made a fire. Do you see the smoke? You will get them now if they do not get away."

The lieutenant softly pulled his revolver, and raising it over his head, looked behind. The six soldiers opened their eyes wide like babies, and yanked out their guns. They raised up their horses' heads, pressed in the spurs, and as though at exercise in the riding-hall, the seven horses broke into a gallop. Pedro staid behind ; he had no further interest in L Troop than he had already displayed.

With a clattering rush the little group bore fast on the curling wreath of the camp fire. Three white figures dived into the labyrinth of thicket, and three ponies tugged hard at their lariats; two shots rang, one from the officer's revolver, one from a corporal's carbine, and a bugler-boy threw a brass trumpet at the fleeting forms.

"Ride 'em down! ride 'em down!" sang out the officer, as through the swishing brush bounded the aroused horses, while the bullets swarmed on ahead.

It was over as I write, and in two minutes the three bandits were led back into the path, their dark faces blanched.

The lieutenant wiped a little stain of blood from his face with a very dirty

"THE THREE BANDITS WERE LED BACK INTO THE PATH."

pocket-handkerchief, a mere swish from a bush; the corporal looked wofully at a shirt sleeve torn half off by the thorns, and the trumpeter hunted up his instrument, while a buck soldier observed, "De 'old man' ull be hotter'n chilli 'bout dis."

The noble six looked at the ignoble three half scornfully, half curiously, after the manner of men at a raffle when they are guessing the weight of the pig.

"Tie them up, corporal," said the lieutenant as he shoved fresh shells into his gun; "and I say, tie them to those mesquit-trees, Apache fashion—sabe?—Apache fashion, corporal; and three of you men stay here and hold 'em down." With which he rode off, followed by his diminished escort.

The young man rode slowly, with his eyes on the ground, while at intervals he shoved his campaign hat to one side and rubbed his right ear, until suddenly he pulled his hat over his eyes, saying, "Ah, I have it." Then he proceeded at a trot to the camp.

Here he peeped cautiously into the "old man's" dog-tent. This he did ever so carefully; but the "old man" was in a sound sleep. The lieutenant betook himself to a bush to doze until the captain should bestir himself. L Troop was uneasy. It sat around in groups, but nothing happened until five o'clock.

At this hour the "old man" came out of his tent, saying, "I say, Mr. B——, have you got any water in your canteen?"

"Yes, indeed, captain. Will you have a drop?"

After he had held the canteen between his august nose and the sky for a considerable interval, he handed it back with a loud "Hount!" and L Troop fell in behind him as he rode away, leaving two men, who gathered up the dog-tent and the empty bottle.

"Where is that —— —— greaser? Have him get out here and run this trail. Here, you tan-colored coyote, kem up!" and the captain glared fiercely at poor Pedro, while the lieutenant winked vigorously at that perturbed being, and patted his lips with his hand to enjoin silence.

So Pedro ran the trail until it was quite dusk, being many times at fault. The lieutenant would ride out to him, and together they bent over it and talked long and earnestly. L Troop sat quietly in its saddles, grinned cheerfully, and poked each other in the ribs.

Suddenly Pedro came back, saying to the captain: "The men are in that bush —in camp, I think. Will you charge, sir?"

"How do you know that?" was the petulant query.

"Oh, I think they are there; so does the lieutenant. Don't you, Mr. B——?"

"Well, I have an idea we shall capture them if we charge," nervously replied the younger officer.

"Well— Right into line! Revolvers! Humph!" said the captain, and the brave old lion ploughed his big bay at the object of attack—it did not matter what was in front—and L Troop followed fast. They all became well tangled up in the dense chaparral, but nothing more serious than the thorns stayed their progress, until three shots were fired some little way in the rear, and the lieutenant's voice was heard calling, "Come here; we have got them."

In the growing dusk the troop gathered around the three luckless "greasers," now quite speechless with fright and confusion. The captain looked his captives over softly, saying, "Pretty work for L Troop; sound very well in reports. Put a guard over them, lieutenant. I am going to try for a little sleep."

The reflections of L Troop were cheery as it sat on its blankets and watched the coffee in the tin cups boil. Our enterprising lieutenant sat apart on a low bank, twirling his thumbs and indulging in a mighty wonder if that would be the last of it, for he knew only too well that trifling with the "old man" was no joke.

Presently he strolled over and called the old first sergeant—their relations were very close. "I think L had best not talk much about this business. G Troop might hear about it, and that wouldn't do L any good. Sabe?"

"Divel the word kin a man say, sir, and live till morning in L Troop."

Later there was a conference of the file, and then many discussions in the ranks, with the result that L Troop shut its mouth forever.

Some months later they returned to the post. The canteen rang with praise of the "old man," for he was popular with the men because he did not bother them with fussy duties, and loud was the pæan of the mighty charge over the big insurgent camp where the three great chiefs of

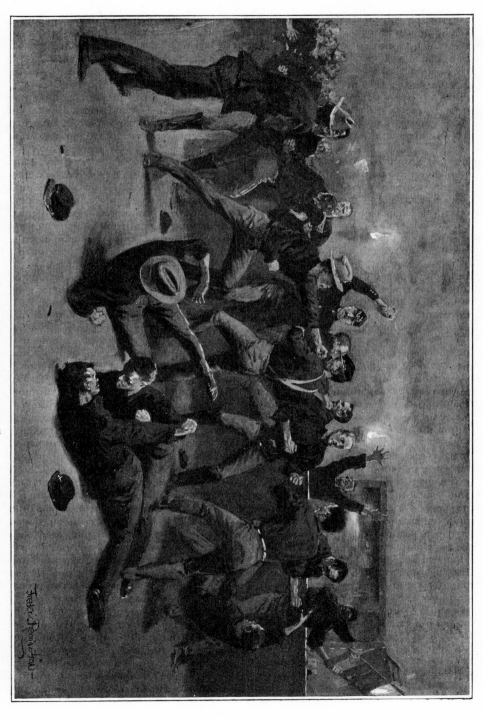

"A BEAUTIFUL FIGHT ENSUED."

the enemy were captured. Other troops might be very well, but L was "it."

This hard rubbing of the feelings of others had the usual irritating effect. One night the burning torch went round and all the troopers gathered at the canteen, where the wag of G Troop threw the whole unvarnished truth in the face of L members' present. This, too, with many embellishments which were not truthful. A beautiful fight ensued, and many men slept in the guard-house.

After dark, L Troop gathered back of the stables, and they talked fiercely at each other; accusations were made, and recrimination followed. Many conferences were held in the company-room, but meanwhile G men continued to grind it in.

Two days later the following appeared in the local newspaper:

. . . . "Pedro Zacatin, a Mexican who served with troops in the late outbreak, was found hanging to a tree back of the post. There was no clew, since the rain of last night destroyed all tracks of the perpetrators of the deed. It may have been suicide, but it is thought at the post that he was murdered by sympathizers of the late revolution who knew the part he had taken against them. The local authorities will do well to take measures against lawless Mexicans from over the border who hang about this city," etc.

36.
The
Story
of the
Dry Leaves

THE STORY OF THE DRY LEAVES.

BY FREDERIC REMINGTON.

IF one loves the earth, he finds a liveliness in walking through the autumn woods: the color, the crackling, and the ripeness of the time appeal to his senses as he kicks his way through the dry leaves with his feet.

It is a wrong thing to dull this harmlessness, but still I must remind him that it was not always so; such leaves have been the cause of tragedy. How could bad come of such unoffending trifles? Listen.

Long ago a very old Indian—an Ottawa—recalled the sad case of Ah-we-ah from the nearly forgotten past. His case was similar to ours, only more serious, since if we could not approach a deer in the dry forest because of the noise the leaves made it meant only disappointment, but with Ah-we-ah it meant his utter undoing.

Ah-we-ah grew up or came up as all Indian boys do who manage to escape the deadfalls which nature sets in such num-

bers and variety for them, and was at the time of the story barely a man. His folks lived in the Northwest, in what is now known as Manitoba, and they were of the Ojibbeway people. As was a very common thing in those days, they were all murdered by the Sioux; the very last kinsman Ah-we-ah had on earth was dead when Ah-we-ah came in one day from his hunting and saw their bodies lying charred and wolf-eaten about the ashes of his father's lodge.

He found himself utterly alone in the world.

The woods Indians, who followed the moose, the bear, and trapped the small animals for the Fur Company, did not live together in great tribal bodies, as did the buffalo Indians, but scattered out, the better to follow the silent methods of their livelihood.

Ah-we-ah was thus forced to live alone in the forest that winter, and his little bark hut was cold and fireless when he came in at night, tired with the long day's hunting. This condition continued for a time, until grief and a feeling of loneliness determined Ah-we-ah to start in search of a war party, that he might accompany them against their enemies, and have an opportunity to sacrifice honorably a life which had become irksome to him.

Leaving his belongings on a "sunjeg-wun," or scaffold made of stout poles, he shouldered his old trade gun, his dry meat, called his wolf-dogs, and betook himself three days through the forest to the small settlement made by the hunting-camps of his tribesman, old Bent Gun,—a settlement lying about a series of ponds, of which no name is saved for this story; nor does it matter now which particular mud-holes they were—so long ago—out there in the trackless waste of poplar and tamarack.

The people are long since gone; the camps are mould; the very trees they lived among are dead and down this many a year.

So the lonely hunter came to the lodge of his friend, and sat him down on a skin across the fire from Bent Gun; and as he dipped his hollow buffalo horn into the pot he talked of his losses, his revenge, his war-ardor, inquired where he was like to find a fellow-feeling—yes, even pleaded with the old man that he and his sons too might go forth together with him and

slay some other simple savage as a spiritual relief to themselves. He chanted his war-song by the night fire in the lodge, to the discomfort and disturbance of old Bent Gun, who had large family interests and was minded to stay in his hunting-grounds, which had yielded well to his traps and stalking; besides which the snow was deep, and the Sioux were far away. It was not the proper time of the year for war.

By day Ah-we-ah hunted with old Bent Gun, and they killed moose easily in their yards, while the women cut them up and drew them to the camps. Thus they were happy in the primeval way, what with plenty of maple sugar, bears' grease, and the kettle always steaming full of fresh meat.

But still by night Ah-we-ah continued to exalt the nobleness of the wearing of the red paint and the shrill screams of battle to his tribesmen; but old Bent Gun did not succumb to their spirit; there was meat, and his family were many. This finally was understood by Ah-we-ah, who, indeed, had come to notice the family, and one of them in particular—a young girl; and also he was conscious of the abundance of cheer in the teeming lodge.

In the contemplation of life as it passed before his eyes he found that his gaze centred more and more on the girl. He watched her cutting up the moose and hauling loads through the woods with her dogs. She was dutiful. Her smile warmed him. Her voice came softly, and her form, as it cut against the snow, was good to look at in the eyes of the young Indian hunter. He knew, since his mother and sister had gone, that no man can live happily in a lodge without a woman. And as the girl passed her dark eyes across his, it left a feeling after their gaze had gone. He was still glorious with the lust of murder, but a new impulse had seized him—it swayed him, and it finally overpowered him altogether.

When one day he had killed a moose early in the morning, he came back to the camp asking the women to come out and help him in with the meat, and Mis-kau-bun-o-kwa, or the "Red Light of the Morning," and her old mother accompanied him to his quarry.

As they stalked in procession through the sunlit winter forest, the young savage gazed with glowing eyes upon the

girl ahead of him. He was a sturdy man in whom life ran high, and he had much character after his manner and his kind. He forgot the scalps of his tribal enemies; they were crowded out by a higher and more immediate purpose. He wanted the girl, and he wanted her with all the fierce resistlessness of a nature which followed its inclinations as undisturbedly as the wolf—which was his totem.

The little party came presently to the dead moose, and the women, with the heavy skinning-knives, dismembered the great mahogany mass of hair, while the craunching snow under the moccasins grew red about it. Some little distance off stood the young man, leaning on his gun, and with his blanket drawn about him to his eyes. He watched the girl while she worked, and his eyes dilated and opened wide under the impulse. The blood surged and bounded through his veins—he was hungry for her, like a famished tiger which stalks a gazelle. They packed their sleds and hung the remainder in the trees to await another coming.

The old woman, having made her load, passed backward along the trail, tugging at her head-line and ejaculating gutturals at her dogs. Then Ah-we-ah stepped quickly to the girl, who was bent over her sled, and seizing her, he threw his blanket with a deft sweep over her head; he wrapped it around them both, and they were alone under its protecting folds. They spoke together until the old woman called to them, when he released her. The girl followed on, but Ah-we-ah stood by the blood-stained place quietly, without moving for a long time.

That night he did not speak of war to old Bent Gun, but he begged his daughter of him, and the old man called the girl and set her down beside Ah-we-ah. An old squaw threw a blanket over them, and they were man and wife.

In a day or two the young man had washed the red paint from his face, and he had a longing for his own lodge, three days away through the thickets. It would not be so lonesome now, and his fire would always be burning.

He called his dogs, and with his wife they all betook themselves on the tramp to his hunting-grounds. The snow had long since filled up the tracks Ah-we-ah had made when he came to Bent Gun's camp.

He set up his lodge, hunted successfully, and forgot his past as he sat by the crackle of the fire, while the woman mended his buckskins, dried his moccasins, and lighted his long pipe. Many beaverskins he had on his "sunjegwun," and many good buckskins were made by his wife, and when they packed up in the spring, the big canoe was full of stuff which would bring powder, lead, beads, tobacco, knives, axes, and stronding, or squaw-cloth, at the stores of the Northwest Company.

Ah-we-ah would have been destitute if he had not been away when his family were killed by the Sioux, and, as it was, he had little beyond what any hunter has with him; but he had saved his traps, his canoe, and his dogs, which in the old days were nearly everything except the lordly gun and the store of provisions which might happen.

At a camp where many of the tribe stopped and made maple sugar, the young pair tarried and boiled sap along with the others, until they had enough sweets for the Indian year. And when the camp broke up they followed on to the post of the big company, where they traded for the year's supplies—"double-battle Sussex powder" in corked bottles, pig-lead, blue and red stronding, hard biscuit, steel traps, axes, and knives. It is not for us to know if they helped the company's dividends by the purchase of the villanous "made whiskey," as it was called in the trade parlance, but the story relates that his canoe was deep-laden when he started away into the wilderness.

The canoe was old and worn out, so Ah-we-ah purposed to make a new one. He was young, and it is not every old man even who can make a canoe, but since the mechanical member of his family had his "fire put out" by the Sioux on that memorable occasion, it was at least necessary that he try. So he worked at its building, and in due time launched his bark; but it was "quick" in the water, and one day shortly it tipped over with him while on his journey to his hunting-grounds. He lost all his provisions, his sugar, biscuits, and many things besides, but saved his gun. He was suffering from hunger when he again found the company's store, but having made a good hunt the year before, the factor made him a meagre credit of powder,

lead, and the few necessary things. He found himself very poor.

In due course Ah-we-ah and his family set up their lodge. They were alone in the country, which had been hunted poor. The other people had gone far away to new grounds, but the young man trusted himself and his old locality. He was not wise like the wolves and the old Indians, who follow ceaselessly, knowing that to stop is to die of hunger. He hunted faithfully, and while he laid by no store, his kettle was kept full, and so the summer passed.

He now directed himself more to the hunting of beaver, of which he knew of the presence of about twenty gangs within working distance of his camp. But when he went to break up their houses he found nearly all of them empty. He at last discovered that some distemper had seized upon the beaver, and that they had died. He recovered one which was dying in the water, and when he cut it up it had a bloody flux about the heart, and he was afraid to eat it. And so it was with others. This was a vast misfortune to the young hunter; but still there were the elk. He had shot four up to this time, and there was "sign" of moose passing about. The leaves fell, and walking in them he made a great noise, and was forced to run down an elk —a thing which could be done by a young and powerful man, but it was very exhausting.

When an Indian hunts the elk in this manner, after he starts the herd, he follows at such a gait as he thinks he can maintain for many hours. The elk, being frightened, outstrip him at first by many miles, but the Indian, following at a steady pace along the trail, at length comes in sight of them; then they make another effort, and are no more seen for an hour or two; but the intervals in which the Indian has them in sight grow more and more frequent and longer and longer, until he ceases to lose sight of them at all. The elk are now so much fatigued that they can only move at a slow trot. At last they can but walk, by which time the strength of the Indian is nearly exhausted; but he is commonly able to get near enough to fire into the rear of the herd. This kind of hunting is what Ah-we-ah was at last compelled to do. He could no longer stalk with success, because the season was dry and

the dead leaves rattled under his moccasins.

He found a band, and all day long the hungry Indian strove behind the flying elk; but he did not come up, and night found him weak and starved. He lay down by a little fire, and burned tobacco to the four corners of the world, and chanted softly his medicine-song, and devoutly hoped that his young wife might soon have meat. It might be that on his return to his lodge he would hear another voice beside that familiar one.

Ah-we-ah slept until the gray came in the east, and girding himself, he sped on through the forest; the sun came and found the buckskinned figure gliding through the woods. Through the dry light of the day he sweated, and in the late afternoon shot a young elk. He cut away what meat he could carry in his weakness, ate the liver raw, and with lagging steps hastened backward to his far-off lodge.

The sun was again high before Ah-we-ah raised the entrance-mat at his home, and it was some moments before he could discern in the dusk that the wife was not alone. Hunger had done its work, and the young mother had suffered more than women ought.

Her strength had gone.

The man made broth, and together they rested, these two unfortunates; but on the following day nature again interposed the strain of the tightened belly.

Ah-we-ah went forth through the noisy leaves. If rain or snow would come to soften the noise; but no; the cloudless sky overspread the yellow and red of the earth's carpet. No matter with what care the wary moccasin was set to the ground, the sweesh-sweesh of the moving hunter carried terror and warning to all animal kind. He could not go back to the slaughtered elk; it was too far for that, and the wolf and wolverene had been there before. Through the long day no hairy or feathered kind passed before his eye. At nightfall he built his fire, and sat crooning his medicine-song until nature intervened her demands for repose.

With the early light Ah-we-ah looked on the girl and her baby.

The baby was cold.

The dry breasts of Mis-kau-bun-o-kwa had been of no purpose to this last comer, but the mother resisted Ah-we-ah when

THE PASSION OF AH-WE-AH.

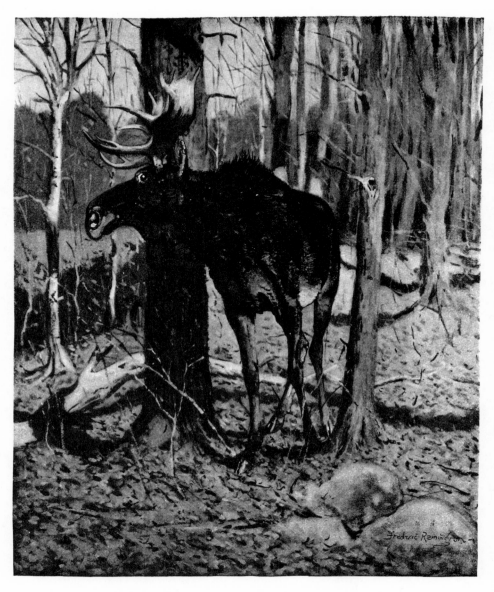

"THE MOOSE COULD HEAR HIM COMING FOR AN HOUR."

he tried to take the dead child away, and
he left it. This cut and maddened the
hunter's mind, and he cursed aloud his
medicine-bag, and flung it from him. It
had not brought him even a squirrel to
stay the life of his first-born. His fam-
ished dogs had gone away, hunting for
themselves; they would no longer stay
by the despairing master and his dreary
lodge.

Again he dragged his wretched form
into the forest, and before the sun was an
hour high the blue smoke had ceased to
curl over the woful place, and the faint-
ing woman lay quite still on her robe.
Through the dry brush and the crackling
leaves ranged the starving one, though
his legs bent and his head reeled. The
moose could hear him for an hour before
he would sight it.

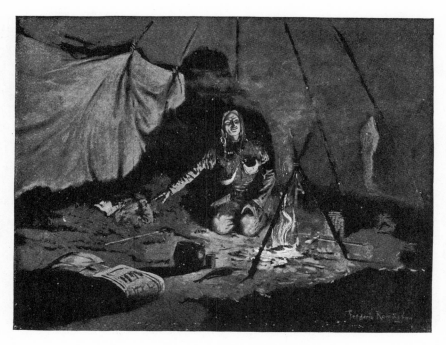

"THE DRY LEAVES HAD LASTED LONGER THAN SHE."

And again at evening he returned to his bleak refuge; the hut was gray and lifeless. He dropped into his place without making a fire. He knew that the woman was going from him. From the opposite side of the wigwam she moaned weakly—he could scarcely hear her.

Ah-we-ah called once more upon his gods, to the regular thump-thump of his tomtom. It was his last effort—his last rage at fate. If the spirits did not come now, the life would soon go out of the abode of Ah-we-ah, even as the fire had gone.

He beat and sang through the doleful silence, and from the dark tamaracks the wolves made answer. They too were hungry.

The air, the leaves, the trees, were still; they listened to the low moan of the woman, to the dull thump of the tomtom, to the long piercing howl of the wolf, the low rising and falling voice of the man chanting: "He-ah neen-gui-o-ho o-ho man-i-to-we-tah-hah gah-neen-qui-o we-i-ah-nah we-he-a."

The air grew chill and cold. Ah-we-ah was aroused from his deep communion by cold spots on his face. He opened the door-mat. He peered into the gray light of the softly falling snow. The spirits had come to him, he had a new energy, and seizing his gun, the half-delirious man tottered into the forest, saying softly to himself: "A bear—I walk like a bear myself—myself I walk like a bear—a beast comes calling—I am loaded—I am ready. Oh, my spirit! Oh, my mani-tou!"

A black mass crossed the Indian's path —it had not heard the moccasins in the muffle of the snow. The old trade gun boomed through the forest, and the mani-tou had sent at last to Ah-we-ah a black bear. He tore out his knife and cut a small load of meat from the bear, and then he strode on his back track as swift-ly as he could in his weakness. He came to the hole in the forest in the middle of which sat the lodge, calling: "Mis-kau-bun-o-kwa! Mis-kau-bun-o-kwa!" but there was no answer.

He quickly lighted a fire—he threw meat upon it, and bending backward from the flame, touched her, saying, "Good bear, Mis-kau-bun-o-kwa; I have a good bear for the bud-ka-da-win—for the hun-ger"; but Mis-kau-bun-o-kwa could not answer Ah-we-ah. The dry leaves had lasted longer than she.

37.
Joshua
Goodenough's
Old Letter

JOSHUA GOODENOUGH'S OLD LETTER.

BY FREDERIC REMINGTON.

THE following letter has come into my possession, which I publish because it is history, and descends to the list of those humble beings who builded so well for us the institutions which we now enjoy in this country. It is yellow with age, and much frayed out at the foldings, being in those spots no longer discernible. It runs:

ALBANY *June* 1798.

TO MY DEAR SON JOSEPH. —It is true that there are points in the history of the country in which your father had a concern in his early life and as you ask me to put it down I will do so briefly. Not however, my dear Joseph, as I was used to tell it to you when you were a lad, but with more exact truth, for I am getting on in my years and this will soon be all that my posterity will have of their ancestor. I conceive that now the descendents of the noble band of heroes who fought off the indians, the Frenche and the British will prevail in this country, and my chil-

427

dren's children may want to add what is found here in written to their own achievements.

To begin with, my father was the master of a fishing-schooner, of Marblehead. In the year 1745 he was taken at sea by a French man-of-war off Louisbourg, after making a desperate resistence. His ship was in a sinking condition and the blood was mid-leg deep on her deck. Your grandfather was an upstanding man and did not prostrate easily, but the Frencher was too big, so he was captured and later found his way as a prisoner to Quebec. He was exchanged by a mistake in his identity for Huron indians captivated in York, and he subsequently settled near Albany, afterwards bringing my mother, two sisters, and myself from Marblehead.

He engaged in the indian trade, and as I was a rugged lad of my years I did often accompany him on his expeditions westward into the Mohawk townes, thus living in bark camps among Indians and got thereby a knowledge of their ways. I made shift also to learn their language, and what with living in the bush for so many years I was a hand at a pack or paddle and no mean hunter besides. I was put to school for two seasons in Albany which was not to my liking, so I straightway ran off to a hunters camp up the Hudson, and only came back when my father would say that I should not be again put with the pedegogue. For this adventure I had a good strapping from my father, and was set to work in his trade again. My mother was a pious woman and did not like me to grow up in the wilderness — for it was the silly fashion of those times to ape the manners and dress of the Indians.

My father was a shifty trader and very ventursome. He often had trouble with the people in these parts, who were Dutch and were jealous of him. He had a violent temper and was not easily bent from his purpose by opposrition. His men had a deal of fear of him and good cause enough in the bargain, for I once saw him discipline a half-negro man who was one of his boat-men for stealing his private jug of liquor from his private pack. He clinched with the negro and soon had him on the ground, where the man struggled manfully but to no purpose for your grandfather soon had him at his mercy. "Now" said he "give me the

jug or take the consequences." The other boat paddlers wanted to rescue him but I menaced them with my fusil and the matter ended by the return of the jug.

In 1753 he met his end at the hands of western indians in the French interest, who shot him as he was helping to carry a battoe, and he was burried in the wilderness. My mother then returned to her home in Massassachusetts, journeying with a party of traders but I staid with the Dutch on these frontiers because I had learned the indian trade and liked the country. Not having any chances, I had little book learning in my youth, having to this day a regret concerning it. I read a few books, but fear I had a narrow knowledge of things outside the Dutch settlements. On the frontiers, for that matter, few people had much skill with the pen, nor was much needed. The axe and rifle, the paddle and pack being more to our hands in those rough days. To prosper though, men weare shrewd-headed enough. I have never seen that books helped people to trade sharper. Shortly afterwards our trade fell away, for the French had embroiled the Indians against us. Crown Point was the Place from which the Indians in their interest had been fitted out to go against our settlements, so a design was formed by His Majesty the British King to dispossess them of that place. Troops were levid in the Province and the war began. The Frenchers had the best of the fighting.

Our frontiers were beset with the Canada indians so that it was not safe to go about in the country at all. I was working for Peter Vrooman, a trader, and was living at his house on the Mohawk. One Sunday morning I found a negro boy who was shot through the body with two balls as he was hunting for stray sheep, and all this within half a mile of Vrooman's house. Then an express came up the valley who left word that the Province was levying troops at Albany to fight the French, and I took my pay from Vrooman saying that I would go to Albany for a soldier. Another young man and myself paddled down to Albany, and we both enlisted in the York levies. We drawed our ammunition tents, kettles, bowls and knives at the Albany flats, and were drilled by an officer who had been in her Majesty's Service. One man

was given five hundred lashes for enlisting in some Connecticut troops, and the orders said that any man who should leave His Majesty's service without a Regular discharge should suffer Death. The restraint which was put upon me by this military life was not to my liking, and I was in a mortal dread of the whippings which men were constantly receiving for breaches of the discipline. I felt that I could not survive the shame of being trussed up and lashed before men's eyes, but I did also have a great mind to fight the French which kept me along. One day came an order to prepare a list of officers and men who were willing to go scouting and be freed from other duty, and after some time I got my name put down, for I was thought too young, but I said I knew the woods, had often been to Andiatirocte (or Lake George as it had then become the fashion to call it) and they let me go. It was dangerous work, for reports came every day of how our Rangers suffered up country at the hands of the cruel savages from Canada, but it is impossible to play at bowls without meeting some rubs. A party of us proceeded up river to join Captain Rogers at Fort Edward, and we were put to camp on an Island. This was in October of the year 1757. We found the Rangers were rough borderers like ourselvs, mostly Hampshire men well used to the woods and much accustomed to the Enemy. They dressed in the fashion of those times in skin and grey duffle hunting frocks, and were well armed. Rogers himself was a doughty man and had a reputation as a bold Ranger leader. The men declaired that following him was sore service, but that he most always met with great success. The Fort was garrissoned by His Majesty's soldiers, and I did not conceive that they were much fitted for bush-ranging, which I afterwards found to be the case, but they would always fight well enough, though often to no good purpose, which was not their fault so much as the headstrong leadership which persisted in making them come to close quarters while at a disadvantage. There were great numbers of pack horses coming and going with stores, and many officers in gold lace and red coats were riding about directing here and there. I can remember that I had a great interest in this concourse of men, for up to that time I had not seen

much of the world outside of the wilderness. There was terror of the Canada indians who had come down to our borders hunting for scalps—for these were continually lurking near the cantanements to waylay the unwary. I had got acquainted with a Hampshire borderer who had passed his life on the Canada frontier, where he had fought indians and been captured by them. I had seen much of indians and knew their silent forest habits when hunting, so that I felt that when they were after human beings they would be no mean adversaries, but I had never hunted them or they me.

I talked at great length with this Shankland, or Shanks as he was called on account of his name and his long legs, in course of which he explained many useful points to me concerning Ranger ways. He said they always marched until it was quite dark before encamping —that they always returned by a different route from that on which they went out, and that they circled on their trail at intervals so that they might intercept any one coming on their rear. He told me not to gather up close to other Rangers in a fight but to keep spread out, which gave the Enemy less mark to fire upon and also deceived them as to your own numbers. Then also he cautioned me not to fire on the Enemy when we were in ambush till they have approached quite near, which will put them in greater surprise and give your own people time to rush in on them with hatchets or cutlasses. Shanks and I had finally a great fancy for each other and passed most of our time in company. He was a slow man in his movements albeit he could move fast enough on occassion, and was a great hand to take note of things happening around him. No indian was better able to discern a trail in the bush than he, nor could one be found his equal at making snow shoes, carving a powder horn or fashioning any knick-nack he was a mind to set his hand to.

The Rangers were accustomed to scout in small parties to keep the Canada indians from coming close to Fort Edward. I had been out with Shanks on minor occasions, but I must relate my first adventure.

A party . . . (here the writing is lost) . . . was desirous of taking a captive or scalp. I misdoubted our going alone by our-

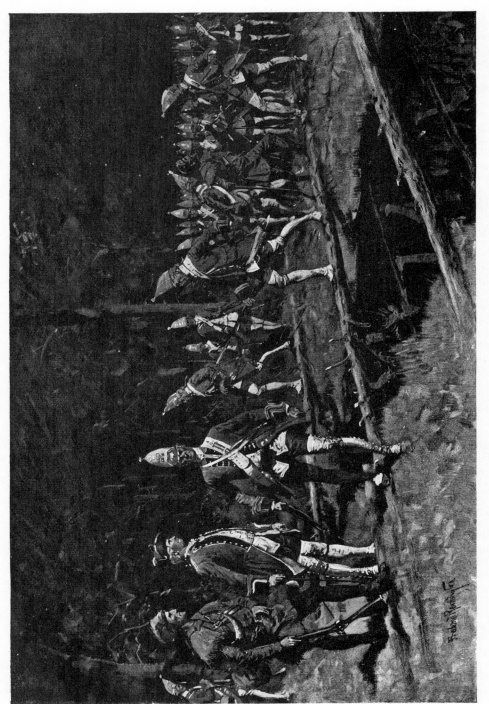

"I DID NOT CONCEIVE THAT THEY WERE MUCH FITTED FOR BUSH-RANGING."

selvs, but he said we were as safe as with more. We went northwest slowly for two days, and though we saw many old trails we found none which were fresh. We had gone on until night when we lay bye near a small brook. I was awakened by Shanks in the night and heard a great howling of wolves at some distance off togther with a gun shot. We lay awake until daybreak and at intervals heard a gun fired all though the night. We decided that the firing could not come from a large party and so began to approach the sound slowly and with the greatest caution. We could not understand why the wolves should be so bold with the gun firing, but as we came neare we smelled smoke and knew it was a camp-fire. There were a number of wolves running about in the underbrush from whose actions we located the camp. From a rise we could presently see it, and were surprised to find it contained five Indians all lying asleep in their blankets. The wolves would go right up to the camp and yet the indians did not deign to give them any notice whatsoever, or even to move in the least when one wolf pulled at the blanket of a sleeper. We each selected a man when we had come near enough, and preparing to deliver our fire, when of a sudden one figure rose up slightly. We nevertheless fired and then rushed forward, reloading. To our astonishment none of the figures moved in the least but the wolves scurried off. We were advancing cautiously when Shanks caught me by the arm saying " we must run, that they had all died of the small-pox," and run we did lustily for a good long distance. After this manner did many Indians die in the wilderness from that dreadful disease, and I have since supposed that the last living indian had kept firing his gun at the wolves until he had no longer strength to reload his piece.

After this Shanks and I had become great friends for he had liked the way I had conducted myself on this expedition. He was always arguing with me to cut off my eel-skin que which I wore after the fashion of the Dutch folks, saying that the Canada indians would parade me for a Dutchman after that token was gone with my scalp. He had (writing obliterated).

Early that winter I was one of 150 Rangers who marched with Captain Rog-

ers against the Enemy at Carrillion. The snow was not deep at starting but it continued to snow until it was heavy footing and many of the men gave out and returned to Fort Edward, but notwithstanding my exhaustion I continued on for six days until we were come to within six hundred yards of Carrillion Fort. The captain had made us a speech in which he told us the points where we were to rendevoux if we were broke in the fight, for further resistence until night came on, when we could take ourselvs off as best we might. I was with the advance guard. We lay in ambush in some fallen timber quite close to a road, from which we could see the smoke from the chimneys of the Fort and the centries walking their beats. A French soldier was seen to come from the Fort and the word was passed to let him go bye us, as he came down the road. We lay perfectly still not daring to breathe, and though he saw nothing he stopped once and seemed undecided as to going on, but suspecting nothing he continued and was captured by our people below, for prisoners were wanted at Headquarters to give information of the French forces and intentions. A man taken in this way was threatened with Death if he did not tell the whole truth, which under the circumstancs he mostly did to save his life.

The French did not come out of the Fort after us, though Rogers tried to entice them by firing guns and showing small parties of men which feigned to retreat. We were ordered to destroy what we could of the supplies, so Shanks and I killed a small cow which we found in the edge of the clearing and took off some fresh beef of which food we were sadly in need, for on these scouts the Rangers were not permitted to fire guns at game though it was found in thir path, as it often was in fact. I can remember on one occassion that I stood by a tree in a snow storm, with my gun depressed under my frock the better to keep it dry, when I was minded to glance quickly around and there saw a large wolf just ready to spring upon me. I cautiously presented my fusee but did not dare to fire against the orders. An other Ranger came shortly into view and the wolf took himself off. We burned some large wood piles, which no doubt made winter work for to keep some Frenchers at home. They only fired some cannon at us, which be-

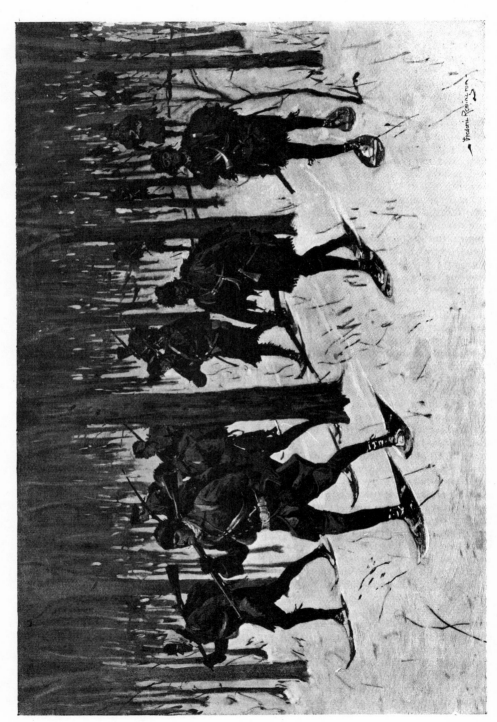

THE MARCH OF ROGERS'S RANGERS

yond a great deal of noise did no harm. We then marched back to Fort Edward and were glad enough to get there, since it was time for snow-shoes, which we had not with us.

The Canada indians were coming down to our Forts and even behind them to intercept our convoys or any parties out on the road, so that the Rangers were kept out, to head them when they could, or get knowledge of their whereabouts. Shanks and I went out with two Mohegon indians on a scout. It was exceedingly stormy weather and very heavy travelling except on the River. I had got a bearskin blanket from the indians which is necessary to keep out the cold at this season. We had ten days of bread, pork and rum with a little salt with us, and followed the indians in a direction North-and-bye-East toward the lower end of Lake Champlain, always keeping to the high-ground with the falling snow to fill our tracks behind us. For four days we travelled when we were well up the west side. We had crossed numbers of trails but they were all full of old snow and not worth regarding—still we were so far from our post that in event of encountering any numbers of the Enemy we had but small hope of a safe return and had therefore to observe the greatest caution.

As we were making our way an immense painter so menaced us that we were forced to fire our guns to dispatch him. He was found to be very old, his teeth almost gone, and was in the last stages of starvation. We were much alarmed at this misadventure, fearing the Enemy might hear us or see the ravens gathering above, so we crossed the Lake that night on some new ice to blind our trail, where I broke through in one place and was only saved by Shanks, who got hold of my eel-skin que, thereby having something to pull me out with. We got into a deep gully, and striking flint made a fire to dry me and I did not suffer much inconvenience.

The day following we took a long circle and came out on the lower end of the Lake, there laying two days in ambush, watching the Lake for any parties coming or going. Before dark a Mohigon came in from watch saying that men were coming down the Lake. We gathered at the point and saw seven of the Enemy come slowly on. There were three indians two Canadians and a French officer. Seeing they would shortly pass under our point of land we made ready to fire, and did deliver one fire as they came nigh, but the guns of our Mohigons failed to explode, they being old and well nigh useless, so that all the damage we did was to kill one indian and wound a Canadian, who was taken in hand by his companions who made off down the shore and went into the bush. We tried to head them unsuccessfully, and after examining the guns of our indians we feared they were so disabled that we gave up and retreated down the Lake, travelling all night. Near morning we saw a small fire which we spied out only to find a large party of the Enemy, whereat we were much disturbed, for our travelling had exhausted us and we feared the pursuit of a fresh enemy as soon as morning should come to show them our trail. We then made our way as fast as possible until late that night, when we laid down for refreshment. We built no fire but could not sleep for fear of the Enemy for it was a bright moonlight, and sure enough we had been there but a couple of hours when we saw the Enemy coming on our track. We here abandoned our bearskins with what provissions we had left and ran back on our trail toward the advancing party. It was dark in the forest and we hoped they might not discover our back track for some time, thus giving us a longer start. This ruse was successful. After some hours travel I became so exhausted that I stopped to rest, whereat the Mohigans left us, but Shanks bided with me, though urging me to move forward. After a time I got strength to move on. Shanks said the Canadians would come up with us if we did not make fast going of it, and that they would disembowel us or tie us to a tree and burn us as was their usual way, for we could in no wise hope to make head against so large a party. Thus we walked steadily till high noon, when my wretched strength gave out so that I fell down saying I had as leave die there as elsewhere. Shanks followed back on our trail, while I fell into a drouse but was so sore I could not sleep. After a time I heard a shot, and shortly two more, when Shanks came running back to me. He had killed an advancing indian and stopped them for a moment. He kicked me vigorously, telling me to come on, as

THE STORMING OF TICONDEROGA.

the indians would soon come on again. I got up, and though I could scarcely move I was minded diligently to persevere after Shanks. Thus we staggered on until near night time, when we again stopped and I fell into a deep sleep, but the enemy did not again come up. On the following day we got into Fort Edward, where I was taken with a distemper, was seized with very grevious pains in the head and back and a fever. They let blood and gave me a physic, but I did not get well around for some time. For this sickness I have always been thankful, otherwise I should have been with Major Rogers in his unfortunate battle, which has become notable enough, where he was defeated by the Canadians and Indians and lost nigh all his private men, only escaping himself by a miracle. We mourned the loss of many friends who were our comrades, though it was not the fault of any one, since the Enemy had three times the number of the Rangers and hemmed them in. Some of the Rangers had surrendered under promise of Quarter, but we afterwards heard that they were tied to trees and hacked to death because the indians had found a scalp in the breast of a man's hunting frock, thus showing that we could never expect such bloody minded villiains to keep their promises of Quarter.

I was on several scouts against them that winter but encountered nothing worthy to relate excepting the hardships which fell to a Ranger's lot. In June the Army having been gathered we proceeded under Abercromby up the Lake to attack Ticonderoga. I thought at the time that so many men must be invincible, but since the last war I have been taught to know different. There were more Highlanders, Grenadiers, Provincial troops, Artillery and Rangers than the eye could compass, for the Lake was black with their battoes. This concourse proceeded to Ticondaroga where we had a great battle and lost many men, but to no avail since we were forced to return.

The British soldiers were by this time made servicible for forest warfare, since the officers and men had been forced to rid themselvs of their useless incumbrances and had cut off the tails of their long coats till they scarcely reached below thir middles—they had also left the women at the Fort, browned thir gun barrells and carried thir provisions on their backs, each man enough for himself, as was our Ranger custom. The army was landed at the foot of the Lake, where the Rangers quickly drove off such small bodies of Frenchers and Indians as opposed us, and we began our march by the rapids. Rogers men cleared the way and had a most desperate fight with some French who were minded to stop us, but we shortly killed and captured most of them. We again fell in with them that afternoon and were challenged Qui vive but answered that we were French, but they were not deceived and fired upon us, after which a hot skirmish insued during which Lord Howe was shot through the breast, for which we were all much depressed, because he was our real leader and had raised great hopes of success for us. The Rangers had liked him because he was wont to spend much time talking with them in thir camps and used also to go on scouts. The Rangers were not over fond of British officers in general.

When the time had come for battle we Rangers moved forward, accompanied by the armed boatmen and the Provincial troops. We drove in the French pickets and came into the open where the trees were felled tops toward us in a mighty abbatis, as thiough blown down by the wind. It was all we could undertake to make our way through the mass, and all the while the great breast-works of the French belched cannon and musket balls while the limbs and splinters flew around us. Then out of the woods behind us issued the heavy red masses of the British troops advancing in battle array with purpose to storm with the bayonet. The maze of fallen trees with their withered leaves hanging broke their ranks, and the French Retrenchment blazed fire and death. They advanced bravely up but all to no good purpose, and hundreds there met their death. My dear Joseph I have the will but not the way to tell you all I saw that awful afternoon. I have since been in many battles and skirmishes, but I never have witnessed such slaughter and such wild fighting as the British storm of Ticonderoga. We became mixed up—Highlanders, Grenadiers, Light Troops, Rangers and all, and we beat against that mass of logs and maze of fallend timber and we beat in vain. I was once carried right up to the breastwork, but we were stopped by the bristling mass of sharpened branches,

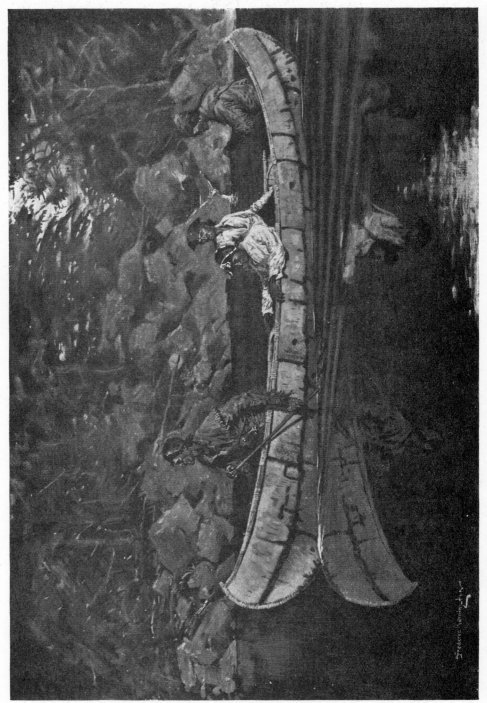

PADDLING THE WOUNDED BRITISH OFFICER.

while the French fire swept us front and flank. The ground was covered deep with dying men, and as I think it over now I can remember nothing but the fruit bourne by the tree of war, for I looked upon so many wonderous things that July day that I could not set them downe at all. We drew off after seeing that human

back to Albany I started, and there met Major Rogers, whom I acquainted with my desire to again join his service, whereat he seemed right glad to put me downe. I accordingly journeyed to Crown Point, where I went into camp. I had bought me a new fire-lock at Albany which was provided with a bayonet. It was short,

THE CAPTURE OF THE FRENCH GRENADIER.

valor could not take that work. We Rangers then skirmished with the French colony troops and the Canada indians until dark while our people rescued the wounded, and then we fell back. The Army was utterly demoralized and made a headlong retreat, during which many wounded men were left to die in the woods. Shanks and I paddled a light bark canoe down the Lake next day, in the bottom of which lay a wounded British officer attended by his servant.

I took my discharge, and lived until the following Spring with Vrooman at German Flats, when I had a desire to go again to the more active service of the Rangers, for living in camps and scouting, notwithstanding its dangers, was agreeable to my taste in those days. So

as is best fitted for the bush, and about 45 balls to the pound. I had shot it ten times on trial and it had not failed to discharge at each pull. There was a great change in the private men of the Rangers, so many old ones had been frost bitten and gone home. I found my friend Shanks, who had staid though he had been badly frosted during the winter. He had such a hate of the Frenchers and particularly of the Canada Indians that he would never cease to fight them, they having killed all his relatives in New Hampshire which made him bitter against them, he always saying that they might as well kill him and thus make an end of the family.

In June I went north down Champlain with 250 Rangers and Light Infantry in

sloop-vessels. The Rangers were (writing lost) but it made no difference. The party was landed on the west side of the Lake near Isle au Noix and lay five days in the bush, it raining hard all the time. I was out with a recoinnoitering party to watch the Isle, and very early in the morning we saw the French coming to our side in boats, whereat we acquainted Major Rogers that the French were about to attack us. We were drawn up in line to await their coming. The forest always concealed a Ranger line, so that there might not have been a man within a hundred miles for all that could be seen, and so it was that an advance party of the Enemy walked into our line and were captured, which first appraised the French of our position. They shortly attacked us on our left, but I was sent with a party to make our way through a swamp in order to attack their rear. This we accomplished so quietly that we surprized some Canada indians who were lying back of the French line listening to a prophet who was incanting. These we slew, and after our firing many French grenadiers came running past, when they broke before our line. I took a Frenchman prisoner, but he kept his bayonet pointed at me, all the time yelling in French which I did not understand, though I had my loaded gun pointed at him. He seemed to be disturbed at the sight of a scalp which I had hanging in my belt. I had lately took it from the head of an Indian, it being my first, but I was not minded to kill the poor Frenchman and was saying so in English. He put down his fire-lock finally and offered me his flask to drink liquor with him, but I did not use it. I had known that Shanks carried poisoned liquor in his pack, with the hope that it would destroy any indians who might come into possession of it, if he was taken, whether alive or dead. As I was escorting the Frenchman back to our boats he quickly ran away from me, though I snapped my fire-lock at him, which failed to explode, it having become wet from the rain. Afterwards I heard that a Ranger had shot him, seeing him running in the bush.

We went back to our boats after this victory and took all our wounded and dead with us, which last we buried on an island. Being joined by a party of Stockbridge Indians we were again landed, and after marching for some days came to a road where we recoinnoitered St. John's Fort but did not attack it, Rogers judging it not to be takeable with our force. From here we began to march so fast that only the strongest men could keep up, and at day-break came to another Fort. We ran into the gate while a hay-waggon was passing through, and surprised and captured all the garrison, men women and children. After we had burned and destroyed everything we turned the women and children adrift, but drove the men along as prisoners, making them carry our packs. We marched so fast that the French grenadiers could not keep up, for their breeches were too tight for them to march with ease, whereat we cut off the legs of them with our knives, when they did better.

After this expedition we scouted from Crown Point in canoes, Shanks and myself going as far north as we dared toward Isle au Noix, and one day while lying on the bank we saw the army coming. It was an awsome sight to see so many boats filled with brave uniforms, as they danced over the waves. The Rangers and indians came a half a mile ahead of the Army in whale-boats all in line abreast, while behind them came the light Infantry and Grenadiers with Provincial troops on the flanks and Artillery and Store boats bringing up the Rear.

Shanks and I fell in with the Ranger boats, being yet in our small bark and much hurled about by the waves, which rolled prodigious.

The Army continued up the Lake and drove the Frenchers out of their Forts, they not stopping to resist us till we got to Chamblee, where we staid. But the French in Canada had all surrendered to the British and the war was over. This ended my service as a Ranger in those parts. I went back to Vroomans intending to go again into the indian trade, for now we hoped that the French would no longer be able to stop our enterprises.

Now my dear son—I will send you this long letter, and will go on writing of my later life in the Western country and in the War of Independence, and will send you those letters as soon as I have them written. I did not do much or occupy a commanding position, but I served faithfully in what I had to do. For the present God bless you my dear son.

JOSHUA GOODENOUGH.

38.
A Sergeant
of the
Orphan
Troop

A SERGEANT OF THE ORPHAN TROOP.

BY FREDERIC REMINGTON.

WHILE it is undisputed that Captain Dodd's troop of the Third Cavalry is not an orphan, and is, moreover, quite as far from it as any troop of cavalry in the world, all this occurred many years ago, when it was, at any rate, so called. There was nothing so very unfortunate about it, from what I can gather, since it seems to have fought well on its own hook, quite up to all expectations, if not beyond. No officer at that time seemed to care to connect his name with such a rioting, nose-breaking band of desperado cavalrymen, unless it was temporarily, and that was always in the field, and never in garrison. However, in this case it did not have even an officer in the field. But let me go on to my sergeant.

This one was a Southern gentleman, or rather a boy, when he refugeed out of Fredericksburg with his family, before the Federal advance, in a wagon belonging to a Mississippi rifle regiment; but nevertheless, some years later he got to be a gentleman, and passed through the Virginia Military Institute with honor. The desire to be a soldier consumed him, but the vicissitudes of the times compelled him, if he wanted to be a soldier, to be a private one, which he became by duly enlisting in the Third Cavalry. He struck the Orphan Troop.

Physically, Nature had slobbered all over Carter Johnson; she had lavished on him her very last charm. His skin was pink, albeit the years of Arizona sun had heightened it to a dangerous red; his mustache was yellow and ideally military; while his pure Virginia accent, fired in terse and jerky form at friend and enemy alike, relieved his natural force of character by a shade of humor. He was thumped and bucked and pounded into what was in the seventies considered a proper frontier soldier, for in those days

the nursery idea had not been lugged into the army. If a sergeant bade a soldier "go" or "do," he instantly "went" or "did"—otherwise the sergeant belted him over the head with his six-shooter, and had him taken off in a cart. On pay-days, too, when men who did not care to get drunk went to bed in barracks, they slept under their bunks and not in them, which was conducive to longevity and a good night's rest. When buffalo were scarce they ate the army rations in those wild days; they had a fight often enough to earn thirteen dollars, and at times a good deal more. This was the way with all men at that time, but it was rough on recruits.

So my friend Carter Johnson wore through some years, rose to be a corporal, finally a sergeant, and did many daring deeds. An atavism from "the old border riders" of Scotland shone through the boy, and he took on quickly. He could act the others off the stage and sing them out of the theatre in his chosen profession.

There was fighting all day long around Fort Robinson, Nebraska—a bushwhacking with Dull-Knife's band of the Northern Cheyennes, the Spartans of the plains. It was January; the snow lay deep on the ground, and the cold was knifelike as it thrust at the fingers and toes of the Orphan Troop. Sergeant Johnson with a squad of twenty men, after having been in the saddle all night, was in at the post drawing rations for the troop. As they were packing them up for transport, a detachment of F Troop came galloping by, led by the sergeant's friend, Corporal Thornton. They pulled up.

"Come on, Carter—go with us. I have just heard that some troops have got a bunch of Injuns corralled out in the hills.

They can't get 'em down. Let's go help 'em. It's a chance for the fight of your life. Come on."

Carter hesitated for a moment. He had drawn the rations for his troop, which was in sore need of them. It might mean a court martial and the loss of his chevrons —but a fight! Carter struck his spurred heels, saying, "Come on, boys; get your horses; we will go."

The line of cavalry was half lost in the flying snow as it cantered away over the white flats. The dry powder crunched under the thudding hoofs, the carbines banged about, the overcoat capes blew and twisted in the rushing air, the horses grunted and threw up their heads as the spurs went into their bellies, while the men's faces were serious with the interest in store. Mile after mile rushed the little column, until it came to some bluffs, where it drew rein and stood gazing across the valley to the other hills.

Down in the bottoms they espied an officer and two men sitting quietly on their horses, and on riding up found a lieutenant gazing at the opposite bluffs through a glass. Far away behind the bluffs a sharp ear could detect the reports of guns.

"We have been fighting the Indians all day here," said the officer, putting down his glass and turning to the two "non-coms." "The command has gone around the bluffs. I have just seen Indians up there on the rim-rocks. I have sent for troops, in the hope that we might get up there. Sergeant, deploy as skirmishers, and we will try."

At a gallop the men fanned out, then forward at a sharp trot across the flats, over the little hills, and into the scrub pine. The valley gradually narrowed until it forced the skirmishers into a solid body, when the lieutenant took the lead, with the command tailing out in single file. The signs of the Indians grew thicker and thicker—a skirmisher's nest here behind a scrub-pine bush, and there by the side of a rock. Kettles and robes lay about in the snow, with three "bucks" and some women and children sprawling about, frozen as they had died; but all was silent except the crunch of the snow and the low whispers of the men as they pointed to the telltales of the morning's battle.

As the column approached the precipitous rim-rock the officer halted, had the horses assembled in a side cañon, putting Corporal Thornton in charge. He ordered Sergeant Johnson to again advance his skirmish-line, in which formation the men moved forward, taking cover behind the pine scrub and rocks, until they came to an open space of about sixty paces, while above it towered the cliff for twenty feet in the sheer. There the Indians had been last seen. The soldiers lay tight in the snow, and no man's valor impelled him on. To the casual glance the rim-rock was impassable. The men were discouraged and the officer nonplussed. A hundred rifles might be covering the rock fort for all they knew. On closer examination a cutting was found in the face of the rock which was a rude attempt at steps, doubtless made long ago by the Indians. Caught on a bush above, hanging down the steps, was a lariat, which, at the bottom, was twisted around the shoulders of a dead warrior. They had evidently tried to take him up while wounded, but he had died and had been abandoned.

After cogitating, the officer concluded not to order his men forward, but he himself stepped boldly out into the open and climbed up. Sergeant Johnson immediately followed, while an old Swedish soldier by the name of Otto Bordeson fell in behind them. They walked briskly up the hill, and placing their backs against the wall of rock, stood gazing at the Indian.

With a grin the officer directed the men to advance. The sergeant, seeing that he realized their serious predicament, said,

"I think, lieutenant, you had better leave them where they are; we are holding this rock up pretty hard."

They stood there and looked at each other. "We's in a fix," said Otto.

"I want volunteers to climb this rock," finally demanded the officer.

The sergeant looked up the steps, pulled at the lariat, and commented: "Only one man can go at a time; if there are Indians up there, an old squaw can kill this command with a hatchet; and if there are no Indians, we can all go up."

The impatient officer started up, but the sergeant grabbed him by the belt. He turned, saying, "If I haven't got men to go, I will climb myself."

"Stop, lieutenant. It wouldn't look right for the officer to go. I have noticed a pine-tree the branches of which spread over the top of the rock," and the sergeant pointed to it. "If you will make

"MILE AFTER MILE RUSHED THE LITTLE COLUMN."

the men cover the top of the rim-rock with their rifles, Bordeson and I will go up;" and turning to the Swede, "Will you go, Otto?"

"I will go anywhere the sergeant does," came his gallant reply.

"Take your choice, then, of the steps or the pine-tree," continued the Virginian; and after a rather short but sharp calculation the Swede declared for the tree, although both were death if the Indians were on the rim-rock. He immediately began sidling along the rock to the tree, and slowly commenced the ascent. The Sergeant took a few steps up the cutting, holding on

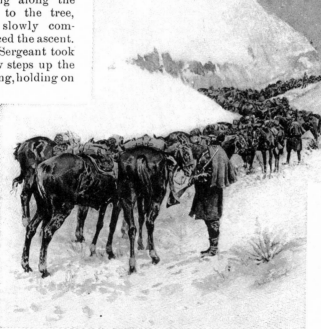

"THE HORSES ASSEMBLED IN A SIDE CAÑON."

wise, and he too saw nothing. Rifle-shots came clearly to their ears from far in front—many at one time, and scattering at others. Now the soldiers came briskly forward, dragging up the cliff in single file. The dull noises of the fight came through the wilderness. The skirmish-line drew quickly forward and passed into the pine woods, but the Indian trails scattered. Dividing into sets of four, they followed on the tracks of small parties, wandering on until night threatened. At length the main trail of the fugitive band ran across their front, bringing the command together. It was too late for the officer to get his horses before dark, nor could he follow with his exhausted men, so he turned to the sergeant and

by the rope. The officer stood out and smiled quizzically. Jeers came from behind the soldiers' bushes—"Go it, Otto! Go it, Johnson! Your feet are loaded! If a snow-bird flies, you will drop dead! Do you need any help? You'd make a hell of a sailor!" and other gibes.

The gray clouds stretched away monotonously over the waste of snow, and it was cold. The two men climbed slowly, anon stopping to look at each other and smile. They were monkeying with death.

At last the sergeant drew himself up, slowly raised his head, and saw snow and broken rock. Otto lifted himself like

asked him to pick some men and follow on the trail. The sergeant picked Otto Bordeson, who still affirmed that he would go anywhere that Johnson went, and they started. They were old hunting companions, having confidence in each other's sense and shooting. They ploughed through the snow, deeper and deeper into the pines, then on down a cañon where the light was failing. The sergeant was sweating freely; he raised his hand to press his fur cap backward from his forehead. He drew it quickly away; he stopped and started, caught Otto by the sleeve, and drew a long breath. Still

"THE TWO MEN CLIMBED SLOWLY."

holding his companion, he put his glove again to his nose, sniffed at it again, and with a mighty tug brought the startled Swede to his knees, whispering, "I smell Indians; I can sure smell 'em, Otto—can you?"

Otto sniffed, and whispered back, "Yes, plain!"

"We are ambushed! Drop!" and the two soldiers sunk in the snow. A few feet in front of them lay a dark thing; crawling to it, they found a large calico rag, covered with blood.

"Let's do something, Carter; we's in a fix."

"If we go down, Otto, we are gone; if we go back, we are gone; let's go forward," hissed the sergeant.

Slowly they crawled from tree to tree.

"Don't you see the Injuns?" said the

Swede, as he pointed to the rocks in front, where lay their dark forms. The still air gave no sound. The cathedral of nature, with its dark pine trunks starting from gray snow to support gray sky, was dead. Only human hearts raged, for the forms which held them lay like black bowlders.

"Egah — lelah washatah," yelled the sergeant.

Two rifle-shots rang and reverberated down the cañon; two more replied instantly from the soldiers. One Indian sunk, and his carbine went clanging down the rocks, burying itself in the snow. Another warrior rose slightly, took aim, but Johnson's six-shooter cracked again, and the Indian settled slowly down without firing. A squaw moved slowly in the half-light to where the buck lay. Bordeson drew a bead with his carbine.

"Don't shoot the woman, Otto. Keep that hole covered; the place is alive with Indians;" and both lay still.

A buck rose quickly, looked at the sergeant, and dropped back. The latter could see that he had him located, for he slowly poked his rifle up without showing his head. Johnson rolled swiftly to one side, aiming with his deadly revolver. Up popped the Indian's head, crack went the six-shooter; the head turned slowly, leaving the top exposed. Crack again went the alert gun of the soldier, the ball striking the head just below the scalp-lock and instantly jerking the body into a kneeling position.

Then all was quiet in the gloomy woods.

After a time the sergeant addressed his voice to the lonely place in Sioux, telling the women to come out and surrender— to leave the bucks, etc.

An old squaw rose sharply to her feet, slapped her breast, shouted "Lela washa-tah," and gathering up a little girl and a bundle, she strode forward to the soldiers. Three other women followed, two of them in the same blanket.

"Are there any more bucks?" roared the sergeant, in Sioux.

"No more alive," said the old squaw, in the same tongue.

"Keep your rifle on the hole between the rocks; watch these people; I will go up," directed the sergeant as he slowly mounted to the ledge, and with levelled six-shooter peered slowly over. He stepped in and stood looking down on the dead warriors.

A yelling in broken English smote the startled sergeant. "Tro up your hands, you d—— Injun! I'll blow the top off you!" came through the quiet. The sergeant sprang down to see the Swede standing with carbine levelled at a young buck confronting him with a drawn knife in his hands, while his blanket lay back on the snow.

"He's a buck—he ain't no squaw; he tried to creep on me with a knife. I'm going to kill him," shouted the excited Bordeson.

"No, no, don't kill him. Otto, don't you kill him," expostulated Johnson, as the Swede's finger clutched nervously at the trigger, and turning, he roared, "Throw away that knife, you d—— Indian!"

The detachment now came charging in through the snow, and gathered around excitedly. A late arrival came up, breathing heavily, dropped his gun, and springing up and down, yelled, "Be jabbers, I have got among om at last!" A general laugh went up, and the circle of men broke into a straggling line for the return. The sergeant took the little girl up in his arms. She grabbed him fiercely by the throat like a wild-cat, screaming. While nearly choking, he yet tried to mollify her, while her mother, seeing no harm was intended, pacified her in the soft gutturals of the race. She relaxed her grip, and the brave Virginian packed her down the mountain, wrapped in his soldier cloak. The horses were reached in time, and the prisoners put on double behind the soldiers, who fed them crackers as they marched. At 2 o'clock in the morning the little command rode into Fort Robinson and dismounted at the guard-house. The little girl, who was asleep and half frozen in Johnson's overcoat, would not go to her mother: poor little cat, she had found a nest. The sergeant took her into the guard-house, where it was warm. She soon fell asleep, and slowly he undid her, delivering her to her mother.

On the following morning he came early to the guard-house, loaded with trifles for his little Indian girl. He had expended all his credit at the post-trader's, but he could carry sentiment no further, for "To horse!" was sounding, and he joined the Orphan Troop to again ride on the Dull-Knife trail. The brave Cheyennes were running through the frosty

"THE BRAVE CHEYENNES WERE RUNNING THROUGH THE FROSTY HILLS."

hills, and the cavalry horses pressed hotly after. For ten days the troops surrounded the Indians by day, and stood guard in the snow by night, but coming day found the ghostly warriors gone and their rifle-pits empty. They were cut off and slaughtered daily, but the gallant warriors were fighting to their last nerve. Toward the end they were cooped in a gully on War-Bonnatt Creek, where they fortified; but two six-pounders had been hauled out, and were turned on their works. The four troops of cavalry stood to horse on the plains all day, waiting for the poor wretches to come out, while the guns roared, ploughing the frozen dirt

and snow over their little stronghold; but they did not come out. It was known that all the provisions they had was the dead horse of a corporal of E Troop, which had been shot within twenty paces of their rifle-pits.

So, too, the soldiers were starving, and the poor Orphans had only crackers to eat. They were freezing also, and murmuring to be led to "the charge," that they might end it there, but they were an orphan troop, and must wait for others to say. The sergeant even asked an officer to let them go, but was peremptorily told to get back in the ranks.

The guns ceased at night, while the

"THROUGH THE SMOKE SPRANG THE DARING SOLDIER."

troops drew off to build fires, warm their rigid fingers, thaw out their buffalo moccasins, and munch crackers, leaving a strong guard around the Cheyennes. In the night there was a shooting—the Indians had charged through and had gone.

The day following they were again surrounded on some bluffs, and the battle waged until night. Next day there was a weak fire from the Indian position on the impregnable bluffs, and presently it ceased entirely. The place was approached with care and trepidation, but was empty. Two Indian boys, with their feet frozen, had been left as decoys, and after standing off four troops of cavalry for hours, they too had in some mysterious way departed.

But the pursuit was relentless; on, on over the rolling hills swept the famishing troopers, and again the Spartan band turned at bay, firmly intrenched on a bluff as before. This was the last stand—nature was exhausted. The soldiers surrounded them, and Major Wessells turned the handle of the human vise. The command gathered closer about the doomed pits—they crawled on their bellies from one stack of sage-brush to the next. They were freezing. The order to charge came to the Orphan Troop, and yelling his command, Sergeant Johnson ran forward. Up from the sage-brush floundered the stiffened troopers, following on. They ran over three Indians, who lay sheltered in a little cut, and these killed three soldiers together with an old frontier sergeant who wore long hair, but they were destroyed in turn. While the Orphans swarmed under the hill, a rattling discharge poured from the rifle-pits; but the troop had gotten under the fire, and it all passed over their heads. On they pressed, their blood now quickened by excitement, crawling up the steep, while volley on volley poured over them. Within nine feet of the pits was a rim-rock ledge over which the Indian bullets swept, and here the charge was stopped. It now became a duel. Every time a head showed on either side, it drew fire like a flue-hole. Suddenly our Virginian sprang on the ledge, and like a trill on a piano poured a six-shooter into the intrenchment, and dropped back.

Major Wessells, who was commanding the whole force, crawled to the position of the Orphan Troop, saying, "Doing fine work, boys. Sergeant, I would advise you to take off that red scarf"—when a bullet cut the major across the breast, whirling him around and throwing him. A soldier, one Lannon, sprang to him and pulled him down the bluff, the major protesting that he was not wounded, which proved to be true, the bullet having passed through his heavy clothes.

The troops had drawn up on the other sides, and a perfect storm of bullets whirled over the intrenchments. The powder blackened the faces of the men, and they took off their caps or had them shot off. To raise the head for more than a fraction of a second meant death.

Johnson had exchanged five shots with a fine-looking Cheyenne, and every time he raised his eye to a level with the rock, White Antelope's gun winked at him.

"You will get killed directly," yelled Lannon to Johnson; "they have you spotted."

The smoke blew and eddied over them; again Johnson rose, and again White Antelope's pistol cracked an accompaniment to his own; but with movement like lightning the sergeant sprang through the smoke, and fairly shoving his carbine to White Antelope's breast, he pulled the trigger. A 50-calibre gun boomed in Johnson's face, and a volley roared from the pits, but he fell backward into cover. His comrades set him up to see if any red stains came through the grime, but he was unhurt.

The firing grew; a blue haze hung over the hill. Johnson again looked across the glacis, but again his eye met the savage glare of White Antelope.

"I haven't got him yet, Lannon, but I will;" and Sergeant Johnson again slowly reloaded his pistol and carbine.

"Now, men, give them a volley!" ordered the enraged man, and as volley answered volley, through the smoke sprang the daring soldier, and standing over White Antelope as the smoke swirled and almost hid him, he poured his six balls into his enemy, and thus died one brave man at the hands of another in fair battle. The sergeant leaped back and lay down among the men, stunned by the concussions. He said he would do no more. His mercurial temperament had undergone a change, or, to put it better, he conceived it to be outrageous to fight these poor people, five against one. He characterized it as "a d—— infantry fight," and rising, talked in Sioux to the enemy—asked them to surrender, or they

must otherwise die. A young girl answered him, and said they would like to. An old woman sprang on her and cut her throat with a dull knife, yelling meanwhile to the soldiers that "they would never surrender alive," and saying what she had done.

Many soldiers were being killed, and the fire from the pits grew weaker. The men were beside themselves with rage. "Charge!" rang through the now still air from some strong voice, and, with a volley, over the works poured the troops, with six-shooters going, and clubbed carbines. Yells, explosions, and amid a whirlwind of smoke the soldiers and Indians swayed about, now more slowly and quieter, until the smoke eddied away. Men stood still, peering about with wild open eyes through blackened faces. They held desperately to their weapons. An old bunch of buckskin rags rose slowly and fired a carbine aimlessly. Twenty bullets rolled and tumbled it along the ground, and again the smoke drifted off the mount. This time the air grew clear. Buffalo-robes lay all about, blood spotted everywhere. The dead bodies of thirty-two Cheyennes lay, writhed and twisted, on the packed snow, and among them many women and children, cut and furrowed with lead. In a corner was a pile of wounded squaws, half covered with dirt swept over them by the storm of bullets. One broken creature half raised herself from the bunch. A maddened trumpeter threw up his gun to shoot, but Sergeant Johnson leaped and kicked his gun out of his hands high into the air, saying, "This fight is over."

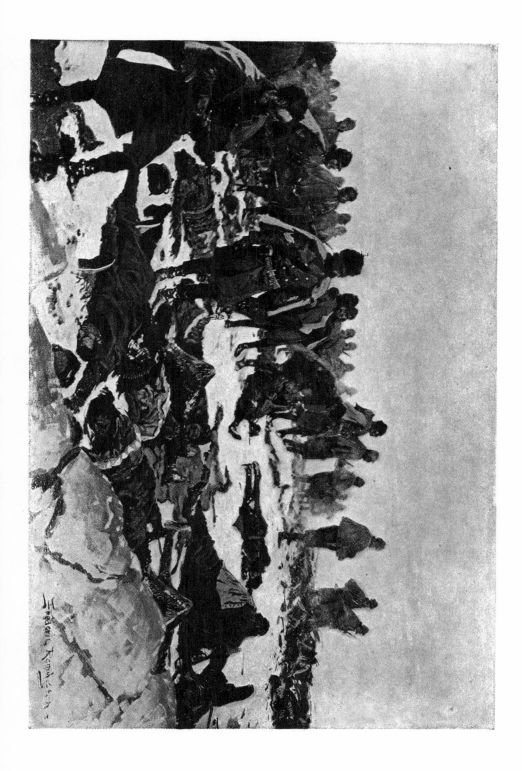

39.
How a Trout Broke a Friendship

HOW A TROUT BROKE A FRIENDSHIP.

By Frederic Remington.

I F I were an angler there would be no story, but I shall wish all my days that I had been a fisherman when I think of how my lack of experience refrigerated the nature of my old friend Joel B——.

It was early spring in Canada, and Lake Edwards was ice-water. I was camped on a point of rocks in company with three "Complete Anglers" and three French-Indians. A chilling rain had fallen incessantly for days—the fish would not be suited by any fly in our books. Everything was soggy and mildewed. An ill-tempered little box-stove smoldered, and helped Mr. Walker's creation to keep our miserable bodies alive. Our minds were becoming jaded by a draw-poker game which seemed to have had no beginning. As I view the situation from afar, I can perceive how carefully tilled was that ground to bear the seeds of trouble.

They were all friends of mine, with strong mutual sympathies in many directions; but they were fishermen, while I was not. They were men who at home have sacred dens in their houses, and in them they worship a heathen god in the form of a glass case full of dainty rods. They have hundreds of flies, suited to all kinds of moods of all kinds of fish. They have stuffed bass and wadded trout, colored artificially as falsely as a rose on Indian trade calico. There are creels, reels, silver ammunition flasks, rare prints of the forefathers of the lure, books of tall stories so dear to the craft, and things which you and I could not call by name.

In such places these men gather—through the tobacco smoke the lakes blow softly, the ponds wait idly, and the brooks bubble pleasantly in imagination.

These fellows mix fish up with their dessert and coffee, and in importance to them old Leonard is to President McKinley as a million to one.

So things to fish with to these men, things of wood and silk and steel, are invested with souls almost. They are like Japanese jugs or early English portraits to other enthusiasts.

The trout of Lake Edward floated idly beneath the boats, and if they looked at our bait they did no more, in consequence of which the anglers sat on boxes and dealt five cards round on the top of a trunk, and stub-flushes took the place of "cockie-bondhus" and "yellow sallies."

Having been ruined by the last "jackpot," I got up and trod forth into the rain, which was beating the lake into silver. I was listless—tired of the eternal "three-card draws"—tired of the rain and dreaming of elsewhere. I sauntered down towards the water and passed a shed under which were hung a great number of rods, all strung with reels, lines and flies.

"Why not fish—we came here to do that—that was our theory? Suiting the action to the thought, I took down a rod at random, called a Frenchman, and got into a boat.

We two sat there, the guide holding us a short way from the point of rocks. The rain poured in jumping drops on the flat water, while the pine forests faded softly into its obscuring sheets.

Presently one of our party, a gentleman from Pennsylvania, who must have encountered a disappointing "jack-pot," emerged from the tent, and, calling a guide, began to cast from a boat not far away.

The poker game evidently languished, since the capitalists came out in the rain and gazed about in a yawning way. They guyed Mr. Pennsylvania and me, who am no fisherman. Then they espied a bark canoe which was one of the "quickest" boats I ever saw. They remembered having recently seen an Indian stand upright in the tottlish craft—a balancing feat which was the inherited trait of ages of canoe-living ancestors. This inspired a five-dollar sporting proposition that one of them could do what the Indian had done. He pushed out in the canoe, while my friend Joel B—— stood on the rocks amusing himself with the thought of the easy five dollars.

At this point my rod doubled into

something like a figure eight, then it acted like a whip-snake having a fit—it was near to parting from me at times—the reel sang and the line hissed about in the water. The Frenchman stood up in the boat and poured Lake St. John French into me in a Maxim rumble. While this was at its height, Mr. Pennsylvania hooked the mate to my whale, but he knew his business. There was a great splash in front of me, and I only glanced long enough to see that Joel B—— had won his bet.

Joel—he of the rocks—tipped backward and forward, laughing until the forests echoed with his roars. Things were all his way.

The swimmer tried to board Mr. Pennsylvania's boat, but was told to get away —not to bother his fish—that human life was nothing now—to "swim to the rocks" —"don't be a d—— fool."

The Cannuck French of my guide was beginning to tell on me. I was almost willing to let the fish go while I threw the Frenchman overboard. I was so hot at him that I grew cooler toward the fish end of my troubles, and no doubt was doing better reel work for it all.

Events having slowed down a bit, Mr. Joel B—— began to observe things more closely. As he ran his eyes curiously over the activities on the water, they alighted on my rod. He gazed hard, earnestly, knowingly, at my rod. It was now in a figure eight, now bent this way, now that, being pulled half under water, and Joel B—— raised both hands high above his head while he yelled "—— —— ——, you have got my rod— my seventy-five-dollar Leonard rod! Cut that line, —— —— ——! What in —— do you mean by taking my best rod, —— —— ——?"

The Editor will not let me tell you all that Joel B—— vouchsafed on this galling occasion.

Now my affrighted friend walked the rocks like Mrs. Leslie Carter in the third act of "Zaza." He nearly turned handsprings; he gesticulated and roared for a boat or a deadly weapon. Steadily through it all surged his quick-chosen words of rebuke to me.

I now regretted the whole thing, but I couldn't let go, and the fish wouldn't. The seventy-five-dollar bamboo was getting action for the money, and the Frenchman knew that war had been declared.

Seeing that his present methods would never get the rod ashore without the fish, Joel B—— changed his scheme quickly, as an able tactician should. He stood still, and, beating like the leader of an orchestra, he said: "Reel him in—slowly, now —slowly—slowly. There—let him out— don't hold that rod against your belly, —— —— ——!"

There were tears streaming from the rod-owner's eye which rivaled the rain.

"Can't you check him easily—there now! Do you think you have got a bean-pole, —— —— Easy—don't get excited! Baptiste, back that boat ashore."

"If you back this boat ashore I'll murder you! By St. George, I'll burn you alive, Baptiste!" I shouted, and nothing was done.

Joel coached, more carefully now— more intelligently—and my divided interest in the trout cooled me down until, under able direction, I finally landed a five-pound trout on the rocks, and I was no fisherman. It was one of the mistakes of my life.

Joel B—— took his rod amid my apologies. He cared not for the latter. It was not the seventy-five dollars. It was that the clumsy hands of a bean-pole, worm-baiting, gill-yanking outcast had taken the soul out of Leonard's masterpiece.

No longer would that rod look out to him from the middle of the glass case, seeming to say, "Your hands and my subtle curves—what, Master—what can we not do?"

He sat around the tent and cast wolfish glances at me, and public sentiment sat stolidly by him. I carried an open jackknife in my outside coat-pocket. I sat alone there, deep in the forest, with men whose sense of right and justice had been outraged to the breaking point. They did not even say good-by to me at the railroad station.

The moral of this unfortunate occasion is that if you are going to play marbles with Paderewski you had better take a few lessons on the piano.

40.
A Shotgun
Episode

OUTING

MAY, 1900.

A SHOTGUN EPISODE.

By Frederic Remington.

OLD Captain Jack, as he is known throughout the army, and I had been working quail all the morning when we struck a stream and sat down to a small lunch, which we managed with more ease than was agreeable to us.

We began loading our pipes, and I noticed the Captain was overcome by a series of half-suppressed gurgles of amusement He was regarding his shotgun, which leaned against a bush in front of him.

"Why this levity?" I asked. "Do you recall some hallowed memory, when you had eight dozen hard-boiled eggs instead of only two separate ones?"

When the Captain relaxed he got rid of an elegant diction, which was his at will, and to his listener became charming in something like an inverse ratio. I felt that he could be made to do a gay picture with his golden pink method, and I always cared more for the Captain's wonderful past than the inconsequential quail.

"Do you know," he replied, "I never see a shotgun but I think of my old friend Chief Winnemucca; and if he is alive I guess old Chief Winnemucca never sees one but it makes him think of his old friend Captain Jack S——."

"How now?"

"It was a little glove-call I made on old Chief Winnemucca. He was a good sort of an Injun and a heap big chief of all the Piutes up there in Nevada. He was a great friend of General Crook, and Crook admired Winnemucca, too, because he had earned his respect by lift-

ing all Crook's horses on an occasion when the general wasn't looking. That seldom happened to Crook.

"See! this was in '77 that this shotgun business happened up at old Fort McDermitt, which was a lonely old one-company 'dobe, in the middle of a million miles of sage-brush. Right back of this post there was a high bench-land. The Indians used to sit up there and shoot into the camp in a spirit of cheerfulness, when there wasn't anything else going. I think the Eighth Infantrymen used rather to encourage the thing—for McDermitt would make a New England cemetery look like a French ball—so little episodes of this sort helped us out.

"No one else had much to do, but I was a scrub lieutenant then, and the Captain covered me with all the honors of adjutant, commissary, quartermaster, post treasurer, chaplain, and Indian agent, and I was made to scout once a month just to keep my hand in. In the post were only thirty enlisted men, and the company officers, besides a civilian doctor named Todd. This Todd was 'the original Mr. Glue from Gum Arabia' when it came to staying with a friend.

"As Indian agent I had charge of 298 solid mahogany Piutes, whom we had rounded in during the Bannock campaign. They were a touchy lot and hard to curry around the heels. I put them in a camp about a mile from the post, and old Chief Winnemucca was held personally responsible for them, but I didn't have any childlike confidence in 'Win.' He was too much of

a flirt himself for a good chaperon. When you get an old Injun warmed up with corn-juice he can turn moral hand-springs until you can't see anything but the buzz. However, Winnemucca had not gone 'out' and was all right in the main. He 'heap savied' the white man and was many weary journeys from a fool.

"Twice each week it was my duty to run a count on these Injuns in order to get my commissary right, and to see the 'Johnny on the Spot' theory was working. But I kept missing. They worked into all kinds of numerals—sometimes going as high as 350. As rations were based on the count, and as Uncle Sam don't pay his commissary officers for Injun lawn parties, it was up to me good and hard. I was getting horribly mixed up with my books until I found that by marking down certain birds, which I could remember by their tail feathers, I discovered that they ran from one tepee to another during my tallies.

I suggested to the commanding officer, who was afterward the Colonel Corliss shot while leading the assault on El Caney, that we divide them into bands—drive a series of stakes in the parade ground—line 'em up between the stakes at attention until they could show cause why they should eat Uncle Sam's grub. This seemed to be reasonable to the K. O., but old Winnemucca and his braves made a swing-mule buck, and stopped the whole team. Still we were bound to have our way because of the books. Commissary accounts have got to be as simple as a Greek column in Washington. Postscripts about thirty men and three hundred Indians are barred.

"The order went forth, and we sat up and scratched our heads over the possibilities. No Injun came in, and we began to worry some about the lay of things. It began to look like our move. We knew that wild waves of thought came over the spirit of an Injun camp, and no man can see into the future as far as his horse's ears when the tom-toms begin to thump.

"Presently an Injun came into camp —one of the small chiefs of the Piutes, Natchez by name. His head was badly cut, he was wounded in the body, and was red all over. He said he had always been a friend of the white man; that

Winnemucca's camp was full of Shoshones. His people were all drunk, and getting ready to dance — that after the dance they were coming up to wipe McDermitt off the map, and that he had only escaped with his life to tell us.

"What to do with our small force was not at all clear. Three hundred or more to thirty men, and the nearest possible relief ninety miles, was the proposition, and things due to happen on the jump. We could not take the initiative. Besides the women and children there was a lot of government property in the post.

"The Captain ordered me to go into the camp and arrest Winnemucca. He offered to spare me ten men, but I said I would go alone. I knew ten men wouldn't stand the styles down at Winnemucca's. Here is when Doctor Todd began to roll his tail—he said he would go with me. Todd would have made as good a phlebotomist with a saber as with a lancet. He was the old holiday goods.

"I went to my quarters and got a shotgun with a belt full of buck cartridges. My wife thought I was going hunting. Todd had a six-shooter, and we saddled up and started. Now this old pitcher had been to the well a good many times, but I was afraid she was going to get cracked this trip.

Winnemucca's drunken, dancing camp was a *recherché* bunch for two men to mob. I made no doubt of that. The more I thought my scheme over, however, the madder I got. I concluded to ride through the camp as hard as I could and get to Winnemucca personally. I then intended to make him protect me, or to kill him. Todd was to sit on his horse in front of the tepee and hold mine while I went in. When he heard firing he was to make a break to try and get through to the post and to leave me.

"We went through the camp, whirlwind fashion. There wasn't a buck, a squaw, or a papoose in sight, and from what I knew of Injun domesticity, I didn't get much encouragement out of this.

"We got to the tepee—Todd held my horse, and I dove into the plant and squatted quickly down by the door. The light was bad, and I was keyed up. On the left of the tepee was old Winnemucca

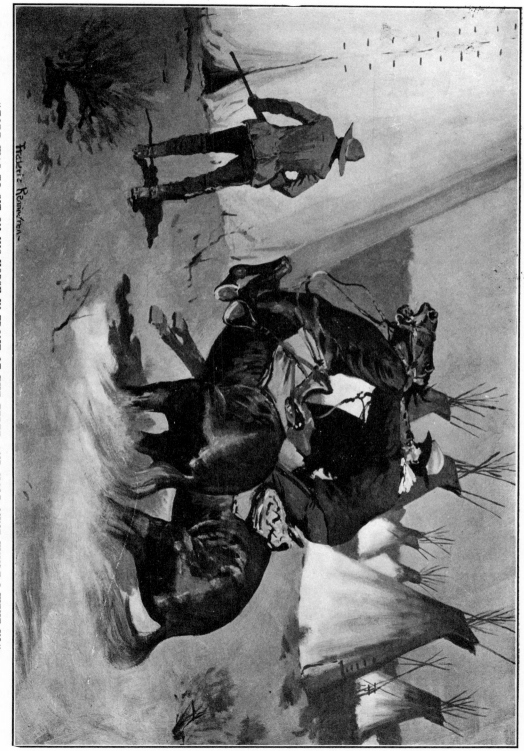

"TODD WAS TO SIT ON HIS HORSE IN FRONT OF THE TEPEE, AND HOLD MINE WHILE I WENT IN."

and Charlie Thatcher, the interpreter, lying down. Across from them were two Shoshone bucks squatting down with their blankets drawn tightly around them to their chins.

"They were all very much surprised, and somewhat drunk. I quickly shoved the double-barrel under Thatcher's ear, and told him to put his six-shooter at my feet, or I would blow his d—— head off. He did as I directed. Then I elevated the gun until it covered old Winnemucca, and he did likewise. All this time I was keeping my eyes on the two

came around to my way of thinking. I told Thatcher that he would lose his hundred dollars a month from the government—that we would make an old woman out of Winnemucca, and I made the two Shoshones sit up like maids in school. But all the time I was running this bluff I was somewhat perturbed— would you call it—no—I was scared stiff-legged.

"Winnemucca and Thatcher promised to report at the post next day, and to run all the Shoshones out of camp during the night.

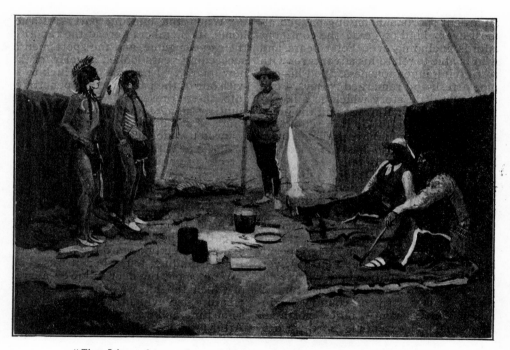

"Then I jumped to my feet and told the visitors to throw off their blankets."

Shoshones, and had figured to let one barrel into Winnemucca, then to let the other go at the Shoshones, while I hoped to get my hands on the six-shooters during the smoke and confusion. They were too surprised to do anything; then I jumped to my feet and told the visitors to get up and throw off their blankets. They were stark naked, and in full war paint, but unarmed.

"I made a speech which I can't remember, but I cussed them out, and held a debate with myself as to whether I ought to kill them, but anyhow they

"Telling Thatcher to take the two guns out to Todd, I backed out, jumped on my horse, and we trotted out of camp. All this time there was not an Indian in sight. I don't know where they were, and I could never find out.

"They came up the next day all right, and the incident was closed. I got to be a good friend of Winnemucca's, who always hit me on the back, and said I was a 'big chief,' but if he had known how scared I was, I don't think he would have thought so.

"For shotgun work give me quail."

41.
The
War
Dreams

THE WAR DREAMS

At the place far from Washington where the gray, stripped war-ships swing on the tide, and toward which the troop-trains hurry, there is no thought of peace. The shore is a dusty, smelly bit of sandy coral, and the houses in this town are built like snare-drums; they are dismal thoroughly, and the sun makes men sweat, and wish to God they were somewhere else.

But the men in the blue uniforms are young, and Madame Beaulieu, who keeps the restaurant, strives to please, so it came to pass that I attended one of these happy-go-lucky banquets. The others were artillery officers, men from off the ships, with a little sprinkle of cavalry and infantry just for salt. They were brothers, and yellow-jack — hellish heat — bullets, and the possibility of getting mixed up in a mass of exploding iron had been discounted long back in their schoolboy days perhaps. Yet they are not without sentiment, and are not even callous to all these, as will be seen, though men are different and do not think alike — less, even, when they dream.

"Do you know, I had a dream last night," said a naval officer.

"So did I."

"So did I," was chorussed by the others.

"Well, well!" I said. "Tell your dreams. Mr. H—, begin."

"Oh, it was nothing much. I dreamed that I was rich and old, and had a soft stomach, and I very much did not want to die. It was a curious sort of feeling, this very old and rich business, since I am neither, nor even now do I want to die, which part was true in my dream.

"I thought I was standing on the bluffs overlooking the Nile. I saw people skating, when suddenly numbers of hippopotamuses — great masses of them — broke up through the ice and began swallowing the people. This was awfully real to me. I even saw Mac there go down one big throat as easily as a cocktail. Then they came at me in a solid wall. I was crazed with fear — I fled. I could not run; but coming suddenly on a pile of old railroad iron, I quickly made a bicycle out of two car-wheels, and flew. A young hippo more agile than the rest made himself a bike also, and we scorched on over the desert. My strength failed; I despaired and screamed — then I woke up. Begad, this waiting and waiting in this fleet is surely doing things to me!"

The audience laughed, guyed, and said let's have some more dreams, and other things. This dream followed the other things, and he who told it was an artilleryman:

"My instincts got tangled up with one of those Key West shrimp salads, I reckon; but war has no terrors for a man who has been through my last midnight battle. I dreamed I was superintending two big 12-inch guns which were firing on an enemy's fleet. I do not know where this was. We got out of shot, but we seemed to have plenty of powder. The fleet kept coming on, and I

465

had to do something, so I put an old superannuated sergeant in the gun. He pleaded, but I said he was old, the case was urgent, it did not matter how one died for his country, etc. — so we put the dear old sergeant in the gun and fired him at the fleet. Then the battle became hot. I loaded soldiers in the guns and fired them out to sea, until I had no more soldiers. Then I began firing citizens. I ran out of citizens. But there were Congressmen around somewhere there in my dreams, and though they made speeches of protest to me under the five-minute rule, I promptly loaded them in, and touched them off in their turn. The fleet was pretty hard-looking by this time, but still in the ring. I could see the foreign sailors picking pieces of Congressmen from around the breech-blocks, and the officers were brushing their clothes with their handkerchiefs. I was about to give up, when I thought of the Key West shrimp salad. One walked conveniently up to me, and I loaded her in. With a last convulsive yank I pulled the lock-string, and the fleet was gone with my dream."

"How do cavalrymen dream, Mr. B— ?" was asked of a yellow-leg.

"Oh, our dreams are all strictly professional, too. I was out with my troop, being drilled by a big fat officer on an enormous horse. He was very red-faced, and crazy with rage at us. He yelled like one of those siren-whistles out there in the fleet.

"He said we were cowards and would not fight. So he had a stout picket-fence made, about six feet high, and then, forming us in line, he said no cavalry was any good which could be stopped by any obstacle. Mind you, he yelled it at us like the siren. He said the Spaniards would not pay any attention to such cowards. Then he gave the order to charge, and we flew into the fence. We rode at the fence pell-mell — into it dashed our horses, while we sabred and shouted. Behind us now came the big colonel — very big he was now, with great red wings — saying, above all the din, 'You shall never come back — you shall never come back!' and I was squeezed tighter and tighter by him up to this fence until I awoke; and now I have changed my cocktail to a plain vermouth."

When appealed to, the infantry officer tapped the table with his knife thoughtfully: "My dream was not so tragic; it was a moral strain; but I suffered greatly while it lasted. Somehow I was in command of a company of raw recruits, and was in some trenches which we were costructing under fire. My recruits were not like soldiers — they were not young men. They were past middle age, mostly fat, and many had white side whiskers after the fashion of the funny papers when they draw banker types. I had a man shot, and the recruits all got around me; they were pleading and crying to be allowed to go home.

"Now I never had anything in the world but my pay, and am pretty well satisfied as men go in the world, but I suppose the American does not breathe who is averse to possessing great wealth himself; so when one man said he would give me $1,000,000 in gold if I would let him go, I stopped to think. Here is where I suffered so keenly. I wanted the million, but I did not want to let him go.

"Then these men came up, one after the other, and offered me varying sums of money to be allowed to run away — and specious arguments in favor of the same. I was now in agony. D—n it! that company was worth nearly a hundred million dollars to me if I would let them take themselves off. I held out, but the strain was horrible. Then they began to offer me their daughters — they each had photographs of the most beautiful American girls — dozens and dozens of American girls, each one of which was a 'peach.' Say, fellows, I could stand the millions. I never did 'gig' on the money, but I took the photographs, said, 'Give me your girls, and pull your freight!' and my company disappeared instantly. Do you blame a man stationed in Key West for it — do you, fellows?"

"Not by a d—d sight!" sang the company, on its feet.

'Well, you old marine, what did you dream?"

"My digestion is so good that my dreams have no red fire in them. I seldom do dream; but last night, it seems to me, I recall having a wee bit of a dream. I don't know that I can describe it, but I was looking very intently at a wet spot on the breast of a blue uniform coat. I thought they were tears — woman's tears. I don't know whether it was a dream or whether I really did see it."

"Oh, d—n your dreams!" said the Doctor. "What is that bloody old Congress doing from last reports?"

42.
Wigwags from the Blockade

WIGWAGS FROM THE BLOCKADE

Modern war is supposed to be rapid, and we Americans think "time is money," but this war seems to be the murder of time, the slow torture of opportunity.

For seven long days and nights I have been steaming up and down on the battle-ship *Iowa*, ten miles off the harbor of Havana. Nothing happened. The *May-flower* got on the land side of a British tramp and warned her off, and a poor Spanish fishing-schooner from Progreso, loaded with rotting fish, was boarded by a boat's crew from us. When the captain saw the becutlassed and bepistolled "tars" he became badly rattled, and told the truth about himself. A Spaniard has to be surprised into doing this. He had been many days out, his ice was gone, and his fish were "high." He wanted to make Havana, telling the boarding-officer that the people of Havana were very hungry. He had been boarded five times off the coast by our people; so the lieutenant — who had just gotten out of bed, by-the-way — told him to take his cargo of odors out into the open sea, and not to come back again.

The appalling sameness of this pacing up and down before Havana works on the nerves of every one, from Captain to cook's police. We are neglected; no one comes to see us. All the Key West trolley-boats run to the Admiral's flag, and we know nothing of the outside. We speculate on the Flying Squadron, the *Oregon,* the army, and the Spanish. I have an impression that I was not caught young enough to develop a love of the sea, which the slow passage of each day re-enforces. I have formed a habit of damning the army for its procrastination, but in my heart of hearts I yearn for it. I want to hear a "shave-tail" bawl; I want to get some dust in my throat; I want to kick the dewy grass, to see a sentry pace in the moonlight, and to talk the language of my tribe. I resist it; I suppress myself; but my homely old first love comes to haunt me, waking and sleeping — yes, even when I look at this mountain of war material, this epitome of modern science, with its gay white officers, who talk of London, Paris, China, and Africa in one breath. Oh, I know I shall fall on the neck of the first old "dough-boy" or "yellow-leg" I see, and I don't care if he is making bread at the time!

The Morro light has been extinguished, but two powerful searches flash back and forth across the sky. "Good things to sail by," as the navigator says. "We can put them out when the time comes." Another purpose they serve is that "Jackie" has something to swear at as he lies by his loaded gun — something definite, some-thing material, to swear at. Also, two small gunboats developed a habit of running out of the harbor — not very far, and with the utmost caution, like a boy who tantalizes a chained bear. And at places in the town arises smoke.

"What is it?" asks the captain of marines.

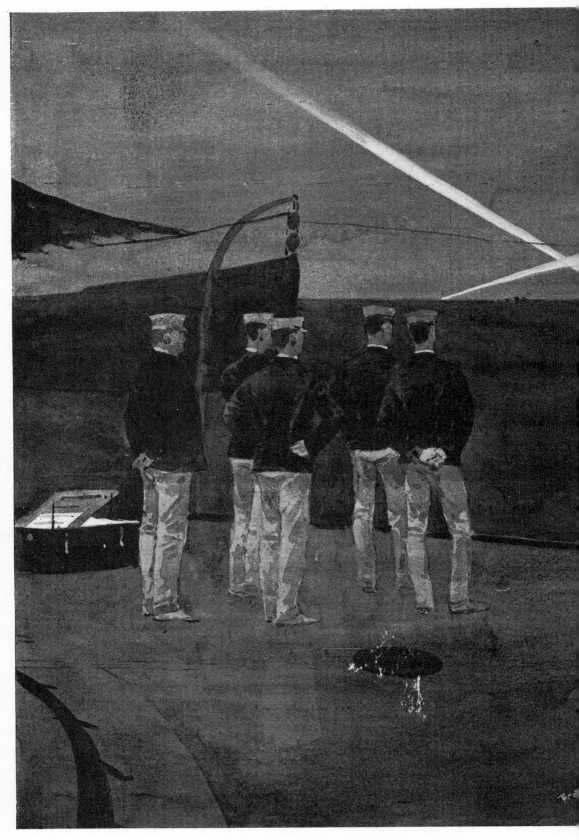

WATCHING THE BIG SEARCH-LIGHTS IN HAVANA.

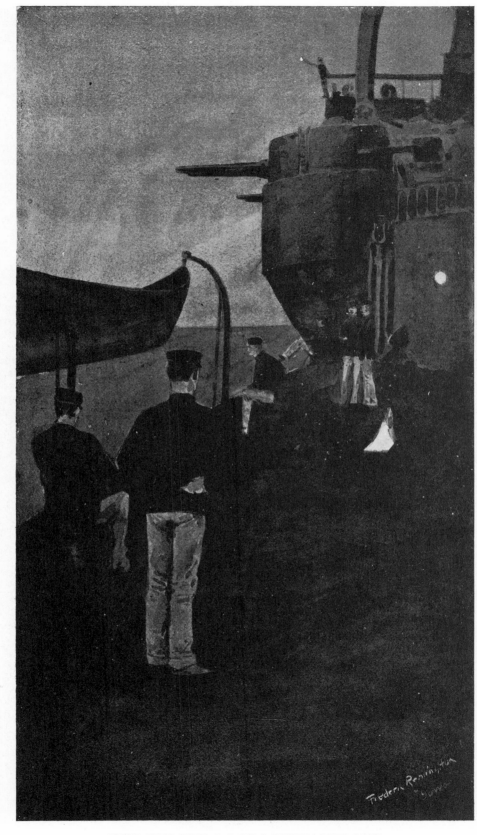

WIGWAGGING WITH A DARK LANTERN—AFTER-DECK.

"Big tobacco-factories working over-time for us," replies Doctor Crandell.

I was taken down into the machinery of the ship. I thought to find in it some human interest. Through mile after mile of underground passages I crawled and scrambled and climbed amid wheels going this way and rods plunging that, with little electric lights to make holes in the darkness. Men stood about in the overpowering blasts of heat, sweating and greasy and streaked with black — grave, serious persons of superhuman intelligence — men who have succumbed to modern science, which is modern life. Daisies and trees and the play of sunlight mean nothing to these — they know when all three are useful, which is enough. They pulled the levers, opened and shut cocks, showered coal into the roaring white hells under the boilers; hither and yon they wandered, bestowing motherlike attentions on rod and pipe. I talked at them, but they developed nothing except preoccupied professionalism. I believe they fairly worship this throbbing mass of mysterious iron; I believe they love this bewildering power which they control. Its problems entrance them; but it simply stuns me. At last when I stood on deck I had no other impression but that of my own feebleness, and, as I have said, felt rather stunned than stimulated. Imagine a square acre of delicate machinery plunging and whirling and spitting, with men crawling about in its demon folds! It is not for me to tell you more.

Don't waste your sympathy on these men belowdecks — they will not thank you; they will not even understand you. They are "modern" — are better off than "Jackie" and his poor wandering soul — they love their iron baby, so leave them alone with their joy. Modern science does not concern itself about death.

The *Iowa* will never be lost to the nation for want of care. By night there are dozens of trained eyes straining into the darkness, the searches are ready to flash, and the watch on deck lies close about its shotted guns. Not a light shows from the loom of the great battleship. Captain Evans sits most of the time on a perch upon the bridge, forty feet above the water-line. I have seen him come down to his breakfast at eight bells with his suspenders hanging down behind, indicating that he had been jumped out during the night.

The executive officer, Mr. Rogers, like the machinery down below, never sleeps. Wander where I would about the ship, I could not sit a few moments before Mr. Rogers would flit by, rapid and ghostlike — a word here, an order there, and eyes for everybody and everything. Behind, in hot pursuit, came stringing along dozens of men hunting for Mr. Rogers; and this never seemed to let up — midnight and mid-day all the same. The thought of what it must be is simply horrible. He has my sympathy — nervous prostration will be his reward — yet I greatly fear the poor man is so perverted, so dehumanized, as positively to like his life and work.

Naval officers are very span in their graceful uniforms, so one is struck when at "quarters" the officers commanding the turrets appear in their "dungaree," spotted and soiled. The *Iowa* has six turrets, each in charge of an officer responsible for its guns and hoisting-gear, delicate and complicated. In each turret is painted, in a sort of Sam Weller writing, "Remember the *Maine.*" The gun-captains and turret-men acquire a strange interest and pride in their charges, hanging about them constantly.

Two gun-captains in the forward turret used to sit on the great brown barrels of the 12-inch rifles just outside the posts, guard-

ing them with jealous care; for it is a "Jackie" trick to look sharply after his little spot on shipboard, and to promptly fly into any stranger who defiles it in any way. At times these two men popped back into their holes like prairie-dogs. It was their hope and their home, that dismal old box of tricks, and it may be their grave. I was going to die with them there, though I resolutely refused to live with them. However, the *Iowa* is unsinkable and unlickable, and the hardware on the forward turret is fifteen inches thick, which is why I put my brand on it. So good luck to Lieutenant Van Duzer and his merry men!

"Jackie," the prevailing thing on a man-of-war, I fail to comprehend fully. He is a strong-visaged, unlicked cub, who grumbles and bawls and fights. He is simple, handy, humorous, and kind to strangers, as I can testify. The nearest he ever comes to a martial appearance is when he lines up at quarters to answer "Here!" to his name, and there is just where he doesn't martialize at all. He comes barefooted, hat on fifty ways, trousers rolled up or down, and everything blowing wide. He scratches his head or stands on one foot in a ragged line, which grins at the spectators in cheerful heedlessness, and he looks very much gratified when it is all over. His hope is for a bang-up sea fight, or two roaring days of shore liberty, when he can "tear up the peach" with all the force of his reckless masculinity.

The marine, or sea soldier, has succumbed to modern conditions, and now fights a gun the same as a sailor man. He manages to retain his straight-backed discipline, but is overworked in his twofold capacity. This "soldier and sailor too" is a most interesting man to talk to, and I wish I could tell some of his stories. He marches into the interior of China or Korea to pull a minister out of the fire — thirty or forty of him against a million savages, but he gets his man. He lies in a jungle hut on the isthmus or a "dobie" house on the West Coast while the microbes and the "dogoes" rage.

But it's all horribly alike to me, so I managed to desert. The *Cushing,* torpedero, ran under our lee one fine morning, and I sneaked on board, bound for the flag-ship — the half-way station between us and Cayo Hueso. We plunged and bucked about in the roaring waves of the Gulf, and I nearly had the breakfast shaken out of me. I assure you that I was mighty glad to find the lee of the big cruiser *New York.*

On board I found that the flag-ship had had some good sport the day previous shelling some working parties in Matanzas. Mr. Zogbaum and Richard Harding Davis had seen it all, note-book in hand. I was stiff with jealousy; but it takes more than one fight to make a war — so here is hoping!

43.
Coaching in
Chihuahua

COACHING IN CHIHUAHUA

That coaching is a grand sport I cannot deny, but I know almost nothing of it beyond an impression that there is a tremendous amount of mystery connected with its rites. As a sport, I have never participated in it, but while in the process of travelling the waste places of the earth I have used it as a means on occasion. I never will again, but I have in the past. There is no place to which I desire to go badly enough to go in a coach, and such points of interest as are inaccessible except by coach are off my trail. I am not in the least superstitious, and am prone to scout such suggestions, but I am a Jonah in a stage-coach, and that is not a superstition, but a fact amply proved by many trials.

I remember as a boy in Montana having been so hopelessly mixed up with a sage-bush on a dark night when the stage overturned that it left an impression on me. Later in life I was travelling in Arizona, and we were bowling along about ten miles an hour down a great "hog-back" to the plains below. A "swing mule" tripped up a "lead mule," and the stage — on the box of which I was — ran over the whole six; and when the driver and I separated ourselves from the mules, the shreds of harness, splinters, hair, hide, cargo, and cactus plants, I began to formulate the notion that stage coaching was dangerous.

While riding in an army ambulance with Major Vielé, of the First Cavalry, and the late Lieutenant Clark, of the Tenth, the brake-beam broke on the descent of a hill, and we only hit the ground in the high places for about a mile. I will not insist that every man can hold his breath for five consecutive minutes, but I did it. Thereupon I registered vows and pledges; but, like the weak creature I am, I ignored them all and got into a coach at Chihuahua winter before last, and did 500 miles of jolting, with all the incident and the regulation accident which go to make up that sort of thing. Now, I like to think that I have been through it all, and am alive and unmaimed, and I take a great deal of comfort in knowing that, however I may meet my end, a stage-coach will be in no way connected with it.

On the trip out we had mules. They were black and diminutive. To me a Mexican mule seems to be the Chinaman of the dumb animals. They are enduring beyond comprehension, and they have minds which are patient, yet alert and full of guile. The Mexican *cocheros* have their mules trained, as bankers train their depositors in our land. They back up against a wall and stand in line while one by one they are harnessed. In the early morning I liked to see the lantern light glorify the little black creatures against the adobe wall, and hear the big *cochero* talk to his beasts in that easy familiar way, and with that mutual comprehension which is lost to those of the human race who have progressed beyond the natural state. This coachman

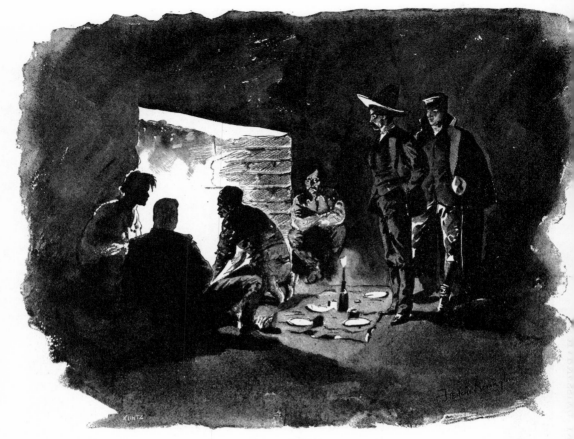

GRUB.

was an enormous man, big, bony, and with Sullivanesque shoulders, gorilla hands, and a blue-black buccaneer beard, and but for a merry brown eye and a mouth set in perpetual readiness to grin, he would have belonged to the "mild-mannered" class, to which, as a matter of fact, he did not. It is written in the lease of his land that he shall drive the Bavicora Ranch coach: it is life-service, it is feudal, and it carries one back.

If the little mules and ponies did not stand in the exact six feet of ground where he wanted them, he grabbed hold of them and moved them over to the place without a word, and after being located, they never moved until he yanked or lifted them to their place at the pole. The guards were Mexican Indians, hair cut à la Cosaque, big straw hats, serapes, and munitions of war. William, whose ancestors had emigrated from the Congo region before the war, was the cook. He was also guide, philosopher, and friend to Mr. H— and myself in this strange land, and he made all things possible by his tact and zeal in our behalf. William knows every one in the state of Chihuahua, and he is constantly

telling us of the standing and glittering position of the inhabitants of the mud huts which we pass, until it sounds like that ghastly array of intelligence with which a society reporter quickens the social dead in a Sunday newspaper.

At night we stay at convenient ranches, and rolling ourselves up in our blankets, we lie down on the mud floors to sleep. It is not so bad after one becomes used to it, albeit the skin wears off one's femur joint. The Mexican hen is as conscientious here as elsewhere, and we eat eggs. The Mexican coffee is always excellent in quality, but the people make it up into a nerve-jerking dose which will stand hot water in quantities. Nearly all travellers are favorably impressed with the *fréjoles* and *tortillas* of the country. The beans are good, but, as old General Taylor once said, "they killed more men than did bullets in the Mexican War." Of the -tortillas I will say as my philosophical friend Mr. Poultney Bigelow says of the black bread of the Russian soldier, "it's a good strong food to march and fight on," which can in no way be a recommendation of its palatability.

HARNESSING IN THE PATIO

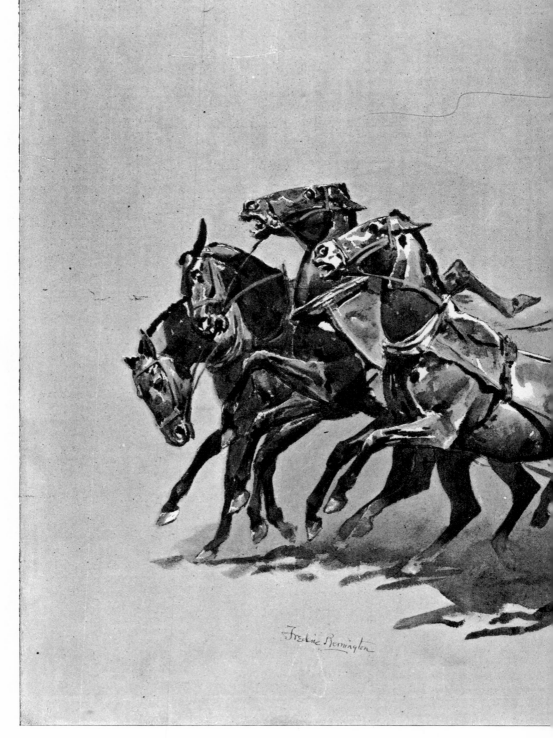

Frederic Remington

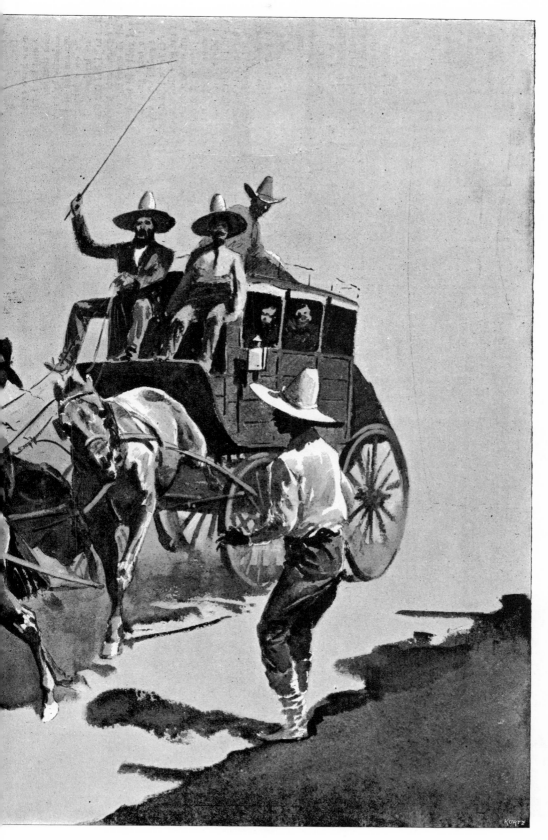

ALL OFF IN A BUNCH.

The coach starts by gray dawn, and we are aroused at an early hour. The white men take sponge baths in a wash-basin, and the native who stands about deep in the folds of his serape fails utterly to comprehend. He evidently thinks a lot, but he doesn't say anything. I suppose it seems like "clay-eating" or penitents' mutilations to him — not exactly insanity, but a curious custom, at any rate. On the return trip we have a half-broken team of buckskin broncos, which have to be "hooked up" with great stealth. And when the coachman had climbed quietly into the box and we were inside, the guards let go of the team and the coachman cracked his whip, while we looked out of the window and held our breath. Then there were horse pyrotechnics, ground and lofty tumbling — Greatest Show on Earth — for about a minute, when we made a start down the big road, or didn't, as the case might be. After the first round we often had to get out, and would find that two ponies had

got themselves into the same collar. We would then rearrange them and hope for better luck next time.

In Mexico they drive four mules abreast in the lead and two on the pole, which seems to be an excellent way. Mexican coachmen generally keep "belting" their stock and yelling "Underlay mula," which is both picturesque and unintelligible. Our man was, however, better educated. Forty or fifty miles is a day's journey, but the exact distance is so dependent on the roads, the load, and the desire to "git thar" that it varies greatly.

We pass the Guerrero stage as it bowls along, and hundreds of heavy creaking ox carts as they draw slowly over the yellow landscape, with their freight, to and from the mines. Bunches of sorrowful *burros*, with corn, wood, pottery, and hay, part as we sweep along through and by them.

We have the inspiring vista of Chihuahua before us all the time. It is massive in its proportions and opalescent in color.

AN EARLY MORNING BATH.

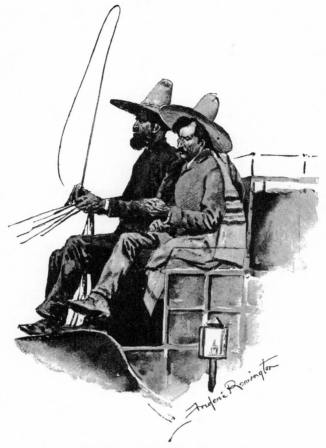

THE BOX OF THE BAVICORA COACH.

There are turquoise hills, dazzling yellow foregrounds — the palette of the "rainbow school" is everywhere. There are little mud houses, ranches, and dirty little adobe towns to pass, which you must admire, though you may not like them. Gaunt cattle wander in their search for grass and water, and women squat by the riverbed, engaged in washing or in filling their *ollas.*

The people are enchanting. It is like reading the Bible to look at them, because it is so unreal; yet there they are before one, strange and mysterious, and, like other things which appeal to one's imagination, it would be a sad thing if one were to understand them. One is tempted to think that the people of our Northern races know too much for their own good. When I heard the poor Mexican asked why he thought it had not rained in eighteen months, he said, "Because God wills it, I suppose." And

we were edified by the way they shifted the responsibility which Farmer Dunn in our part of the world so cheerfully assumes.

One afternoon we were on a down grade, going along at a fair pace, when a wheel struck a stone, placed there by some freighter to block his load. It heaved the coach, pulled out the king-pin, and let the big Concord down and over on its side. The mules went on with the front wheels, pulling Jack off the box, while we who were on top described graceful parabolic curves and landed with three dull thuds. I was caught under the coach by one leg and held there. A guard inside made all haste to crawl out through a window, and after a bit I was released; we were all pretty badly bruised, and Mr. H— had his foot broken. The mules were recovered, the coach righted, and we were off again. We made the town of Tamochica that night, and the

townsfolk were kind and attentive. They made crutches, heated water, and sent a man to the creek to catch leeches to put on our wounds. Two men were shot in a house near by during the night, and for a few minutes there was a lively fusillade of pistol-shots. It was evident that life in Tamochica would spoil a man's taste for anything quiet, and so as soon as we could move we did so.

We passed an old church, and were shown two Jesuits who had been dead over a hundred years. They were wonderfully preserved, and were dressed in full regalia. I wondered by what embalmer's art it had been accomplished. A guard of "punchers" met us to conduct us over a mountain pass. They were dressed in terra-cotta buckskin, trimmed with white leather, and were armed for the largest game in the country. The Bavicora coach has never been robbed, and it is never going to be, or, at least, that is the intention of the IF folks. One man can rob a stage-coach as easily as he can a box of sardines, but with outriders before and behind it takes a large party, and even then they will leave a "hot trail" behind them.

One morning as I was lolling out of the window I noticed the wheel of the coach pass over a long blue Roman candle. I thought it was curious that a long blue Roman candle should be lying out there on the plains, when with a sudden sickening it flashed upon me — "giant powder!" The coach was stopped, and we got out. The road was full of the sticks of this high explosive. A man was coming down the road leading a burro and picking up the things, and he explained that they had dropped out of a package from his bull-wagon as he passed the night before. We didn't run over any more pieces. If the stick had gone off, there would have been a little cloud of dust on the Guerrero road, and I hope some regrets in various parts of the world. The incident cannot be made startling, but it put the occupants of the Bavicora coach in a quiet train of reflection that makes a man religious.

Now, as I ponder over the last stage-coach ride which I shall ever take on this earth, I am conscious that it was pleasant, instructive, and full of incident. All that might have happened did not, but enough did to satiate my taste.